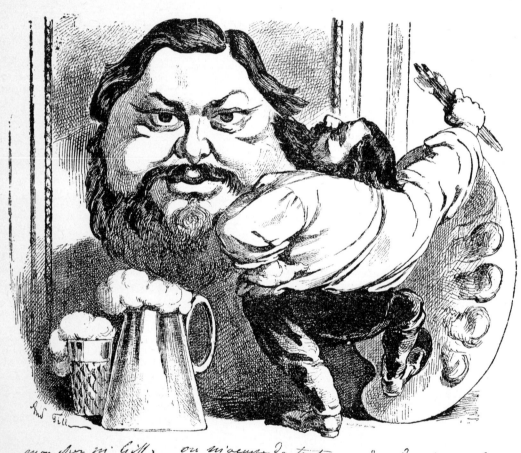

mon cher mi Gill, on m'accuse de toutes parts de dépenser trop d'argent pour l'exposition de mes tableaux — l'argent que je puis gagner, doit être dépensé par moi en le mettant chez mon notaire ... serais ... l'impression de les dépenser plus utilement

Gustave Courbet

Courbet, by himself and by Gill
La Lune (9 June 1867)

Arts Council of Great Britain
1978

Gustave Courbet

1819–1877

At the Royal Academy of Arts
19 January–19 March, 1978

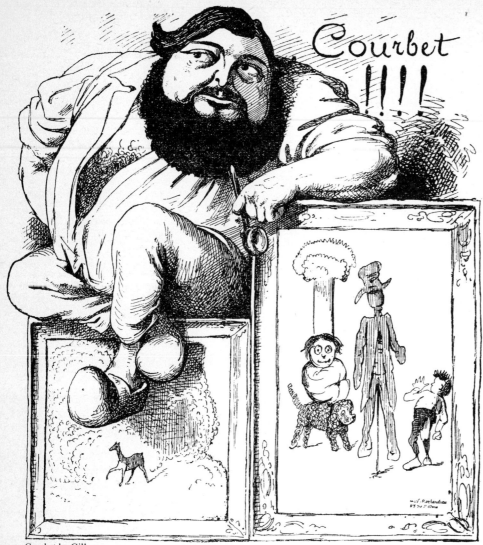

Courbet by Gill
Le Salon pour rire (1868)

Designer: Bruno Pfäffli (Atelier Frutiger et Pfäffli) Arcueil (France)
Printer: Lund Humphries, London and Bradford

Soft cover ISBN: 0 7287 0152 9
Hard cover ISBN: 0 7287 0153 7

Cover: *The corn sifters* (detail, Cat. no.42)

Organizing committee:

Alan Bowness
Reader in the History of Art, Courtauld Institute of Art

Marie Thérèse de Forges
Conservateur honoraire des musées nationaux

Michel Laclotte
Conservateur en chef du département des peintures, musée du Louvre

Hélène Toussaint

An exhibition organized by the Réunion des musées nationaux
and first held in the Galeries nationales d'exposition du Grand Palais, Paris
from 1 October 1977–2 January 1978

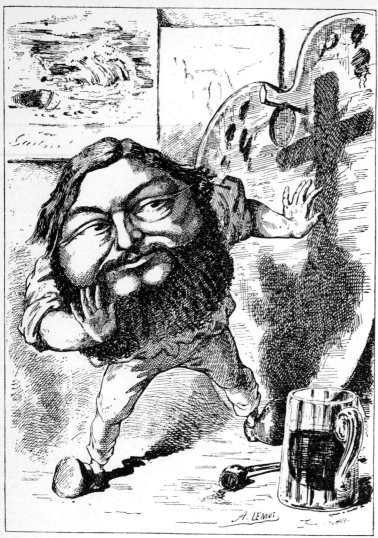

Courbet by Lemot
Le monde pour rire (3 July 1870)

It is a privilege to be able to present in London the Courbet centenary exhibition recently shown at the Grand Palais. The idea that Courbet's paintings might be seen to the fullest advantage in the great daylit rooms at Burlington House was first put to the late President of the Royal Academy, Sir Thomas Monnington, and his enthusiastic response has been sustained by Sir Hugh Casson and the Council of the Royal Academy. We are most grateful to the President and Council for putting their galleries at our disposal and grateful to all the staff of the Royal Academy who have worked with us in all the arrangements.

Like the Millet exhibition, shown at the Hayward Gallery two years ago, the Courbet exhibition has been organised by the Réunion des musées nationaux and we would like to express our thanks to Monsieur Emmanuel de Margerie, formerly Directeur des musées de France, and to the present Director, Monsieur Hubert Landais as well as to Mlle Irène Bizot, for their friendly collaboration.

The exhibition has been realised under the direction of Monsieur Michel Laclotte, Conservateur en chef du département des peintures du Musée du Louvre. The selection was made by Mlle Marie-Thérèse de Forges, Conservateur honoraire des musées nationaux, Mlle Hélène Toussaint, of the département des peintures du Musée du Louvre, and Mr Alan Bowness, of the Courtauld Institute.

The immensely informative catalogue entries have been written by Mlle Hélène Toussaint and the authoritative biography by Mlle de Forges. We are most grateful to them and to Mr Alan Bowness for his catalogue introduction. The work of translating the French catalogue was undertaken by Mr P. S. Falla with his usual skill and erudition. We have included in the English edition Mlle Toussaint's fascinating study of the *Atelier du peintre* which together with *Un enterrement à Ornans* and *Départ des pompiers courant à un incendie* could not, owing to their great size, travel to London. A number of pictures selected and catalogued by Mr Bowness have been added for London and we are most grateful to the museums and collections who have lent them, as we are to all those who have consented to part with their pictures for eight months in order that they might be seen in London as well as in Paris.

It is not possible to thank individually all the owners and museum directors who have been so helpful to us, but we should particularly like to single out the generosity of our friends in the Department of Paintings in the Louvre, and the museums at Besançon, Montpellier, and the Petit Palais. We are particularly happy that the generosity of Smith College Museum of Art enables Londoners to see once again (and under a modified title) the extraordinary painting *La toilette de la morte* shown at the National Gallery under our auspices on its way back from the Courbet exhibition in Venice in 1954.

Robin Campbell
Director of Art

Joanna Drew
Director of Exhibitions

Courbet before the letter by Gill
L'Eclipse (2 July 1870)

We would like to express our gratitude to all those people who through their generous assistance have helped in the realization of this exhibition, we are especially indebted to:

Lord Astor of Hever
Mr and Mrs James S. Deely
M. Jacques Dupont
M. Jacques Guérin
M. Adolfo Hauser
M. Kotani

Also those who wish to remain anonymous.

We would also like to thank the Trustees, Directors and Curators responsible for public collections:

Bowes Museum, Barnard Castle; Musée des Beaux-Arts, Besançon; Staatliche Museen Preussischer Kulturbesitz, Berlin; Museum of Fine Arts, Boston; Museum and Art Gallery, Bristol; Szémmqvészeti Museum, Budapest; Musée des Beaux-Arts, Caen; Fitzwilliam Museum, Cambridge; National Museum of Wales, Cardiff; Staatliche Kunsthalle, Karlsruhe; The Art Institute of Chicago, Chicago; Wallraf Richartz Museum and Ludwig Museum, Cologne; Ordrupgaard Museum, Copenhagen; Chateau-Musée, Dieppe; Musée de la Chartreuse, Douai, National Gallery of Ireland, Dublin; Art Gallery and Museum, Glasgow; Burrell Collection, Glasgow; Hamburger Kunsthalle, Hamburg; Mesdag Museum, The Hague; Musée Cantonal des Beaux-Arts, Lausanne; City Art Galleries, Leeds; Musée des Beaux-Arts, Lille; Walker Art Gallery, Liverpool; National Gallery, London; Musée de Lons-le-Saunier; Musée des Beaux-Arts, Lyon; Musée Fabre, Montpellier; Milwaukee Art Center, Milwaukee; The Minneapolis Institute of Art, Minneapolis; Musée des Beaux-Arts, Nantes; Laing Museum and Art Gallery, Newcastle upon Tyne; The Metropolitan Museum of Art, New York; Smith College Museum of Art, Northampton; Musée Gustave Courbet, Ornans; Musée du Louvre (Department of Paintings, Department of Drawings), Paris; Musée de Petit Palais, Paris; The Pennsylvania Academy of Fine Arts, Philadelphia; The Philadelphia Museum of Art, Philadelphia; Galleria Nazionale d'Arte Moderna, Rome; Kunst Museum, Saint Gallen; The Saint Louis Art Museum, Saint Louis; Museum of Fine Arts, Springfield; Nationalmuseum, Stockholm; Musée des Beaux-Arts, Strasbourg; The Toledo Museum of Art, Toledo; Musée des Augustins, Toulouse; Musée Jenish, Vevey; Worcester Art Museum, Worcester; Kunsthaus, Zurich.

The Préfet du Doubs
The President of the Association des Amis de Gustave Courbet.

The Mayors of the towns of Besançon, Caen, Dieppe, Douai, Lille, Lons-le-Saunier, Lyon, Montpellier, Nantes, Ornans, Paris, Pontarlier, Strasbourg, Toulouse.

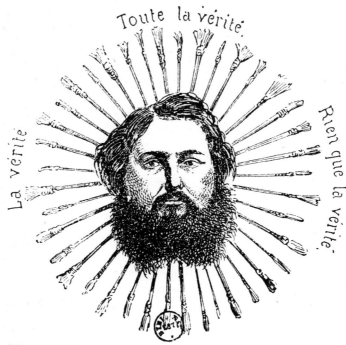

'The master' by Randon
Journal amusant (1867)

If you look carefully at the lower right hand corner of Courbet's first portrait of Alfred Bruyas (1853; 31), you will see that the sitter's hand rests on a book. This is inscribed: *Study of Modern Art. Solution. A. Bruyas*. Now Bruyas was the young Montpellier banker who had come forward at a critical moment for Courbet, his exact contemporary, with encouragement that was not merely financial. He was, the painter thought, willing to sponsor the exhibition that would allow Courbet to show his revolutionary new paintings to the Parisian public alongside his patron's own private collection. This was to be the *Exhibition of paintings by the master Courbet and from the Bruyas Gallery* of which Courbet speaks in a letter to Bruyas, probably written very early in 1854.[1]

But to return to the portrait, and the mysterious volume in its corner. There was never any book of this title, and the paradox of the realist painter depicting a non-existent book should remind us that Courbet's art is never simple. In a sense then, the words *Etude sur l'Art moderne* are written on the picture, not on the book, and it is Courbet's own painting, not anything between the green covers, which is the study of modern art. It is also the solution, just as much as is Bruyas' patronage.

Courbet believed in 1853 that he had at last come to an understanding of the art of painting. It was perhaps the decisive year of his career, because that understanding was not confined to the *act* of painting – it embraced a new conception of art's place in society, and a new vision of society itself. Courbet was making other new friends apart from Bruyas, and among them was the anarchist, Proudhon. It is surely significant that Courbet's tribute, painted at the time of Proudhon's death in January 1865 was called, quite specifically, *Portrait of Pierre-Joseph Proudhon in 1853* (80), and to underline the point when he reworked the picture in 1866, Courbet carved *P.J.P. 1853* on the second step.

Proudhon's profound contribution to Courbet's creative thinking and doing will be discussed later: first there is more to say about the projected and never realized Courbet–Bruyas exhibition. Courbet now calls himself, for the first time, *maître Courbet*: he has served a seven-year apprenticeship[2] which had culminated in the *After dinner at Ornans* of 1848–1849 (now at Lille, see p.206). Its immediate successor, *A burial at Ornans* of 1850–1851 (in the Louvre, see p.208) was, as he told Bruyas in 1853,[3] 'my beginning and my declaration of principles'.

It is difficult to discern any clear sense of direction in Courbet's apprentice work. He was searching for a style and for a subject, and achieved neither until he began to paint *After dinner at Ornans* in 1848. Though he had some instruction from Steuben when he arrived in Paris in 1839, this was of little value or consequence to Courbet. He was always quick to deny that he had had any master, proud to claim that he had taught himself by diligent study of the paintings in the Louvre.[4]

Little more than a year after his arrival in Paris, the 21-year-old Courbet submitted a large double portrait of his Ornans friends, Cuenot and Marlet, to the Salon Jury. It was refused, as were all but three of the 24 paintings that Courbet sent in between 1841 and 1847 inclusive.[5] Courbet's temerity vis-à-vis the Salon establishment was plain from the beginning, but his natural self-confidence must at times have been sapped by the successive rejections. He had to justify his existence to his bourgeois parents, who had hoped that their only son and heir would become a polytechnician or a lawyer and no doubt thought that he was wasting his time trying to become a painter in Paris.[6]

Characteristically Courbet's first appearance before the Salon public was with his own *Self portrait with the black dog* (7) in 1844. He looks at us, with an air of supercilious disdain. His debut is made in person, and not as anybody's pupil imitating someone else's work. He is smartly dressed and coiffeured in the Parisian fashion of the day, almost a dandy, but the background is his native Franche-Comté. The artist appears to show himself out on a favourite walk, resting for a moment; alongside him are his English spaniel dog, his pipe, his sketchbook, his walking stick. All these details are important.

The *Self portrait* should remind us that Courbet came from solid, comfortable, middle-class circumstances. Both parents came from the small property and land-owning class – his father was a garrulous, convivial country farmer with an interest in new agricultural methods and improved machinery, his mother a good manager of the land and vineyards she and her eccentric husband owned.[7] No modern research has been done on the Courbet land and properties: I suspect that they may have been considerable, and the profound love of the Ornans landscape that is a constant factor

1. Borel, 1951, p.28.

2. Courbet's life seems to run in seven year cycles. He recognized this himself when, in 1855, he subtitled the *Atelier* 'a real allegory, summing up a seven year phase of my artistic life'. The visit to Saintes in 1862–1863, the Franco-Prussian War of 1870–1871, and Courbet's death at the end of 1877 are equally crucial divisions of his life.

3. Borel, 1951, p.71.

4. Two letters recently noticed by Marie Thérèse de Forges (see p.22) have shown that Courbet arrived in Paris a year earlier than hitherto recorded, and that he certainly attended Steuben's classes regularly for a time.

5. See M. T. de Forges, *A propos de l'exposition Autoportraits de Courbet: documents inédits* in *La Revue du Louvre*, 1972, no.6, pp.451–8.

6. Riat, 1906, passim; Léger, 1929, p.26; Courthion, 1950, p.25. Writing his own autobiography in 1865–1866, Courbet states 'His father intended him for the bar' and it is clear that, so far as the family were concerned, Courbet was supposed to be studying law in Besançon and during the first years in Paris. Art was at this time a side-line.

7. Riat, 1906, p.2: Courbet's youngest sister, Juliette, gave Georges Riat a great deal of help during the preparation of this biography, and showed him many family documents which have unfortunately not survived. Riat's book remains the prime source of knowledge about Courbet.

in Courbet's work can perhaps be explained because he owned a part of it. On Gustave's birth certificate, his father, then only 20 years old, is described as a *rentier*: he had a vote, which implies a substantial annual income for himself and his family. Neither Gustave nor his three sisters ever experienced poverty or needed to find work: there was always a secure financial background. The girls were farmer's daughters, who would naturally undertake everyday country tasks – Zoë and Juliette probably modelled for the *Corn sifters* (42), though whether they were accustomed to sifting corn is another matter – but they travelled to Paris, mixed with the professional classes to which their relatives belonged and could dress prettily when they wished – as we see them all in the 1852 Salon pciture, *Young ladies of the Village*, for which no.27 is the study.

Nevertheless, as a young man Gustave found it hard to live on his father's allowance, but his father was, after all, hoping he would give up art and do something sensible. Naturally Courbet liked to sell his pictures, and later at times he earned considerable sums of money. His father outlived him, so he never inherited, and there are references to his waiving financial interests in family property for the benefit of his sisters.[8] Because of events at the end of his life when he was expected to pay for the restitution of the Vendome Column, Courbet pleaded poverty, and it is difficult to find out much about his actual sources of income. But, land apart, we know for example that his socialist principles did not prevent his owning railway shares. And it is well to remember that like many of the great artistic innovators of the nineteenth century – Delacroix, Manet, Degas, Cézanne – Courbet benefited from an economic system which gave him the moneyed leisure to devote himself single-mindedly to painting.

Courbet's preoccupation with self portraiture when a young artist suggests a certain search for identity: like an actor, he appears before the public in a bewildering variety of roles, surprising us at each reappearance, and making it impossible for us to decide which is the real self portrait. Is it the young lover (11), or the merry fellow playing draughts with a friend in a tavern (10)? Is it the dreamy poet-sculptor, lost in reverie (9), or the inspired cellist (16), or the poised Renaissance artist (12)? Is it the dying man (33), or the lunatic (5)? By 1849 when Courbet painted himself as the *Man with the pipe* (19) some sort of resolution had been achieved. As the artist later told Bruyas (who had been allowed to buy the picture after Courbet had refused the Emperor himself)[9]:

'It's the portrait of a fanatic, an aesthete; the portrait of a man, disillusioned with the stupidity that made up his education, who is now trying to live in harmony with my principles. In my life I've done many self portraits, corresponding to the changes in my state of mind. In a word, I've written my autobiography.'

Self portraiture apart, no subject matter made an immediate appeal to the young painter. By 1848 he had tried almost everything – biblical subjects (*Lot and his daughters*, refused at the 1844 Salon), literary illustration (*Souvenir of Consuelo*, after George Sand, refused in 1847 – see 16), nudes, genre painting, portraits, landscapes. There was an absence of commitment in what he was doing, and perhaps this partly accounts for the lack of Salon success. But, as he told his parents on 23 March 1847[10]: 'to become known, you have to exhibit, and unfortunately there's only this one exhibition'. He would try yet again to paint a big picture for the next Salon.

It was at this moment, in 1847, that Courbet moved into a new circle of friends – the Paris literary Bohemia of his contemporaries, Champfleury (1820–1889) and Baudelaire (1821–1867). This marked a major change. For the first seven years in Paris he had spent his time mainly with old companions of school and college days – Adolphe Marlet, an aspirant painter, like himself; Alphonse Promayet, a music student; Urbain Cuenot, a wealthy playboy and constant café companion and convenient model for Courbet. These were his closest friends, with whom the summer days in Ornans were also passed.[11]

Significant too, were the political contacts that the young Courbet had made. There is no echo of this in Riat's biography, which was written with the help of Courbet's sister, Juliette, and perhaps Courbet had hidden his activities from his own bourgeois family. In 1866, however, he wrote in the third person a short note about himself for Victor Frond,[12]

'This man, of complete independence, from the Doubs and Jura mountains, republican by birth through his maternal grandfather, pursued the revolutionary ideas of his father, a liberal of 1830 and a sentimentalist, and of his mother, a rationalist and a Catholic republican. He forgot the ideas and the teaching of his youth to follow in 1840, socialists of every sect. On his arrival in Paris, he was a Fourierist. He followed the disciples of Etienne Cabet and of Pierre Leroux. At the same time as painting, he continued his philosophical studies. He studied the French and German Philosophers, and was for ten years with the publishers of the *Réforme* and the *National* among the active revolutionaries right up to 1848. Then his pacifist ideas failed when faced with the reactionary behaviour of the liberals of 1830, of the Jacobins, and of the restorers of a spiritless history.'

8. Mack, 1951, pp.223–4.

9. Borel, 1951, pp.19–20, but in the manuscript the word in the first sentence quoted is *esthète* (aesthete) and not *ascète* (ascetic) as Borel gives it.

10. Riat, 1906, p.45.

11. Riat, 1906, pp.9, 40, etc.

12. Courthion, 1950, p.27.

Courbet's political ideas were to develop slowly, and it is to his new literary friends that Courbet must surely be referring when he writes home to his parents early in January 1848[13]:

'My picture is progressing rapidly. I hope to finish it for the Salon exhibition, and if it is accepted it will be most helpful and will secure me a great reputation. In any event I am on the threshold of success, for I am surrounded by people, very influential in the press and the arts, who are enthusiastic about my work. At last we are about to found a new school, of which I shall be the representative in painting.'

Now the new school is not, as one might imagine, that of realism, for the picture on which Courbet was working was a *Classical Walpurgis Night*. It was the largest he had yet attempted – its framed size measuring $2·50 \times 2$ metres – and though Courbet later painted it out and used the canvas again[14] we know what it looked like, because Jean Gigoux visited the studio in the winter of 1847–1848 and wrote[15]:

'I saw on the enormous canvas a Nymph pursued by some kind of Apollo, who had his arms extended, was running with the steps of a gymnast, and to crown it all, was wearing a dress coat – a swallow tail one – and the floating tails kept in step with the movements of his legs – and a large felt hat over his ears in the fashion of the day . . .'

Georges Riat, probably following information given to him by Juliette Courbet describes the picture more succinctly[16] as 'an alchemist pursuing a young woman who personifies Nature'; and Silvestre, Courbet's first biographer interpreted it[17] as 'Nature escaping Science'.

Given the size, and the energy required to produce it, we can scarcely dismiss the *Classical Walpurgis Night* as a joke. It appears to have been a rather naïve attempt at a modern allegory according to the Baudelairean precept, expressing the painter's pursuit of nature in terms similar to those that Cézanne was to use twenty years later in such paintings as the *Pastorale*.[18]

There are two more lost paintings by Courbet, probably executed in 1847 or 1848, which also fall into this modern allegory category. Courbet told Silvestre (probably in 1853),[19] that he had painted 'a large allegorical picture: *Man delivered from death by love*. Laughing, death carried off a woman that the distracted lover (portrait of Courbet) was striving to contest with him. Soon the idea of this picture seemed false to me, and I said to myself: why hate Woman? . . . I began to understand tolerance and freedom, which are the principles of Realism'.

The third allegorical painting is described by Silvestre[20] as follows:

'France, in a chariot drawn by both healthy horses and old nags, pulling in opposite directions, alternately pushed by both revolutionaries and conservatives, while the Jesuits put spokes in the wheels – it's a silly picture, happily abandoned. *The chariot of state* now amuses the rats in some attic or other.'

The conception of *The chariot of state* may well be connected with the competition for an allegorical picture of the new Republic which Courbet tells his parents on 17 April 1848 he has decided not to enter.[21] It seems to reflect that mood of growing disenchantment felt by both Courbet and Baudelaire after the euphoric moment of the February Revolution had passed. Their original excitement was expressed in the appearance of a 4-page radical magazine *Salut Public* (*Public Salvation*), edited by Champfleury, Baudelaire and Toubin, for the second and last number of which (1/2 March 1848) Courbet designed the cover. His top-hatted figure urging the crowd of workers across the barricade is a pastiche of Delacroix's *Liberty guiding the people*, newly on public view in Paris after many years of official neglect, and an example of a modern allegory at which Baudelaire must have looked with enthusiasm.

There was no jury to vet the submissions at the 1848 Salon, and 5,500 works were exhibited – nearly three times the usual number. Though Courbet showed no less than seven paintings and three drawings, he attracted little attention. Scarcely anyone seems to have commented upon the *Classical Walpurgis Night*. Baudelaire had stopped writing about modern art, and saw no reason to defend his friend. Only Champfleury wrote an enthusiastic notice,[22]

'I tell you here and now, remember it. This one, the unknown who painted the *Night* will be a great painter one day. Theophile Gautier, who likes to discover new talents, and looks for them, has forgotten him. The painter is called Courbet. He has left for the mountains to follow nature which he hasn't seen since the republic.'

13. Mack, 1951, p.45.

14. For the painting of the *Wrestlers* (Sacon, 1853), now in Budapest. When this was exhibited in 1867, Courbet wrote in the catalogue: 'Underneath the *Wrestlers*, you would find, if you scraped it, the *Walpurgis Night*, an allegorical picture based on Goethe's *Faust* – one of the artist's first attempts.' Unfortunately, the *Wrestlers* could not be included in the exhibition, and has not yet been X-rayed or subjected to the kind of detailed examination the laboratories of the Louvre have undertaken with such spectacular success.

15. *Revue franc-comtoise*, October 1884.

16. Riat, 1906, p.31.

17. Courthion, 1948, p.38.

18. Venturi, *Cézanne*, 1936, no.104.

19. Courthion, 1948, pp.37–8.

20. *Op. cit.*, p.38.

21. Riat, 1906, p.49.

22. *Champfleury*, ed. Lacambre. *Le Réalisme*, 1973, p.153.

Young painters, still uncertain of their direction, are often inclined to produce paintings that they imagine will appeal to persuasive and influential critics. Was not Manet a few years later to paint *The absinthe drinker* for Baudelaire and *The Spanish guitarist* for Gautier? I believe that Courbet, having tried and failed to produce the kind of modern allegory that might have been expected to meet Baudelaire's favour, was now asking himself what kind of painting his other new writer-friend, Champfleury, would like.

Champfleury was a supporter of the new regionalism that was emerging in the later 1840s with such works as George Sand's short novel *La mare au diable* (*The Devil's pool*) of 1846 and the Breton paintings of the Leleux brothers. If Baudelaire remained wedded to Romanticism – (had he not declared in the Salon of 1846[23] that 'who says Romanticism says modern art'?) – Champfleury believed that Romanticism was at an end, and that a new, post-Romantic art, was a necessity.

The subject matter was to be found in the here and now, presented in as simple and unforced style as possible. No message, no moral, no drama – simply a statement of fact. So Courbet, perhaps having just read Champfleury's encouraging words, sat down and painted the *After dinner at Ornans*. 'It was in the month of November, we were at the house of our friend Cuenot, Marlet had returned from hunting, and we had asked Promayet to play the violin for my father' – this was how the artist described his picture in a note provided for the Salon of 1849.[24]

This painting, which was only exceptional because of its size, made Courbet's reputation, bringing him the coveted gold medal that would give him immunity from Salon juries in the future. The most enthusiastic review once again came from Champfleury:[25]

'Courbet forces the Salon doors with nine paintings. Yesterday no one knew his name: today, it's on every tongue. For a long time there's not been such a sudden success . . .

Last year I was the only one to mention his name and his qualities, the only one to speak with enthusiasm about certain pictures hidden away in the last Salon . . . I was not mistaken . . . Courbet has dared to paint a genre picture life size . . . This picture could be brazenly hung in the museums of the low countries, among Van der Helst's grand assemblies of burgemasters . . . Courbet, before many years are out, will be one of our greatest artists.'

Courbet returned to Ornans full of confidence in the summer of 1849. He had just celebrated his thirtieth birthday, and was determined to prepare for the next Salon an entry that would confirm his reputation as the outstanding painter of his generation. In quick succession he set to work on three more large pictures: *The peasants from Flagey returning from the fair, Ornans* (206 × 275; 39), *The stonebreakers* (159 × 259;

destroyed in Dresden in 1945) and *A burial at Ornans* (314 × 665; in the Louvre).

The first two are roadside subjects, from what Courbet called *The high way series*[26] – everyday scenes, familiar to any Ornanais – Regis Courbet returning from market with his farm hands, driving a pair of oxen to be fattened up: old Gagey and his boy at work breaking stones for the road. There are many precedents for both subjects, and the *Stone breakers* belongs to that sub-genre of occupations which had become fashionable in the 1849 Salon with Bonvin's *The cook, or the woman cutting up bread for soup* (which attracted Champfleury's enthusiastic praise[27]) and Millet's *Winnower* (which the pose of Courbet's boy echoes, perhaps consciously).

In view of the subsequent interpretations placed on *The stone breakers*, and to some extent accepted by Courbet, it is important to note that the artist's motive in choosing the subject was not, so far as we can tell, political. He writes to his friends, M. and Mme Francis Wey, on 26 November 1849[28]:

'I had taken our carriage and was going to the Chateau of Saint Denis, near Maisières to paint a landscape. I stopped to look at two men breaking stones on the road – it's very unusual to come across such a total expression of misery and destitution. The idea of a picture came to me at once. I asked them if they would come to my studio on the next day, and since then I've been working on my picture . . . Would you like me to describe it to you? On one side is an old man of seventy, bent over his work, his hammer in the air, his skin tanned by the sun, his head covered by a straw hat; his trousers of coarse material are all patched, inside his cracked wooden shoes are faded blue socks through the holes of which his heels show. On the other side is a young man with a dusty head and a grey-brown complexion, through his filthy tattered shirt you can see his back and arms, one leather brace holds up the remains of a pair of trousers and his leather boots, mud covered, gape sadly in many places.

23. Baudelaire, *Œuvres complètes*, 1976, II, p.421.

24. Published by M. T. de Forges, *op. cit.* The picture was bought by the state, and presented to the Museum at Lille after the closure of the Salon. Its size (195 × 257 cm) and delicate condition made it impossible to bring the picture to London.

25. *Champfleury, op. cit.*, pp.154–5.

26. Borel, 1951, p.29. *The return from the conference* (1863; destroyed deliberately by a pious owner) and *The charity of a beggar at Ornans* (cf.p.182) also belong to the series.

27. 'It's a picture which can stand for a whole school of young painters, a new generation which sets out from principles opposed to those of the Romantic painters of 1830', *Champfleury, op. cit.*, p.119.

28. Francis Wey: *Etude sur G. Courbet.* This is an unpublished manuscript in the Bibliothèque Nationale (Estampes), some parts of which appear in Courthion, 1950, pp.75–6.

The old man is on his knees, the young man behind him standing, carrying with vigour a basket of broken stones. Alas, in these jobs this is how you begin and how you end . . . All around is scattered their gear – a basket, a barrow, a pickaxe, etc. Everything takes place in full sunlight, out in the country, by the side of a ditch in the road . . .'

We should observe how Courbet enumerates the content of his painting: indeed, so striking was his description that Francis Wey plagiarized this passage in the novel he was writing, *Biez de Serine*. But here Courbet suggests, I believe, how we should look at his pictures. The scene represents for him 'a total expression of misery and destitution', but he seems to accept the conditions that condemn men to a life of toil: 'in these jobs, this is how you begin and how you end'. The sentiments are conventionally humanitarian and hardly revolutionary (*The stonebreakers* was after all requested for the official Exposition Universelle in 1855). What catches Courbet's interest are the objects that he remembers seeing and describes so vividly to the Weys. And it is his concern to render them in paint, exactly as they are.

It is this strikingly matter-of-fact quality which also characterizes *A burial at Ornans*, but the message is both more personal and more universal. The pit of the grave opens at our feet, and as we raise our eyes, although most heads are turned away, some faces look at us as if to remind us of our own mortality. We are confronted with the people of Ornans, each one a particular and identifiable person.

When Courbet began to paint *A burial at Ornans* it aroused great public interest. 'Everybody wants to be in the *Burial* – I'll never satisfy them all', he told Champfleury.[29] The picture was after all a celebration of the little town, or more specifically I believe, a celebration of the contribution made to the town by Courbet's maternal grandfather, Jean-Antoine Oudot.

Courbet's triumphant return in 1849 had been overshadowed by the absence of his grandfather, who had died the preceding year. Perhaps because of their closeness in age, Courbet showed little respect to his father: his grandfather, however, he clearly venerated, and it was from him that Courbet took his anti-clerical and republican opinions.[30] We can surmise that the death of his grandfather was a profound and moving personal experience for the young painter, which demanded commemoration in paint. And it was a homage that cannot be construed as anti-religious, as Hélène Toussaint has shown in her study of the picture (see p.208).

Yet Courbet did not simply paint a reconstruction of the funeral scene. In fact his grandfather is present in *A burial at Ornans*, for he is the figure on the extreme left. Standing in the centre, on the left of the man weeping into his handkerchief, is Régis Courbet, with Courbet's mother on the extreme right, holding a child by the hand, Courbet's three sisters, from left to right, Juliette, Zoë (her face covered) and Zélie, are prominent among the female mourners. Closer to the grave are the town's dignitaries, and the contemporaries of the dead man. If the grave-digger has a position of prominence it is not that he is the only worker in the picture (a dubious proposition) but because he is the one who will see us all to our earthly ends. And if there is an absentee in the picture it is surely the painter himself.

In choosing his canvas size and arranging the figures in his composition Courbet no doubt remembered the *Romans of the decadence* which had made Couture's reputation at the 1847 Salon. He was also aware of the paintings he had seen in Holland in 1846, especially Rembrandt's *Night watch* and the Dutch burghers depicted by Van der Helst whom Champfleury so admired; aware of the Zurbarans in the Galerie Espagnole and of Velasquez' *Thirteen cavaliers* in the Louvre; aware of the Le Nains, French provincials like himself, Laônborn like Champfleury who was promoting their revival; aware too of the popular religious prints familiar to him from childhood.

Nevertheless *A burial at Ornans* is entirely Courbet's picture, and something quite new in the history of art. Not for nothing did Courbet call it 'my beginning and my declaration of principles'. It was also 'the burial of Romanticism',[31] for Courbet was re-defining the possibilities of art, making the statement that the artist can paint only what he sees and what he has himself experienced. Human experience can however be universal, and never more so than in our awareness of the finality of death. As Baudelaire had said in those prophetic words in the closing sections of the Salon of 1846, when he asked for a new tradition that would match the beauty and heroism of modern life: 'we all celebrate some burial'.[32] And Courbet had found a style appropriate to the representation of modern life: arbitrary, concrete, naïve in Baudelaire's sense of the word.[33]

The 1850 Salon had been postponed until the end of the year because of the uncertain political situation: when it finally opened *A burial at Ornans* created a sensation (little notice was taken of *The stonebreakers*). It was ugly: 'Is it possible to paint such frightful people?'; it was an 'ignoble and impious caricature', 'a disgraceful picture . . . it must be nauseating to be buried at Ornans'.[34] The latent antagonism between Paris and the provinces suddenly came into public view.

Worst of all, *A burial at Ornans* was assumed to have a political intent: it was socialism, and its creator was 'the

29. Champfleury, *Souvenirs . . .*, 1872, p.174.

30. Courthion, 1950, p.49.

31. Riat, 1906, p.191.

32. Baudelaire, *Œuvres complètes*, 1976, II, p.494.

33. Courthion, 1948, pp.92–3.

34. Riat, 1906, pp.86–7.

messiah of democratic art'.[35] Courbet's friend Cuenot, writing to the painter's sister Juliette in Ornans on 13 February 1851,[36] tried to reassure the family:

'In some drawing rooms they maintain that Courbet was a carpenter or a builder's mason who, one fine day, driven by his genius, began to paint and then produced masterpieces at the first attempt. In others they assert that he's a terrible socialist, the leader of a band of conspirators. You can see that from his painting, they say. This man's a savage ... And every day there are more nonsenses debited against his account.'

Champfleury, writing in the *Messager de l'Assemblée* on 25/26 February[37] also tried to quash the idea of Courbet as a political painter: 'there is not a shadow of socialism in *The Burial* ... It's the death of one bourgeois who is followed to his last resting place by other bourgeois ... It shows the modern bourgeoisie, with its absurdities, its ugliness and its beauty.'

Of course one can argue that Courbet was caught up in the revolutionary spirit of 1848 and its aftermath and could hardly fail to produce political pictures. Courbet himself was later quite prepared to accept the label 'socialist painter'. We find him writing from Ornans on 19 November 1851 to declare publicly in the *Messager*[38] that he is 'not only a socialist, but also a democrat and a republican – in a word a supporter of the Revolution, and, above all, a Realist – that is to say, a sincere friend of the truth'.

But even granted that these were Courbet's own political convictions, it does not necessarily follow that he believed that his painting should embody those convictions. And this is an interpretation of Courbet's art too often and too easily made. Those who want to argue that Courbet had become a political painter must explain why his magnificent debut with the *Stonebreakers* and the *Burial* should have been immediately followed by such paintings as the *Young ladies of the village giving alms to a cow girl in a valley at Ornans* (cf. 27), already in the collection of the Prince President's half brother when shown at the 1852 Salon, or *The sleeping spinner* (29), *The bathers* (30) and *The wrestlers*, Courbet's three submissions in 1853. One must assume that Courbet was already beginning to decline, had lost his nerve etc.[39] – and this is not I believe a reasonable interpretation of the painting.

The bathers and *The wrestlers* might have been designed as demonstration pictures of the female and male nude figures – primitive, uncouth even; female sensuality compared with male virility. The women's gestures, which so puzzled Delacroix,[40] surely indicate mutual admiration. There is a whole language of gesture in Courbet's painting; compare, for example, the encircling arms of *The sleeping spinner* and those of the foreground figure in *The young ladies on the banks of the Seine in summer* (49). But the meaning of *The bathers* is deliberately veiled, I believe, hiding perhaps a first statement of that interest in the lesbian relationship which so fascinated Courbet and reached its culmination in *Sleep* (90) of 1866.

And if the models of *The bathers* were, as has been suggested,[41] Courbet's mistress Josephine and perhaps with her, but clothed, Zoë, the most impetuous and outspoken of his sisters, then the reasons for concealment are even stronger. We have no more than a hint of those private sexual relationships between Courbet and his sisters and his mistresses which undoubtedly permeate the paintings. Zoë in particular was very close to her brother at this time, and she posed, I am sure, for the nude model in *The studio*.[42] She rather than Zélie may be *The sleeping spinner* (29), a painting in which the sexual symbolism of the objects – distaff and wheel linked by a thread – is particularly striking.

The spinner is asleep, and Courbet's association of sleep and sexuality is another constant feature of his art. Sleep, dream, trance fascinated Courbet – witness *The sleepwalker* (45), who is however in a drugged state rather than sleep-walking. Some of Courbet's closest friends were involved in the revival of interest in mysticism and the occult which stirred intellectual circles in the early 1850s. Many were freemasons, and, although as yet no positive evidence for Courbet's association with freemasonry has been found, Hélène Toussaint's suggestion that this may explain certain baffling aspects of his great painting of 1855, *The artist's studio* (see p.218), must be given serious consideration. The breadth of Courbet's interests and contacts should never be under-estimated.

The mysterious sensuality of *The sleeping spinner* is also to be found in the next major painting, *The corn sifters* (42). Again Courbet's sisters posed for him, and again there is an obvious echo of an old master painting – in this case, Velasquez' *Spinners* (*The fable of Arachne*). But Courbet's painting is remarkable on two counts that might appear to be contradictory. On the one hand, it is such an intense record of the painter's visual sensations that conventional spatial constructions are jettisoned and each object is presented separately and with extraordinary directness; on the other hand the painter's formal language now imposes itself so strongly that the elliptical shape of the sieve in the centre of the picture

35. Phillipe de Chennevières, quoted in Riat, 1906, p.86.

36. Courthion, 1948, p.98.

37. Quoted in Riat, 1906, p.90.

38. Riat, 1906, p.94.

39. A point of view expressed by Clark, *Image of the People*, 1973, p.15, where he speaks of a 'decline after 1856'.

40. *Journal*, 15 April 1853.

41. Riat, 1906, p.103.

42. This was first suggested by G. Grimmer in his article on Zoë Courbet in the *Bulletin des Amis de Gustave Courbet*, 1956, no.17–18, p.5.

sets up a rhythm that dominates first the central figure and then the whole composition.

Courbet took this kind of painting a stage further in the picture hitherto known under the title, *The toilet of the bride*, but correctly called, as Hélène Toussaint makes clear, *Laying out the dead woman* (24). In this great picture Courbet reached the position where he could no longer bring the work to a conclusion and had to abandon it unfinished. The composition revolves around the central group of the woman and her attendants, in which Courbet establishes forms and pictorial rhythms (notice the positioning of the arms) that extend into the subsidiary activities of spreading the winding sheets and preparing the funeral repast. Courbet now reconciles his plastic (sculptural) and painterly treatment of the human figure. Everything takes place in the same space, and that space is not seen from a fixed perspective position, but is explored by Courbet's eye, searching for information which is then recorded on canvas in as direct a way as possible. Here is a remarkable anticipation of the way Cézanne was to paint, recording what the eye sees, distorting anatomy and natural forms in order to approximate more closely to our visual sensations.

The corn sifters was probably begun in 1853, and it is in this year that Courbet reached a full awareness of his maturity as a painter. He has the solution to the problem of modern art; he now knows the final form of painting. This awareness however was not purely a matter of knowing how and what to paint – he knew also what sort of person the painter should be. In an undated letter to Francis Wey, probably written in 1850, Courbet had already said:[43]

'In our over-civilized society, I must lead the life of a savage – I must free myself even from governments. The ordinary people have my sympathies – I must speak to them directly, draw my inspiration from them, find my livelihood from them. Because of that I have just embarked upon the wandering and independent life of a gypsy.'

Thus the artist is necessarily an outsider: he may draw strength *from* the people, but he must not and cannot identify *with* the people – he must retain his independence.

Courbet no doubt took some years to reach this position, but was forced to clarify it in 1853. When told by the Director of the Beaux-Arts, Nieuwerkerke, that the government would like him to contribute an important work to the projected 1855 Exposition Universelle, Courbet refused. He was not prepared to accept the authority of any selection committee; indeed he did not consider that the artist should accept any authority at all. He explained what had happened in a letter to Bruyas, written late in 1853:[44]

'I replied at once that I didn't understand a word he said, since he claimed to be a government and I did not consider myself in any way a part of that government. I told him that I was a government too, and I challenged his to do anything whatever for mine that I could accept . . .

I went on to tell him that I was the only judge of my own paintings; that I was not only a painter but also a man; that I painted, not to produce art for art's sake, but rather to establish my intellectual freedom; that through the study of traditional art I had finally liberated myself from it; and finally that I alone, of all the French artists who are my contemporaries, had the strength to express and represent in an original way both my own personality and society itself; etc. etc. . . .'

It is in this letter that Courbet shows most clearly, I believe, his debt to Pierre Joseph Proudhon.[45] There was certainly a strong bond of personal sympathy between painter and anarchist philosopher, both from the Franche-Comté. Courbet had visited Proudhon in prison, and was with him on the day of his release in June 1852. He shared Proudhon's hatred of central government, his preference for country against town, his dislike of the ideal, his pacifism, his faith in a classless society. The little community of Ornans, to which Courbet remained devoted, could serve as a model for the society of the future. It was real, a practical solution and not a utopian one. We should always remember that Courbet was a pre-Marxist, and never thinks in terms of a class struggle, nor does he show any interest in the rise of the urban proletariat. More importantly he saw that the artist could only operate if he had absolute freedom, and owed no obligation to anyone. 'I was a government too', Courbet had told the Minister, thus establishing his belief in the artist as anarchist. And if the government was going to have a major art exhibition in 1855, then he would have a major exhibition too, and his new friend, Alfred Bruyas, the Montpellier banker and collector, was at hand to provide the necessary backing.

In the major work that he himself provided as the centrepiece for his exhibition in 1855 Courbet offers us the visual expression of his ideas on the grandest possible scale. *The painter's studio, a real allegory summing up seven years of my artistic life*, is Courbet's consummate achievement – mysterious, ambiguous, open to endless interpretation, 'one of the most unusual works of our times', as Delacroix immediately recognized.[46] In a letter to Champfleury, written very late in 1854,[47] Courbet claimed that the picture would show:

43. Riat, 1906, pp.80–2.

44. Borel, 1951, pp.68–70.

45. I am preparing a study on the relationship between Courbet and Proudhon, for publication in the March 1978 number of the *Burlington Magazine*.

46. *Journal*, 3 August 1855.

47. The complete text of this letter was published for the first time by Hélène Toussaint in the Paris edition of this catalogue: it appears (in Mr Falla's translation, which differs slightly from mine) on pp.254–255.

'that I am not yet dead, and nor is realism, since it's realism we're on about. It's the moral and physical history of my studio, part one; these are the people who support me, sustain my ideas and share my activities. These are the people who thrive on life, and who thrive on death; this is society seen from the top, from the bottom and from the middle – in a word, it's my way of seeing society in all its interests and passions; it's the world which comes to me to be painted . . .

The scene is set in my Paris studio. The picture is divided into two parts, and I am in the middle, painting. On the right are all the shareholders – that is to say, friends, workers and art lovers. On the left, is the other world of everyday life – the masses, misery, poverty, wealth, the exploited and the exploiters – people who live on death. In the background, hanging on the wall, are the paintings of *The return from the fair*, *The bathers*, and the picture I am working on now . . .

I will tell you who everybody is, starting on the extreme left . . .'

And Courbet continues, giving us an exact inventory of the content of his painting in its then still unfinished state.

'The painter steps back from the picture.'[48] Courbet's *Studio* invites extended analysis of the order given by Michel Foucault to one of its precursors, Velasquez' *Las meninas*. There is time here to observe only that the scene is in no sense a reconstruction of an assembly of friends and models in Courbet's Paris studio: the composition is additive and synthetic. As Delacroix observed, the painting on the easel invites us to enter a world more 'real' than anything we see in the studio itself; and the artist who paints it, with his supporting group of child, dog, and nude model, exists in that overlapping middle position belonging to both the opposing groups on right and left of him. Courbet's major paintings of the early 1850s have all been about confrontation – his sisters confront the goatherd, the wrestlers fight one another, the bathers respond to each other's sexuality. Then Courbet presents himself as protagonist – he meets Bruyas at Montpellier (34), he greets the Mediterranean sea at Palavas (36). But in *The painter's studio* Courbet proposes a more complex triadic structure: the moment of confrontation certainly exists between the masses and the friends (who in their turn repeat the male versus female arrangement of *The burial at Ornans*) but there is now a central group which resolves the dialectical programme. Courbet places himself, as the artist-creator, in that middle position of ambiguity in order to convey to the spectator something of the special, magical, sacred position in society which he sees the artist as possessing.

It is a position of total independence, which Courbet publicly adopted when he showed *The painter's studio* in an exhibition of forty of his pictures – the first one-man retrospective exhibition of importance ever held outside state-backed institutions. Even at this moment however, Courbet was not beyond compromise, for in the government sponsored Exposition Universelle Courbet showed eleven oil paintings, including *The stonebreakers*. But the artist had no wish to make a political gesture, then or at any time during the Empire. He was quite prepared to find some accommodation with the existing machinery of the state, providing that his basic libertarian principles were not being compromised.

Courbet labelled his one-man exhibition *Realism*, because that was what everyone now called his paintings, but in the catalogue preface he makes it clear that the term is a convenient label and nothing more. Courbet's statement, which is certainly his own work, is printed complete on p.77 of this catalogue.

After 1855, Courbet goes his own way, painting what he sees. Each of the traditional categories of painting – portrait, landscape, seascape, still life, flower piece, animal subjects,[49] the nude – is presented in its definitive, final form. This, Courbet seems to be telling us, is modern art. Moral and intellectual judgments are for the most part excluded.[50] The historical painter, depending on book knowledge and imagination, makes way for the naïve, untutored artist who works directly from nature and relies on his own sensibility. Observation is what counts. Art is a question of the artist's reaction to his subject, his way of seeing. The decisive change has been made to a style based on visual sensation: Courbet has laid the groundwork for the art of the future. We are indeed at the moment when modern art can be said to have been invented, and Courbet's grandiose claim to have found the solution is in fact the literal truth. What he could not and did not foresee was that he had provided not a definitive and final statement, but the basis from which so much was to spring.

For Courbet's painting from 1855 until his death in 1877 does not represent a decline from the ambitious middle period compositions; it is a richly suggestive body of work, uneven at times perhaps, but containing enough masterpieces to permit us to rank Courbet among the greatest of all painters. If the general public has not always been appreciative of the quality of Courbet's works, the artists themselves have, for surely no painter has ever been so widely and warmly admired by the professionals who succeeded him.

Unfortunately Courbet is still often regarded as the painter of primarily *The stonebreakers* and secondly *A burial at Ornans*, but these are, in a strict sense, immature pictures, painted before Courbet reached a full understanding of his art. The influence of *The stonebreakers* has been enormous:

48. These are the first words of Michel Foucault, *Les Mots et les choses*, 1966, p.19.

49. One can see the influence of Landseer, the most admired of English artists at the 1855 Exposition Universelle, in Courbet's paintings of animals, picnics and hunting scenes.

50. This was the opinion of Castagnary, when in his review of the 1857 Salon he wrote about Courbet for the first time. See Mack, 1951, p.146.

virtually a whole school and theory of art has been based upon this picture, and I would not wish to suggest for one moment that great ideas and great works of art have not followed in its wake.[51] But there is more to Courbet than this – the debt owed him by Monet and Cézanne is obvious, but it is evident that there is an equally strong proto-symbolist element in certain of Courbet's late works. This begins with *The studio*, which disconcerted Champfleury so much that his friendship with Courbet rapidly cooled. Courbet was not pursuing realism as Champfleury conceived it. Indeed, after Courbet's death, the critic wrote that the painter was 'on the tiresome slope of symbolizing'.[52] That same generous open-mindedness which explains Courbet's sympathetic interest in the work of Fantin and Manet, Pissarro and Renoir, Monet and Bazille, led him to be curious in 1865 about the ideas of his pupil (as he called him) Whistler, and Whistler's new friend Rossetti. The English painter was propagating a kind of art very different to that of the impressionists. But in that prolific summer of 1865 when he painted the long first series of marines that anticipate Monet's series (85, 86), Courbet also painted Whistler's mistress Jo (87) as a pure Rossetti girl.[53] And I believe that the new symbolist ideas of the Rossetti–Whistler–Swinburne circle now affected Courbet's painting. Courbet is no longer satisfied with painting the sea as it appears to the eye: he watches the great waves breaking on the Normandy coast, and sees in them the threatening, menacing power of the sea, the force of nature itself (112). The boats on the shore become symbols of people, a point taken up by Monet and then, at Saintes Maries de la Mer, by Van Gogh.

The symbolism inherent in late Courbet could scarcely be more explicit than in his association of the nude with the sea. *The woman in the waves* (106) arises, Venus-like, out of the waters – a calm sea extends behind the canopied *Reclining nude* (55). The girl in *The spring* (68) holds out her hand to feel the fresh spring water, and one could without difficulty write an essay on water symbolism in Courbet, drawing attention, for example, to the painter's fascination with caves and grottoes (69, 70) as sources of the streams that fertilize the landscape – images of a dark sexuality that should remind us of the way Courbet could project his bodily self and his deepest feelings into the landscapes that he painted.

In the last resort, we are left with the sheer materiality of Courbet's paintings, those wonderful surfaces of his pictures in which the paint itself is so vital and alive. Courbet's realism exists essentially in this, the object-ness of his work. It was this aspect that so appealed to a later generation, that of Braque and Picasso, when they sought in 1912 a way out of the dilemma into which their cubist analyses had taken them, a way of reasserting the physical rather than the illusionistic nature of art. The point is again made by André Breton in *The Political Position of Surrealism*, when he compares David, the official painter of the revolution who contributed nothing to the development of the arts, with Courbet, the revolutionary idealist whose subjects have nothing to do with insurrection, but who 'by the single virtue of his technique has greatly influenced the modern movement'.[54]

Instances of Courbet's influence of the art since his time could easily be multiplied tenfold. Redon called him 'the great realist who was simply a great painter' … 'this misunderstood classical painter'. He would like to see the *Stonebreakers* 'placed beside a Titian, of which it reminds me. Same breadth, same power'.[55] There are paintings in this exhibition which belonged to Puvis de Chavannes (86), to Matisse (20), to Segonzac (119). Chirico wrote a little book on Courbet in 1925. Picasso copied Courbet, and owned and loved his paintings. Nobody better deserves the description of a painter's painter.

One hundred years after Courbet's death the time has surely come for the artists' adulation to be shared by the general public. This exhibition, close in content and size to those arranged by Courbet himself in 1867, and by his friends in 1882, offers a magnificent opportunity for a fresh and unprejudiced reassessment of the man who claimed, with some justice, to have invented, or at least established, modern art.

Alan Bowness

51. See for example the discussion in Linda Nochlin's *Realism*, London, 1971.

52. In *Les chef-d'œuvre du Luxembourg*, 1881, p.116.

53. There is a chapter on the relationship between Courbet and Whistler in my forthcoming book, *Courbet and his friends*.

54. *La position politique du Surréalisme*, 1935, p.30.

55. *A soi-même*, 1961, pp.24, 160–1.

Biography

by Marie-Thérèse de Forges
Conservateur honoraire des musées nationaux

Jean Désiré Gustave Courbet was born at Ornans in the Franche-Comté, in the department of the Doubs, on 10 June 1819. His parents were Eléonor Régis Jean Joseph Stanislas Courbet, a landed proprietor domiciled at Flagey, and Suzanne Silvie, née Oudot. The Courbet family had lived at Flagey for centuries; a tradition that they had originally come from Spain is supported by the fact that in the eighteenth century the name is supposed to have been spelt Corbet.

The Oudot family, also landowners, lived at Ornans, five or six miles north of Flagey. This was the birthplace of Gustave Courbet's grandfather Jean-Antoine Oudot (1767) and his mother (1794), also the painter's four sisters Clarisse (1821–1834), Zoé (1824–1905), Zélie (1828–1875) and Juliette (1831–1915).

Courbet's family background was thus extremely homogeneous, and throughout his life he remained a loyal son of his native province. We know from Castagnary, who stayed more than once at Ornans, and from Courbet himself how important local and family ties were to him, and how strongly his appearance and character were marked by heredity. From his mother he inherited 'not only his large, brown, quiet eyes but also a serene and gentle disposition, kindness and sociability', according to Castagnary, who thought Madame Courbet 'sweet-natured, pious and extremely beautiful'. He believed, however, that Courbet took principally after his father, who had given him 'the higher qualities that are decisive in life: boldness, ambition and an enterprising spirit'. From both parents he inherited 'straightforwardness, good humour, honesty, a love of order and thrift'. Régis Courbet was a curious figure: Castagnary described him as noisy, given to mockery, a man of freaks and whimsies, and 'the most frightful chatterbox I ever met'. He had made plenty of money from the land, and was interested in improving conditions of work for farm labourers: a barn was filled with labour-saving devices he had invented. Gustave too, in 1868, was to spend much time trying to construct a vehicle of his own invention. Finally, Castagnary believed that the artist's 'unusual personality' owed much to Jean-Antoine Oudot: 'as all those who knew him would confirm', he had transmitted to his grandson 'two supreme sources of strength: unshakable self-confidence and indomitable tenacity' (Bibliothèque Nationale, Estampes).

1831–1838

The young Courbet began his studies at the junior seminary of Ornans, which he entered at the age of about twelve, and proceeded to a school kept by the abbé Oudot, a relative of his mother's. In the former establishment he had as a classmate his cousin Max Buchon, a year older than himself, and they remained friends till Buchon's death in 1869. The latter describes Courbet as having been a lively, noisy youth with little taste for study. An art instructor appeared in 1833 in the shape of 'père Baud' (or Beau), a former pupil of Gros who had copied the latter's pictures in his studio. Courbet was grateful all his life to this teacher, who introduced him to an artistic career and who trained his pupils to paint 'from nature'.

In the autumn of 1837 Courbet went to the Collège Royal at Besançon. He was enrolled as a boarder, but found this intolerable after the free life of the countryside, and was allowed to lodge in town from the beginning of the following year. He followed courses at the Academy and was an assiduous pupil of the painter Flajoulot, who claimed to have been taught by David and was a fervent admirer of Raphael and classical antiquity. Under his encouragement Courbet made many studies from life, while continuing to be interested in landscape. He was much attracted by lithography, and produced some specimens: at the end of 1838 he contributed four illustrations for Max Buchon's *Essais poétiques*, published in the following year at Besançon.

1839–1843

It is usually said that Courbet arrived in Paris in 1840, but two letters in the library of the Institut d'art et d'archéologie show that the correct date is autumn 1839. On 26 December of that year Courbet wrote to his parents that his life was 'as quiet as at Besançon'. He was 'still working with M. Steuben, who does not take much care of his pupils, as he only turns up every morning. He is pleased with me; I think I am the best in his studio, there are only three or four of us'. He went on to say that a cousin of the family was introducing him to friends, and that he would need a dress-coat if he was to continue 'going into society'.

In the second letter, dated 21 June 1840, he told his father of the state in which he had presented himself to the army medical board, having spent the previous night drinking a bottle of 'eau de vie de Cognacq' [*sic*] and smoking more than twenty pipes. He had also armed himself with certificates provided by his father. He had stammered so much that 'these gentry could not make up their minds' and wanted him to sit before another board in his home territory, where he was better known. He asked his father to get him another certificate, from Flajoulot for instance ('I already have one from my master, M. Steuben'), so that he would not have the bother of travelling to the Franche-Comté; this would be an unnecessary expense and harmful to his work at a time when 'I shall be doing more than hitherto, as up to now I have only been studying, and it is time to turn my studies to account'.

It thus appears that, contrary to Courbet's later claim that he was self-taught, he attended Steuben's studio for some months and regarded the latter as his master. He makes no mention in these letters of any studies other than art, although his father had planned that he should be a lawyer and this decision was encouraged by Courbet's cousin in Paris. This was Julien-François Oudot, a nephew of the painter's grandfather and a professor at the École de Droit. Born in 1804 at Ornans, 'to which he was devoted', he kept in regular touch with the family and interested himself in Courbet's artistic career, while expressing the fear that he was not receiving a sufficient grounding. On 18 November 1842 he wrote to Courbet's parents: 'Is he going about things the right way, expecting to succeed on his own and without a teacher? I doubt it somewhat, but he is convinced, and it shows courage on his part.'

Certainly Courbet was not lacking in ardour and determination. He frequented independent studios and met new friends who opened up fresh horizons: Alexandre Schanne (the 'Schaunard' of Murger's *Vie de Bohême*) and the painter Bonvin, who according

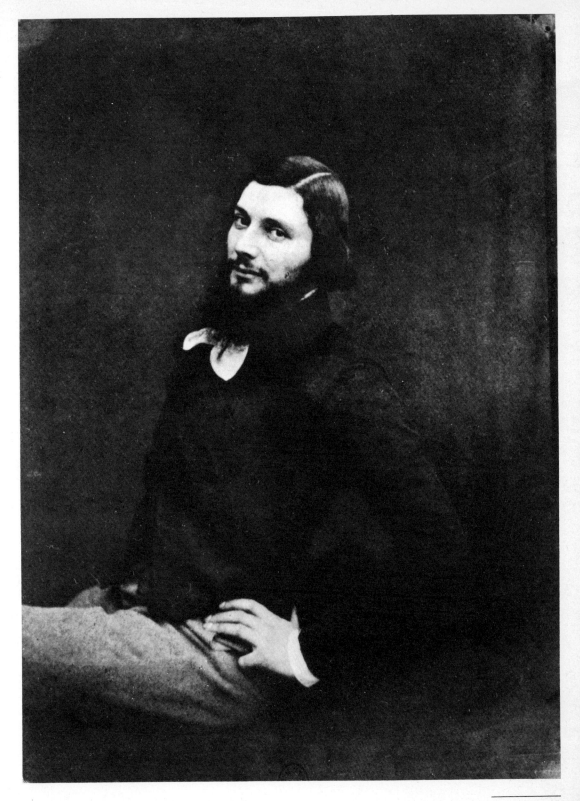

Courbet in 1853. Photo by
V. Laisné and E. Defonds,
Paris.

to Francis Wey, acted as Courbet's guide to the treasures of the Louvre. Adolphe Marlet, a friend from the Franche-Comté, introduced him to the artist Hesse, who took an interest in him and gave him advice. Courbet worked mostly in the museums, where he made many copies of pictures; few of these have survived, as he re-used most of the canvases for original works (cf. 13). He frequently proclaimed his debt to the Dutch, Flemish, Venetian and Spanish masters; as for contemporaries, curiously enough he copied not only Géricault and Delacroix but also Ziegler and Schnetz. A study after Ingres has recently been discovered beneath a self-portrait (Forges, *Annales*). His first original works were mostly romantic compositions (*Ruins beside a lake, Man delivered from love by death*), landscapes of the Franche-Comté or the forest of Fontainebleau, scenes of everyday life and portraits of himself, his friends and members of his family. Many of these pictures are only known from documents. Receipt books in the national museum archives provide a list of Courbet's offerings, all of which were rejected, for the Salons of 1841–1843:

1841
Portraits of M.M. U.C. and A.M. (Urbain Cuenot and Adolphe Marlet)
Portraits de MM. U.C. et A.M.
140 × 110

1842
Hunters resting
Halte de chasseurs
32 × 38

An interior
Un intérieur
32 × 26

1843
Portrait of M. Ansout (cf. 4)
Portrait de M. Ansout
85 × 100

Self-portrait (cf. 3)
Portrait de l'auteur
35 × 30

The receipt books also give Courbet's addresses in Paris: in 1841, 4 rue Saint-Germain-des-Prés; in 1842, 28 rue de Bussy (Buci); in 1843, 29 rue de la Harpe, where he had a proper studio and remained until 1848. During these years he seems to have scarcely left Paris except for short stays with his family and, in 1841, a trip with his childhood friend Urbain Cuenot to Le Havre, which he found 'delightful'. The travellers stopped two days at Rouen to admire the monuments of Gothic art, and 'at last beheld the sea, the real sea with no horizon – how strange it is to a denizen of the valley' (letter to his parents; Bibliothèque Nationale, Estampes).

1844–1845

'It is all very well for my father to accuse me of laziness', wrote Courbet on 21 February 1844. 'M. Hesse, for example,

Marlet's teacher, whom I often visit to show him my work and who has also been to see me, as he takes a lot of interest in what I do – M. Hesse and many others keep telling me that if I go on at this rate I shall ruin my health.' Courbet had painted a large picture of *Lot and his daughters* for the Salon, and on Hesse's advice he also submitted the portrait of himself with a black dog, 'done two years ago'. The latter was accepted and, to Courbet's delight, was hung in a very favourable position: 'everyone compliments me on it'. Altogether he submitted three pictures in 1844:

Lot and his daughters (rejected)
Lot (sic) et ses filles
110 × 130

Self-portrait (accepted; cf. 7)
Portrait de l'auteur
60 × 70

Landscape study (rejected)
Etude de paysage
34 × 30

In 1845 he submitted an important selection of work:

Guittarero, young man in a landscape (accepted by 13 votes out of 18)
Guittarero, jeune homme dans un paysage
75 × 65

Dream (rejected)
Rêve
94 × 118

Draughts players (rejected; cf. 10)
Coup de dames
40 × 46

Portrait de m. U.C. (Urbain Cuenot) (rejected)
Portrait de M. U.C.
120 × 136

Portrait of Mlle la B. (Baronne) de M. (rejected; cf. 8)
Portrait de Mlle la B. (Baronne) de M.
98 × 78

The *Guitarrero* which, according to Silvestre was a self-portrait, aroused the interest of two purchasers, but they demurred at the price of 500 francs which Courbet asked on Hesse's advice. The *Dream* is deservedly well known, but under a different title, *The hammock* (Winterthur, Oskar Reinhart Collection), while *Mlle la Baronne de M.* conceals the identity of Courbet's youngest sister Juliette.

Encouraged by his renewed success at the Salon, Courbet resolved to try something more ambitious. 'Small pictures are not all I can do, I mean to paint something larger.' Hesse admired one of his studies and told him that 'if I could paint something like that for next year, he could promise that I would be highly regarded as an artist'. Courbet for his part decided that 'I must make a name for myself in Paris in the next five years. There is no middle course – that is what I am working for'. He set to work at once, telling his family that he would leave for Ornans on 1 September 'provided my picture is finished, for I don't want to do

things in the same way as in the past few years. I am starting on it today, and shall work at it all summer'. He kept his parents informed of progress ('It's a terrific job') but did not tell them the subject. Having been obliged by the needs of his work to take his holiday at Ornans at the end of the summer, he generally chose the same period in subsequent years, as it was also convenient for hunting purposes. While amidst his family he continued to work on landscapes, portraits and even a religious theme, a *St. Nicholas* now in the parish church of Saule near Ornans. Max Buchon saw Courbet working on this picture 'in about 1844 or '45; . . . Cuenot was the model for the life-size St. Nicholas'.

1846–1847

'Since getting back here I have resumed work with my usual fervour', wrote Courbet to his family from Paris at the end of 1845 or in the first days of 1846. He feared that his big picture would not be ready for the Salon, but he had others in his studio that he could submit, and he hoped the Paris papers would pay him some attention. When the Salon opened in March he wrote with disappointment: 'The winds are contrary for the present. Of all the pictures I sent in only one has been accepted, a self-portrait'. He goes on to criticize the selection committee: 'The one they couldn't reject they have stuck up near the ceiling, so that nobody can see it.' He had asked them to hang it elsewhere but, according to his letter, in vain. However, in a list of 'requests for change of position' in the Archives des musées nationaux there is an entry 'no.429 (Courbet) moved'; this number in the Salon catalogue figures against the title *Portrait of M.xxx*. Whatever the facts, Courbet's self-portrait seems to have been ignored by the critics. We cannot identify it with certainty, as there is no description of it, but it seems very likely that it was *Man with a leather belt* (13).

Besides *Portrait of M. xxx* (140×110) Courbet submitted seven works which were all rejected:

Portrait of Mme P.B.
Portrait de Mme P.B.
80×70

Walse (Waltz) (reading uncertain; cf. 11)
Walse
100×80

A prisoner
Un prisonnier
100×90

View of Maubouck valley
Vue de la vallée de Maubouck
53×40

View of the Maubouck valley
Vue de la vallée de Maubouck
52×42

Landscape
Paysage
30×36

Woman's head with wild flowers
Tête de femme, fleurs des champs
50×40

The picture *Walse* may be that of Courbet and his mistress Virginie Binet, now in the Musée des Beaux-Arts at Lyons. They had a son who died at Dieppe in 1872 and who, according to the death certificate, was born on 15 September 1847 (*A.G.C.*, no.10 1951, p.3).

Courbet's visit to Holland is generally supposed to have taken place in the summer of 1847, but according to Castagnary's notes (Bibliothèque Nationale, Estampes) it was in 1846. In 1845 Courbet 'was visited in Paris by an Amsterdam dealer who had been much impressed by his style of painting'; desirous of making a name for Courbet in Holland, he had bought two of his works

Lot and his daughters (Private coll.).

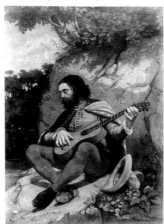

Guitarrero (Private coll.).

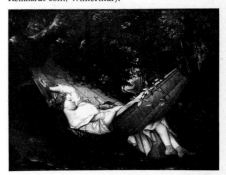

The dream or The hammock (Oskar Reinhardt coll., Winterthur).

(including a pendant to the *Guitarrero* – cf. 9) and had commissioned another. Castagnary quotes a letter of 1 August 1846 (he adds in a footnote that this date is certain) in which Courbet tells his parents that he is off to Holland and hopes to paint some portraits there; he expects to be at Ornans by 1 September. He probably got there sooner, as after only two days at Amsterdam he wrote that it was so expensive that he would return before long. He had spent 'three or four days in Belgium', where he was very kindly received, and was 'delighted' with all he had seen in Holland. He had admired the 'finest collection' in The Hague, and found 'a trip like this more instructive than three years' work'. He does not refer in this correspondence to the *Portrait of a man* which he showed at an exhibition of living artists (*Tentoonstelling van levende meesters*) at Amsterdam, or to the portrait of Van Wisselingh, the dealer mentioned above, although this bears the date 1846 (cf. 14). He may, however, have had it in mind when he wrote: 'I don't yet know when I shall leave here, as I may very likely be doing a portrait'.

On 19 March 1850, replying to the curator of the Lille Museum who had asked him for some information, Courbet wrote: 'All my affinities (*sympathies*) are with the Northern peoples. I have travelled twice in Belgium and once in Holland for my instruction, and I hope to go there again'. Courbet's second trip must have been made with the novelist Champfleury who, in a letter of 1858 to the publisher Hetzel, mentioned that 'ten years ago' he had gone with Courbet to Brussels for three days, and that a month later his friend was still touring the *brasseries* (*A. Parménie and C. Bonnier de la Chapelle, Histoire d'un éditeur et de ses auteurs.* P.-J. Hetzel (Stahl), 1953; cf. pp.30–1 below). Courbet does not seem to have left France in 1848 or 1849, so presumably his second trip to Belgium was in 1847.

Courbet submitted only three works to the 1847 Salon; all were rejected.

Ballad
Ballade
77 × 85

Portrait of M. Urbain (Cuenot)
Portrait de M. Urbain
141 × 110

Memory of Consuelo (cf. 16)
Souvenir de Consuelo
145 × 120

1848–1849

Undaunted by this reverse, Courbet set about preparing for the 1848 Salon. In January he wrote to his parents that he had finished a picture which, if accepted, would secure him 'a big reputation'. He was in a hopeful mood: 'I am on the verge of success, having around me people of great influence in the newspapers and the arts who are keen on my painting, and in short we are about to form a new school of which I shall be the chief member as far as painting is concerned' (Bibliothèque Nationale,

Estampes). The most noteworthy of these 'people of great influence' were Baudelaire and Champfleury; at the end of February Courbet designed the frontispiece for the second number, which was also the last, of their journal *Le salut public*. Despite the revolutionary events the Salon opened its doors in March 1848; there was no selection committee. This time Courbet, who had only exhibited three canvases in the previous seven years, was represented by no fewer than ten works:

Classical Walpurgis night
Nuit classique du Walpurgis
250 × 200

Sleeping girl
Jeune fille dormant
75 × 52

Evening landscape
Le soir, paysage
60 × 75

Midday landscape
Le milieu du jour, paysage
50 × 55

Morning, landscape
Le matin, paysage
45 × 38

The cellist (cf. 16)
Violoncelliste
145 × 115

Portrait of M. Urbain C. (Cuenot)
Portrait de M. Urbain C.
135 × 110

Portrait of Mme A.D., drawing
Portrait de Mme A.D.
70 × 60

Portrait of M.C.S.
Portrait de M.C.S.
60 × 55

Girl in reverie (drawing)
Jeune file rêvant
85 × 60

This time Courbet's contribution did not go unheeded. Haussard, in *Le National*, was especially enthusiastic about *The cellist*, which reminded him of Caravaggio and Rembrandt. Champfleury, in *Le Pamphlet*, was impressed by the *Classical Walpurgis night*: 'Mark my words and remember! The unknown author of this *Night* will be a great painter'.

At this time there came into being a group which, by the end of 1848, transformed the Andler brasserie into what Champfleury called a 'temple of Realism'. The first habitués – Courbet, Champfleury, Schanne, Murger, Promayet, Max Buchon – were followed by many others (cf. 43). On 18 March a competition was announced: painters were invited to design a figure symbolizing the Republic. Courbet, after some hesitation, decided not to take part,

but he thought of entering for *le chant populaire donné aux musiciens*. Courbet himself played the violin from time to time; his interest in music was fostered at Ornans, where members of his family and his friend Promayet played various instruments, and also in Paris, where Champfleury and Schanne organized quartets and played at sight 'all the classics of German chamber music' (Champfleury, *Souvenirs et portraits de jeunesse*, 1872). Courbet also composed songs, and took an interest in Champfleury's and Buchon's researches into folklore. In 1860 he illustrated Champfleury's *Les chansons populaires des provinces de France*; Buchon's *Chants populaires de la Franche-Comté* was not published until 1878, after Courbet's death.

The 'Days of June' horrified Courbet, who did not take part in the street fighting because, he wrote to his anxious parents, 'I do not believe in fighting with guns and muskets, it does not accord with my principles. For the past ten years I have been fighting with my intellect'.

On 13 August he was saddened by the death of his maternal grandfather, whose wife had died almost a year before, on 16 August 1847.

By now Courbet had several new friends. Through Champfleury, who until about 1860 was his closest companion, he met Francis Wey, another Franche-Comté man (always a recommendation in Courbet's eyes), who relates in his *Memoirs* a visit to Courbet's studio while the latter was at work on *After dinner at Ornans*. At the Salon, Wey, Delacroix and Ingres met in front of the finished canvas. Delacroix was full of admiration – 'There's an innovator for you!'; Ingres was decidedly reserved, but nonetheless remarked 'The fellow has an eye'. Wey entertained Courbet, as well as Gigoux and Corot, in his home at Louveciennes. Courbet's friendship with Baudelaire was to be of shorter duration, but at this time he sometimes gave the impoverished poet shelter under his roof, while Baudelaire wrote on Courbet's behalf a letter to the chairman of the commission set up by the Government to select works of art for a lottery organized for the benefit of artists 'reduced to poverty by the revolution' (Crépet, pp.111–12).

Baudelaire also composed the notes on paintings submitted by Courbet to the Salon of 1849 (Claude Pichois, *Études baudelairiennes*, II, 1970, pp.69–71). That year the Salon did not open until 15 June; the right to exhibit was no longer unconditional (as in 1848), but the jury was elected from among the exhibiting artists instead of being composed of Academicians as in 1847 and previously. Courbet (then living in the rue Hautefeuille, close to the Andler brasserie) submitted eleven works:

After dinner at Ornans (accepted; cf. 134)
Après dinée à Ornans
230 × 295

M.T. (Marc Trapadoux) looking at a book of prints (accepted)
M.T. examinant un livre d'estampes
110 × 90

Wine harvest at Ornans, under La Roche du Mont (accepted)
La Vendage à Ornans, sous la Roche du Mont
95 × 116

The Loue valley near the Roche du Mont (accepted)
La Vallée de la Loue, prise de la Roche du Mont
70 × 95

Evening view of the Chateau de Saint Denis, near the village of Scey-en-Varais (accepted)
Vue de château de Saint-Denis le soir, prise du village de Scey-en-Varais
75 × 85

The common at Chassagne, sunset (accepted)
Les communaux de Chassagne, soleil couchant
60 × 74

The painter (drawing; accepted)
Le peintre
75 × 60

Vallée de la Tuilerie (rejected)
Vallée de la Tuilerie
62 × 78

Rocks (rejected)
Rochers
75 × 85

Roche du Miserere (Doubs) (rejected)
Roche du Miserere (Doubs)
110 × 130

Mlle Zélie (rejected)
Mlle Zélie
80 × 70

The notes accompanying the works sometimes give valuable information on them (cf. 134).

Courbet's work aroused interest throughout the press, but, more important still, the Government purchased *After dinner at Ornans* and placed it in the Lille museum; moreover Courbet was awarded a medal, which carried with it the valuable privilege of exempting him from submitting future works to the selection committee. The Salon did not close until 31 August, and Courbet must have gone to Ornans soon after that date. Francis Wey relates that he wrote to Courbet to inform him of his triumph and, 'as though by mistake', addressed the letter to the mayor of Ornans, with the result that there was general merry-making, with dancing and serenades. The medal was conferred on 10 September (Bibliothèque Nationale, Estampes), and the Government purchase took place on the 20th (Archives Nationales). Courbet's stay at Ornans was a prolonged and fruitful one, and he painted large canvases in a studio provided by his father. On 26 November he explained to Francis Wey how he had had the idea of painting *The stone-breakers*, and gave a description of the work (acquired by the Dresden museum in 1904, destroyed during the second world war). In December he began *Funeral at Ornans*, which he composed directly on to the canvas.

1850–1851

Courbet's letters to Francis Wey and Champfleury describe his life at Ornans in the winter of 1849–1850. He went out shooting with friends – his favourite sport – and threw himself into local entertainments such as organizing the Carnival. He took an interest in old pottery, collected folksongs and enjoyed the countryside. 'You can imagine how delightful it is to roam about, especially in one's home territory and when one hasn't seen the spring for twelve years'. At the same time he worked extremely hard. His improvised studio was on the small side for the enormous *Funeral at Ornans*. Everyone in the village wanted to appear in the painting. 'I shall never satisfy them all, I'll make a lot of enemies', he wrote to Champfleury, adding that he had almost completed fifty life-size figures. As the opening of the Salon was postponed from month to month he exhibited his pictures in the seminary chapel at Ornans, to the joy of the local community. He also showed them at Besançon in May and Dijon in June – making a charge this time, as he found the Ornans people had thought him a fool for not doing so in the first place. As he wrote to Buchon, 'It's silly to be generous – you simply limit your own freedom of action without doing any good to others, either in their minds or in their purses. If you make people pay, they feel free to judge without being hampered by gratitude; they prefer it that way, and they're quite right. I want to learn, and I must be thick-skinned enough to allow everyone to tell me the harshest truths'.

Returning to Paris in the summer of 1850, Courbet exhibited his recent works in his studio. 'They are famous all over Paris; wherever I go, people talk to me about them.' At this time he painted portraits of the 'apostle' Jean Journet (an eccentric disciple of Fourier) and the composer Berlioz: Of the former picture he wrote: 'It looks like *Malborough* [sic] *s'en va-t-en guerre*. Journet is so well known in Paris that they will have to station a policeman beside the picture when it is shown in public.' The portrait of Berlioz was commissioned through Wey's good offices, but the musician was not pleased with it (cf. 25).

The Salon did not open until 30 December, and the public was not admitted until 3 January 1851. Courbet presented nine works:

Funeral at Ornus (*sic* in the catalogue; cf. 135)
Un enterrement à Ornus
350 × 872

Peasants of Flagey, returning from the fair (Doubs) (cf. 41)
Les paysans de Flagey revenant de la foire (Doubs)
250 × 218

The stonebreakers (Doubs)
Les casseurs de pierre (Doubs)
190 × 300

Portrait of M. Jean Journet
Portrait de M. Jean Journet
190 × 105

Landscape with the ruins of the château of Scey-en-Varais (Doubs)
Vue et ruines du château de Scey-en-Varais, paysage (Doubs)
90 × 105

Banks of the Loue near Maizières (*Doubs*)
Les bords de la Loue sur le chemin de Maizières (Doubs)
75 × 95

Portrait of Hector Berlioz (cf. 25)
Portrait de M. Hector Berlioz
80 × 65

Portrait of M. Francis Wey
Portrait de M. Francis Wey
80 × 165

Portrait of the artist (cf. 19)
Portrait de l'auteur
60 × 50

The self-portrait, known as *Man with a pipe*, was the only one of these works to meet with almost universal approval. The *Funeral* excited most attention and also most criticism. Caricaturists seized on it, as they did on Courbet's work for the next twenty years. Cuenot wrote from Paris to Juliette Courbet: 'Gustave is still the great subject of conversation in the artistic world. The most contradictory rumours about him are in circulation, and the funniest anecdotes . . . In society they make out that he was a joiner's or stonemason's assistant who, one fine day, was impelled by his genius to start painting and produced masterpieces straight off. Others say he is a frightful socialist and that you can tell from his pictures that he is a wild man and the chief of a band of conspirators' (Courthion, I, 98).

The passionate reactions of critics, either in blame or, less often, in praise of Courbet testify to the impact of his style. As Théophile Gautier remarked, 'We have been very hard on M. Courbet, but he is strong enough to stand up to criticism'. Describing the ceremony of 3 May at which awards were formally conferred, Gautier expressed surprise that Courbet was not among the recipients, since his work 'was a real event at the Salon. His faults, for which we have rebuked him soundly, are mingled with outstanding qualities and undoubted originality; he has made a strong impression on the public and his fellow-artists. He deserved to be given a first-class medal'.

Courbet's relations with the new political régime were bad from the start, yet they might quite easily have been otherwise. *Man with a pipe* was noted down for purchase by the Prince-

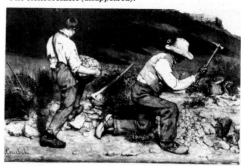

The stonebreakers (disappeared).

President himself, but owing to credit restrictions only sixteen works were bought (on 18 May 1851) out of the fifty-five originally selected, and Courbet's was not among them (Forges, 1972). When Bruyas acquired it three years later Courbet wrote to him: 'I am delighted that you should have my portrait . . . It's a miracle, for when I was desperately poor I still had the courage to refuse Napoleon's offer of 2,000 francs . . .' (Borel, 1951, p.22).

Later in the year Courbet, with the song-writer Pierre Dupont, stayed for a time with the young lawyer Clément Laurier (cf. 44) in the province of Berry, and was able to rest as well as painting landscapes. He reached Ornans in October, having been in Brussels and Munich where, he said, he had been invited to take part in exhibitions. On 19 November he wrote from Ornans to a newspaper editor in reply to a charge by one Garcin that he had attended a political meeting in Paris on the 10th. He had left Paris on 1 September, he declared, and had only been in his native province for a month, having arrived there from Switzerland after visiting Belgium and Germany. He took the opportunity to make a regular profession of faith: 'M. Garcin calls me "the socialist painter"; I am very willing to be so described. I am not only a socialist but a democrat and a republican; in short I am in favour of the whole revolution, and above all I am a "realist". But this, I would like to point out, is no longer M. Garcin's business, since a realist means a sincere friend of truth (de la vraie vérité).' Courbet concludes by saying that he was going on with a picture called *Young ladies of the village* (cf. 27), for which his sisters were posing.

1852–1853

At the beginning of 1852 Courbet wrote to Champfleury: 'I find it hard to tell you about my work for the Exhibition this year, I am afraid of expressing myself badly. When you see one of my pictures you can judge better for yourself. In the first place I have given my judges the slip by moving on to fresh ground: I have done something attractive (du gracieux); so everything they have said up to now ceases to count'. In the letter to which he was replying, Champfleury had written that Courbet's mistress Virginie had taken their small son off to Dieppe, her own part of the country; Courbet does not seem to have been unduly grieved by her decision. 'May life treat her kindly, as she thinks she is acting for the best. I miss the boy very much, but art keeps me busy enough without a family, and anyway a married man, to my mind, is a reactionary' (cf. 33).

The coming months were a trying time for Courbet, who was so disturbed by the political situation that he hesitated whether to return to Paris. In a letter of 1 February 1852 (Riat, p.100) he asked Francis Wey's opinion. His homecoming in the previous October had not been so triumphant as in 1849, for the people of Ornans took umbrage at the remarks of Parisian critics and also feared that they might 'be suspected of collusion with "the monster" because they had at one stage allowed him to paint their faces and clothes' (Champfleury, 1861, quoted by Lacambre, 1973, p.159). Various signs led Courbet to think he was being watched by the gendarmerie. Max Buchon, whose activities had been investigated, thought it wise to take refuge in Switzerland.

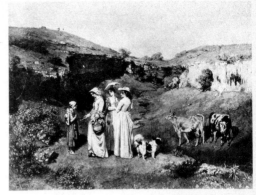

The young ladies of the village (Metropolitan Museum, New York).

Courbet, however, continued to paint and exhibit pictures. At the 1852 Salon, which opened on 1 April, artists were restricted to a maximum of three entries; Courbet's were:

Young ladies of the village (cf. 27)
Les demoiselles de village
240 × 130

Portrait of M. U. Cuenot
Portrait de M. U. Cuenot
150 × 140

Landscape on the banks of the Loue (Doubs)
Paysage des bords de la Loue (Doubs)
120 × 180

For the first time Courbet had sold a picture even before it was hung at the Salon: the catalogue entry for *Young ladies of the village* stated that it was the property of the comte de Morny. Despite its owner's exalted position the work was vigorously attacked. At the end of the year a satirical comedy by Boyer an Banville featured a 'realist' painter exhibiting a grotesque caricature of the *Young ladies*, or 'village wenches' as they were called. Courbet thought that for once he had painted something 'attractive', yet a majority of critics still accused him of a penchant for ugliness. Another disappointment arose over Courbet's large canvas *The fire alarm* (136): the facilities granted him for painting this picture at a Paris fire station were withdrawn, so that he was unable to finish it. According to Riat the idea of the picture came from Proudhon. The two Franc-Comtois were in close sympathy and Proudhon took an interest in art as Courbet did in social questions. In the summer of 1852 they visited Chenavard together; Proudhon was delighted with the meeting and with Chenavard's 'historical and philosophical painting, which gave him the opportunity of a discussion with a man professing the system of M. Auguste Comte' (letter from Champfleury to Buchon, quoted by Troubat, 1900).

Champfleury, who followed Courbet's work closely, confided to Buchon that he feared *The Bathers* would cause a scandal,

but hoped *The spinner* would be a popular success (Troubat, 1900, p.104). His predictions were fulfilled. In a letter of 13 May, two days before the Salon opened, Courbet told his parents that he had heard from the painter Français that his own pictures 'were very well hung. *The spinner* is the most popular. People are rather startled by *The bathers*, although since you saw it I have painted a cloth across the woman's behind. The landscape part of it is admired on all sides'. Courbet had already received an offer for the painting (Riat, p.102).

The three works shown by him at the 1853 Salon were:

Wrestlers
Les lutteurs

The bathers (cf. 30)
Les baigneuses

Sleeping spinner
La fileuse

A note in the catalogue stated that Courbet had been a pupil of Auguste Hesse; he immediately denied this, however, in a letter to the editor of *La Presse*. 'Truth compels me to declare that I never had a master . . . The most constant endeavour of my life has been to preserve my independence.' Like Gigoux, Courbet claimed to be a pupil of nature only.

The critics, even Nadar who was an admirer of Courbet's, were disappointed and even shocked, especially by *The bathers*. Champfleury was disconcerted: 'I no longer know what to think of Courbet's pictures in this year's Salon' (Champfleury, 1872,

The wrestlers (Musée des Beaux-Arts, Budapest).

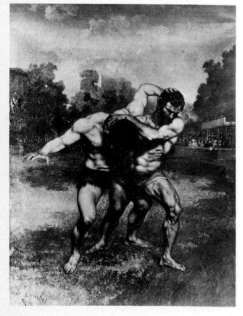

quoted by Lacambre, 1973, p.169). Courbet increasingly became a butt of caricaturists and a subject of lively discussion; he himself would start arguments about his work in the cafés he frequented. In a letter of 7 June 1853 Jongkind relates that on one occasion when Courbet and Couture met at the Divan Le Peletier, 'the conversation grew so heated that people outside stopped to listen, and the street was crowded with people' (Victorine Hefting, *Jongkind d'après sa correspondence*, Utrecht, 1968, p.18).

Courbet's three entries for the 1852 Salon were photographed by his wish and that of the art critic Théophile Silvestre, who proposed to write a booklet about Courbet in a series *Histoire des artistes vivants*. A prospectus of the series which appeared in 1853 was illustrated with reproductions of Courbet's work and photographs of himself and ten other artists. Silvestre described him (1856, pp.243, 245) as a 'very tall, very handsome young man; his bright, black eyes with their long silken lashes have a calm, gentle lustre like those of an antelope . . . The skull with its conical, clerical shape indicates obstinacy, as do the prominent cheekbones . . . while the quivering nostrils betray a passionate temperament . . . His hands are long, elegant and of unusual beauty. His dress is that of a well-to-do person with simple tastes but also a sense of style'. His plebeian gait and his two invariable accessories, 'a cane made of oak or a vinestock with a curved handle' and an old-fashioned pipe (*pipe de fromager*), seemed consciously designed to indicate the role he saw himself playing in the world of art.

Still more important than the advertisement of Silvestre's work was the purchase of *The bathers* and *The spinner* by Alfred Bruyas, the rich connoisseur from Montpellier. Bruyas also had his portrait painted by Courbet in June, two months after Delacroix had executed a similar commission; thus the two artists, so diverse in style, today appear side by side at the Montpellier museum.

In spite of all the circumstances that might have caused a rift between Courbet and Bruyas, their friendship endured until the former's death. They began to correspond soon after the Salon of 1853 and it was to Bruyas that Courbet wrote in that year describing his celebrated interview with the comte de Nieuwerkerke. (The letter was formerly thought to date from 1854, but its true date was established by Georges Grimmer: 'Courbet et Chenavard', in *A.G.C.* no.9, 1951, p.5.) Invited to lunch by the 'Director of Fine Arts', Courbet refused the latter's proposal that he should paint an important picture for the World Exhibition of 1855, with the proviso that he should first submit a sketch and that the finished work should be vetted by a group of artists chosen by Courbet and another committee to be chosen by the Government. 'I leave you to imagine what a fury this put me into', says Courbet, and he quotes at length his reply to Nieuwerkerke. He did not regard himself as 'involved in any way with the Government', which to him was 'simply an individual' buying whatever paintings it liked; art must be free, and the artist must be sole judge of his work. Courbet had fought for his intellectual freedom, and alone of contemporary French artists he had 'the ability and the power to express and interpret in an original way my personality and the society to which I belong. To which Nieuwerkerke replied: "M. Courbet, you are a proud man." I answered: "I am surprised, Monsieur, that you should not have realized it before. I am the proudest man in France." '

It was not only in Paris that Courbet aroused discussion. At Frankfurt, where he was invited to exhibit, a friend wrote to him that he had 'formidable opponents and partisans; so violent were the arguments that a notice had to be placed in the Casino: "M. Courbet's pictures must not be discussed in this Club"'. The subject was similarly tabooed at a private dinner (letter from Courbet to Marlet).

1854–1855

By an Imperial decree of 22 June 1853, the Salon of 1854 was postponed to 1855 and combined with the World Exhibition. Courbet, in his argument with Nieuwerkerke, did not refuse to take part but indicated his intention of staging a rival exhibition of his own which, he said, would be much more profitable financially than any arrangement with those responsible for 'official' art. A letter he wrote to Bruyas at the beginning of 1854 indicates that the latter was interested in the plan and that they intended jointly to rent a site opposite the great Exhibition. Courbet made a sketch of a 'huge tent with a single column in the middle' which would be erected to house an 'Exhibition of paintings by the master, Courbet and from the Bruyas gallery'. With this in view he was working busily, 'retouching' his *Return from the fair* and sketching out two other pictures – the *Grain-sifters* and a *Gipsy woman with her children* – which he intended to finish 'straight away', while he also had three landscapes 'on the stocks'. He added that he was delighted to be visiting Montpellier and that he would do his best to find out what had happened to the *Man with a pipe* that Bruyas wanted: it might have been sold at the Frankfurt exhibition, where a buyer had come forward (Borel, 1951, pp.25–30, letter wrongly dated).

At the beginning of May Courbet wrote to Bruyas, who was now his 'dear friend': 'My self-portrait arrived from Frankfurt yesterday – I am so pleased.' He was on the point of leaving for Montpellier and would therefore bring it himself; 'I am greatly looking forward to the trip, to seeing you and working together' (Borel, 1951, pp.19–25). From 1851 onwards Bruyas had written booklets about his own collection and related matters, and in 1854 he produced an extended work, *Explication des ouvrages de peinture du cabinet de M. Alfred Bruyas*, concerning the search for what he called his *Solution d'artiste* (the title of a booklet of 1853). In the portrait commissioned by Bruyas in 1853 Courbet showed him resting his left hand on a book inscribed *SOLUTION*, 'with the gesture of one sealing a pact'. At that time Courbet believed that he himself had 'attained the solution of all the difficulties of art and life thanks to the plenitude of his genius, his supreme rationality and perfect craftsmanship', and he christened the portrait his *tableau-solution* in token of the 'perfect harmony between himself and the friend and patron who was his model'. These words are taken from pages 176–7 of the catalogue of Bruyas's gallery compiled at his request by the critic Silvestre and published in 1876; they must have been personally approved by Bruyas, who closely followed the preparation of the catalogue.

Courbet stayed at Montpellier from the end of May to the end of September 1854. During that time he painted several portraits, as well as *The meeting* – one of his most famous composi-

tions (cf. 34) and his first views of the Mediterranean. He went on to Ornans via Lyons, Geneva and Berne, where he spent ten days with his exiled friend Max Buchon. During his journey he reported to Bruyas on the poor state of his health: an attack of 'cholerine' contracted at Montpellier had been cured by the attentions of a Spanish lady (cf. 39), but since arriving at Ornans he had been confined to his room for a month and six days by a violent attack of jaundice. 'Nevertheless I have managed to sketch out my picture, and now it has been entirely transferred in outline to the canvas . . . It is a moral and physical history of my studio.' Courbet's energies were entirely absorbed by this immense canvas (cf. 137), which he intended to present at the World Exhibition. As it was not ready for submission by the due date, he wrote to the painter Français asking him to try to secure an extension of 'ten days or a fortnight'; he also mentioned that the plan for a 'Courbet Bruyas exhibition' had fallen through because 'the financial backer, *père* Bruyas, is afraid of being sent to [the penal settlement at] Cayenne'. Français's approach was successful, and Courbet prepared to return to Paris on 29 or 30 March 1855. He asked Bruyas to send to the rue Hautefeuille the pictures he was lending for the exhibition, and added: 'If I have trouble with the Government we might try the big scheme, the exhibition of your whole gallery along with my pictures' (Borel, 1951, pp.58–63). Trouble was not long in coming, however. 'I am in an awful state . . . Terrible things are happening. They have gone and rejected my *Funeral* and my last picture *The studio* and the portrait of Champfleury. They say it is vital to put a stop to my tendencies which are disastrous to French art . . . People keep urging me to put on a one-man show, and I have agreed' (Borel, 1951, pp.78–9). Bruyas's contribution to Courbet's rival exhibition was confined to *The bathers*, but Courbet kept him informed of his negotiations and the special building he had constructed in the avenue Montaigne near the Fine Arts pavilion of the World Exhibition. 'Champfleury is doing an annotated catalogue which will be put on sale, and I shall also sell photographs of my pictures which I am having taken at this moment' (Borel, 1951, p.88).

The World Exhibition opened on 15 May 1855, and Courbet's private show six weeks later, on 28 June. At the World Exhibition Courbet was represented by:

The stone breakers (Salon of 1850–1851)
Les casseurs de pierre

Young ladies of the village (Property of M. le comte de Morne; Salon of 1852: cf. 27)
Les demoiselles de village

The meeting (Property of M. Bruyas; cf. 34)
La rencontre

Women sifting grain (cf. 42)
Les cribleuses de blé

The spinner (Property of M. Bruyas; Salon of 1853: cf. 29)
La fileuse

Self-portrait (cf. 35; Courbet in a striped collar)
Portrait de l'auteur

Self-portrait (cf. 19; Man with a pipe)
Portrait de l'auteur

A Spanish lady (cf. 39)
Une dame espagnole

The roche de dix heures, valley of the Loue
La roche de dix heures, vallée de la Loue

The ruisseau du puits noir, valley of the Loue
Le ruisseau de puits noir, vallée de la Loue

Château d'Ornans (cf. 27)
Château d'Ornans

The private exhibition was advertised by a large sign inscribed: *REALISM. G. Courbet: exhibition of forty of his pictures*. A pamphlet costing 10 centimes was entitled *Exhibition and sale of 40 pictures and 4 drawings by M. Gustave Courbet*; it contained a brief preface headed 'Realism' and a list of the works shown, beginning with *The painter's studio: a real allegory summing up seven years of my artistic life* (cf. 137). The remaining compositions, several of which had been shown at the Salon in previous years, included about fifteen landscapes of the Franche-Comté or the environs of Paris, and nine or ten portraits. The oldest works, dating from 1841–1842, were landscapes; two 'pastiches' dated from 1843, a *Girl's head* in the Florentine manner and a 'Flemish' *Imaginary landscape*. There was only one hunting scene, *L'affût* (Stalking), stated to have been painted in 1845 (but Courbet's dates often have to be corrected in the light of contemporary evidence). The preface on 'Realism', signed 'G.C.' has often been attributed to Castagnary, but it seems more likely that Champfleury was the author. In any case it was an authoritative statement of Courbet's position: 'The title "realist" has been imposed on me in the same way as the title "romantic" was imposed on the men of 1830. Titles have never given the right idea of things; if they did, works would be unnecessary . . . All I have tried to do is to derive, from a complete knowledge of tradition, a reasoned sense of my own independence and individuality. To achieve skill through knowledge – that has been my purpose; . . . to create living art – that is my aim.'

Courbet had expected his private exhibition to be a great success, financially and otherwise, but he was disappointed. Few people came, and critics showed less interest in it than in his contribution to the World Exhibition. Their reactions continued to be adverse, though less so than in previous years. Champfleury who feared that Courbet would not even cover his expenses, published a long article of praise in *L'Artiste* of 2 September 1855, ostensibly in reply to a letter from George Sand (Troubat, 1900, p.112). This was the more to Champfleury's credit as he had been upset by the 'monstrous' portrait of himself in *The painter's studio*; he was also displeased by the *comédie du réalisme* and by Courbet's excessive vanity ('Lettres inédites de Champfleury', in *Revue Mondiale*, 1 December 1919, pp.532–3). By September Courbet was looking for a site on the Boulevards to which he could transfer his gallery, as the Champs-Elysées district would be deserted in the winter months (letter from Zoé Courbet to Bruyas, Institut d'art et d'archéologie, Fonds Doucet). He did not find one, however, and at the beginning of December (the World Exhibition had closed on 15 November) Bruyas's pictures were sent back to him.

Before returning to Ornans for the winter Courbet went with Champfleury and some other friends to see a revue at the Théâtre des Variétés which included a skit on 'the realistic studio': Courbet was taken to task for 'love of ugliness', and was alleged to be mending his ways in response to criticism.

1856–1857

On 16 April 1856 Champfleury wrote to thank Buchon for sending him a copy of his work *Recueil de dissertations sur le Réalisme*, published at Neuchâtel. 'Your defence of Courbet and myself will not please the journalists . . . Courbet is dying to have it reprinted together with a short letter of reply to Silvestre. I continue to deprecate all this writing and I entirely approve Silvestre's work.' This referred to the *Histoire des artistes vivants*, announced three years earlier; Courbet had been impatiently awaiting the volume on himself but was grievously disappointed, as it contained more criticism than praise. He felt that the 'realist' Silvestre was 'sacrificing him to romanticism' and, with his Southern volubility, was putting nonsense into his, Courbet's, mouth. Champfleury, on the other hand, thought Courbet's painting was 'going off the rails', and looked back with regret to *After dinner at Ornans* and the *Funeral*.

There was no Salon in 1856, but on 16 April Courbet sent two pictures to an exhibition in the Crystal Palace, re-erected at Sydenham two years earlier (Bibliothèque Nationale, Estampes).

Courbet stayed for the second time in Berry with his friends the Lauriers (cf. 44). During the summer he worked on a large picture which he was to exhibit next year. At the end of August he wrote to his family that he was so tired he could hardly stand. He was anxious to return home, but decided to accept an invitation to Belgium which he described as 'a superb opportunity of seeing many pictures by the great Dutch masters which are very useful for my education'. At the beginning of September he wrote from Ghent that he was leading a 'princely' life and had been to Brussels, Mechlin and Antwerp. He subsequently visited Bruges and Ostend and returned to Ornans via Liège, Dinant, Cologne, the Rhine as far as Mainz, Strasbourg, Mulhouse and Besançon.

In 1857 the regulations for the Salon were radically altered. In future it was only be to held every two years; the number of works that an artist might submit was no longer limited to three; the selection committee was to consist only of members of the Académie des Beaux-Arts; and the only works exempted from the need for scrutiny were those of 'members of the Institute and artists who had been decorated for their work'. Courbet thus lost the privilege he had enjoyed since 1849, as Salon medals did not count as 'decorations'. The pictures he submitted in 1857 must all have been accepted, however, as otherwise echoes of his rage would no doubt have reverberated to the present day. They were:

Young ladies beside the Seine (summer) (cf. 49)
Les demoiselles des bords de la Seine (été)

The quarry: a deer-hunt in the forests of the Grand Jura (cf. 50)
Chasse au chevreuil dans les forêts du grand Jura: la curée

Doe exhausted in snow
Biche forcée à la neige (Jura)

Banks of the Loue (Doubs)
Les bords de la Loue (Doubs)

The Opera singer M. Gueymard in the role of Robert the Devil: 'Oui, l'or est une chimère' (cf. 51)
Portrait de M. Gueymard, artiste de l'Opéra, dans le rôle de Robert-le-Diable 'Oui, l'or est une chimère'

Portrait of M. A.P. (probably Alphonse Promayet)
Portrait de M. A.P. (probablement Alphonse Promayet)

There were two novelties in this list: for the first time it contained hunting scenes, which disarmed some critics and, instead of country women, it presented females of the sort that Proudhon termed 'damaged fruits of Parisian civilization'. The *Young ladies* were vigorously attacked by columnists, who accused Courbet of angling for attention by choosing a subject of doubtful taste. 'Courbet's position is a tricky one', wrote Champfleury to Buchon on 20 August 1857 (five days after the close of the Salon), 'because he wants to flatter popular taste and shock people at the same time' ('Lettres inédites de Champfleury', *op. cit.*).

Courbet's choice of hunting scenes may have been partly inspired by Landseer's success with similar works at the Paris Exhibition of 1855, where he received a gold medal. Although *Young ladies beside the Seine* caused a real scandal, and although the jury was composed of Academicians, they rewarded Courbet, eight years after his first distinction, by a *rappel de médaille*.

In May 1857, as recorded by Troubat (*Plume et pinceau: Étude de littérature et d'art, 1878*), Courbet and Champfleury joined a party of two or three hundred Paris students who were going to Montpellier for a short stay; Champfleury tells us that the trip was sponsored by the Société de Botanique. Schanne was of the party, and the three friends spent less time botanizing than amusing themselves in the town and countryside. On 21 June, according to Bruyas's friend Fajon, Courbet was at the village of les Cabanes and painted *The pools of Palavas*. He left Montpellier some time after the 23rd (letter to A. Gautier) and, as Bruyas was away that day, wrote to express his regret at not having said good-bye. 'I need not repeat how very much my friends and I enjoyed the delightful time you gave us at Montpellier . . . I wish you could see the work I did by the seaside!' (Borel, 1951, p.56).

Some weeks later, on 15 August, the *Revue des Deux Mondes* published a satirical sketch by Champfleury entitled *Histoire de M. T.**** and describing a bizarre character whom the people of Montpellier had no difficulty in identifying as Bruyas; the latter was deeply hurt; Fajon mentioned this to Courbet, who replied before even reading Champfleury's skit: 'Without knowing what has happened, if M. Champfleury has given the slightest vexation to my friend Bruyas I blame him very much, and I am very supet that anyone should think I had any hand in it.' He went on to say that his pictures 'have been a great success and brought a lot of people back to me; they are now in Belgium and are having the same effect there'. He was leaving for Brussels in ten days' time (Borel, 1951, pp.100–5). Four works, including *The quarry* and *Grain-sifters*, appear in the catalogue of the *Exposition générale des Beaux-Arts* in Brussels; in November they were asked for by the Frankfurt Artists' Club.

1858–1859

On 28 March 1858 Champfleury wrote to the publisher Hetzel, then in exile in Belgium: 'I was almost certain that Courbet must have drowned in a mug of Belgian beer. Ten years ago he played me the same trick, also in Brussels: we were only supposed to stay three days, but a month later he was still doing the rounds of the *brasseries*. If he is not careful, too much beer and talking will spoil his pictures' (Praménie, *op. cit.*, p.287). While in Belgium Courbet painted some portraits, but according to Cuenot (in a letter of 10 August) he seems to have been in a lethargic state for most of the time. At Frankfurt, on the other hand, where he went in September for a stay of some months, 'all his energy has returned. He has just painted a portrait of his friend Leuterschutt [actually Lunteschutz] in only seven hours. He has a picture in progress, the canvas for another has been ordered, and as soon as the hunting season opens and he can go after a stag, he will make a full-size version of the fine sketch I mentioned' (Bibliothèque Nationale, Estampes).

His stay in Frankfurt was one of the happiest periods in Courbet's life. A certain Van Isachers paid him 11,000 francs for *La grande chasse* and *Doe exhausted in snow*, and commissioned a landscape for 1,000 francs. The director of the Frankfurt Academy placed at his disposal a fine studio which enabled him to embark on large works (cf. 57), and he had the opportunity to paint well-to-do members of local society (cf. 54). He was fêted everywhere and invited to hunts of great splendour, where he gave an excellent account of himself. On New Year's Eve 1858 he had 'a superb adventure. Hunting in the German mountains I shot an enormous stag, a twelve-pointer, which means it was thirteen years old. It was the biggest to have been killed in Germany for twenty-five years'. This exploit had made many people jealous and caused some difficulties. The Sporting Club had sold the carcase instead of giving it to Courbet. 'It's a wonderful tale: the whole city has been agog for a month. The newspapers took it up. They couldn't return the whole stag to me – it had been sold by mistake and eaten – but they gave me the teeth and antlers, and the Club made amends by presenting me with a very fine skin, though not such a big one. They also gave me a photograph of the stag I had shot.' Courbet kept both these trophies as cherished possessions.

Some of his letters are on more serious matters. Explaining to his family the advantages of his long stay abroad, he wrote: 'I travel in foreign countries to achieve the independence of mind that I need and to keep away from that Government which, as you know, does not think highly of me. My absence has worked extremely well; my stock is going up in Paris . . . I have no intention of asking the Government for anything.' His fame was such that two Russians entered into negotiations with his sister Zoé and a certain M. Nicolle for the purpose of buying all the pictures in his Paris studio. Courbet set a price of 76,000 francs, and was greatly disappointed when the affair fell through.

Early in 1859 (probably in February, six weeks before his works were supposed to be ready for the Salon) Courbet wrote to Radou, a Brussels photographer who had made an excellent portrait of him. In this letter he mentioned that there was no longer time to finish both the big pictures he had meant to exhibit, and that he would be sending only one of these and two or three small ones (Musée du Louvre, Cabinet des dessins). In the end he

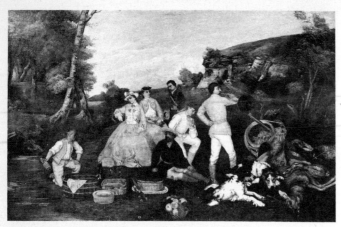

The picnic on the hunt (Wallraf-Richartz Museum, Cologne).

1860–1861

Two important events took place in these years: in 1860 Courbet met Castagnary, and in 1861 he suffered a severe disappointment at the Salon.

'I began to see the painter Gustave Courbet regularly from 1860 onwards' – such are the opening words of a book that Castagnary, at the request of Courbet's sister Juliette, began to write soon after the painter's death, but which remained as an unfinished manuscript (Bibliothèque Nationale, Estampes). Castagnary began his career as an art critic in 1857; describing Courbet's contribution to the Salon in that year he acknowledged his skill as a portrait-painter but summed up his work in severe terms: 'M. Courbet is a respectable craftsman who, failing to comprehend the aesthetics of his art, squanders his fine and unusual abilities to no purpose.' He thought Courbet was too much influenced by Proudhon: 'It is not the business of art to unfold ideas; the artist should not be an apostle or a rhetorician.' When, however, Castagnary visited Courbet's studio in 1860, he found it as much a revelation as Astruc had done in the previous year. From then onwards he became a friend of Courbet's; he remained faithful to the artist's memory after his death, defending him in print and organizing a large exhibition at the École des Beaux-Arts in 1882.

Castagnary's aesthetic and political ideas were distinctly different from Champfleury's, and this may have been one reason for the cooling of relations between the latter and Courbet. In 1859–1860, however, Courbet collaborated in two of Champfleury's works: *Les amis de la nature* (frontispiece by Bracquemond after G. Courbet) and *Les chansons populaires de France* (two illustrations by Courbet). In 1860 Champfleury wrote a long article in which he reviewed Courbet's development and paid homage to his efforts. 'He has a genius for large-scale works (*des grandes machines*) . . . The only purpose for which the nineteenth century has found an architectural style of its own is for covered markets and railway stations. Why should not Courbet find a fresh outlet for his talent in designing large mural decorations for rail termini?' (Lacambre, 1973, p.184). Thus Champfleury opened up new prospects for Courbet's art. In the same year he made an interesting reference to Courbet in his study of Wagner. A Belgian critic writing under the name 'Fétis' had called Wagner 'the Courbet of music'; Champfleury saw in this comparison a proof that Wagner's music was the music of the future.

Courbet was delighted with Champfleury's articles on himself and Wagner, and wrote 'I am extremely grateful to you, I found them charming and very sensible; the whole of Ornans is delighted'. To his friend Amand Gautier he wrote at the beginning of 1861: 'Champfleury has sent a book in which he says very nice things about me, I am very pleased'. This was *Grandes figures d'hier et d'aujourd'hui*, in which the articles were reprinted.

For some time longer Courbet remained in friendly correspondence with Champfleury. At the end of 1860, during which year he scarcely left Ornans except for a stay in Paris, he gave the writer an account of his plans. 'For the next exhibition I want first to finish my big picture of stags fighting, and then the dramatic one of a stag taking to the water. This is neutral ground; everyone can understand it, and it satisfies the general love of landscape and animals. Then – here is something much more risqué – I am finishing the *Cupid and Psyche* that you know of, with slight

did not send anything to that year's Salon, but not all the critics forgot him. Zacharie Astruc went to see him paint and, in 'Fourteen Stations of the Salon', gave a 'dolorous history' of the injustice from which his reputation suffered, with a full description of the works of every period and style to be found in his studio. Astruc concluded that 'in a hundred years' time all critics will pay homage to his name, and his pictures will sell for enormous prices. The lack of appreciation and the absurd hostility from which he suffers at present are crimes against art, reason and intelligence – and, little though this may matter, against justice as well'.

Courbet meanwhile lost no opportunity of showing his work, in response to invitations from many quarters in France and abroad. In particular he exhibited at Le Havre and in London (cf. 43). Although his finances were not in a very good state, he chose at this time to acquire a piece of land near Ornans. This provoked a curious rebuke from Cuenot, who wrote on 3 July reminding him urgently that he (Courbet) had to meet a bill of 800 francs and adding: 'All the nonsense you talk in Paris cafés doesn't count as legal tender. *Père Crétin* [the seller of the land] wants to be paid . . . You oughn't to go buying land, because, like your poor father, you are determined not to make money out of anything.'

Courbet was certainly an assiduous frequenter of Paris cafés – the Andler brasserie, the Divan le Peletier and the Brasserie des Martyrs – and was constantly making new acquaintances, artistic and other: he met Whistler and Boudin in Paris and Le Havre respectively. Schanne has left some account of evening parties in Courbet's studio. On 1 October 1859 there took place a *grande fête du Réalisme*, an event solemn enough for a printed programme which declared: 'This is the last party of the summer. The artist Courbet will not be receiving guests this winter.' Monselet gives an interesting description of this party, at which a police spy is said to have slipped in among those present ('Une soirée chez Courbet', in *A.G.C.*, 1975, no.54). Not long afterwards, a more intimate gathering took place at Salins: Max Buchon, who had returned from exile three years earlier, wrote on 11 October to Courbet, then at Ornans, inviting him and Cuenot and mentioning that Champfleury would also be there.

additions. Finally I would like to send in a war picture', which he proceeds to describe (Musée du Louvre, Cabinet des Dessins). On 30 March 1861 he wrote to Pothey with the titles of three works he was sending to the Salon: *Stags fighting, Stag taking to the water* and *Huntsman blowing his horn* – 'three pictures that are absolutely in the English taste'. He went on to say that he would have liked also to send some 'figure paintings' but had been prevented; he seems to have dropped the two subjects mentioned in his letter to Champfleury.

The Salon opened on 1 May 1861; Courbet's works appear in the catalogue as follows:

Fighting stags: spring rutting (Musée du Louvre)
Le rutt (sic) du printemps (Combat de cerfs)

Stag taking to the water (Musée des Beaux Arts, Marseilles)
Le cerf à l'eau (Chasse à courre)

The huntsman
Le piqueur

Fox in the snow
Le renard dans la neige

The Oragnon rock, Mézières valley (Doubs)
La roche Oragnon, vallon de Mézières (Doubs)

On this occasion the critics were especially flattering: even Théophile Gautier 'abandoned his reservations', as Tabarant writes (p.281), while Hector de Callas observed that 'the movement that is taking shape in Courbet's favour may well prove no less strong than the previous movement against him'. On 30 May Champfleury wrote to Buchon how much he admired *Fighting stags*, and wondered if it would be bought by the Musée du Luxembourg ('Lettres inédites', *op. cit.*, 1919). There was in fact some talk of this. Philippe de Chennevières relates in his *Souvenirs d'un Directeur des Beaux-Arts* that he urged M. de Nieuwerkerke to buy 'this magnificent work ... He did not reject the idea, and I broached it through Poulet-Malassis, who wrote to me on 5 June 1861 as follows: "I saw Courbet two days ago, when a Realist banquet with plenty of cheap wine was being given in his honour at the barrière Clichy. His pride, overweening though it is, did not prevent him being deeply touched by your suggestion, and I am sure the word Luxembourg has since been hovering in his dreams. As to the price, he leaves this entirely to you: 'Luxembourg' has the effect of an extra nought at the end." But official relations with Courbet were fated never to run smoothly: the negotiations I should have been so happy to conduct never reached a conclusion'.

From the previous April onwards, when the selection committee embarked on its duties, it had also been rumoured that Courbet might receive a decoration. Jules Laurens wrote to Bruyas on 16 April 1861: 'I am assured that the Emperor himself struck Courbet's name off the list of those to be decorated. The bad behaviour of which he and his friend were guilty towards yourself played a large part in this.' This statement may be compared with another letter from Laurens to Bruyas dated 23 November 1860, in which he wrote: 'Français is cold-shouldering Courbet (as is everyone else, largely on your account) and has broken with Champfleury, whom he calls a scoundrel' (Bibliothèque de Montpellier). Silvestre, who records that Bruyas was much offended by Champfleury's squib of 1857, wrote to the former as late as 1874: 'Do you remember our meeting on the boulevard near Tortoni's? It was I who warned Champfleury to clear out of the Café de Bade as quickly as he could, and not to cross your path or come within range of your boot.' Are we to suppose that it was because of Champfleury's conduct four years earlier, and Courbet's association with him, that the Emperor refused to let Courbet have the Legion of Honour, and vetoed the acquisition of *Fighting stags* by the Government after Nieuwerkerke and Chennevières had agreed on it?

The story that the Emperor struck Courbet's name off the list is also related by Thoré-Bürger (quoted by Bonniot, p.144). What is certain, in any case, is that Courbet received no higher reward than a second *rappel de médaille* for a contribution to which he attached special importance – as he wrote to Francis Wey in April 1861, '*Fighting stags* should, in a different way, be as important as *Funeral at Ornans*' – and which had been enthusiastically received by the press. Wey records that 'Courbet's bitterness became more pronounced after his disappointment over the admirable pictures of stags', and that 'after 1861 he broke for ever with the ideas and art traditions of his time . . . When Courbet was refused a decoration after painting his fine hunting scenes, the Emperor sank as low in his eyes as "M'ssieu Raphael" and "M'ssieu Michelangelo" – he became "M'ssieu Buonaparte." '

What Wey does not says is that he himself took steps to secure a decoration for Courbet. In a letter to Nieuwerkerke he wrote: 'The artist is a poor and conscientious man . . . His work has a character all its own . . . A little official success and some mark of kindness would be a gentle and salutary lesson, even from the artistic point of view, to this man whose struggles are the cause of his unbending spirit.' Nieuwerkerke replied that he 'was already full of good will towards this artist, whose talent is indisputable' (Chamson Mazauric, p.27). In writing to his parents, having joyfully announced that he was going to be decorated, Courbet put a good face on things when he got no more than a *rappel de médaille*, merely observing that 'it is really too absurd, when everybody without exception has hailed me as the king of this year's Salon'. He went on to say that 'in spite of all that' he still hoped that his picture would be bought for the Luxembourg, 'which is all I wanted'.

Courbet did not, however, forget the trick which he thought had been played on him. In 1863 he asked the dealer Luquet whether he could not sue the Government over the picture of *Fighting stags*, and in a letter to the writer and journalist La Fizelière he spoke of 'the Emperor's insult to me last year'. In 1866, when there was a misunderstanding between Courbet and Nieuwerkerke concerning *Woman with a parrot*, he reminded the Superintendent of their previous 'dispute over *Fighting stags*', which he thought Nieuwerkerke had agreed to buy 'one day at the railway station at Fontainebleau' (Chamson Mazauric, p.30). The draft of Courbet's letter (Bibliothèque Nationale, Estampes) goes on to say that when he presented himself at Nieuwerkerke's office a fortnight later he was met with a blank denial that any agreement had been reached.

Courbet was receiving more and more invitations from exhibition organizers. His works were shown at Lyons and Metz, where they were awarded medals, at Montpellier (including important pictures lent by Bruyas), and at Brussels, where *Woman*

with a mirror was much in demand: in December 1860 he wrote to Champfleury that he had been asked for two copies of it and had almost completed them. He also exhibited at Nantes, where the city authorities purchased *The grain-sifters* (42). In Paris he was invited to exhibit in Détrimont's gallery and to take part in a group exhibition in the Galerie Martinet.

Two other shows of especial importance to Courbet were at Besançon in 1860 and Antwerp in 1861. According to a letter to Champfleury he sent fourteen pictures to Besançon; the catalogue mentions twelve, and states that he had received medals at Paris, Lyons, Munich, Brussels, Dijon and Amsterdam. In the capital of his native province, however, the jury did not see fit to award him a medal, nor did he sell a single picture.

Courbet was warmly welcomed at Antwerp and left vivid memories there. A local artist, Eugène Dubois, wrote to him on the day of his departure, 22 August 1861 (Bibliothèque Nationale, Estampes), recalling with enthusiasm evenings spent at the local club, at which Courbet had sung songs of his own composition – 'What profound rustic poetry I felt in your original melodies!' – and asking to be warmly remembered to several friends, including Chaudey and Jules Simon. Courbet's personality, and still more his painting, made a strong impression on Belgian artists: *Fighting stags* was especially admired. Invited to address a congress held during the exhibition, Courbet declared his principles. 'Realism is based on negation of the ideal ... *Funeral at Ornans* was really the funeral of the romantic school of painting except for that part of it which was an assertion of the human spirit and therefore had the right to exist, that is to say the works of Delacroix and Rousseau ... Romantic art, like classical, meant art for art's sake ... In all things man must be ruled by reason ... Deducing from this the negation of the ideal with all its consequences, I arrive at the emancipation of the individual and, finally, democracy. Realistic art is essentially democratic' (Riat, pp.191–2).

Courbet's address was published on 22 August in *Le Précurseur d'Anvers*; four months later, in Paris, the *Courrier du Dimanche* printed the text of a letter dated 25 December 1861, in which he expounded his theories to the members of a studio which, at Castagnary's suggestion, he had established at 82 rue Notre-Dame-des-Champs. The letter, which began *Messieurs et chers confrères*, explained that Courbet did not regard himself as a teacher. 'You have decided to open a studio where you could freely continue your artistic education, and you were kind enough to offer to place it under my direction. Before replying, I must explain to you what I understand by "direction". I must not lay myself open to any suggestion of a pupil–teacher relationship between us.' Every artist should be his own master. Art is wholly individual; for each artist, it is nothing but the talent which results from his own inspiration and his own studies of tradition. Courbet then enlarges on the importance of studying nature and society in the form in which they actually meet the artist's eye (*l'étude de la nature et de la société qu'ils avaient sous les yeux*). Bonniot (1973, pp.16–17), who believes that this manifesto was drawn up by Castagnary, rightly calls it the best exposition of Realism in the field of plastic art.

1862–1863

On 2 February 1962, barely two months after the studio opened, Cibot, the owner of the premises hired by Castagnary, complained of the damage caused by Courbet's pupils and gave them notice to leave. He also pointed out that many original members of the group were leaving and few were taking their place (Bibliothèque Nationale, Estampes). Some members of the studio, such as Lansyer and Fantin-Latour, recorded that they were soon put off by its slovenliness and degeneration into a 'club for pointless political arguments' (Bonniot, 1973, p.18). Nevertheless, the experiment of founding a studio without a master had aroused much interest in Paris. Castagnary brought it to the attention of two journalist friends, Eugène Pelletan (from the Saintonge province) and Gustave Chaudey, who became a friend of Courbet's; he arranged for them to visit the studio, and described the scene vividly. 'Opening the door, my companions beheld the strange spectacle of a reddish ox with white markings, standing on spread-out hay, its eyes dilated, lowering its black muzzle and whisking its tail impatiently; it was tethered by the horns to an iron ring firmly sealed into the wall. This was the model ... At each easel an artist worked in silence. The black-bearded master walked to and fro giving words of advice, and taking up the palette each time to show more clearly what he had in mind.' On 10 March as the experiment was drawing to a close, Courbet wrote to his father that the studio was providing plenty of interest but too much work. He added that he had just made a carving of a boy fishing for chub, which he hoped might be placed on a fountain in his native town. Régis Courbet was able to write to his son on 24 May: 'I have taken the necessary steps about the statue you are presenting to the town of Ornans, and it is accepted with pleasure.'

At this time Courbet also took an interest in mural decoration, which Champfleury had encouraged in the past. On 22 April 1862 Sainte-Beuve wrote to the dramatist Charles Duveyrier: 'I was talking the other day to Courbet; he is a solid, energetic fellow who also has ideas, including what I think the important one of creating a monumental form of painting in tune with modern society ... His idea is to turn the big railway stations into churches for the painter's benefit: those great walls could be covered by all kinds of highly suitable subjects, such as previews of the main sites through which the traveller will pass, portraits of great men associated with cities on the line of route, picturesque and moral themes, industry, metallurgy – in short all the "saints and miracles" of modern times.' Sainte-Beuve wanted Duveyrier to help Courbet realize this project, but nothing seems to have come of it.

Castagnary, a native of Saintonge, introduced Courbet to a school friend of his, Etienne Baudry, a rich young connoisseur who came to Paris frequently and was forming an art collection. Baudry invited Courbet to stay with him, and the artist travelled to Saintes with Castagnary, who was visiting his family in that town. They arrived on 31 May, intending to return to Paris a fortnight later, but in the event Castagnary stayed several weeks and Courbet eleven months. Until September he was Baudry's guest at the château de Rochemont outside Saintes; he then spent some time at Port-Berteau, not far off, where he used to go painting in the countryside with a neighbour, the artist Auguin. In January he moved into Saintes, where he became a familiar guest

in the home of the captivating Madame Borreau. Thanks to Roger Bonniot's exhaustive research this is the best-known period of Courbet's life, and the details given here are based on that author's *Gustave Courbet en Saintonge*. Courbet, who was no admirer of the Bonapartist régime, saw much of a dissident group who were friends of Baudry's. All sorts of entertainments went on: musical evenings, picnics and moonlight parties in the park at Rochemont. On 17 August Courbet wrote to Castagnary describing the local amusements and regretting his friend's absence. 'I have been carried in triumph by the ladies of Port-Berteau before an audience of two thousand . . . The festivities continue tomorrow, Sunday . . . At Rochemont, in a week's time, the same thing again; before I leave, a public exhibition of the work I have done in this part of the country; what is more, I am in love with a marvellous woman, the one who organized my triumph.' This last sentence, in Roger Bonniot's opinion, explains the length of Courbet's stay in the Charente region.

As he wrote to Troubat, he continued to work hard, painting 'nudes and landscapes in the most delightful countryside you can imagine and in a magnificent château'. At the beginning of August, Corot was also Baudry's guest for ten days or so, and the two painters had a fresh opportunity of working together (cf. 63).

On 15 January 1863 an exhibition, the catalogue of which has been preserved, opened at the town hall of Saintes under municipal auspices. As well as local artists, painters from outside the area were represented: Corot, Courbet, Fantin-Latour, Gourlier, Héreau. Courbet in fact contributed nearly a quarter of the exhibition: 47 or 48 pictures out of about 200, three of them painted before his stay in Charente. Few of the works he showed were portraits; most were inspired by the landscapes and flora of Saintonge (cf. 66). One significant work, the most important of this period, was not shown at Saintes, as Courbet wished to reserve it for the Parisian public. In December 1862 he wrote to his parents: 'I have taken advantage of all these postponements to paint a picture for the next Exhibition . . . this work is critical and comical in the highest degree. Everyone here is delighted with it. I won't tell you what it is, I will show it to you at Ornans; it is nearly finished. I am undecided whether to paint anything else for the Salon. As it's an exhibition picture, if I paint others they will only reject it so as to accept those.'

The picture in question was *Return from the conference*, 'a scene of drunken ecclesiastics in very doubtful taste' (Bonniot, p.139). It was subsequently destroyed, but is known from reproductions. Courbet's letters to his family and friends show that he was anxious to have it exhibited at the Salon. However, his statement that 'everyone here is delighted with it' was untrue, as many documents prove. A journalist at Saintes, for example, wrote: 'When we last had the pleasure of talking to M. Courbet we assured him without hesitation that his *Return from the conference* would not be accepted by the selection committee. We told him then that it was regrettable that he should employ so much talent (and we would add here "genius", for Courbet is a genius where painting is concerned) on a work which has no purpose but to give scandal.' Théodore Duret, also a native of Saintes, said later that Courbet had composed an imaginary scene 'in a polemical and anti-clerical spirit which had nothing to do with art'; if he had painted it 'naturalistically . . . it would have been simply a slice of life, like *Funeral at Ornans* or the *Stone-breakers*'.

Baudry, who watched Courbet paint *Return from the conference*, told Castagnary that the artist had engaged 'a lot of bourgeois from Saintes to put on cassocks for the occasion'. Auguin, who had become a firm friend of Courbet's, gave him emphatic advice as regards the Salon: in May 1863 he wrote to Castagnary that Courbet had 'collapsed into farce this year in every respect. We had dreamt of a splendid Exhibition for him, we had drawn up a plan, he was in agreement, charmed, delighted, and now the devil comes along and messes everything up'. Auguin, it is true, was obsessed by anxiety over Courbet and the Salon. In January, after telling Castagnary how overjoyed he was that Courbet treated him 'like a brother', he went on: 'Only one thought mars our happiness to some extent. The Paris Exhibition is coming on, and our friend is wasting time, sleeping, smoking, drinking beer and painting very little, at all events little for the Salon. I am more concerned for his reputation than he supposes.' Auguin may have been over-anxious, as M. Bonniot points out, but it is certainly true that the only picture he painted for the 1863 Salon neither made him rich nor enhanced his reputation.

The selection committee met at the beginning of April; the architect Isabey wrote from Paris to keep Courbet informed, and the latter replied: 'I was delighted to hear from you the other day. I have achieved my purpose, if the picture of the *Curés* has caused such an upset . . . Keep the revolution going. If they reject the painting, take it back at once and put it in my studio . . . If they don't accept the *Curés*, the picture of magnolias will have to take its place; they'll accept that one all right.' Bonniot (p.270) points out that by 'revolution' Courbet meant 'the new Realism in art, linked in his mind with opposition to the régime'. *Return from the conference* was, sure enough, rejected by the Salon jury, and was not even allowed to be shown at the exhibition of rejected works organized that year at the Emperor's command.

Courbet explained his position once more in a letter of 23 April 1863 to La Fizelière. 'I wished to find out how much liberty the present age allows us. I sent in a picture called *Return from the conference*, a heartfelt piece depicting a lot of curés – it seemed

The return from the conference (disappeared).

fitting in view of the Emperor's insult to me last year, and of what is going on now with the clericals. I painted the picture so that it would be rejected – that's how it will make money for me.' Throughout April Courbet insisted that his friends should 'bestir themselves' and arouse public opinion. He relied especially on Champfleury, and charged Isabey to tell him to 'make the biggest possible splash in the newspapers'. For the first time, Champfleury jibbed at complying with Courbet's wishes. On 8 April he told Buchon that the picture, which he had not yet seen, had been rejected, and remarked: 'Given Courbet's ponderousness, I do not consider it a happy subject.' When he did see the work he told Buchon that he thought it very bad, and on 30 June he wrote to him that he was 'half angry' with Courbet. He did not conceal his views from the artist, to whom he wrote: 'You do yourself a great deal of harm by what you say. You talk far too much and don't paint enough. Your true friends are concerned at the position you are taking up as a man and the status you are losing as a painter.' Courbet retorted that he was working hard and had painted seventy or eighty pictures in the course of a year. 'As regards what you say about the Government, you are entirely mistaken as to my good opinion and hatred of it.' He believed that France should govern herself for the liberty of all; 'as far as I personally am concerned this Government suits me admirably, it puts me in the proud position of being a personality.' Champfleury returned to the charge: 'You think my letter harsh . . . Whatever you may say, and even though you have brought back eighty canvases from the South, anyone who has been observing you since you began to paint can see that there is a moral deviation which is affecting your art as well.' Champfleury condemned Courbet's ambition to play a political part, and his attitude of personal revolt against the Government. 'You must eliminate all rancour from your heart – otherwise it will affect your handiwork and all your faculties, sour your temper as well as your art, and prevent you from seeing life clearly.' Then, in a postscript, he fired a parting shot: 'Your picture of *Curés* needs a good month's further work before it can be shown. Don't try to rework the group of *Peasants* – it's a complete failure. It must be scrapped and repainted from life. All the hands are weakly done. The landscape needs repainting too . . .'

In the end Courbet exhibited two paintings at the 1863 Salon:

Fox-hunting
Chasse au renard

Portrait of Mme L. (Cleveland, Museum of Art, cf. 141)
Portrait de Mme L.

and one sculpture:

Fisherboy in the Franche-Comté: marble statue (referred to in Courbet's letters as the *Chub-fisher* (*Pêcheur de chabots*))
Petit-Pêcheur en Franche-Comté

He was once more attacked by the critics, the more harshly as they had expected better things. On 26 May he wrote to the *Figaro*: 'In Saintonge I painted seventy or eighty pictures or sketches, including the two works that are in the Salon. But the picture of the *Curés* was the most important in all respects and the only one I wanted to exhibit . . . I intend to show it in the other big European cities. Meanwhile it is on view at my own studio, where honest critics can come and see it and where there is a crowd every day.' For more than a month the studio was indeed full of spectators. 'Courbet was radiant . . . Standing there with pipe in hand, he explained his whole idea in detail', wrote Castagnary, one of the few who defended the picture. Later Castagnary recorded: 'There was a fearful uproar . . . All the ground he [Courbet] had gained with public opinion in 1861 was lost again.' The philosopher Proudhon, however, took up the cudgels for the painting and Courbet's work in general. On 9 August he wrote: 'I am involved just now in a dissertation on art which will run to about a hundred and twenty pages, on the occasion of Courbet's last painting, the *Curés*, which was turned down by the Salon. I am anxious to get on quickly with this little work, which is of some importance in the general pattern of "justiciary" doctrine' (quoted by Courthion, I, 175). Courbet wrote to his parents on 28 July of his collaboration with Proudhon: 'We are preparing between us an important work which will relate my art to philosophy and connect his work with mine.' The dissertation in its final form was three times longer than planned; it was published among Proudhon's posthumous works under the title *Du principe de l'art et de sa destination*.

In August Courbet went back to Charente for a few days' holiday at Fouras near Rochefort. By the autumn he was at Ornans. Champfleury advised Buchon to keep him there as long as possible, and he in fact stayed for the rest of 1863 and most of 1864.

He continued to take part in exhibitions, notably at Besançon, Toulouse, Bordeaux and London. Cadart, the Paris dealer, was a regular agent for his work. 'The pontiff Courbet – still at Ornans, his realistic Olympus – can be seen [at this gallery] in majesty with his *Quarry* and several landscapes and flower pieces, etc., and M. Castagnary (what an Auvergnat name, what clod-hopping ideas and what cacophonous prose! (*quelle prose de chaudron!*) is his prophet' (letter from Jules Laurens to Bruyas, 17 December 1863, Bibliothèque de Montpellier). Martinet, a member of the Institut and an inspector of Fine Arts, invited Courbet to be represented at the opening, on 15 June 1862, of the Société des Beaux-Arts which he had just founded, and to take part in its 'permanent exhibition' which opened on 10 March 1863. Courbet sent some recent work including *Magnolias*, a painting to which he attached considerable importance and which he had thought of entering for the Salon.

1864–1865

On 16 January 1864 Courbet wrote to Castagnary from Ornans: 'Dear friend, my life is a long string of accidents. I had started on an epic picture for the next Exhibition, a satire of my usual sort . . .' He had painted two-thirds of *The fount of Hippocrene* when the canvas was accidentally torn. 'Farewell, picture, I've no time to begin it again . . . It was about the state of contemporary poetry – a serious piece of criticism, though in a comic vein.' The picture showed a group of poets drinking at the sacred spring – Lamartine, Baudelaire, Pierre Dupont, Gustave Mathieu,

with Théophile Gautier 'smoking a chibouk and attended by an oriental dancing-girl', while Monselet 'looked on sceptically as usual'. The sacred spring was represented by 'a very pretty nude like those in Ingres's pictures – a first-class model from Paris'. Courbet was saddened by the spoiling of the canvas – 'Goodbye to the recriminations of my friends, the onslaught of critics, the poets' rage against odious Realism!' If there was not time to do another figure-composition he intended to paint a big landscape. 'Our mountains are covered with snow, the winter is delightful and I feel full of zest for work' (quoted from Larousse, *Grand Diction-naire Universel*, n.d., *c*.1870).

In the event, however, he painted a figure composition for the 1864 Salon. In a letter of 3 March (Institut d'art et d'arché-ologie, Fonds Doucet) he informed the dealer Haro that, having had two canvases torn one after the other, he was painting a third work for the Exhibition; it would be called *Étude de femmes* and might be a study of Venus pursuing Psyche ('*Pesichée*' in Courbet's spelling) with her jealousy. He wanted to send it to Paris as late as possible, and asked Haro to take the necessary steps on his behalf. The work was due to be sent off on 16 March for the opening of the Salon (once more an annual event) on 1 May. In a letter prob-ably written on 26 April (private archives) Courbet told Fajon, one of his Montpellier friends, that the jury had rejected it as immoral; 'this is sheer prejudice on the Government's part, for if that picture is immoral we ought to shut up all the museums in Italy, France and Spain. The title is: *Venus, pursuing Psyche with her jealousy, finds her asleep.*'

Later, on 11 May, he wrote to ask Haro whether the picture had been rejected or not. He had heard that it was lying about in one of the exhibition rooms, in which case it should be taken to his studio. It was rumoured, he went on, that the clergy and the Empress were against the picture being shown but that the Super-intendent had no objection. Nieuwerkerke had not informed Courbet of the jury's decision, which suggested that he was leaving the task of doing so to 'those who rejected the work by order'.

As early as 4 April the rejection was known to Millet, who wrote indignantly to Castagnary: 'I hear that a picture of nude women by Courbet has been rejected on the ground of impro-priety. I have not seen the picture and cannot form any judgement on the jury's decision, but I find it very hard to imagine that any picture of Courbet's could be more improper than the indecent works of Cabanel and Baudry at the last Salon, for I have never seen anything that seemed to me a more frank and direct appeal to the passions of bankers and stockbrokers' (quoted by Courthion, I, 190). The *Figaro*'s critic thought otherwise: 'What an idea to reproduce Baudelaire's *Femmes damnées* and to paint, with em-bellishments, what is already so obscene in print!' (quoted by Tabarant, p.334). The virtuous Proudhon made up his mind, as early as 1 June, to defend the picture in his forthcoming treatise: in a letter of that date to Chaudey he writes: 'I have received an enormous letter from Courbet . . . sending me a photograph of his rejected painting. After the *Curés* people said "That's enough!"; after *Venus and Psyche*, it'll be a hue and cry. Courbet must be joking when he suggests that people expected anything of the kind; but I can tell you that I shall defend it through thick and thin, even more stoutly that the *Curés*.'

Courbet, once again, was anxious to have his work seen by the public, as he made clear in a letter written from Ornans on

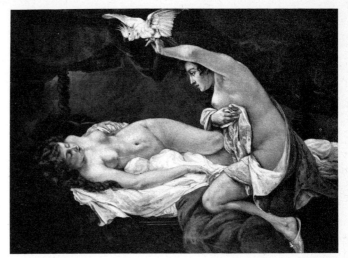

Venus and Psyche (disappeared).

15 August to the Belgian painter Werwée. 'It seems that the clergy, who haven't forgotten *Return from the conference*, were determined to have their revenge this year and got the Empress to see that the Salon jury rejected the picture of *Women* that I am sending you . . . I am entitled to suppose that it will not have such a bad reception in Brussels as it did from the Fine Arts administra-tion in Paris.' On 30 August he returned to the charge: 'Try to ensure that my picture of *Women* is accepted for your Exhibition, you don't know how pleased I shall be.' His efforts were successful and the picture was shown at Brussels under the title *Venus pur-suing Psyche with her jealousy*. (It was subsequently acquired by the Gerstenberg collection in Berlin, and was destroyed in the second world war.)

Courbet spent most or all of 1864 in Franche-Comté, where he painted many landscapes. Max Claudet speaks in his memoirs of having seen him paint a *Source of the Lison*, 'a three-foot canvas', from nature in the space of two hours. In January 1865 Courbet wrote to Luquet that he would send him some landscapes if he knew what kind were wanted; the ones he had done were 'wild scenes'. He enjoyed going to see his friend Buchon at Salins, and had painted several landscapes in that neighbourhood. He went in autumn 'to stay three days', and was still there three months later. He travelled in a donkey-cart, with no luggage or change of clothes except a spare shirt and two pairs of socks. When the cold weather came he bought a blanket from a Jew at a fairground, cut a hole in the middle to put his head through, and called it his winter overcoat. These details are related by Max Claudet, who calls him 'the most happy-go-lucky person to be found anywhere'.

On 11 November 1864 Courbet wrote from Salins to Victor Hugo in Guernsey, suggesting that he might go there in the spring to paint his portrait. The poet's reply filled him with delight. 'Dear, great painter, I thank you and accept your offer. The doors of Hauteville House are open wide. Come whenever you wish. My features and my thoughts are yours. You will paint a masterpiece,

of that I am sure.' However, Courbet committed a *faux pas* and the plan came to nothing (cf. Bonniot in *Gazette des Beaux-Arts*, 1972, pp.241–8).

On 10 December, while still at Salins, Courbet wrote to Castagnary, who was planning a trip to Franche-Comté, suggesting that he come there and make Buchon's acquaintance. He himself was working hard and had painted several portraits. *Venus and Psyche* had returned from Brussels and was 'again on view' in his Paris studio. On 14 December he wrote once more urging Castagnary to come to Salins; they could visit Ornans by donkey-cart and thus see something of the country. Castagnary accordingly left Paris on the 20th, and the two friends set out from Salins ten days later. Stopping en route at Nouans, they reached Ornans on the 31st. Castagnary cannot have stayed long, for on 13 January 1865 Courbet wrote to him in Paris to ask if it was still possible to paint Proudhon's portrait; if so, he would come at once. A week later he wrote again to Castagnary, who had meanwhile told Buchon the news of the philosopher's death. 'Smitten by the irremediable blow that has befallen us all, I intend in spite of everything to make an historical portrait of my very dear friend, the great man of the nineteenth century', wrote Courbet; he asked for iconographic documents, explaining that he was putting everything aside in order to devote himself to portraying the philosopher 'with his children and his wife, as befits the sage and genius of our time'.

In letters to Luquet and Carjat, written for publication in the papers, Courbet described the genesis and execution of his portrait of Proudhon and his family. 'I am pleased with my picture, and every one here is touched by it. It was painted in thirty-six days.' The work was sent to Paris on 18 March, the latest date for Salon entries being the 20th. On 6 April Laurens wrote to Bruyas that Courbet would be exhibiting 'a *Portrait of Proudhon* and a *Landscape*. I am assured that these works are not calculated to repair his reputation' (Montpellier library). Champfleury, who had been delighted to hear in October that Courbet was working hard, was again anxious; on the 23rd he confided to Buchon his fear of another setback, and said that Luquet was 'aghast' at the Proudhon portrait.

When the Salon opened on 1 May 1865, Courbet presented:

Portrait of Pierre-Joseph Proudhon in 1853 (cf. 80)
Portrait de Pierre-Joseph Proudhon en 1853

Valley of the Puits-Noir (Doubs); twilight
Entrée de la vallée du Puits-Noir (Doubs); effet de crépuscule

Critical comment on this occasion varied between ridicule and pity. Laurens, writing to Bruyas on 8 May, expressed the view that Cabanel was on the up-grade while Courbet was declining. 'His *Proudhon* and his *Landscape* this year do not rise above the standard of a village stonemason who might, one fine day, take it into his head to be an amateur painter' (Bibliothèque de Montpellier).

On 19 June Courbet wrote to his parents apropos of *Du principe de l'art*: 'I have sent you the book that P.-J. Proudhon wrote about me. It is the most marvellous thing imaginable, and the greatest benefit and honour that one could possibly desire in life . . . The whole of Paris is in a state of jealousy and alarm. It will add to the number of my enemies, and make me absolutely unique (*sans pareil*) . . . Bouchon and Urbain [Cuenot] will be delighted.'

During his long stay in his native province in 1864–1865 Courbet had allowed himself to be involved in matrimonial plans by his sister Juliette and a recently married friend of hers, Lydie Jolicler (née Chenoz). Juliette and Lydie noted that 'the lovers are writing to each other', and resolved that they must be brought together again when Courbet returned to the Franche-Comté in September 1865 (private archives). By that time, however, Courbet was at Trouville, which he so enjoyed that he stayed for three months. On 17 November he described to his father, not without exaggeration, what a wonderful life he was leading. 'I have made the acquaintance of all these people who may be useful to me. I have had over two thousand women visiting my studio; they all want to be painted . . . I have done thirty-five pictures, which has astonished everyone . . . I have bathed in the sea eighty times; only six days ago we went bathing with the painter Whistler, who is with me here – he's an Englishman and is my pupil.' As for marriage plans, Courbet was tired of such 'nonsense' and had 'let it all go to blazes' (Riat, p.222).

On 16 September he had written about his work to Urbain Cuenot: 'I am painting the prettiest women at Trouville – I have already done a portrait of the Hungarian countess Karoly [i.e. Károlyi], and it is a tremendous success. Over four hundred ladies came to see it, and nine or ten of the most beautiful want me to paint them too. At present I am painting Mlle Houbé de la Holde . . . I also have a marine to do for the comte de Choiseul, and the seascape part of a picture I have started called the podoscaf [*sic*, correctly *podoscaphe*] or "modern Amphitrite" . . . I am gaining a matchless reputation as a portrait-painter, the ladies whom I can't fit in here will sit for me in Paris this winter, I shall have a huge clientèle.' Courbet's success in the smart world of Trouville was the subject of a sketch by Pierre Véron in *Charivari* of 17 October 1865, entitled 'La conversion de M. Courbet', which spoke of him as a pupil of the fashionable portraitist Édouard Dubufe.

The podoscaphe (Private coll.).

On 20 November Courbet was back in Paris, where he decided to spend the winter finishing pictures he had begun, securing new commissions and making ready for the Salon.

Despite the critics his work had a good many admirers at this time, and he continued to exhibit in Paris and elsewhere: Brussels (as we have seen), Ghent, Nancy, Limoges, Marseilles, Besançon and Bordeaux. In August 1865 he was visited at his studio in the rue Hautefeuille by the comte de Nieuwerkerke, who expressed interest in an unfinished nude that he saw there; he urged Courbet to complete it so that it could be bought at the Salon, and meanwhile purchased a landscape on the Emperor's behalf; the sequel to this is related below.

1866–1867

On 3 January 1866 Courbet wrote joyfully to his parents of the 'enormous reputation' he had made for himself at Trouville and the pictures he had sold. That very day the comte de Choiseul and his sister, the marquise de Montalembert, had bought some sea landscapes at his studio; what was more, the père Hyacinthe (a fashionable preacher of the time) had mentioned him in a course of lectures at Notre-Dame. His letters to Bruyas were less jubilant. 'If you knew how much painting I've done since we last met, you would be dumbfounded! I must have painted a thousand pictures altogether, if not more, and nevertheless, thanks to ignorance and the absurdity of the authorities, I am still in the position you first found me in . . . I spent three months at Trouville this summer . . . where I painted thirty-eight pictures including twenty-five sea landscapes similar to yours and the ones I did at Les Sables-d'Olonne – twenty autumn skies, each more wild and fantastic than the last. It was great fun . . . I also painted ladies' portraits etc.' In a postscript he adds: 'I would be grateful if you could send me some money for Proudhon's widow. Forgive my indiscretion, but one can only ask such things of generous people. When he was alive he confided his family to my care, and so I must appeal to everyone on their behalf.'

Bruyas responded, and also asked Courbet to sell him a picture. In a letter of thanks the artist described his plans for the next Salon. 'I only have six weeks left; I have done a landscape like yours with roedeer in it, and a female nude' (Borel, 1951, pp.106–14). To his parents he wrote: 'I am getting on with the big landscape of the *Puits Noir*, putting in some roedeer that I hire from a game butcher.'

The Salon opened on 1 May 1866. Courbet exhibited:

Woman with a parrot (cf. 91)
La femme au perroquet

Covert of roedeer by the stream of Plaisir-Fontaine, Doubs (cf. 92)
Remise de chevreuils, au ruisseau de Plaisir-Fontaine (Doubs)

To the general surprise Courbet's works were hung in the most coveted position, in the centre of the wall facing the visitor as he entered the main room from the vestibule. According to Tabarant, this was by order of M. de Nieuwerkerke. 'Seeing M.

Courbet's triumphant air . . . spectators remarked to one another that the Senator and Superintendent was not a man to put his money on the wrong horse, and at the sight of the two works so imperatively honoured there was no choice but to bow, admire and applaud . . . What a chorus of praise broke out in the newspapers!' Such was the enthusiasm that the independent Thoré-Bürger exclaimed ironically: 'Well, my dear Courbet, you are done for now, your good times are over! Here you are accepted, bemedalled, decorated, glorified, embalmed!' He was mistaken, however: when awards were ceremonially handed out on 14 August, Courbet received neither medal nor decoration. This was a fresh source of astonishment, despite a warning paragraph in *Le Monde illustré* of 11 August. 'We could relate what took place between M. Courbet and the Superintendent of Fine Arts, but it is more proper to keep such tales to oneself . . . M. Courbet seems to have ruffled the Government's feelings, and in consequence he probably wont get his *Croix du 15 août* . . . How, indeed can one expect the authorities to confer distinctions on a man who declares that he attaches little value to favours that are legitimately offered and might legitimately be accepted?'

Courbet's response was to inform *Le Monde illustré* on 15 August that 'a year ago' M. de Nieuwerkerke had agreed to buy *Woman with a parrot* (i.e. the unfinished nude mentioned above), and that he now denied having done so. As to the Legion of Honour, 'I am not bound to explain to you what I think about it, but, without boasting of the independence which is the main principle of my life and the true source of the talent I am acknowledged to have, let me point out how easy it would have been to avoid giving offence to the authorities on the very eve of the distribution of those rewards to which so many people attach such great importance'. Further explanations were published by Courbet in the columns of Castagnary's *Le Nain jaune*. According to documents published seventeen years later by Chennevières, negotiations for the purchase of *Covert of roedeer* (cf. 92) had begun in April 1866, and in the following month Courbet had visited Nieuwerkerke who, with Chennevières, was understood to be acting on the Empress's behalf. The picture, however, was sold to the broker Lepel-Cointet, who had made Courbet an excellent offer.

On 29 June Courbet asked Chennevières to provide him with a letter from Nieuwerkerke concerning the permission granted to him to retouch *Woman with a parrot* before the Salon opened, in a room adjacent to those in which the Exhibition was being held. According to Courbet this letter referred to the picture as being his property; in fact, however, it was spoken of as the property of the administration. The letter was delivered to him on 11 July. Courbet's concern was due to his belief that Nieuwerkerke, when he visited the studio ten months earlier, had promised to buy the picture for 10,000 francs; the Government was now offering only 6,000, and Courbet was unwilling to sell at this price. In a letter of 27 June to Nieuwerkerke he set out the facts as he saw them and concluded: 'I am not in such a hurry to appear in the Luxembourg [gallery].' On 3 July Nieuwerkerke replied protesting at Courbet's interpretation and denying that any price had been agreed for the painting. Courbet wrote again on 27 July, maintaining his point of view and defending his independence as an artist (Chamson Mazauric, pp.28–36). Castagnary undoubtedly had a hand in the composition of this long letter. He supported

Courbet throughout the affair, and on 6 August the latter told his parents that he and Castagnary had written forty pages of a 'masterly' pamphlet setting out the case against Nieuwerkerke.

At the end of summer Courbet stayed for a month with the comte de Choiseul at Deauville. On 27 September he wrote to his sister describing the wonderful time he was having and the luxury of the Count's villa. At the latter's suggestion he also invited the painters Boudin and Monet with their respective 'ladies'.

Writing to Luquet from Deauville on 10 October, he announced that he would be back in Paris in a few days and would then go to Ornans. At his studio in the rue Hautefeuille he finished a picture commissioned by a rich Turk, Khalil Bey. The latter having heard of *Venus and Psyche*, had visited Courbet and been captivated by the work. Learning that it had been sold to Lepel-Cointet he asked for a copy, but Courbet offered to paint a different work of the same kind (cf. 90).

Courbet continued to be represented at numerous exhibitions – Lille, Amsterdam, Brussels, The Hague, The Allston Club in Boston bought and displayed *The quarry*, which gave him great pleasure. In March 1867 Luquet exhibited some pictures painted by Courbet in Normandy, which were praised by Jules Vallès in *L'Événement* of 11 March (quoted in Courthion, II, 226–8).

Courbet spent the late autumn and winter in Franche-Comté, painting pictures of the chase – his favourite sport (cf. 96, 99) – and preparing for the World Exhibition of 1867. He painted intensively, using a reflector for night work. On 31 January 1867 he wrote to Bardenet, a Franche-Comté man who was looking after his affairs in Paris, that he had done 'a series of snow landscapes, like seascapes'. On 21 March Bardenet, writing about the projected sale of various works, wrote: 'You ask me to sell, but you know quite well I cannot sign with a brush'.

Courbet was also in close touch with his friend and lawyer, Chaudey: at this time he had a lawsuit on hand with Lepel-Cointet and also with Andler, the brasserie owner. On 2 March he told Chaudey that he was working on a 'snow landscape 18 feet long' but was afraid it would not be ready for the Exhibition; 'I took the opportunity of a metre of snow falling in this part of the world to paint a picture I had projected for a long time'. 'I have never worked so hard in my life', he told Castagnary on 21 April; he was then staying with the Ordinaire family at Maizières (modern spelling Maisières) and was painting 'a haymaking scene with oxen, which will be just as good as the roedeer' (cf. 101). He was leaving for Paris on 1 May to continue the arrangements he had begun for another private exhibition. He was not sending anything to the annual Salon and only four pictures to the World Exhibition: he preferred to have a one-man show as in 1855 and was having a temporary building erected on the place de l'Alma. (This time he had a neighbour, as Manet was doing the same on the corner of the avenue Montaigne.) On 18 February he told Bruyas of his plans and asked him to send to Paris for the World Exhibition 'the portrait of myself in profile, which has never been seen there and is, as far as I remember, one of the best things I have ever done'. Apart from this he wanted Bruyas to lend several important works. He intended to build 'on about the same site as in '55; from now on I shall have a permanent studio for the rest of my life and will hardly ever again send anything to the Government's exhibitions, as it has always behaved so badly to me'

(Borel, 1951, pp.121–3). On 27 April he wrote asking Bruyas to have the kindness to send 'whatever pictures you consider suitable, such as *The bathers*, *The spinner*, your portraits and those of myself etc., . . . only not the last landscape I sent you, because the Empress has one very like it at the Champs-de-Mars exhibition'. He went on to say that he and Castagnary were making a tally of all the pictures he had painted: 'We have identified another 270 in provincial museums and private collections. This means that I have painted a thousand pictures in the course of my life' (Borel, 1951, pp.126–8).

The World Exhibition opened with great *éclat* on 1 April 1867. Altogether 684 works were exhibited by 254 artists; Courbet's contribution consisted of:

The hunted hare
Le lièvre forcé

The clairvoyant (cf. 45)
La Voyante

Portrait of a man (cf. 35; Courbet in a striped collar)
Portrait d'homme

Landscape (Ministry of the Imperial Household and of the Fine Arts; cf. 88 Le Puits Noir)
Paysage (Ministère de la Maison de l'Empereur et des Beaux-Arts)

Courbet's private exhibition opened on 29 May. The catalogue listed 115 items, grouped under various headings, to which about twenty were afterwards added. Notes were provided on some eighteen of the 'Pictures': thus it was stated that *Woman with a parrot* had been the occasion of a dispute between the artist and M. de Nieuwerkerke, and that *Wrestlers* was copied from 'one of the painter's earliest works, an allegorical *Walpurgis night* based on Goethe's *Faust*'. The only recent 'Picture' in the list was *The kill, a hunting scene in the snow*: this is the large work, now in the Musée des Beaux-Arts at Besançon, about which Courbet had written to his friends. Of the eighteen 'Landscapes' – a separate section – the only new one was that painted while staying with the Ordinaires (cf. 101). Out of seven 'Snow landscapes' five were dated 1867, the others 1860 and 1866 respectively (cf. 96, 97, 99). Of twenty-three 'Sea landscapes' twenty were painted 'at Trouville, in summer 1865, during the bathing season'. 'Portraits' were twenty-five in number; the only new one, that of the artist Amand Gautier, must have been hardly dry, as it was painted in Paris. Four 'Flower pieces' were listed as having been painted at Saintes in 1863. Out of fifteen 'Studies and sketches', *Mounted huntsman finding the trail* (Ornans, 1867) was a record of the snowy winter that had just elapsed, while others were dated variously between 1855 and 1866. The exhibition was completed by three drawings and two sculptures.

Some important pictures were missing (*After dinner at Ornans, The studio, Grain-sifters, Stag taking to the water* and *The quarry*), and there were only nine works dating from before 1850. Nevertheless the exhibition was a full-scale anthology of Courbet's work. On the eve of its opening he wrote a long and jubilant letter to Bruyas. 'I have had a cathedral built on the finest site in Europe, by the pont de l'Alma, with unlimited horizons, beside the Seine

The kill, episode during the deer hunt in a snowy terrain (Musée des Beaux-Arts, Besançon).

and in the middle of Paris! And I have astonished the entire world.' He reverted to the idea of a joint exhibition which he had broached in 1855. 'You, as a collector, have the same kind of influence as I. Bring your gallery and I shall complete it, we can add a second Salon on to mine, which is already completed. We shall make a million francs between us . . . If the width is the same as mine we shall have a gallery 204 metres long, 10 metres wide and 30 metres high – as good as the Louvre, never mind about the Champs-Elysées, the Luxembourg or the Champ-de-Mars!' In other words, Courbet and Bruyas would outclass the World Exhibition, the Salon and the Musée d'art contemporain. In a postscript Courbet expressed his real wish: 'If you decide to build, it can be done in a month. The rest open in a year's time, all yours. If we buy the site together, perhaps for good' (Borel, 1951, pp.118–20). Bruyas, however, was living comfortably at Montpellier and was about to move into a new house; he did not rise to the bait, and the demolition of Courbet's gallery began in November.

The exhibition was only a qualified success: visitors were not numerous and the press paid little attention to Courbet, except for the cartoonists, who never forgot him. His reputation continued to spread, however, and he received commissions. A Brussels art-lover named Olin bought some of his pictures and entered into a long correspondence concerning a plan to decorate his drawing-room with panels composed of works by Courbet, some of which would be painted to order. A well-known collector, Laurent-Richard, bought two pictures at the exhibition, one of which was *The stone-breakers*, a major work. His friend Fourquet invited the artist to visit him at Saint-Aubin-sur-Mer; he went there for ten days in August but did not wish to spend longer away from his exhibition, which was being looked after by his sisters. A very polite letter from the comte de Choiseul, unfortunately not dated, begins: 'I hope, my dear Courbet, that it is not only because of myself and the introduction to my picture-dealer that you and

your sister have been unable to leave for Ornans? – for Choiseul was helping Courbet to sell his pictures, notably *Woman with a parrot*. The comte went on to advise him to hold on to *Young ladies of the village* pending the return of Mme de Morny from Madrid. He hoped Courbet would paint his portrait, and he proposed to fetch back the pictures that belonged to him 'and to my sister Montalembert, who will be delighted to recover hers – she is more attached to it than I can possibly tell you' (Bibliothèque Nationale, Estampes). In the catalogue of Courbet's exhibition no.47, *Dunes at Deauville* (Deauville, 1866), is listed as belonging to the comte de Choiseul, and no. 54, *Seascape* (Trouville, 1865) to the marquise de Montalembert.

1868–1869

On 9 January 1868 Courbet sent greetings from Paris to his sisters, and expressed the hope that Juliette would follow Zoé's example (cf. p.44 below) and get married. Their father, he observed, would have liked to marry off all his four children at once, for economy's sake; but he himself intended to remain a bachelor ('Art and marriage don't mix') and thought Zélie should not marry at all, as she was 'too delicate'. He added that if their parents carried out the plan of dividing up the family fortunes, he did not on any account wish to receive a larger share than the others.

On 7 February, still in Paris, he wrote to Bruyas: 'The situation as between me and Society is still the same, except that I cut a bigger figure each day. This last year I had a huge exhibition in the finest part of Paris; I wish it could have been permanent, but, alas, it must be scrapped. What a pity! As of now, therefore, I still haven't got my permanent exhibition or museum, but I hope to have it before I die.' He did not give up exhibiting at the Salon, and even seems to have had thoughts of joining the selection committee, as his name figures on a printed list of *candidats du comité des artistes non exempts*: the list comprises twelve names in all, including Castagnary and Daubigny (Bibliothèque Nationale, Estampes). At the 1868 Salon he exhibited:

Hunted roedeer on the alert; springtime
Le chevreuil chassé aux écoutes; printemps

The charity of a beggar at Ornans (cf. 108)
L'aumône d'un mendiant à Ornans

These prompted one critic to ask 'What is left of Courbet now?', and another to speak of 'art in a state of decomposition'. Even Thoré-Bürger thought *The charity of a beggar at Ornans* a bad picture, but maintained that Courbet was nevertheless 'the most accomplished painter of the French school'.

Exhibitions in the provinces and abroad gave Courbet more satisfaction. On 10 September he wrote to Bruyas: 'I am off tomorrow to Le Havre, where I have eight pictures on show, including the *Charity of a beggar*, that I would very much have liked you to see. When I get back in a few days' time I shall go to Ornans and make some more heartfelt socialist pictures . . . I am pestered with worries, and my hair has gone white. I also have twelve

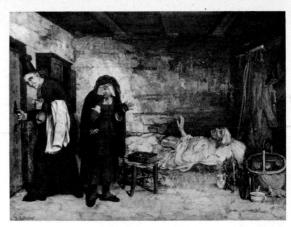

The death of Jeannot or The cost of worship (Private coll.).

The charity of a beggar at Ornans (cf. 108).

pictures at the Ghent exhibition, including pictures and drawings of our friends the clergy ... There is an illustrated book to accompany the pictures.' He refers to the new home that Bruyas was building, and remarks: 'I am glad to feel that you are happy in your tastes.' There was no further talk of bringing the 'Bruyas gallery' to Paris; on 12 November 1868 Bruyas signed the document bequeathing his collection to the Montpellier museum.

The reference to an 'illustrated book' denotes two anti-clerical pamphlets published in Brussels, *Les curés en goguette* (*Curés in merry mood*) and *La mort de Jeannot*. In the same year Courbet illustrated *Le camp des bourgeois* for his friend Étienne Baudry.

Courbet was at Ornans by October 1868, and was at pains to welcome publicly his sister Zoé, who had married Eugène Reverdy in Paris on 11 August (Bibliothèque Nationale, Estampes). In January 1869 the couple legally acknowledged their two sons, born out of wedlock on 1 March 1858 and 30 May 1860 and previously registered as the children of Zoé and an 'unnamed father' (Georges Grimmer, 'Zoé Courbet', in *A.G.C.*, 1956, nos.17–18, pp.1–27). The Courbet family do not seem to have known of their existence before 1868. In later years the painter refused to consider them his nephews.

Castagnary, who was Courbet's most regular correspondent in Paris, informed him of a rumour that he was seeking election to the vacancy in the Academy created by the death of the history-painter Picot. Courbet replied on 17 October 1868: 'This is really a splendid joke – that I should replace Picot, who for seven whole years, either directly or through his influence, kept me out of the Salon exhibitions from 1840 to 1848, when I was painting some of the best things I've ever done!' Developing this line of thought, he went on: 'Established institutions, academics, authoritarian government – all these create a false state of affairs and are a direct obstacle to progress' (Courthion, II, 111).

Both Courbet and Castagnary were close friends and welcome guests of Dr Ordinaire of Maisières, who was of some importance in local politics. During Courbet's long stays at Maisières the doctor's son Marcel used to paint by his side. In these pleasant surroundings Courbet tried, with the aid of a local blacksmith, to construct a one-wheeled carriage of his invention called the *monocycle*. On 18 December Dr Ordinaire wrote to Castagnary that Courbet had worked out his plan carefully, 'designing every part of the carriage including the stout traces ... By the time you get here the master craftsman will no longer be tied to the forge'. The doctor took Courbet's efforts seriously and urged him to take out a patent as soon as possible. According to Castagnary's notes the painter went on working at his machine for some years, first as a one-wheeled vehicle and then as a bicycle. Around the middle of 1872 he tried harnessing a horse to it, but it overturned and broke at the first attempt.

At the Salon of 1869, contrary to his custom, Courbet presented two works which had already been seen in Paris (at his private show in 1867):

The kill
L'hallali du cerf, épisode de chasse à cour par temps de neige

Haymakers' siesta: mountains of the Doubs (cf. 101)
La sieste pendant la saison des foins; montagne du Doubs

The second, it is true, had been considerably reworked.

On 1 May Courbet heard from the architect Isabey, who had been in charge of the construction and demolition of the gallery on the place de l'Alma, that *The kill* had been hung in the Salon carré d'honneur (Bibliothèque Nationale, Estampes). Despite this compliment, on which Isabey congratulated him, critical opinion of the huge canvas was very much divided.

On 13 May Courbet, still at Ornans, wrote to his parents at Flagey explaining that he could not drive over to visit them in his 'new carriage', a tilbury of his own invention that he was sending to the Longchamp exhibition in the Bois de Boulogne. By July he was in Paris arranging, among other things, to send four of his pictures to Brussels and six to Munich; he then went on to Etretat, where he had commissions to execute. (He had gone there briefly in the previous year from Le Havre, accompanied by Monet.) From Etretat he wrote to his parents that he had had a lot of business trouble in Paris, and would be going to Munich before returning to Ornans. This letter, undated, seems to have been written on about 6 September; on the same date he wrote to Castagnary that he had been at Etretat for twenty-five days and intended to leave for Munich between the 20th and 25th. In both letters he described how hard he was working – he had painted ten 'sea landscapes' and was engaged on another, a big one 'of 1·70 metres' for the Salon of 1870 – and proudly announced two successes: King Leopold II of Belgium had awarded him a gold medal for his contribution to the 1869 exhibition, and Ludwig II of Bavaria had conferred on him the order of St Michael. Passing through Paris at the end of September, he invited Castagnary to lunch on the 29th (he was leaving for Munich on 1 October). He told Castagnary that he had painted twenty seascapes at Etretat, two of which were for the Salon (Bibliothèque Nationale, Estampes).

Courbet's visit to Munich was a great success: he was received with enthusiasm by the young Bavarian artists, and impressed them by painting several canvases rapidly before their eyes. On 20 November, on the return journey, he wrote from Interlaken to his parents (Bibliothèque Nationale, Estampes) and to Castagnary (Courthion, II, 113–16), giving them his impressions and describing the progress of his work. He had left Munich 'a fortnight ago' and intended to stop at Pontarlier (which in fact he did) before coming to Ornans. To Castagnary he gave details of the eleven canvases he was bringing back with him: 'At Munich I painted five pictures, including three copies – a Frans Hals, a portrait by Velázquez and the Rembrandt portrait in the Museum there [cf. 110, 111] – a female nude and a Tyrolean landscape (Lake 'Stamberg': this is perhaps a mistake for 'Starnberg'). Since coming to Switzerland I have done six autumn landscapes in the mountains.'

The end of 1869 was clouded by the death of Courbet's lifelong friend Max Buchon. On Friday, 16 December he wrote to Castagnary from Salins: 'My poor old friend and cousin died in my arms on Tuesday at six in the morning' (Courthion, II, 116). Their boyhood companion Urbain Cuenot had already died, in April 1867.

1870–1871

In March 1870 Courbet was still at Ornans: he was upset by Buchon's death and found it impossible to work. 'For two months I was in a state of invincible lethargy', he wrote to Castagnary; however, he had to return to Paris to submit his pictures to the Salon (Bibliothèque Nationale, Estampes). He told Gauchez, who

was active in arranging for the sale of his works, that he had been 'elected to the Paris painters' jury' (Bibliothèque d'art de archéologie, Fonds Doucet). This, however, was a mistake, as Ziem wrote to him: 'As I was about to have you placed on the list, Millet came along. So you will be runner-up in case anyone should resign' (Bibliothèque Nationale, Estampes).

Courbet sent to the 1870 Salon the two landscapes he had painted for the purpose at Etretat the previous summer:

Stormy sea (Musée du Louvre)
La mer orageuse

Cliff at Etretat after the storm (Musée du Louvre, cf. 108a)
La falaise d'Etretat après l'orage

This time the critics were full of enthusiasm; Courbet had become a popular artist. On 29 April he told his sister Juliette of his pleasure at having sold 52,000 francs worth of painting. At this time he became close friends with an art lover named Bordet, and there was even talk of his marrying the latter's sister. With their help he organized an exhibition of painting in Bordet's home town of Dijon in aid of the wives of strikers at the Creusot armament works. Among other activities he presided over a *soirée littéraire et artistique* at the Gymnase de la Sorbonne, for the benefit of the draughtsman and engraver Rodolphe Bresdon; he bought, *en bloc*, a large collection of supposed Old Masters which subsequently turned out to be worthless copies; he kept in touch with exhibition organizers and sent pictures to Brussels and Antwerp. The Dijon exhibition, in view of its social purpose, was of especial importance to him and he felt obliged to attend it in person; this, at any rate, was the ground on which he refused an invitation to visit Maurice Richard, the newly appointed minister for literature, science and the fine arts (Bibliothèque Nationale, Estampes). According to Riat, Richard was a friend of Courbet's, who wrote in very polite terms, sending regrets to Mme Richard also. On 13 May Courbet wrote to Castagnary to thank him for an article about his work, and mentioned that he had declined an invitation from Richard. Six weeks later, on 22 June, a sensation was caused by the announcement that Courbet had been nominated for the Legion of Honour. The very next day he wrote a letter declining the award: 'My opinions as a citizen are such that I cannot accept a distinction which belongs essentially to the monarchical order.' He went on to say that in any case he regarded titles and decorations as valueless: moreover 'the State has no competence in the field of art. When it takes on itself to confer rewards, it is encroaching on the sphere of public taste'.

Courbet's friends congratulated him on his attitude and organized a banquet to celebrate it. In July he visited the historian and politician Thiers who, as Courbet reported, also commended his refusal. He wrote exultantly to his parents: 'Everybody esteems me the first man in France . . . What I have just done is a master-stroke; it is like a dream; everybody envies me.' He went on: 'I shall be at Ornans in September . . . I have been a three weeks sensation in Paris, in the provinces and abroad; now it's over, they've got the war to think about instead.'

The Franco-Prussian war had broken out in mid-July. Courbet changed his mind about leaving the capital, and on 6 September – four days after the surrender at Sedan – an assembly

of artists elected him chairman of the Arts Commission charged with the protection of works of art in and around Paris. A committee met daily from the 7th onwards. On the 14th Courbet sought to put forward a proposal concerning the Vendôme Column – regarded as a symbol of Napoleonic imperialism – but the rest of the committee thought it was not the appropriate place to discuss the matter. On 18 September the committee minutes were read to the general assembly of artists, and Courbet requested authority to address a petition for the dismantling of the Column to the Government of National Defence which had replaced the Imperial régime. The proposal ran:

> 'Whereas the Vendôme Column is a monument devoid of artistic value and tending by its character to perpetuate ideas of war and conquest . . .,
>
> 'Whereas it is for this reason in conflict with the spirit of modern civilization and the universal fraternity and unity which should henceforth prevail among peoples;
>
> 'Whereas it also wounds their legitimate susceptibilities...
>
> '[Citizen Courbet, chairman of the Art Commission] expresses the hope that the Government of National Defence will see fit to authorize him to dismantle (*déboulonner*) this Column, or will itself take the initiative in doing so, entrusting the task to the administration of the Artillery Museum and ordering the materials to be transported to the Hôtel de la Monnaie [the Mint].'

The assembly, however, 'did not think it feasible to consider this proposal in present circumstances' (Institut d'art et d'archéologie Fonds Doucet.)

Courbet's activity in protecting works of art was indefatigable. Together with Philippe Burty he was also a member of the Archives Commission appointed to look into the administration of museums. On 29 October he read at the Athénée lecture hall two open letters – to the German army and to German artists – pleading for peace and fraternity; these were afterwards published as a pamphlet. Articles appeared in the newspapers advocating the demolition of the Vendôme Column; the metal could be used to make guns, as some suggested, or for a bronze statue representing the city of Strasbourg. In a letter addressed to the Government on 5 October and published in *Le Réveil*, Courbet explained that he had never suggested destroying the Column but only removing it from the neighbourhood of the rue de la Paix, where it was inappropriate. 'Let the reliefs be moved to an historical museum, or used as panels to decorate the walls of the cour des Invalides – I would see no harm in that.'

The brasseries frequented by the *gros peintre Courbet* were the haunts not only of artists but of politicians, and he met there, among many others, Vallès, Grousset, Gambetta, Delescluze and Rigault. Not content with presiding over various artistic commissions, he felt an urge to engage in politics. This was not new: he had displayed a similar ambition in 1863, when Champfleury dissuaded him on the ground that he was neither rich nor eloquent enough for parliamentary life. Now, in February 1871, he stood for election to the National Assembly, and failed by only a narrow margin. On 26 March municipal elections were held in Paris (now in revolt against the national Government at Versailles); Courbet was again unsuccessful, but remained in the political arena and proclaimed his convictions in frequent communiqués. He was still chairman of the Arts Commission, and presided over discussions on the reorganization of museums and the training of artists. These talks led to the establishment of an Artists' Federation which on 27 April set up a committee of forty-seven members with Courbet as its chairman. Meanwhile, at the supplementary municipal election of 16 April, Courbet was elected a councillor for the 6th arrondissement and thus a member of the Commune (the Paris municipality), which appointed him delegate for the fine arts.

Before Courbet's election, on 12 April, the Commune had adopted a decree consisting, apart from the preamble, of a single article stating that 'The column in the place Vendôme shall be demolished'. Rodolphe Walter, who has studied the evidence with great care, does not believe that Courbet had any part in this decision, 'even from outside' ('Un dossier délicat: Courbet et la colonne Vendôme' in *Gazette des Beaux-Arts*, March 1973, pp.173–84). On 17 April Courbet suggested that effect should be given to the decree by preserving the lower part of the monument and replacing the Imperial column by a Genius representing the revolution of 18 March 1871 (the establishment of the Commune). He was, at any rate, thus reported in the Commune minutes; later, when on trial for his part in the destruction of the Column, he claimed to have been misunderstood. From 1 May onwards he was one of a group within the Commune who dissented from the majority policy of setting up a Committee of Public Safety. He afterwards claimed to have resigned from the Commune on 11 May; many writers have accepted this, but according to the minutes he was present several times after that date. Rodolphe Walter (*op. cit.*) states that he had nothing to do with the preparations for the demolition of the Column, which was entrusted to a contractor.

Courbet continued to work conscientiously as delegate for the fine arts and chairman of the Artists' Federation, which was busy reorganizing museums and art schools and arranging for the next Salon. At his trial many witnesses, including curators who had been relieved of their jobs, testified to the value of his work. He was particularly concerned with preserving the national collections, and was working at the Louvre as late as 24 May. A few days afterwards it was rumoured that he had been killed in the fighting which followed the entry of the Versailles troops into Paris on the 21st. The rumour reached Ornans, where Courbet's mother, who was already in a decline, died on 3 June.

Courbet was arrested on 7 June, and on 14 August his trial opened before a military court at Versailles. He spent the intervening weeks soliciting help from friends and influential acquaintances, including Jules Grévy, Jules Simon and Pierre Dorian; he maintained that he had always had the public good at heart and had never wanted the Column to be destroyed. Castagnary did his best to defend Courbet's interest. Many gave evidence in his favour: Baudry (who did not attend the trial but addressed a lengthy deposition to the court), Castagnary, the comte de Choiseul, Dupré, Arago, Jules Simon, Philippe de Chennevières and Barbet de Jouy. Sentence was pronounced on 2 September; out of seven charges only one was upheld, viz. that as a member of the Commune he had caused the destruction of the Column (Ministère de la guerre, archives historiques). The sentence was six months' imprisonment and a fine of 500 francs. Courbet did not appeal. On 3 September he wrote to his father that he expected to be pardoned or that the prison sentence would be commuted to

exile. On the 22nd, however, he was removed from Versailles to Sainte-Pélagie prison in Paris, where he was to serve his term. He was visited there by friends and by his sister Zoé Reverdy; she brought fruit and flowers, which aroused in him a desire to paint. On 2 November he was given brushes and a palette and began to produce a series of still lives (cf. 114, 115).

1872-1874

For some years Courbet had suffered from a distressing complaint for which he was briefly treated in the military hospital at Versailles. As the condition got worse he was released from Sainte-Pélagie on 30 December 1871 and admitted, as a prisoner on parole, to Dr Duval's clinic at Neuilly. 'It's a paradise', he wrote to his father on 4 January. At the end of the month he underwent a painful operation, and on 3 March he told his sister Juliette that he had been cured by the skill of the well-known surgeon, Dr Nelaton. He added that he had painted eighteen pictures since entering the clinic.

He had plenty of troubles, however. Several of his works had been stolen from a hiding-place at a house in the passage du Saumon where a Mlle Girard had given him lodging from January to May 1871. This woman, who claimed to be his cousin by marriage, had given evidence against him on 9 June and was one of the few witnesses for the prosecution at his trial. Not content with refusing to hand over his clothes and other effects, she subsequently demanded a considerable sum by way of rent. A trunk full of papers had been confiscated at her house, and Zoé took steps to have them released (Préfecture de police, archives). Courbet also had difficulties with the occupants of some premises in the rue du Vieux-Colombier which he had hired in order to store his collection of Old Masters and had sublet to a club. All these matters ended in lawsuits. However, money was coming in; Courbet's public did not desert him, and he sold many pictures through Durand-Ruel, who organized an exhibition in March 1872. In April he reverted to the idea of a permanent exhibition of his work in Paris, but the prefect of police refused the necessary authority (Préfecture de police, archives).

Another disappointment was the rejection at the 1872 Salon (the first since 1870) of the two works submitted by him, *Female nude seen from behind* (painted at Munich in 1869) and *Red apples on a garden table*. This was due to an intrigue led by Meissonier and opposed only by Fromentin and Robert Fleury. The press, however, was much more divided in its opinions than the selection committee.

Courbet's prison sentence had come to an end on 2 March, but he felt so comfortable at the clinic that he remained there. On 1 May he wrote to his family, who were anxious to see him, that he still had business to do in Paris; he had painted fifty pictures at Neuilly and sold them all. He reached Ornans at·the end of May and was well received by the local population, although the municipal authorities had, a year earlier (on 28 May 1871), removed his statue of the *Chub-fisher* from the fountain to which it was attached, and returned it to the painter's family. He suffered heavy losses as Ornans as well as in Paris: as he wrote to Baudry, the Prussians 'ransacked my mother's house and my studio and,

with 150 men and the same number of horses, made off with all the valuables and collections that were there'. He stayed for a considerable time with the Ordinaire family at Maisières and the Joliclercs at Pontarlier; while with the latter he confided to Lydie his grief at the loss of his son, who had died at Dieppe on 6 July.

On 16 January 1873 he wrote to Zoé Reverdy: 'I have been ill more or less all winter, with rheumatism in my side and an enlarged liver . . . I had several commissions for paintings that I could not carry out.' Zoé and Castagnary were looking after his affairs in Paris. A big exhibition was in preparation in Vienna, but Courbet feared that if he took part in it officially his pictures might be confiscated; at present, in any case, Du Sommerard and Meissonier were denying him access to them. Castagnary, informing him of this in January, advised him to exhibit in an artists' club in Vienna and to seize the opportunity to get as many of his pictures as possible out of France. The danger which Castagnary foresaw took shape after the fall of Thiers's government in May 1873. On the basis of a statement by Courbet during his trial to the effect that he would restore the Vendôme Column at his own expense if it were proved that he was responsible for its demolition, and on the strength of the military court's verdict, the Civil Tribunal of the Seine ruled that Courbet should pay the cost of reconstructing the Column and restoring it to its original site. This judgement was not handed down until 26 June 1874, by which time Courbet had fled to Switzerland, but confiscatory measures were carried out from June 1873 at the request of the prefect of the Seine, and from July 1873 in the department of the Doubs. Courbet, with the help of friends, had done the best he could to disperse and hide his paintings, and he also took steps to protect family property. Meanwhile he continued to work (cf. 117–19), and with newly-engaged assistants, established a regular studio at Ornans. 'We have more orders than we can deal with. There are about a hundred pictures to be done . . . Pata and Cornu are doing well. Marcel [Ordinaire] has come back; I hope he will work here too, as I pay them a commission on the paintings they prepare for me. Pata and Cornu have had 1,800 francs already.' (Letter of 26 April 1873: Riat, pp.346–7.)

Under the government of Marshal MacMahon, who succeeded Thiers as President, Courbet no longer felt safe. On 30 May 1873 the National Assembly adopted a proposal to reconstruct the Vendôme Column. When his property began to be confiscated Courbet feared that he might be imprisoned for debt, and after some hesitation he decided to leave France. On 20 July he wrote to his sisters Zélie and Juliette that he was sorry not to have seen them at Flagey 'as I was rushing from Besancon to Ornans, executing deeds of gift, to safeguard what little I have for your benefit', but that he and Marcel Ordinaire would dine with them on Wednesday the 23rd at noon before leaving for Switzerland. On the same day he wrote to Lydie Joliclerc: 'The time for departure has come. Troubles are piling on me, and the upshot must be exile. If, as there is every reason to expect, the court orders me to pay 250,000 francs, it is tantamount to finishing me off. What I must do now is to get out of France unobtrusively, since if I don't pay up after the sentence it'll mean five years in prison or thirty in exile.' He crossed the frontier with Marcel Ordinaire and Lydie; on the 23rd they were already at Neuchâtel, whence Courbet wrote to reassure his father that they had had no difficulties en route.

Before settling at La Tour de Peilz, near Vevey, Courbet stayed in the Val de Travers, at Lausanne and then at Fribourg. On 13 September 1873 Dr Ordinaire, who had gone with his wife to stay with him at La Tour de Peilz, wrote to Castagnary that Zoé Reverdy was making difficulties about returning some papers that Courbet had entrusted to her. This was the beginning of a disagreement which developed into a regular feud between the brother and sister. In June 1873 Courbet was still asking Zoé insistently to collect together some pictures which Durand-Ruel was to despatch to him, and in October he wrote to his father a full-dress complaint against Zoé and her husband, whom he believed to be in league with his enemies.

Dr Ordinaire wrote regularly to Castagnary from La Tour de Peilz with news of Courbet. On 25 December 1873 he expressed anxiety at the painter's drinking: he was 'drowning himself' in the local white wine and was taking part in 'Bacchic cellar-parties' till five in the morning. Courbet's father had come to stay for a few days, and the painter had been strong enough to paint his portrait in two sittings (cf. 122). The dealer Pascal Pia, who had a permanent exhibition of paintings in Geneva, wanted Courbet to remain active and was giving him work to do. Pata, who was acquiring too much influence over Courbet, was copying some of his landscapes; Ordinaire wished Castagnary would warn his friend against his commercial *patasseries* (a pun on the pupil's name, on *pâtisserie* and *pâte* in the sense of 'paint, impasto'). Courbet was still staying at the Pension Bellevue, while his friends were in another hotel. On 2 January 1874 the doctor wrote again that he was distressed by Courbet's drunkenness. At this time forgeries of his work started to come on the market. When a report on the subject appeared in *La République française* in June, Courbet and Pia wrote a joint letter to the editor asking him to make clear that the Geneva 'factory' from which the fakes emanated had nothing to do with Pia's gallery (Meusé du Louvre, Cabinet des Dessins).

Castagnary continued to watch over Courbet's interests in Paris. With Baudry's help he took steps to recover some of the pictures stolen in 1871, which had turned up on the market (cf. 33, 43, 54). Castagnary was in constant touch with the lawyers defending Courbet before the Civil Tribunal of the Seine. In a letter published in the London *Times* on 24 June 1874 Félix Pyat, who had been a member of the executive committee of the Commune and was now in exile, attempted to exonerate Courbet by claiming that the decision to destroy the Column was a political one and that he himself was responsible for it as the author of the decree of 12 April 1871. Nevertheless, in its judgement of 26 June the court pronounced Courbet guilty of the demolition 'by abuse of authority'. The damages payable were to be assessed, and the confiscated funds or valuables were meanwhile to be deposited with the administrator of property of the department of the Seine. Courbet, full of indignation, lodged an appeal.

Fortunately the painter was surrounded by friends: he received many visits from France, and from exiled compatriots living near by. However, on 3 October 1874 Silvestre wrote to Bruyas that Détremont, who had just returned to France from Switzerland, had found Courbet in a bad state. He was drinking too much and had got fat; his brain was 'starting to be affected'; he spoke with fury of the 'thieving' French government. On 28 November Silvestre wrote again, quoting Détrimont on the unevenness of the painter's activity: at times he would dash off a

study almost every day (Institut d'art et d'archéologie, Fonds Doucet). Courbet's friends did not desert him, and their letters to one another are full of affection for the painter; they sympathized with his sad life in exile and did their best to lighten his troubles. Thus, in September 1874, Pascal Pia wrote to Castagnary that Courbet had returned from La Chaux de Fonds and that there was a plan for himself, Mme Charles Hugo, the journalist Lockroy (Edouard Simon) and Henri Rochefort (another radical journalist, who had escaped from the convict settlement in New Caledonia) to visit La Tour de Peilz, where Courbet was to paint Rochefort's portrait.

1875–1877

'I have just made a [bust of the] Helvetian Republic with the cross of the Confederation', wrote Courbet to Castagnary on 4 February 1875. This was intended as a present to his place of exile; the mayor of La Tour de Peilz expressed his gratitude in a letter of 29 March. 'You have found refuge on Swiss soil from the storms of revolution, and as a return for hospitality you have presented us with a bust to ornament the chief fountain in our town ... We appreciate the friendly and pleasant feelings that have inspired your offer ... We thank you for this tribute of affection, which is doubly precious as being the work of a great artist.'

Courbet was in fact very grateful for the peaceful refuge he enjoyed in Switzerland. Local painters became friends of his, especially Baud-Bovy, who visited La Tour de Peilz and was 'intoxicated', not with drink but with what Courbet had shown him: portraits, seascapes, *The wounded man*, etc. 'What a great and wonderful artist Courbet is!' he wrote to Castagnary (Courthion, I, 303). In his home, known as 'Bon Port', Courbet organized an 'Exhibition of a hundred and thirty ancient and modern pictures, among which, besides those of the undersigned G. Courbet, the public will view with pleasure works of the most famous masters'. The show, over which Courbet presided with great amiability, opened on 15 August 1875; it consisted essentially of his own paintings and part of the collection he had bought in 1870. Some travellers' accounts describe the simplicity of the setting. 'Two wretched little rooms with very low ceilings ... threadbare rugs, dirty pinewood floors, low windows ... Most of the pictures were unframed, or were in poor-quality frames with wormholes here and there.' Courbet was 'fairly corpulent, of middle height, with long grey hair and a full beard, with no pretensions to elegance in his dress', says another visitor, who admired the painter's 'urbanity, friendliness and childlike naiveté'. Pupils and assistants – Pata, Morel, sometimes Marcel Ordinaire – were in attendance; Castagnary came to stay in March 1875, and Baudry for the whole of May.

Nevertheless Courbet pined in exile. Castagnary thought it would be safe for him to come back to France until the Court of Appeal pronounced judgement; according to Riat, 'the prefect of police did not mind, so long as he did not attract attention'. Courbet was under vigilant police surveillance, as appears from a report to Paris, dated 25 September 1874, that he was painting

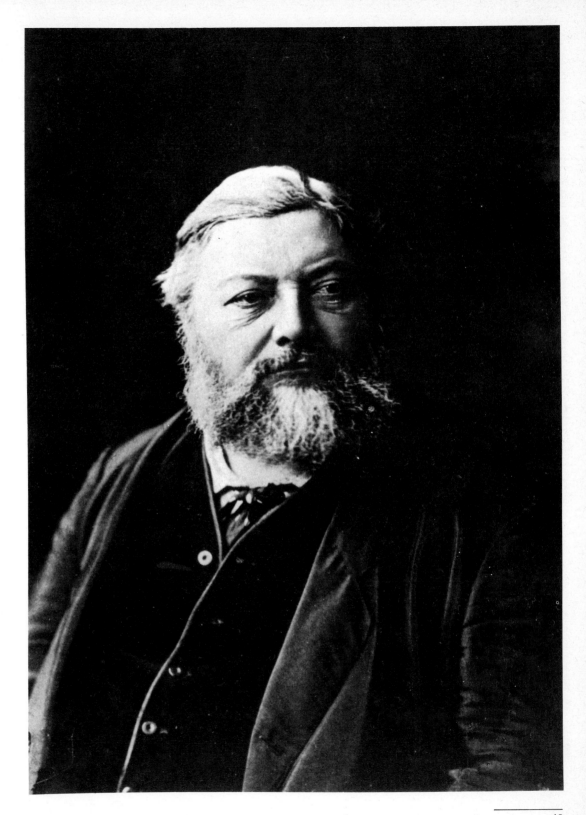

Courbet in 1877.
Photo by Paul
Metzner and Son.
La Chaux-de-Fonds.

Rochefort's portrait (cf. above; Préfecture de Police, archives). He chose not to leave Switzerland, and it was there that he received the news of another bereavement, the death of his sister Zélie. On 29 May 1875 he wrote to Juliette: 'I have shed every tear in my body – my poor Zélie, whose sole pleasure in life was to please and serve others . . . I am heartbroken too for my father's sake, he so loved our poor dear girl and has already suffered enough from the monsters who want to destroy our family and who have now been the death of my poor sister.' The 'monsters' were Zoé and her husband Reverdy, who had settled at Ornans and were at loggerheads with all the Courbet family. To these trials were added the burden of Courbet's struggle to vindicate his legal position: he drew up memoranda for his lawyer and made what use he could of influential friends. Mestreau, a friend of Baudry's whom Courbet had met at Saintes, made an unsuccessful approach to Léon Say, the minister of finance. On 29 July 1875 he wrote to Castagnary: 'The minister does not wish . . . to oppose the execution of measures decided by his predecessors . . . If, however, it is impossible to avoid the sentence being upheld, the damages could certainly be reduced later on . . . He does not think the ministry can possibly prevent the case coming up on Monday [2 August]: the press would hear about it, and our opponents would certainly kick up a row' (Bonniot, 1967, p.15).

On 6 August 1875 the Court of Appeal confirmed the judgement of the Civil Tribunal of 26 June 1874; the total damages were to be assessed later. On 19 November Courbet's solicitor wrote that they might amount to 400,000 or 500,000 francs. Courbet did not relax his efforts. In March 1876, contrary to Castagnary's advice, he printed over a thousand copies of a letter addressed to all deputies and senators, pleading for reparation of the injustice he had suffered. He sent the text to Victor Hugo and the politicians Raspail and Grévy, and asked Castagnary to recommend a publicity office for further distribution. On 24 December, in a letter of New Year greetings to his father and Juliette, he wrote: 'When you're in trouble, no one dares to help you any more . . . I write all day long to this person or that, with no result. Jourde and Castagnary, the editors of the *Siècle*, tell me I can return to France so long as I keep out of Paris: most reassuring! If I ever get put in gaol while these people are in power, I might never come out . . . I have offered them a composition, i.e. to pay so much per annum; we shall see.' A few days later, on 7 January 1877, he replied to his father, who was urging him to go back to France, that he thought it too dangerous. Recently, with some friends, he had swum across the Doubs into France 'for a lark'; next day the French gendarmes had warned their Swiss colleagues that they had a warrant for his arrest (Riat, p.369).

The final judgement was proclaimed on 24 May 1877: the sum owed by Courbet to the French State was 323,091.68 francs, to be paid by annual instalments of 10,000 francs. Courbet still hesitated to return to France; Castagnary advised him to wait, and meanwhile to get on with preparing his contribution to the World Exhibition of 1878 (cf. *Grand panorama of the Alps, La Dent du Midi*, Cleveland Museum of Art, g. 150). The commission, which met in July 1877 under Chennevière's chairmanship, agreed, apparently after some debate, that Courbet would be eligible to take part.

Courbet, however, had fallen ill with dropsy. 8 On October he entered a private hospital at La Chaux de Fonds, where he was treated for twelve days by a certain Guerrieri. His friends grew anxious. One of them, Leloup, wrote on 31 October, probably to Castagnary: 'We have good hope of pulling him through. His father and sister have been to see him.' He was still in Guerrieri's establishment on 13 November, when Castagnary begged him to go to Paris for treatment, since he needed 'proper doctors and careful nursing . . . As to your personal security I don't even speak of it, since you are entitled to return to France and settle wherever you please'.

A final blow was inflicted by the forced sale, on 26 November at the Hôtel Drouot, of the pictures, furniture and *objets d'art* in Courbet's Paris studio. He had had good reason to hope that this would not take place, as he was not in debt to the State and had decided to pay the first annual instalment due on 1 January 1878.

On 1 December 1877 he returned to La Tour de Peilz; his dropsy was now so acute that he had to be transported in a special railway coack with double doors. Dr Blondon, a friend from Besançon had been following his illness, was alarmed by his condition and called in Dr Collin from Paris. Tapping brought little relief, and he died at 6.30 on the morning of 31 December. His father was at his bedside, and his sister Juliette arrived later on the same day. He was buried on 3 January 1878 in the cemetery of La Tour de Peilz. A large crowd of mourners was present, including many political exiles. Not until the centenary of his birth, in June 1919, were his remains transferred to the cemetery at Ornans.

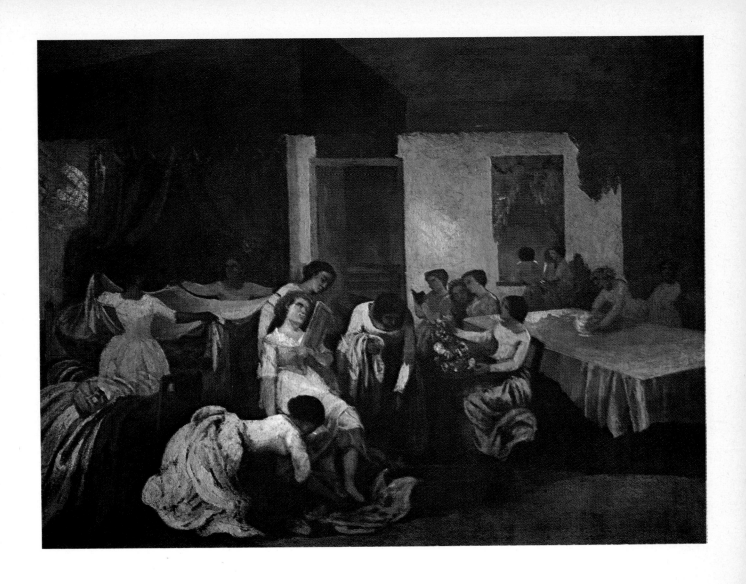

24
The toilette of the dead

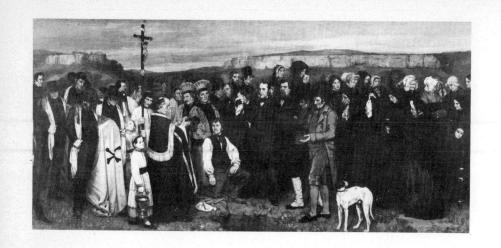

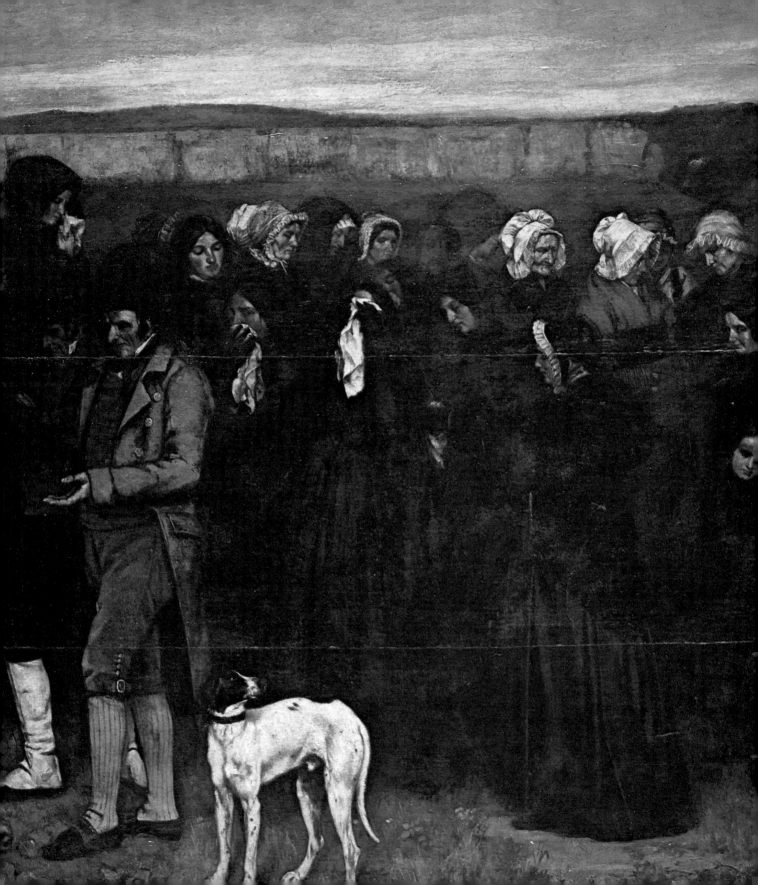

136
Departure of the fire brigade
Petit Palais, Paris

27
Young ladies of the village giving alms to a cow-girl in a valley near Ornans

30
The bathers

34
The meeting or Bonjour M. Courbet

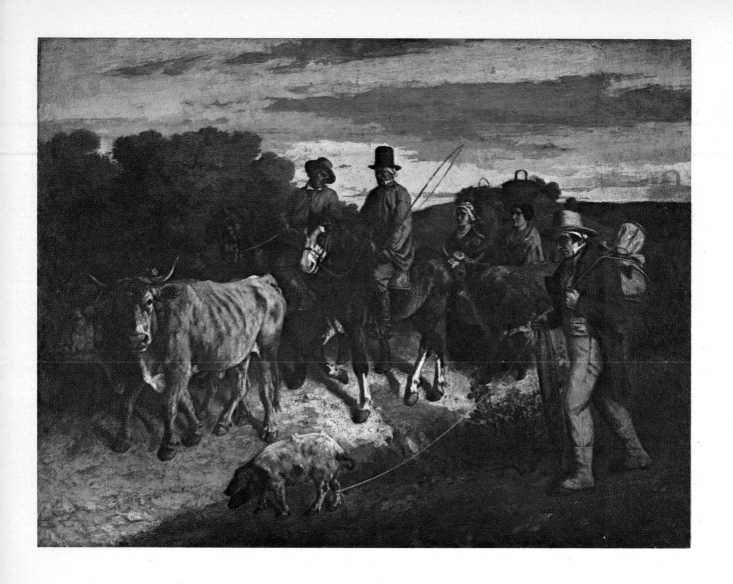

41
The peasants from Flagey returning from the fair

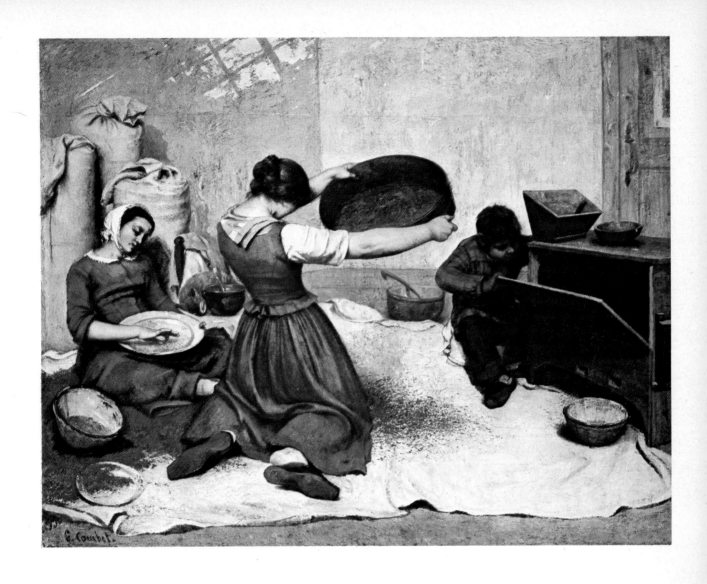

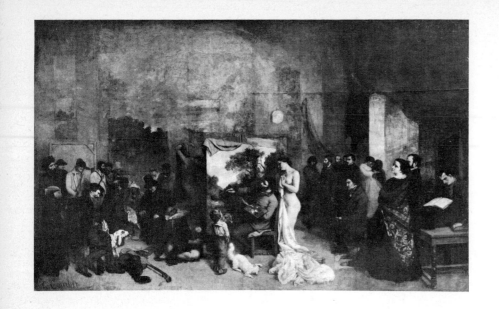

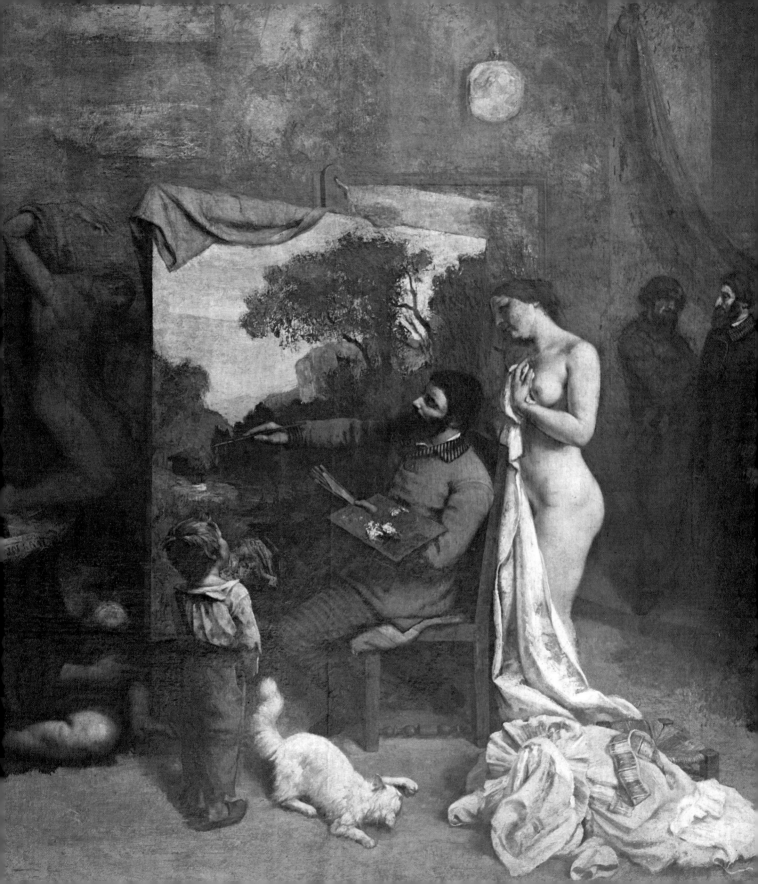

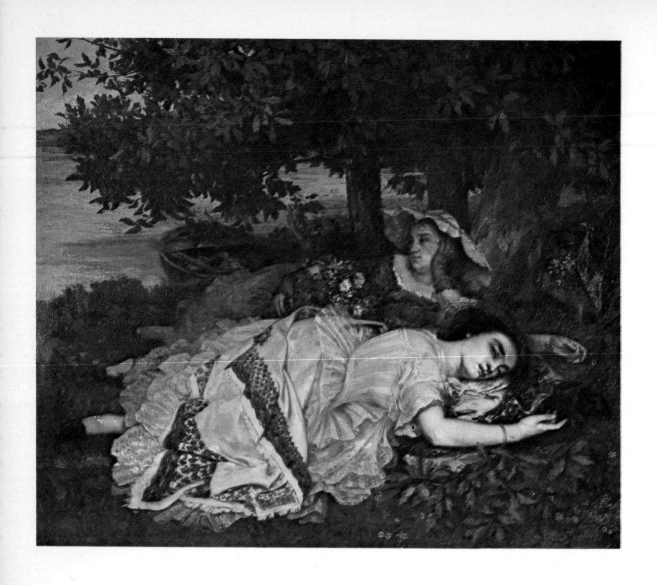

49
Young ladies on the banks of the Seine

67
The trellis, or young girl arranging flowers

84
Girl with sea-gulls, Trouville

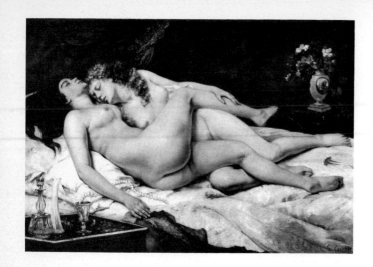

99
The gamekeepers, Ornans

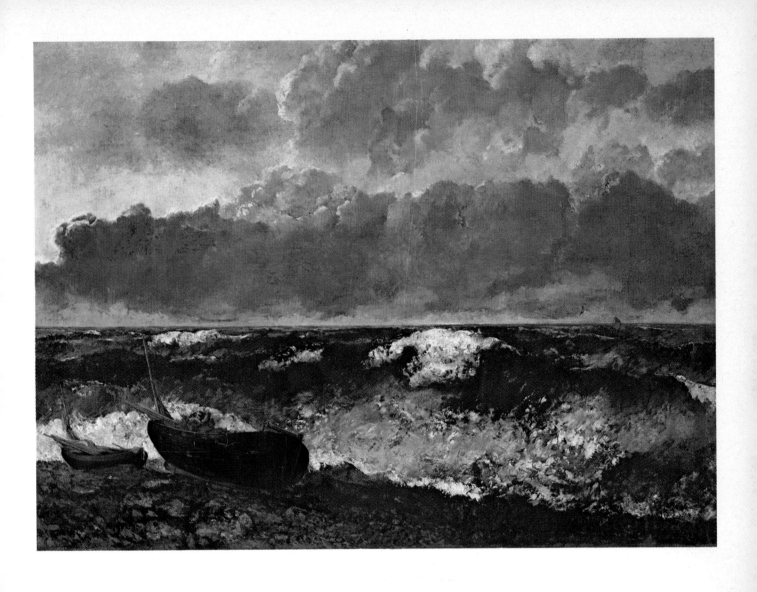

147
Stormy sea called 'The wave'

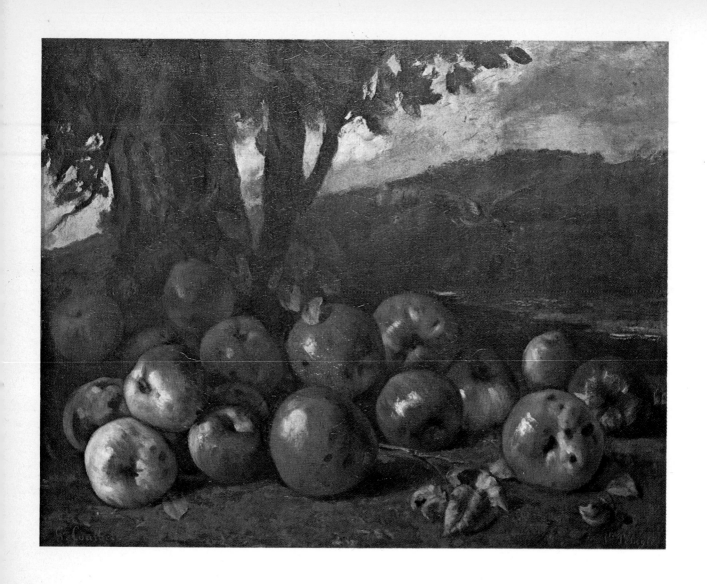

114
Still life with apples

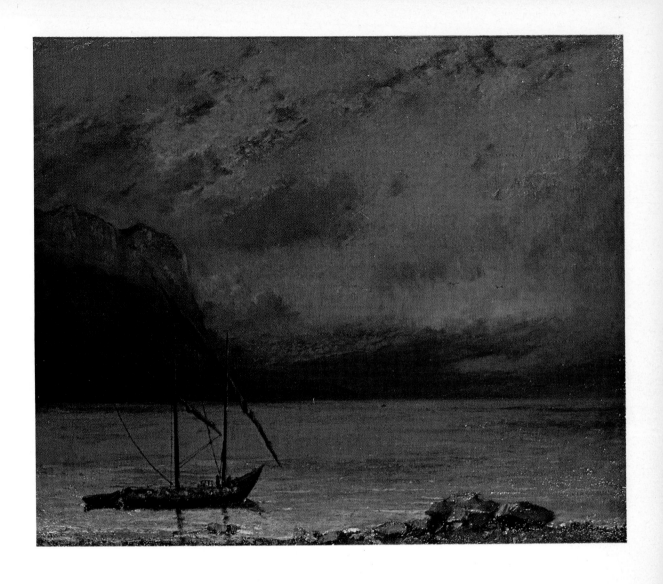

124
Sunset on Lake Geneva

Catalogue

by Hélène Toussaint

We would like to thank the following professors, historians and specialists who, in the course of our research, have given most generously their advice and assistance:

Mme Hélène Adhémar
M. Jean Adhémar
Mme Maria-Teresa Arizzoli-Clémentel
M. Jean-Pierre Babelon
Mlle Jeannine Baticle
M. Roger Bonniot
M. Jean Bossu
Mme Bourasset
Mr Alan Bowness
M. Arnaud Brejon de Lavergnée
Mme Anne Bruno
M. Bernard Ceysson
M. Chestier
Mlle Isabelle Compin
M. Roger Cotte
M. Courbet, Maire d'Ornans
M. Alfred Daber
M. Jacques Daber
le lieutenant-colonel Delannay
M. Charles Durand-Ruel
M. and Mme Robert Fernier

Mlle Marie-Thérèse de Forges
M. Jean-René Gaborit
M. l'abbé Lucien Goguey, Curé of Ornans
Mme Madeleine Hours
Mlle Pierrette Jean-Richard
Mme Geneviève Lacambre
M. Jean Lacambre
M. Michel Laclotte
M. Roger Lecotté
Mme Florence de Lussy
le colonel Martel
M. Albert P. de Mirimonde
M. Michel Mollat du Jourdin
M. Philippe Néagu
Mrs Linda Nochlin
M. François Pérot
M. René Perrot
Mme Odile Picard
Mlle Anne Pingeot
Mme Chantal de Quiqueran-Beaujeu
M. Pierre Quoniam
Mme Nicole Reynaud
M. Michel Terrapon
M. Arthur Tournois
M. Auguste Viatte
Mlle Nicole Villa
M. Zeiger-Viallet

We wish to express particular recognition of Robert Fernier who has recently died. He was the Founder President of the Société des Amis de Courbet, and directed for thirty years the publication of the *Bulletin*; he installed the Courbet Museum in the artist's birthplace in Ornans, where through his efforts are assembled several important works by Courbet, manuscripts and documents essential for the study of the artist.

Realism

The title 'realist' has been imposed on me in the same way as the title 'romantic' was imposed on the men of 1830. Titles have never given the right idea of things; if they did, works would be unnecessary

Without going into the question as to the rightness or wrongness of a label which, let us hope, no one is expected to understand fully, I would only offer a few words of explanation which may avert misconception.

I have studied the art of the ancients and moderns without any dogmatic or preconceived ideas. I have not tried to imitate the former or to copy the latter, nor have I addressed myself to the pointless objective of 'art for art's sake'. No – all I have tried to do is to derive, from a complete knowledge of tradition, a reasoned sense of my own independence and individuality.

To achieve skill through knowledge – that has been my purpose. To record the manners, ideas and aspect of the age as I myself saw them – to be a man as well as a painter, in short to create living art – that is my aim.

G.C.

The above words, which are regarded as the 'manifesto' of Realism, were prefaced by Courbet to the catalogue of the exhibition of his works in avenue Montaigne in 1855.

Note

In the English edition of this catalogue the titles of exhibits are also given in French, followed by the catalogue number referring to the French edition. The entries for catalogue nos.56, 77, 86a, 86b, 108 have been written by Alan Bowness.

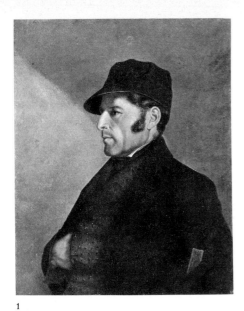

1

1
Portrait of Regis Courbet,
the artist's father

Portrait de Régis Courbet père du peintre (1)

c.1840?

Canvas: 73 × 59. Lower left: Courbet studio sale stamp; on the back of the stretcher: wax seal of the same sale.

History: Juliette Courbet coll.; inherited from the previous owner by Mmes de Tastes and Lapierre; Courbet sale, Paris, 1919, no.22; bought jointly by Galeries Durand-Ruel and Bernheim-jeune; sold to the present owner 1923.

Exhibitions: 1919, Paris, no.22; 1952–1953, Paris, no.19; 1953, London, no.2; 1954, Venice, no.2; 1954, Lyon, no.2; 1955, Paris, no.7; 1959–1960, Philadelphia–Boston, no.4; 1962, Ornans, no.4; 1962, Berne, no.3; 1969–1970, Rome–Milan, no.1; 1975, Paris, no.1.

Eléonor Régis Courbet (1798–1882) was a well-off landowner and a strong personality. Independent and irreverent by nature, a man of ideals and imagination, an eloquent speaker, generous and litigious, acquisitive and open-handed, restless rather than active, he pursued with enthusiasm countless ideas and inventions that proved of little practical use, a typical example being a five-wheeled carriage. Francis Wey wrote of him: *Le père de famille . . . était un bel homme d'une rare et fastueuse sottise* (The father of the family . . . was a handsome man, exceptionally and ostentatiously fool-

ish) (unpublished MS, Bibliothèque Nationale, Estampes).

Gustave painted two portraits of him, at the outset and at the close of his artistic career. The present one was painted in Gustave's early youth, while the other (122) shows his father at the age of seventy-six. Régis Courbet also figures in several compositions: *After dinner at Ornans, Funeral at Ornans, Peasants of Flagey* (134, 135, 41) and *Returning Huntsmen* (Musée d'Ornans).

For a long time this painting was believed to date from 1844, owing to a misreading of Riat's list of portraits painted by Courbet in that year. This refers to 'A Belgian baron' and 'His father', but the portrait is of the baron's father, not Courbet's. This is quite clear from Castagnary's copy of a letter from Courbet to his parents, which was the source of Riat's information and which reads: *J'ai fait ces jours passés un ou deux portraits, celui d'un baron belge, major de cavalerie, ainsi que celui de son père.* ('In the last few days I have done one or two portraits, one of a Belgian baron who is a major in the cavalry, and one of his father.' Bibliothèque Nationale, Estampes, box III.)

The portrait is in a perfect classical tradition. The sober composition and bare background, the clear diffused light and

the model's conscious 'pose' are all in the style of neo-classical portraiture. Comparing it with other works of the artist's youth, we find it had to assign a date later than 1841.

Boulogne-sur-Seine, private collection.

2
Mouth of the River Seine

L'embouchure de la Seine (2)

1841?

Canvas: 43 × 65. Signed lower left: *G. Courbet.*

History: Bought from the artist by Auguste Richebé; given by the previous owner to the Musée de Lille, 1861.

Exhibitions: 1860, Brussels, (?) (*Falaises à Honfleur*); 1956, Hazebrouck, no.20.

We cannot accept the rather late date usually suggested for this work, viz. 1859, the year in which Courbet met Boudin at the farm of Saint-Siméon near Honfleur, the home of Mère Toutain. Despite its sensibility, the painting is somewhat timid. The trees in the form of a screen – a device for suggesting space – the minute treatment of the foliage, which nevertheless

2

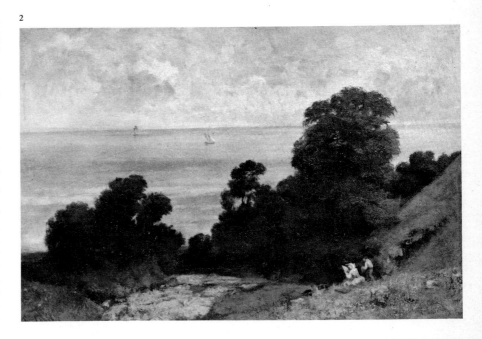

forms a compact mass, and the general sense of distance from the subject are all characteristic of Courbet's youthful works.

Perhaps this is the first of the painter's 'sea landscapes', as he often called them in later years. He first visited the Normandy coast in 1841, when he went to Le Havre with his friend Urbain Cuenot. We do not believe that this canvas can be later than 1842 or 1843. Courbet may have retouched it when it was sold to Auguste Richebé: this idea is supported by the autograph signature, painted over an earlier one which can still be seen.

Lille, Musée des Beaux-Arts.

3
Small portrait of the artist with a black dog

Petit portrait de l'artiste au chien noir (3)

1842

Canvas: 27 × 23. Lower left, monogram: *GC.*

History: Bought 1938 by the town of Pontarlier with help from the Amis du Louvre and Mr. Horace Finaly.

Exhibitions: 1855, Paris, no.17 (*1843, Portrait de l'auteur, essai*) (?); 1867, Paris, no.83

3

(*L'auteur jeune, 1842*) (?); 1939, Ornans, no.6; 1947, Pontarlier, no.85; 1950, La Tour de Peilz, no.2; 1952, Besançon, no.2; 1953, London, no.1; 1955, Paris, no.1a; 1962, Ornans, no.1; 1962, Berne, no.1; 1971, Gentilly; 1973, Paris, no.23; 1977, Ornans, no.1.

Bibliography: Forges, 1972, p.456; Forges, 1973, no.23; Forges, *Annales*, p.23, fig.19, 20.

It is common knowledge that Courbet is one of the artists who made the greatest number of self-portraits. We may pass rapidly over two very early ones published by Marie-Thérèse de Forges: one of *c.*1833 in the Musée Carnavalet and the other, dated 1840, in a private collection (Forges, 1973, nos.22, 26). Some drawings in an early sketchbook in the Louvre are also regarded as self-portraits (Forges, 1973, nos.9, 25).

The first self-portrait of aesthetic interest is the present one, which must have been painted soon after Courbet wrote to his parents in May 1842 that he had acquired a spaniel puppy. 'I now have a splendid little English dog, a pure-bred spaniel given to me by a friend, which everyone admires' (Riat, p.34).

Clearly this little painting in traditional style was inspired by the old masters. The outstretched hand resting on a table recalls the attitude of many sitters for seventeenth-century portraits, standing behind a table as here or leaning over a balustrade. One example is the *Portrait of a man* by Philippe de Champaigne formerly known as *Arnaud d'Andilly*, which Courbet could have seen at the Louvre. The long hair and the austere garment brightened by a collar and linen cuff show the relationship of this self-portrait to its predecessors of the *Grand Siècle*.

In this picture Courbet still has the fixed look of a man eyeing his reflection in the glass; before long, he will have learnt to depict himself in a freer style. The paint is somewhat thinly applied and the technique a little uncertain, but the work already shows traces of the mastery of one who was to be among the most skilful of French artists in the painting of hands.

Marie-Thérèse de Forges suggests that this small painting is the one rejected by the Salon jury of 1843. The receipt book of works submitted includes a *Self-portrait* measuring 35 × 30; these dimensions, which include the frame, would be correct for the present work.

We suggest that this is the picture

which Courbet included in his exhibition of 1855 under the title *Portrait of the artist (sketch). 1843*, and which he exhibited in 1867 as *The artist as a young man (1842)*.

Pontarlier, Hôtel de Ville.

4
Portrait of Paul Ansout

Portrait de Paul Ansout (4)

1842, 1843?

Canvas: 81 × 65. Signed with a point, in the paint, lower left: *Gustave C.*

History: Bought from the artist by Paul Ansout of Dieppe; inherited by his relation, M. Dupré; given by M. Dupré's widow to the Musée de Dieppe in the name of her late husband in 1910.

Exhibitions: 1929, Paris, no.26; 1935–1936, Zurich, no.3; 1950, La Tour de Peilz, no.6; 1952, Besançon, no.5; 1953, London, no.3; 1955, Paris, no.10; 1962, Berne, no.2.

Bibliography: Jacques Guillouet, 'Le portrait de Paul Ansout' in *A.G.C.*, 1950, no.8, pp.9–11.

Paul Ansout (1820–1894), a student from Dieppe, was one of Courbet's first friends in Paris. Traditionally this portrait is dated 1844, on the strength of a letter from Courbet telling his parents that a 'gentleman from Dieppe' was posing for him (Riat, p.34). But there is no proof that he was referring to the present work, which we believe to be earlier. The 'gentleman from Dieppe' may have been a different person altogether, and in any case Courbet painted at least two portraits of his friend. The second portrait was in the possession of Ansout's heirs during the second world war, when it was destroyed at Caudebec-en-Caux (oral communication from M. Pierre Bazin, curator of the Dieppe Museum).

Despite its intimate character there is a certain dryness and solemnity about this work which recalls Chassériau's early portraits in the style of Ingres. The clear-cut draughtsmanship appears somewhat awkward in comparison with the *Portrait of Juliette* of 1844 (8). In the latter work, the cursive line is more skilful and purposeful than in the *Portrait of Ansout*, and the graceful curves of the brocade curtain contrast with the stiff, lifeless background drapery of the earlier painting.

There is, moreover, a valuable clue in the receipt book of works submitted to the Salons, now in the library of the Musée du Louvre. In 1843 Courbet submitted a *Portrait of M. Ansout* which the jury rejected; its dimensions, including the frame, are given as 85 × 100. If, as seems likely, this was identical with the present portrait, the dimensions were given the wrong way round, as happened in several other cases. We suggest therefore that the present portrait is in fact the one submitted for the 1843 Salon but not accepted.

Ansout figures twice in a sketchbook of Courbet's in the Louvre (RF 29234, fo.2 and 22 recto). The first drawing is annotated *Paul Ansout, law student*, and we propose the same identification for the second in view of the similarity of the model's features to the subject of the present portrait. The two sketches appear in the book next to *Harbour views*, which Roger Bonniot has shown to represent Le Havre and not La Rochelle as was previously thought (Bonniot, p.315).

Ansout, whose father was a merchant draper at Dieppe, soon returned permanently to his native town, where he worked in the Registrar's office and engaged in charitable works. His inclinations as a young man were towards Christianity and social welfare, and in the present portrait

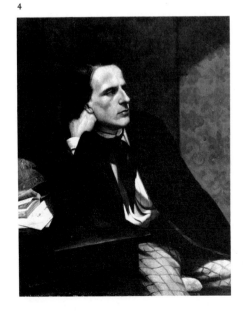

4

he has beside him a half-open copy of Lamennais's *Paroles d'un croyant*. In discussing the *Funeral at Ornans* (135) we shall have more to say of the religious interests of Courbet's friends during his first years in Paris.

Although Ansout had left Paris he no doubt remained in touch with Courbet, who frequently visited Dieppe in later years to see his unacknowledged son Désiré Binet (1847–1872), who lived there with his mother. Ansout's uncle, Louis Belletête (1787–1832), was a well-known ivory carver at Dieppe; Ansout may have maintained contact with that industry and may have arranged for Désiré to be admitted to the ivory carvers' guild.

Dieppe, Château Musée.

5
Self-portrait entitled The desperate man

Portrait de l'artiste dit Le désespéré (5)

1843

Canvas: 45 × 54. Signed and dated lower left . . . *41 G. Courbet* (doubtful authenticity).

History: Juliette Courbet coll.: Courbet sale, Paris, 1881, no.1; bought by M. Cusenier.

Exhibitions: 1873, Vienna; 1876, Geneva, Galerie Pia; 1950, La Tour de Peilz, no.3; 1952, Besançon, no.1; 1955, Paris, no.2; 1969–1970, Rome–Milan, no.2.

Bibliography: Toussaint, no.2; Forges, *Annales*, p.27, fig.24–5; 1973, no.36.

Bruno, 1972, *Il était fou de terreur*, p.82.

In this picture Courbet presents himself not in a sartorial disguise, but in a moral one. According to tradition his exaggerated attitude is one expressing despair, but to us it rather suggests terror, hallucination or madness.

The 1840s witnessed the last manifestations of the science of 'physiognomy' (in French *physiognomonie*) popularized by Lavater at the end of the eighteenth century. The disciples of this movement claimed, by examining a man's physical features, to discover his personality, inclinations, antecedents and destiny. Their

interest in occultism, mysticism and the nature of the self was in line with the first stirrings of romanticism (Viatte, I, pp. 153 ff.). The influence of the new science on Géricault's *Portraits of Madmen* is well known. Courbet is here seen indulging in a pastime which of course has no 'scientific' value in itself, but which associates him with the movement started by Lavater half a century earlier.

The vigour of the painting makes it impossible for us to accept the date of 1841 which appears on the canvas, but which in any case we believe to be apocryphal. We prefer to relate this work to *The draughts players* (10), the somewhat caustic effect of which it reproduces in a different style. Courbet appears to be of the same age, with the same scanty beard and carelessly knotted scarf. We therefore propose a date around 1843.

Dr. Collin, who was present at the artist's death-bed, describes the studio at La Tour de Peilz and mentions 'a painting of Courbet with a desperate expression, which he entitled for that reason *Despair*. This was painted in 1845 and exhibited at Geneva last year.' (Repr. in Courthion, II, p.255.) The reference is undoubtedly to the present work, although there is another, *The man mad with fear* (Oslo, Nasjonalgalleriet; Forges, 1973, p.30), in which Courbet painted himself running or plunging into an abyss with the same wild expression: that work, however, is unfinished and cannot have been exhibited during the painter's lifetime. The present painting is entitled *Study head of a man mad with fear* (45 × 55) in the list of works entrusted to the Galerie Durand-Ruel for safe keeping on 16 February 1873 (Blondon Papers, Bibliothèque de Besançon).

We have suggested elsewhere that this painting was inspired by the Spanish works which Courbet admired in the Louis Philippe gallery in the Louvre (the ex-monarch's Spanish pictures were returned to him in London after 1848), where there were no fewer than 82 paintings by Zurbarán or attributed to him. The white shirt with its stiff creases and their transparent shadows is reminiscent of Zurbarán, as is the treatment of flesh and the subject's impassioned expression: the half-open mouth can be seen in many versions of *St. Francis in ecstasy*, seven of which were in Louis Philippe's collection. The clenched hands are also familiar from works by the

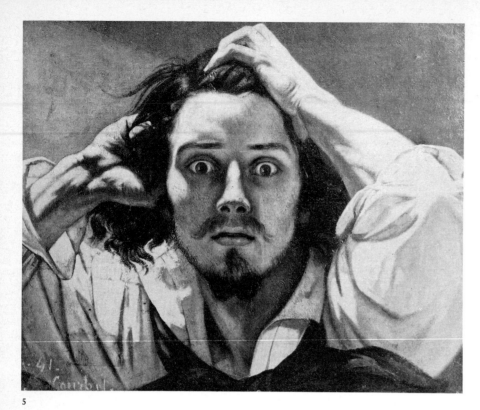

5

great Spanish artists, such as Ribera's martyrs.

Linda Nochlin makes an interesting comparison between this picture and Rembrandt's engraved *Self-portrait with haggard eyes*, which she suggests as having inspired it (cf. Ten Doesschate, p.58); the same suggestion is made by René Huyghe (p.399). Edith Hoffmann, on the other hand, believes it to be influenced by the frightened woman in David's *Sabines* in the Louvre ('Courbet Self-Portraits in Paris', *Burlington Magazine*, August 1973, p.264). We would propose a further source in addition to these – the engravings of 'heads with expression' used in art schools.

People nowadays have forgotten what it was like to study painting in Courbet's time. The choice of an artist's career was often dictated by mere inclination. Painters were trained like technicians in a thoroughly academic fashion, by reading textbooks on artistic method, by constant exercises in schematization and composition, by

practising drawing from the round and from live models and, to a large extent, by incessantly copying mouths, noses and hands from compilations which were made for the purpose and at which masters had been working over since the Renaissance. If the pupil was a genius, this training made him an Ingres, a Delacroix or a Courbet. If he was a lesser talent he became one of the Salon painters whose names can be read by thousands in the catalogues, whom no one now remembers but who nevertheless 'knew their job'. Courbet himself undoubtedly went through the mill. The exactness of his compositions, even in the most casual sketches, show that he underwent a strict training of the traditional kind. His claim to have received no academic instruction was merely showing off. Flajoulot certainly instilled classical principles into him, and he stayed longer in Steuben's studio than he admitted (cf. Biography, p.22). As to the present head expressing *Fright*, it resembles one by

Lebrun in his diagrammatic drawing illustrating his *Lecture on Expressing the Passions* (1668; the drawing is in the Louvre). These heads were engraved twice, by Leclerc in 1696 and by Picart in 1701, and were among the basic models used by aspiring historical painters (cf. Charles Lebrun exhibition, Versailles, 1963, nos. 130, 132).

Luxeuil, private collection.

6
The large oak

Le gros chêne (6)

Canvas: 29 × 32. Dated on the root, beneath the shadow: *1843*. Inscribed on the tree trunk: *Lise et*.

History: Juliette Courbet coll.: bequeathed to Mmes de Tastes and Lapierre; Courbet sale, Paris, 1919, no.8; private coll., Paris.

Bibliography: Forges, 1973, no.28.

This idyllic little picture is traditionally regarded as 'autobiographical', representing the artist with one of his lady-loves whose name is carved on the trunk of the old tree. All we can read is '*Lise et*': gossip adds the name Gustave which is quite likely although there is no actual proof, as Courbet liked to celebrate his adolescent loves in this way. Marie-Thérèse de Forges enumerates a series of works – from *Rural siesta* (129), *Country lovers (Justine and Gustave)* (private collection) to *Happy lovers* (11, 12) (Forges, 1973, pp.13, 27) – in which Courbet depicted his amorous encounters in a rustic setting, thus giving them a chaste and romantic character after the style of Bernardin de Saint Pierre's *Paul et Virginie*.

There is perhaps a certain awkwardness in the young man's figure, but intelligent deliberation is shown in the skilful arrangement, the use of contrasts, and the treatment of the atmosphere.

The figure of a young man, in reverse direction, in a sketchbook dating from Courbet's early years is identical with this one and must be the model for it (Louvre, Cabinet des Dessins, RF 29234, fo.53).

Paris, private collection.

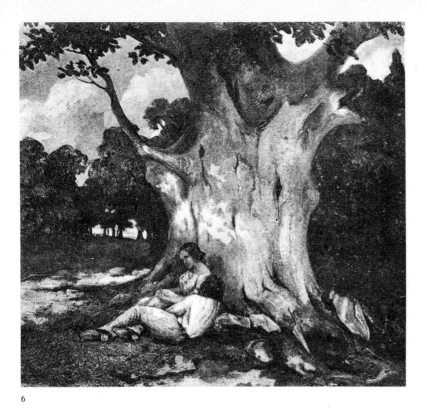

6

dimensions in the receipt book, in the Louvre, of works submitted for the Salons: viz. 60×70 including the frame. After being rejected by the Salon jury in 1841, 1842 and 1843, Courbet was finally successful with this work.

We cannot accept the date of 1842 which, like the signature, was added to the picture at an unknown date and perhaps not by Courbet himself. It is not certain that the work was signed for the Salon. *After dinner at Ornans* (134), which was purchased by the State at the 1849 Salon and did not revert to the artist's possession, was never signed. In any case Courbet would not have indicated a date earlier than that of the Salon: as we shall often see, when exhibiting works he marked them with the date of the current year even if they were painted earlier.

No doubt the painting was originally conceived in 1842: it is a development of the *Self-portrait with a black dog* at Pontarlier (3). But the execution shows that a period of time must have elapsed between the two works, during which the painter learnt a good deal. In addition, inspection at the Laboratoire des Musées de France

7
Self portrait entitled Courbet with a black dog

(7)

Portrait de l'artiste, dit Courbet au chien noir

1844

Canvas: 46×55. Signed, dated lower left: *Gustave Courbet, 1842.*

History: Juliette Courbet coll.; given by Juliette Courbet to the Petit Palais in 1909.

Exhibitions: 1844, Paris Salon, no.414 (*Portrait de l'auteur*); 1876 or 1877, Geneva (?); 1882, Paris, no.35; 1900, Paris, no.147; 1917, Barcelona, no.1398; 1929, Paris, no.3; 1932, London, no.312; 1935–1936, Zurich, no.1; 1949, Copenhagen, no.1; 1950, La Tour de Peilz, no.4; 1955, Paris, no.3; 1959–1960, Philadelphia–Boston, no.3; 1968, Atlanta; 1973, Paris, no.24.

Bibliography: Forges, *Annales*, pp.21–22, fig.17, 18; Forges, 1973, no.34.

As indicated in the catalogue of the Courbet exhibition of 1882, this self-portrait is the first of the painter's works to have been shown at a Salon, that of 1844. This is confirmed by the indication of

7

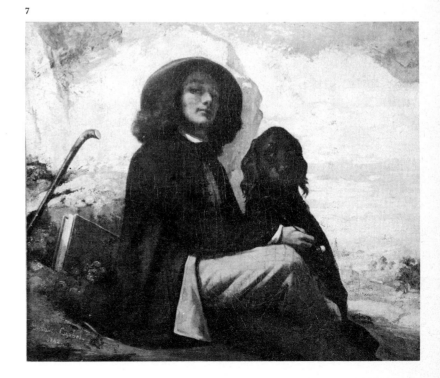

has shown that the self-portrait was painted on a previously used canvas and was itself subjected to alteration.

Originally the scene was rounded at the top; the portions added to make it rectangular have aged badly and are very conspicuous. The rounded shape was fashionable at the time, and the composition was designed accordingly. There may also have been a practical reason: Marie-Thérèse de Forges suggests that the painting was intended for a mural decoration, a pier or an overdoor. This is supported by two arguments: firstly the view *di sotto in su*, and secondly the fact that the work did not figure in Courbet's two private exhibitions, as though it was not readily available for the purpose. We believe that no.17 of 1855 – *1843, Sketch for a self-portrait* – is the *Small portrait with a black dog* (3) which reappears in 1867 as no.83: *The artist as a young man (1842)*, *rejected at the Salons of 1842, 1843, 1844, 1845, 1846 and 1847*. As the receipt book shows, the statement about rejection is only true for 1843; the present work was in fact the first of Courbet's to be accepted at the Salon of 1844. Moreover, it was never caricatured like the other self-portraits exhibited by him, which suggests that the cartoonists never saw it.

See p.235 for continuation of text.

Paris, Musée du Petit Palais.

8
Portrait of Juliette Courbet

Portrait de Juliette Courbet (8)

1844

Canvas: 78 × 62. Signed and dated, lower left: *Gustave Courbet 1844*.

History: Juliette Courbet coll.; given by Juliette Courbet to the City of Paris in 1909.

Exhibitions: 1882, Paris, no.164; 1929, Paris, no.10; 1935, Brussels, no.932; 1935–1936, Zurich, no.4; 1937, Paris, Rosenberg, no.1; 1939, Belgrade, no.21; 1947, Zurich, no.187; 1949, Copenhagen, no.2; 1952–1953, Rotterdam, no.23; 1955, Paris, no.9; 1963, Schaffouse, no.25; 1969–1970, Rome–Milan, no.3.

Bibliography: Pérot, no.3.

Juliette (1831–1915) was the youngest of Courbet's sisters. Twelve years his junior, it was she whose portrait he painted most often and whom he was fondest of representing anonymously in his paintings. She hero-worshipped her brother (whether sincerely or from self-interest), and became his sole heir at the expense of her elder sister Zoé. A devout spinster, eccentric in character and dress, inordinately touchy and litigious, she gives the impression of a miserly woman and a somewhat possessive sister. Some years before her death, however, she made valuable donations in memory of her brother, presenting to the State his *Funeral at Ornans* (135) and to the city of Paris several masterpieces including the present work and *Departure of the fire brigade* (136). She also made donations to the municipalities of Besançon, Ornans and Vevey.

The portraits and photographs of Juliette as a grown woman show her to have had a bony face with huge, frightening eyes and a mouth like a pillar-box. In this picture, however, painted in 1844, she is an attractive child of thirteen. Two earlier portraits of 1841 and 1842 are known from texts and reproductions (Léger, 1929, pp.31, 32), and there was also an early drawing (127). In this catalogue we shall encounter several other representations of Juliette.

Courbet, we are told, professed a violent hatred for Ingres and neo-classical art in any shape or form; yet when he first set foot in Paris as a young man he felt much less strongly on this subject. X-ray examination of the Besançon self-portrait by the Laboratoire des Musées de France has shown that it is painted on a partial copy of Ingres's *Angélique* in the Louvre (cf. Annales, 1973, p.8, fig.2). At least two of Courbet's pictures show the influence of Ingres or his school: the present one and, still more, *The hammock* (1844, Winterthur, Oskar Reinhart collection), in the latter which is the most important of Courbet's youthful works, the female figure is unmistakably inspired by Ingres at his most skilful and exalted.

The portrait of Juliette at thirteen presents an ascetic design, a fresh tonality dominated by yellows and tender blues, a diffused clarity, in short a style proving that Courbet is not deaf to Ingres's message. The model's stiff attitude, the preciosity of the candy-striped satin dress, the detailed lace-work and finally the setting, with a light flowering plant in front of a mirror, recalling Ingres's *Portrait of Madame d'Haussonville* (1842–1845, New York, The Frick Collection) – all these features suggest that Courbet was a visitor to Ingres's studio.

The painting has an ambiguous charm due not only to the little girl's fixed, faraway expression but to the disconcerting combination of an exaggerated verism, omitting neither a bead of the gilded frame nor a shackle-bolt of the armchair, with the deceptive art which treats the cane back of the chair as a perfectly regular trellis-work, in defiance of probability and perspective, and which shows us a mirror in which there is no reflection whatever.

This trifling with the truth makes us think of surrealist art, or one of the *Tales of Hoffmann*, which had just appeared in a celebrated translation by Courbet's friend Théodore Toussel. In this story another Juliet bewitches a man and robs him of his reflection in the looking-glass. Lifting a curtain in front of a mirror and discovering this, the young man flees in the company of Chamisso's Peter Schlemihl, who has lost his shadow, and the two are condemned to roam the world for evermore.

Undoubtedly the young Courbet was profoundly sensitive to that part of romantic literature which consists of symbolic, mysterious, ambiguous tales. The titles of his first works, which no longer exist, are full of examples. They include an *Odalisque* inspired by Hugo's poem *Si je n'étais captive . . .*, a *Walpurgis Night* bringing the Faust story up to date, a scene from George Sand's *Lelia* and, especially, a *Memory of Consuelo* which, according to Marie-Thérèse de Forges, is identical with the self-portrait entitled *The cellist* (16). George Sand's *Consuelo* is one of the most perfect examples of the esoteric novel of the nineteenth century. To these titles may be added others inspired, in all probability, by similar literary works that can no longer be identified; in some cases the picture itself is lost, *e.g. Man delivered from death by love*, while in others it survives, *e.g. Man mad with fear* (Oslo, Nasjonalgalleriet) and *The desperate man* (5). This early predilection of Courbet's makes us think that he may well have been inspired by Hoffmann and by the coincidence of Christian names to depict his sister in front of a looking-glass which, when the curtain is drawn, proves to contain no reflection. This would also tend to confirm our suspicion that Courbet maintained contact with certain

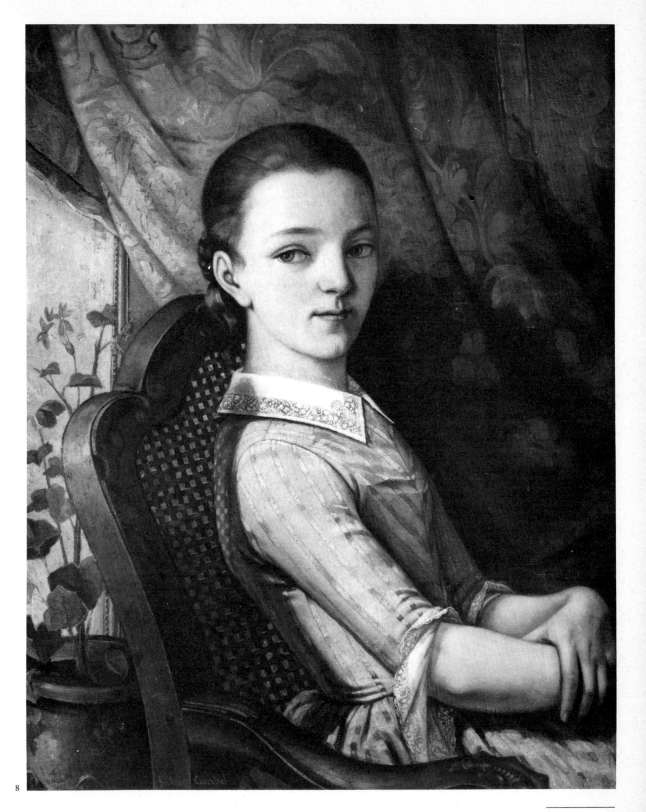

8

circles interested in mysticism and the occult.

The *Portrait of Juliette* was submitted for the Salon of 1845. In a letter to his parents in February Courbet listed five paintings that he hoped to exhibit, including '. . . Juliette's portrait, which I call *Baroness de M.* for a joke' (Riat, p.35). Only one was accepted, however, namely *Guitarrero* (U.S.A., private collection).

Paris, Musée du Petit Palais.

9
The sculptor

Le sculpteur (9)

1844

Canvas: 55 × 41. Signed and dated lower left: *G. Courbet, 1845*.

History: Sold by Courbet about 1845–1846 to a Dutch dealer? (H. J. van Wisselingh?); Galerie Hessel, Paris; bought from Galerie Hessel by Galerie Durand-Ruel, 24 October, 1916; sold by Galerie Durand-Ruel to Galerie Georges Bernheim, 16 October, 1923; Dr. Hans Graber coll., Zurich.

Exhibitions: 1935–1936, Zurich, no.12; 1957, Montclair, no.14; 1958, London, no.8; 1959–1960, Philadelphia–Boston, no.6; 1962, New York, no.8; 1962, Berne, no.5; 1965, New York, no.8.

Bibliography: Forges, 1973, p.30.

Courbet is traditionally supposed to have depicted himself in this painting, sometimes called *The poet*. This seems quite plausible if we compare it with other known self-portraits. The painter has indulged the fantasy of painting himself in medieval costume and, intentionally or otherwise, with the emblems of a Masonic apprentice: he is seen carving the 'living rock' with a mallet in his right hand and a chisel in his left. The inchoate sculpture can be seen: a woman's head leaning against an amphora from which water is trickling. The connection between women and water is also part of Masonic symbolism. It does not follow that Courbet was himself a Mason: the era was one in which romantic minds were attracted by secret societies, and he may moreover have been influenced by an engraving which forms the frontispiece to Oswald Wirtz's book *L'Apprenti Franc-Maçon*.

The painting bears the date 1845,

but was probably executed a year earlier: in the first place it shows Courbet without a beard, and secondly it forms a perfect pendant to a painting of the same dimensions and the same engaging 'troubador' style, *The guitarrero*, dated 1844 (U.S.A., private collection). The latter is usually thought to be a self-portrait also, but we believe it to be of Courbet's musician friend Promayet, who accompanied him to Paris. It would not be surprising for Courbet to have composed in this way a sort of diptych showing the two Franche-Comté friends in picturesque and fantastic garb.

The *Guitarrero* was Courbet's second picture to be accepted for the Salon, in 1845. A purchaser came forward, but Courbet refused to sell it. We read, however, in Castagnary's papers that in 1845 or 1846 a dealer from Amsterdam (H. J. van Wisselingh?) bought a small picture from Courbet, a 'pendant to the Guitarrero' (Bibliothèque Nationale, Estampes, Box III). This can only have been *The sculptor*.

New York, private collection.

10
The draughts players

Coup de dames (10)

1844

Canvas: 25 × 34. Signed, dated, lower left: *Gustave Courbet, 1844*.

History: Public sale, Geneva, 23 May, 1936; Sale, 'Tableaux modernes de l'école fran-

9

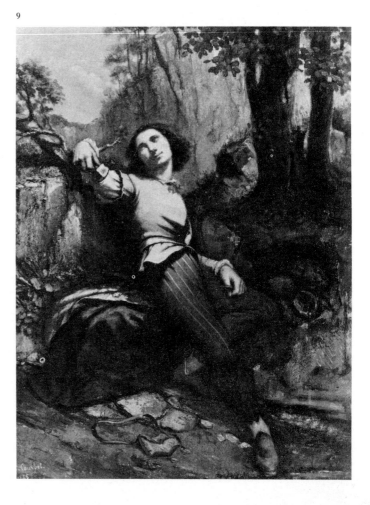

86

çaise', 13 June, 1933, Frédéric Muller & Co. Amsterdam; Galerie Kohler, Zurich.

Bibliography: Forges, 1973, pp.31, 32.

In all probability this small picture is the one submitted unsuccessfully by Courbet to the Salon of 1845: its dimensions (40 × 46, including the frame) agree with the record in the receipt book of works submitted to the Salons, now in the Bibliothèque du Louvre.

In this humorous genre picture Courbet has represented himself as a mephistophelian gnome (Forges, *op. cit.*), giving even freer rein to the 'troubador' spirit than in *The sculptor* (9). His picturesque disguise, the large hat worn by his companion, the overt pastiche of seventeenth-century Dutch and Flemish scenes of gamesmen and still life (one may think of Rombouts) make this youthful work one of the most romantic imaginable.

The scene must be in Courbet's studio in the rue de la Harpe, a disaffected chapel in which he lived from 1843; one of the arches can be seen. The room is cluttered with paraphernalia, depicted with enormous care, including a cast of *The flayed man*, attributed to Michelangelo, which Marie-Thérèse de Forges has also recognized in *Man with a leather belt* (13).

Is the inspiration of this picture derived from a literary work? Certainly at this period Courbet was interested in fantastic and exotic tales like those popularized by Charles Nodier (also a Franche-Comté man), and extracted from them pictorial themes whose significance is often lost to us. The intrusion of mystery into everyday life is a familiar aspect of romanticism.

Caracas, collection of Sr. Adolfo Hauser.

11
The lovers in the country, youthful sentiments, Paris

Les amants dans la campagne, sentiments du eune âge, Paris (11)

1844

Canvas: 77 × 60. Monogram, dated lower left: *G.C. 1844.*

History: Juliette Courbet coll.; Courbet sale, Paris, 1881, no.3; bought at the Courbet sale

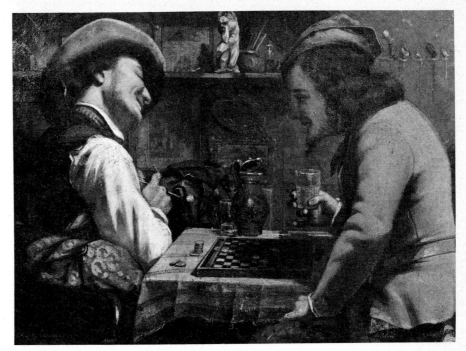

10

by the picture dealer Haro; Galerie Brame; bought from the previous owner by the Musée des Beaux Arts in 1892.

Exhibitions: 1855, Paris, no.9 (*Sentiments du jeune âge – 1845*); 1867, Paris, no.17 (*Les Amants dans la campagne, sentiments du jeune âge, Paris, 1844*); 1882, Paris, no.20; 1935–1936, Zurich, no.8; 1950, Cologne, no.29; 1952, Besançon, no.4; 1954, Venice, no.1; 1954, Lyon, no.1; 1955, Paris, no.5; 1957, Paris, Charpentier, 1959, London, no.81.

Bibliography: Caricature by Randon in *Le Journal amusant* (repr. in Léger, 1920, p.69); Vincent, pp.125–128; Forges, 1973, pp.26–27.

Bruno, 1872, *Lazare et Miss Ann*, p.64.

We suggest that this painting is to be identified with the one submitted to the Salon of 1846 under the title *Walse*, entered in Courbet's own hand in the receipt book kept in the library of the Louvre. The dimensions given are 100 × 80, which is correct seeing that the frame is included. The title serves to explain the fact that the characters are dancing. The work was rejected by the jury, who in that year accepted only one of Courbet's pictures, *Portrait of M. XXX* (13).

Courbet is seen here with one of his conquests, thought to be Virginie Binet, the only woman with whom he carried on a liaison for any length of time; she bore him

a son in 1847. Virginie was the daughter of a Dieppe shoemaker and was eleven years older than Gustave. Apparently they grew apart in 1851 or thereabouts and finally parted in 1855, to judge from a letter of Courbet's to Champfleury telling him that Virginie was getting married (cf. *The painter's studio* (137). In actual fact she never married; either she changed her mind, or she was lying to Courbet to put pressure on him. She died in 1865.

When Courbet sent Bruyas his self-portrait *Man with a pipe* (19) he drew up a kind of reference list of his portraits (Borel, p.20). This list has always seemed obscure, but it is important to remember that in Courbet's time a clear distinction was made in catalogues and elsewhere between 'portraits' and 'pictures'. When Courbet speaks of the 'portrait of a man in the ideal state of absolute love, after the manner of Goethe, George Sand etc.' he is not referring, as might be thought, to the *Lovers*, which figures in his exhibitions as a 'picture'. In the light of this distinction the list sent to Bruyas becomes intelligible. We propose the following identifications. 'The third most recent was that of a gasping and dying

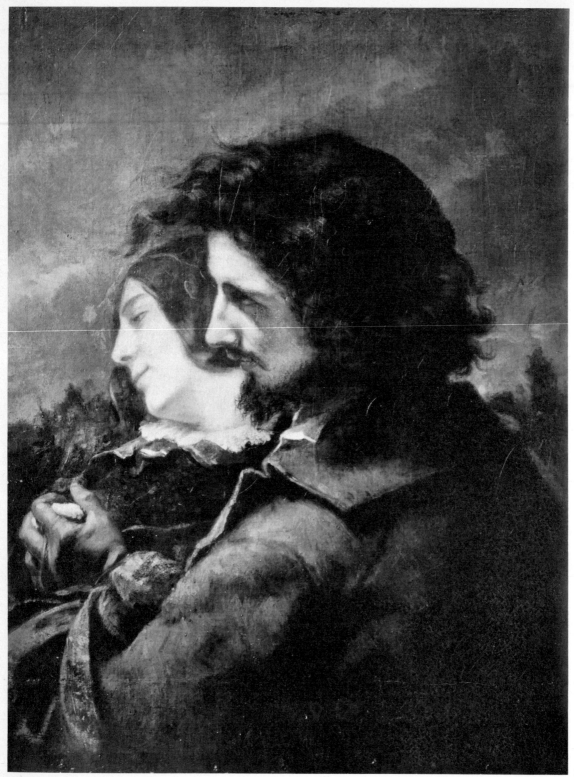

man' – evidently *The wounded man* (33). 'The second was the portrait of a man filled with ideals and love': this, in our opinion, is the *Man with a leather belt* (13). 'And now this one' – the *Man with a pipe* (19) accompanying his letter. The first two, which he does not mention, as he begins with the third portrait, are the two *Self-portraits with a black dog* (3, 7).

The *Lovers* is certainly a romantic work *par excellence*, and appears even more so when we are told to imagine it accompanied by a waltz tune. It is also called *The happy lovers*, but we have used the title given it by Courbet at his exhibition of 1867. In his note on that occasion he adds, incorrectly, that it was rejected by 'Members of the Institute' at the Salons of 1844, 1845, 1846 and 1847. As the receipt book shows, if the picture is indeed the *Walse* this is only true for 1846. None of the other rejected pictures are of the right size or subject.

The mood of the *Lovers* is similar to that of the *Man with a leather belt* (13): both are eminently 'Venetian' and reminiscent of Titian.

Lyons, Musée des Beaux-Arts.

12
The lovers in the country

Les amants dans la campagne (*12*)

After 1844

Canvas: 61 × 51. Signed lower right: *G. Courbet* (doubtful authenticity?).

History: Juliette Courbet coll.; given by Juliette Courbet to the Petit Palais in 1909.

Exhibitions: 1921, Basle, no.41; 1929, Paris, no.31; 1935–1936, Zurich, no.9; 1947–1948, Brussels, no.69; 1949, Copenhagen, no.4; 1950, Belgrade, no.19; 1950, La Tour de Peilz, no.5; 1955, Paris, no.6; 1955, Winterthur; 1958, Stockholm, no.135; 1962, Ornans, no.5; 1962, Berne, no.4; 1964–1965, Munich, no.45; 1968–1969, Moscow–Leningrad, no.76; 1971, Bucharest, p.42; 1971, Budapest, no.10; 1973, Paris, no.31.

Bibliography: Forges, *Annales*, p.27, fig.21, 22; Forges, 1973, no.31.

A certain softness of execution suggests to us that this is a repetition of the *Lovers* in the Lyons Museum (12) rather than a preparatory sketch. X-ray examination by the Laboratoire des Musées de

12

France has shown that it was painted directly, without hesitations, on an unused canvas. It would be interesting to subject the Lyons picture to a similar examination and compare the X rays.

The present work is hard to date, but in view of the smooth, glazed surface we believe it to be some years later than the original. One of the two versions, if not both, remained in Courbet's possession until his death and was seen by visitors to his studio at La Tour de Peilz (Courthion, II, p.256).

Paris, Musée du Petit Palais.

13
Self portrait, entitled 'Man with a leather belt'

Portrait de l'artiste dit L'homme à la ceinture de cuir (*13*)

1845–1846?

Canvas: 100 × 82. Signed lower left: *Gustave Courbet*.

History: Juliette Courbet coll.; Courbet sale, Paris, 1881, no.5; bought at the Courbet sale by M. Hecht who advanced the necessary funds on behalf of the State; moved to the Louvre, 10 December, 1881; allotted to the Musée du Luxembourg, but stopped 31 July, 1882; entered the Louvre 1888.

Exhibitions: 1846, Paris, Salon, no.429 (*Portrait de M. XXX*); 1867, Paris, no.81 (*L'auteur Paris, 1852*) or no.83 (*L'auteur jeune, 1842*); 1873, Vienna, no.51; 1882, Paris, no.36; 1928, Oslo, no.16; 1929, Paris, no.4; 1935–1936, Zurich, no.6; 1948, Paris, no.575; 1959, London, no.82; 1973, Paris, no.1.

Bibliography: Caricature by Randon in *Le Journal amusant*, 1867 (repr. in Léger, 1920, p.70); Forges, 1973, no.1; Forges, *Annales*, p.27, fig.5; Delbourgo-Faillant, p.10, figs.5, 6.

Bruno, 1872, *Le Charlatan Patapouf*, p.208.

The date of this painting cannot be reliably inferred from the information given by Courbet in the catalogues of his private exhibitions, as this data is frequently untruthful, approximate or vitiated by misprints. It is thus not easy to reconstruct the history of the composition of *Man with a leather belt*, which we regard as the most important of Courbet's self-portraits.

The one certain fact is that the picture figured in the exhibition which opened at the Pavillon de l'Alma in 1867, when it was the subject of a caricature by Randon (*op. cit.*). But to what catalogue number does it correspond? It cannot be no.83 – *The artist as a young man, 1842* – unless the date is misprinted; Courbet appears as an older man than in the *Portraits with a black dog* (3, 7), and in any case he was not sufficiently master of his art to have painted it at that time. Is it no.81 – *The artist, Paris, 1852*? This is too late a date, but again there may be a misprint. There is no third possibility.

It is not clear that the painting was in the 'private exhibition' of 1855, though several critics identify it with no.25: *1849, Self-portrait, a study in the Venetian style*. The date is improbably late and, while the picture may remind us of the Venetians, Courbet himself always insisted that it was inspired not by them but by Velázquez. Nor can it be no.17: *Portrait of the artist, a sketch*: the work is not a mere study. Can it have been no.24: *1848, Portrait of M.****? In that case it would have the same title as it is supposed to have borne at the Salon of 1846, but a different date.

The following reasons lead us to think that the work was painted in 1845–1846. Firstly, Marie-Thérèse de Forges (*op. cit.*) suggests convincingly that it was submitted to the 1846 Salon under the title *Portrait of M.XXX*. The measurements,

according to the receipt book, are 140×110 including the border. This would mean a wide frame, but a difference of this order is frequent in cases where all the measurements are known for certain. Courbet wrote to his parents that the Salon had accepted his *Self-portrait* (Riat, pp.42–3). Of all his known self-portraits, this is the only one that the above measurements would fit.

Secondly, from his face in this portrait Courbet looks about the same age as he does in *Lovers in the country* (11). His sentimental expression and the hint of a complacent smile remind us of the man 'filled with ideals and love' of whom he wrote to Bruyas, and would fit into the chronology described to the latter, between the first version of *The wounded man* in 1844 and *Man with a pipe* of 1849 (33 and 19; cf. 11).

There is a perceptible continuity of inspiration between this *Portrait* and the *Small portrait with a black dog* (3): the pose with the elbow propped on a table, the austere dress and the prominence of the hands. The earlier work, of course, is only an apprentice effort, while the present painting is a masterpiece. On the left can be seen the statuette of the *Flayed man*, attributed to Michelangelo, which we noted in *The draughts players* (10). The album of prints on which the painter's elbow rests is probably the one seen in Trapadoux's hands in the *Portrait* of him in the 1849 Salon (Federal Republic of Germany, private collection).

This *Portrait* is one of the few works by Courbet that have at all times been acclaimed by a majority of critics and historians. This is perhaps due to its traditional style and its references to the past, which have been seen as recalling the greatest portraitists of the Italian Renaissance and seventeenth-century Holland. When Courbet's admirers spoke of Rembrandt in his presence, however, he disclaimed the latter's influence and insisted that the work was a piece of 'super-Velazquez' (Forges, 1973, *op. cit.*). More exactly, it is the work of a man inspired by all the masters whom Courbet copied in the Louvre. Each of them gave him a little of themselves, and it would be vain to seek to identify the share of each. A shadow, in any case, is not a metaphor. X-ray examination at the Laboratoire des Musées de France has shown that the work is painted on a canvas on which Courbet had previously made a copy, the other way up, of Titian's *Man with a glove*. Long before this was known, the close similarity of the two works was pointed out by Haavard Rostrup (1931, p.219), and thanks to the X ray their relationship is confirmed once and for all (Delbourgo-Faillant, *op. cit.*).

A small version of this *Portrait* in the National Gallery, London is thought by Martin Davies to be a replica, probably by Courbet himself (Davies, p.36).

Paris, Musée du Louvre.

14
Portrait of H. J. van Wisselingh

Portrait de H. J. van Wisselingh (14)

1846

Panel: 57×46. Signed, dated lower right: *G. Courbet, 1846*.

History: Acquired from the artist by the sitter, an Amsterdam picture dealer, 1846; Mlle. N. van Wisselingh coll., Amsterdam; E. J. van Wisselingh coll., Amsterdam; Dr. Hans Alfred Wetzlar coll., Amsterdam (1949).

Exhibitions: 1846, Amsterdam, no.402 (*Portrait d'Homme* (?)); 1941, Amsterdam, no.9; 1949, Paris, no.3; 1953, London, no.4; 1954, Venice, no.5; 1954, Lyon, no.5; 1955, Paris, no.12; 1959–1960, Philadelphia–Boston, no.10; 1957, Cardiff–Swansea.

The Dutch picture-dealer H. J. van Wisselingh noticed Courbet's work at the Salon of 1845 or 1846, and was in all probability the purchaser of *The sculptor* (9). Later he asked Courbet to paint his portrait. From the 1846 catalogue of the *Exposition des artistes vivants* held annually at Amsterdam we see that Courbet exhibited

13

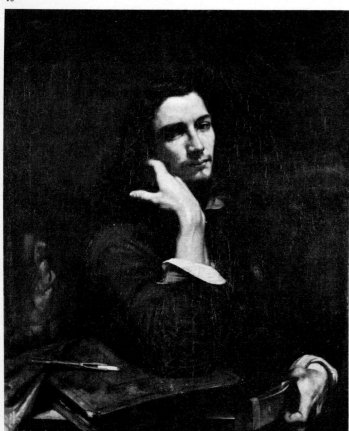

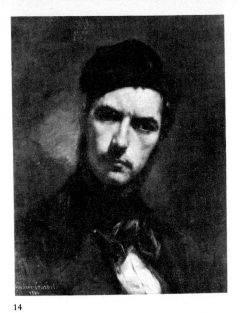

14

Exhibitions: 1855, Paris, no.8 (*1850*); 1938, Amsterdam, no.63; 1939, Paris, no.21; 1939, Berne, no.20; 1948, Paris, no.577; 1968–1969, Paris, no.10; 1976–1977, Paris, no.6.

Bibliography: Bruyas, 1876, p.428.

We do not know when Courbet and Baudelaire became friends; they may have met at the Café Momus, of which they were both habitués. In any case it is not surprising that their paths crossed – they had friends in common: Champfleury, Trapadoux, Toubin – or that they took to each other. The young Courbet, it should be recalled, was a carefully dressed dandy, not the obese sloven we see in his last photographs, and he must have captivated Baudelaire by the natural force of his imperturbable energy. If he still had a provincial accent or rustic habits, Paris could be expected to lick him into shape as it had so many others.

They were definitely friends at the time of the 1848 revolution, and in the following year, but probably not for long after the establishment of the Empire in 1852. In *The artist's studio* in 1854 Baudelaire is depicted close to the door and 'half-sitting, half-standing'. Does this ambiguous pose signify a dismissal, or is it an attempt to renew a fading friendship? At all events, from 1852 onwards the two men's ways had begun to part. Baudelaire's article *Si Realisme il y a*, written in 1855 but not published (Baudelaire, II, pp.57–9), records his sceptical and even hostile feelings towards the Realist movement. The title of that movement, if indeed it was one – for the question is still open – had wider implications than the mere defence of an aesthetic theory: its followers were what we would nowadays call 'committed', in the politico-social sense. This was not to

the *Portrait of a man* in that year; possibly the present work.

Marie-Thérèse de Forges suggests in her biography of Courbet that the artist's visit to Holland, hitherto thought to have been in 1847, took place a year later. Certainly this fine portrait shows the influence of Rembrandt more definitely than any previous one of Courbet's that is known to us. It may indeed have been painted at Amsterdam, and it is interesting to compare it with the *Portrait of Adolphe Marlet*, painted some years later (26).

Edenbridge, Kent, collection of Lord Astor of Hever.

15
Portrait of Baudelaire

Portrait de Baudelaire (15)

1847?

Canvas: 53 × 61.

History: Sold by the artist to the publisher Poulet-Malassis, 1859; bought from Poulet-Malassis by Alfred Bruyas, 1874; bequeathed by Bruyas to the Musée Fabre, 1876.

15

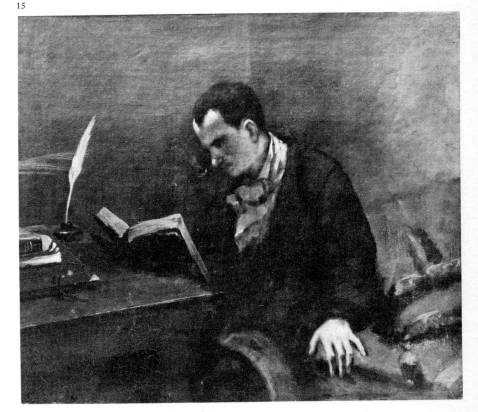

the taste of Baudelaire, who mistrusted democrats and who, from 1851 onwards, followed a different course inspired by Joseph de Maistre and Edgar Allan Poe, with a penchant for the supernatural and an aristocratic notion of persons and things. He was not, indeed, the only one to desert the 'movement'. George Sand's disapproval of it provoked Champfleury's famous *Lettre à Madame Sand*, a lengthy defence of the Realists and of Courbet (in *L'Artiste*, 2 September, 1855; reprinted in Lacambre, 1973, pp.169–178).

Baudelaire, moreover, belonged to certain circles in which Courbet was unwelcome. The painter may have wished to curry favour with Madame Sabatier: there is a clear hint to this effect in *The studio* (137), but it does not seem to have been taken. Baudelaire had a place in her little group along with Théophile Gautier, Maxime Du Camp, Boissard de Boisdenier, Ricard, Meissonier and Clésinger; all these looked askance at the renegade from Ornans who had joined the category stigmatized as 'socialist louts' (*pignoufs*) by Flaubert, the spokesman of the habitués of the rue Frochot (letter to the Goncourt brothers, 12 August, 1865). Finally, Baudelaire had a profound and deferential admiration for Delacroix, and the latter's influence could not fail to diminish the poet's attachment to Courbet.

In the catalogue of Courbet's private exhibition of 1855 this portrait is dated 1850. Historians agree, however, in assigning it to 1847. They do not give much reason for their view, but it is quite plausible, as it was in that year that Baudelaire adopted a close-cropped hairstyle instead of romantically flowing locks.

As regards the pose, so many subjects have been depicted writing or reading, seated at a table with a pen or a candle standing on it, that it would be pointless to suggest one model rather than another: dozens could be cited from every school, from the Renaissance onwards.

Courbet complained that he did not know how to finish the portrait, as Baudelaire's face 'changed daily'. It is indeed no more than an elaborate sketch, which the painter used for the figure of Baudelaire in *The Studio* (137).

The portrait is a handsome one, but as a representation of Baudelaire we may still prefer the silhouettes left by Manet, or Fantin-Latour's portrait in *Hommage à*

Delacroix (1864, Louvre – Jeu de Paume), or the innumerable photographs by Nadar, and Carjat; or even the 'daub', to use the sitter's own term, painted by Deroy in 1845 and showing Baudelaire as a young romantic with long curly hair (Château de Versailles).

Legros made a copy of this painting in 1862 (exhibition *Cent ans de peinture française*, Galerie Charpentier, 1929, no. 104).

Montpellier, Musée Fabre.

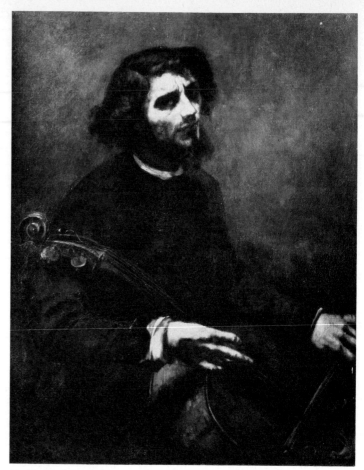

16

16
The cellist, self portrait

Le violoncelliste, portrait de L'artiste (16)

1847

Canvas: 117 × 90. Monogram, lower left: *GC.*

History: Entrusted by the artist to Galerie Durand-Ruel, 1873; Ivar Kreuger coll., Stockholm; given to the Föreningen Nationalmusei Vänner, 1936.

Exhibitions: 1848, Paris, Salon, no.1015; 1851, Brussels (*Le Bassiste*); 1955, Paris, no.10; 1867, Paris, no.82; 1877, Brussels; 1923, Stockholm, no.3; 1959–1960, Philadelphia–Boston, no. 11.

Bibliography: Caricature by Quillenbois in *L'Illustration*, 21 July, 1855 (repr. in Léger, 1920, p.30); R. Hoppe, *Courbet och hans arbeten i Nationalmuseum och andra nozdiska samlingar* in *National Musei Arsbok*, 1924, no.6, pp.20–22; R.

Hoppe, *Kring Courbets självporträtt* in *National
ärsbok*, 1938, no.8, pp.104, 107–110, 112–113, repr.;
Forges, 1973, pp.32–33.

The date of this picture was given as
1845 at Courbet's exhibition in 1855. At
his private exhibition in 1867 the catalogue
gave the date of 1847, stating that it had
been rejected for the Salon of that year but
accepted in 1848. As we know, Courbet
was highly unreliable in such matters. If,
however, we follow up his statement and
consult the receipt book in the Louvre for
the list of his paintings rejected in 1847, we
find: *Ballade* (75 × 85), *Portrait of M.
Urbain* (141 × 110) and *Memory of Consuelo*
(145 × 120) (all measurements including
frame). Nothing is known of *Ballade*; the
M. Urbain is doubtless Cuenot. As to
Memory of Consuelo Marie-Thérèse de
Forges has suggested very convincingly
(oral communication) that it is in fact the
picture submitted to the Salon of the
following year under the title *The cellist*.
Its original title may have been the reason
why it was rejected, either because it was
too obscure or, paradoxically, because it
was over-explicit.

George Sand's novel *Consuelo*, pub-
lished in 1842–1843, made a great impres-
sion in her day. The character of the
heroine, a street singer, was inspired by
Pauline Viardot. A sequel, *La comtesse de
Rudolstadt*, belongs to the category of
George Sand's mystical and hermetic
novels influenced by Pierre Leroux and
Michel de Bourges. These romantic and
mysterious tales seem to have attracted and
inspired the young Courbet, and the title of
the work submitted in 1847 shows that he
was affected by the character and adventures
of Consuelo. Is that work the same as the
one we are now considering? It may be, for
Consuelo's supernatural universe is dedi-
cated to music. Why does Courbet disguise
himself as a left-handed cellist (it is a self-
portrait), playing with an exalted expres-
sion on an instrument with broken strings?
Here, once again, he is a painter of
fantasies.

Alan Bowness has studied the rela-
tions between George Sand and the young
Courbet (cf. Bowness, 1972, p.121), but
they do not present a very clear picture.
History, or legend, tells us that the painter
executed a miniature portrait (?) of the
authoress with her small daughter Solange;
but the latter was born in 1828 and it is un-
likely that Courbet knew her as a little girl.

Possibly he met Solange through the sculp-
tor Clésinger, whom she married in 1847
and who, like Courbet, was a native of the
Franche-Comté. In any case, Courbet did
not need to have known George Sand in
order to read works that everyone was
talking about and that interested him for
more than one reason.

The cellist attracted the critic's atten-
tion; Prosper Haussard was reminded of
Caravaggio and Rembrandt (*Le National*,
15 June, 1848). Champfleury wrote in his
review of the 1848 Salon: 'Nurtured by
Rembrandt and Ribera, this young man
developed such solid qualities as even to
outdo his ancestors. If his "Man with a
bass viol" were put in a Spanish museum,
it would have no reason to fear the paint-
ings of Velázquez and Murillo.' (*Le
pamphlet*, 28–30 September, 1848; repr. in
Lacambre, 1973, pp.153–4.)

A version of *The cellist* in which a
musical score is depicted exists in the U.S.

Stockholm, Nationalmuseum.

18
Peasant girl with a head-scarf

La paysanne au madras (17)

*c.*1848

Canvas: 60 × 73. Signed lower right: *G.
Courbet.*

History: Weill coll.; Galerie Durand-Ruel;
private coll. Switzerland; private coll. U.S.A.

Exhibitions: 1935–1936, Zurich, no.49;
1938, Paris, no.32; 1950, La Tour de Peilz, no.15;
1952, Besançon, no.19; 1953, London, no.12; 1954,
Venice, no.16; 1954, Lyon, no.20; 1955, Paris,
no.38; 1959, Paris, no.30; 1962, Berne, no.16.

Charles Léger (1929, pl.22) assigns
this picture to a date around 1858, but does
not state the grounds for his opinion. We
believe it to be about ten years earlier, for
the following reasons.

Firstly, the landscape on the right is
one of the most Dutch in character to be
found in Courbet's work, in a style re-
sembling Jacob van Ruisdael. It is also

18

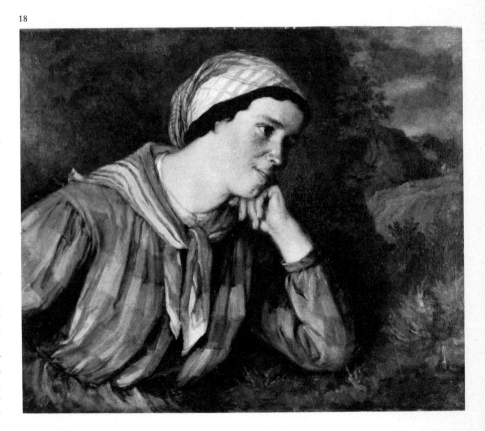

reminiscent of landscapes of the Barbizon school deriving from Ruisdael: *e.g.* Corot for a short period after his return from Italy, in 1828, Rousseau, Diaz, Dupré and Decamps before his return to neo-classicism. But it was not long before Courbet moved away from this style: he did not turn his back on the Dutch masters, but he came to express a stronger personal element and less of the baroque spirit. A comparison of the landscape in this picture with that in the *Lady of Frankfurt* (54) which is known to date from 1858, will show all the difference that lies between them.

Secondly, this dreamy peasant girl, with her rustic sentimentality, is reminiscent of George Sand's country novels and especially *Petite Fadette* (1848). The retreating figure seen in the distance may be an allusion to the plot of that work, which describes the love of two twin brothers for a shepherd girl: her unsuccessful suitor leaves the village and enlists in the army. After 1850 Courbet's works ceased to be influenced by contemporary literature, this being one of the chief signs of his 'retreat' from romanticism.

Thirdly, we believe this picture to be a portrait of Juliette. The face, rendered with tender emotion – the dimple in the chin, the line of the nose, the wide-open eyes – all suggest the features of the artist's youngest sister. We have seen Juliette as a child (8), as a grown woman in *The artist's studio* and in middle age at La Tour de Peilz in 1874 (São Paulo Museum), but no portrait of her in the bloom of adolescence. In *The corn sifters* of 1854 (42) when she was twenty-three her cheeks are already hollow.

New York, private collection.

19
Self portrait entitled Man with the pipe

Portrait de l'artiste dit L'homme à la pipe (19)

1849?

Canvas: 45 × 37. Signed lower left: *G. Courbet.*

History: Bought from the artist by Alfred Bruyas, 1854; given by Bruyas to the Musée Fabre, 1868.

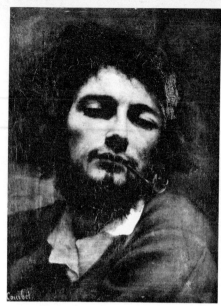

19

Exhibitions: 1850–1851, Paris, Salon, no.420; 1854, Frankfort-on-Main; 1855, Paris, Exposition Universelle, no.2807; 1860, Montpellier, no.62; 1861, Marseille; 1867, Paris, no.80; 1932, London, no.332; 1939, Paris, no.20; 1959–1960, Philadelphia–Boston, no.9; 1961, Paris; 1973, Paris, no.40.

Bibliography: Caricature by Randon in *Le Journal amusant* in 1867 (repr. in Léger, 1920, p.70); Bruyas, 1854, no.82; Bruyas, 1876, no.32; Forges, *Annales*, pp.27–29, fig.26, 27; Forges, 1973, no.40.

Bruno, 1872, *Eloir la pipe aux lévres*, p.121.

This is undoubtedly the *Self-portrait* submitted to the Salon of 1850–1851, as is confirmed by descriptions of it on that occasion. It was noticed by the Prince-President, who included it in the list of works he wished to buy; however, credit restrictions prevented the purchase from taking place, and in 1854 Courbet sold the work to Bruyas. At this time he wrote to the latter at Montpellier: 'It is not only my portrait; it's yours. When I saw it, I was impressed; it's a fearful element in our solution. (For this word cf. 31.) It's the portrait of a fanatic, an aesthete [not 'ascetic', as usually transcribed]; a man unburdened of the nonsense that made up his education, one who is trying to find stability with his principles.' Later he adds: 'I am delighted that you should have my portrait. At last it is out of the barbarians' clutches. It's a miracle, for when I was

desperately poor I still had the courage to refuse Napoleon's offer of 2,000 francs, and also Gortchatcoff [*sic*] who tried to buy it through dealers' (Borel, pp.19–20, 22.) In this way the painter turned to account Louis Napoleon's failure to buy the work, which had greatly disappointed him.

See p.235 for continuation of text.

Montpellier, Musée Fabre.

20
Sleeping blonde girl

La blonde endormie (20)

1849

Canvas: 65 × 54.

History: Juliette Courbet coll.; Courbet sale, Paris, 1881, no.16; bought back by Juliette Courbet; inherited from Juliette Courbet by Mme. de Tastes; Henri Matisse coll.

Exhibitions: 1867, Paris, no.12 (?) (*Dormeuse, 1849*); 1882, Paris, no.31; 1929, Paris, no.40; 1938, London, no.7; 1938, Amsterdam, no.67; 1953, London, no.19; 1959–1960, Philadelphia–Boston, no.29; 1962, Ornans, no.15; 1969–1970, Rome–Milan, no.4.

Bibliography: Caricature by Randon in *Le Journal amusant*, 1867, no.598 (Léger, 1970, p.71); Toussaint, no.4.

We know that Courbet included this work in his private show at the Pavillon de l'Alma in 1867, as it was caricatured on that occasion (*op. cit.*). It has been identified with no.102 in the catalogue: *Femme endormie, étude de nu* (*Woman asleep, nude study*), *1857*, but we think it is more probably no.12, *Dormeuse* (*Woman asleep*), dated 1849. This view is based on the fact that the drawing *Liseuse endormie* (*Woman with book, asleep*), (130) bears the date 1849 and shows the same model, clothed, in a similar pose.

This date is the more likely as the dominant influence in the painting is that of seventeenth-century Holland: Courbet is still clearly under the vivid impression of his trip to Amsterdam. He may also, without going abroad, have seen Rembrandt's *Bathsheba* in La Caze's collection. However, the treatment of the rug covering the woman's legs and the vase of flowers beside her show the influence not only of Rembrandt himself but, still more, of his disciples and successors.

There is a similarity of features between this model and the heroine of *Happy*

lovers (11, 12), and we suggest that she is Virginie Binet, who was the painter's mistress for fourteen years on and off, and who bore him a son in 1847. She is also seen in *Woman sleeping by a stream* (1845, Winterthur, Oskar Reinhart collection; replica at the Detroit Institute of Art), where her pose recalls the present work though she appears somewhat younger.

This painting, with other works by Courbet, belonged to Matisse, who said of him: 'How grateful I am to Courbet for showing me new directions in the Louvre. I bought these pictures in memory of old days, and now he brings me back to Rembrandt' (Dominique Fourcade, *Henri Matisse, écrits et propos sur l'art*, Paris, 1972, p.85).

Paris, private collection.

20

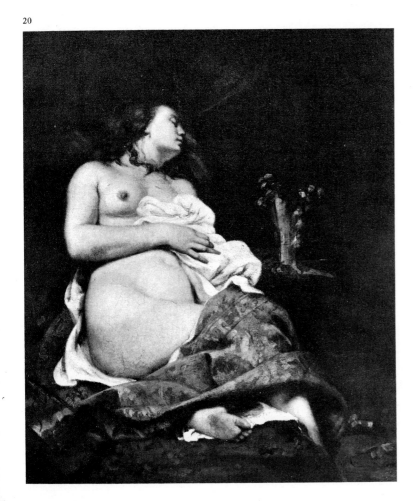

21
Château d'Ornans

Le Château d'Ornans (22)

1849

Canvas: 81 × 117. Signed, dated lower right: *G. Courbet . . 55.*

History: Acquired from the artist by M. Vauthrin before the 1855 Exposition Universelle; Laurent Richard sale, Paris, 1878, no.7, repr.; M. van Den Eynde coll.; Georges Lutz coll., Paris (1882); Richard Slade coll.; acquired by the Minneapolis Institute of Arts, 1972; The John R. van Derlip and William Hood Dunwoody Funds.

Exhibitions: 1855, Paris, Exposition Universelle, no.2811; 1858, Besançon, no.109; 1858, Dijon, no.193; 1867, Paris, no.21; 1882, Paris, no.58.

Bibliography: Charles F. Stuckey, 'Gustave Courbet's Château d'Ornans' in *The Minneapolis Institute of Arts Bulletin*, 1971–1973, vol. LX, pp.27–36, repr.

The hamlet of this name, overlooking Ornans from the west, is built on the ruins of a fortress which commanded the Loue Valley in the Middle Ages. The scene still presents the same appearance as in Courbet's picture. The site offers no room for the village to expand, and the only difference is that it is shaded by trees which were not there in Courbet's time.

The date of 1855 inscribed on the painting seems to us much too late. We suspect that it means only that the picture was shown at the World Exhibition of that year, on loan from M. Vauthrin who was then its owner. It would be quite characteristic of Courbet to date it in this fashion. Comparing it with the sketch of *Young ladies of the village* (27), which is regarded as certainly dating from 1851, it is clear that the present work cannot be of later origin.

Panoramic views of this kind belong still more to the pre-romantic than to the romantic period. Many examples are found in the eighteenth century, especially in the work of British landscape painters. By 1850 the fashion had had its day, and in 1855 Courbet would not have used a foreground such as we see here, with a woman spreading out laundry in front of a trough. This figure may be compared with those in the *Loue valley in stormy weather* (22); we believe this to be prior to 1850, and we suggest a similar date for the present work.

Another painting of the same title (Switzerland, private collection) gives a close-up impression of the village; the date of 1853 is generally assigned to it and seems acceptable (Riat, p.117). There is another, later picture of the village in a private collection in Paris (exhibition 'Hommage à Gustave Courbet', Ornans Museum, 1977, no.10).

Minneapolis Institute of Arts.

22
The Loue valley in stormy weather

La vallée de la Loue par temps d'orage (23)

c.1849

Canvas: 54 × 65. Signed, lower left: *G. Courbet.*

21

native countryside that his landscapes cannot be dated from written evidence alone. We believe this to be a work of his early period, perhaps even prior to 1849, and that it may have been a study for the Salon painting, the subsequent fate of which is unknown.

It was only at the beginning of his career that Courbet followed the tradition of a coulisse-type foreground; very soon he adopted the revolutionary nineteenth-century technique of rendering space by light effects and not by a succession of planes, so that the eye is led directly to the centre of the picture without intervening obstacles. How far his art had evolved by 1851 is shown by the landscape of *Roche de 10 heures* (Léger, 1928, pl.18), which is that of *Young ladies of the village* (27) without the human and animal figures.

Another version of this painting, with the same measurements, is in a Swiss private collection.

Strasbourg, Musée des Beaux-Arts.

History: Bought by the Musée de Strasbourg at Galerie Gérard in 1941.

Exhibitions: 1947, Basle, no.194; 1947–1948, Brussels, no.75; 1950, La Tour du Peilz, no.33; 1951, Amsterdam, no.30; 1952, Besançon, no.46; 1953, London, no.32; 1954, Venice, no.42; 1954, Lyon, no.47; 1955, Paris, no.78; 1959–1960, Philadelphia–Boston, no.76; 1962, Ornans, no.36; 1966, Dallas, no.5; 1969–1970, Rome–Milan, no.5.

In the Salon of 1849 (no.453) Courbet showed a landscape to which he gave the title *The Loue valley taken from Roche du Mont; the village on the river bank is Montgesoye*. This description fits the present work so well that the present author once supposed that it might be the one in question. This cannot be so, however, as the Salon receipt book gives the dimensions, including frame, as 70 × 90, which would mean that the frame must have measured 15 cm at the sides and only 8 cm at the top and bottom.

While accepting that this picture cannot be the one exhibited in 1849, we still find ourselves unable to accept a date of c.1870 as has long been suggested. Courbet so often repainted scenes of his

22

23
View of Ornans known as The Bridge of Scey

Vue d'Ornans connu comme Le pont de Scey
(24)

c.1850

Canvas: 71 × 90. Signed lower left: *Gustave Courbet*.

History: Fiske Hammond coll., Boston; MacKinley Helm coll., Santa Barbara; Paul Rosenberg Gallery, New York.

Exhibitions: 1956, New York, no.2; 1959–1960, Philadelphia–Boston, no.46; 1975, New York, Wildenstein Gallery.

Bibliography: Bruno, 1872, *Le village de Villeneuve*, p.144.

For reasons unknown to us this picture has been supposed to represent the bridge at Scey, a village situated a few miles down-river from Ornans. The scene is in fact Ornans itself. The distinctive spire can easily be recognized; the rocky cliff overlooking the river is the Roche du Mont.

See page 235 for continuation of text.

New York, private collection.

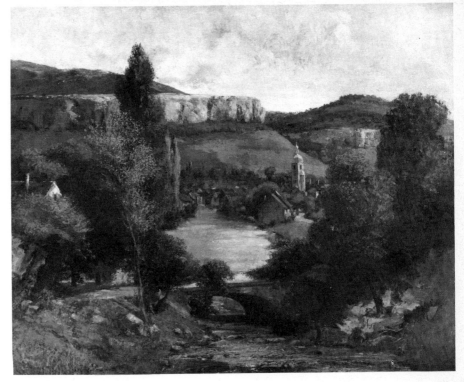

23

24
Toilet of a dead woman generally known as Toilet of a bride

La toilette de la morte connu comme La toilette de la mariée (25)

c.1850

Canvas: 188 × 251.

History: Juliette Courbet coll.; inherited from Juliette Courbet by Mmes de Tastes and Lapierre; Courbet sale, Paris, 1919, no.1 (*La toilette de la mariée*); Zoubaloff coll., Paris; Galerie Rosenberg, Paris (1924); private coll., New York (1929); acquired by Smith College Museum of Art, 1929.

Exhibitions: 1924, New York, Wildenstein Gallery; 1927, Paris, Galerie Rosenberg; 1927, Paris, Galerie Bernheim-jeune; 1928, Copenhagen, no.3; 1929, Cambridge, no.15; 1932, Buffalo, no.11; 1935, Chicago, no.238; 1936, Pittsburg, no.15; 1948–1949, New York, no.28; 1951, Pittsburg, no.105; 1953, New York, no.20; 1954, Venice, no.30; 1954, Lyon, no.46; 1955, Paris, Orangerie, no.11; 1955, London–Manchester; 1959–1960, Philadelphia–Boston, no.50.

Bibliography: Estignard, p.185 (*Le repas de la morte*); Guy Eglington, 'An unpublished Courbet' in *International Studio*, September, 1924, pp.447–453; A. V. Churchill in *Bulletin of the Smith College Museum of Art*, April, 1929, pp.2–4; Jean Seznec in *La chouette aveugle*, February, 1955, no.5 (translated into French in *A.G.C.*, 1955, no.16, pp.7–9); Douglas Cooper, 'Courbet in Philadelphia and Boston' in *The Burlington Magazine*, June, 1960, p.245; Nochlin, 1967, p.210, fig.13; Nochlin, 1971, pp.31–54, repr.

It is to be feared that this picture has been misnamed since 1919, when it first figured as *Toilet of a bride* in the Courbet sale. (In English it has also been called *Dressing the bride* and *Preparation for the wedding*.) No written source in the artist's lifetime mentions any work that would fit this title, and if we look at the painting carefully we find that its subject bears no relation to the name it has borne for nearly sixty years. Light is thrown on this problem by tracing the history of the work, which is fairly well known from the beginning.

Courbet undoubtedly painted at, an uncertain date, a picture entitled *Toilet of a dead woman*. This title figures, firstly, in the list of large paintings not at La Tour de Peilz that were delivered to Juliette Courbet in 1878 (Bibliothèque Nationale, Estampes, Box VI) and, secondly, in Dr Blondon's inventory of works still in Juliette's possession after the public sales of 1881 and 1882 (Blondon papers, Bibliothèque de Besançon; reproduced by Charles Léger, 1929, p.118).

Alexandre Estignart (*op. cit.*) gives a somewhat different title, *Le repas de la morte (Funeral feast)*. His monograph on Courbet, published in 1897 with Juliette's collaboration, included a catalogue of the artist's works – a very incomplete one, it is true, but reliable as regards the works in Juliette's possession. It does not list any work called 'Toilet of a bride'. The title *Le repas de la morte*, on the other hand, is also mentioned by Castagnary, who wrote that Courbet 'was afraid of death and never painted it, except for the unfinished *Repas de la morte*' (MS, Bibliothèque Nationale – Courthion, II, 282).

Juliette bequeathed a large part of her property to Mmes de Tastes and Lapierre, who sold it off in 1919. No doubt the real subject of this picture was considered so macabre as likely to spoil the

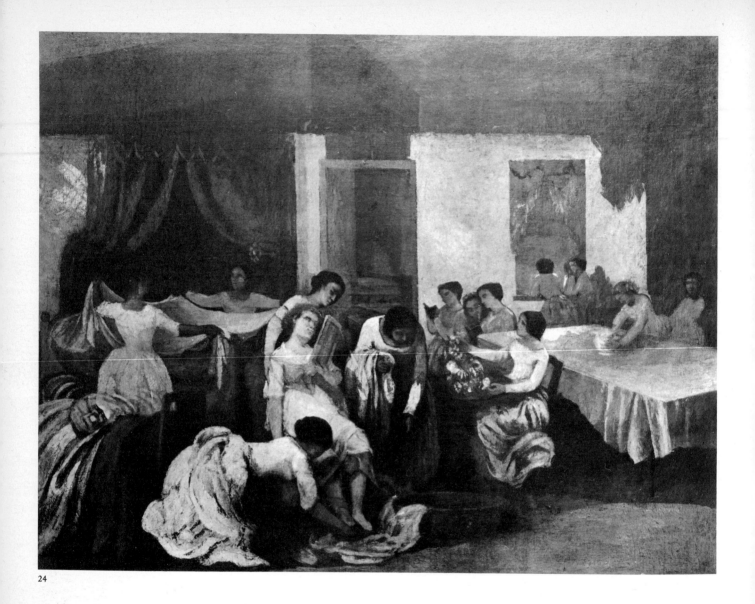

24

price that would otherwise be obtained for a large work of such quality, so the expedient was adopted of touching up the picture and renaming it. Such, we suggest, is the explanation of why the corpse was turned into a bride.

If we look at the iconography, it can be seen that there is nothing in the picture that suggests a wedding. The faces are solemn, so is the scene itself and so are the actions being performed. Brides on their wedding-day do not generally have their feet washed by attendants. There is no sign of a sumptuous wedding-dress, yet the artist would surely have seized the chance of depicting the bride's attire, if only a veil or a beribboned headdress; the more so as the girls in the picture are not peasants or poor folk but (bourgeoises or 'young ladies of the village'). They do not wear rustic bonnets, their clothes and hair-style proclaim them to be well off; so does the furniture, the tester over the bed, the pedestal table and the huge cloth-covered table in the background. As for the women on the right, what can they be reading except prayer-books? Certainly there is no written ritual appropriate to dressing a bride for her wedding.

Let us now consider the central figure of a woman seated in a chair. An X-ray examination performed in 1960 in the Research Laboratory of the Boston Museum of Fine Arts (Nochlin, 1971, fig.5) shows that prior to being dressed in a bodice and petticoat she was naked; her

head rested on her left shoulder, and her left arm hung down as limply as the right. This arm and the woman's face are so feebly painted, in the version we now see, that it may well be doubted whether they are Courbet's work. Moreover, unless the 'bride' is extremely short-sighted she is holding her mirror in a highly unnatural fashion.

If we dismiss the idea of a wedding from our minds, the picture becomes comprehensible; what it depicts is preparation for the laying-out of a dead woman, on a bed which is being spread with a winding-sheet. This is why the body is propped so firmly on a chair, why devout women are saying prayers for the dead, and why the large table is being made ready for a wake. A girl seems to be standing a coffee-pot on it; the women will sit up around it all night, and next day there will be a funeral feast.

We know from Sâr (Joséphin) Péladan (in *L'Artiste*, 1884; repr. in Courthion, II, p.268) that Courbet intended to paint a scene of this kind: 'When one of his countrymen asked what he had on the stocks, he replied "Oh, I'm going to paint a Franche-Comté custom, *The wake* in fact. You'll see the dead person's friends gorging and guzzling, forgetting all about death and the dear departed, finishing up blind drunk and full of cheerful thought".' Allowance must be made, of course, for Péladan's hatred of Courbet: we doubt whether the painter intended to make fun of death or mourning, and we suspect that Péladan twisted his words a little. It was not Courbet's style to caricature a country wake in the malicious fashion of Maupassant; in any case, we have the picture before us and we can see exactly what the painter was doing.

The custom was that the corpse was tended by female friends and was laid out on a bed; the family and other friends would then file past it to pay their last respects to the dead. The girls in this picture are as young as the dead woman and were no doubt her childhood companions. Such is the scene that Courbet wishes to bring before our eyes in this justly admired picture.

Castagnary referred to this picture as a *Wake* (*Repas de la morte*) when expressing regret that the Salon regulations prevented the submission of a large number of paintings. He gave a list of works that Courbet might otherwise have sent in in 1866, including the present one (*Salons 1857–1870*, I, 237). We do not think it follows from this that the work was itself of so late a date. Its dating is in fact a matter of dispute, and is made harder to ascertain by its unfinished state and the retouching it has undergone. We agree with those who place it around 1855, but we believe this to be the latest possible date: it can hardly be subsequent to *The studio* (137), which marks a turning-point after which Courbet seems to have lost interest in genre painting. It is true that he painted *Curés on the spree* (1862, destroyed) and, a little later, *Church expenses* (*Frais de culte*, private collection), but these were mere exercises in anticlerical propaganda, outside the mainstream of his work as regards both manner and substance. The theme of death, on the other hand, is eminently romantic, especially when treated, as here, in a religious spirit – as witness the praying women and perhaps other details that have been painted out. It is unlikely that Courbet would have treated a theme of this sort much after 1850.

Is there a parallel to be drawn between this work and Rottenhammer's *Feast of the gods* (Leningrad, Hermitage), which was so often engraved, copied and imitated? Courbet's composition is similar, with the large table on the right and the central figure – originally naked, with her head turned to one side and resting on her shoulder – recalling Flora in the German master's work; while the women spreading out the shroud correspond to Rottenhammer's figures with arms outstretched to the left.

Courbet's debt to popular imagery has been exaggerated: in most cases he drew inspiration from great works of the past, either directly or through engravings. When he professed, not without a measure of humbug, to be painting for the delectation of the common people, his object was not to reduce art to simple terms but rather to bring its highest manifestations within the reach of the masses.

Courbet must have thought well of this picture, since he kept it in his possession in its unfinished state and did not reuse the canvas, as was frequently his custom in such cases.

Northampton, Mass., Smith College Museum of Art.

25

Portrait of Hector Berlioz

Portrait d'Hector Berlioz (26)

1850

Canvas: 61 × 48. Signed, dated lower left: *1850, G. Courbet.*

History: Refused by Berlioz after its completion; offered by the artist to Paul Chenavard; Basset coll. (1867); Hecht coll. (mentioned from 1878); coll. Joseph Reinach (mentioned from 1912); bequeathed by the previous owner to the Musée du Louvre, 1921.

Exhibitions: 1850–1851, Paris, Salon, no. 667; 1855, Paris, no.38; 1860, Besançon, no.106; 1861 and 1862, Paris, Galerie Martinet; 1867, Paris, no.69; 1878, Paris, no.26; 1882, Paris, no.40; 1883, Paris, no.29; 1889, Paris, Exposition Centennale, no.204; 1912, Paris, no.21; 1917–1918, Paris, no.3, 1928, Oslo–Stockholm, no.18; 1928, Copenhagen, no.24; 1935–1936, Zurich, no.25; 1947, Paris, Bibliothèque Nationale, no.9; 1949, Clamart; 1950, Paris, Delacroix, no.9; 1952, Besançon, no.9; 1954, Lyon, no.8; 1955, Paris, no.14; 1956, Moscow–Leningrad, p.90; 1956, Warsaw, no.19; 1957, Besançon, Concerts, no.61; 1958, Agen, no.9; 1959–1960, Philadelphia–Boston, no.15; 1964–1965, Munich, no.46; 1967, Paris, no.123; 1969, Paris, no.358; 1958, Lisbon, no.298.

Francis Wey, a writer of Franche-Comté extraction, made Courbet's acquaintance through Sainte-Beuve in 1848. A close friend of Berlioz, he persuaded the latter to have his portrait painted by Courbet. We do not know when the sittings took place. The painting bears the date 1850, but with Courbet this frequently signifies

25

the date of the Salon at which a work was exhibited, even though it may have been painted a year or two earlier. In the catalogues of his private exhibitions of 1855 and 1867 it is dated 1848.

A comparable picture, neither signed nor dated but with the same measurements, is now in the National Gallery at Oslo; it was no.15 in the Courbet sale of 1881, where it was bought by the painter Alfred Roll. In 1912 it appeared as no.21 in the exhibition *La musique et la danse* at Bagatelle, to which it was lent by the violinist Raoul Pugno.

The two portraits present the model in the same attitude, but differ in style (the face is less mottled in the Oslo version) and in some details: in the Oslo painting the expression is more scowling and the white collar is less visible.

Berlioz, who was forty-five years old at the time, appears prematurely aged; Sâr Péladan declared that he looked 'as though he had been drowned for a fortnight'. It has been suggested that his morose expression is due to the melancholy that overcame him after the failure of the *Damnation of Faust* in 1846. Be that as it may, Berlioz was displeased with the portrait and refused to buy it, influenced in this by his mistress (later his second wife), the singer Marie Recio. He did not take to Courbet either; he knew nothing of painting and, as we

26

know from Wey, he was exasperated by Courbet's musical pretensions, so that the acquaintance came to an abrupt end.

Courbet, with the portrait on his hands, offered it to Wey, but the latter did not dare accept it. Accordingly, it was presented to Paul Chevanard, who got rid of it shortly afterwards.

Courbet's portrait of Berlioz is inspired by the old masters, but it is less 'Venetian' than *Man with a leather belt* (13) and less 'Dutch' than *Man with a pipe* (19); like the *Portrait of Baudelaire* of the same period (15), it bears the imprint of Courbet's own personality.

Paris, Musée du Louvre.

26
Portrait of Adolphe Marlet

Portrait d'Adolphe Marlet (28)

1851

Canvas: 56 × 46. Monogram lower left: *GC*.

History: Juliette Courbet coll.; Courbet sale, 1881, no.19; bought by the painter Raffaelli; Théodore Duret coll.; Marczell de Nemes sale, Paris, 1913, no.96; Galerie Durand-Ruel, Paris; Galerie Barbazanges, Paris (1921); H. M. Calmann coll., Hamburg; Hazlitt Gallery, London (1938); Matthiesen Gallery London; bought by the National Gallery of Ireland, 1962.

Exhibitions: 1867, Paris, no.77; 1882, Paris, no.41; 1912, Dusseldorf, no.84; 1913, Paris, no.96; 1921, Basel, no.33; 1949, London, Hazlitt; 1953, London, no.8; 1954, Venice, no.9; 1955, Paris, no.18; 1964, Dublin, no.186.

Bibliography: In *Apollo*, July, 1962, pp. 402–403, pl.7; J. White, 'National Gallery of Ireland, recent acquisitions' in *Apollo*, February, 1967, p.125, repr.

The Marlet brothers – Adolphe, four years older than Courbet, and Tony – were boyhood friends of the artist's. Adolphe must have tried his hand at painting, for Riat (p.29) quotes a letter of 1844 in which Courbet informed his parents that he had had a visit in his studio from the artist Hesse 'Marlet's teacher'. However, Adolphe was evidently more assiduous than Courbet in his attendance at Law Faculty lectures, for he was eventually called to the bar; in the roll of the Besançon Lodge for 1857 he is listed as an 'unattached member' (*membre libre*), barrister and councillor (*conseiller de préfecture*) for the department of the Mayenne.

Adolphe Marlet may be the man with a pipe, seen from behind in *After dinner at Ornans* (134); he also appears in *Burial at Ornans* (135).

At his 1867 exhibition, Courbet dated this portrait 1851. It is one of the most typical examples of the influence exerted on him by seventeenth-century Dutch portrait painters, and may be compared with the *Portrait of H. J. van Wisselingh* (14).

Dublin, National Gallery of Ireland.

27
Young ladies of the village giving alms to a cow-girl in a valley near Ornans

Les demoiselles de village faisant l'aumône à une gardeuse de vaches dans un vallon d'Ornans (29)

1851

Canvas: 54 × 66. Signed and dated lower left: *G. Courbet 1851*.

History: Sold by the artist to the collector Lauwick, 20 April, 1854; sale of 26 modern paintings, Paris, 4 April, 1868, no.3; Clapisson coll. (1882); Charles Roberts coll.; given by Charles Roberts to the City Art Gallery, Leeds, 1937.

Exhibitions: 1855, Paris, no.14; 1865, Gand, Salon, no.118; 1882, Paris, no.177; 1953, London, Marlborough Gallery, no.7; 1954, Venice, no.11; 1954, Lyon, no.9; 1955, Paris, no.17; 1957, Cardiff–Swansea; 1959–1960, Philadelphia–Boston, no.17; 1961–1962, London, no.209; 1962, Berne, no.8; 1962, Ornans, no.8; 1969–1970, Rome–Milan, no.8.

Bibliography: *Leeds Art Calendar*, 1951, V, no.16, pp.15–17, 20–23, repr. p.14.

Courbet submitted to the Salon of 1852 (no.292) a large picture entitled *Young ladies of the village giving alms to a cow-girl in a valley at Ornans, 1851*, which had just been bought by the Prince-President's half-brother, the comte (later duc) de Morny. The present picture is a sketch for that work, which attracted the sarcasm of critics and cartoonists but is one of Courbet's masterpieces; it is now in the Metropolitan Museum, New York. The two paintings differ in that the group of young ladies occupies a more prominent position in the New York version, as they stand on raised ground overlooking the valley; the sketch, by contrast, is not a

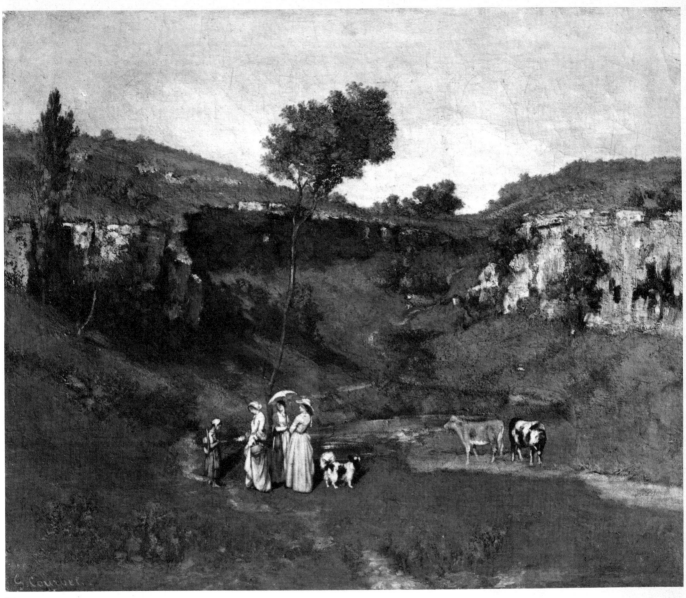

27

figure-painting but a landscape animated by figures. The landscape itself is somewhat different in the two works: in particular, the tree in the middle of the sketch was painted out during the execution of the final version, though its outline can still be seen.

The young ladies in the scene are Courbet's sisters Zoé, Zélie and Juliette, who are pausing in the course of a walk to bestow some kindness on a peasant girl. The narrative theme is important in the New York painting but is quite secondary in the present sketch. The landscape, which has not been clearly identified, is the same as in Courbet's *Roche de dix heures* exhibited in 1855 (no.2809) (former Durand-Ruel collection; repr. in Léger, 1929, pl.18); according to some local inhabitants it is behind Château d'Ornans, near the source of the brook called ru de Mambouc.

The proportions of the composition have been criticized with good reason: Courbet did not fully succeed in incorporating the figures and cattle into the landscape, which is really a panoramic view but

in which the tree is too tall and the cows too big considering their distance from the spectator. But this is a minor blemish in a painting of such quality – the work is one of the earliest surviving examples of the sunny, clear and luminously pure landscapes of which Courbet learnt the secret from the Barbizon painters.

This painting has been wrongly identified with the *Landscape at Ornans* from the former Cardon collection, now in the Musées royaux des Beaux-Arts in Brussels.

A painted study of the group of cows was in the sale of the Saunier collection (Paris, 1882).

Leeds, City Art Gallery.

28
The homecoming

Le retour au pays (*30*)

c.1852

Canvas: 81 × 64. Signed lower left: *G. Courbet.*

History: Juliette Courbet coll.; Courbet sale 1882, no.40; private coll.

Exhibition: Paris, 1882, no.132 (supplement).

28

Estignard (p.19) mentions a *Portrait of the artist making a salutation* which may be identical with the present work, as he does not list any with the title *Homecoming*; it would be strange, on the other hand, if he omitted the present painting altogether, since it belonged to Juliette until 1882 and she collaborated in Estignard's work. Apart from *The meeting* (34) there is no trace of any picture in which Courbet is greeting anyone and which is entitled *Portrait of the artist*; apparently, therefore, Courbet is the figure depicted in *Homecoming*.

What date is to be assigned to this unfinished picture? One is tempted to associate it with *The meeting* on account of the analogous theme and because Courbet, if it is he, is wearing a similar yellow-fronted waistcoat. If we accept that the subject is Courbet, the short, thick beard provides an indication as to the date, since it resembles his beard in a drawn *Self-portrait* of 1852 in the British Museum (Forges, 1973, no.46).

The jellaba suspended from the way-farer's stick appears amongst the assortment of varied objects cluttering up the studio in a small early painting of Courbet's *The draughts players* (10). Oriental garments of this sort were part of the romantic stock-in-trade, and there may be a suggestion here that the character is returning from some North African campaign. The work would thus be a pendant, some years later, to a lithographic vignette of *The recruit's departure*, designed by Courbet to illustrate Max Buchon's *Essais poétiques* (1839), in which the young conscript is seen setting out with a bundle tied to a stick. A picture by Courbet of the same title, about which nothing else is known, was used in 1872 by the engraver Méaulle to illustrate Jean Bruno's *Les misères des gueux*, under the title *Le conscrit dans les bois* (p.209).

Private collection.

29
The sleeping spinner

La fileuse endormie (*31*)

1853

Canvas: 91 × 115. Signed, dated lower left: *G. Courbet 1853.*

History: Bought from the artist by Alfred Bruyas, 1853; given by Alfred Bruyas to the Musée Fabre in 1868.

Exhibitions: 1853, Paris, Salon, no.301; 1855, Paris, Exposition Universelle, no.2805; 1860, Montpellier, no.64; 1867, Paris, no.9; 1889, Paris, Exposition Centennale, no.200; 1935–1936, Zurich, no.28; 1939, Paris, no.23; 1939, Berne, no.22; 1954, Venice, no.13; 1954, Lyon, no.14; 1955, Paris, no.22; 1960, Nice, no.115; 1962, Berne, no.11; 1971, Paris, no.282.

Bibliography: Caricature by Nadar in *Le Journal pour rire*, 1853 (repr. in Léger, 1920, p.22) and by Cham in *Le Charivari*, 1853 (repr. in Léger, 1920, p.24) and by Quillenbois in *L'Illustration*, 21 July, 1855 (repr. Léger, 1920, p.29) and by Randon in *Le Journal amusant*, 1867 (repr. in Léger, 1920, p.69); Bruyas, 1854, p.79; Proudhon, pp.172–174; Bruyas, 1876, no.35.

Bruno, 1872, *Elle feignit de dormie*, p.185.

The *Spinner*, the *Wrestlers* (Budapest Museum) and the *Bathers* (30) were the three works exhibited by Courbet at the Salon of 1853. The *Spinner* was the 'safest' of the three, designed to assuage the passions that were all too certain to be aroused by the other two.

There is a persistent legend that Courbet's sister Zélie sat for this picture. The artist himself, however, declared that his model was a 'cow-girl' (Léger, 1948, p.61). He would not have said this of the prettiest and most elegant of his sisters, and her portraits (Paris, Musée du Petit Palais; São Paulo museum) bear no resemblance to the plump creature represented here.

There are plenty of *Spinners* in genre pictures by seventeenth-century Dutch artists, and many models that may have inspired Courbet. However, another possible source has been suggested. Marie-Thérèse de Forges has drawn attention to a sculpture of *Penelope asleep* by Cavalier which had a striking success at the 1849 Salon (Luynes collection, Château de Dampierre)

Caricature by Nadar

Une fileuse qui ne s'est jamais débarbouillée.

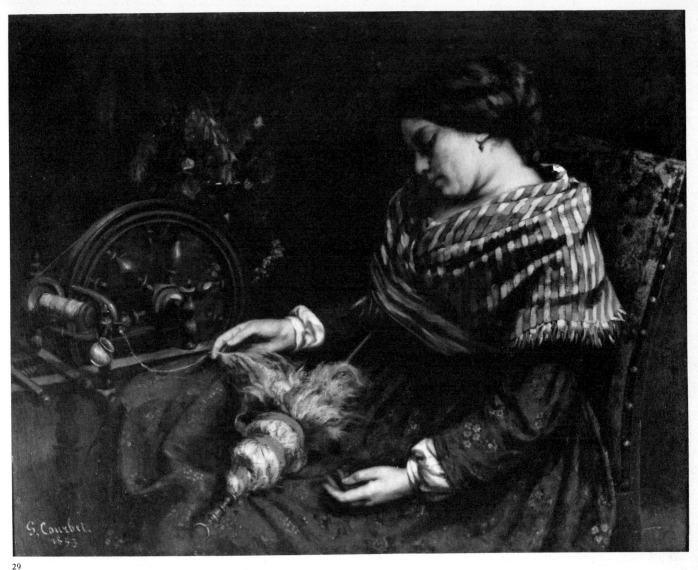

29

and remained so popular that, not long after, it was published by Barbedienne. The attitude of Courbet's model is so like that of Penelope in the sculpture, whose spindle drops from her hand as the distaff does in the present painting, that we may wonder if the buxom peasant girl in her fleshly reality is not indeed Courbet's answer to the classic Penelope.

The picture presents a scene of peaceful, everyday country life, of a type that Courbet was fond of. It succeeds *After*

dinner at Ornans (134) and is a year earlier than *The corn sifters* (42). It lacks the amazing refinement of the latter work, but there is a splendid, Rembrandtesque opulence in the chiaroscuro with its flashes of brightness.

We find it difficult to agree wholly with the criticism of Delacroix, who wrote in his *Diary* on 15 April 1853: 'There is also a sleeping *Spinner* which displays the same qualities of vigour and also of imitation [as the *Bathers*]. The wheel and distaff

are admirable; the dress and armchair, heavy and graceless.' To us, on the contrary, it seems that Courbet has endowed the rustic cotton fabric of the dress and shawl with a kind of nobility.

The theme of sleep had a perennial attraction for Courbet. In this painting we see one of its finest interpretations, not least in the inertness of the open hands, a motif which we shall encounter once again in the brunette model for *Young ladies on the banks of the Seine* (49).

Bruyas bought this picture at the Salon together with the *Bathers*. Courbet made a replica of it which is in the Musée national du château de Compiègne.

Montpellier, Musée Fabre.

30
The bathers

Les baigneuses (32)

1853

Canvas: 227 × 193. Signed, dated lower right: *G. Courbet, 1853*.

History: Bought from the artist by Alfred Bruyas, 1853; given by Bruyas to the Musée Fabre in 1868.

Exhibitions: 1853, Paris, Salon, no.300; 1855, Paris, no.4; 1860, Montpellier, no.63; 1867, Paris, no.6; 1939, Paris, no.22; 1939, Berne, no.21.

Bibliography: Caricature by Cham in *Le Charivari* (repr. in Léger, 1920, p.24) and by Nadar in *Le Journal amusant* (repr. in Léger, 1920, p.23); Bruyas, 1854, no.8; Proudhon, pp.177–181; Bruyas, 1876, no.33.

This monumental and astonishing work had the distinction of being the scandal of the 1853 Salon. Even before the official opening, it was made legendary by a quip of the Empress and by what is reputed to have been the Emperor's reaction. The imperial couple, as usual, enjoyed a private view; pausing before Rosa Bonheur's *Horse-fair* (New York, Metropolitan Museum), the Empress exclaimed at the size of the animals' hindquarters. It was explained to her that these were Percheron draught-horses, a different type of creature from the elegant mounts to which she was accustomed. When she came to Courbet's *Bathers*, she asked laughingly whether the lady also hailed from the Perche region (Ph. de Chennevières, *Souvenirs d'un directeur des Beaux-Arts*, II, p.15). As for the story that the Emperor struck the picture with his riding-crop, there is no confirmation of this and we may suspect that it is a figment of Courbet's imagination; the painter added that he wished the blow had torn the canvas, as then there could have been a splendid political lawsuit (Riat, p.104). The Emperor may well have permitted himself some ribald comment on Courbet's figure with its ample behind, but

it is quite certain that he would not have carried a riding-crop on his visit to the Salon.

During the next few days, such crowds collected in front of the picture that the police inspector in charge thought of having it removed as an affront to public decency (Courthion, I, p.112). Usually at least one critic spoke up for Courbet, but this time the hue and cry was universal. Even Delacroix wrote in his *Diary*: 'Friday, April 15 . . . I went beforehand to have a look at Courbet's pictures. I was amazed by the vigour and depth (*saillie*) of the principal painting; but what a picture it is! The vulgarity of the forms would not matter; what is abominable is the vulgarity and pointlessness of the idea; and anyhow, if only that idea, such as it is, were clear! What do these two figures mean? A fat bourgeoisie, seen from behind and stark naked except for a strip of cloth, carelessly painted and covering the lower part of her buttocks, is stepping out of a little pool

that looks too shallow even for a foot-bath. She makes a meaningless gesture towards another woman, presumably her maid, who is seated on the ground taking her shoes off. We see her stockings, just removed; one of them, I think, is only half off. As for the thought linking the two women, it is incomprehensible. The landscape is extraordinarily vigorous, but it is simply the full-scale version of a sketch exhibited near by; the figures have been painted in afterwards and bear no relation to their surroundings. This raises the whole question of harmony between accessories and the main subject, in which most great painters are deficient. It is not Courbet's worst fault . . . O Rossini, Mozart and inspired geniuses in every art, who draw out of things only so much as needs to be presented to the mind – what would you say to pictures like this?'

This curious reaction is typical of Delacroix as a history painter who is evidently struck by the importance and robust-

Caricature by Cham

LES BAIGNEUSES.

De vieilles connaissances qu'on revoit toujours avec un nouveau plaisir.

Dis—moi si jamais main plus blanche
A tressé de plus noirs cheveux,
Et si jamais pareille hanche
A porté corps plus grassieux.

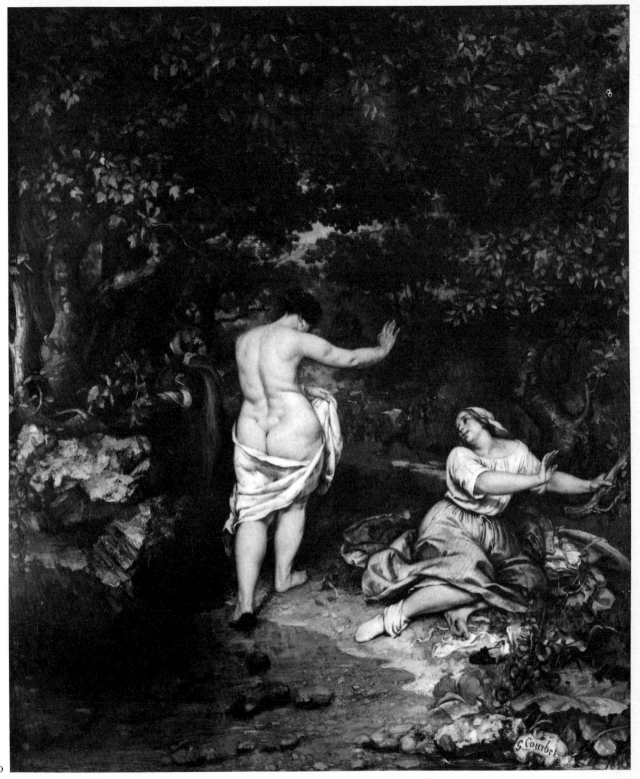

30

ness of the work, since he gives so much space to it, and who is determined to discover a 'plot'. He is vexed by what seem to him meaningless poses, and by the bourgeois female's enormous rump. Yet he, Delacroix, did not always paint Venuses either. Apparently it was all right to display ugliness in the shape of a haggard old crone, as in the *Massacre of Chios* (Louvre), but not in a woman of forty stepping out of a bathing-pool. It is extraordinary that a mind so unprejudiced as that of Delacroix should have been so enslaved to the classical ideal – admirer of Rubens as he was, had he forgotten the nymphs attendant on Marie de' Medici?

Again, how could Delacroix have failed to notice the musical rhythm – since he actually mentions music – of the orchestrated movements of the two women, which by their very lack of obvious meaning give poetic suggestiveness to the work, while their fluidity prevents it from being too heavy and compact? The gestures are like those of the mythological figures that inhabit country scenes from the Renaissance onwards, the difference being that Courbet gives them to women of flesh and blood. The unreal and meaningless quality of the picture is part of its greatness; it is the first of Courbet's works to display the miraculous skill with which he turns prosaic reality into a dream-world. Delacroix too was a man of dreams, but he had to place them in the escapist setting of a fairy-tale or an exotic journey. Was he of too early a period to realize that art can also take on a dream-like quality by presenting images which, though truthful, are disconnected?

Courbet painted this work in Paris, using a model whose ample haunches were well known to him and his fellow-artists; they usually preferred, however, to paint her pretty face, a study of which by Courbet is in the Musée Fabre at Montpellier. Aaron Scharf (p.133) suggests that the standing woman's pose may have been inspired by some photographs by Vallou de Villeneuve that had been acquired by the Bibliothèque Nationale in the same year, 1853. The woman sitting on the ground resembles the nymph in Jordaens's *Nurture of Jupiter* (Louvre). The thick foliage is typical of ravines in the Franche-Comté as depicted in so many versions of the *Puits noir* (cf. 88); as for the landscape sketch mentioned by Delacroix in the passage quoted above, it is not referred to elsewhere and must have been uncatalogued.

A critic of our own day, Roberto Longhi, regards Courbet's *Bathers* as deriving from Caravaggio. Apropos of the *Bathing Venus* attributed to Elsheimer(?), in the former Briganti collection in Rome, he writes: 'The radiant luminosity of this bare flesh beside the dark ravine – the first contact with the subject in an immediate, essential vision – is forgotten to the point where it clearly foreshadows the humble, recollected attitude of Rembrandt's women no less than the animal crassness of one of Courbet's Bathers. We perceive the fruitful influence of Caravaggio's style . . .' ('Ultimi studi sul Caravaggio e la sua cerchia', *Proporzioni*, 1943, no.1).

The *Bathers* and the *Spinner* (29) were bought direct from the Salon by Alfred Bruyas, and this first contact between him and Courbet soon developed into a lasting friendship.

Montpellier, Musée Fabre.

31
Portrait of Alfred Bruyas

Portrait d'Alfred Bruyas (33)

1853

Canvas: 91 × 72. Signed, dated, lower left: *G. Courbet, 1853*. Annotated, lower left on the book: *Etudes sur l'art moderne. Solution A. Bruyas.*

History: Commissioned from the artist by the sitter, 1853; given by Bruyas to the Musée Fabre in 1868.

Exhibitions: 1867, Paris, no.75; 1938, Amsterdam, no.64; 1939, Paris, no.24; 1939, Berne, no.23; 1941, Los Angeles, no.19; 1960, Copenhagen, no.8.

Bibliography: Bruyas, 1854, no.65; Bruyas, 1876, no.34.

Alfred Bruyas, the son of a financier, was born at Montpellier in 1821. A trip to Italy at the age of twenty-five confirmed his resolution to devote his life and fortune to defending and protecting the arts and artists. He suffered from tuberculosis, and was correspondingly hyper-sensitive in character. Delacroix said of him: 'He is a complex of nerves, bronchitis and fever. I suffer from all this too, but less than he does' (Borel, p.9). One effect of his illness was to make him profoundly introspective and interested in the effect of different emotions on his own facial expression. This in turn made him keenly interested in portraits of himself, of which he amassed no fewer than thirty-four by more or less celebrated artists. The best-known are four by Courbet and one by Delacroix, while the most unusual is no doubt Verdier's portrait of him as *Christ crowned with thorns* (1852).

In addition to collecting artists' impressions of himself, Bruyas created in his home at Montpellier one of the most imposing modern art collections of the period – paintings, drawings and sculpture – which he presented to the Musée Fabre in 1868. At his death on 1 January 1877 – almost precisely a year before Courbet – he completed the donation by bequeathing to the Museum the works he had collected in the meantime.

The present work is Courbet's first portrait of Bruyas, painted in Paris in 1853. From then onwards they were linked by a close friendship, at all events on the part of Bruyas, who was indefatigable in aiding Courbet by his purchases and later by many acts of hospitality and generosity. Although far from sharing Courbet's political opinions he did not desert him at the time of the Commune, when Courbet was prosecuted for the destruction of the Vendôme column. Like all invalids Bruyas needed constant moral reassurance, and Courbet was prodigal of flattery and protestations of affection. His letters to Bruyas, now in the Bibliothèque Doucet in Paris, are valuable as a record of the pictures they refer to, and also shed light on many aspects of Courbet's character.

'Yes, I understand you, and the portrait you have is a living proof of this' (Borel, p.24) – thus Courbet wrote to his new friend in May 1854, when about to leave for Montpellier. The picture had been painted a year earlier, shortly after Delacroix completed his own portrait of Bruyas. The latter posed in Courbet's studio in the rue Hautefeuille, and is seen with his hand resting on a book, the inscription on which reads: *Etudes sur l'art moderne Solution A. Bruyas*. Bruyas's booklet, published in 1853, was in fact entitled *Solution d'artiste. Sa profession de foi*. The word *solution* recurs like a leitmotiv in Courbet's relations with Bruyas, a sort of vague catchword that either party would probably have found it hard to elucidate

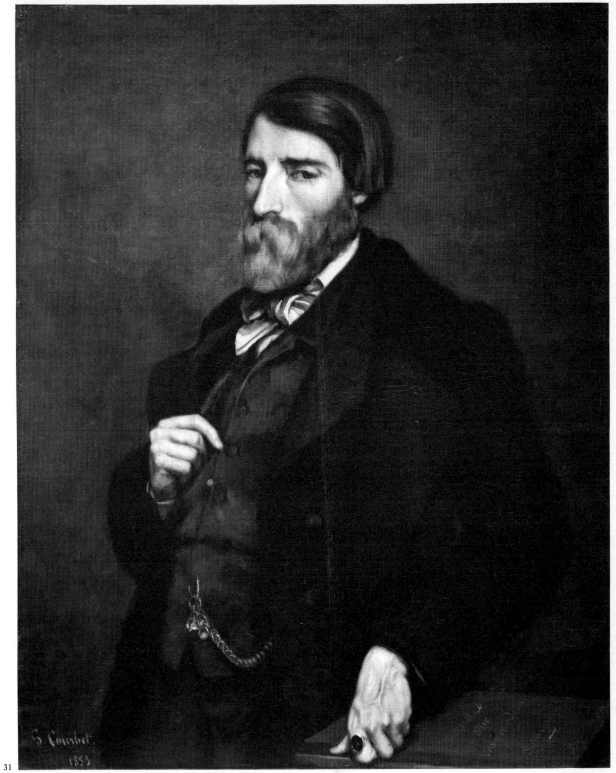

31

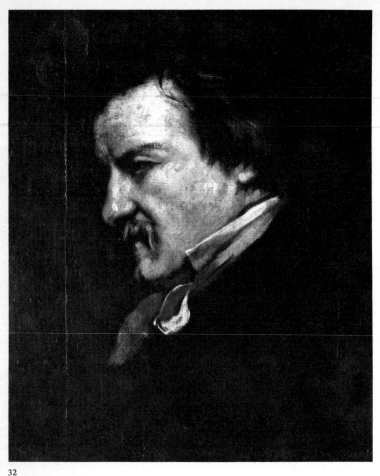

32

Exhibitions: 1855, Paris, no.7; 1867, Paris, no.70; 1882, Paris, no.45; 1928, Anvers; 1929, Paris, Charpentier, no.198; 1948, Besançon; 1962, Ornans, no.60; 1962, Berne, no.14.

Jules François Félix Husson, known as Fleury and later as Champfleury, was born at Laon in 1821, the son of a printer and journalist. He came to Paris at an early age and took part in the Bohemian life immortalized by Murger. From 1848 onwards the sworn enemies of romanticism in art used to meet regularly for lunch at the Brasserie Andler (cf. 43). Champfleury was the moving spirit of their assemblies and was soon dubbed the 'supreme pontiff of Realism'; he did not himself care for this title, and afterwards wrote that 'the critics, by constantly using the term '[Realists'], obliged us to use it ourselves' (Lacambre. 1973, p.17).

Champfleury is a neglected figure who epitomized a whole aspect of his time. As he himself insisted, he was not an initiator but a champion of the 'realistic' predecessors who inspired the new trend in art, from the seventeenth-century Spanish and Dutch masters to Callot, Chardin and the Le Nain brothers, the revival of whose fame was directly due to him. A novelist of significance, though not a Balzac, he depicted scenes of historical importance, including *Les aventures de Mlle Mariette* (1844), a pendant to Murger's *Scènes de la vie de Bohème* and *Chien-Caillou* (1847), inspired by the life of the engraver Bresdin; turning to provincial life, in 1864 he portrayed the Courbet family in *Les demoiselles Tourangeau*. As an art critic and contributor to *L'Artiste* and other journals he preached new forms of vision and defended his friends against all comers; in particular he was one of Courbet's first champions. As a collector he favoured previously neglected art forms such as cartoons, popular prints and crockery and, from 1855 onwards, Far Eastern objects which he punningly called *japoniaiseries* (from *japonais*, Japanese, and *niais*, foolish).

His friendship with Courbet had its ups and downs. After Balzac's death in 1850 Champfleury helped the novelist's widow, the former Mme Hanska, to set his papers in order, and at that time he accused Courbet of seeking to supplant him in her good graces. Later, Courbet had occasion to complain that Champfleury had made improper use of his confidences concerning

but which somehow struck a common chord; Courbet in particular made abundant use of it.

The present portrait is eminently classical and is in the tradition of the great post-Renaissance portraitists. It was the first time Courbet had been commissioned to paint a 'noble' portrait, and the work is of a more solemn character than his subsequent portraits of Bruyas (cf. 37). We may note, nevertheless, that whenever Courbet painted portraits to order he tended to adopt a majestic style: e.g. those of Laurier (44), Mme de Brayer (53) or Mme Robin (61). Although such works as *Young ladies of the village* (New York, Metropolitan Museum; cf. 27) or *The corn sifters* (42)

are among the first modern French paintings, Courbet as a portraitist did not break with tradition and convention.

Montpellier, Musée Fabre.

32
Portrait of Champfleury

Portrait de Champfleury (34)

1854

Canvas: 46×38. Signed lower right: *G. Courbet*; dated lower left: *55*.

History: Acquired from the artist by the sitter; given to the Musée du Louvre by Champfleury's heirs in 1891.

Bruyas for the purpose of an insulting sketch entitled *Histoire de M. T . . .*, published in the *Revue des deux Mondes* on 15 August 1857. Champfleury's close contact with Baudelaire was also not calculated to improve his relations with Courbet, and these practically ceased after 1864.

Late in life Champfleury (who died in 1889) married Mlle Pierret, a goddaughter of his old friend Delacroix, who had painted her in 1838 as the blonde child in *Medea's Fury* (Lille Museum).

The present portrait was used by Courbet for the figure of Champfleury in *The artist's studio* (137). It was therefore painted before the latter work, and was perhaps dated only when delivered to Champfleury.

A *Portrait of Champfleury* (property of M. Méric) supposedly by Courbet, was no.54 in the exhibition of 1908 at Bagatelle, *Portraits de femmes et d'hommes célèbres*. We know nothing of this work.

Paris, Musée du Louvre.

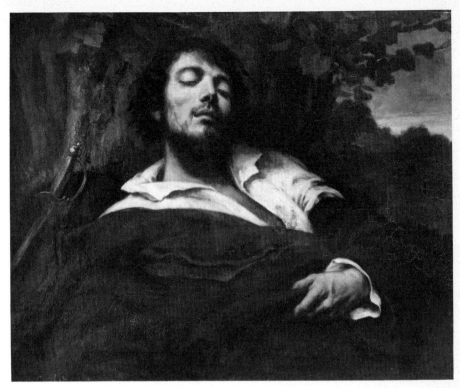

33

33

Portrait of the artist known as The wounded man

Portrait de l'artiste dit L'homme blessé (*35*)

1844–1854

Canvas: 81 × 97. Signed lower right: *G. Courbet* (doubtful authenticity?)

History: Juliette Courbet coll.; Courbet sale, Paris, 1881, no.6; bought at the Courbet sale by M. Hecht who advanced the necessary funds on behalf of the State; moved to the Musée du Louvre 10 December 1881; allotted to the Musée du Louvre by an order dated 31 July 1882; does not seem to have been exhibited at the Musée du Luxembourg.

Exhibitions: 1855, Paris, no.12 (*1844*); 1862, Bordeaux; 1867, Paris, no.11 (*Paris, 1844*); 1882, Paris, no.16; 1910, Venice, no.10; 1929, Paris, no.5; 1935–1936, Zurich, no.10; 1949, Copenhagen, no.3; 1952, Besançon, no.3; 1954, Venice, no.3; 1954, Lyon, no.3; 1955, Paris, no.8; 1968–1969, Moscow–Leningrad, no.75; 1969–1970, Rome–Milan, no.10; 1973, Paris, no.2.

Bibliography: Caricature by Quillenbois in *L'Illustration*, 21 July 1855 (repr. in Léger, 1920, p.30); Forges, 1969, no.10; Forges, 1972, p.456; Forges, 1973, no.2; Forges, *Annales*, p.33, figs.7, 9; Delbourgo-Faillant, p.11, figs.7, 9.

Bruno, 1872, *La Mort de Musoni*, p.65.

X-ray examination at the Laboratoire des Musées de France has revealed the curious fact that three pictures are superimposed on this canvas (Delbourgo-Faillant, *op. cit.*).

The first, a female figure, bears no relation to the present work. As we know, Courbet frequently reused the canvas of paintings that he did not like or did not complete. But the man we now see in a state of collapse at the root of a tree, with blood streaming over his shirt, exactly covers a representation of the same man as a happy lover, with a young woman nestling under his arm – the composition seen in the drawing *Country siesta* (129).

The wounded man is Courbet himself, as is clear from the mention of a *Dying man* (*Homme râlant et mourant*) in the list of self-portraits sent by him to Bruyas, to whom he wrote in May 1854: 'I have done many portraits of myself in successive states of mind – in a word, I have written the history of my life' (Borel, p.20). At that time Courbet still had a long course to run, but he might have added that he altered his self-portraits when they ceased to be authentic. For, as Marie-Thérèse de Forges argues cogently, the transformation of the lovers' bliss into a death-scene appears to be accounted for by the troubles of Courbet's love-life.

Riat (p.94) quotes Courbet's reply, written from Ornans, to Champfleury when the latter told him of the disappearance of Courbet's mistress and their son, born in 1847. 'May life treat her kindly, as she thinks she is acting for the best. I miss the boy very much, but art keeps me busy enough without a family, and anyway a married man, to my mind, is a reactionary.' A few lines further on he says that he has done 'something attractive' (*du gracieux*) for the next Salon. Riat thinks this refers to the *Young ladies of the village*, and that the letter must date from 1851 or 1852. This is probably correct, but Courbet's liaison must have lingered on for some years, as in 1854 he wrote to Champfleury (in a letter which we publish in full for the first time: cf. 137, *The artist's studio*): 'My mind is saddened, my soul is empty, my heart and liver are eaten up with bitterness . . . You know my 'wife' has married. I

no longer have her or the child . . . We had been together fourteen years.' Whether from *amour propre* or from a sense of shame, Courbet never assigned to the present picture any other date than that of its first, happy version, contemporaneous with the *Lovers* (11) of which it was a complement.

Castagnary, in a note written for the Courbet exhibition of 1882, said that the painter had shown the work in 1855, when he dated in 1854. This is not so, but Castagnary may have confused what Courbet told him with what he believed himself to have read. In any case we are of the opinion that it was actually in 1854 that Courbet altered the painting by suppressing the female figure, giving the man an older expression and adding the death-dealing sword and the cloak hiding the man's hand. Courbet was more deeply sentimental than he admitted, and was always given to expressing himself in symbols; and the object of the transformation was to depict himself as a lover whose heart was fatally wounded.

The picture thus combines two essentially romantic attitudes: preoccupation with death and with lyrical introspection. In literature this expressed itself in long outpourings, while artists, or Courbet in any case, were never tired of depicting the effects of emotion on facial expression, in line with Lavater's theories. This was also the subject of Bruyas's perpetual heart-searching (cf. 31).

Courbet was certainly not telling the truth when, at the time of the exhibition at the Pavillon de l'Alma in 1867, he stated that this work had been rejected at four Salons, from 1844 to 1847. In the first place it probably did not have its present form in those years: the workmanship, especially the painting of the hand, is much later in date. Secondly, as the receipt book shows, no work with the measurements of this picture was submitted in the years in question. The 'Academicians' who were in general so guilty in Courbet's eyes were innocent on this occasion at least.

Courbet was greatly attached to this picture in its final form, and made one or more copies of it. One was commissioned by an art-lover in 1865 (Riat, p.227). Castagnary's papers in the Bibliothèque Nationale and those of Dr Blondon in the Besançon Library mention a '*Wounded man, repetition*' among the paintings stored

in the passage du Saumon during the Commune, which were stolen in 1872 and recovered from a dealer in the rue Le Pelletier. Etienne Baudry kept this version and took it to Courbet at La Tour de Peilz so that the artist could sign it (anonymous note by Pata(?) in Castagnary's papers). In 1906 Baudry made it over to Bernheim. There is also in Castagnary's papers an ambiguous reference to 'a *Man wounded to death*', not a 'slavish copy of the picture in the Louvre' but representing 'the same character in the same attitude, a Courbet fifteen years older than he appears in the Louvre painting'. This would mean a date of about 1870 – did Courbet once more depict himself as a martyr at that date? At all events we have no knowledge of this work, unless it be identical with one in Vienna (*Galerie des neunzehnten Jahrhunderts im Oberen Belvedere*, Vienna, 1924, no.62, repr. p.35).

The present work is sometimes referred to as *The duel* or *The duellist*. It probably inspired Carolus-Duran's large painting *The murdered man* in the Salon of 1866 (Lille museum).

Paris, Musée du Louvre.

34

The meeting or 'Good day Monsieur Courbet'

La rencontre ou Bonjour Monsieur Courbet

(*36*)

1854

Canvas: 129 × 149. Signed and dated, lower left: . .*54 Courbet*.

History: Commissioned from the artist by Alfred Bruyas in 1854; given by Bruyas to the Musée Fabre in 1868.

Exhibitions: 1855, Exposition Universelle, no.2803; 1855, Paris, an addition at the closure of the Exposition Universelle; 1867, Paris, no.129; 1900, Paris, no.143; 1929, Paris, no.6; 1937, Paris, no.274; 1939, Paris, no.26; 1955, Paris, no.23.

Bibliography: Caricature by Quillenbois in *L'Illustration*, 21 July 1855 (repr. in Léger, 1920, p.29) and by Cham in *A L'Exposition* (repr. in Léger, 1920, p.32) and by Random in *Le Journal amusant*, 1867 (repr. in Léger, 1920, p.68); Bruyas, 1876, no.37; Robert L. Alexander, 'Courbet and Assyrian sculpture' in *The Art Bulletin*, 1965, vol. 47, p.448, figs.2, 3; Nochlin, 1967, *passim*, figs.1, 2, 3, 4; Forges, 1973, p.39.

Bruno, 1872, *Bonjour Monsieur Courbet*, p.233.

This is one of the most famous paintings of the nineteenth century, thanks to the originality of its composition and

Caricature by Quillenbois

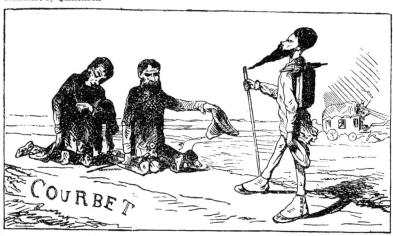

L'adoration de M. Courbet, imitation réaliste de l'adoration des Mages.

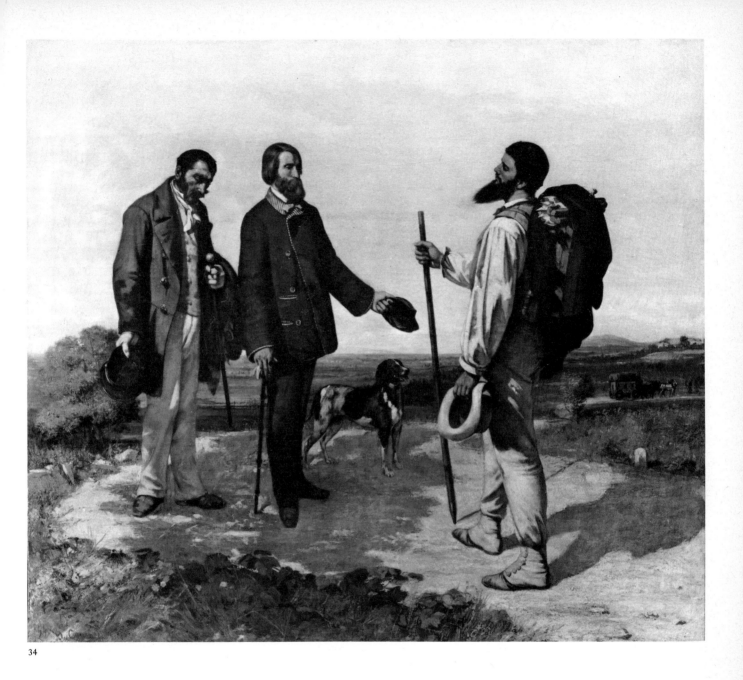

34

subject – a mixture of the quaint and the grandiose – and its extraordinary pictorial quality.

The scene here immortalized is Courbet's arrival at Montpellier as the guest of Alfred Bruyas in May 1854. Courbet, it appears, alighted from the diligence before it reached the town, and was met on the high road by his host, the latter's man-servant Calas and his dog Breton. The location appears to be at Lattes, where the road to Sète crosses that leading to Saint-Jean-de-Védas, or a little further on towards Miraval; in any case not far from the estate of Bruyas's friend Emile Mey.

The 'meeting' is a symbolic one, a kind of rite with a hidden meaning; its complexities are explored in a forthcoming article by Roger Cotte in the *Revue du Louvre*. Once again, Courbet presents himself as an historical painter.

As Linda Nochlin (*op. cit.*) has brilliantly demonstrated, the idea of Courbet's composition was derived from a

popular engraving by Pierre Leloup of Le Mans (1769–1844), from a series of the comic-strip type depicting the story of the Wandering Jew: the print in question shows the Jew meeting two prosperous townsmen.

The medieval legend of the Wandering Jew was revived by Eugène Sue in a book of that title in 1844, in which political and sociological themes are treated in terms of an opposition between the Jesuits and a large family named Rennepont, including in its members people of every class. This work, a kind of primitive serial story, was so popular that it was performed in a dramatic adaptation at the Théâtre de l'Ambigu in 1849 and was the subject of an opera by Halévy (1852). It is thus not surprising that further illustrations of the legend became popular, especially in Courbet's circle. Champfleury, it will be recalled, was interested in all forms of popular art, especially prints and pottery; in 1869 he was to publish an *Histoire de l'imagerie populaire* with, as its frontispiece, an engraving of the scene in which the Jew meets the two bourgeois.

It has been said that at Montpellier Courbet encountered a dry climate and a new, vivid form of sunlight. This, however, is far from accurate: Montpellier is near the sea, and the air there is much mistier than in the Franche-Comté with its hot, continental summers. The arrangement of the three figures in *The meeting* is an echo, three years later, of the *Young ladies of the village* (New York, Metropolitan Museum) in the earlier work the silhouettes already stand out sharply against a merciless light, and the stony landscape appears overwhelmed by the heat. The atmosphere and aesthetic effect of the two paintings is similar, but there is a difference in the treatment of landscape: in *The meeting*, the horizon is lower. From this point of view Courbet evolved in the opposite direction to Millet: as time went on, his skies became increasingly important in relation to the landscape proper.

The work was accepted, with some hesitation, for the World Exhibition of 1855. '*The meeting* was accepted with difficulty', Courbet wrote to Bruyas; 'it was thought too personal and pretentious' (Borel, p.79). A few days later, however, things had changed and Courbet was able to write: '*The meeting* is having a tremendous success. The Parisians call it *Bonjour, Monsieur Courbet*, and the Exhibition attendants take foreigners straight to it' (Borel, p.87).

Courbet was undoubtedly right: the success of the picture was confirmed by all the pamphlets, caricatures and witticisms that were launched against it. The cartoonist Cham, for example, wrote: 'Here we see M. Courbet giving a lesson in manners to two bourgeois. Whereas they only take off their hats on meeting him, he takes off his hat, jacket and waistcoat' (*op. cit.*). Popular songsters joined in with parodies of well-known rhymes ('*As-tu vu la binette au grand Courbet?*' – 'Have you seen Courbet's great big mug?'), while Gustave Matthieu wrote in mock-heroic vein:
Passant, arrête-toi, c'est Courbet que voicy.
Courbet dont le front pur attend le diadème;
Et ne t'estonne pas s'il te regarde ainsy:
Courbet te regardant, se regarde luy-même.
('Stay, traveller, this is Courbet whose pure brow awaits the diadem; and be not astonished that he looks at you thus, for in looking at you he looks at himself.') As for Banville, he composed no fewer than thirteen verses of an *Ode funambulesque* dedicated to the picture.

Edmond About wrote: 'The most important of M. Courbet's new pictures is *The meeting* or *Good-day, Monsieur Courbet*, or *Fortune bowing to genius*. The theme is as simple as can be. It is a hot day; the Paris–Montpellier diligence is seen in the distance, with a cloud of dust in its wake; but M. Courbet has made the journey on foot. He left Paris at about 4 this morning, walking cross-country with haversack and alpenstock, and here he is at the outskirts of Montpellier between 11 and noon. That's the kind of traveller he is! His friend and admirer M. Bruyas has come to meet him and bows very politely. Fortunio – M. Courbet, I should say – takes off his hat with a lordly gesture and smiles over the top of his beard. M. Courbet has done full justice to the perfections of his own person: even his shadow is slim and vigorous, with well-turned calves such as you seldom see in the land of shades. M. Bruyas is less flatteringly treated – he is a bourgeois. The poor manservant is humble and self-effacing, as if he were serving Mass. Neither master nor man casts a shadow on the ground; M. Courbet alone has power to obstruct the sun's rays' (*Voyage à travers l'Exposition des Beaux-Arts*; Courthion, I, pp.119–20).

Squibs like these bore witness to the stir that the picture created, and to the critics' realization that Courbet was the champion of a new form of art manifested in *The meeting*, *Bathers* (30) and *Young ladies of the village* (27).

Bruyas preferred this work to all other portraits of himself, and was grateful all his life to Courbet for the gift of this masterpiece. He had a photograph taken of it at Montpellier; Courbet sold this at his exhibition, although he described it as 'dark and burnt' (Borel, p.53).

Professor Robert Herbert believes that *The meeting* inspired Millet's drawing of *A shepherd showing travellers their way* (1857, Washington, D.C., Corcoran Gallery of Art; 'Millet revisited', *Burlington Magazine*, 1962, p.378, figs.16, 17, and Millet exhibition, London, 1976, no.76).

Montpellier, Musée Fabre.

35
Self-portrait known as
Courbet in a striped collar

Portrait de l'artiste dit Courbet au col rayé
(*37*)

1854

Canvas: 46 × 37. Signed, dated lower right: *G. Courbet 54.*

35

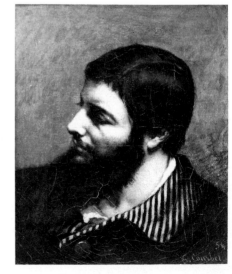

History: Acquired from the artist by Alfred Bruyas in 1854; given by Bruyas to the Musée Fabre in 1868.

Exhibitions: 1855, Paris, Exposition Universelle, no.2806; 1860, Montpellier, no.65; 1861, Marseille, Salon; 1929, Paris, no.1; 1935–1936, Zurich, no.31; 1937, Paris, no.275; 1939, Paris, no.27; 1939, Berne, no.26; 1954, Venice, no.14; 1954, Lyon, no.15; 1955, Paris, no.34.

Bibliography: Bruyas, 1854, no.80; Bruyas, 1876, no.36; Robert L. Alexander, 'Courbet and Assyrian sculpture' in The Art Bulletin, 1965, vol.47, p.447; Forges, 1973, no.50.

When Courbet sent Bruyas his *Man with a pipe* (19) he described his other self-portraits and added: 'I still have one more to do – that of a man sure of his principles, a free man' (Borel, p.20). This must refer to the present work, painted at Montpellier in 1854.

Courbet used this, his last important *Self-portrait*, for the representation of himself in *The painter's studio* (137). In the long letter describing that work to Champfleury he wrote that he would depict himself 'painting, with my Assyrian profile showing'. In this connection Robert L. Alexander (*op. cit.*) recalls that the excavations of Paul Émile Botta had recently acquainted the Western world with the art of ancient Ninevah. Courbet was no doubt pleased with the resemblance between his own countenance, with the long, languorous eyes and pointed beard, and those seen in Assyrian reliefs.

Courbet painted a replica of this picture, probably when Bruyas lent it to him so that he could use it for *The studio*. He evidently did not tell Bruyas about the replica, and hesitated over sending it to Vienna with his other works in 1873, being apparently seized with belated misgiving as he was in the case of *Man with a pipe* (19). The fate of the replica is unknown to us.

Henri Matisse possessed the tracing drawing used for the transfer of this portrait to the canvas of *The studio* – one of the few such specimens that have survived (cf. Forges, 1973, p.40).

Montpellier, Musée Fabre.

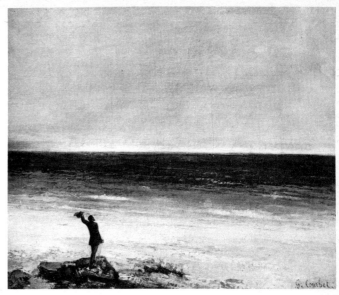

36

36
The seaside at Palavas

Le bord de la mer à Palavas (38)

1854

Canvas: 27 × 46. Signed lower right: *G. Courbet*; dated lower left: *..54*.

History: Acquired from the artist by Alfred Bruyas 1854; given by Bruyas to the Musée Fabre 1868.

Exhibitions: 1860, Montpellier, no.60; 1867, Paris, no.134; 1911, Petersburg, no.337; 1939, Liège; 1939, Paris, no.29; 1939, Berne, no.28; 1955, Paris, no.25; 1959–1960, Philadelphia–Boston, no.19.

Bibliography: Bruyas, 1876, no.38; Forges, 1973, p.39.

While Courbet first saw the Mediterranean in 1854, this was not his first contact with the sea: as we have argued, *The mouth of the river Seine* (2) must date from his early years.

Courbet executed several seascapes in and around Palavas in 1854. In the present one he depicted himself, by way of glorifying his encounter with the mighty element. A sentence from a letter of his, written at this time to Jules Vallès, is often quoted in this connection: 'The sea's voice is tremendous, but not loud enough to drown the voice of Fame, crying my name to the entire world.'

Eleven years later Whistler imitated this *Seascape* at Trouville, where he met Courbet. He also introduced his fellow-artist, with a silhouette resembling the one in this picture, into his *Harmony in blue and silver* (1865, Boston, Isabella Stewart Gardner Museum).

Montpellier, Musée Fabre.

37
Portrait of Alfred Bruyas when sick

Portrait d'Alfred Bruyas dit Bruyas malade (39)

1854

Canvas: 45 × 37. Signed lower left: *G. Courbet*; dated lower left: *..54*.

History: Commissioned from the artist by the sitter 1854; given by Bruyas to the Musée Fabre 1868.

Exhibitions: 1932, London, no.327; 1938, Lyon, no.11; 1939, Paris, no.28; 1939, Berne, no.27; 1947–1948, Brussels, no.73; 1959–1960, Philadelphia–Boston, no.20.

Bibliography: Bruyas, 1876, no.40 (*Tête d'étude avec main*).

37

Exhibitions: 1939, Belgrade, no.27; 1950, La Tour de Pielz, no.12.

We do not know when Courbet stayed with François Sabatier at La Tour de Farges (cf. 132): it may have been when he first visited Montpellier in 1854, or when he returned in 1857, or on a third trip he may have made in 1863.

This picture was inspired by the picturesque ruins of a Roman bridge across the Vidourle, not far from Lunel and the Sabatier estate. As a young man Courbet had painted ruined fortresses around Ornans, but he soon quitted such romantic themes, reverting to them only during his exile in Switzerland: cf. *Chillon Castle* (125).

Montpellier, Musée Fabre.

Did Bruyas himself commission this portrait showing him as a sick man? Although a chronic invalid, he certainly did not pose with an expression like this on any other occasion. In the catalogue describing his collection this work is described merely as *Study head with hand*, as if he felt bashful at associating himself with the sickly being here depicted.

This is probably the picture that Courbet referred to as *Portrait of proud repose*(?) in his farewell letter on leaving Montpellier in 1854, when he asked Bruyas to send him a photograph of it (Borel, p.57). At the same time he painted a small profile of Bruyas, which he used for the latter's head in *The studio* (137).

Montpellier, Musée Fabre.

38
The bridge of Ambrussum

Le pont d'Ambrussum (40)

1854 or 1857

Paper on panel: 43 × 68. Signed lower left: *GC*. Inscription on the back in François Sabatier's hand: *Vue du pont d'Ambrussum sur le Vidourle par Courbet durant son séjour chez moi.*

History: Acquired from the artist by François Sabatier; bequeathed by Sabatier to the Musée Fabre 1891.

39
A Spanish lady

Une dame espagnole (41)

1854

Canvas: 81 × 65. Signed and dated lower right: *G. Courbet . .55.*

History: Consigned by the artist to Galerie Durand-Ruel in 1873; Juliette Courbet coll.; Courbet sale, 1881, no.9; bought by Galerie Durand-Ruel; acquired from Galerie Durand-Ruel by Jules Paton; Paton sale, Paris, 1883, no.31; bought by John J. Johnson, Philadelphia, 1914–1918; acquired by the Philadelphia Museum of Art with the John J. Johnson Collection.

Exhibitions: 1855, Paris, Exposition Universelle, no.2808; 1867, Paris, no.84; 1882, Paris, no.21; 1939, San Francisco, no.142; 1948–1949, New York, no.9; 1949, Fort Worth; 1951, Birmingham (Alabama); 1956, New York, no.5; 1956–1957, Providence; 1959–1960, Philadelphia–Boston, no.21.

Bibliography: Caricature by Quillenbois in *L'Illustration*, 21 July 1855 (repr. in Léger, 1920, p.29), and by Randon in *Le Journal amusant* in 1867 (repr. in Léger, 1920, p.69).

In the late summer of 1854 Courbet left Montpellier and stayed for a time at Lyons before returning to the Franche-Comté. He suffered at this time from a masked cholera, which was effectively cured by a female friend of his. As he wrote to Bruyas in November: 'At Lyons I fortunately met a Spanish lady of my acquaintance, who introduced me to a remedy which produced a radical cure' (Borel, p.48). The amateur nurse, who may have been Spanish by birth, was the model for this fine portrait.

While the mixture of bright and dull tonality is reminiscent of Velazquez, the sitter's pose may be inspired by that of the *Young man* in the Louvre, long regarded as a *Self-portrait* by Raphael but now restored to Parmigianino. The direction is here

38

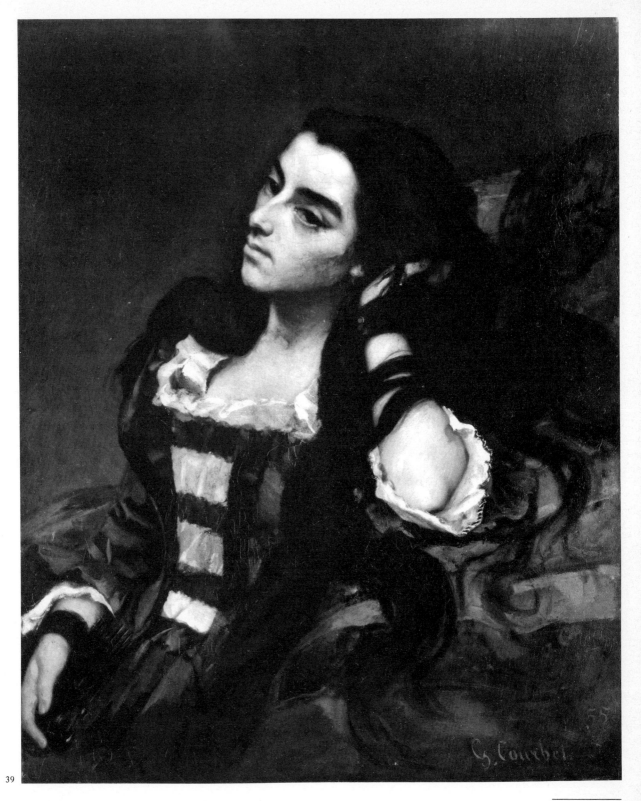

39

reversed, as it would appear in an engraving and, notably, in a collection of models for budding artists published in about 1830–1840 and entitled *Nouvel album de dessins mis à la portée de la jeunesse par divers auteurs*. Works of this kind were widely disseminated and were much used by artists of all types as a source of ideas on form and composition.

Courbet used the same pose for the *Portrait of Gabrielle Borreau* (65).

The *Spanish lady*, so justly admired today, aroused the indignation of critics at the World Exhibition. Théophile Gautier exclaimed in the *Journal officiel*: 'We have seen gipsy women – thin, gaunt and sun-burnt – on the threshold of their caves in the Monte Sagrado at Granada, or in the Barrio de Triano at Seville; but none of them was so dried-up, blackened or strangely haggard as this face painted by M. Courbet' (Riat, p.138). Edmond About added further sarcasms: 'The *Portrait of a Spanish lady* is not painted with oil or pommade but with some greyish unguent that has no name in any language. Has M. Courbet some vendetta against Spain? Why does he attribute such strange fruit to the garden of the Hesperides? This portrait rather suggests to me a person from the purlieus of the Luxembourg gardens, a dancer from a shady left-bank cabaret, a victim of Paris life atoning at the age of thirty for the supper-parties of her youth' (*Voyage à travers l'Exposition des Beaux-Arts de 1855*; Courthion, I, 119).

It is surprising that in 1855 a work of this kind could still appear shocking to Théophile Gautier, who was scarcely a reactionary. We must realize, however, that with the *Spanish lady* a fresh wind had begun to blow and that the seeds of a new art were being scattered afar, for in contemplating this work we cannot help being reminded of Manet.

We are especially grateful to the Conservation Department of the John G. Johnson collection for kindly furnishing an X ray of this picture. The X ray, which is perfectly clear, shows a fine half-length portrait of a woman, underneath the Spanish lady and the other way up; she wears an elegant lace cap, and is leaning her right hand on a table.

Philadelphia Museum of Art, John G. Johnson collection.

41

Peasants from Flagey, returning from the fair, Ornans

Les paysans de Flagey, revenant de la foire, Ornans (42)

1850, 1855

Canvas: 206 × 275.

History: Entrusted by Courbet to Durand-Ruel to be sold on 15 April 1871, indicating the figure of 25,000 ff; sold 1872 (10,000 ff); Dreyfus sale, Paris, 1889, no.21; Dreyfus–Gonsalès sale, Paris, 1806, no.18; Goldschmidt coll.; Galerie Durand-Ruel; A. Clement Griscow sale, New York 1914; Galerie Bernheim-jeune; Matsuka coll. (1929); acquired by the Musée du Louvre in 1952 as a result of the peace treaty with Japan; deposited at the Musée de Besançon, 1959.

Caricature by Bertall

Exhibitions: 1855, Paris, no.3 (*La retour de la foire, Jura*); 1867, Paris, no.4; 1882, Paris, no.5; 1914, Copenhagen, no.3; 1919, Paris, no.1; 1921, Basle, no.38; 1929, Paris, no.123; 1947–1948, Brussels, no.68; 1948, Paris, no.65; 1949, Copenhagen, no.6; 1950, La Tour de Peilz, no.8; 1952, Besançon, no.8; 1959–1960, Philadelphia–Boston, no.12; 1969, Ornans, no.9; 1969–1970, Rome–Milan, no.11.

Bibliography: Caricature by Bertall in *Le Journal pour rire*, 7 March 1851 (repr. in Léger, 1920, p.13); Proudon, 1865, pp.161–70; Toussaint, no.11.

Bruno, 1872, *Les gens de Villeneuve revenant de la foire*, p.144.

Together with the *Burial at Ornans*,

Courbet submitted to the Salon of 1850–1851 a composition entitled *Peasants of Flagey returning from the fair* (*Doubs*) (no. 662). Thus, once more, he painted a work accompanied by a full explanatory title, indicating the circumstances of the scene, the place of origin of the individuals depicted, and even the department of France to which they belonged. For a third time – the previous examples being the *Burial* and *After dinner at Ornans* – Courbet elevated an everyday genre scene to the rank of an historical painting, conferring on a particular place and time the dignity of an historic event. Louis de Geoffroy, in his review of the Salon, made fun of Courbet's meticulous description: 'These are peasants of Flagey in the Doubs, not of Pontoise' (alluding to the humorous associations of the latter place) (*Le Salon de 1850* in *Revue des Deux Mondes*, 1 March 1851, pp.36–7).

According to tradition the rider in the top hat is the artist's father Régis Courbet, who was mayor of Flagey, and the woman with a basket is Josette d'Arbon, a peasant who lived near by. The exact locality is the Mont des Feuilles between Salins and Flagey.

The picture here exhibited is not the original, which has disappeared, but a

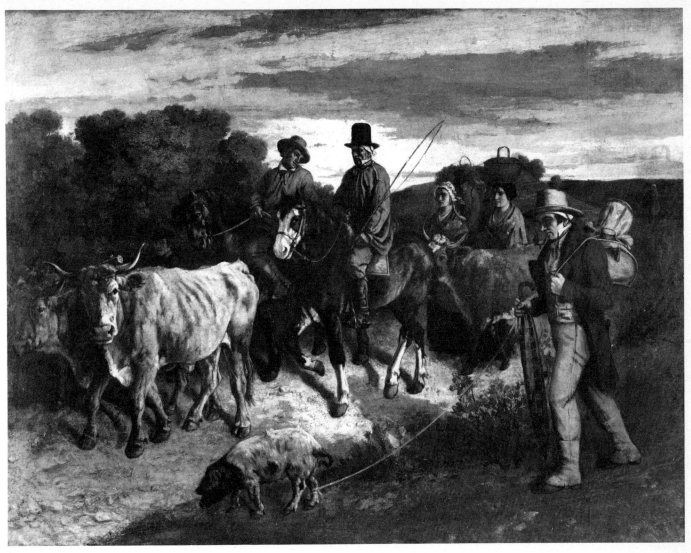

41

replica painted before the 1855 Exhibition. In a letter to Bruyas Courbet wrote: 'I repainted my *Return from the fair*, which needed much alteration and in which the perspective was wrong, also I enlarged it by a quarter' (Borel, p.28).

It has been hastily concluded from these words that the enlargement consists of the strip, about 40 cm wide, which has clearly been added on the right, with the figure of a man leading a pig by a cord. This, however, is not so, as the figures in this version are all mentioned in Buchon's description of the original (*Le Salon de 1850* in *L'impartial, Journal de Besançon*, 17 January 1851). The similarity is also confirmed by a cartoon which appeared in the *Journal pour rire* (Léger, 1920, p.13), except that in the original the woman with a basket on her head was at the extreme right and not in the centre. In his revised version Courbet followed the same arrangement: the trace of the basket beneath the repainting is visible with the naked eye and casts a shadow on the sky to the right. X-ray examination at the Laboratoire des Musées de France confirms this modification and shows that Courbet did not paint the revised version over the original but used a fresh canvas.

The measurements of the original, as recorded in the receipt book, were 218×250 cm including the frame. It follows from this that the present version is perhaps not much higher than the original, but is at least 30 cm wider.

An engraving by Vernier, dating from 1855, shows the present composition, but with some variations which can hardly

41 (detail).

be due to the engraver. A young man, carrying a basket with a spinning-wheel on top, appears between the two women; and the woman with a basket is not replaced, as here, by a young couple but by a group consisting of two old men, a woman and a man using an umbrella as a walking-stick. Thus the artist evidently introduced further modifications into his second version.

The shifting of the woman with a basket from the right to the centre of the picture does not seem very important at first sight, but it alters the whole rhythm of the composition, changing the frieze arrangement to an ovolo formation of a kind popular with some Dutch landscape painters of the seventeenth century and generally imitated by the Barbizon school. This is very unusual with Courbet, but was perhaps suggested by the close resemblance between this picture and Dutch landscapes by animal painters such as Berchem, showing peasants en route with their livestock.

Courbet was not the first to revive the seventeenth-century fashion of realistic country scenes: these were already in vogue as a natural consequence of the development of landscape painting since 1800. The eighteenth-century romantics were attracted by nature in its pristine state, and French artists who broke with the classical tradition of a 'composed' landscape drew

inspiration from the seventeenth-century Dutch, either directly or through British painters such as Constable. At the outset, in the work of Georges Michel for instance, shepherds and their flocks were mere staffage, corresponding to the heroic or mythological figures in historical paintings. By degrees, however, they grew in importance and became the main subject, as they had done in the work of followers of Bercham or Potter. In the second quarter of the century French artists like Brascassat, Rosa Bonheur, Troyon, Jacque and Millet anticipated Courbet in turning peasants and their animals into principal figures. This type of painting remained popular throughout the nineteenth century, and beyond it in the work of Lhermitte and Lerolle. From 1850 onwards it was so prevalent that some exhibition catalogues used the neologism *paysanniste* or 'peasant-painter' to denote a speciality analogous to the painting of landscapes or seascapes. Together with Millet, the most popular painter of peasant scenes was Jules Breton.

The fashion for peasant scenes was at its height during the social convulsions of 1848, and such artists as Millet and Courbet, especially the latter, were closely associated with 'liberal' thinkers. Accordingly it has often been suggested that their work contained a propaganda element of a humanitarian and socialist kind, such as was undoubtedly present in contemporary literature, e.g. George Sand's novels of country life or the songs of Pierre Dupont. As far as painters are concerned, however, we should be careful not to distort or exaggerate intentions of this kind.

Let us recall some lines written by Proudhon on the subject of the present painting, and first and greatest of a brief series of works by Courbet depicting peasants in action. The radical philosopher who often had much to say about Courbet's works and should have known better than anyone what politico-moral message the picture was intended to convey, if any, remarked on it as follows. 'People have said that Courbet did no more than develop Dutch naturalism . . . it would indeed be to his discredit if he derived from no one . . . But Courbet is a Frenchman from the Jura, not a Dutchman from the Zuyder Zee – he is a born Catholic and has nothing Protestant about him.' Later Proudhon continues: 'The middle-aged man returning home on horseback is a rich peasant, mayor of his community, a substantial farmer and an official personage who can keep his dignity while wearing a rustic smock . . . This is the Franche-Comté peasant in all his natural sincerity. What you will find in our people, in every class of French society regardless of age, wealth or sex, before its true nature was spoilt by the excitements of the present age, is a moderate temper, an unruffled smoothness of character and manners.'

Where is the revolutionary intent in all this? Proudhon begins by defending Courbet's originality, emphasizing the historical interest of the work and the fact that it exalts the national character and is racy of the soil. He sees it, in short, as carrying a salutary moral message.

In general it does not appear that the *paysannistes* tended, as has been claimed, to depict their subjects as victims. They show us men and women assured of their social utility and convinced of their spiritual value. Millet's peasants are hard workers, but they can spare time to fondle their children or to murmur the Angelus. Courbet's peasants in the picture before us are proud and free: not only the dignified father on his horse, but his companions walking beside him would be deeply offended at the idea that they were objects of pity. Millet and Courbet were themselves sons of the soil; they painted what they knew and loved, singing the praises of a way of life threatened by the drift of countrymen towards the towns and factories. Their work also foreshadows the calm and relief experienced in modern times by those who take refuge in the countryside from the anxieties of civilization with its machines and crowded cities. In our opinion, paintings like these are not revolutionary manifestations but are meant to commend a particular way of life. They may be called glorifications of the peasantry and its ways; what they certainly lack is any kind of satirical or comic intent. Millet could paint dissolute scenes when he chose, Courbet depicted all forms of debauchery, but neither of them ever showed peasants forgetful of their dignity or displaying the faults traditionally ascribed to them. Unlike writers of the realist school, the *paysannistes* did not deal in seductions of shepherdesses or present the peasantry as greedy and intemperate; instead they show us noble characters, very different from those depicted by Balzac and Flaubert, and still more so from the peasants of Zola or Maupassant.

Return from the fair is certainly an epitome of pictorial realism, but it is of a visual and not an intellectual kind. The popular style of the painting is enhanced by its resemblance to the illustrations in a picture-book. Courbet's craftsmanship, in this work, is not modelled on old masters: the figures stand out sharply, their facial expressions are like those of puppets carved out of hard wood. The man leading the pig is clearly related to certain figures in *Burial at Ornans* (135). The present work is the last in which Courbet goes into this sort of minute detail. At the same time the work is grandiose in conception, in the extraordinary composition with its disregard for perspective and in the arbitrary jumbling of human beings and animals. Courbet appears here as an innovator, but the work is less revolutionary than *The corn sifters* (42). It does not deny the existence of a third dimension; space is rendered, in traditional fashion, by shaded volumes, an extended range of values punctuated by points of emphasis, and contrasts of light and dark.

In a letter of 1855 Courbet told Bruyas that he was making a reduced copy of the picture (Borel, p.28). We do not know what has become of it, but there is another version in a private collection, which may be a copy or a pastiche. The central group of the two men on horseback recurs, in altered costume, in a *Return from the hunt* in the Ornans museum.

Besançon, Musée des Beaux-Arts.

42
The corn sifters

Les cribleuses de blé (43)

1855

Canvas: 131 × 167. Signed and dated lower left: *..55 G. Courbet.*

History: Bought by the City of Nantes in 1861.

Exhibitions: 1855, Paris, Salon, no.2804; 1857, Brussels, no.1267 (*Les cribleuses de blé, scene de moeurs agricoles, Franche-Comté*); 1859, London, no.40 (*Sorting the corn*); 1860, Besançon, no.312 (*Les cribleuses ou les enfants des cultivateurs de Doubs*); 1861, Nantes, no.183; 1900, Paris, no.142; 1947, Nantes, no.8; 1949, Copenhagen, no.10.

Bibliography: Caricature by Cham in *Le Charivari* (Léger, 1920, p.31); Francis Haskell, 'L'art française et l'opinion anglaise dans la première moitié du XIXe siècle' in *Revue de l'art*, 1975, no.30, p.76, note 48; Claude Souviron, 'Documents autographes de Courbet; achat des Cribleuses de blé par le Musée des Beaux-Arts de Nantes' in *La Revue de Louvre*, 1977, no.4.

The scene of this work, painted at Ornans, is in a bolting-room. At the Besançon Exhibition in 1860 it was sub-titled *Farmers' children from the Doubs*. It has long been known that Zoé Courbet posed for the principal figure, and we suggest that Juliette was the model for the woman seated on the ground; also that the small boy may be Courbet's unacknowledged son, Désiré Binet, who was born in 1847 and would thus have been six years old at the time. He may be compared with the child seen drawing in *The studio* (137), who we think also represents Courbet's young son: there was every reason for him to be included in a picture representing seven years of the painter's life.

Courbet's letter 'explaining' *The studio* to Champfleury (cf. 137) ends with the words: 'I have a picture of country life showing girls sifting grain: it is in the series of *Young ladies of the village*, a strange picture too.' *The corn sifters* is certainly an unusual painting, with no parallel in Courbet's previous or subsequent work.

What can have been the inspiration of a picture that suddenly breaks with every Western tradition? We suggest that it may be one of the first instances of Far Eastern influence on French painting.

Champfleury, who was an enthusiastic collector of Hokusai, wrote in 1888: 'Around 1855 some painters and poets, always in search of novelty, made the fortune of a certain shop with a rich store of Japanese materials and bronzes, also albums and attractively coloured broadsheets' (Lacambre, 1973, p.140). There was at that time a shop in Paris called 'La porte chinoise', founded during the Bourbon restoration, which sold articles from the furthest parts of Asia, and later on Mme Desoye opened a similar establishment which became a meeting-place for Champfleury's friends. Japanese goods were not imported officially before 1860, but we are told by Japanese writers on art that their country's products found their way to Europe many years earlier, disguised more or less thoroughly as of Chinese origin. Thus Japanese works could be seen in the Chinese pavilion at the World Exhibition of 1855 and also in the separate collection of Chinese goods outside the Exhibition precincts.

In our opinion, *Corn sifters* recalls the art of Japanese prints by the following characteristics: the view from above, which is not found in any other composition of figures by Courbet; the fact that this master of chiaroscuro here creates an effect of space by means of vanishing lines alone; the monochrome grey and blond colour-scheme, animated only by a red and a blue patch; the flatness and uniform pallor of the women's faces and arms; the background of large plane rectilinear surfaces, on which the shadow of a trellis-work (lighter, by an anomaly, than that cast by the bolting-machine) is reminiscent of the sliding screens called *shoji* which often impose a grill-like pattern on parts of Japanese prints and paintings; and, finally, the extraordinary number of round and oval forms – the large sieve and the plates, dishes and bowls – which fill the composition with independent curves. This is a phenomenon peculiar to Japanese prints with their rounded vases and lanterns which, like the objects in the present work, seem to be placed haphazardly, without any apparent relation to the structural lines of the composition. The bolter itself resembles the low chests that often appear in Japanese prints.

Caricature by Cham

D. 1362

Une jeune fille travaillant avec tant de zèle dans une grange qu'elle n'a pas encore pu trouver une seule minute pour se livrer à quelques soins de propreté.

A further argument consists in the poses of the two women. Juliette is seated on the floor, but we do not believe that a French peasant woman of the period would have adopted such a position for a job of this kind; pictures always show them seated on a chair or chest. Again, the attitude of Zoé's body resembles that seen in popular prints of Kabuki plays, which were among the first Japanese engravings seen in France, and in which the mood is expressed by vehement gestures of the actors' robust, outstretched arms, just as here the whole meaning and animation of the picture are conveyed by the arms of the central figure.

Writing of *The quarry* (50) in 1857, Théophile Gautier spoke of 'The two huntsmen, although in a Chinese perspective . . .' (*L'Artiste*, 20 September, p.34): this implies that a reference to Far Eastern art was understood by readers at that time and was not out of keeping with a work by Courbet. Naturally there were limits to such experimentation in 1855: Courbet neither could nor wished to break with tradition altogether, and we are still a long way from Gauguin; not does any of his later work reflect the same Oriental influence.

The corn sifters was the first of Courbet's pictures to be bought by a municipality.

The catalogue of an exhibition held at Le Havre in 1868 mentions under Courbet's name 'no.127: young woman sifting grain, sketch for *The corn sifters*'. We know nothing of this work and have seen no other record of it, unless it be that quoted by Francis Haskell (*op. cit.*) from a London catalogue of 1859 with the title *Sorting the corn*.

Nantes Museum.

43
Mère Grégoire

La mère Grègoire (45)

Canvas: 128×97. Monogram, lower left: *GC*.

History: Stolen from Courbet in 1871, at passage du Saumon; found by Etienne Baudry at a dealer's in the rue Neuve St Augustin in 1873; Prince de Wagram coll.; Princess de la Tour d'Avergne coll.; Alexander Reid and Lefevre; acquired by the Art Institute, 1930 (Wilson L. Mead Fund).

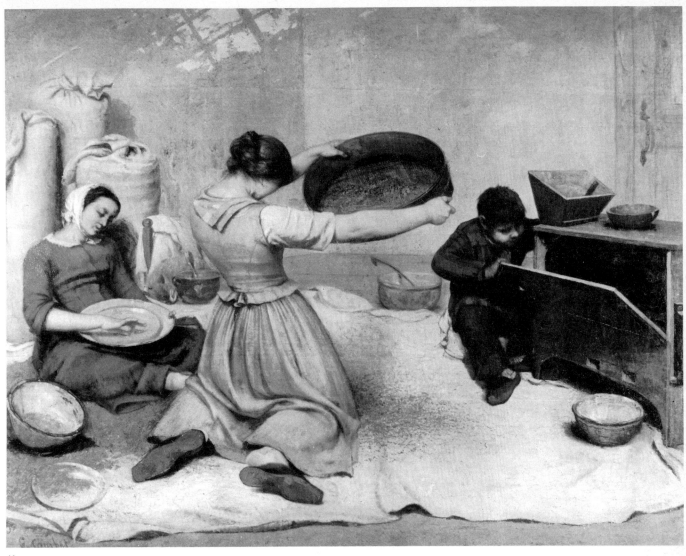

42

Exhibitions: 1867, Paris, no.96; 1912, Petersburg; 1933, Chicago, no.237; 1934, Chicago, no.176; 1937, Hartford, no.37; 1946, Toledo, no. 26; 1947, Toronto, no.26.

Bibliography: Caricature by Randon in *Le Journal amusant*, 1867 (repr. Léger, 1920, p.69); D. C. Rich, *Mère Grégoire by Courbet* in *Art Institute of Chicago Bulletin*, 1930, vol.24, pp.42–43; D. C. Rich, *The Exhibition of French art in Formes*, 1933, vol.33, pp.381–3.

Bruno, 1872, *Madame Gervais*, p.145.

In 1848 a new type of café-restaurant made its appearance in Paris: the *brasserie*, modelled on the German *Bierkeller*, serving beer and German delicacies. A Bavarian named Andler opened a brasserie in the rue Hautefeuille, near the studio that Courbet rented in 1849, and this establishment became famous as a rendezvous of Realist writers, artists and critics. Day after day it witnessed exuberant gatherings of painters – Courbet, Daumier, Corot, Decamps, Amand Gautier, Bonvin; sculptors – Barye, Préault; writers – Baudelaire, Champfleury, Buchon; philosophers – Proudhon, Toussenel; and critics – Planche, Silvestre and others. In a celebrated drawing (present location unknown to us: cf. Forges, 1973, p.35) Courbet depicted himself, in dandified attire, sitting at a table in the Andler-Keller with his friends Trapadoux and Wallon; he also designed an etching to illustrate Alfred Delvau's *Histoire anecdotique des cafés et carabets de Paris*, 1862.

Jean Dethier's researches in connection with the current exhibition *Cafés, bistrots et compagnie* at the Centre National Georges Pompidou have brought to light much information concerning the German *brasseries*. One of their innovations was that

food and drink were served by waitresses, who were known to the police as women of easy virtue, and there were often adjacent premises in which customers could enjoy their favours more or less openly. Delvau's book does not suggest that this was necessarily the case at the Andler-Keller, but he is also euphemistic in his description of the other *brasseries*. Riat, on the other hand (p.54), makes a significant reference to what he calls 'a monastic refectory, if you like, but in that case it belongs to the Abbaye de Thélème'. If the model depicted here is connected with the Andler-Keller, as historians have always supposed, this tends to confirm the suggestion of Rabelaisian goings-on at that establishment.

Why, to begin with, is the model called 'Mère Grégoire'? Up to now she has been identified with Mme Andler, but there is no evidence that that lady ever went by such a name. The study of a woman in the Petit Palais, which is supposed to represent Mme Andler, is certainly of a different person. May not this plump, austerely dressed female be the manageress of a bordello?

Courbet's interest in symbolism is well known. The model in this picture is holding out a flower, a gesture which, since medieval times, has signified an offer of love. Engaged couples were similarly shown offering each other flowers, but with the right hand. The portly lady whose left hand holds a flower in this picture is certainly not offering love on her own account, especially as her left hand is outstretched in the no less eloquent gesture of someone asking for money. It may be thought a piece of irreverent humour on Courbet's part that this gesture brings to mind the similarly outstretched hand of the lady on the left of Hals's picture of the Regentesses of the almshouse at Haarlem – an association, as it were, of two kinds of governors of hospitable institutions.

Champfleury's description of the Andler *brasserie* (in *Souvenirs et portraits de jeunesse*) speaks of 'bare whitewashed walls, no mirrors and no sofas'. This picture, on the other hand, shows a luxurious interior, with a mirror and red velvet upholstery. If we are really in the Andler-Keller, it must be in the 'secret' annexe.

In the catalogue of his 1867 exhibition Courbet dated the picture 1855 and described it as a 'study'. As we know, his dating was not always reliable, and we are inclined to place it some years aerlier. It still shows the direct influence of Dutch and Flemish masters. We have already mentioned Hals; the warm, resonant colours are evocative of Rubens, and the whole conception of the painting recalls the northern countries. In Courbet's masterly treatment of a picturesque 'character' study there is a curious combination of modernity and reminiscence of the past. Bearing in mind the period at which the work was painted, it is easy to understand why caricaturists fastened upon this portrait of a middle-aged lady in a welcoming attitude.

In about 1865(?) Courbet wrote to Edouard Reynart, administrator of the Lille museums: 'My friend Thoré recently came to my studio and, seeing *Mère Grégoire*, said to me: "There's a picture I really must sell for you to the Antwerp museum, I would like to see it alongside the Rubenses. I am sure the city would buy it." I told him I was delighted by the idea, but that I must ask you first as you wanted it for the Lille museum' (*L'Art*, July 1883, p.43). In the end *Mère Grégoire* did not go to Antwerp, nor did it join *After dinner at Ornans* at Lille: Courbet kept it for himself. Its later history was unfortunate. Shortly after the Commune it was stolen together with other works that Courbet had hidden with his 'landlady' in the passage du Saumon. Two years later some of these paintings were found by Baudry and Castagnary in the possession of a dealer in the rue Neuve-Saint-Augustin. Castagnary wrote to Courbet: 'I saw – what a surprise! – Madame Grégoire, whose head had been delicately cut off; she was afterwards remounted, but the join of the neck has not yet been repaired.' Baudry wrote: 'I was luckily in time to save Mme Grégoire from the restorers who had begun repainting her; fortunately they had only had time to retouch the background a bit. The hands are in a bad state, but that can easily be fixed' (Bibliothèque Nationale, Estampes, Boxes VII and II).

Traces of the decapitation, for which no reason can be suggested, are still visible if the picture is looked at from a low angle.

The Morlaix museum possesses a study by Courbet which is also believed to be a *Portrait of Mère Grégoire*.

Chicago, Art Institute.

44

Portrait of Clément Laurier

Portrait de Clément Laurier (46)

1855

Canvas: 100 × 81. Signed, dated, inscribed lower left: *A mon ami Laurier, Gustave Courbet, 1855.*

History: Acquired from the artist by Clément Laurier, the sitter; Laurier coll.; Rodolphe d'Adler coll., Paris; Sale, Paris, Galliera, 23 June 1963; Knoedler Gallery, New York; given by the 'Friends of Art' to the Milwaukee Art Center, 1968.

Exhibitions: 1930, Berlin, no.10; 1937, Paris, Rosenberg, no.5; 1938, London, no.3; 1952, Paris, no.11; 1952, Besançon, no.15; 1953, London, no.10; 1954, Lyon, no.16; 1955, Paris, no.31; 1955, Rome–Florence, no.21; 1957, Paris, Jacquemart-André, no.67.

Bibliography: Charles Woerler, 'Portrait de Clément Laurier' in *A.G.C.*, 1968, no.39, pp.8–10, repr.

Clément Laurier (1831–1878) is here seen at the age of twenty-three. He was a member of the Paris bar and secretary to the lawyer and statesman Adolphe Crémieux. As a young man he specialized in financial questions, and in 1858 published his principal work, *La liberté de l'argent*. Subsequently he was a defence lawyer in several *causes célèbres*, appearing e.g. for the family of Victor Noir (a journalist murdered by the Emperor's cousin Pierre Bonaparte in 1870) and for the *Communards* of Marseilles in 1871.

He entered politics as a republican socialist, but before his early death he had moved over to the right wing. After the fall of the Empire he became under-secretary for the Interior in the Government of National Defence, and in that capacity negotiated an important loan in London.

In *L'Insurgé* (1880) Jules Vallès painted a spiteful picture of him which we may set beside Courbet's: 'He was scepticism incarnate, a man who shot at things and people for the pleasure of doing so, White by conviction and Red in his love of bloodshed. This little man with no lips or chin, who looked like a linnet or a weasel, was one of the cleverest men of the day, a Machiavelli of our time . . . foxy, inquisitive, a lover of jokes and good living.'

We do not hear of him in connection with Courbet's trial in 1871, by which time they may well have become estranged.

Laurier, a rich man and a connoisseur, used to entertain poets and artists at his home, the château de l'Epineau near Le

44

The clairvoyante or the sleep-walker

La voyante ou La somnambule (*48*)

1855?

Canvas: 47 × 39. Signed, dated lower left: ..*65 G. Courbet*.

History: Entrusted by the artist to the Galerie Durand-Ruel, 15 April 1871 to be sold; sequestered by the State; restored to Juliette Courbet; Courbet sale, Paris, 1881, no.12; bought by Elisée Cusenier; bequeathed by Elisée Cusenier to the Musée de Besançon, 1928; entered the museum 1934.

Exhibitions: 1864, Munich; 1866, Amsterdam, no.269; 1866, The Hague, no.87; 1867, Paris, Exposition Universelle, no.172; 1868, Gand; 1873, Vienna; 1882, Paris, no.160; 1935–1936, Zurich, no.24; 1950, La Tour de Peilz, no.10; 1952, Besançon, no.12; 1954, Venice, no.8; 1954, Lyon, no.7; 1955, Paris, no.15; 1957, Paris, no.29; 1958, Munich, no.23; 1968–1969, Moscow–Leningrad, no.77; 1969, Ornans, no.8; 1969–1970, Rome–Milan, no.24.

Bibliography: Silvestre, 1856, pp.273, 278; Toussaint, no.24.

In a letter of 24 April 1867 to Bruyas (Bibliothèque Doucet) Courbet complained that *The clairvoyant* was badly hung at the World Exhibition. He must have had a soft spot for this picture, as he sent it to so many exhibitions – Munich, Amsterdam, The Hague, Ghent, Vienna. As to the date of 1865 which appears on the canvas, either it

45

Blanc in the Indre department. Courbet stayed there in 1852–1856 and presented his host with several paintings of the surrounding countryside. In 1856 he painted Laurier's mother-in-law, Mme Maquet (Stuttgart, Staatsgalerie).

One of Courbet's sayings was: 'Titian is a robber'. As we have seen, he did not always disdain the Italian master: his *Man with a leather belt* (13) was painted after a copy of the *Man with a belt* in the Louvre. In 1877 (*Le Petit Parisien*, 31 October) he wrote of the *Portrait of Laurier*: 'This will be my *Man with a glove*'. What was the point of this allusion; was it some kind of secret shared by Courbet and Laurier, or did the painter really consider himself inspired by Titian on that occasion? Laurier's pose, and the way his face is set off by a thin linen collar over a dark garment, do indeed call to mind the picture in the Louvre, with the important omission of the hand holding the gloves. Before concluding this note we should have liked to re-study the work at Milwaukee. There is something awkward about the composition of the right-hand part of this fine picture. Can it have been altered, either during the original execution or afterwards?

Milwaukee, Wisconsin. Art Center.

46

Bibliography: R. Fernier, 'Gustave Courbet à Besançon' in *A.G.C.*, 1952, no.12, p.13.

is much later than the real date of execution or else the present picture is a repetition. As early as 1856 Silvestre admired *The clairvoyant* in Courbet's studio (*op. cit.*). Estignard mentions two pictures entitled *The sleep-walker*, that in the Cusenier collection (p.184) and a *Study* which still belonged to Juliette Courbet in 1897 (p.188). In our opinion the present work is probably the original, post-dated by several years. The use of chiaroscuro and the blobs of paint laid on close together with the brush-tip, creating a sparkling impression, reflect the influence of Rembrandt on the young Courbet; he no longer painted in this style in 1865. We are, moreover, inclined to regard the picture as a portrait of Juliette, Courbet's youngest sister. Comparing it with pictures and photographs of her we recognize the bulging forehead, the prominent cheekbones, the nutcracker chin and the generally unattractive expression of her rough-hewn features; also the remarkably large, staring eyes. Juliette was born in 1831, and while she looks haggard in the picture she is still young: a woman of thirty-five at that period would have looked older. A final argument bearing on the date is that while magnetism, the occult and similar subjects were popular throughout the nineteenth century, an interest in sleep-walking was at its height in the 1850s. We therefore believe that the picture was painted *c.*1850–1855.

Courbet received a gold medal for it at The Hague in 1868, when it was exhibited with *Dogs fighting over a hare*.

In 1936 an exhibition was held at Amsterdam entitled *French masters of the nineteenth and twentieth centuries* and comprising works owned by the E. J. van Wisselingh gallery. One of these was a *Sleep-walker* by Courbet (no.8, 41 × 39, signed at lower left). We do not know if this was the *Study* formerly owned by Juliette Courbet or a replica.

Besançon, Musée des Beaux-Arts.

46
Rocky landscape near Ornans

Paysage rocheux, environs d'Ornans (49)

*c.*1855

Canvas: 85 × 160. Signed lower right: *G. Courbet.*

History: Ribbentrop coll.; assigned to the Musée du Louvre by the 'Office des Biens privés' (Ministry of Foreign Affairs), 1951.

Exhibitions: 1952, Besançon, no.18; 1954, Venice, no.17; 1954, Lyon, no.19; 1955, Paris, no.27; 1958, Agen, no.10; 1959–1960, Philadelphia–Boston, no.22; 1962, Ornans, no.13; 1964–1965, Munich, no.49.

Robert Fernier identified this landscape with one of Courbet's at the World Exhibition of 1855 entitled *Roche de dix heures* (no.2809), on account of its resemblance to Bertall's caricature of the latter work, captioned *View of Roquefort* and published in the *Journal pour rire* on 3 November 1855. However, the cartoon also bore the legend 'No one could produce a better blue cheese (*persiller le fromage avec plus de goût*) than our great Courbet', and this seems more appropriate to certain other rocky landscapes such as that in *Young ladies of the village* (27) which are traditionally thought to be close by the *Roche de dix heures*. Another, stronger argument against the identification is provided by Théophile Gautier's description of the work of 1855: 'A huge sandstone mass, of silvery hue, casts an abrupt black shadow on a space of bright green turf. Above the rock a corner of blue sky can be seen through the undergrowth' (*Les Beaux-Arts en Europe*, 1855, II, p.155). This does not fit the picture in the Louvre. Moreover Riat, when visiting Ornans in 1902, made a note that 'the *Roche de Dix Heures*, which receives the sunlight at ten o'clock, is above the village beside the *Roche du Mont*' (Bibliothèque Nationale, Estampes, Box VII). This cannot be identical with the site represented here.

Several informants at Ornans have suggested that the present picture represents the valley of Norvaux or that of Valbois, where the Courbet family owned vineyards. These narrow valleys below the plain of Flagey are now covered by trees and vegetation which have altered their appearance, so that it is difficult to recognize them. In the nineteenth century they were bare of trees and were devoted to pasture and wine-growing.

The date of *c.*1855 may well be right, although it is impossible to be certain with Courbet's landscapes, partly because of his habit of post-dating pictures in the year in which they were shown or sold, and partly because his style and technique did not evolve continuously but were subject to constant variation.

Paris, Musée du Louvre.

47

History: Charles de Bériot sale, Paris, 1901, no.42 (*Rochers à Ornans*, repr. in the catalogue); Thébant-Sisson sale, Paris, 1907, no.22; bought by Galerie Durand-Ruel; sold by Durand-Ruel to the Musée de Lille in 1908.

Exhibitions: 1918, Valenciennes, no.79; 1949, London, no.214; 1954, Venice, no.12; 1954, Lyon, no.13; 1955, Paris, no.20; 1962, Tourcoing, no.20; 1969–1970, Rome–Milan, no.13.

These cliffs overlook the Meuse near Dinant, and Courbet is thought to have painted them in 1856, at the same time as the *Roche à Bayard* (47).

Lille, Musée des Beaux-Arts.

49

Young ladies on the banks of the Seine in summer

Les demoiselles des bords de la Seine (été) (52)

1856–1857

Canvas: 174×200. Signed lower left: *G. Courbet*.

History: Acquired from the artist by Etienne Baudry in 1875; returned by Baudry to Juliette Courbet in 1901 to be given to a museum; placed in the Petit Palais by Juliette Courbet 1906.

Exhibitions: 1857, Paris, Salon, no.620; 1860, Brussels, no.174; 1867, Paris, no.8; 1873, Vienna; 1878, Paris, no.19; 1882, Paris, no.10; 1889, Paris, no.207; 1909, Paris, no.32; 1919, Paris, no.27; 1928, Oslo, no.19; 1928, Copenhagen, no. 26; 1928, Stockholm, no.23; 1929, Paris, no.61; 1932, London, no.439; 1935–1936, Zurich, no.41; 1937, Paris, no.276; 1947, Zurich, no.189; 1950, La Tour de Peilz, no.13; 1952–1953, Rotterdam, no.26; 1955, Paris, no.33; 1968–1969, Paris, no. 227; 1969–1970, Rome–Milan, no.12.

Bibliography: Ed. About, *Nos artistes au Salon de 1857*, Paris, 1858, p.148–53; Maxime Du Camp, *Le Salon de 1867*, p.102; Th. Gautier in *L'Artiste*, 1857, II, p.34; Castagnary, 1892, I, p.28–9; Gustave Planche in *Revue des Deux Mondes*, 1857, 3rd quarter, p.396; Proudhon, p.198 ff.; Paul de Saint-Victor in *La Presse*, 4 August 1857; Alphonse van Kamp, *Le Salon de 1860 de Bruxelles*, p.290; Suzanne Kahn and Martine Ecalle, 'Les Demoiselles des bords de Seine' in *A.G.C.*, 1957, no.19, pp.1–17; Pérot, no.12; Bonniot, pp.326–8.

Bruno, 1872, *Isaure et son amie*, p.129.

'If you could only save one painting by Courbet, which would it be?' Most people, faced with this question, would choose the present work, which has something to please everybody: escapists and realists, lovers of tradition and of the new, and lovers of painting altogether. Even its dimensions are attractive: somewhat small-

47

The Roche at Bayard, Dinant

La Roche à Bayard, Dinant (50)

c.1856

Canvas: 55×46. Signed lower right: *G. Courbet*.

History: Félix Gérard sale, Paris, 1905, no.25; F. Hindley Smith coll.; bequeathed by F. Hindley Smith to the Fitzwilliam Museum, Cambridge 1939.

Exhibitions: 1930, London, no.6; 1932, Manchester, no.59; 1936, London, no.28.

In 1850 Courbet wrote to Édouard Reynart, administrator of the Lille Museum, 'I have made two trips through Belgium' (*Arts*, July 1883, p.42). The style of this work suggests that it was painted after 1850. It is generally assigned to 1856, but Courbet visited Belgium so often that it is impossible to be certain.

Cambridge, Fitzwilliam Museum.

48

The Meuse at Freyr

La Meuse à Freyr (51)

1856?

Canvas: 58×82. Signed lower right: *G. Courbet*.

48

er than an easel-painting, it is of manageable size and can be taken in at a single glance.

The picture was begun at Ornans in 1856, finished in Paris and shown at the 1857 Salon, where it created a stir. It set out to recall the pleasures of Parisians and their womenfolk who went for walks or river parties on the Seine on fine Sunday afternoons in summer: Courbet was one of the first to depict these joys that the Impressionists were to paint so often. The theme should have been harmless enough; the pleasures were innocent, and it is a natural part of the painter's task to paint pretty women in attitudes of repose. Nevertheless the work produced an outcry from critics and others who thought it their right or duty to object even if they recognized its pictorial qualities. Théophile Gautier exclaimed: 'Courbet is beating the big drum of publicity to attract the attention of an unheeding crowd.' The word 'crowd' is an exaggeration, but there were no doubt some people who had reason to be offended by the picture or to adopt a

Pecksniffian attitude towards it. We say this for the following reasons.

In the first place, the two women in the picture were doubtless intimately known to many. A likeness of this sort can be embarrassing, especially when one of the figures is in déshabillé. Our contemporaries, lacking a detailed knowledge of the refinements of feminine underwear at this period, are delighted by the women's summery elegance. The woman in the foreground is lightly attired in a chemise, corset and petticoat with a bustle (known, the *Parisien* informs us, as a *jupon-tournure*: Boucher, fig.975, dated 1857). The corset is of twill, and the pink ribbons of the chemise are coming out of the ribbon-holes. In her haste to get rid of her dress, on which she is lying, the young lady has kept on a pair of lemon-coloured gloves, which complete the erotic effect of hér elegant déshabillé.

Proudhon, once again, took on himself to expound Courbet's reasons for painting this picture, viz. to expose the easy morals of kept women. The true title,

according to him, is 'Two young women of fashion under the Second Empire'. Proudhon seems to know the young ladies, at least by reputation, as he describes the moral character of each. The brunette in the foreground is a creature of purely animal instincts. 'She lies full length on the grass, pressing her burning bosom to the ground; her half-closed eyes are veiled in erotic reverie . . . There is something of the vampire about her . . . Flee, if you do not want this Circe to turn you into a beast.' The blonde woman, on the other hand, is chiefly interested in her bank-balance. 'She too indulges fancies, not of love but of cold ambition. She understands business, she owns shares and has money in the Funds . . . Quite different from her friend, she is the mistress of her own heart and knows how to bridle her desires' (*op. cit.*).

This kind of moralizing was very much in Proudhon's style, and he lost no opportunity of striking a blow for virtue. Whether Courbet intended his picture to have a moral is much more doubtful. He had no objection to easy-going young ladies; these two arouse envy rather than pity, and set a bad example to the working class by demonstrating that pleasure-trips on the Seine, rather than days spent at the factory, are the best way to acquire cashmere shawls and other finery. No, Courbet's intention here is far from moralistic; what he appears to be doing, not for the first time, is playing a joke on someone, perhaps in revenge for a snub or repulse of some kind. These ripostes did not always achieve the desired effect, but on this occasion he seems to have struck home. In all the press comment on the picture, not a single line contains even a veiled reference to the dark young lady's state of undress – which, presumably, is why it is not mentioned today either. Yet it was only seven years before the scandal of Manet's *Déjeuner sur l'herbe*, when the liveliest horror was expressed at the depiction of a naked woman and another in her chemise – perhaps more shocking still – in the company of fully-dressed gentlemen. These, however, were studio models and not young ladies who kept their carriage, and who might take umbrage at any suggestion that their toilet left something to be desired. It should be remembered that even at the end of the century a camisole was considered the last word in daring by one of Feydeau's audiences – so evidently Courbet's young

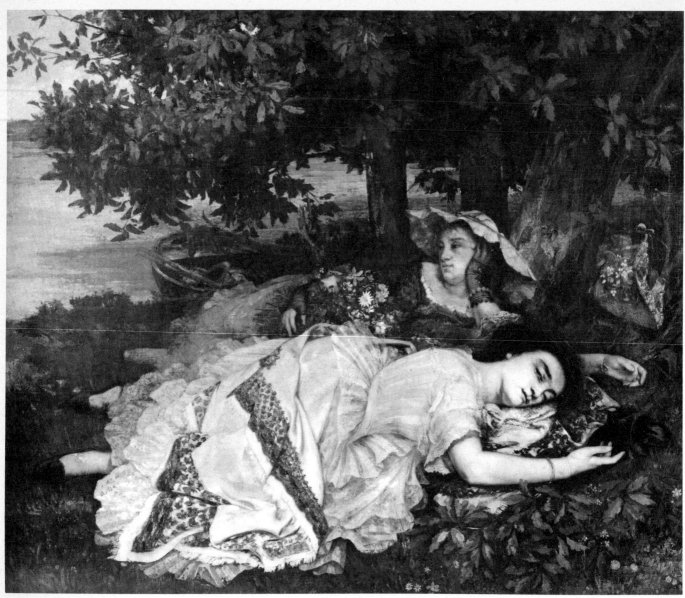

49

woman in her corset was meant to shock, yet there was no overt reaction. True, Castagnary wrote 'The very title is an impertinence'; but he did not explain why, and we have now no means of knowing.

However, the speculation is an idle one. Courbet's taste for mockery caused him plenty of trouble throughout his life but for our part we can afford to ignore such trivialities and simply admire the painting: the feeling expressed in the faces and gestures of the two women, their splendid attire, the flounce as light as a dragon-fly's wing, the sensual cashmere so popular with painters from Gros and Ingres onwards, the sun-bonnet – originally a simple straw hat but now so delicately scalloped; the refined elegance of pearls and mittens; and finally the brilliant landscape, bathed in the torpor and stillness of a summer afternoon.

Everything is concrete and everything abstract in the reinvented world which we seem to behold through the sleepy gaze of the dark young lady. Courbet's genius consists in bringing dreams within our reach and convincing us that they are real. Delacroix's *Women of Algiers* (1834, Louvre) does not require the same participation as Courbet's work; the African shore is an unattainable paradise. Courbet, by contrast, offers us a genuine escape to the banks of the Seine, and this is the supreme achievement of Realism.

Many sources contribute to the wealth of the painting. The foreground resembles a Flemish medieval flowered tapestry, and the bedizened women under the thick green foliage have all the opulence of Venetians by Veronese. There is a reminiscence of Dutch technique in the composition, and the great oval shape in which so much passion is concentrated. Everything is robust and solid; the impasto with its gem-like reflections, the broad sweep of the design that imposes simplicity on the arabesques, and the sculptural weight of the figures which, if closely regarded, appear not to rest on the ground but to be part of a perfectly abstract structure.

Several canvases preceded this picture, but we are not convinced that Courbet painted them with the final work in mind. For the blonde woman we suggest two antecedents: *Woman in a flowered straw hat* (Prague, National Museum, 46 × 55) and *Woman leaning on her elbow* in a meadow, in a scarlet dress, holding a fan and a bunch of flowers (Paris, private collection; former Humbert collection; 90 × 110). These paintings differ considerably from the present one in technique: the pigment is smooth and oily, the colours are bright. For the brunette Courbet used a *Portrait* of a blonde woman in a maroon dress, her right forearm (the only one visible) showing the sleeve of an undergarment (private collection; former Baudry and Stang collections; 66 × 91).

Juliette Courbet possessed a sketch of the entire work, which was apparently destroyed in 1940. Another painting of the whole composition, with some variants (also from the Juliette Courbet collection), is in the National Gallery, London (96 × 30); it has been called in question by several critics.

A drawing in the Lyons museum entitled *Women in a cornfield*, dated 1855, is unrelated to this picture.

The work was the subject of a wrangle between Juliette Courbet and Étienne Baudry, who came into possession of it in 1875. After her brother's death Juliette called Baudry to account, for reasons that are difficult to fathom. Perhaps Courbet made a gift of the work to Baudry in return for the latter's patience and generosity over a period of ten years and his timely help after Courbet's prosecution. At all events Juliette, having inherited her brother's estate, expressed anxiety to her business agent on the subject of payments due from Baudry. She professed the intention of founding a Courbet museum at Ornans and, with the irrationality of her family in business matters, seemed to think that the works in Baudry's possession were hers by right. In 1890 she managed to get him to surrender the *Lady of Frankfurt* (54; now at Cologne), which he had bought and paid for, for the prospective museum; then, as she continued pestering, he sent her the present work in 1901. Hearing nothing more of the museum project, Baudry made enquiries of the mayor of Ornans in 1906. By that time Juliette had quarrelled with her fellow-townsmen and given up the idea, but Baudry's enquiry prompted her to present the picture to the Petit Palais; she sent him a laconic telegram to this effect on 6 May. Curiously enough, Baudry's part in the gift received no official recognition: the prefectorial decree of 4 August 1906 speaks only of Juliette as the donor (Bonniot, pp.326–8).

Among modern painters, Courbet's work inspired Soutine in 1932 (Soutine exhibition, Paris, 1973, no.66) and Picasso in 1950.

Paris, Musée du Petit Palais.

50
The quarry, a deerhunt in the forests of the Grand Jura

La curée, chasse au chevreuil dans les forêts du Grand Jura (53)

1857

Canvas: 210 × 180. Signed lower right: *G. Courbet.*

History: Acquired from the artist by M. van Isacher, Anvers (1858?); acquired from the previous owner by Galerie Cadart et Luquet (1862?); bought from the previous owner by the Allston Club, Boston, in April 1866; bought from the Allston Club by Henry Sailes of Boston, c.1877; deposited by Henry Sailes at the Museum of Fine Arts from 1877 to 1889; inherited by G. C. Francis in 1918; bought from G. T. Francis by Museum of Fine Arts 1918.

Exhibitions: 1857, Paris Salon, no.621; 1857, Brussels, no.1265 (*La curée dans les forêts de sapins du Grand Jura, Doubs*); 1858, Frankfurt-on-Main; 1860, Paris, no.125; 1862, Besançon, no.99 (property of M. Luquet); 1863, Paris, no.80; 1866, Boston, no.1; 1867, Boston, no.1; 1868, Boston, no.1; 1868, 1869, 1870, 1871, Boston, The Athenaeum, 'Annual Exhibition'; 1871–1872, Boston; 1897, Boston, no.14; 1903, Boston, no.61; 1919, New York, no.10; 1929, Cambridge, no.14; 1940, New York, no.261; 1959–1960, Philadelphia–Boston, no.28.

Bibliography: Bruce MacDonald, 'The Quarry by Gustave Courbet' in *Bulletin, Museum of Fine Arts*, 1969, no.348, pp.52–77; Forges, 1973, no.53.

The Salon of 1857 was one of those to which Courbet submitted two or three major works: *Young ladies on the banks of the Seine* (49), *Doe lying exhausted in the snow* (former Douville-Maillefeu collection), *Portrait of Louis Gueymard* (51) and the present painting.

It is a somewhat enigmatic work. Courbet himself appears in it, with a pipe in his mouth and a mocking smile, but he remains in half-shadow with folded arms and seems detached from the scene. The title (curée, i.e. the feeding of the deer's entrails to the hounds) also seems to be a misnomer. What we see is a solitary huntsman, a horn-blower, two hounds who show more interest in each other than in the deer

they are supposed to have run down, and a buck suspended by one leg in an attitude quite unlike that of an exhausted animal that has just been dispatched.

The composition, in itself a fine one, consists of a juxtaposition of realistically handled themes, combined in an arbitrary grouping with a suggestion of allegory. Bruce MacDonlad (*op. cit.*) gives an elaborate account of the picture as a 'patchwork' consisting of the deer on the left, the two hounds on the right and, at the top, a piece of canvas on which the horn-blower is depicted.

A picture of *Hounds* resembling these, and a precisely similar one of a *Dead buck*, belong respectively to two other museums.

The former, undated, in the Metropolitan Museum, New York, shows the same two animals with a dead hare, on a canvas of horizontal shape. We know that Courbet painted such a picture at Frankfurt in 1858, i.e. after *The quarry*: it is described in a letter from the painter Schoelderer to Fantin-Latour (Léger, 1948, p.69). It may, however, have been a repetition of a previous work, painted for a German customer: replicas of 'commercial' paintings are frequent in Courbet's œuvre.

The painting in the Metropolitan Museum depicts a plausible scene with two dogs about to fight over the carcase of a hare which the huntsman has shot; this, however, is quite different from a *curée*. Charles Sterling and Margaretta Salinger point out that the picture recalls paintings of hounds by Desportes or Oudry, the composition of which has been imitated by Courbet. There is nothing mysterious about such a work, and the lower right-hand part of *The quarry* probably consists of a truncated picture of this kind.

The *Dead buck* in the Mesdag Museum at The Hague, which bears the date 1858, is a fine work by Courbet, of the kind for which he used carcases bought from the game-merchants of the rue Montorgueil; and it is either a repetition or the original – since one can never trust Courbet's dates – of the left-hand part of *The quarry*. The latter was completed by adding the figure of Courbet himself and the horn-blower in the space above the hounds.

The quarry was almost unanimously praised by critics of the Salon and was a popular success. Champfleury seemed to regret this when he wrote in 1861: 'The

Buck, which was a great success at the Salon and at the private show in the boulevard de Italiens, came as a reassurance to timid souls who, seeing only a dead animal in a landscape and no longer frightened by human figures, tried to encourage the artist to follow a sideline' (Lacambre, 1973, pp.183–4).

The quarry was Courbet's first big hunting picture and ushered in a longish series of commercialized 'Woodland scenes' featuring bucks and does, both living and dead, for which there was a growing demand. Most of them fall far short of the quality of the present work; they are the weakest part of Courbet's output, along with the landscapes of his latter years.

We do not think Courbet improved *The quarry* by adding pieces of canvas at the top and on the left, where the joins are still visible. He did so at the instance of the dealer Luquet, who owned the work from 1862, and who thought the composition needed more 'air': as it was, the huntsman's head was level with the top of the picture. The pictures by Courbet that are most admired today are those in which the figures fit closely within the overall format – for instance, *The German huntsman* (57), *The trellis* (67) or the *Portrait of Proudhon* (80) – in a style that derives from seventeenth-century Holland and was successfully adopted by British artists in the eighteenth century; this gives a density to the composition which harmonizes well with Courbet's robust craftsmanship.

Margaret (Paul) Robinson suggests that Courbet painted himself from a photograph in which he is leaning against a trellis (cf. B. MacDonald, *op. cit.*), but Marie-Thérèse de Forges thinks this doubtful. The photograph, she believes, is later than the painting (1861?), and Courbet appears older in it (*op. cit.*, p.43).

The quarry was Courbet's first work to cross the Atlantic; it was followed by many others.

In a note now in the Bibliothèque Nationale (1872–1873?) Castagnary told Courbet that a 'bogus *Quarry*' had been on the market; it was no doubt painted from Vernier's lithograph (Estampes, Box VII).

The buck is reproduced by itself in a small canvas with the annotation 'L'ami Cluseret' (Paris, Petit Palais). This was executed in Switzerland, where Courbet gave painting lessons to his fellow-exile General Cluseret (1823–1900). The Gen-

eral, like Courbet, had been sentenced by the Conseil de Guerre for joining the Commune, and the stricken animal could be regarded as a symbol of his fate.

A slightly larger, somewhat theatrical composition entitled *After the hunt* painted by Courbet at an unknown date, is in a similar style to *The quarry* (New York, Metropolitan Museum of Art).

Boston, Museum of Fine Arts.

51
Portrait of Louis Gueymard

Portrait de Louis Gueymard (54)

1857

Canvas: 148 × 106. Signed, lower left: *G. Courbet.*

History: Sale, Paris, 19 January 1872, no.23 (unknown vendor, perhaps Gueymard?); Adolphe Reignard coll., Paris (indicated from 1878–1896); given by Elizabeth Milbank Anderson to the Metropolitan Museum in 1919.

Exhibitions: 1857, Paris Salon, no.624 (*Portrait de Gueymard, artiste de l'Opéra dans le rôle de Robert le Diable 'Oui, l'or est une chimère'*); 1878, Paris, no.35; 1882, Paris, no.18; 1919, New York, no.8; 1938, Baltimore, no.3; 1951, Winnipeg.

Bibliography: Silvestre, 1856, p.278; Sterling, Salinger, p.113.

The only information we have as to the date of this painting is that Théophile Silvestre saw it in an unfinished state at Courbet's studio in 1856 (*op. cit.*). It was shown at the Salon in the following year.

The singer Louis Gueymard (1822–1880) made his début at the Opéra in 1848 in the title-role of Meyerbeer's *Robert the Devil*, composed in 1831. He was one of the most famous interpreters of the part, and no doubt himself chose to be depicted in a scene from the opera. He is seen dicing with soldiers and singing '*Oui, l'or est une chimère*'; behind him is Bertram, his father and evil genius.

Some critics find the painting ridiculous, but it shows great skill in distinguishing Gueymard's natural expression from the others who are merely 'acting', and in rendering the various poses, costumes and décor. The spectator at once perceives what is true to nature and what is artificial and contrived.

51

Exhibitions: 1867, Paris, no.87 (*Mme M...C...* [1857]; 1873, Vienna; 1882, Paris, no.163; 1907, Paris, no.63; 1919, New York, no.9.

Bibliography: Sterling-Salinger, pp.115–16.

Until recent times this work has been catalogued and described under the title *Portrait of Mme Marie Crocq*. The name is correctly spelt in Dr Blondon's papers (Besançon Library), but this was lost sight of until 1967, when the sitter's great-grandson wrote to the Metropolitan Museum, to whom we are indebted for permission to reproduce the text: 'My great-grandmother's correct name was Mme Cuoq . . . The painting was identified once and for all by my father at the Bagatelle exhibition in 1907. My mother always kept two pages from *L'Illustration* of June 1, 1907, on which my father wrote beneath a reproduction of the work "Portrait of my grandmother Cuoq by Courbet". My great-grandmother, née Mathilde Desportes, was born in Paris on May 31, 1827. She married Auguste Cuoq in 1838 and died in Paris in 1910. She was thus still alive when my father identified the portrait at Bagatelle. Her father-in-law was a parliamentary representative for the Haute-Loire . . . her mother, Joséphine Hendricks, was Dutch, and her grandmother was lady-in-waiting to Queen Hortense, wife of Louis Bonaparte, king of Holland . . . The tradition is that my great-grandfather did not like the portrait and refused to accept it; he did the same in the case of another painter, Henner . . .'

The difficulty of pleasing the husband, and his insistent demand for a masterpiece that would represent his wife as she really was, or as he saw her, must have lingered in the memory of Courbet and his friends. The following passages by two of his contemporaries may, we suggest, be related to this portrait, though their subject has not hitherto been identified with certainty.

Francis Wey writes: 'An unknown couple turned up, the wife so beautiful that we were astonished . . . Looking at Courbet who had turned pale, the young man went on to say that four famous painters had done portraits of her but had not succeeded in satisfying him. Courbet asked her to sit in the armchair on the dais. He painted her portrait four times on as many canvases, reverting to them every now and then; this

For some years it had been the fashion to photograph actors in costume, in scenes from plays in which they appeared, with the décor more or less accurately imitated. One photographer who specialized in such portraits was Vallou de Villeneuve (Bibliothèque Nationale, Estampes, deposit of 1853). Courbet's picture is in a similar style; the accessories were no doubt borrowed from a costumier.

Courbet yielded to the temptation of painting a *Self-portrait* in which he is wearing the same helmet as the soldier leaning against the table. It does not appear, however, that he painted the soldier with his own features (Forges, 1973, p.43).

New York, Metropolitan Museum of Art.

52
Portrait of Mathilde Cuoq, née Desportes

Portrait de Mathilde Cuoq, née Desportes (55)

1857

Canvas: 176 × 108. Signed lower right: *G. Courbet.*

History: Deposited by Courbet at Galerie Durand-Ruel, February 1873 (*no.20, Portrait de Mme Cuoq, grandeur naturelle, en pied, cadre,* 175 × 108); Juliette Courbet coll., Courbet sale, Paris, 1882, no.17; sale in Brussels 1891 (Estignard dixit); Mme. de V. sale (Vermeulen de Villiers), Paris, George Petit, 6 May 1909, no.38 (*La Femme à la main gantée*); acquired by H. O. Havemeyer, New York, 1909; bequeathed to the Metropolitan Museum by Mrs. H. O. Havemeyer, 1929.

52

53

went on for two years' (Bibliothèque Nationale, Estampes).

Champfleury wrote, in *Grandee figures d'hier et d'aujourd'hui*: 'I saw in his studio the portrait of a charming woman which had remained unfinished for four years and will doubtless never be completed. By exhibiting it Courbet would have shown that he understood the charm and elegance of a Parisian face; but the model's fussiness over clothes, which she changed from each sitting to the next, and the incessant advice of relatives and friends, who kept suggesting a sofa instead of an armchair or a garden setting instead of an interior, tired him out so that, being unable to work freely, he turned the canvas to the wall until such time as the sitter should

behave more obediently' (1861; repr. in Lacambre, 1973, p.180).

Courbet must have finished the work for his own satisfaction, and showed it at his exhibition at the Pavillon de l'Alma with the date 1857. But we may gather from the above quotations why the portrait is in a different style from the rest of his work. It was doubtless at the insistence of Cuoq and his wife that she was painted in the attitude usual in fashionable photographs at the time: the full-length pose on a dais, the period furniture and the subject's affected manner are features that we do not encounter in any other portrait by Courbet.

New York, Metropolitan Museum of Art.

53
Portrait of Madame de Brayer called the Polish exile

Portrait de madame de Brayer dit L'exilée polonaise (56)

1858

Canvas: 91 × 72. Signed, dated lower right: *G. Courbet . .58.*

History: Acquired from the artist by the Brayer family, Brussels; bought by Mary Cassatt on behalf of the Havemeyer coll., New York; bequeathed by Mrs. H. O. Havemeyer to the Metropolitan Museum, 1929.

Exhibitions: 1858, Brussels; 1921, New York, no.25; 1930, New York, no.26; 1934,

54

Chicago, no.178; 1937, Paris, no.278; 1951–1952, Detroit; 1959–1960, Philadelphia–Boston, no.34.

Bibliography: Sterling-Salinger, pp.118–119.

According to tradition this work, painted by Courbet on a trip to Brussels, is the portrait of a young Polish exile married to a Belgian, M. de Brayer, of whom nothing else is known.

Mary Cassatt chose it as a present for her friend Louisine-Henry Havemeyer, who wrote to Théodore Duret that it was a 'very fine canvas' (Léger, 1948, p.192). The work is one of Courbet's finest portraits, recalling Bronzino and the noble portraitists of the Renaissance; the sitter, in her aristocratic gravity, is portrayed with tender comprehension. Mrs Havemeyer speaks in her memoirs of the admiration Degas expressed for the portrait when he saw it in Brussels.

New York, Metropolitan Museum of Art.

54
The lady of Frankfurt

La dame de Francfort (57)

1858

Canvas: 104 × 140. Signed lower left: *G. Courbet.*

History: Stolen from Courbet, passage du Saumon, 1871; found by Etienne Baudry, 1873, at a picture dealer's, Rue Neuve-St-Augustin; Etienne Baudry coll., Saintes; given by Baudry to Juliette Courbet, 23 May 1890; bequeathed by the previous owner to Mme de Tastes; Courbet estate sale, Paris, 1919, no.4; Jakob Goldschmidt coll.,

Berlin–New York; H. W. Lang sale, Berlin, 1941; Goldschmidt coll.; given by previous owner to the Wallraf-Richartz Museum.

Exhibitions: 1867, Paris, no.125; 1919, Paris, no.27; 1921, Basel, no.37; 1929, Paris, no.34; 1930, Berlin, h.c.; 1935–1936, Zurich, no.48; 1950, Cologne, no.34; 1954, Essen, no.18; 1959–1960, Philadelphia–Boston, no.32; 1962, Berne, no.17; 1969–1970, Rome–Milan, no.14.

Bibliography: Hans Voss, *Courbet, der französisches maler in Frankfurt*, Frankfurt, 1958, pp.18–20; id. translated from the German by Nicole Fermier in *A.G.C.*, no.21, 1958, pp.9, 10; Toussaint, no.14.

Bruno, 1872, *La directrice de la banque noire*, p.89.

This picture, also called *A German lady* or *Lady on a terrace*, represents the wife of a banker at Frankfurt-on-Main; historians disagree as to whether it is Frau Erlanger or Frau Goldschmidt. Courbet's stay in Frankfurt from autumn 1858 to February 1859 was among the most triumphant periods of his life. His friend Carjat, the photographer and caricaturist, was a guest of Erlanger's, and it was no doubt through him that Courbet was introduced to local society, where he enjoyed a great success.

We have no detailed information on the execution of this painting, in which several afterthoughts are visible. The railing formerly extended to the extreme right of the picture, and the steps at the edge of the terrace were added when the alteration was made. Behind the tea-table can be seen the shadow of a man, now replaced by the temple in the park.

In its present form the picture gives an impression of poetic unreality; perhaps romantic Germany revived the emotions of Courbet's youth. At all events the vision is a happy one. Each separate element of the composition is real, yet the ensemble has a dream-like quality which a more surrealistic work might not have achieved. The woman's faraway gaze and the stillness of the dog's attitude give the effect of magic spell, enhanced by the russet and bluish tones of the colour-scheme.

An unsigned note (by Pata?) in the Cabinet des Estampes of the Bibliothèque Nationale states that the 'Lady with the sherbet', as Courbet liked to call her, was exhibited at the Trocadéro (i.e. no doubt the Pavillon de l'Alma) but was not signed until 1877, when the artist was in Switzerland; it was brought for the purpose by Etienne Baudry, who visited his friend at La Tour de Peilz.

From 1899 onwards Juliette Courbet pestered Baudry to make over the picture to her. She wrote letter after letter (private collection, Bordeaux) saying how much her brother had loved the painting and how anxious she was to unite it with others in a collection to be bestowed on a French museum. Baudry gave way to her insistence on 23 May 1890. Later Juliette bequeathed the work to Mme de 'l'astes, the friend of her old age, who had it sold at auction.

Cologne, Wallraf Richartz Museum.

55
Woman resting

Femme couchée; le repos (58)

1858

Canvas: 51×64. Signed and dated lower left: *..58 Gustave Courbet*.

History: Desfossés sale, Paris, 1899, no.21; Ernest Cognacq coll., Paris; Gabriel Cognacq sale, Paris, 1952, no.35; bought at the Cognacq sale by Marlborough Fine Art, London; private coll., London.

Exhibitions: 1910, Paris, no.30; 1923, Paris, no.176; 1937, Paris ex-catalogue; 1937, Paris, Rosenberg, no.8; 1953, London, no.5.

This is one of the most delightful specimens of the class of small nudes or 'boudoir paintings' that are sought after by picture-lovers and which distantly carry on the tradition of Giorgione and Titian. Besides Courbet, Delacroix and the young Millet were the chief romantic exponents of the genre.

The present painting is one of Courbet's first works of this kind. It was followed by many others of similar inspiration, in which the painter's lyric gift imparted to a stuffy alcove the freshness of a landscape. The last of them, the *Lady of Munich* (1869, former Hatvany collection), had the unhappy distinction of being summarily rejected by the judges of the 1872 Salon.

London, private collection.

55

56

56 (L)
View of Ornans, with the bell tower

Vue d'Ornans au clocher

c.1856–1859

Canvas: 50·5 × 61. Signed lower left: *G. Courbet.*

History: A. Daber coll.; A. Tooth and Sons, London; Mrs A. E. Pleydell-Bouverie.

Exhibitions: 1949, Paris, no.7; 1954, London, Tate Gallery, the Pleydell-Bouverie coll., no.12; 1955, Paris, no.37.

Bibliography: *A.G.C.* 6; Mack 154, repr.

Comparison with a photograph taken in 1949 by Alfred Daber (reproduced alongside the picture, plates 31 and 32 in Mack) shows how little Courbet felt it necessary to adapt the natural language for the composition of his painting. A.B.

Private collection.

57
The German huntsman

Le chasseur allemand (59)

1859

Canvas: 118 × 174. Signed, dated lower left: *. .59 Gustave Courbet.*

History: Sold by the artist to Jean Paul Mazaroz, manufacturer of Lons-le-Saunier in 1863; given by Mazaroz to the Musée de Lons, 13 July 1886.

Exhibitions: 1860, Besançon, no.309; 1861, Metz, no.1109; 1882, Paris, no.17; 1935–1936, Zurich, no.50; 1939, Ornans, no.23; 1969–1970, Rome–Milan, no.15.

57

Bibliography: Castagnary, *Courbet* in *Le Boulevard*, 7 June 1863; G. Delestre, *Courbet à l'Exposition universelle de Besançon en 1860* in *A.G.C.*, 1960, no.26, p.15.

This picture, painted during Courbet's stay in Germany in 1858–1859, is also known as *The Baden huntsman* or *The dying stag*. Courbet was himself a keen sportsman and his letters related in full detail his exploits in Germany, such as the shooting of an old ten-point stag. Dead or alive, this celebrated beast is commemorated in several of his works, the best-known being *Fighting stags* (Louvre).

The present painting shows a powerful naïveté, a blend of imagination and coarseness, which strikes some as vulgar. The craftsmanship is outstanding, the composition original, and the popularity of the work was attested by the award of a silver medal at the Metz exhibition of 1861.

As in *Fighting stags*, the scene is set in a forest with a clear brook running through it. The huntsman is probably a sporting companion of Courbet's whose name has not come down to us.

We have little information about Courbet's contacts during his stay in Germany. One of the most important pictures dating from this time is the *Hunter's meal* or *Picnic*, now in the Cologne museum. That work, of imposing size (207×325), may be considered a modern version of Carle Van Loo's *Hunters' rest* (Louvre), combining an allegory of trophies of the chase with a realistic grouping of figures which suggests a family portrait, and which displays feminine costume with all the elegance of a Second Empire fashion-plate.

The German huntsman resembles a much later painting by Manet, *Portrait of M. Pertuiset*, in which the hero has just shot a lion (1881, São Paulo Museum).

Lons-le-Saunier Museum.

58

The first version was painted at Ornans during the winter of 1859–1860; Courbet painted few portraits and figures at that time, as he was chiefly occupied in finishing off the large hunting scenes that he had brought back from Germany.

The mirror held by the alluring brunette is the same one as Courbet, five years later, placed in the hand of the red-headed Jo Heffernan. Thus the work is a kind of prefiguration of *The beautiful Irish girl* (87), but in a quite different spirit.

Private collection, on loan to the Kunstmuseum, Basle.

59

Dead fox hanging from a tree in the snow

(60) *Renard mort suspendu à un arbre dans la neige*

1860–1865

Canvas: 133 × 100. Signed, lower left: *G. Courbet.*

History: Georges Menier coll., Paris (1929); Alfred Daber coll., Paris; Grace and Philip Sandblom coll., Lund, Sweden; given by the previous owners to the Nationalmuseum, 1970.

Exhibitions: 1929, Paris, no.122; 1954, Paris, no.10; 1955, Paris, no.51; 1958, Paris, no.12; 1959, Copenhagen, no.11; 1962, Berne, no.42.

On several occasions Courbet effectively portrayed the contrast of a fox's tawny fur seen against snow. His first important work of this kind was *Fox in the snow* in the 1861 Salon (no.720; private collection); *Fox caught in a trap* in the Tokyo Museum of Western Art is, in our opinion, a late work. The present fine painting may, we believe, be dated between 1860 and 1865.

Stockholm, Nationalmuseum.

61

Portrait de Mme Robin called 'The grandmother'

(63) *Portrait de Mme Robin dit La grande-mère*

1862

Canvas: 92 × 73. Signed and dated, lower left: ..62 *G. Courbet.*

58
Woman with a mirror

La femme au miroir (Addendum p.230)

1860

Canvas: 64 × 54.

History: Former private coll., Berlin.

Exhibitions: 1860, Brussels, no.176(?); 1930, Berlin, no.31; 1931, Paris, no.17; 1935–1936, Zurich, no.53; 1938, Amsterdam, no.68.

Bibliography: W. Burger, *Exposition générale des Beaux-Arts à Bruxelles* in *Gazette des Beaux-Arts*, 15 October 1860, p.96.

Courbet sent four pictures to the Brussels Exhibition in 1860. The critics were unanimously hostile to *Young ladies on the banks of the Seine* (49), but were captivated by *Woman with a mirror*. Thoré-Burger's description of the latter (*op. cit.*) corresponds to the present work; it is not certain that they are identical, however, as Courbet, describing his success to Champfleury, wrote: 'I have had commissions for two others like it, and they are nearly finished.'

Thoré-Burger declared that: 'the flesh tones are of rare subtlety and recall the work of the greatest colourists, even Correggio ... *Woman with a mirror* is having a profound effect on the group of young artists in Brussels who are interested in new developments of every kind' (*op. cit.*).

What particular novelty did Thoré-Burger have in mind? As he himself points out, the technique belongs to an old tradition; as to the theme, it is somewhere between a portrait and a graceful fantasy of an amatory kind, akin to romantic works by such painters as Claude and Édouard Dubufe or Eugène Devéria. Courbet, it is true, introduces a sensual element that is not found in their pictures; his touch is lively and spontaneous, and the treatment of the chemise is especially charming. As to the picture's appeal to young Belgian painters, there is perhaps an echo of this in Louis Dubois's *La roulette* (1860, Brussels, Musées Royaux des Beaux-Arts), which shows a similar blend of scumbling and impasto and resembles Courbet's work in its warm colouring.

59

61

Still life with poppies and skull

Nature morte aux pavots et au crâne (64)

1862

Canvas: 36 × 29. Inscribed, signed lower left: *à P.G., G. Courbet.*

History: Offered by the artist to his friend Phoedora Gaudin, in 1862 at Saintes; Durand-Ruel coll., Paris; Moderne Galerie Thannhauser, Munich; The Topstone Fund Foundation, New York; sold by the previous owner at New York 10 March 1971, no.25; Wildenstein Gallery, New York.

Exhibitions: 1963, Saintes, no.93; 1863, Bordeaux, no.159.

Bibliography: Gruet, p.25; Bonniot, p.85, fig.14.

In May 1862 Courbet went to stay at the château of Rochemont near Saintes, the home of his friend Ètienne Baudry. Having intended to remain in Saintonge only a few days he eventually stayed for a whole year, and paid a further visit of a few weeks in the summer of 1863 (cf. Bonniot).

During his stay Courbet painted an exceptional number of flower pieces. He had always been interested in flowers, as is shown by the bouquets that figure in his compositions and portraits – *Sleeping blonde* (20), *The spinner* (29), *Mère Grégoire* (43) – and by an occasional piece such as the Hamburg *Bunch of flowers*; but in Saintonge this developed into a real 'vocation'. In May 1863 he wrote to his friend the architect Isabey: 'I am coining money out of flowers' (Bonniot, p.280). He did not show a comparable interest in flower painting again until his imprisonment in 1871–1872, when he was allowed fruit and flowers but not human models.

Many reasons may be suggested for his sudden development of interest at Saintonge. Although of 'independent' mind, he was always much influenced by his surroundings. Baudry, his host, was an enthusiast for gardening and botany; he owned magnificent conservatories, and believed in the virtue of plants and herbs (Bonniot, p.41). The library at Rochemont may well have contained books on this subject and on plant symbolism, a subject we shall encounter apropos of the *Basket of flowers* at Glasgow (66).

The present work, with all its poetic realism, is also primarily symbolic. It is a

History: Offered by the artist to the Robin family in 1862; Mme Bally coll., Paris, daughter of the sitter, until 1937: Germain Seligman coll., New York; Galerie Jacques Seligman, New York; acquired from the previous owner by the Minneapolis Institute of Arts, The William Hood Dunwoody Fund.

Exhibitions: 1802, Paris, no.46 (*La grandmère*); 1940, New York, no.262; 1948–1949, New York, no.18; 1950, Detroit, no.103; 1954, Saint-Paul; 1954, Baltimore; 1959, Houston; 1959–1960, Philadelphia–Boston, no.37; 1973, Los Angeles; 1973, Minneapolis.

Bibliography: 'A portrait by Courbet', in *The Bulletin of the Minneapolis Institute of Arts*, **2** March 1940, pp.42–44, repr.; Bonniot, 1973, p.214.

M. Bonniot has kindly furnished us with some unpublished details concerning the execution of this fine portrait and the identity of the sitter, Mme Robin.

During his first years in Paris, Courbet made friends with a student named Gustave Robin, whose father, an importer of wine from the West Indies, was of an old Paris family. The painter, when short of cash, accepted a loan from his friend; finding repayment difficult he offered instead to paint a portrait of his mother, whom he thought a woman 'of great character'. Thus it was that Mme Robin, née Anika Psalmon and of Greek extraction, sat for Courbet at her home in the rue Chanoinesse in Paris, in a house that has disappeared.

Minneapolis Institute of Art.

Vanitas addressed to a colourful personality, the lawyer Phoedora Gaudin. Gaudin was the local head of the republican opposition under the July Monarchy; under the Second Republic he was assistant commissioner for the Charente Inférieure and, in April 1848, became a deputy to the Constituent Assembly. He ceased to be active in politics in 1862, but was kept under strict police supervision (Bonniot, p.45). His opinions were calculated to appeal to Courbet, as was his taste for the arts and his interest in mysticism, symbolism and the occult. Altogether he may well have been partly responsible for the rich and unexpected development of Courbet's art during his stay at Saintes.

The two small allegorical paintings done by Courbet at Gaudin's request are now separated. The present one depicts poppies and some marigolds (French *soucis*) standing in a skull from which the top has been removed and which rests on a legal volume; in the catalogue of the exhibition at Saintes it was captioned: 'Death conquers law, and poppies still the cares (*soucis*) of life'. The companion picture of *Marigolds* (former Sacha Guitry collection) bore the motto 'Cares wither (*effeuillent*) the roses of life'. It is said that Courbet wrote these mottos with his own hand on the back of each canvas; this cannot be verified in the present case, as the picture has been remounted.

Paris, private collection.

63
Undergrowth at Port-Berteau; children dancing

Dessous de bois à Port-Berteau, la ronde enfantine (65)

1862

Canvas: 67 × 52. Signed lower left: *G. Courbet.*

History: Baudry coll., Saintes(?); bought in Switzerland by Tooth & Son, London, 1951; bought the same year by The Very Reverend E. Milner-White, CBE, DSO, Dean of York, and given in memory of his father to the Fitzwilliam Museum, 1951.

Exhibitions: 1863, Saintes, no.109 (*Dessous de bois, Port-Berteau*); 1951, London, Tooth, no.13.

Bibliography: G. Delestre, *Courbet et Corot à Saintes* in *A.G.C.*, 1961, no.27, p.4, repr.; Bonniot, p.104.

62

63

64

Gaston Delestre (*op. cit.*) perceptively compared this with a painting of the same title by Corot (Robaut, no.1280; Belgrade Museum). Corot and Courbet were both in Saintonge in 1862, and from time to time used to set up their easels an 'race' each other in painting the same landscape. Duret (p.59) mentions two scenes painted in this way: a *View of Saintes* (Corot's is in the Liège muséum, Courbet's in a private collection) and a *Rabbit-hole*. The latter might be a suitable sub-title for the present work, which is the best example of the two artists' competition.

Corot and Courbet painted exactly the same landscape; Corot's version is animated by a single figure, said to be the wife of the local painter Auguin, while Courbet introduced some children in a round game and a young woman in a light-coloured dress who may likewise be Mme Auguin.

Riat adds that Courbet's *Rabbit-hole* became the property of Ètienne Baudry (Riat, p.199).

Cambridge, Fitzwilliam Museum.

64
Forest

Forêt (66)

1862

Canvas: 57 × 73. Monogram, dated lower right: *..62 GC.*

History: Offered by the artist to the Bordeaux painter, Hippolyte Pradelles, during a visit they made together to Port-Berteau, Saintonge, in 1862; by descent to the present owner.

Exhibition: 1863, Saintes, no.165.

Bibliography: Gruet, p.21; Bonniot, p.171, fig.37.

In the late summer of 1862 Courbet left Rochemont, the home of his friend Étienne Baudry, and went to stay for a few months in a nearby hamlet, Port-Berteau, a few miles below Saintes on the banks of the Charente, where this scene was painted. The local artists Hippolyte Pradelles and Louis-Augustin Auguin accompanied Courbet at this time and profited by watching him at work.

Bordeaux, private collection.

65
The dream, portrait of Gabrielle Borreau

La rêverie, portrait de Gabrielle Borreau (67)

1862

Canvas: 63 × 77. Signed, dated lower left: *G. Courbet ..62.*

History: Théodore Duret coll.; Larcade coll.; Mlle Sée coll.; Galerie Paul Rosenberg et Bernheim-jeune; Alphonse Kann coll. (1931).

Exhibitions: 1863, Saintes, no.166 (*La rêverie*); 1906, Paris; 1917, Zurich, no.69; 1922, Paris, no.30; 1929, Paris, no.18; 1937, Paris, Rosenberg, no.12; 1938, London, no.9; 1960, Copenhagen, no.9; 1962, Paris, no.10; 1962, Berne, no.24; 1969–1970, Rome–Milan, no.17; 1975, Paris, no.6.

Bibliography: *L'Exposition de Saintes* in *L'indépendant de la Charente Inférieure*, 31 January, 3 February 1863; Pierre Conil, *L'Exposition de Saintes* in *Le courrier des Deux Charente*, 19 February 1863; Gruet, pp.25–26; Toussaint, no.17; Bonniot, p.216, fig.51.

This was formerly believed to be a portrait of Courbet's mistress Mme Borreau, but it is now known to be her daughter; this was proved by Roger Bonniot's researches into Courbet's life at Saintes, which he kindly communicated to us on the occasion of the Rome exhibition in 1969.

Louise Laure Zoïde Borreau, born in 1848, was known as Gabrielle after a sister who died in infancy; Courbet gave her the pet-name Briolette. She is seen here at the age of fourteen, with the self-satisfied, sly and somewhat tart expression that is not infrequent in young girls. However, the painting is eminently romantic and is a kind of hymn to adolescence, with an inner illumination recalling some 'opulent' portrait by a Renaissance artist. The rich pigment, the elegant costume and the bright sunset show that Courbet lavished on his young friend all the resources of the great Venetians. The work was suitably praised by the critics when it was shown, freshly completed, at the Saintes exhibition.

In 1869 Courbet used the same pose, in reverse, for a picture of an unknown model entitled *Gipsy reverie* (Tokyo, National Museum of Western Art). The pose, often imitated by artists, is that of the *Portrait of a young man* in the Louvre, formerly attributed to Raphael but now to Parmigianino (cf. 39).

The Borreau family moved to Paris shortly before the war of 1870; Gabrielle

visited Courbet in prison at Sainte Pélagie, and he gave her a small panel picture of *Flowers*. At her death this work was presented anonymously to the French State; it was transferred to the Ornans museum, where it now is.

Paris, private collection.

66
Basket of flowers

Fleurs dans un panier (69)

1863

Canvas: 75 × 100. Signed, dated lower left: *. .63 Gustave Courbet.*

History: Bignou coll., Paris; sold by the previous owner to Alexander Reid, Glasgow, March 1924; re-sold the same day to D. W. T. Cargill, Lanark, Scotland; offered to Glasgow Art Gallery by the executors of the estate of D. W. T. Cargill, 1950.

Exhibitions: 1927, Glasgow, no.9; 1930, Paris, no.5; 1932, London, no.351; 1954, Venice, no.20; 1954, Lyon, no.25; 1955, Paris, no.46; 1959–1960, Philadelphia–Boston, no.41.

Bibliography: *Scottish Art Review*, 1947, vol.1, no.4, p.25; *id.*, 1950, vol. III, no.1, p.31; *id.*,

65

66

1953, vol. IV, no.4, p.9; *id.*, 1960, vol. VII, no.3, p.29; 1962, vol. VIII, no.3, p.33.

Together with the *Bowl of magnolias* in the Kunsthalle at Bremen, this is one of the finest of the many flower pieces that Courbet painted at Saintes.

These were no doubt inspired by the work of innumerable Dutch seventeenth-century artists. We find in Courbet the same centred arrangement and the same even distribution of light; no part of the subject is in shadow, while it is presented against a sombre, abstract background. Courbet's paintings are also of similar dimensions to those of the Dutch masters.

The latter's flower pieces were straightforwardly allegorical: each species of plant had its own significance, and the combination formed a message which contemporaries could read. Is the same true of Courbet's sudden and brilliant output of flower paintings during his stay at Saintes? In the present picture we recognize peonies, roses, tulips, lilac, holly, bleeding hearts, a cyclamen (yellow!), asters, a

dahlia, snapdragon, love-in-a-mist and saxi-frage. These are flowers that belong to all four seasons of the year, and even in a conservatory they could not be made to bloom at the same time. It thus seems likely that the composition owed something to Étienne Baudry with his passionate interest in botany, and to Phoedora Gaudin with his taste for the esoteric and for symbols of all kinds (cf. 62). This supposition is confirmed by the fact that Courbet painted no more pictures of this kind after he left Saintes: there is no trace of symbolism in the flower-pieces he painted in confinement in 1871–1872.

The spontaneity of these works, the seeming genuineness of the blossoms despite their artificial juxtaposition, may suggest that Courbet could not have painted them from memory. But we should be on our guard here: did he not say that any painter who could not repeat his work in the absence of the model should doubt the reality of his own genius?

Glasgow Art Gallery.

67
The trellis or Young girl arranging flowers

Le treillis ou Jeune fille arrangeant des fleurs (70)

1863

Canvas: 110 × 135. Signed, lower left: *G. Courbet.*

History: Sold by Courbet to the Galerie Durand-Ruel, 29 November 1873(?); Cotel coll., Paris (1878?); Jules Paton coll., Paris; Paton sale, Paris, 24 April 1883, no.23; bought by Galerie Bernheim-jeune; T. J. Blakeslee sale, New York, 10–11 April 1902, no.50; bought by Galerie Durand-Ruel; Adrien Hébrard coll., Paris (1906); Prince de Wagram coll., Paris 1908; Baron Cacamizy coll., London(?); Blanche Marchesi coll., London, 1909–1920; Mrs R. H. Workman coll., London, 1920–1929; Galerie Paul Rosenberg, Paris; Wildenstein Gallery, 1929–1950; offered by Mr Edward Drummond Libbey to the Museum of Art in 1950.

Exhibitions: 1863, Saintes; 1867, Paris, no.108 (*Jeune fille arrangeant des fleurs*, Saintes, 1863); 1882, Paris, no.128; 1909, London, no.131; 1922, no.28; 1929, Paris, no.41; 1930, Berlin, no.32; 1933, New York, no.11; 1934, Chicago, no.180; 1935, San Francisco, no.5; 1935, London, pl.22; 1935–1936, Zurich, no.70; 1936, Cleveland, no.261; 1938, Hartford, no.56; 1938, Washington, no.12; 1938, Baltimore, no.10; 1938, Amsterdam, no.72; 1939, San Francisco, no.144; 1948–1949, New York, no.19; 1950, Detroit, no.104; 1591, New York, no.36; 1953, New Orleans, no.59;

1954, Venice, no.21; 1954, Lyon, no.26; 1955, Paris, no.45; 1956, New York, no.8; 1959–1960, Philadelphia–Boston, no.39.

Bibliography: M. Conil, 'L'exposition des peintres de Saintes, G. Courbet' in *Le Courrier des Deux Charente*, Saintes, 19 February 1863; 'Exposition de peintre, M. Courbet' in *L'indépendant de la Charente Inférieure*, Saintes, 19 February 1863; Bonniot, pp.87, 229, 243, 262.

Bruno, 1872, *Alise à la serre*, p.136.

Painted during Courbet's stay at Saintes, *The trellis* is by far the most important of the flower-pieces on which he concentrated during this brief but important period.

The division of the composition into two parts – a graceful feminine figure and a luxuriant display of flowers – recalls certain Dutch and Flemish canvases of the seventeenth century in which flower-painters and figure-painters collaborated. The genre, thus revived after two centuries, was popularized from Antwerp to Naples by Abraham Bruegel, whose name comes to mind because of a resemblance between *The trellis* and, for example, his *Woman plucking fruit* (1669), formerly in the Talleyrand and Pèreire collections and recently acquired by the Louvre. It is possible that Courbet in Paris saw this or a similar work, or reproductions of them.

Courbet's debt to the old masters who handled this theme is confirmed by his evident knowledge of the inner significance of their works. Their purpose is to glorify youth and love by representing a young girl with flowers of spring, summer and autumn, symbolizing the stages of her amorous life. Thus in *The trellis* we see primulas, salvia, stock, lilies, ipomeas, hollyhocks and begonias – the blossoming of which corresponds to the whole span of human life and happiness. Here, as in no. 62, we suggest that Courbet was influenced by the 'botanist' Baudry or by Phoedora Gaudin, the expert in flower symbolism.

Courbet may also have travelled as far as the Bordeaux museum and seen the still lifes by A. Breugel, purchased by the city in 1829, one of which is a picture of hollyhocks.

Courbet's reliance on the old masters, however, was confined to formal and symbolic elements. His craftsmanship and treatment of light and volume are entirely modern, and are more noteworthy for their influence on his successors than for any reminiscence of the past. Degas may have had *The trellis* in mind when he completed

a *Bouquet of flowers* with the portrait of Mme Hertel (1865, New York, Metropolitan Museum).

It is clear from critics' descriptions that *The trellis* was shown at the Saintes exhibition in 1863. It cannot, however, be no.76, *Woman with flowers*, as that appears to have been the Cleveland Museum of Art *Portrait of Mme Borreau*, to judge from the review by V. Gruet.

It has been suggested that *The trellis* is identical with a *Woman with flowers* (1966, Paris, no.10), but the latter is only an unfinished sketch and is not mentioned in any contemporary account of Courbet's work at Saintes. We think it is rather to be identified with *Woman with a garland*, showing a girl in a Franche-Comté landscape (1939, Ornans, no.9).

The trellis is certainly the picture twice mentioned in Dr Blondon's papers in the Besançon Library under the title *Mlle Viot arranging flowers*. It occurs firstly in a 'List of pictures referred to in Baudry's letters', where it is said to be among those which returned from Belgium and were made over to the Galerie Durand-Ruel, and secondly in a list of 'Pictures sold to Durand-Ruel on 29 November 1873'. Roger Bonniot speaks of a Mlle Viot or Viaud having posed for Courbet in Saintonge (p.90).

Toledo, Museum of Art.

68
The spring at Fouras

La source à Fouras (71)

1863

Canvas: 62 × 81. Signed, lower right: *G. Courbet.*

History: Formerly Herzog coll., Budapest.

Bibliography: Léger, 1948, fig.28; Bonniot, pp.314–15.

This landscape is published by Léger (*op. cit.*) with the caption *A Toures (Charente maritime), 1863 (Collection Baron Herzog, Budapest).* However, as Roger Bonniot has pointed out, there is no such place as Toures in Charente maritime; the correct name of the locality is probably Fouras. The mistake must either be a misprint in Léger or due to a misreading of an inscription on the back of the canvas.

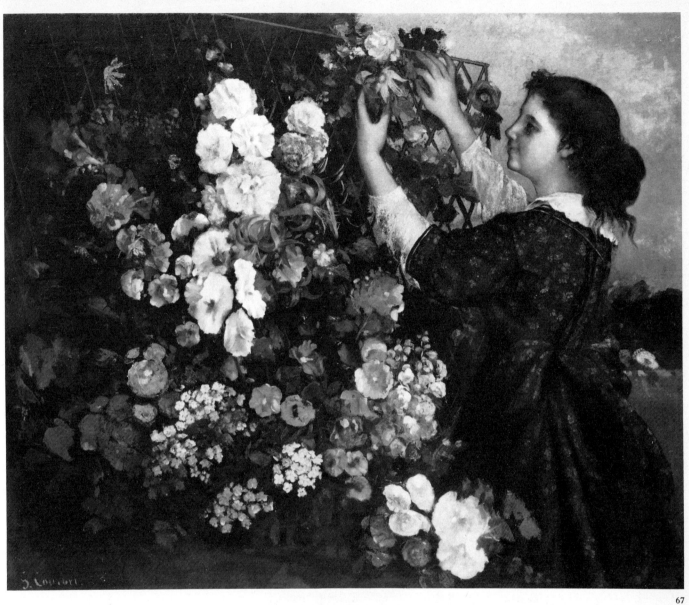

67

68

69

The source of the Loue

La source de la Loue (72)

1863

Canvas: 84×107. Signed, dated lower left: ..63. G. Courbet.

History: Private coll., Lausanne; acquired by the Kunsthaus, Zurich, 1946.

Exhibition: 1962, Berne, no.30.

Bibliography: W. Wartmann, 'Courbet, dit Grotte der Loue' in *Jahresbericht der Zürcher Kunstgesellschaft*, 1946, p.31, repr.

Among the beauty-spots of the Franche-Comté, the source of the river Loue is one of those that inspired Courbet most often and most profoundly. Whereas a certain weariness can be felt in his repeated versions of the *Puits Noir* (88), the *Cave of the Loue*, which he painted many times, gives the impression of being seen with a fresh eye on each occasion.

The scene is one of the most famous natural curiosities in a region which is noted for them. The Loue, thought be to a

Courbet returned for a time to Saintonge in the summer of 1863 (Bonniot, pp.313–318); he spent some days at Fouras, about thirty miles from Saintes, attracted by the marine landscape and sea-bathing of which he was very fond. He met some old friends there (Riat, p.209), and it is no doubt they who figure in this charming landscape. The painter under a sun umbrella may be Pradelles or Auguin, and the young woman seated near the spring may be Mme Auguin or Mme Borreau.

Budapest, Szépmüvészti Museum.

69

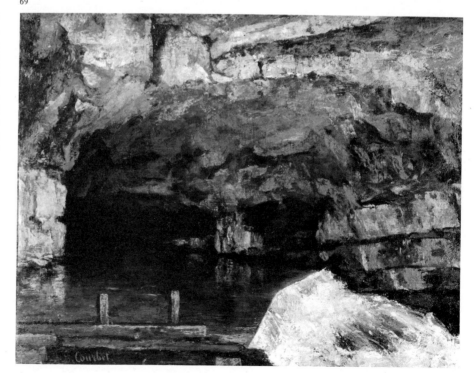

subterranean branch of the Doubs, is already an imposing stream at the point where it gushes out of a cavernous grotto.

The most important and most finished of Courbet's versions of this subject is the one in the National Gallery at Washington, D.C., which shows a man standing on the projecting structure that can be seen here. Other versions, such as that in the Metropolitan Museum, New York, are painted from further back and show the mills on the river-bank.

Each of these landscapes – whether in warm pink and brown tones or in cool greenish ones – conveys a fresh impression of the atmosphere of the scene. We have selected this one, dated 1863, and the companion picture at Hamburg (70). These are close to the reality in their different ways, but in other variants Courbet gives a fantastic shape to the rocks and indulges in violent colour-contrasts such as orange-red and emerald green. An example is in the Musées Royaux des Beaux-Arts in Brussels: in that version Courbet has even turned the grotto into a tunnel, at the far end of which can be seen an imaginary sunny landscape.

These pictures with the dark patch at the centre and the gradual transition to light tones at the periphery form a contrast to certain neo-classical and romantic landscapes by painters of the previous generation, who preferred a luminous centre surrounded by dark masses.

Zurich, Kunsthaus.

70
The source of the Loue

La source de la Loue (73)

1864

Canvas: 98 × 130. Signed, dated lower left: *. . 64 Gustave Courbet.*

History: Bequeathed *to* the Kunsthalle by Ed. L. Behrens, 1913.

Exhibition: 1967, Paris, no.22 (*La source de la Loue, Franche-Comté, 1864?*).

This work, dating from 1864, is one of Courbet's many versions of this celebrated beauty-spot: cf. 69.

Hamburg, Kunsthalle.

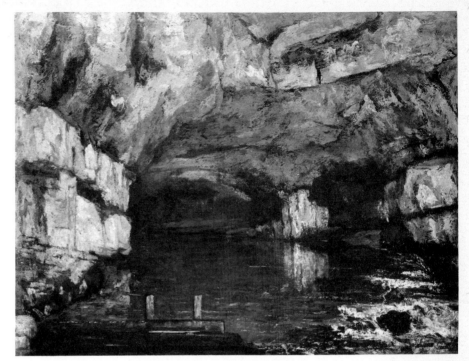

70

71
Reflection

La réflexion (74)

1864

Canvas: 54 × 45. Signed, lower left: *G. Courbet.*

History: Bought from the artist by the town of Douai, June 1870 (500 f.) with the Fortier bequest.

Exhibitions: 1867, Paris, no.100 (*Tête de jeune fille, Ornans, 1864?*–); 1870, Douai, no.16; 1953, Brussels, no.29; 1954, Venice, no.40; 1954, Lyon, no.57; 1955, Paris, no.60; 1956, Paris, no.7; 1956, Hazebrouck, no.19; 1961–1962, Tokyo-Kyoto, no.5; 1969–1970, Rome–Milan, no.21.

Bibliography: Caricature by Randon in *Le Journal amusant*, 1867, no.598 (*Mimi Pinson*); *La Réflexion* in *A.G.C.*, 1955, no.16, pp.20–2, repr.; Toussaint, no.21.

We know from Randon's caricatures that this picture was in Courbet's one-man show at the Pavillon de l'Alma in 1867. By elimination we believe it to be no.100, listed as a *Study of a girl's head, Ornans, 1864.* It may seem surprising that Courbet should have been able to find, in a small town at that period, a young woman willing to pose in such a pronounced déshabillé. This objection, however, is answered by the fact that the girl in the picture is the same as the model who posed for Venus in *Venus and Psyche*, painted at Ornans in the same year and intended for the Salon of 1864. This is clear from photographs of the latter work, which was destroyed in the second world war; the resemblance to the figure in Courbet's variant *The awakening* (Berne, Kunstmuseum) is less close. Courbet, as is known, brought to the Franche-Comté models from Paris who took a mischievous pleasure in startling the inhabitants by the freedom of their behaviour. We suggest that the model in this picture is also the same as in *Woman in the waves* (106). She must apparently have been of a certain consequence in Courbet's life, but her name is not known.

A replica of this picture, with the same dimensions, was in the Émile De Kens collection in Brussels in 1886, according to papers in the Bibliothèque Nationale, Cabinet des Estampes.

Douai Museum.

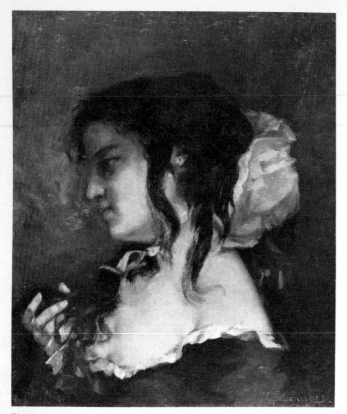

71

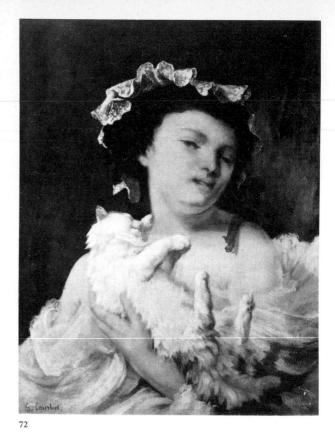

72

72

Woman with a cat

La femme au chat (75)

1864

Canvas: 73 × 57. Signed, lower left: *G. Courbet.*

History: Sold by the artist to Galerie Durand-Ruel, 15 February 1872; seized by the State in June 1877; Courbet sale, Paris, November 1877; bought by Hubert Debrousse; Debrousse sale, Paris, 1900, no.108; bought by Mary Cassatt (without doubt on behalf of H. O. Havemeyer); Havemeyer sale, New York, 1930, no.72; Joseph Stransky coll., New York, bought by Wildenstein Gallery, New York, for the Art Museum, 1940.

Exhibitions: 1882, Paris, no.161 (supplement, Debrousse coll.); 1933, New York, no.5; 1934, Cambridge, Fogg; 1936, London, Wildenstein, no.5; 1938, Baltimore, no.14; 1940, New York, French Art Gallery, no.3; 1948–1949, New York, no.20; 1950, Detroit, no.105; 1951, New York, no.35; 1954, Buffalo, no.25; 1959, Atlanta, no.24; 1963, New York, no.26.

Bibliography: *European Paintings in the Collection of the Worcester Art Museum,* 1974, pp.231–33, repr. p.583.

Bruno, 1872, *Louise chez sa tante,* p.49.

In 1865 Max Buchon wrote in the *Revue littéraire de Franche-Comté* (p.299) that, after the rejection of *Venus and Psyche* (Berne, Kunstmuseum) for the Salon of 1864, Courbet was painting a *Woman with a cat.* This probably refers to the present painting and enables us to date it. It can also be clearly recognized in a photograph of the Ornans studio in June 1864 (*A.G.C.,* 1972, no.48, p.5).

Comparing this picture with *Reflection* (71), it can be seen that the same woman posed for both. This helps to confirm our suggestion that *Reflection* is identical with a picture in Courbet's one-man show of 1867, the catalogue entry for which stated that it was painted at Ornans in 1864.

The present work and *Reflection* are similar in spirit and recall the amorous fantasies that were popular in the eighteenth century. The genre was long continued by lesser masters such as Baron, Edouard de Beaumont and Chaplin, and enjoyed a revival under the Second Empire, when rococo was once more in fashion. Courbet, as we see, was not averse to it but was able to preserve it from insipidity.

The catalogue of the Worcester Art Museum (*op. cit.*) states that X-ray photographs show that the position of the head was altered several times; a veil originally hung down on the left. The figure of the cat was also modified once or twice.

Worcester Art Museum, Massachusetts.

73

The oak at Flagey, known as The oak of Vercingétorix

La chêne de Flagey appelé chêne de Vercingétorix (76)

1864

Canvas: 89 × 110. Signed, dated lower left: *..64 G. Courbet.*

History: Galerie Durand-Ruel, Paris; Henry C. Gibson coll., Philadelphia; bequeathed by the previous owner to Pennsylvania Academy of the Fine Arts, 1896.

Exhibitions: 1867, Paris, no.25; 1954, Venice, no.24; 1954, Lyon, no.29; 1955, Paris, no.53; 1956, New York, no.10; 1956–1957, Providence; 1959–1960, Philadelphia–Boston, no.44; 1966, New York; 1968, New York, no.1; 1974, Philadelphia.

Bibliography: Nochlin, 1967, p.213, fig.19.

We propose to restore to this picture hitherto called *The oak at Ornans* its proper title, *The oak at Flagey*. It is certainly the work that Courbet showed at the Pavillon de l'Alma in 1867, with an annotation reading: 'known as the Oak of Vercingétorix, Caesar's camp near Alesia, Franche-Comté 1864'.

The landscape cannot in any case be that of Ornans, which lies in a valley between two cliffs. The distant prospect seen through the branches is exactly like that of the Flagey plain, where the Courbet family had property. Alaise is not far off, and the 'battle of Alesia' (the Roman name for the place of Caesar's victory over the Gauls) still raged between its inhabitants and those of Alise-Sainte-Reine in the Côte d'Or. In 1862 a team of archaeologists appointed by Napoleon III carried out excavations and pronounced that Alise was the true Alesia; this is now generally accepted, but the Francs-Comtois did not accept the verdict, and Courbet's sub-title has the ring of a challenge.

This is the fifth of Courbet's pictures in which a tree is the main subject. As to the first of these, we would draw attention to a work of obscure provenance in the museum at Saint-Étienne near Lyons, bearing the signature *G. Courbet*, which is to all appearances genuine and is written in the customary manner of his early youth. A huge tree stands in the centre of a landscape which strongly recalls the style of the painter Aligny; at its foot, some rather insignificant figures are enacting the story of Daphnis and Chloe. This is in all prob-ability one of Courbet's earliest works, painted at a time (1840–1841?) when he was given to copying and imitating past and present models.

His second picture of a tree is the *Large oak* (6) – a partial view of the oak at Flagey, as may be seen by comparing it with Riat's reproduction (p.23) of a painting entitled *The oak at Flagey*. The configuration of the trunk is the same in both pictures. The one reproduced by Riat, the third in the series, was in Juliette Courbet's collection; its present location·is unknown to us.

The fourth tree, which may be prior to the one in Riat's reproduction, is the central feature and essential motif in *The wine-harvest at Ornans* (no.452 in the Salon of 1849), now in the Oskar Reinhart Collection at Winterthur. Finally, the present picture completes the series.

Courbet may have imbibed a mystic love of trees from the Barbizon painters, who for some time past had chosen them as a main motif in some of their pictures. The *Rageur*, an oak in the forest of Fontainebleau, was a frequent subject for Corot among others (*Le Rageur, c.*1833; Robaut, II, 266). Later Théodore Rousseau painted similar works, e.g. *Oak-grove at Apremont* (1850, Louvre), where the trees form a dense mass like a bouquet, and *The old oak* (1852, The Hague, Mesdag Museum), where the tree resembles a sheaf. All these pictures are similar in spirit.

The composition of this painting differs from previous versions by Courbet; the oak tree is only partially shown, the outer branches being cut on three sides, like a book illustration. Linda Nochlin has pointed out the close relation between this picture and an engraving in the *Magasin pittoresque* (1850) entitled *Chêne gigantesque de Montravail* (op. cit.).

Philadelphia, Pennsylvania Academy of Fine Arts.

73

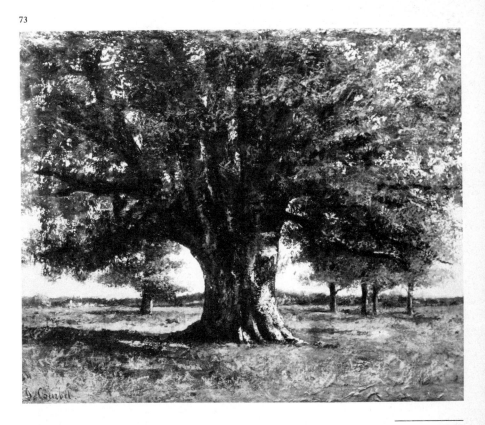

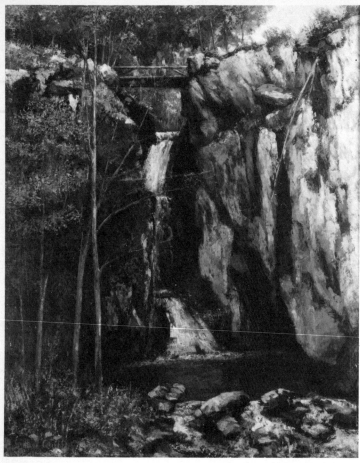

74

74
The Gour de Conche

La Gour de Conches (77)

1864

Canvas: 70×60. Signed, dated lower left: *Gustave Courbet, 1864.*

History: Sold by the artist to Alfred Bouvet of Salins, December 1864; Bouvet coll. until the Second World War; assigned to the Musée du Louvre by the 'Office des Biens privés' (Ministry of Foreign Affairs) in 1951; deposited at the Musée des Beaux-Arts, Besançon, 1953.

Exhibitions: 1928, Pontarlier, no.10; 1935–1936, Zurich, no.74; 1939, Ornans, no.22; 1952, Besançon, no.25; 1953, London, no.21; 1955, Paris, no.55; 1956, Moscow–Leningrad, p.96; 1956, Warsaw, no.22; 1957, Paris, no.30; 1959–1960, Philadelphia–Boston, no.45; 1961, Vichy, no.42; 1969, Ornans, no.17; 1969–1970, Rome–Milan, no.19; 1974, Rochechouart, no.5.

During his long stay with Buchon at Salins in 1864 Courbet made the acquaintance of Alfred Bouvet, a rich industrialist, who admired his work and commissioned four pictures: a portrait of his daughter *Beatrice* (75), a portrait of his wife (Courbet exhibition, Ornans, 1977, no.7) and two landscapes, this one and a companion piece, the *Fort de Joux* (Jacques Guerin collection, Paris).

The Gour de Conches is a beauty-spot about five miles from Salins in the direction of Alaise. The present picture has hitherto been considered the archetype of a realistic landscape, but close study reveals that it is in fact a distortion and a caricature. This throws light on an anecdote associated with the work: Toubin is supposed to have exclaimed: 'What about

realism?', to which Courbet replied laughingly: 'Oh, that's nothing, just beauty-spots (*grains de beauté*). It doesn't happen often' (Léger, 1929, p.104).

The *Fantastic landscape with anthropomorphic rocks* (78) is a broader example of the same type of caricature as is seen in the present work: in this one, Courbet's discretion is such that we may suspect he concealed his intention for the benefit of Alfred Bouvet, the commissioner of the painting. Bouvet had the reputation of being an arrant turncoat in politics – a fact for which he was pilloried in a pamphlet of 1877 published at Dole by Courbet's friends Max Claudet and Arthur Ligier, entitled *Réponse à M. Alfred Bouvet, ancien Maire de Salins*; this work caused a considerable stir at Salins and in the surrounding country.

To revert to Courbet's picture, it resembles puzzle-drawings for children in which human figures are concealed under the semblance of objects. Can we not distinguish a policeman in a képi at either side of the bridge? The rocks are carefully arranged to suggest the appropriate outline, and other human heads can be found here and there throughout the composition. In playing this game Courbet was following in the footsteps of many landscape painters since the Middle Ages – not least the Dutch and Flemish artists whom he knew so well – who transformed accidents of terrain into human or animal figures with jocular intent.

The work is a striking example of Courbet's skill and precision in spreading paint with a palette-knife, even on such a small canvas as this one. This accounts for the richness which makes it one of his most successful paintings.

Besançon, Musée des Beaux-Arts.

75
Portrait of Béatrice Bouvet

Portrait de Béatrice Bouvet (79)

1864

Canvas: 91×73. Signed, inscribed, dated lower left: *Gustave Courbet, Salins, 1864.*

History: Commissioned from the artist by Alfred Bouvet of Salins, 1864; Mme Pierre

Puiseux (sitter); sale, Paris, Galliera, 13 March 1964, no.236; Marlborough Gallery, London private coll., London; acquired by Tooth & Sons, London, for the National Museum of Wales, 1976.

Exhibitions: 1929, Paris, no.45; 1935–1936, Zurich, no.75; 1938, London, no.11; 1953, Brussels, no.24; 1955, Paris, no.56; 1962, Berne, no.32; 1966, London.

Alfred Bouvet, the Salins industrialist who bought two of Courbet's landscapes (74 and 142), also commissioned this portrait of his small daughter, later Mme Puiseux.

Courbet seldom painted portraits of children, though he frequently included them in his compositions. The choirboys in *Burial at Ornans* (135), the peasant boy in *The artist's studio* (137) and the gipsy lad in *The charity of a beggar at Ornans* (108) are among the most charming. The only 'posed' portraits of children, however, are that of his sister Juliette and the present blonde Béatrice. The *Three English girls at the window* (1865, Copenhagen, Ny Carlsberg Glyptotek) and Proudhon's daughters in the admirable painting of the philosopher (80) are special cases, since they were not official family portraits.

Did Courbet find some difficulty in painting this portrait? In the course of

76

75

doing so he wrote: 'It is the hardest thing you can imagine: a three-year-old girl, as fair as tow, as white as milk and, by Jove, extremely pretty' (Riat, p.209). The work is reminiscent of some of Jordaens's blond children.

Cardiff, National Museum of Wales.

76
The farm called Les Pussets

La ferme des Pussets (80)

1864

Canvas: 54 × 65. Signed, dated lower left: *1864, Gustave Courbet*.

History: Félix Courbet sale, Paris, 1882, no.19; bought by Galerie Barbedienne; Henri Rouart sale, Paris, 1912, no.151 (*La ferme des Poncets*); Oppenheimer coll.; Gerstenberg coll., Berlin; Galerie F. et P. Nathan, Zurich; Delestre coll., Paris.

Exhibitions: 1882, Paris, no.85; 1900, Paris, Exposition Centennale, no.145 (*La forêt dans le Jura*); 1862, Berne, no.34; 1962, Ornans, no.21; 1969, Ornans, no.22; 1969–1970, Rome–Milan, no.20; 1976–1977, Tokyo, no.67.

Courbet often visited his friends the Joliclers at Pontarlier, and this charming landscape was painted during a stay with them in 1864. The scene still looks the same today. The farm, rebuilt after a fire, is situated above the hamlet of La Gauffre, not far from the main road and near the Fort de Joux.

Osaka, collection of Mr Kotani.

77

popular imagery of the Romantic period (cf. J. Baltrusaitis, *Anamorphoses*, Paris, 1969).

In this painting all concealment is abandoned: two undisguised heads are seen, as well as about a dozen human and animal shapes. In the water in the foreground can be seen a handsome countenance with hollow eyes and fleshy lips, while a sprite is visible at the foot of the cascade which is anamorphic.

Although inspired by the Gour de Conche as far as the scene is concerned, this work was not necessarily painted at the same time as Courbet's picture of that name (74). It is hard to suggest a date, but we think it may be considerably later.

Paris, private collection.

77 (L)
Ornans landscape

Paysage d'Ornans

1864

Canvas: 86·4 × 129·5. Signed and dated lower left: *64 Gustave Courbet.*

History: Purchased by John Bowes from M. Basset on 21 July 1865.

This painting seems to have been purchased by Mr Bowes from Courbet himself through the intermediary of an agent, and it is thus an interesting example of the early patronage of Courbet in this country. It has at times been suggested that it was done with assistance, but because of the early date and the circumstances of the purchase its autograph quality cannot in my opinion be doubted. Courbet was to develop the harvesting subject in the even larger *Siesta* of 1867 (101). A.B.

Barnard Castle, County Durham. Bowes Museum.

78
Fantastic landscape with anthropomorphic rocks

Paysage fantastique aux roches anthropomorphes (81)

After 1864?

Canvas: 87 × 93. Signed, lower left: *G. Courbet.*

History: Unknown provenance; in the owner's family since the 19th century.

Exhibitions: 1945, Paris, no.25; 1966, Paris, Bibliothèque Nationale, no.359; 1975, Paris, no.2.

This painting, hitherto unpublished, illustrates an aspect of Courbet's art that has not been adequately recognized. As we have seen several times in this exhibition, he sometimes yielded to the temptation, felt by landscapists of many schools and periods, of unobtrusively turning rocks and vegetation into humorous likenesses of animal or human faces. This fashion revived in France at the beginning of the nineteenth century, and was frequent in

79
Stag in a river

Le cerf à la rivière (82)

1864?

Canvas: 73 × 92. Signed, lower right: *G. Courbet.*

History: Bought from the artist by the publisher P. J. Hetzel, 1865; Bonnier de la Chapelle coll. (Hetzel family) until 1974.

Exhibitions: 1945, Paris, no.25; 1966, Paris, Bibliothèque Nationale, no.359; 1975, Paris, no.2.

In a letter to the publisher Hetzel, Courbet wrote: 'My dear Hetzel, I am extremely short of money. If you would pay me 200 francs for the stag you bought it would give me the greatest pleasure, as I have just built a studio in the country to work quietly there' (private archives).

The animal in this painting is the same as in *Fighting stags* (Musée du Louvre) and *Stag taking to the water* (Marseilles Musée des Beaux-Arts), which were begun in Germany in 1859. The present work seems to be of later date, however, to judge by the modern treatment of the light on the tree-trunks to the left, and the bold freshness of the green tints.

Paris, private collection.

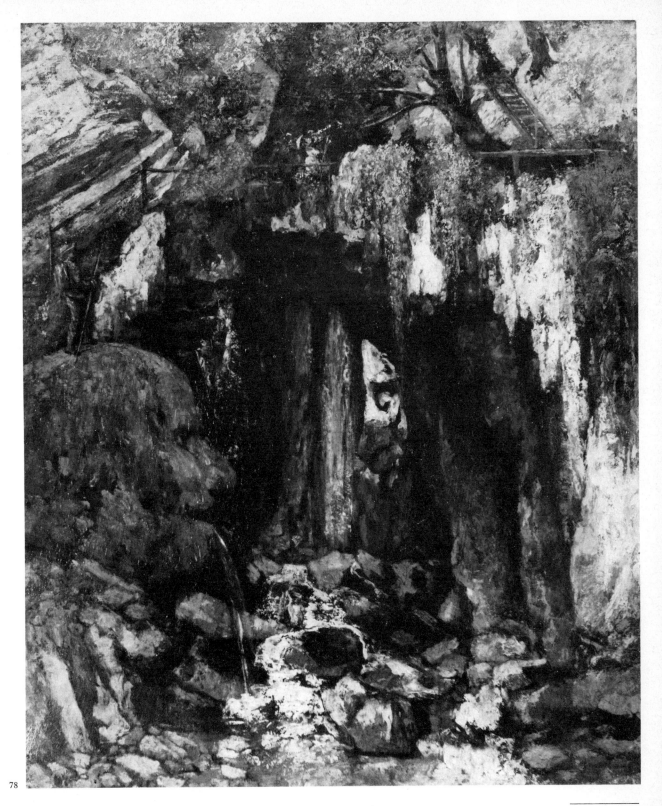

78

79

80
Portrait of P. J. Proudhon, 1853

Portrait de P. J. Proudhon en 1853 (83)

1865

Canvas: 147 × 198. Signed and dated lower left: *Gustave Courbet, 1865*; inscribed, to the left, on the upper step: *P.J.P. 1853*.

History: Consigned by the artist to Galerie Durand-Ruel, 1873; seized by the State from Galerie Durand-Ruel, June 1877; sold on the authority of the Judiciary, 26 November 1877; bought by Hubert Debrousse; Debrousse sale, Paris, 1900, no.105; bought by the City of Paris.

Exhibitions: 1865, Paris, Salon, no.520; 1867, Paris, no.136; 1868, Grand Salon (*Proudhon et sa famille*); 1882, Paris, no.7; 1929, Paris, no.17; 1935, Paris, Galliera, no.431; 1935–1936, Zurich, no.30; 1948, Paris, no.153; 1949, Copenhagen, no.14; 1950, Belgrade, no.22; 1950, La Tour de Peilz, no.22; 1952, Besançon, no.27; 1952–1953, Rotterdam, no.25; 1953, London, no.23; 1954, Venice, no.27; 1954, Lyon, no.32; 1955, Paris, no.57; 1956, Warsaw, no.21; 1959–1960, Philadelphia–Boston, no.54; 1965, Lisbon, no.31; 1968–1969, Paris, no.219; 1969–1970, Rome–Milan, no.25; 1971, Bucarest, p.38; 1971, Budapest, no.12.

Bibliography: Caricature by Bertall in *L'Illustration*, 3 June 1865 (repr. in Léger, 1920, p.60); Martine Ecalle, *A propos du portrait de Proudhon et ses enfants* in *Bulletin du Laboratoire du Musée du Louvre*, 1959, no.4, p.31, publication of the X ray; Pérot, no.25; Delbourgo-Faillant, p.19, figs.12, 13, 14, 15, 16.

Bruno, 1872, *Proudhon et ses enfants*, p.33.

Proudhon – like Courbet, a native of Franche-Comté – settled in Paris at the end of 1847. The two men must have made contact soon after, and remained fast friends until the philosopher's death in January 1865: aged only fifty-five, he was worn out by hard work, privation and persecution. Courbet felt his death profoundly and wrote to his lawyer friend Chaudey: 'The nineteenth century has lost its pilot and the man who it created. We are left without a compass; deprived of his authority, humanity and the Revolution will drift back into the hands of soldiers and barbarism' (cf. *A.G.C.*, 1948, no.4, pp.20–21).

Courbet and Proudhon were convinced socialists but believed in a peaceful revolution; they abhorred violence and conspiracies. This was one of the chief reasons why Proudhon and Marx failed to agree.

Proudhon's doctrines are little remembered today. His thinking was confused and contradictory; his ideas were prophetic but premature – e.g. the separation of church and state, or the organization of long-term economic planning – and gained little acceptance in his time. His *Avertissement aux propriétaires* (1842) made his name with the celebrated maxim 'Property is theft'. He substituted the right of use for that of property, and denied that either workers or managers had any right to monetary profits. A sincere, upright man of noble instincts, devoid of hatred and jealousy and a sworn enemy of demagogy, he led the austere life of a secular saint and imagined in his simplicity that all men would be equally content to live frugally and derive their happiness from bringing up children.

As a rule excess of virtue made him profoundly misanthropic towards those whom he did not love. He was fond of Courbet, however, and seemed oblivious of the fact that the latter's ambitions, aspirations and way of life were such as normally incurred his censure.

When Proudhon was imprisoned on political grounds from 1849 to 1852, Courbet went to visit him and accompanied him when he was let out once a week on parole he was also present when Proudhon was finally released. When, in 1862, he painted his anticlerical *Curés en goguette* (Priests in merry mood; also known as *Return from the conference*), he asked Proudhon to write an explanatory booklet on the subject. This turned into a major work entitled *Du principe de l'art et de sa destination sociale*, on the manuscript of which Proudhon wrote the words *À propos de Courbet*. We shall often refer to this dissertation, which was published only after the philosopher's death.

Courbet had for a long time wished to paint his friend's portrait, but Proudhon refused to pose. When he included Proudhon in *The painter's studio* (137) he made use of a lithograph. In 1863 he sent his friend to the photographer Reutlinger, to whom he gave instructions as to the required pose (letters in *A.G.C.*, 1958, no.21, pp.5–6), intending no doubt to use the result later. On Proudhon's death Courbet

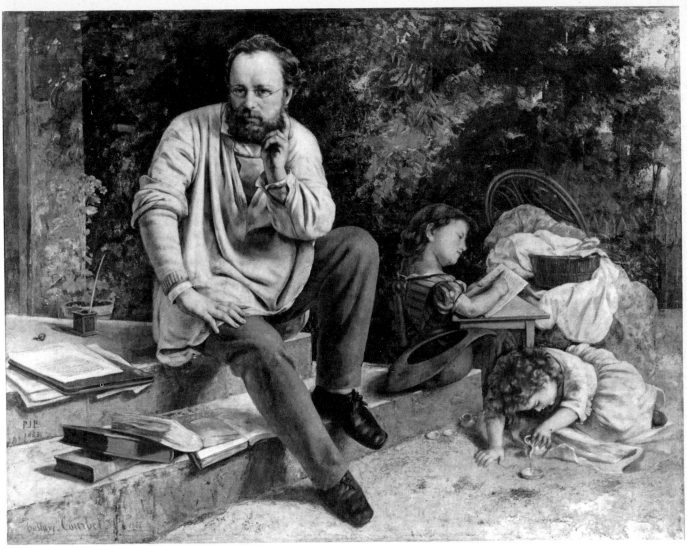

80

finally made up his mind and wrote to Castagnary: 'Smitten by the irremediable blow that has befallen us all, I intend after all to make an historical portrait of my very dear friend' (Courthion, II, p.102).

Courbet had a reason for depicting Proudhon as he was in 1853 – a year of moral crisis for the philosopher, and one of the cruellest in his life, witnessing the confiscation of two of his writings, *La philosophie du progrès* and *Manuel d'un spéculateur*

à la bourse. On 1 January 1854 he wrote despairingly to his friend Mathey: 'I am faced with starvation, as I can neither write a book nor publish in any periodical . . . Desperate poverty is all I can expect . . . Such is my end-of-year balance-sheet.' The date 1853, painted in a corner of the picture as it might appear on an *ex voto*, marks the beginning of the last phase of Proudhon's persecuted existence.

Proudhon is seated on the steps out-

side his house in the rue d'Enfer: 'Whenever it wasn't raining he used to carry out there all his paraphernalia, his books, papers, briefcase and writing equipment, and when the sun shone his wife and children would come and work beside him' (letter from Courbet to Carjat, repr. in Léger, 1948, p.103). At Proudhon's feet is the light felt hat that he habitually wore, to the amusement of townsfolk for whom the only correct garb was a top hat. The phil-

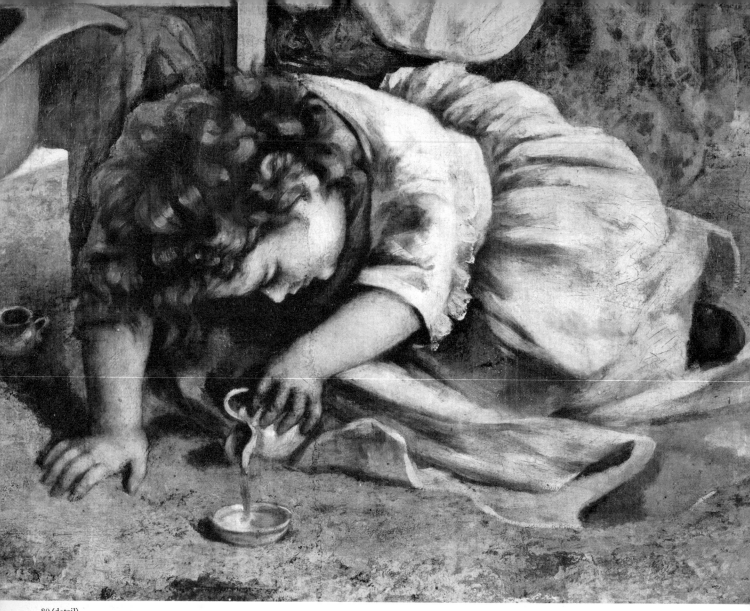

80 (detail)

osopher is wearing a farmer's smock of the Beauce province, a gift from one of his fellow-prisoners at Sainte-Pélagie.

The original version of the painting was altered after the Salon of 1865. In it, the seated figure of Mme Proudhon appeared where there is now a chair piled with garments. It is doubtless unique in the history of husband-and-wife portraits for the wife to be thrust into the background like this, but Courbet knew what he was doing: Proudhon's egalitarian convictions did not extend to the opposite sex, and he regarded women as a lesser breed whose proper place was in bed or in the kitchen. As his letters show, he treated the mother of his children respectfully, but he kept her at a distance nevertheless. In the summer of 1853 Mme Proudhon was pregnant with her third daughter Stéphanie, and her figure was heavy and ungraceful. Courbet, painting his picture twelve years later, could have placed it a few months earlier, or a month later after the child's birth. But in Proudhon's own view motherhood was the highest dignity of woman, and it was no doubt in deference to this that Courbet showed the philosopher's wife in a pregnant condition. The initial composition of the work is clearly seen from the X rays published by Martine Ecalle (*op. cit.*).

The two small girls are Catherine, poring over the alphabet, and her sister Marcelle. Catherine, born in 1850, married in 1877 Félix Henneguy, a biologist and

future professor at the College de France; she died, almost a centenarian, in 1947. Marcelle, on the other hand, died of cholera in 1854, eleven years before the picture was painted. Proudhon, a loving father, was deeply afflicted by her death: some weeks earlier, in September 1854, he had written to Bergman: 'In the last four years my wife has presented me with three fair, rosy-cheeked little girls whose lives today fill my soul to the uttermost.'

The painting was executed at Ornans with the aid of Reutlinger's photograph and another taken by Carjat on Proudhon's death-bed, also a portrait by the Belgian artist Amédée Bourson, painted when Proudhon was in exile in Brussels (Salon of 1861, no.392; replica in the Musée Granvelle, Besançon). On 11 March 1865 Buchon wrote to Champfleury that the picture was nearly finished – it had taken only thirty-six days. Some afterthoughts are shown by the X ray: originally Proudhon's head was inclined to one side (cf. Delbourgo-Faillant, *op. cit.*). The final pose is that of Reutlinger's photograph and Bourson's portrait.

The work met with a sarcastic reception at the Salon. Bertall's caricature featured several bundles of dirty linen, and versifiers wrote: 'Poor old Proudhon, what hard lines! You've been dead three months, and now Courbet comes and kills you again.' Thoré, generally a friendly critic where Courbet was concerned, wrote: 'Proudhon is stuck against a wall of the same hue as his philosopher's smock ... while his wife is bunched up in a corner of the picture' (*Salons 1861 à 1868*, II, pp.269–270).

Although the composition, with the main figure seated, appeared outlandish to contemporary critics, Courbet was only following a tradition customary in Dutch open-air portraits in the seventeenth century and British ones in the eighteenth. Sensitive to the critics' gibes, however, he retouched the picture, changing the blank wall behind Proudhon into a leafy background. As for Mme Proudhon, realizing her inelegant appearance and perhaps regretting the subordinate place to which she was relegated, he painted her out and substituted the chair with her work-basket upon it.

When the picture was confiscated by the State in 1877 Courbet protested that he had intended to present it to the city of Besançon. This was probably a recent intention, for when he entrusted it to Durand-Ruel for sale he set on it a price of 12,000 francs.

Courbet painted two other portraits of Proudhon. The first a bust portrait that seems to be a copy of Bourson's, may have been done as a study for the main picture (Louvre). Courbet also made a drawing of *Proudhon on his death-bed* (private collection) after Carjat's photograph, intending to publish it in Jules Vallès's journal *La rue* in the issue of 19 January 1866, which commemorated the anniversary of the philosopher's death. The censor, however, intervened and the drawing was not published.

Paris, Musée du Petit Palais.

81
Portrait of Euphrasie Proudhon, née Piégard

Portrait d'Euphrasie Proudhon, née Piégard

(*84*)

1865

Canvas: 73×59. Unsigned.

History: Offered by the artist to the sitter at the same time as a portrait of P. J. Proudhon, her husband in 1868; inherited from the sitter by her daughter Catherine, Mme Felix Henneguy, 1900; inherited from the previous owner by her daughters Mme Emmanuel Fauré-Frémiet and Mlle Suzanne Henneguy in 1947; given by the previous owners to the Musée du Louvre in 1958, maintaining a life interest; entered the Louvre in 1970.

Exhibitions: 1867, Paris, no.68; 1952–1953, Paris, no.20; 1953, London, no.23; 1955, Paris, no.58; 1967–1968, Paris, no.350; 1969–1970, Rome–Milan, no.26.

81

Bibliography: Charles Léger, *Histoire des Portraits de Proudhon* in *A.G.C.*, 1947. no.2, p.9; Forges, 1969, no.26.

Louise Euphrasie Piégard (1822–1900) was a young woman of humble station employed in a braid (*passementerie*) workshop. Her father, an active partisan of the Bourbon dynasty, was prosecuted on political grounds in 1854 and received a two-year sentence, but was not imprisoned owing to his advanced age. His daughter was thus no stranger to political resistance. Her marriage to the militant socialist Pierre-Joseph Proudhon was celebrated on the last day of 1849 in the chapel of Sainte-Pélagie prison – a fact which amused Proudhon's fellow-prisoners and gained him the nickname of 'the bigot socialist'. The couple were able to maintain a semblance of conjugal life, as Proudhon was allowed out of prison once a week, and on his release in 1852 they already had two children.

Proudhon's idea of the marriage can be gathered from a letter he wrote in 1854 to his old friend Bergmann. 'At the age of forty I married a poor girl of the working class, not out of passion – you can imagine well enough what my passions are – but out of sympathy for her lot and esteem for her person; also because, my mother having died, I was without a family, and because – would you believe it? – without being in love, I had a fancy that I would like to be a husband and father! That was all the thought I gave to the matter.'

Euphrasie Proudhon's life was one of more sorrow than joy. In 1854 her second daughter Marcelle, not yet three years old, was carried off by cholera, and in 1856 another child, Charlotte, died in infancy. Proudhon himself died in 1865, and so, soon afterwards, did Stéphanie, who was born in 1853. The only child to survive Euphrasie was her eldest daughter Cathering (1850–1947).

When Courbet painted the *Portrait of Proudhon* (80) at Ornans he included a 'provisional portrait' of the philosopher's wife. His intention was to execute a rapid study when he returned to Paris and transfer it to the canvas which was already at the palace where the Salon was being held. However, when the study was ready he was refused permission to retouch the painting. The date of execution of the *Portrait* is uncertain. A manuscript note by Castagnary says that it was painted in April 1865 at

10, Grande-Rue, Passy; accompanying this is a press cutting of 11 August saying that Courbet had just completed a *Portrait of Mme Proudhon*. He must have worked up his hasty sketch into the fine *Portrait* that we see here. He did not use it for the picture of Proudhon's family, as he decided to exclude Euphrasie from that work; in any case the portrait of 1865 shows her twelve years older than she was at the supposed period of the family group. Quite possibly she herself preferred not to figure in the group, in view of the subordinate position assigned to her.

The Louvre possesses a photograph of Mme Proudhon by Carjat in which she is wearing a black taffeta gown similar to this one and a formidable widow's cap. We may wonder if the photograph was not taken at Courbet's request when he began work on his picture at Ornans. The cap, which was clearly not from a fashionable

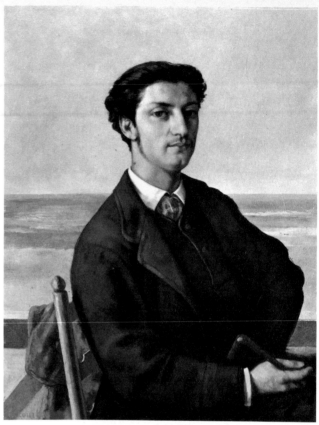

82

modiste, was replaced by the attractive white ruched confection that we see here, and the colour of the taffeta softened to a bluish grey.

Paris, Musée du Louvre.

82

Portrait of M. Nodler, the elder

Portrait de M. Nodler, âiné (85)

1865

Canvas: 93×73. Signed, dated lower left: ..66 G. Courbet.

History: Acquired from the artist by the Nodler family in 1865; Knoedler Gallery, New York; bought by Smith College Museum of Arts in 1935.

Exhibitions: 1867, Paris, no.78; 1938, Amsterdam, no.73; 1938, Baltimore, no.15; 1940, Chicago, no.5; 1940, New York, Harriman, no.10; 1948–1949, New York, no.32; 1953, New York, no.9; 1954, Lyon, no.36; 1954, Venice, no.33; 1956, New York, no.12; 1959–1960, Philadelphia–Boston, no.49.

Bibliography: *Smith College Museum Bulletin*, 1935, pp.11–12; Hitchcock, *Forty French pictures in the Smith College Museum*, no.21.

In the summer of 1865 Courbet spent some time at Trouville, a seaside resort made fashionable ten years earlier by the duc de Morny, and by then at the height of its popularity. Morny's widow came there regularly and Courbet painted a picture of her villa (former Bignou collection).

Courbet's portraits and 'sea landscapes' soon gained him a reputation among the holiday-makers of the *beau monde*. One of the first portraits was of the Hungarian Countess Károlyi (Japan, private collection): this attracted many other patrons, so that the socialist artist was transformed into a fashionable portrait-painter. In a letter of 16 September to Urbain Cuenot he boasted with some exaggeration that 'over four hundred ladies' had come to see the Countess's portrait (*A.G.C.*, 1959, no.23, p.9), and also mentioned that he had recently finished a portrait of 'M. Nodeler, *fils*' [*sic*]. This gives us the real date of the present work, which is inscribed 1866. Courbet, who always preferred to exhibit recent works, no doubt gave it this date when showing it at the Pavillon de l'Alma, as though it had been painted the previous summer.

The present portrait and that of Countess Károlyi are the first portraits of individuals in which Courbet made use of a luminous setting and azure skies. He used a similar atmosphere in *The meeting* (34), but that was to achieve the dazzling effect of a southern landscape. The *Portrait of Laure Borreau* (141) shows a development in the direction which fully asserted itself at Trouville. Thus, after twenty-five years and a long sojourn in the realm of Dutch baroque, Courbet unexpectedly adopted a style typical of such neo-classical portraits as Ingres's *Mlle Rivière* (1805, Louvre) or the same artist's *Belle Zélie* (1806, Rouen Museum), in which the naïve purity of the sitter's countenance is similarly set off by a sky limpid.

Northampton, Mass., Smith College Museum of Art.

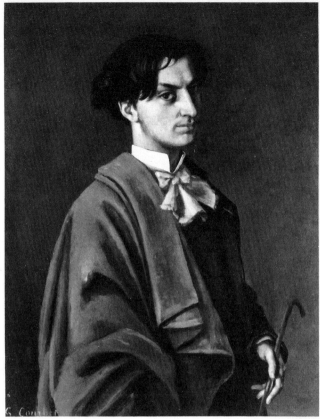

83

83
Portrait of M. Nodler, the younger

Portrait de M. Nodler, cadet (86)

1865

Canvas: 93 × 73. Signed, dated, lower left: ..66 G. Courbet.

History: Acquired from the artist by the Nodler family, 1865; Knoedler Gallery, New York; acquired from the previous owner by the Museum of Fine Arts, 1954.

Exhibitions: 1867, Paris, no.79; 1937, Philadelphia; 1937–1938, Washington; 1938, Baltimore, no.16; 1939, Pittsburg, no.5; 1940, New York, Harriman, no.11; 1941, Chicago, no.3; 1942, Milwaukee; 1943, New York, no.2; 1944, Baltimore; 1948, Decatur, no.10; 1955, Atlanta, no.10; 1959–1960, Philadelphia–Boston, no.56.

This is the younger brother of the M. Nodler whose portrait Courbet also painted (82). It has always been stated that the two works were painted in successive years, but this is not so. Both were exhibited at the Pavillon de l'Alma in 1867, but the date of 1866 only reflects Courbet's habit of putting a recent date on his pictures before showing them. The evidence is that both the Nodler portraits were painted in 1865.

In his letter of 16 September 1865 to Cuenot (cf. 82) Courbet wrote: 'I have painted M. Nodeler *fils* [i.e. presumably the elder son]; I still have to do his brother and his father. It is a good thing I work quickly!' In a letter to his father we read: 'I have had over two thousand women visiting my studio' (the number has thus multiplied by five since he wrote to Cuenot). 'They all want to be painted, having seen my portrait of Princess Karoly' [*sic*: the Countess has come up in the world]. 'Apart from women, I have painted portraits of two men' (private archives).

These are probably the Nodler brothers, and the letter to his father, like that to Cuenot, must date from 1865, in which year Courbet stayed at Trouville until late autumn.

All doubt is removed, in any case, by an undated letter in the Bibliothèque Nationale, addressed to Haro. The unknown writer describes his stay at Trouville in 1865 and his visit to Courbet, and tells us that 'he was painting the portrait of "a Hungarian princess, I think", which was coming along marvellously. At the same time he was painting, separately, the two young sons of a friend of his, and while he was working on these portraits – in which the knife was no less important than the brush – we used to keep him company and drink beer together. It was wonderful how steadily he could keep on painting, while talking and drinking the whole time' (Bibliothèque Nationale, Estampes, Box V).

The two Nodler portraits form a pair, but are judiciously varied: the elder brother (82) has a down-to-earth expression, contrasting with the dreamy look of his junior and the romantic atmosphere of the cape and loose bow-tie.

Springfield, Museum of Fine Arts.

84
The girl with seagulls, Trouville

La fille aux mouettes, Trouville (87)

1865

Canvas: 81 × 65. Signed lower left: *G. Courbet.*

History: Sold by the artist to the Société Artésienne des Amis des Arts (1000 f.) for their annual lottery for charity in 1869; Binoche coll.; Paul Rosenberg Gallery, New York.

Exhibitions: 1867, Paris, no.101; 1928, Paris, no.46; 1929, Paris, no.48; 1933, London, no.10; 1934, New York, no.8; 1935–1936, Zurich, no.79; 1936, London, no.27; 1937, Paris, Rosenberg, no.14; 1938, London, no.12; 1939, Belgrade, no.25; 1939, Buenos Aires, no.23; 1939, Montevideo, no.14; 1939, Rosario, no.14; 1940–1941, San Francisco, no.14; 1941, Chicago, no.23; 1941, San Diego, no.8; 1950, New York, no.4; 1952, New York, no.7; Venice, no.29; 1956, New York, no.13; 1959–1960, Philadelphia–Boston, no.48; 1962, Williamstown.

Bibliography: M. J. Wentworth, 'Tissot on the Thames, a Heron', *Minneapolis Institute of Arts Bulletin*, vol. LXII, 1975, repr. p.45.

Bruno, 1872, *Madame Patapouf dans sa jeunesse*, p.216.

Courbet was fascinated by human hair and birds' plumage, and in this picture the shimmering of the blonde girl's flowing locks is blended with that of the gull's outstretched wings. These are the true motifs of the painting, and their importance is enhanced by the arrangement of the composition. It is divided in two, rather curiously, by a pole held by a small girl, whose face thus plays both an essential and a secondary part. The tones are also distributed unexpectedly: white, black and half-tone are arranged in a mosaic effect which has no parallel in the rest of Courbet's œuvre.

It appears from correspondence between Castagnary and Desavary, now in the Bibliothèque Nationale, that the Société Artésienne des Amis des Arts at Arras, which patronized artists on a considerable scale, bought this picture in 1869 for its annual raffle. It was the Society's custom thus to buy a canvas by a modern painter each year; prior to Courbet, it had chosen works by Corot (Bibliothèque Nationale, Estampes, Box II).

New York, collection of Mr and Mrs James S. Deely.

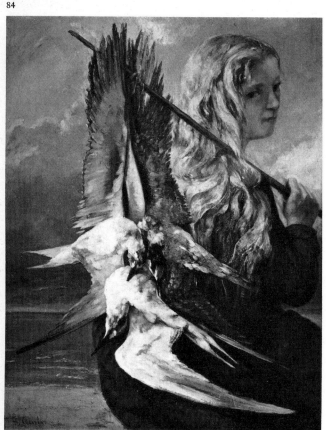

84

85
Low tide at Trouville

Marée basse à Trouville (88)

1865?

Canvas: 59 × 72. Signed, lower left: *G. Courbet.*

History: Reid & Lefevre, London (1936); Lady Chester Beatty coll.; Sir Alfred Chester Beatty coll.; bought by the Walker Art Gallery in

1961; with the aid of the National Art Collection Fund.

Exhibition: 1937, Glasgow.

It would be an impossible task to enumerate all the 'sea landscapes' painted by Courbet on the Atlantic and Channel coasts. Many such scenes are in fact studio repetitions or were painted in prison, like that in the Caen Museum (117). In Courbet's exhibition at the Pavillon de l'Alma in 1867 there were no fewer than ten items comprising seascapes painted at Trouville during the two previous years.

Paintings in this category, like those depicting *Waves* (cf. 112), occupy a special place in Courbet's work, and belong rather to the subsequent course of French painting than to its previous history.

We may observe that as a rule Courbet's landscapes are of a narrative or historical character: they are of a specific object, whereas the Barbizon school avoided all that was picturesque. In his youth Courbet painted panoramic views, generally centred on some inhabited place; later he produced elaborate compositions depicting some curiosity of nature, an isolated rock or tree, a cluster of houses (*Château d'Ornans*, c.1853, Zurich, private collection) or a ruin.

His 'sea landscapes', on the other hand, are chromatic variations of colours and values and have no other significance. Water and clouds were treated in this way by eighteenth-century British painters, especially in watercolour, and subsequently by Turner. But although these painters had a strong influence in France, this aspect of their work was not readily understood. If Delacroix had made his career as a landscapist he might have become an exception by reason of his links with Bonington and the Fielding brothers, or so his watercolours suggest. But the French School of 1830, even such painters as Isabey and Paul Huet, produced work of a more specific nature.

The new note was struck by Boudin, whose acquaintance Courbet made in 1859 at the Ferme Saint-Siméon near Honfleur, and whom he acclaimed as the 'king of skies'. His influence was reinforced by that of Whistler, whom Courbet met at Trouville in 1865.

Liverpool, Walker Art Gallery.

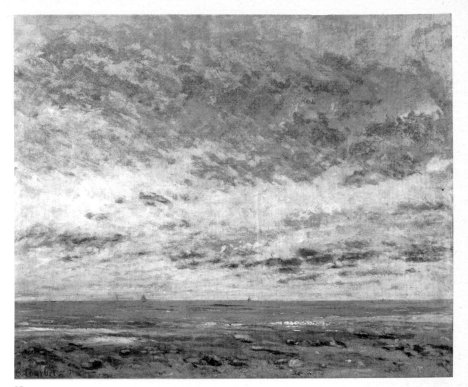

85

86

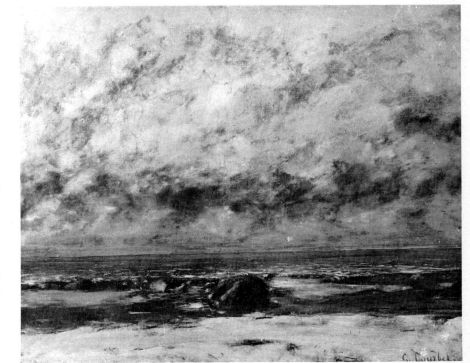

86
Low tide, known as 'Immensity'

Marée basse dit 'L'immensité' (89)

1865?

Canvas: 61×82. Signed, lower right: *G. Courbet.*

History: Puvis de Chavannes coll.; Bunau-Varilla sale, Paris, 1947; no.11, R. C. Pitchard coll.; Tooth & Sons Gallery, London, acquired from the previous owners by Bristol Museum and Art Gallery, 1952, with aid from the National Art Collections Fund.

Exhibitions: 1951, London, no.5; 1957, Cardiff, Swansea; 1962, London, no.211; 1969, London, Wildenstein, no.32.

Another specimen of Courbet's innumerable 'sea landscapes', with their infinite variations reflecting different hours of the day and types of weather (cf. 85).

Bristol, Museum and Art Gallery.

86a

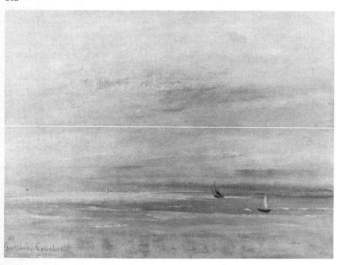

86b

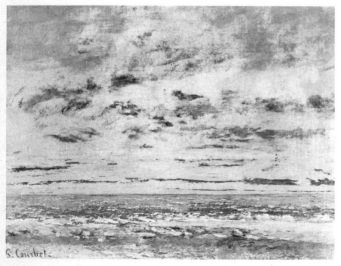

86a (L)
Seascape

Paysage de mer

1866

Canvas: 31·8 × 44·5. Signed and dated lower left: *66 Gustave Courbet.*

Although dated 1866 this small painting belongs to the series of seascapes which Courbet painted at Trouville in the late summer and autumn of 1865 (cf. 85 and 86). Courbet had not intended to stay so long, but the weather was good, the sea-bathing excellent and the company of Whistler and Jo (cf. 87) most attractive. He was absorbed in the problem of painting the sea, and executed '25 seascapes, autumn skies, each one more free and extraordinary than the last' (Courbet's letter to his father, 17 November 1865). Unlike the Liverpool and Bristol pictures, and the celebrated Ionides *L'Immensité*, permanently and immovably on view in the Victoria and Albert Museum, this thinly painted picture shows that Courbet was not above learning a thing or two from Whistler who was himself then painting the *Harmony in blue and silver, Trouville* (Gardner Museum, Boston), in which Courbet is seen contemplating the sea. Twenty of the Trouville seascapes were exhibited at Courbet's 1867 retrospective exhibition, along with ten *Marines diverses*: twenty-five were sold to the dealer Delaroche who went bankrupt in 1869. It is not possible however to identify these works with any certainty. A.B.

Private collection.

86b (L)
Seascape

Paysage de mer

1866

Canvas: 43·2 × 59·1. Signed lower left: *G. Courbet.*

Another of the group of seascapes, probably painted at Trouville in 1865, and dated the following year. A.B.

Helen Sutherland collection.

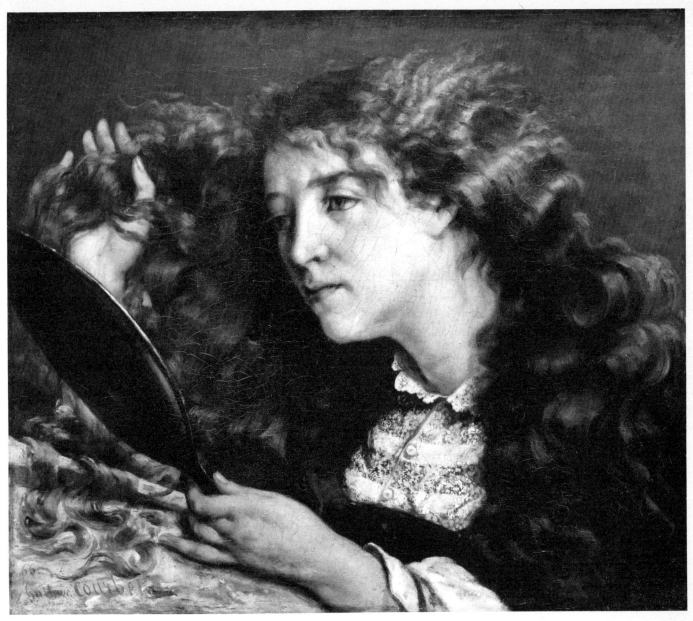

87

87
Portrait of Jo, the beautiful Irish girl

Portrait de Jo, la belle Irlandaise (*90*)

1865?

Canvas: 66 × 56. Signed, dated lower left:
. .66 Gustave Courbet

History: Gérard senior, coll.; Gérard sale, Paris, 25 February 1896, no.13; Galerie Durand-Ruel, Paris; bought from the previous owner in 1919 by H. O. Havemeyer; bequeathed by Mrs H. O. Havemeyer to the Metropolitan Museum in 1929.

Exhibitions: Possibly shown: 1866, Brussels, no.145 (*Femme irlandaise*(; 1867, Paris, no.91 (*La Jo, femme d'Irlande*); 1868, The Hague; 1873, London; 1878, Brussels, Crecle Artistique et Littéraire; 1909, Paris, no.9; 1910, Venice, no.7.

Definitely shown: 1919, New York, no.23; 1930, New York, no.32; 1953, Brussels, no.25; 1959–1960, Philadelphia–Boston, no.55.

Bibliography: Sterling-Salinger, pp.128–9.

Bruno, 1872, *Judith attachant ses cheveux*, p.153.

During Courbet's stay at Trouville in 1865 Whistler was also there with his

mistress, a flamboyant Irish beauty named Joanna Heffernan. According to Riat their liaison lasted five years and a son was born. Before 1865 Jo had posed for two of Whistler's most important paintings, both entitled *The white girl* (1862, Washington, National Gallery; 1864, London, National Gallery). She is said to have posed on a single occasion for Courbet's portrait, which shows her holding a mirror while her opulent red hair falls about her shoulders.

There are four known versions of this picture, with minor variations, and their interrelation is still a matter of controversy. The one in the National Museum at Stockholm is generally thought to be the original. Another version, now in a Parisian collection, was shown in a London gallery in 1959; while the William Rockhill Nelson Gallery of Art in Kansas City possesses a version formerly owned by the painter Trouillebert.

It is difficult to distinguish these canvases in the record of nineteenth-century exhibitions from 1866 onwards, when one of them was shown for the first time in Brussels. At his one-man show in 1867 Courbet added to the title 'Trouville 1866', but we know how unreliable he was in such matters.

The red-headed Jo admiring her reflection is a reminiscence, six years later, of a brunette *Woman with a mirror*, painted in 1859, which was so successful that Courbet had to repeat it several times; there is a version in the Basle Museum. Jo also posed for the red-headed girl in *Women asleep* (90).

Courbet seems to have had a particular fondness for this picture. Dr Collin, who attended him on his death-bed, relates that the painter had with him at La Tour de Peilz 'a picture of an Englishwoman [*sic*] with golden hair, looking at herself in a mirror. Rochefort wanted to buy it for 5,000 francs, but the artist would not sell. As Rochefort tried to persuade him, Courbet took off the wall a delightful *Beach* scene and offered it to him instead' (Courthion, II, pp.255–6).

Jo Heffernan, subsequently Mrs Abbott, is mentioned in a letter written to Castagnary on 18 December 1882 by Juliette Courbet, then on holiday at Nice. Juliette wrote that she had been to see 'a lady who sells antiques and has some of Gustave's pictures. This is "the beautiful

Irish girl": she came from Paris and has lived here since the war, and has all kinds of stories to relate. She is married, and keeps open house every day for artistic celebrities from Paris' (Bibliothèque Nationale, Estampes, Box V). What Juliette did not know was that the Irish beauty was to be in trouble with the law for passing off some drawings by Whistler as the work of Raphael.

New York, Metropolitan Museum of Art.

88

The shaded stream, or 'Le Puits Noir'

Le ruisseau couvert ou Le Puits Noir (*91*)

1865

Canvas: 94 × 135. Signed, dated lower right: ..65 G. Courbet.

History: Bought by the comte de Nieuwerkerke for Napoléon III (detained 23 September 1865; alloted to the State by law 12 February 1879; exhibited at the Musée du Luxembourg; entered the Louvre 1903.

Exhibitions: 1865, Paris, Salon, no.521 (*Entrée de la vallée du Puis Noir, Doubs; effet de crépuscule*); 1867, Paris, Exposition Universelle, no.174 (*Paysage*); 1882, Paris, no.55 (*Le ruisseau couvert*); 1928, Cairo, no.27; 1954, Venice, no.26; 1954, Lyon, no.30; 1955, Paris, no.62; 1961–1962, Tokyo–Kyoto, no.4; 1967, Montreal, World Fair, nn.

Among Courbet's numerous pictures of this beauty-spot, this is the only one which bears the title *Ruisseau couvert*. Courbet referred to it thus in the catalogue of his exhibition of 1867, in connection with *Woman with a parrot* (no.10; 91 in the present catalogue). All his other pictures of the scene are called *Le Puits Noir*.

Le Puits Noir is the name of a spot near Ornans where the river Brème forces its way through a narrow channel between very steep rocks covered with luxuriant vegetation. Even at noon, scarcely any sunlight falls on the water. Courbet painted the scene many times, placing his easel at the entrance to the almost impenetrable gorge. In many versions the angle of vision is the same as in the present painting: we may mention those in the Montpellier Museum (also called *Solitude*), at Besançon, at Toulouse (89), in the Chicago Art Institute

88

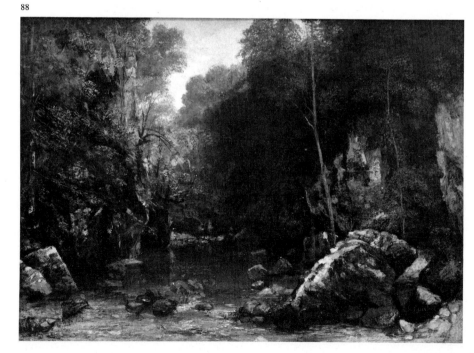

(formerly Mazaroz collection) and the Kunsthistorisches Museum in Vienna, not to speak of others (genuine or spurious) in private collections. Of those which view the scene from a slightly different angle the finest is probably that in the Norton Simon collection, Pasadena, California.

The versions vary according to the season and time of day at which they were painted: the present one depicts the scene at twilight. Not all were painted on the spot: most were done to satisfy the demand for repetitions, and of course cannot be dated. Throughout his career Courbet continued to paint this scene, a version of which was publicly shown for the first time at the World Exhibition of 1855 (no.2810).

Paris, Musée du Louvre.

89
The rivulet of Puits Noir

Le ruisseau du Puits Noir (92)

Canvas: 80 × 100. Signed lower right: *C. Courbet.*

History: Mme Béraldi coll.; given by the previous owner to the Musée des Augustius, *c.*1912.

Exhibitions: 1952, Besançon, no.31; 1969–1970, Rome–Milan, no.22.

One of Courbet's many variations on this theme (cf. 88).

Toulouse, Musée des Augustins.

90
The sleepers

Le sommeil (95)

1866

Canvas: 135 × 200. Signed and dated, lower right: *G. Courbet . .66.*

History: Commissioned from the artist by Khalil-Bey in 1866; sold by the previous owner to the singer Faure after 1868; sold by the previous owner to a Swiss surgeon, Auguste Reverdin, through the intermediary Léon Massol; Valotton coll., Switzerland; acquired from the previous owner by the Petit Palais in 1953.

Exhibitions: 1878, Paris, no.25; 1935–1936, Zurich, no.88; 1950, La Tour de Peilz, no.25; 1954,

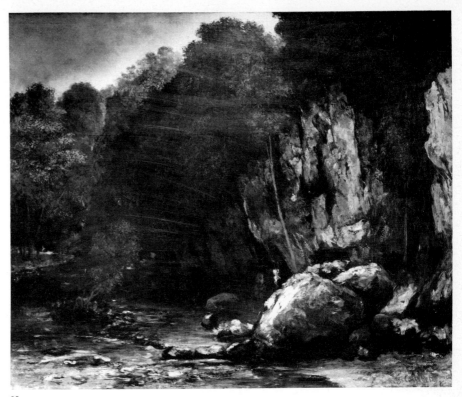

89

Lyon, no.37; 1955, Paris, no.68; 1959–1960, Philadelphia–Boston, no.59; 1968–1969, Paris, no. 229; 1969–1970, Rome–Milan, no.31.

Bibliography: Pérot, no.31.

Sainte-Beuve described *Venus and Psyche* (cf. 144) to Khalil Bey in such glowing terms that he asked to see it and then begged the artist to make him a copy. Courbet replied: 'No, I'll do something else for you'; or, according to another version 'No, I'll do you a picture called *Afterwards.*'

Khalil Bey, formerly Turkish ambassador in St Petersburg, was a wealthy pleasure-lover and connoisseur with a salon in the rue Taitbout, at the corner of the boulevard des Italiens. Before his taste for Paris life reduced him to poverty he acquired many fine contemporary paintings. He was the first purchaser of Ingres's *Turkish bath* (Louvre) which, together with the present work, gives a good idea of the type of subject he preferred.

Courbet, who painted this picture in 1866, used Jo, the beautiful Irishwoman (87), for his red-headed model. The brunette, as can easily be seen, is the same as in the lost *Venus and Psyche* with its existing variant *The awakening* (144); she also appears in *Reflection* (71) and *Woman with a cat* (72).

The picture is also known as *Sleepers, Two naked women, Les amies* and *Idleness and sensuality* (*Paresse et luxure*). It looks back to the Venuses and Danaës of ancient times, and the theme is treated in the same sumptuous style as that used by great masters of the past. These nudes, the most carnal if not the most sensitive ever painted by Courbet, transport us into a dream – or a nightmare, to judge from the look of pain on the face of the auburn-haired girl. Naturalism turns into unreality in this picture with its seraglio atmosphere (Courbet, as we have seen, identified with his models, and perhaps with his customers also?); what is presented to us is not pro-

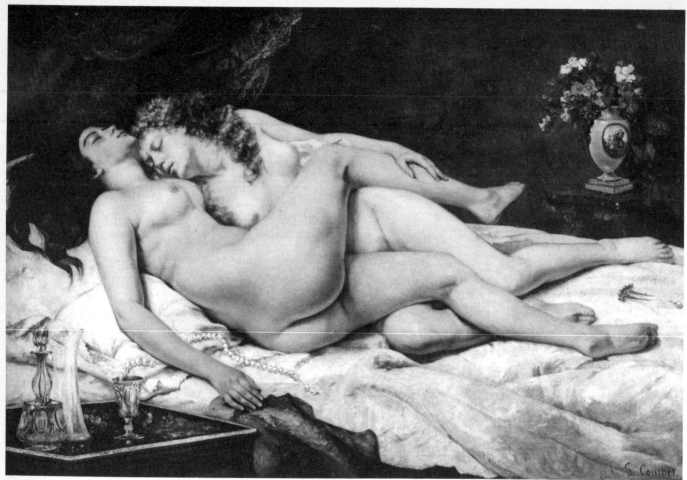

90

saic reality but the visions of the sleeping women. The dazzling blue of the two still lifes is part of the hallucination. The bunch of flowers on the unlikely side-table appears as if poised in mid-air. The square table and the vases on it are fascinating in their ugliness and morbid luxury. Here again Courbet, realist though he was, cannot help expressing himself in allegorical terms, as Castagnary often pointed out. Remorse or absolution is signified by the broken string of pearls trailing from the crystal goblet, in the same way as a snake emerges from the poisoned chalice in old pictures of the legend of St John the Evangelist.

Lesbian loves appear to have fascinated Courbet from an early age. A sketch of 1841 or 1842 shows two women embracing in a bed; they are fully dressed, which adds to the suggestive effect (Louvre, Cabinet des dessins; RF 29234, fol. 22 recto). Later the theme is repeated in *Women in a cornfield* (1855, Lyons Museum), and it culminates in *Venus and Psyche* and in the present work.

Paris, Musée du Petit Palais.

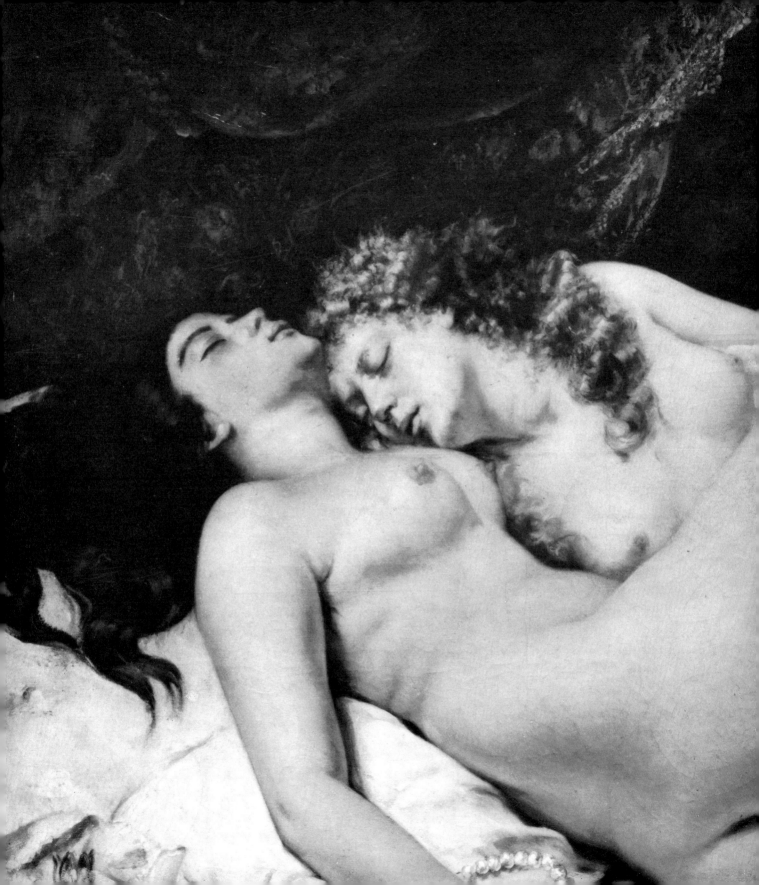

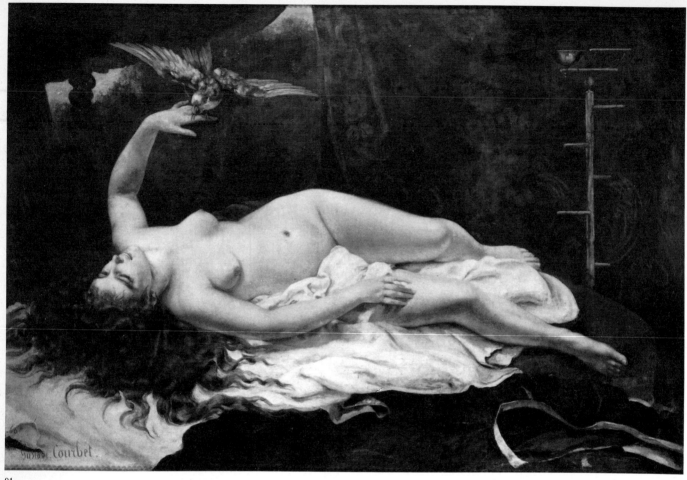

91

91
Woman with a parrot, Paris

La femme au perroquet, Paris (96)

1866

Canvas: 129 × 195. Signed, dated lower left: ..66 Gustave Courbet.

History: Bought from the artist by Jules Bordet of Dijon in 1870, still in his possession in 1889; bought by H. O. Havemeyer in 1919; bequeathed by Mrs Havemeyer in 1929 to the Metropolitan Museum.

Exhibitions: 1866, Paris, Salon, no.463; 1866, Brussels, no.144; 1867, Paris, no.10; 1869, Munich; 1870, Dijon; 1882, Paris, no.13; 1889, Paris, no.210; 1919, New York, no.24; 1930, New York, no.21; 1932, London, no.436; 1956, Cleveland, no.8; 1959–1960, no.60.

Bibliography: Caricature by Cham in *Le Charivari*, May 1866 (repr. in Léger, 1920, p.61); Sterling-Salinger, pp.124–7; L. Chamson-Mazauric, *Comment on perd un tableau* in *La Revue du Louvre*, 1969, no.1, oo.27–36.

Bruno, 1872, *Isaure caressant son perroquet*, p.169.

With this picture, submitted to the Salon of 1866 together with *Covert of roedeer* (92), Courbet became a popular favourite. It was felt that he was at last settling down and that the revolutionary in him was being conquered by the artist. Nevertheless, apart from Théophile Gautier who admired the present work, Salon critics censured it on the ground of careless drawing and the banality of the subject.

Second Empire society had a pronounced taste for pictures of naked women recalling the Venuses, bacchantes and nymphs of the Renaissance and the *grand siècle*. Cabanel's *Birth of Venus* (Louvre) and Paul Baudry's *The pearl and the wave* (Prado; cf. 104) were bought by the Imperial couple at the Salon of 1863, and were thought to represent art at its apogee. For the same reason Jules Troubat, in 1878, accused Courbet of having bowed too much to popular taste at this period (p.254).

Certainly there were plenty of contemporary models. In the Musée du Luxembourg Courbet could see the *Death of Cleopatra* by his fellow-countryman Gigoux, with exactly the same dimensions as his own painting, the composition being reversed and the parrot replaced by an asp (Salon of 1851; Chambéry Museum; Lacambre, 1974, no.96). One of the successes of the 1864 Salon was Reisener's *Erigone* (Louvre).

'Artistic' photographers followed suit; Aaron Scharf (pp.132–133), basing himself on a precedent, offered a photograph of a woman with loosely-falling hair as a model for a painting. In 1858 Courbet actually used a photograph as the model for his *Lady of Munich* (cf. 55), a nude on a bed, similar to the present work. From about that time onwards nudes of this sort were no longer considered shocking, although great scandal had been caused at the Salon of 1847 by the sculpture of a *Woman bitten by a snake* (Louvre), in which Clésinger had portrayed the charms and temperament of Mme Sabatier. Courbet's red-headed woman, who herself seems about to bite, was not calculated to reassure the prudish, but by that time Proudhon was no longer there to strike a moral note.

According to legend this picture was inspired by Thoré who, admiring Courbet's sleeping Psyche (cf. 144), said to the artist one day: 'Ah, if you were to wake her up and stretch out her legs and make her lift up her arm with a flower or a bird perched on it, or something like that, what a charming picture it would be!' Courbet set to work in his Paris studio in the rue Hautefeuille, and gave free rein to his fondness for plumage and for mops of blonde or auburn hair. In 1861 he had already introduced a dazzling macaw into the *Portrait of a woman* (no doubt Solange Clésinger, daughter of George Sand; Paris, private collection).

The *Woman with a parrot* led to a quarrel between Courbet and Nieuwerkerke, the Superintendent of Fine Arts, who had complimented the artist at the Salon and given him the impression that he would buy the work for the state. Either Courbet misunderstood or Nieuwerkerke changed his mind, as he afterwards denied having any such intention. As a result, Courbet's attitude towards the government was further exacerbated for a long time.

A picture showing only the woman's head was bought from Courbet in 1873 by the Durand-Ruel gallery. Charles Sterling and Margaretta Salinger mention a copy of *Woman with a parrot* by Pata.

New York, Metropolitan Museum of Art.

92
Covert of roe-deer by the stream of Plaisir-Fontaine, Doubs

La remise de chevreuils au ruisseau de Plaisir Fontaine, Doubs (97)

1866

Canvas: 174 × 209. Signed, dated lower left: . .66 Gustave Courbet.

History: Bought from the artist by the exchange broker Lepel-Cointet in 1866; Lepel-Cointet sale, Paris, 1881; Laurent-Richard coll.(?); Secrétan sale, Paris, 1889, no.6; bought from the previous owner by an association of art lovers to be offered to the Musée du Louvre; entered the Louvre, 1890.

Exhibitions: 1866, Paris, Salon, no.464; 1882, Paris, no.61; 1883, Paris, no.14; 1889, Paris, Exposition Universelle; 1932, London, no.319; 1959–1960, Philadelphia–Boston, no.62; 1974, Rochechouart, no.9.

Bibliography: Bruno, 1872, *La remise de chevreuils*, p.40.

It has been suggested that Courbet wished to extend an olive branch to the Academicians, with whom he was constantly feuding, by submitting for the 1866 Salon this painting and *Woman with a parrot* (91). H. d'Ideville, who went to see him shortly before the Salon, remarked that no one could interpret the *Covert* as a 'humanitarian [i.e. subversive] manifestation': to which Courbet replied laughingly 'No, unless "they" think it's a secret society of roedeer meeting in the forest to proclaim a republic!' (Courthion, I, p.213).

The picture was a great success at the Salon and was immediately purchased by the broker Lepel-Cointet. After the sale Nieuwerkerke attempted to obtain it on behalf of a 'private individual' (Chennevières, pp.43–44) who, we now know, was the Empress herself.

'I've slaughtered "them" at last!' Courbet wrote to Cuenot: 'all the painters, all painting is turned upside-down. Nieuwerkerke sent me word that I had produced two masterpieces and that he was delighted. All the jury said the same, and no one had any objection to offer. Beyond all question I am the great success of the exhibition. They talk of giving me a medal of honour, or the cross of the Legion of Honour. The landscapists are flat on their backs. Cabanal was complimentary about the *Woman [with a parrot]*, and so were Pils and Baudry. I've been telling you for a long time that I was preparing a knock-down blow like this, and now I have delivered it!' (Courthion, I, p.222).

Courbet could not bring himself to regard praise from 'them' as other than a sign that his enemies were nonplussed and defeated. It would have hurt his pride too much to think that he had painted a picture that genuinely pleased the Academy and its supporters. It had to be a 'knock-down blow'; above all, no one must be able to accuse him of making concessions.

His letter to Cuenot goes on to describe the painting. 'It's a stream shut in by rocks and big trees: everything is light in colour. This winter I hired some deer and made it into a covert: there's a little doe in the middle, like a lady receiving company in her drawing-room. Her mate stands beside her, it is all quite delightful and they are finished like diamonds' (*op. cit.*, p.215).

Thoré teased his friend in a review of the Salon. 'Who would have thought that Courbet would be the great unanimous success of the Salon of 1866! Well, my dear friend, you are done for now, your good times are over! You will miss the little student's room in the rue Saint-Jacques where your old friend, the critic who had applauded the impetuous Romantics, used to go twenty years ago to try and guess what the wild young man from the Vosges was plotting!' (Thoré, *Salon de 1866*, repr. in Courthion, I, pp.215–16). But in fact a series of disappointments was in store for Courbet. *Woman with a parrot* was not bought by the State as he had hoped and expected; nor was he given a chance to refuse any cross or medal, as he had vowed he would do. His efforts were unrequited, and the effect was to redouble the resentment he had felt when 'Monsieur Napoléon' struck his name off the Legion of Honour list five years earlier. These 'knock-down blows' from those he had 'slaughtered' were an injury he never forgave.

92

The *Covert* was painted over a picture which Courbet had begun for the Salon of 1854: *The fount of Hippocrene*, a satire in doubtful taste on the poets Lamartine, Nerval, Baudelaire and Monselet and the song-writers Gustave Mathieu and Pierre Dupont. The canvas, insecurely balanced on an easel, had fallen and been badly torn. It was imperfectly repaired, and the tear can still be seen although a thick coating of paint was spread over the previous work; this acts as a barrier to X rays, so that the exact composition of *The fount of Hippocrene* will never be known.

The landscape of the *Covert* was painted at Ornans: Plaisir-Fontaine is a limpid stream which flows into the Brème up-river from the Puits Noir. The deer were added in Paris. Courbet painted innumerable repetitions to satisfy his customers. None is so important as the original, but the one in the Musées Royaux des Beaux-Arts in Brussels comes closest to it of all the versions known to us: it has the same clarity and freshness, and shows the animals in the same attitudes.

Paris, Musée du Louvre.

93

93
The comte de Choiseul's greyhounds

Les lévriers du comte de Choiseul (98)

1866

Canvas: 89 × 117. Signed, dated lower left: *. .66 G. Courbet.*

History: Comte de Choiseul coll.(?);

Everard sale, London, 1873(?); Juliette Courbet coll. (again in 1906; Riat, p.245); De Knypper sale, Paris, 13 May 1897, no.18; sale, Paris, Charpentier, 12 June 1953, no.34; Rosenberg Gallery, New York; Mrs Mark C. Steinberg coll., Saint Louis; given by the previous owner to the City Art Gallery.

Exhibitions: 1867, Paris, no.124 (property of comte de Choiseul); 1870, Le Havre (*Les deux chiens*); 1854, Chicago, no.10; 1855, Paris, Orangerie, no.12; 1956–1957, Providence; 1957, New York, no.6; 1959–1960, Philadelphia–Boston, no. 57; 1964–1965, Munich, no.52; 1973, Saint Louis.

Bibliography: Bruno, 1872, *Les lévriers*, p.24.

Courbet revisited the Normandy coast in the summer of 1866, when the comte de Choiseul invited him to stay in his villa at Deauville. In letters to his family the painter described, not without vain-glory, the elegance of the nobleman's home and the attentions lavished on himself.

As we have seen (cf. 82), Courbet at Trouville had developed a late vocation as a society portrait-painter. He now, for the first time, painted aristocratic representatives of the animal world – a change from solid, reliable mastiffs and from his mistresses' lapdogs. There is a delightful humour in his treatment of the pointed muzzles, the slender legs, the sly, wary expression and the reserved, solemn attitude of these highly-bred creatures; it was also ingenious to emphasize their tallness by painting them from a low angle.

The history of this painting is somewhat confused, as there must have been two versions. In 1867 Courbet exhibited a picture of *Greyhounds*, indicating that they belonged to the comte de Choiseul, and this work figured in a London sale of 1873. But Juliette Courbet owned a picture of *Hounds belonging to M. de Choiseul*, included in the list of canvases with which she proposed to found the Courbet Museum at Ornans (Bibliothèque Nationale, Estampes, Box II). In the note on the history of the painting, we have included all information relating to either painting, as it is impossible in some instances to be certain which is which.

Saint-Louis, Art Museum.

94

Fishing boats on the beach at Deauville

Barques de pêche sur la plage de Deauville (99)

1866

Canvas: 46 × 60. Signed, dated lower left: *..66 G. Courbet*

History: Acquired from the artist by the Comte de Choiseul; Galerie Alfred Daber, Paris; private coll., Lausanne.

Exhibitions: 1958, Paris, no.14; 1959, Paris, no.32; 1962, Ornans, no.25; 1962, Berne, no.44; 1975, Paris, no.9.

Bibliography: François Daulte, *L'art français des XIX^e et XX^e siècles dans les collections suisses* in *Le jardin des Arts*, 1959, no.54, repr., p.372.

Few boats appear in the many 'sea landscapes' that Courbet painted during two successive summers at Trouville, or in the numerous repetitions characteristic of his work at this period. The beauty of this canvas is enhanced by the rarity of its theme.

Lausanne, private collection.

96

Deer-hunting in the Franche-Comté

Le change, épisode de chasse au chevreuil, Franche-Comté (100)

1866

Canvas: 97 × 130. Signed, dated lower left: *..66 Gustave Courbet.*

History: Paton coll., Paris; Drake del Castillo, Paris; bought from the previous owner by Galerie Durand-Ruel, 3 November 1917; re-sold the same year to the Galerie Bernheim-jeune; Heilbuth coll., Copenhagen.

Exhibitions: 1867, Paris, no.40; 1882, Paris, no.94; 1918, Paris, no.13; 1917–1918, Paris, no.13; 1918, Geneva, no.39; 1923, London, no.21; 1935–1936, Zurich, no.93; 1949, Copenhagen, no.19.

Of the many scenes of hunting in the snow, painted by Courbet at Ornans in the winter of 1866–1867, the biggest (in fact his last monumental picture) but the least interesting is *The kill* (*L'hallali du cerf*; Besançon Museum); the most modern and perhaps the most skilful is *Hunters training hounds* (99); and the most moving is the present one, sometimes called *The alert* or *Does fleeing*, but most often (in French) *Le change* (see below). At his exhibition in 1867 Courbet gave it the full title *Le change, épisode de chasse au chevreuil, Franche-Comté.*

Le change is the name given to a ruse practised by two animals fleeing together over snowy ground, when the one behind plants its hoofs in the tracks made by the other, so that the huntsman thinks he is pursuing a single quarry (hence the idiom *donner le change*, to mislead or sidetrack).

Courbet, who excelled at painting sudden immobility and interrupted movement, here succeeds marvellously in depicting rapid flight: the movement of the deer recalls the galloping horses in Géricault's *Derby at Epsom* (Louvre). Their

94

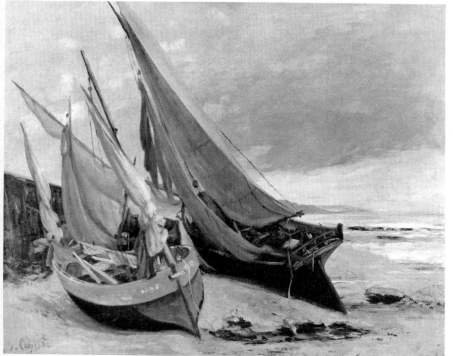

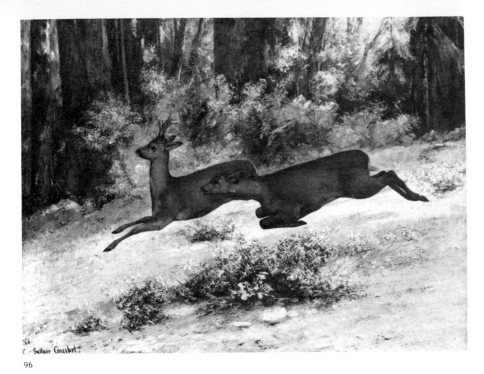

96

This is one of the finest specimens of a genre which Courbet practised extensively to meet the demand from his admirers. From 1855 until his death he continued to produce landscapes of snow-covered forests from his native Franche-Comté and to people them with stags, hinds or roedeer.

Lyons, Musée des Beaux-Arts.

99
Huntsmen training hounds near Ornans

Les braconniers, Ornans (102)

1867

Canvas: 102 × 122. Signed, dated lower left: *Gustave Courbet . . 67.*

History: Dreyfus de Gonzalès sale, Paris, 1896, no.20; François de Curel coll.; sale, Palais Galliera, Paris, 21 June 1961; private coll., Berne;

onward rush is further accentuated by the vertical tree-trunks which form the background.

Copenhagen, Ordrupgaard Museum.

97
Roe-bucks in shelter in the winter

Remise de chevreuils en hiver (101)

*c.*1866

Canvas: 34 × 72·5. Signed lower left: *G. Courbet.*

History: Hecht coll. (1882); Joseph Gillet coll.; given by the previous owner to the Musée de Lyons in 1883.

Exhibitions: 1882, Paris, no.105; 1935–1936, Zurich, no.94; 1949, Copenhagen, no.20; 1950, Belgrade, no.24; 1950, La Tour de Peilz, no.28; 1952, Besançon, no.32; 1953, London, no.28; 1954, Venice, no.35; 1954, Lyon, no.34; 1955, Paris, no.69; 1957, Annecy, no.13; 1959–1960, Philadelphia–Boston, no.63; 1961, Wolfsburg, no.33; 1962, Berne, no.49.

97

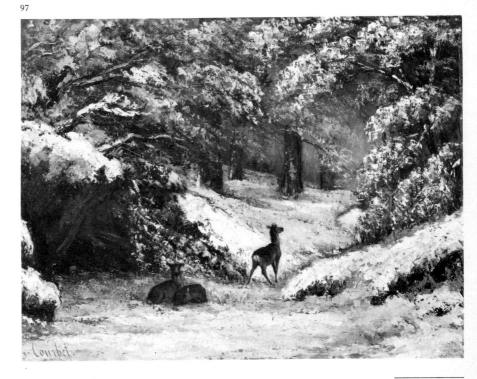

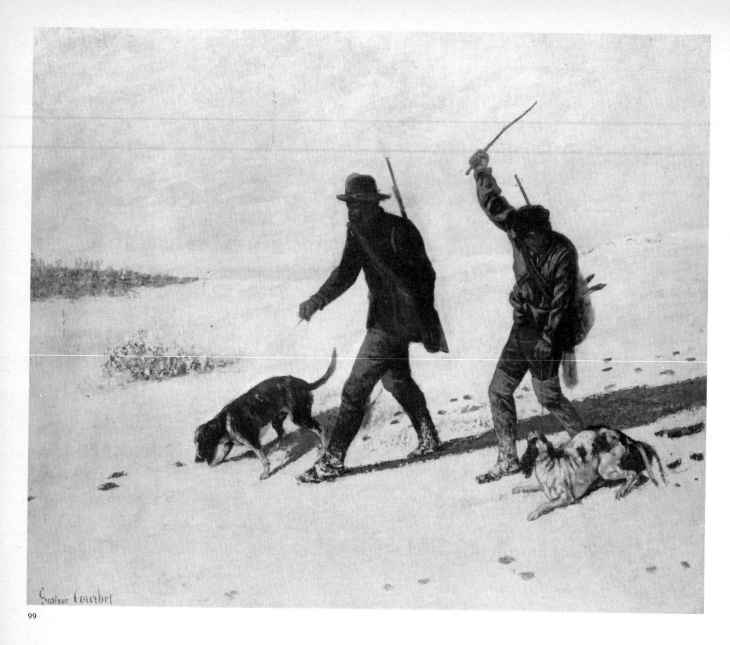

Gustave Courbet.

99

O'Hara Gallery sale, London, June 1964; private coll., Italy; entered the Galeria Nationale d'Arte Moderna in 1970.

Exhibitions: 1867, Paris, no.37; 1889, Paris, no.208; 1962, Ornans, no.27; 1962, Berne, no.52; 1969–1970, Rome–Milan, no.32.

Bibliography: Toussaint, no.32.

Bruno, 1872, *Les chasseurs dans la neige*, p.9.

The title *Les braconniers* is here used in the rare sense given above; the usual English translation *Poachers* is incorrect.

Courbet spent most of the winter of 1866–1867 at Ornans. The snow was particularly heavy that year in Franche-Comté, and he painted numerous landscapes mentioned in his letters to Castagnary (Bibliothèque Nationale). Many are animated by hunting scenes, e.g. *The kill* (Besançon Museum, his last very big canvas) and *Mounted huntsman finding the trail* (New Haven, Conn., Yale University Art Gallery).

The first winter scene painted from nature in a realistic style dates from about twenty years earlier: it is *Hoarfrost*, painted by Théodore Rousseau at L'Isle-Adam in 1846 (Baltimore, Walters Art Gallery). But Courbet was an innovator in his way of treating the rich luminosity of snow. As he said to Castagnary: 'Look at the shadow of the snow, how blue it is!' (Courthion, II, p.61). At the Salon of 1857 he had already presented a winter hunting scene, *Doe*

exhausted in the snow (former collection Douville-Maillefeu), but here he shows an exceptional mastery in the handling of space. The depth of the atmosphere and the immensity of the waste, featureless plain are conveyed by a precise sense of values and the skilful use of simple lines. The vibrant sky and the dazzling white expanse of ground broken by coloured shadows form a glittering contrast to the rhythmic stability of the dark figures. Courbet here shows his mastery of both painting and draughtsmanship.

This new mode of vision, in which shadows are given the iridescence of bright colours, is one which later fascinated the Impressionists.

The Besançon Museum possesses a snowy landscape with the same figures; its attribution to Courbet is probably somewhat hazardous.

Rome, Galleria Nazionale d'Arte Moderna.

100
The poor women of the village, Ornans

La pauvresse du village, Ornans (103)

1867

Canvas: 86 × 126. Signed, dated lower left: *. .66 G. Courbet.*

History: Sold by the artist to M. Laurent-Richard, 1867; private coll., Frankfurt-on-Main (1935).

Exhibitions: 1867, Paris, no.38; 1935–1936, Zurich, no.92; 1941, Los Angeles, no.20.

Bibliography: Bruno, 1872, *La veuve au fagot*, p.161.

According to Gerstle Mack (p.216) this picture, dated 1866, was in fact painted in the following spring. Also called *The goatherd*, it is somewhere between a landscape and a genre scene and resembles an illustration to a fairy story. The dark figures against the snow recall the winter

100

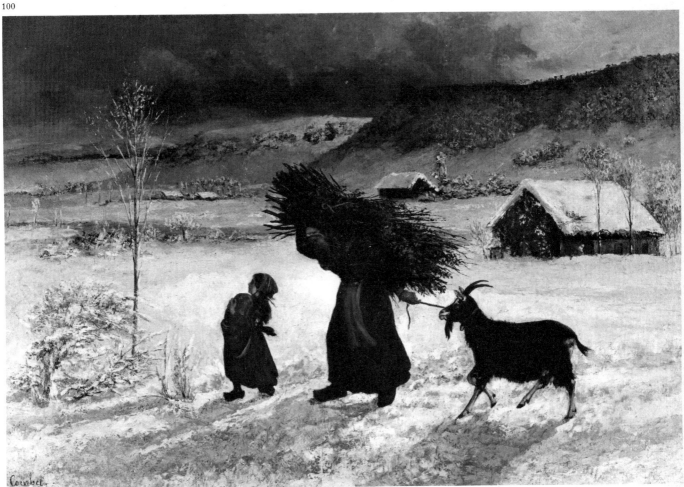

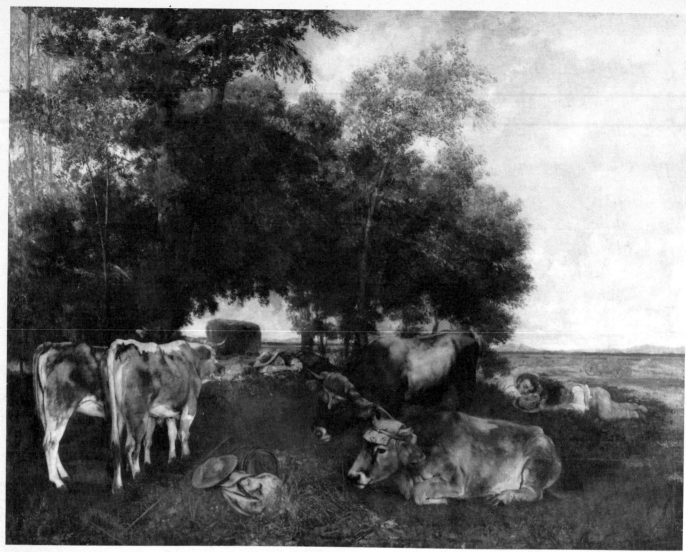

101

scenes of the elder Brueghel, but the frieze-like composition relates it to *Huntsmen training hounds* (99).

Courbet, as this picture shows, was much moved by the theme of poverty, which he treated on many occasions: sometimes in the context of exploitation, sometimes in that of almsgiving. To the former category belong *The stone-breakers* (1849, Dresden Museum; destroyed in the second world war), the poverty-stricken Irishwoman in *The studio* (137) and the wretched

woman in the present work, bent under the weight of a bundle of firewood – her only hope of keeping out the winter cold. Examples of charity are the *Young ladies of the village* and *The charity of the beggar at Ornans* to one even poorer than himself (1868; cf. 108).

Private collection.

101
Siesta at haymaking time (mountains of the Doubs)

La sieste pendant la saison des foins (montagnes du Doubs) (105)

1867

Canvas: 212 × 273. Signed, dated lower right: *G. Courbet . 68.*

History: Bought by the City of Paris at the Courbet sale, Paris, 1881, no.21.

Exhibitions: 1869, Paris, Salon, no.572; 1882, Paris, no.59; 1900, Paris, no.144; 1929, Paris, no.60; 1937, Paris, no.279; 1941, Los Angeles, no. 22; 1947–1948, Brussels, no.72; 1949, Copenhagen, no.24; 1950, La Tour de Peilz, no.30; 1951, Amsterdam, no.28; 1955, Paris, no.70; 1958, Munich, no.25; 1969, Minneapolis, no.18; 1977, Paris, p.79.

Bibliography: Caricatured on the occasion of the 1869 Salon (Léger, 1920, p.85).

Bruno, 1872, *Les Prés-Bas*, p.32.

On 28 April 1867, while staying with Dr Ordinaire, Courbet wrote to Castagnary that he was working on 'a haymaking scene with oxen, which will be just as good as the roedeer' (Bibliothèque Nationale, print-room, Box V). 'The roedeer' was a reference to *The covert* (97), which was such a success at the 1866 Salon.

The faces of the two lads asleep on the right are those of Dr Ordinaire's sons, Marcel and Olivier. History does not say who the girl in the centre is. Originally there was another woman asleep in the foreground, where there is now a hat, a sack and a small barrel. We do not know when the artist made this change, but it is subsequent to the cartoon drawn at the time of the Salon of 1869.

Thirteen years after *Return from the fair* (41) Courbet thus reverts to the theme of a rustic scene with livestock. This, of course, goes back to seventeenth-century Holland, but the genre was so fashionable with nineteenth-century artists, such as Troyon, that its earlier origin was forgotten. The Swiss realist painter Rudolf Koller (1828–1905), who studied in 1847–1848 under Suisse in Paris, whom Courbet probably met at that time and whom he may have revisited during his travels in Switzerland, painted a similar *Siesta* in 1860 (Zurich, Kunsthaus); it is hard not to believe that this work and Courbet's are connected.

Critics of the 1869 Salon were un-enthusiastic about Courbet's offering, which consisted of this work and *The kill* (Besançon Museum; Courbet's last enor-mous painting, measuring 3·59 by 5·08 m). We may agree with them as to the latter, which is insufficiently compact, but the *Siesta* deserves higher praise for the modernity with which it treated what was already a well-worn theme. The broad schematization and the arbitrary distribu-tion of flickering patches of light, are remi-niscent of Monet's *Déjeuner sur l'herbe*, a work in which Courbet himself is depicted (1865–1866, Louvre – Jeu de Paume; Moscow, Pusahkin Fine Arts Museum).

Paris, Musée du Petit-Palais.

102
Lady with jewels

La dame aux bijoux (*106*)

1867

Canvas: 81 × 64. Signed, dated lower right: ..*67 Gustave Courbet.*

History: Offered by the artist to Jules Castagnary while painting the picture; bequeathed by the previous owner to his widow in 1888; sold by the previous owner in 1901 to Galeries Durand-Ruel and Bernheim-jeune who each held a half share; bought entirely by Galerie Durand-Ruel in 1918; re-sold by the previous owner to Galerie Bernheim-jeune in 1921; private coll.; bought by the Musée de Caen in 1975.

Exhibitions: 1867, Paris, no.99 (*La dame aux bijoux*, Paris, 1866); 1868, Gand; 1878, Paris, no.31 (*La femme aux perles*); 1882, Paris, no.25; 1919, Paris, no.8.

Bibliography: Caricature by Randon in *Le Journal amusant*, 15 June 1867 (Léger, 1920, p.70); M. Th. de Forges *Un nouveau tableau de Courbet au Musée des Beaux-Arts de Caen* in '*La Revue du Louvre*', 1976, no.5/6, pp.408/410, fig. 2.

Bruno, 1872, *Lady Robertson*, p.81.

Recently purchased by the Caen Museum, this picture was previously lost to sight for many years. Marie-Thérèse de Forges (*op. cit.*) has shown on the basis of

102

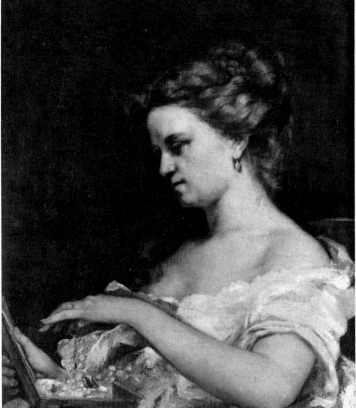

Randon's caricature of 1867 (*op. cit.*) that it is definitely the same as the work with this title in Courbet's one-man show at the Pavillon de l'Alma. Though it bears the date 1867 it may well have been painted, as the catalogue says, in 1866: Courbet, when exhibiting pictures, often painted on them the date of the current year.

The picture was again exhibited at Ghent in 1868, when a lady whose name is unknown to us expressed a desire to buy it. It was then the property of Castagnary, to whom Courbet wrote on 6 October: 'Mme [name illegible] . . . wants to buy the *Lady with jewels* . . . also the *Roedeer by a stream* . . . As to the *Lady*, sell her if you wish and I'll paint something else for you; it's your affair, she belongs to you' (Bibliothèque Nationale, Estampes, Courbet papers, Box I; Forges, *op. cit.*). Castagnary replied on 12 October: 'Thanks for your permission. But I am definitely not selling the *Lady with jewels*, (1) because I do not want to trade in a friend's gifts and (2) because I have an affection for the subject' (private archives). As Riat discreetly informs us (p.246), the *Lady* was in fact Castagnary's mistress. We do not know her name; the picture represents her as having just sprung out of bed, in a scene reminiscent of Marguerite in Gounod's opera.

Here again Courbet, with his fondness for auburn hair and pearly flesh, had found a model well suited to his purpose. Castagnary, who described Courbet as 'chaste, modest and virtuous' (Courthion, I, p.185), apparently felt he could safely allow his mistress to pose for him in a seductive négligé. We may, in any case, once again admire Courbet's psychological finesse as a portrait-painter: to depict the lady's voluptuous charms he recaptures the sensuality and emotional power of a Jordaens or of the Venetian Renaissance. In addition he is a painter of morals, illustrating in this individual figure all the feminine luxury of the heyday of the Second Empire.

We suggest that the same model posed for Courbet's *Portrait of Mme M.*, sold on 21 March 1963 by Galliera, Paris (no.60).

Caen, Musée des Beaux-Arts.

103
The source

La source (107)

1868

Canvas: 128 × 97. Signed, dated lower right: *. .68 Courbet Gustave.*

History: Juliette Courbet coll.; inherited from the previous owner by Mmes de Tastes and Lapierre; Courbet sale, Paris, 1919, no.9; bought by the Musée du Louvre.

Exhibitions: 1869, Brussels, Salon (*La source*)(?); 1882, Paris, no.19 (*Baigneuse vue de dos*); 1900, Paris, no.148 (*La source*); 1928, Copenhagen, no.29; 1928, Oslo, no.23; 1928, Sgockholm, no.24; 1929, Paris, no.50; 1935–1936, Zurich, no.100; 1949, Copenhagen, no.23; 1953, Brussels, no.27; 1953, Compiègne, no.60; 1954, Venice, no.37; 1955, Paris, no.71; 1965, Lisbon, no.32; 1969, Ornans, no.26; 1969–1970, Rome–Milan, no.34.

Bibliography: Forges, 1969, no.34.

We cannot be sure that this is the picture of the same title shown at the Brussels Salon in 1869; that too was of a female nude, but some descriptions of it do not tally with the present work. Castagnary, however, noted in pencil 'The spring' in the margin of his cagalogue of the 1882 Exhibition, opposite the entry which does refer to this work. It was also under that title that Juliette Courbet lent it to the Centennial Exhibition of 1900 (Forges, *op. cit.*). We may therefore safely call it 'The spring', a title which Courbet certainly chose himself and on which we should dwell for a moment.

The symbolic link between women and gushing water has been a theme for artists in all ages and was often treated by Courbet. It already appears in his *Sculptor* of 1845 (9) and, soon afterwards, in *Woman asleep beside a brook* – actually a spring (Winterthur, Oskar Reinhart collection; replica at the Detroit Art Institute); then came the *Spring* in the Metropolitan Museum, New York (1861?), which Charles Sterling and Margaretta Salinger, surprised by the title, believe to have been a reply to Ingres's *Spring* (1856, now in the Louvre; exhibited in 1861 at the Galerie Martinet) (Sterling-Salinger, p.121). The theme is different from that which unites women and the sea, as in *Woman in the waves* (106), which derives from the figure of Amphitrite.

It is interesting that Courbet constantly has recourse to a mythological motif; although a realist, he is full of lyricism and the urge to express abstract ideas. In this he differs from contemporaries such as Bonvin, Ribot and Legros who is a pure realist even in his religious pictures.

A painting like this, one of Courbet's finest nudes, may be compared with the *Bathers* at Montpellier (30), of which we have emphasized the irrational aspect, or with the *Three bathers* in the Petit Palais, those naiads who defy the laws of reason and gravitation; at the same time it is in line with the fashionable productions of Cabanel, Bouguereau, Baudry or Jules Lefebvre. Courbet differs from these, however, by the breadth of inspiration replacing frigid academicism, and by a sense of idealization that is all his own. We certainly feel a special emotion in contemplating this descendant of Rubens's nymphs – or 'super-Velázquez', as Courbet called her (Léger, 1929, p.142). Despite the realism of her flesh and of the corset-pinched figure, she belongs to a legendary world of imagination. We do not feel that we are looking on at an actual scene such as, for example, that of Millet's *Goose-girl bathing* (1863, Baltimore, Walters Art Gallery).

X-ray photography in the Laboratoire des Musées de France has shown that the work is painted over an earlier picture, also of a female nude.

Paris, Musée du Louvre.

104
Female nude

Femme nue (108)

1868

Canvas: 46 × 55. Signed, dated lower left: *. .68 G. Courbet.*

History: Galerie Bernheim-jeune, Paris; Rosenberg Gallery, Paris, New York; bought by Louis E. Stein in 1953.

Exhibitions: 1917, Paris; 1927, Paris; 1929, Paris, no.44; 1934, New York, no.9; 1935–1936, Zurich, no.103; 1937, Paris, Rosenberg, no.15; 1938, London, no.15; 1956, New York, no.15; 1959–1960, Philadelphia–Boston, no.66; 1962–1963, New York, Brooklyn, no.22.

Bibliography: *Philadelphia Museum of Art Bulletin*, Spring 1964, vol. LIX, no.281, *Stern Collection*, repr., p.91.

We may wonder if this poetic little picture was a reply to Paul Baudry's *The*

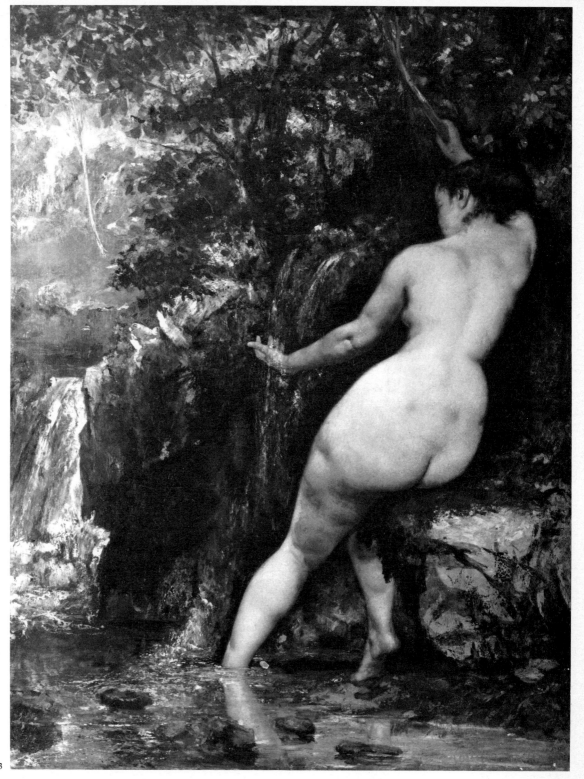

103

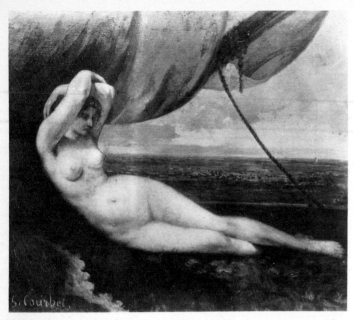

104

106

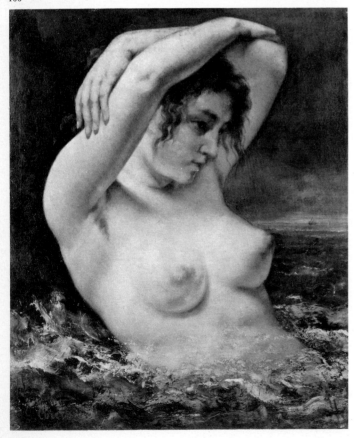

pearl and the wave, an academic composition inspired by a Persian tale and exhibited at the 1863 Salon. Baudry's work, now in the Prado at Madrid, was a popular success and was bought by the Empress. It shows a naked woman lying on the beach, her arms lifted above her head; the nacreous sheen of her body blends with that of the sea.

The pose of Courbet's model may also have been influenced by the odalisque on the right in Ingres's *Turkish bath* (Louvre), sold by the artist to Khalil Bey in 1865 and resold by him in January 1868: it was for Khalil Bey that Courbet painted *Women asleep* (90). René Huyghe makes an interesting comparison between Courbet's nude and Corot's *Bacchante by the sea* (1865, New York, Metropolitan Museum; Huyghe, p.270).

Courbet's *Woman in the waves* (106) also dated 1868 by him, shows the torso of the same model rising out of the sea.

Philadelphia Museum of Art, Louis E. Stern Collection.

106
Woman in the waves

La femme à la vague (109)

1868

Canvas: 65 × 54. Signed, dated lower left: *..68 G. Courbet.*

History: Faure coll. (1882); sold by the previous owner to Galerie Durand-Ruel, 9 January 1893; re-sold by the previous owner to Durand-Ruel Gallery, New York, 1919; acquired by H. O. Havemeyer, New York, 1919; bequeathed by Mrs Havemeyer to the Metropolitan Museum, New York in 1929.

Exhibitions: 1868, Gand; 1870, Brussels, no.143; 1882, Paris, no.24; 1919, New York, no.31; 1930, New York, no.33; 1958, Munich, no.26; 1919–1960, Philadelphia, Boston, no.67.

Bibliography: Sterling-Salinger, pp.130–131.

André Fermigier writes of this picture: '. . . a sort of Venus Anadyomene, dripping with pearly spray, who reminds us of Titian and of romantic nudes; she also foreshadows Renoir, who owed so much to Courbet in his youth and afterwards'.

The small nude in the Stern Collection (104) shows the same woman, with her arms in the same position, stretched out on

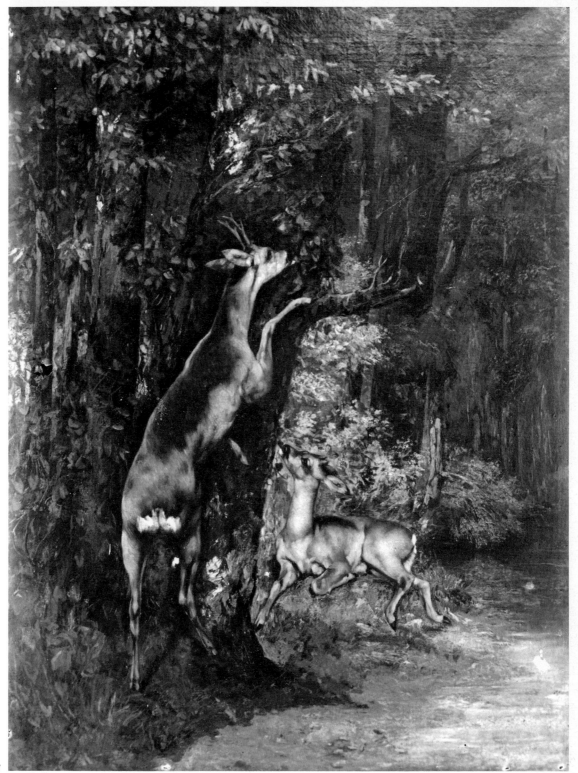

107

the deck of a ship. The model can easily be recognized as the brunette in *The awakening* (144); we suggest that it is also she who figures in *Reflection* (71) and *Woman with a cat* (72).

New York, Metropolitan Museum of Art.

107
Roebuck and doe in the forest

Chevreuil et chevrette dans la forêt (110)

1868

Canvas: 130 × 97. Signed, dated lower left: *..68 Gustave Courbet.*

History: Galerie Durand-Ruel, Paris, given by James J. Hill to the Institute of Arts, 1914.

Exhibitions: 1919, New York, no.30; 1959–1960, Philadelphia–Boston, no.64; 1962, Minneapolis, p.117.

This Eden-like scene is one of the most poetic of its kind in Courbet's work. It is also one of the largest, and is noteworthy for the quality of the landscape.

Minneapolis, Institute of Art.

108 (L)
The charity of a beggar at Ornans–The beggar's alms

L'Aumône d'un mendiant à Ornans

1867–1868

Canvas: 210 × 175. Signed and dated: *G. Courbet 1868.*

History: Cusenier; Chapaz, Béziers; purchased by William Burrell in 1923 and bequeathed to the Corporation of Glasgow, 1958.

Exhibitions: 1868, Paris no.608; 1868, Le Havre.

Bibliography: Caricatured by Alfred Darjon in *L'Eclipse*, 24 May 1868.

This is the last of Courbet's series of paintings *sur la grande route*, of which *The stonebreakers* was the first, and to which belong *The peasants of Flagey* (41) and the *Return from the conference* (rejected even at the Salon des Refusés in 1863 for impro-

priety, and subsequently destroyed by its purchaser). The original conception of *The beggar* goes back to the picture of a gypsy and her children, which Courbet was planning in 1854 (letter to Bruyas, Borel, pp.41–3). Courbet returned to the subject in 1867, perhaps hoping to win some success and notoriety after the relative failure of the 1867 retrospective exhibition. 'My picture will make a great impact at the Salon' he told Buchon in a letter of 9 April 1878 (Riat, p.260), but he was wrong, and the picture was taken as further evidence of Courbet's decline. A.B.

Glasgow, Burrell Collection, City Art Gallery.

108a
The cliff at Etretat after the storm

La falaise d'Etretat après l'orage (113)

1869

Canvas: 133 × 162. Signed, dated lower left; *..70 Gustave Courbet.*

History: Carlin sale, Paris, 1872, no.2; Candamo sale, Paris, 1933, no.9; allotted to the Musée du Louvre in 1951 by the 'Office des Biens Privés' (Ministry of Foreign Affairs).

Exhibitions: 1870, Paris, Salon, no.672; 1882, Paris, no.107; 1955, Paris, no.72; 1959–1960, Philadelphia–Boston, no.69; 1962, Berne, no.58.

Bibliography: Raymond Lindon, 'Etretat et les peintres' in *Gazette des Beaux-Arts*, 1958, p.356.

108

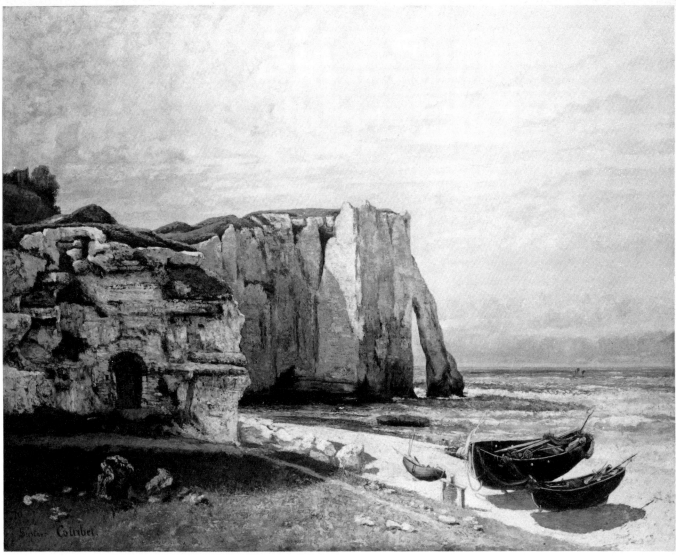

108a

Etretat was an attraction to painters from the beginning of the century onwards; among the first to be inspired by its cliff scenes were Horace Vernet, Eugène Isabey, the Fielding brothers and Delacroix. The picturesque little town became more and more popular as time went on, and was the subject of some magnificent works by Monet.

In the summer of 1869 Courbet painted at Etretat the two pictures he submitted to the Salon of 1870, the present work and *Stormy sea* (147). This was the first time he had used such large canvases for landscapes with no human or animal figures. Other artists had painted landscapes on a large scale for some time past; now that Courbet suddenly took to doing so, it may seem surprising that he did not offer the public two square metres of the *Puits noir* or the *Source of the Loue*.

The Porte d'Aval at Etretat – and the opening in the cliff, with a wooden fence across it – still looks as it does in this picture. The work occupies an outstanding position among Courbet's landscapes by reason of its limpid atmosphere and exquisite balance of values and rhythm.

Courbet painted many other pictures of the Porte d'Aval, some from close up and some from further off, and likewise of the Porte d'Amont on the other side of the bay of Etretat. These are easel paintings, often attractive, but lacking the grandeur of the present work. Some are only studio repetitions, and many, alas, are forged.

Paris, Musée du Louvre.

109

Chenavard moved in extremely diverse circles. He was one of the few close friends of Delacroix; he was on cordial terms with Courbet's associates, and also with members of the imperial court. He was strong and independent enough to maintain 'compromising' friendships, and certainly helped Courbet through his influence with the comte de Nieuwerkerke, Superintendent of Fine Arts under the Empire. We believe, too, that he had a moral influence on Courbet, and perhaps to some extent inspired the *Funeral at Ornans* (135).

Chenavard was painted by several of his contemporaries: Ricard (museums at Lyons, Marseilles and Montpellier), Meissonier (Lyons museum) and Armbruster (Louvre). But the best portraits of him, other than this one by Courbet, are a photograph by Nadar (1856) and a pen-picture by Baudelaire which dates from 1858 and is admirably illustrated by Courbet's work. Baudelaire wrote: 'Lyons is a philosophical town . . . A strange city, fanatical and commercial, Catholic and Protestant, full of mists and coal-dust . . . Chenavard's mind resembles the city of Lyons: it is misty, murky and bristly, like the city of spires and factory chimneys . . . Let us make it clear at once that Chenavard has a great advantage over all other artists: he may be too little of an animal, but they have too little spirituality . . . Chenavard knows how to read and to reason . . . He is extremely well educated, and possesses the art of meditation' (Baudelaire, II, pp.601–602).

For more than twenty years Courbet, the 'peasant' from Ornans, was a close friend of Chenavard, the refugee from what Baudelaire called the 'hulks' of Lyons. Although apparently belonging to two different worlds, they had a close mutual understanding.

In 1869 they went together to Munich, where they were both exhibiting pictures; it may have been at this time that Chenavard sat for Courbet. We recognize in this portrait the striking features photographed by Nadar thirteen years earlier; but the painter-philosopher looks greyer than he did, and the wrinkles in his face are deeper.

109
Portrait of Paul Chenavard

Portrait de Paul Chenavard (114)

1869

Canvas: 54 × 46. Signed, dated lower left: *G. Courbet 69*.

History: Acquired from the artist by the sitter; given by the previous owner to the Musée des Beaux-Arts, Lyon, 1882.

Exhibitions: 1948, Paris, Bibliothèque Nationale, no.572; 1954, Lyon, no.24; 1955, Paris, no.76; 1962, Berne, no.21.

Bibliography: Georges Grimmer, *Courbet et Chenavard* in *A.G.C.*, 1951, no.9, pp.1–7, repr.; Vincent, pp.131–132.

The painter Paul Chenavard (1807–1895) played a much more important part in Courbet's life than is generally supposed. A disciple of the Nazarenes in Rome, he was essentially an intellectual painter who believed that art should be the vehicle of moral and philosophical teaching. In 1849 the Provisional Government of the Second Republic entrusted him with the task of decorating the walls of the Pantheon; to his great disappointment this came to nothing, as the building was restored to religious use after the coup d'état of Napoleon III. The cartoons in the Lyons museum are all that remains of the vast project, known as the *Palingénésie universelle*.

Lyons, Musée des Beaux-Arts.

110
Copy of a self-portrait of Rembrandt

Copie d'un autoportrait de Rembrandt (115)

1869

Canvas: 87 × 73. Signed, dated lower left: *..69 Courbet.* Inscribed lower right: *Copie Mée Munich.*

History: Consigned by the artist to the Galerie Durand-Ruel, 15 April 1871, to be sold; confiscated by the State; restored to Juliette Courbet; Courbet sale, Paris, 1882, no.14; bought in by Juliette Courbet; bequeathed by the previous owner to Mmes de Tastes and Lapierre; Courbet sale, Paris, 1919, no.28; Galerie Barbazanges, Paris (1921); Galerie Cassirer, Berlin (1935); assigned to the Musée du Louvre by the Office des Biens privés (Ministry of Foreign Affairs), 1951; deposited at the Musée de Besançon in 1953.

110

Exhibitions: 1873, Vienna(?); 1882, Paris, no.34; 1921, Basel, no.34; 1935–1936, Zurich, no. 107; 1952, Besançon, no.42; 1953, London, no.30; 1958, Munich, no.27; 1969–1970, Rome–Milan, no.36.

Bibliography: Nochlin, 1967, p.210, note 16, fig.6.

In the summer of 1869 Courbet visited Munich, where he showed three or four pictures and made copies of three Old Masters in the International Exhibition: Frans Hals's *Malle Babbe* (111), an unidentified *Portrait of a man* by Murillo (the copy is now in a private collection in Italy), and the present work. The *Self-portrait*, still in the Alte Pinakothek at Munich, is no longer regarded as a Rembrandt original but as an old copy of excellent quality by an unknown painter (cf. Hofstede de Groot, *Holländische Maler des XVII Jahrhunderts*, 1915, no.595).

As we see, Courbet in his mature years took pleasure in copying old masters and, as it were, recalling his formative period during which he sought to penetrate their secrets. In those days he was interested in seventeenth and nineteenth century painters of all schools and of every description. What we have here, however, is no longer a copy for study purposes, but a kind of duel. Courbet's work is an original painting; not a transposition, but by no means a hesitant, timorous imitation. As we know, he was strongly influenced by Rembrandt in his youth, but in subsequent decades broke away to follow other models or the promptings of his own genius. The present painting is, as it were, a happy return to his youthful days, but he now interprets Rembrandt with the authority and independence of a master craftsman.

Besançon, Musée des Beaux-Arts.

111
Copy of Malle Babbe, the witch of Haarlem by Frans Hals

Copie de Malle Babbe, la sorcière de Haarlem de Frans Hals (116)

1869

Canvas: 85 × 71. Signed, dated lower left: *..69 G. Courbet;* inscribed lower right: *Aix-la-Chapelle;* to the middle right: *F.H. 1645.*

History: Juliette Courbet coll.; Courbet sale, Paris, 1882, no.13; Cheramy sale, Paris, 1908, no.141; Theodor Behrens coll., Hamburg; acquired in 1926 by the Kunsthalle.

Exhibitions: 1882, Paris, no.33; 1906, Paris; 1912, Saint-Petersburg.

At the Munich exhibition of 1869 Courbet copied a Rembrandt *Self-portrait*

111

(110) and also this work by Frans Hals, lent by the collector Suermondt of Aachen. Hals's painting is now in the Museum at Berlin-Dahlem.

Hamburg, Kunsthalle.

112
The wave

La vague (117)

1870

Canvas: 112 × 144. Signed, dated lower left: *..70 G. Courbet.*

History: Gift of the Princes Henckel von Donnersmark, Berlin, 1906.

Exhibition: 1961, Berlin, no.36.

Courbet generally conceived nature in its serener moods, and most of his 'sea landscapes' suggest an idyllic peace: this is most notable in *Immensity* in the Norton Smith collection, Pasadena, California. Nevertheless, he represented the drama and fury of the elements in pictures of *Waterspouts* (New York, Metropolitan Museum; Japan, private collection; Musée de Dijon, Donation Granville) and innumerable *Waves*. To quote André Fermigier once again: 'Since we are talking of Hugo, to whom Courbet seems increasingly

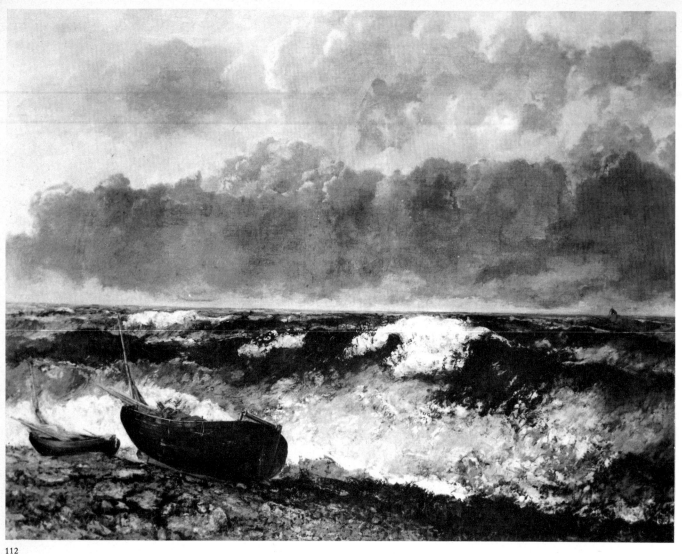

112

close as the war of 1870 approaches, it is natural to think of the ocean with its storms, anger and treachery. The series of *Waves* painted at Etretat, the two most famous of which are in the Berlin Museum and at the Louvre (*Stormy sea*), show us the very heart of Courbet's lyricism, his feeling for the impetuosity of nature and its wild, sudden, elemental outbursts. We recall the words of Cézanne: "These great *Waves* – the one at Berlin is prodigious, one of the marvels of the century, far more swollen and palpitating than this one [*Stormy sea* in the Louvre], a muddier green and a dirtier orange – a tangle of flying spray, a tide drawn from the depths of eternity, a ragged sky, the livid sharpness of the whole scene. It seems to hit you full in the chest, you stagger back, the whole room reeks of sea-spray" ' (Fermigier, pp.112–114).

Angry seas of this kind were popular from the beginning of the Romantic period. In 1861 Paul Huet repeated his *Equinoctial tide* (Louvre) from the Salon of 1838 (U.K., private collection), and in 1853 he painted *Breakers at Granville point* (Louvre).

Whistler's great *Blue wave* (Farmington, Conn., Hillstead Museum) was painted at Guéthary near Bayonne in 1862, and Courbet may have seen it.

It is impossible to enumerate all Courbet's paintings of waves; some of the most famous are at Lyons, Bremen, Frankfurt, Tokyo, Winterthur (Oskar Reinhart Collection) and Edinburgh.

Berlin, Staatliche Museen, Preussischer Kulturbesitz, Nationalgalerie.

113
The old tree in the gorge

Le vieil arbre dans la gorge (118)

1871

Canvas: 92×74. Signed, dated lower left: *G. Courbet ..71.*

History: Formerly Widmer coll.

This poignant work, which deserves to be better known, is unique in Courbet's œuvre as being not merely a grisaille but a 'black painting'. A tree, stripped of its foliage, is about to be crushed by a rock; the date, 1871, is a clear indication that it symbolizes the Paris Commune. It has been said that the defeat of the Commune marks the real moment of Courbet's death, and it is easy to imagine him identifying with the old tree, doomed to destruction.

Lausanne, Musée cantonal des Beaux-Arts.

114
Still life with apples

Nature morte aux pommes (119)

1871–1872

Canvas: 59×73. Signed, dated, lower left: *G. Courbet ..71.* Inscribed lower right: *Ste Pélagie.*

History: Juliette Courbet coll.; Courbet sale, Paris, 1882, no.36; H. G. Mesdag coll.; gift of the previous owner to the Netherlands in 1903.

Exhibitions: 1882, Paris, no.192; 1968, Paris; 1969, London, Meselag, no.6; 1969–1970, Rome–Milan, no.39.

Bibliography: P. Zilcken, *Le Musée Mesdag à La Haye* in *Revue de l'art ancien et moderne*, October 1908, p.307; P. H. N. Domela Nieuwenhuis, *Catalogue des collections étrangères du Musée Mesdag, Ecole français., le XIXᵉ siècle*, Le Hague, 1964, no.73, pl.9; Toussaint, no.39.

Courbet was an expert at still-life painting; he rarely practised it as such but, still lifes form an outstanding part of some of his best compositions, such as *After dinner at Ornans* (134) and *Women sleeping* (90). While staying at Saintes in 1862–1863 he developed a passion for flower painting, and while in prison at Sainte-Pélagie in 1971, as live models were forbidden, he painted flower and fruit which his sisters and friends brought for the purpose. The best of these paintings were in fact done somewhat later, in the first months of 1872, when he was a prisoner on parole in Dr Duval's clinic at Neuilly. In letters from Zoë Courbet-Reverdy to Bruyas (manuscripts in the Bibliothèque Doucet) describing her brother's condition in January, February and May 1872, references to still lifes recur like a leitmotiv: 'Gustave is painting flowers and fruit . . . Gustave is excited about his fruit pictures . . . Gustave is painting a great many pictures of fruit.' Many, including the one here shown, are marked with the legend 'Ste Pélagie' and the date '..71', but this must be put down to Courbet's determination to advertise his

113

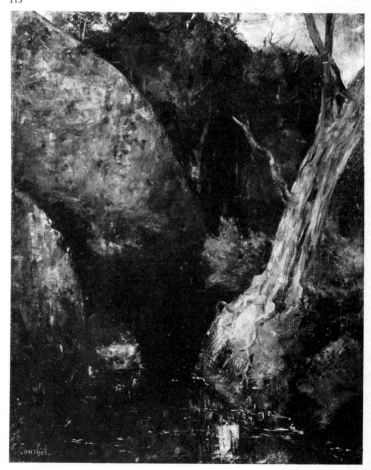

imprisonment and the cruelty of which he was a victim.

Thus in 1872 he submitted to the Salon a *Still life* inscribed *Sainte Pélagie*. The jury, headed by Meissonier, rejected it with contumely, declaring themselves 'Shocked by such senseless impudence'. Cartoonists took the matter up, and on 6 May the *Chronique illustrée* published a drawing by Faustin entitled *Fruits of reflection*. This showed a pile of fruit at the foot of a tree, and answers to the description of no.26 in Dr Blondon's list of Courbet's *Works painted in captivity* (manuscript in the Bibliothèque de Besançon), viz. *Apples and chestnut tree, landscape background, exhibition*. This is one of the few pictures on the list for which no owner is mentioned, implying that it remained in Juliette's collection.

Many similar paintings by Courbet are in the museums at Amsterdam, Munich, Hamburg and elsewhere. The present one is among the largest and finest of its kind. The skilful composition, vigorous workmanship and vivid colouring make it a masterpiece of still-life painting. It is also somewhat unusual in technique: the outline of the fruit is emphasized by a contour-line which gives it greater preci-

114

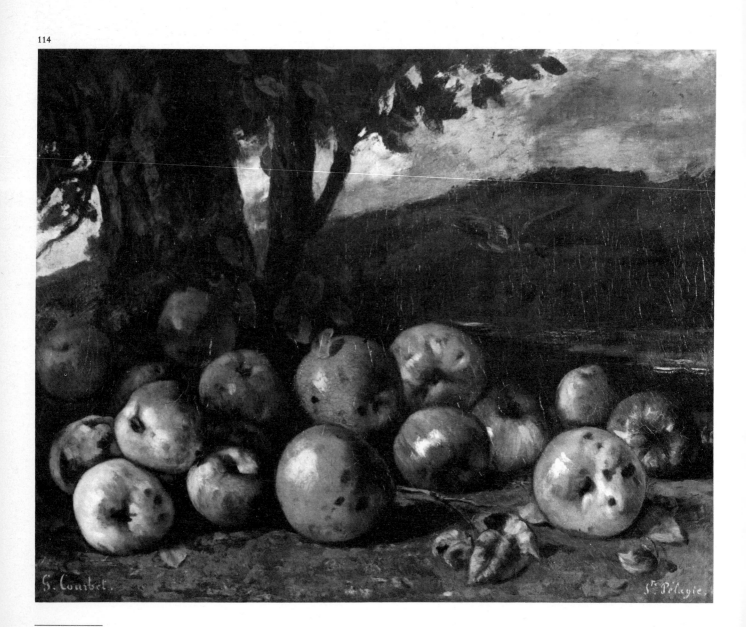

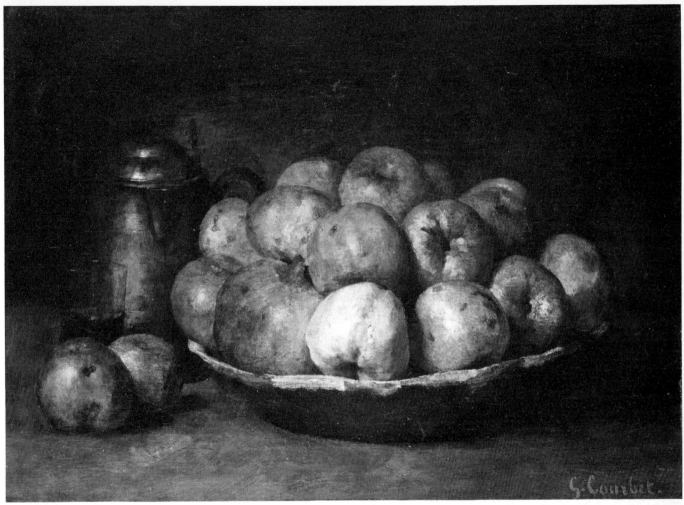

115

sion. This is Courbet's first experiment with such a device; he used it more boldly in two other still lifes inscribed *71 Ste Pélagie* but probably executed somewhat later, viz. *Fruit in a basket* (New York, private collection; 1959–1960, Philadelphia–Boston, no.79) and, especially, *Still life with quinces* in the Norton Smith collection (Pasadena, California). We may suppose that Courbet, who strongly influenced the young painters of 1865–1870, was influenced in his turn and borrowed techniques from Manet, Monet or Cézanne, the last of whom expressed admiration at his 'limitless talent' (cf. J. Rewald, pp.116ff.).

The Hague, Mesdag Museum.

115
Still life, apples and pomegranate

Nature morte, pommes et grenade (120)

1871–1872

Canvas: 44×61. Signed, lower right: *G. Courbet ..71*

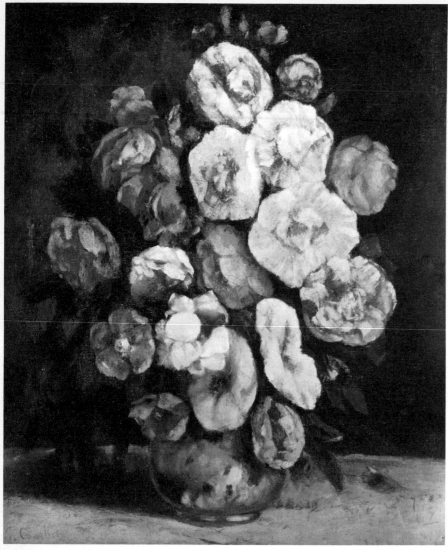

116

thickly applied paint, the bright, concentrated lighting and the admirable chiaroscuro belong to an aesthetic concept very different from Chardin's.

The canvas is folded back over the stretcher, showing that the artist previously used it for another, larger picture. This was also a still life. X-ray photographs show a plate in the upper part of the canvas, and other apples which cannot belong to the present composition.

London, National Gallery.

116
Flowers in a vase

Fleurs dans un vase (121)

1872

Canvas: 59 × 48. Signed, dated lower left: *. . 72 G. Courbet*

History: Reinach coll.(?); Galerie Bernheim-jeune, Paris; Levesque coll., Paris; Pearson coll., Paris; sale at Cassirer, Berlin, 18 October 1927, no.15; Thannhauser coll., Lucerne; John T. Spaulding, Boston; bequeathed by the previous owner to the Museum of Fine Arts, Boston.

Exhibitions: 1914, Copenhagen, no.45; 1929, Cambridge, U.S.A., no.17; 1939, Boston, no.30; 1948, Boston, no.14; 1954, Venice, no.52; 1954, Lyon, no.51; 1956, New York, Rosenberg, no.17; 1958, Santa Barbara; 1959–1960, Philadelphia–Boston, no.81; 1962, Berne, no.71.

Bibliography: Douglas Cooper, *Reflections on the Venice Biennale* in *The Burlington Magazine*, October 1954, p.330.

This is very probably no.27 (*A copper vase with hollyhocks. M. Reinach*) in Dr Blondon's list of pictures painted by Courbet in captivity.

Boston, Museum of Fine Arts.

History: Latouche coll.(?); Galerie Daber, Paris, acquired from the previous owner by the National Gallery in 1951, through Tooth & Sons, London.

Exhibitions: 1949, Paris, no.18; 1949, Copenhagen, no.28; 1951, London, Paris–London, no.22.

Bibliography: Davies, p.39.

This picture bears the date 1871 but may have been executed in the first months of 1872, like many of the still lifes painted by Courbet during his detention. It is identified conjecturally with no.25 – *Apples and a pomegranate* – in Dr Blondon's list of works painted by Courbet in captivity (Bibliothèque de Besançon).

This work is unusual among Courbet's still lifes by reason of its elaborate composition, including such diverse elements as a plate, a pewter jug and a glass of wine, which gives it an intimate character and is reminiscent of Chardin. The resemblance stops there, however: Courbet's

117
The sea

La mer (122)

1872

Canvas: 38 × 45·5. Signed lower left: *G. Courbet.*

History: Sold by Courbet to Dr Jacquette, February 1872; bequeathed by the previous owner to the Musée de Caen in 1898.

Exhibitions: 1929, Paris, no.129; 1954, Lyon, no.42; 1955, Paris, no.74; 1959, Bordeaux, no.187; 1960–1961, Paris, circulating exhibition, no.79; 1961, Vichy, no.43; 1964–1965, Munich, no.53; 1965, Paris, no.27; 1966, Dallas, no.6; 1969–1970, Rome, Milan, no.40.

This corresponds to no.19 in the list of pictures painted by Courbet in captivity, described as *Une marine. Étretat à M. Jacquette.* Six other seascapes figure in the list, showing Courbet's fondness for painting them from memory.

Caen, Musée des Beaux-Arts.

118
The trout

La truite (123)

1872

Canvas: 55 × 89. Signed, dated, inscribed lower left: *. .71 G. Courbet. In vinculis faciebat.*

History: Bought from the artist by Edouard Pasteur in 1873; bought from the descendants of the previous owner by Charles Léger, *c.*1930; acquired by the Kunsthaus, Zurich in 1935.

Exhibitions: 1882, Paris, no.130; 1932, Paris, Galerie Braun, no.7; 1935–1936, Zurich, no.123; 1938, Paris, *Gazette des Beaux-Arts*, no.38; 1947–1948, Brussels, no.77; 1950, Zurich, p.34; 1954, Venice, no.44; 1954, Lyon, no.49; 1955, Paris, no.90; 1957, Besançon, no.56; 1959, Paris, Petit Palais, no.35; 1959–1960, Philadelphia–Boston, no.82; 1962 Berne, no.72; 1974, Zurich, no.8.

Bibliography: W. Wartmann, *Die 'Forelle' von Gustave Courbet* in *Zurcher Kunstgesellschaft, Jahrbericht 1936*, pp.55–58, pl. VI.

In July 1872 Courbet stayed with the Ordinaire family at Maisières near Ornans. His hosts caught some enormous trout, which he was inspired to paint (cf. 149).

Edouard Pasteur, uncle of Courbet's friend Buchon, saw this painting at Ornans and asked for a copy. On 20 February 1873 the artist wrote to him: 'You know, you are in such a hurry that you have made me spoil the copy of the fish still life; so I am sending you the original.' Later he adds: 'I shall send you the two pictures [the other was a landscape] and put an epitaph on the trout, people will see what fun it is to be in prison' (Wartmann, *op. cit.*). In fact the copy was far from being spoilt: it is the version in the former collection of Dunoyer de Segonzac (119). The date and annotation *. .71, in vinculis faciebat*, designed to recall the painter's imprisonment, here take the place of 'Sainte Pélagie', the legend Courbet frequently inscribed on pictures executed after his release (cf. 114).

Comparing this with the trout in the Berne picture (149) we notice a considerable difference of treatment: in the present version the touch is rapid and rough, and the chiaroscuro is unusually dramatic for an open-air scene.

Linda Nochlin sees in this expiring *Trout* an image of death, a favourite theme which the Realist painters inherited from the Romantics (Nochlin, 1971, pp.72–3). There is indeed at atmosphere of anguish and passion about the work which is not found in ordinary still lifes of fish.

Zurich, Kunsthaus.

119
The trout

La truite (125)

1873

Canvas: 65 × 99. Signed, dated lower right: *G. Courbet . .73.*

History: Galerie Bernheim-jeune; bought from the previous owner by André Dunoyer de Segonzac; André Dunoyer de Segonzac coll. until his death in 1974.

Exhibitions: 1928, Paris, Galerie Barbazanges; 1935–1936, Zurich, no.128; 1936, Paris, no.13; 1936, London, no.30; 1937, Paris, no.282; 1946, Paris, no.17; 1950, Paris, no.11a.; 1952, Paris, no.89; 1953, London, no.35; 1954, Rotterdam, no.78; 1964–1965, Munich, no.56; 1966, Paris, no.32; 1969–1970, Rome–Milan, no.42.

This is the so-called 'copy' (cf. 118) which Courbet intended for his friend Pasteur, but instead of which he sent him the original painting. It is not in fact a literal copy, but a variation: the fish is in reverse direction, and there are some differences in the suggested landscape.

Paris, private collection.

117

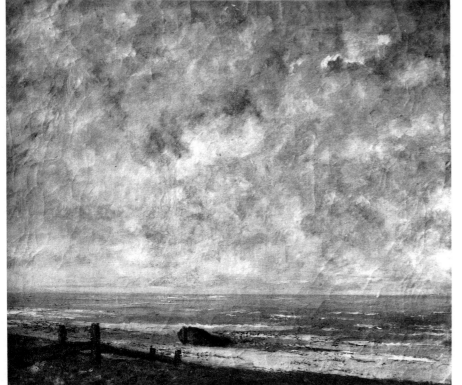

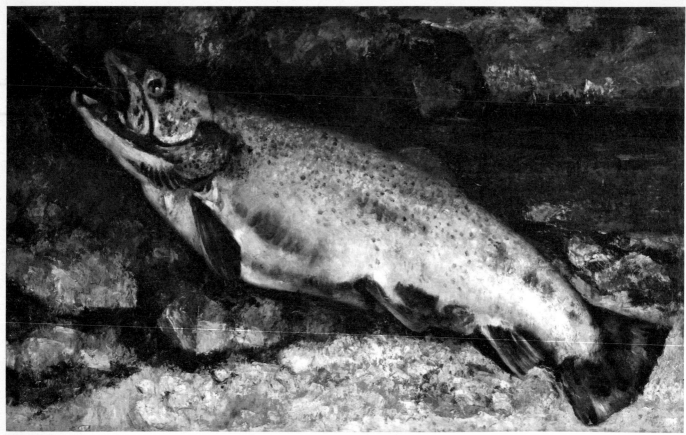

118
119

120
The bridge at Fleurier

Le pont de Fleurier (*126*)

1873

Canvas: 73 × 81. Signed, dated lower left: ..73 G. Courbet.

History: Deposited by Courbet at the Galerie P. Pia, Geneva; sold by Galerie P. Pia to the comte de Courtivron, Brussels, 1875; sold by the previous owner c.1890 to M. Patte; inherited by the descendants of the previous owner in 1935; private coll., Paris, 1935; allotted to the Musée du Louvre by the 'Office of Bien prives' (Ministry of Foreign Affairs) in 1951; deposited at the Musée de Besançon in 1953.

Exhibitions: 1935–1936, Zurich, no.129; 1952, Besançon, no.39; 1957, Paris, no.32; 1959–1960, Philadelphia–Boston, no.83; 1953, Ornans, no.43; 1969–1970, Rome–Milan, no.43; 1974, Rochechouart, no.19.

In July 1873 Courbet crossed the frontier into Switzerland, where he was to spend the rest of his life in exile. He stayed for a time at Fleurier in the Val de Travers and painted this view of the Saint-Sulpice bridge over the Areuse.

The rock on the right is imaginary, and, owing to road-widening, the bridge no longer exists.

Courbet's pupil Marcel Ordinaire, who was with him on the journey, painted the same scene more than once at this time under his master's direction.

Besançon, Musée des Beaux-Arts.

122
Portrait of Régis Courbet, the artist's father

Portrait de Régis Courbet, père du peintre (*127*)

1873

Canvas: 82 × 74. Signed, dated lower left: ..74 G. Courbet.

History: Juliette Courbet coll.; given by the previous owner to the Petit Palais in 1909.

Exhibitions: 1882, Paris, no.38; 1929, Paris, no.9; 1949, Copenhagen, no.29; 1950, La Tour de Peilz, no.47; 1955, Paris, no.92; 1962, Berne, no.78; 1962, Rome, no.53; 1969, Ornans, no.33; 1974, Rochechouart, no.21.

This portrait of the artist's father in old age was painted during a visit to his son

at La Tour de Peilz. It bears the date 1874, but was already completed when Edouard Ordinaire wrote to Castagnary from Vevey on Christmas day, 1873: 'His father came to stay with him for some days, and he was strong enough to paint the old man's portrait in two sittings. It is a fine painting' (Bibliothèque Nationale, Estampes, Box II).

Paris, Musée du Petit Palais.

123
Self-portrait at Sainte-Pélagie

Portrait de l'artist e à Sainte-Pélagie (*128*)

1873–1874?

Canvas: 92 × 72. Unsigned.

History: Juliette Courbet coll.; given by the previous owner to the town of Ornans in 1882.

Exhibitions: 1928, Pontarlier; 1929, Paris, no.7; 1935–1936, Zurich, no.122; 1939, Ornans, no.2; 1947, Fleurier, no.9; 1952, Besançon, no.49; 1953, London, no.33; 1953, Paris, no.39; 1954, Venice, no.45; 1954, Lyon, no.48; 1955, Paris, no.80; 1957, Paris, no.213; 1959–1960, Philadelphia–Boston, no.77; 1962, Ornans, no.37; 1966, Paris, Aubry, no.27; 1966, Ornans, no.13; 1969, Ornans, no.29; 1969–1970, Rome–Milan, no.38; 1973, Paris, no.57; 1974, Rochechouart, no.13.

Bibliography: Forges, 1973, pp.45–6, no.57.

On 2 September 1871 Courbet was transferred from the Orangerie prison at Versailles to Sainte-Pélagie in Paris, where he served the greater part of his six months' sentence. As a special punitive measure the Communards were not treated as 'politicals' but as common criminals. Courbet's cell, no.4, overlooked the Cour de la Dette and received little light, as the window was blocked up. 'I hope,' he remarked, 'that I shall remember what the sun looks like' (Riat, p.324).

This self-portrait clearly bears only a distant relation to the truth. Courbet painted it as a softened-down reminder of the hardships that followed his arrest: we

120

122

Sunset on Lake Geneva

Coucher de soleil sur le lac Léman (*129*)

1874

Canvas: 55 × 65. Signed, dated lower right: *G. Courbet, 74.*

History: Juliette Courbet coll.; given by the previous owner to the Musée Jenisch in 1914; hung in the office of the Syndic de Vevey for many years; returned to the museum in 1960.

Exhibition: 1976, Lausanne, n.n.

From the terrace of Bon-Port, his last home in exile at La Tour de Peilz, Courbet painted many views of Lake Geneva and the further shore which, being French territory, was forbidden to him. These show infinite variations according to the season and time of day, with changing light effects. There are indeed rather too many versions, as a considerable proportion of them are wholly or partly the work of Courbet's assistants Ordinaire, Morel and Pata, and are disappointing in quality.

We present here one of the best of these landscapes, showing the last rays of the setting sun on the Rochers de Mémises overlooking Évian. Another fine example of the series has just been acquired by the Courbet Museum at Ornans (38 × 55) dated 1875; bequeathed by Mlle Mathey of Lausanne.

Vevey, Musée Jenisch.

do not feel here the distress that pervades the fine drawings he made at the Conciergerie in Paris and subsequently the Orangerie at Versailles (153). The tragic element is eschewed, and physically the portrait is a flattering one. Courbet had indeed lost much weight and looks younger for that reason, but his hair and beard were grey and not black, as was noticed by eyewitnesses at his trial; the first photographs taken after his exile show that he had gone quite white.

It has been supposed that this picture was painted early in 1872, when Courbet was a prisoner on parole at the Neuilly clinic, or even after his return to Ornans. Marie-Thérèse de Forges (*op. cit.*) suggests that it was done later still, during his exile at La Tour de Peilz.

In 1882 Juliette Courbet told Castagnary that she was presenting this picture and *Chillon castle* (125) to the city of Ornans, as well as the sculpture of a chub-fisher which is now on a fountain at Ornans (cast in iron) and in the Musée Gustave Courbet (plaster cast). She addressed a letter to the mayor reading: 'I beg the Municipality of Ornans to accept two pictures which my late brother painted for me' (Bibliothèque Nationale, Estampes, Box VI).

Ornans, Musée Gustave Courbet.

125

Chillon castle

Le château de Chillon (*130*)

1874

Canvas: 86 × 100. Signed lower right: *G. Courbet.*

History: Juliette Courbet coll.; given by the previous owner to the town of Ornans in 1882.

Exhibitions: 1928, Besançon, no.42; 1935–1936, Zurich, no.134; 1939, Ornans, no.3; 1943, Pontarlier; 1953, London, no.36; 1962, Ornans, no.44; 1974, Rochechouart, no.22.

This work has been rather hastily identified with the painting of the same

123

124
125

title which was no.26 in the Courbet sale of 1882 and was supposedly repurchased by Juliette. The description of the latter, with the sun setting and a sailing-boat on the lake, does not fit the present work; nor does any other version of this scene in the Courbet sales.

It is impossible to count the views of Chillon castle painted by Courbet, whose home in exile was only a few miles away. Besides genuine ones there are some outright forgeries, while others are partly the work of assistants, members of the 'picture-factory' by which Courbet eked out his income. Chillon was an especially popular theme because of its picturesqueness and its appeal to romantic writers such as Senancour and Byron, whose most famous pictorial interpreter was Delacroix.

Courbet depicted the fortress from every angle, but this fine picture shows an unusual view of it: as Aaron Scharf has shown, the artist drew his inspiration not from nature but from a photograph by Braun (Scharf, p.135, figs.89, 90). Nineteenth-century landscapists and figure-painters, including the greatest of them, often used photographs as the basis of their compositions; the present work is a striking example of this hankering after ultimate precision. In our own day, which has seen the birth of hyper-realism, we can perceive more clearly the scope of this technique, of which Courbet was a kind of forerunner.

On 18 September 1882 Juliette Courbet wrote to Castagnary that she was presenting to the city of Ornans the sculpture of the *Chub-fisher* and two paintings: 'Gustave at Sainte-Pélagie, and Chillon castle as seen from the terrace of La Tour.' Here Juliette was giving rein to her imagination: the castle could never have been visible from there. On the same day she wrote to the mayor offering him the same works (cf. 123).

Ornans, Musée Gustave Courbet.

126
Lake Geneva at sunset

Le lac Léman au coucher du soleil (*131*)

*c.*1876

Canvas: 74×100. Signed, lower left: *G. Courbet.*

126

History: Druet coll., Paris; Fritz and Peter Nathan coll., Zurich; acquired from the previous owners with the aid of the Ernst Schürpf bequest for the Kunstmuseum in 1962.

Exhibitions: 1962, Berne, no.81; 1974, Lucerne, no.33.

This glowing sunset is one of the last painted by Courbet from the shore at La Tour de Peilz.

St Gall, Kunstmuseum.

Drawings

127
Portrait of Juliette Courbet

Portrait de Juliette Courbet (133)

1841?

Pencil on paper: 20 × 26. Unsigned.

History: Ernest Courbet coll.; given by the previous owner to the Musée du Louvre in 1916.

Exhibitions: 1935–1936, Zurich, no.148; 1938, Lyon, no.13; 1938, Bogota, no.34; 1957, Paris, Louvre, no.42; 1962, Mexico, no.14; 1972, Darmstadt, no.20.

To date this drawing we may compare it with the *Portrait of Juliette* at ten years old, painted in 1841 (Courbet sale, Paris, 1919, no.7, repr.): the subject appears to be of the same age.

Paris, Musée du Louvre.

127

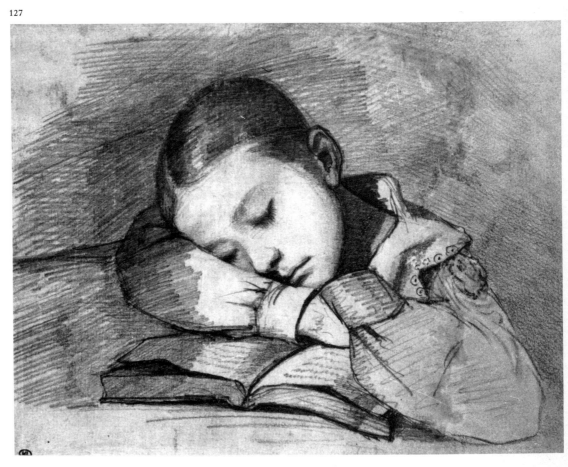

128

128
Man seated

L'homme assis (135)

*c.*1843

Charcoal, red chalk, heightened with white on paper: 33 × 24. Signed lower right: *G. Courbet.*

History: Formerly Claude Daston coll. Avignon.

Exhibitions: 1955, Chicago, no.139; 1958, Stuttgart, no.168; 1962, Bucarest, no.8.

This charcoal drawing may, we suggest, be related to a line drawing in one of Courbet's early sketchbooks in the Louvre (RF 29234, fo.35 recto), showing a fat man in a top hat asleep on a bench.

Paris, private collection.

129
Country siesta

Sieste champêtre (136)

Charcoal and black crayon: 26 × 31. Arched top edge. Unsigned.

History: Juliette Courbet coll.; given by the previous owner to the Musée des Beaux-Arts de Besançon in 1885.

Exhibitions: 1950, La Tour de Peilz, no.58; 1952, Besançon, no.65; 1957, Paris, no.128; 1973, Paris, no.7.

Bibliography: Forges, 1973, no.7; Delbourgo-Faillant, p.11, fig.8; Forges, *Annales*, p.33, fig.8.

This drawing, one of Courbet's finest, is also of interest as showing the original composition of *The wounded man* (33). It is debatable, however, whether it is previous to that work or was executed at the time when Courbet altered the picture, to remind him of its original state.

Elements of comparison to which firm dates can be attached are lacking; we suggest, however, that the date of 1844, which seems acceptable for the first idea of the painting, is too early for a drawing like this one. Its supple and fluent workmanship and skilful chiaroscuro seem to make it later than *Woman asleep* (130). Accordingly we favour the second hypothesis above.

Besançon, Musée des Beaux-Arts.

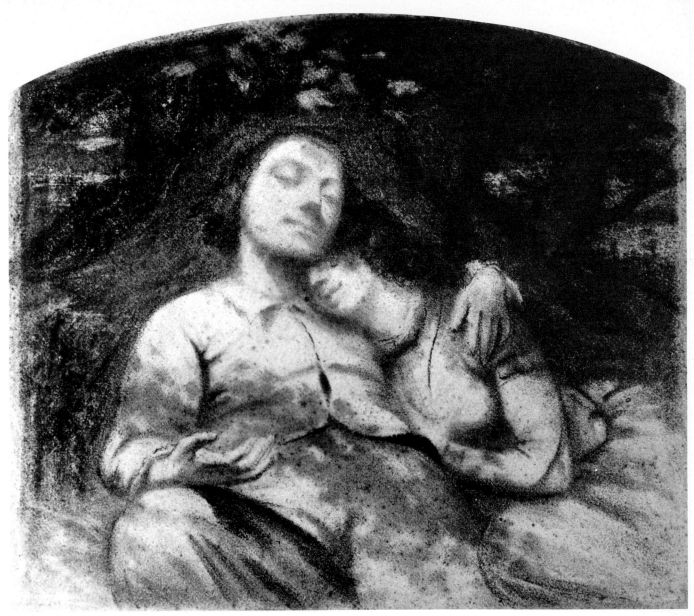

129

130
Woman with a book, asleep

La liseuse endormie (138)

1849

Charcoal on paper: 47 × 30. Signed, dated lower left: *G. Courbet 1849*.

History: Acquired by the Musée du Louvre in 1932.

Exhibitions: 1933, Paris, no.141; 1936, Brussels, no.93; 1939, Belgrade, no.120; 1939, Buenos Aires, drawings, no.216; 1959, Rome–Milan, no.167; 1960, Copenhagen, no.55; 1961, Gray, no.51; 1962, Ornans, no.56; 1967, Copenhagen, no.22; 1972, Rennes, no.38; 1976–1977, Vienna, no.33.

We have already compared this fine drawing with *Sleeping blonde* (20), using its date as a basis for determining that of the picture. The model may be Virginie Binet, who in 1849 had been Courbet's companion for several years.

Paris, Musée du Louvre.

130

131

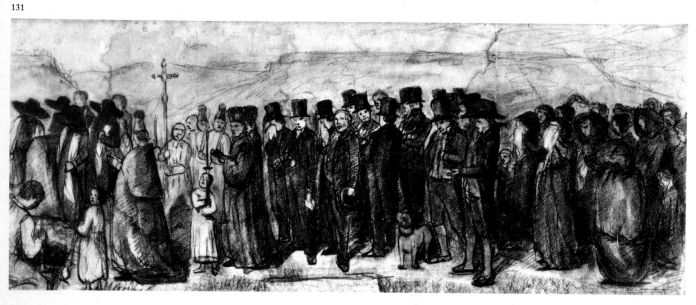

131
Burial at Ornans

Un enterrement à Ornans (*139*)

1849

Charcoal on bluish paper: 37 × 95. Unsigned.

History: Juliette Courbet coll.; given by the previous owner to the Musée de Besançon in 1885.

Exhibitions: 1935, Paris; 1935–1936, Zurich, no.151; 1939, Ornans, no.18; 1947, Pontarlier, no.84; 1950, La Tour de Peilz, no.59; 1959, Geneva, no.101; 1952, Besançon, no.64; 1957, Paris, no.127; 1971, Gentilly.

Did Courbet already have his great picture in mind when he made this drawing? We cannot be sure, but we can follow in the drawing the development of many important elements of the later masterpiece.

The drawing shows a funeral procession: pall-bearers, the clergy, friends and relations, in the order customary on such occasions. The composition is balanced by a man kneeling on the left; there is nothing to indicate that he is a grave-digger. A grave is suggested in the foreground: did Courbet intend it as a central element in the composition, or is it unrelated to the procession moving past it?

It should be noted that four characters in the final painting are identifiable in the drawing: the portly mayor, Teste de Sagey, the austere-looking judge Proudhon and the two 'republicans'. All the others in the drawing are featureless, and this may support our suggestion (cf. 135) that the mayor and the judge were the instigators of the work. The curé Bonnet has his back firmly turned towards us. The crucifix, facing the spectator, appears to play a major part, but in reality it should face in the direction of the procession.

Courbet's final conception of individuals meeting around a central point, the open grave, is superior in moral grandeur; but the rigorous composition of the drawing, like a classical frieze, has the austere nobility of the antique.

Besançon, Musée des Beaux-Arts.

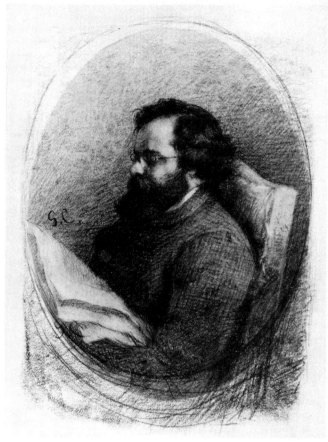

132

132
Portrait of François Sabatier

Portrait de François Sabatier (*140*)

1854 or 1857

Black crayon on paper: 34 × 26. Monogram twice, to the left: *GC* (the upper monogram is perhaps false).

History: Acquired from the artist by the model, François Sabatier in 1854 or in 1857; bequeathed by the previous owner to the Musée Fabre in 1891.

Exhibitions: 1939, Paris, no.138; 1939, Buenos Aires, drawings, no.217; 1952, London, no.37; 1962, Berne, no.92; 1971, Gentilly.

Bibliography: Jean Claparède, *Dessins de la Collection Alfred Bruyas et autres dessins des XIX*; *et XX*; *siècles*, Montpellier, Musée Fabre, 1962, no.47.

François Sabatier (1818–1891) was a rich vine-grower, owner of the château of La Tour de Farges in the Lunel region near Montpellier. A disciple of Fourier and a republican by persuasion, he left his abode in Paris after the coup d'état of 1851 and lived partly in the Hérault and partly at his villa in Florence, where he married the singer Caroline Ungher (1805–1870).

An intimate friend of Bruyas, he was a patron of writers and artists and wrote art criticism under the pen-name of Sabatier-Ungher. Courbet visited his château either in 1854 when he first went to stay with Bruyas, or in 1857 when he was at Montpellier for the second time. The portrait may date from either of these years. It was long thought to be a portrait of Proudhon, until Jean Claparède (*op. cit.*) identified the sitter by comparing it with a portrait of Sabatier by Ricard: both were bequeathed to the Musée Fabre on Sabatier's death in 1891.

Montpellier, Musée Fabre.

133

133
Landscape study

Etude de paysage (141)

Charcoal on white paper: 25 × 35. Signed lower left: *G. Courbet.*

History: Acquired by the Amis de Courbet in 1950.

Exhibitions: 1959, Paris, Baugin, no.5; 1974, Rochechouart, no.29.

Ornans, Musée Gustave Courbet.

Appendix

Paintings and drawings not exhibited
at the Royal Academy.

134
After dinner at Ornans

Une après-dinée à Ornans (18)

1848–1849

Canvas. 195 × 257. Unsigned.

History: Bought by the State at the 1849 Salon; sent to the Musée des Beaux-Arts de Lille after the Salon.

Exhibitions: 1849, Paris, Salon, no.455; 1918, Valenciennes, no.75; 1921, Basel, no.25; 1973, Paris, no.41.

Bibliography: Champfleury, *Le Salon de 1849* in *La Silhouette*, 22 July 1849; Champfleury, 1862 (reprint in Lacambre, 1973, pp.154–155); Meltzoff, p.264, fig.5; Robert Fernier, *Courbet au Salon de 1849* (reprint of critic's review) in *A.G.C.*, 1949, no.5, pp.1–7, repr.; Fermigier, pp.24–28, fig.4; Clark, pp.71–75; Forges, 1973, *Annales*, p.30; Suzy Delbourgo and Lola Faillant, *Courbet, du copiste au maître* in *Annales du Laboratoire de recherche des Musées de France*, p.16; Forges, 1973, no.41.

Champfleury wrote: 'From 1849 onwards, with *After dinner at Ornans*, Courbet became a known figure' (*Courbet existe*). The picture was awarded a gold medal at the Salon, and all at once Courbet was an outstanding success. He had never before attempted a canvas on this scale, nor does he seem previously to have treated a similar theme, although nothing is known of a very small painting (32 × 26 with frame) entitled *An interior*, which was rejected at the Salon of 1842. There is little affinity between *After dinner* and *The draughts players* (10).

The picture was painted in Paris in the winter of 1848. In his unpublished *Souvenirs* Francis Wey relates that he found Courbet working on it when he was taken by Champfleury to visit the artist's studio for the first time.

A note in Courbet's own hand in the list of Salon entries describes how the scene originated. 'It was in November, we were at our friend Cuenot's house. Marlet had come in from hunting, and we had asked Promayet to play the violin to my father' (Archives du Musée du Louvre).

Régis Courbet, the painter's father (cf. 1) is seated sideways in his chair on the left, listening with an absorbed air to Promayet's playing (cf. 152). The man with his back to us, lighting his pipe, is one of the Marlet brothers: history does not say whether it is Adolphe (cf. 26) or Tony, a portrait of whom by Courbet is in the Nationalmuseum in Stockholm. Urbain

Cuenot, the host, is in the background, leaning his head on his hand with a pensive air. Marie-Thérèse de Forges has corrected a mistake to which Riat gave currency (p.66), viz. that this figure represents not Cuenot but the artist himself. (Riat was also mistaken in placing the scene in Courbet's home: Forges, 1973, *Annales*, p.30.) Portraits of Cuenot (Philadelphia Museum of Art, Musée d'Ornans) remove all doubt as to the identification, and as the host he would naturally be in the picture. Moreover, there is no known example of Courbet including himself in a collective portrait, except of course when he is the central figure, and also in a drawing *The Andler brasserie* (location unknown to us; Forges, 1973, no.43). Cuenot, a well-to-do man of leisure, lived on the income from landed property and a flourishing hat factory. He had plenty of time for hunting and travelling about; he and his boyhood friend Courbet were inseparable in their bachelor frolics and otherwise.

The picture does not depict an evening scene, as has been thought: the remains of lunch are illuminated by the wan but clear sunlight of a November day. 'Dinner' in those days was a midday meal in France, as it still is in many provinces.

Stanley Meltzoff (*op. cit.*) describes brilliantly how the artists of this period, as 'painters of reality', displayed a renewed and lively interest in seventeenth-century peasant scenes. He believes that *After dinner* was directly influenced by the Le Nain brothers' *Repas*, and points out that at this time Champfleury was working on his *Essai sur la vie et l'œuvre des Le Nain, peintres laonnois*, which was published in 1850. But where would Courbet have seen the brothers' works? The Louvre in 1848 only possessed the *Adoration of the Shepherds* and the *Forge*. However, the *Repas*, now in the Louvre, may have been already owned by La Caze, and it is quite likely that Courbet visited his collection, as we suggest apropos of *The man with the pipe* (19), and the *Sleeping blonde* (20). It is not surprising that Courbet's work should be reminiscent of Le Nain, since they treat similar themes in a style which derives from the same sources; but it does not seem evident to us that there is a direct link between the *Repas* and *After dinner*. Nor can we accept the suggestion of many authors that Courbet's work is influenced by Rembrandt's *Pilgrims at*

Emmaus (Louvre), as the two pictures are completely unlike in spirit and composition.

Courbet may, on the other hand, have seen at the Musée du Luxembourg a Caravaggesque painting of life-sized figures at table, viz. *Toasting the wine-harvest of 1834* by Grosclaude (1835, Musée de Digne; Lacambre, 1974, no.32): this painting, in its scale and atmosphere, is an anticipation of Courbet's work.

Pictures of guests around a table, deriving from Caravaggio and his followers, are plentiful in the work of all schools at all periods, and there are many models that may have inspired Courbet. We believe, however, that he went to the fountain-head, and that *After dinner at Ornans* is a transposition of the *Calling of St Matthew*, painted by Caravaggio for the church of San Luigi dei Francesi in Rome. Courbet must have seen an engraving of this work, or else a drawing or copy of it must have been shown him by an artist from Rome. The composition of *After dinner* exactly follows that of Caravaggio's painting with its division into two parts. The left-hand side of the *Calling* presents five characters seated at a table; Courbet reproduces the position and attitude of three of these. On the right of the *Calling* two standing figures, forming a single mass, occupy a position corresponding to Courbet's violinist. The light effect in the two works is similar. The rays of light in the Caravaggio, proceeding from an airhole, illuminate the scene in the same way as the sunlight which, in the Courbet, is imagined as coming through a narrow window. Another argument, which we believe to be decisive, is that X-ray examination in the Laboratoire des Musées de France reveals that in *After dinner* the violinist's right arm, holding the bow, was originally stretched out horizontally towards Cuenot, in an exact reproduction of the gesture with which Caravaggio's Christ points to St Matthew (cf. Delbourgo-Faillant, *op. cit.*).

The similarity to the *Calling of St Matthew* would be surprising if it were fortuitous. As André Fermigier observes (p.24), 'In *After dinner at Ornans* the violinist, who is the principal character, is thrust to one side, into the shadow'. This original conception is found in Caravaggio's work: Christ, the spiritual focus of the scene, is displaced to the right in the

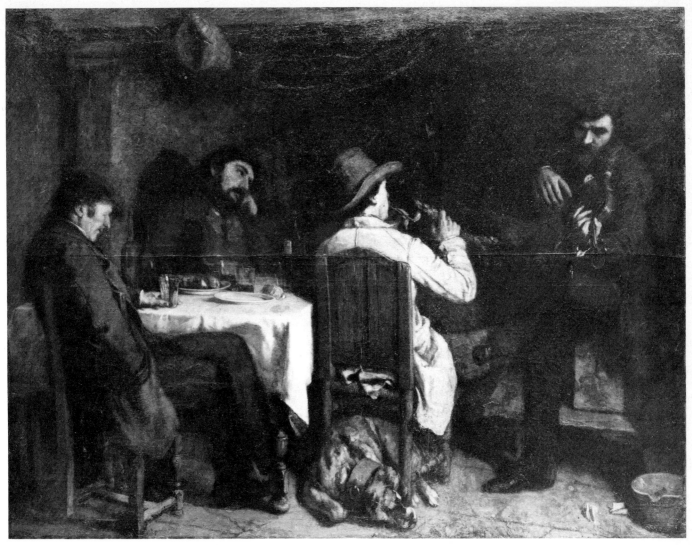

134

same way as Courbet's figure symbolizing music, the abstract motif of his painting.

Courbet's work is eminently in the Dutch style and its manner is very close to that of his friend Bonvin, Courbet's friend who introduced him to the Louvre during his first years in Paris. Courbet's visit to Holland in 1846 improved his knowledge of Rembrandt and his followers, and this painting shows how much he learnt from them. At the same time we are reminded of Chardin by the cosy, unpretentious still life, so rich and yet so modest.

This is Courbet's first narrative painting, prior to the *Burial at Ornans* (135) and *Return from the fair* (41). The after-dinner scene is transformed into an historical event of which Courbet records the details: the time, place and season, the names of the participants and the fact that they have come together to hear the violinist play. In this way, acting as an historian, he records for posterity's benefit a moment in the life of the French rural bourgeoisie.

Courbet was not the first painter of large-sized genre pictures of this kind: as

we have seen, he was anticipated by Grosclaude in 1835. But he was the first to become celebrated by doing so. His boldness was praised by some and reproved by others, but his fame was henceforth beyond question.

Delacroix admired the work: 'Have you ever seen anything like it,' he exclaimed 'anything so strong, with no dependence on anyone else? There's an innovator for you, a revolutionary too; he burgeons all of a sudden, without any precedent; he's an absolute unknown!' (Riat, p.67). Ingres

himself, who disapproved of all that was not 'ideal', acknowledged that the work was of extraordinary pictorial quality, though he prophesied that it would set a dangerous example.

After dinner at Ornans was purchased by the French government and presented to the museum at Lille, at the request of its director, Edouard Reynart. Courbet had hoped it would be hung in the Luxembourg, but he accepted the position with good grace and wrote to Reynart: 'If I had been asked to choose a destination for the picture I would certainly have thought of one less distinguished and less honourable' (Riat, p.68).

The people of Ornans were so proud of their fellow-townsman's success that on his first homecoming after the Salon he was welcomed by Promayet's amateur orchestra; dancing and merrymaking went on till dawn.

Lille, Musée des Beaux-Arts.

135
Burial at Ornans

Un enterrement à Ornans (21)

Canvas: 315 × 668. Signed lower left: *G. Courbet.*

History: Juliette Courbet coll.; given by Juliette Courbet to the State, 1881; entered the Musée du Louvre, March 1882.

Exhibitions: 1850, shown at Ornans, Besançon, Dijon; 1850–1851, Paris, Salon, no.661; 1852, Besançon, Frankfort; 1855, Paris, no.2; 1867, Paris, no.3; 1873, Vienna; 1881, Paris; 1935–1936, Zurich, no.22.

Bibliography: Caricature by Bertall in *Le Journal amusant*, 7 March 1851 (repr. in Léger, 1920, p.15); Louis Peisse in *Le Constitutionnel*, 8 January; G. de Ferry in *L'Ordre*, 10 January; P. Pelioz in *Le vote universel*, 14 January; Courtois in *Le Corsaire*, 14 January; Fabien Pillet in *Le Journal Officiel*, 13 February; Th. Gautier in *La Presse*, 15 February; P. Mantz in *L'Evénement*, 15 February; P. Haussard in *Le National*, 20 February; Champfleury in *Le Messager de L'Assemblée*, 25, 26 February; Clément de Ris in *L'Artiste*, VI, p.34; L. de Geoffroy in *La Revue des Deux Mondes*, 1 March, p.298, sq.; Sabatier-Ungher, *Le Salon de 1851*, p.16; A. de La Fizelière, *Salon de 1851*, p.23; Champfleury in *L'Ordre*, 21 September; Champfleury, 1861 (reprinted in Lacambre, 1973, pp.158–167); Proudhon, 1865, pp.174–177; Riat, 1906, pp.76–78; Schapiro, 1940–1941, pp.165–166; Yoshio Abe, 1962, pp.29–41; Nochlin, 1965, pp.119–126; Nochlin, 1967, pp.209, 211; Clark, 1969, April pp.208–212, May, pp.282–289; Nochlin, 1971, pp.78–81; Bowness, 1971, pp.132–139; Fermigier, 1971, pp.41–43; Bowness, 1972, pp.119–139; MacCarthy, 1971, pp.12–16.

Tableau of human figures: history of a funeral at Ornans – such is the full title of this work, entered in Courbet's own hand in the Salon receipt book in the Bibliothèque du Musée du Louvre. Cumbersome though it may appear, it expresses succinctly the full range of the artist's intention. To show different sorts and conditions of men and to present them in an historical setting – such was the chief purposes of Courbet's first monumental composition, which is one of the great masterpieces of the nineteenth century from both the aesthetic and the historical point of view.

Courbet embarked on his ambitious work at Ornans in the late summer of 1849. His fellow-townsmen posed one after the other, considering it an honour to appear in the painting. The precentors, whom Courbet had not originally invited, took offence and demanded to have themselves 'taken' likewise. Altogether nearly sixty persons were depicted, representing all the different social strata of Ornans.

Having completed his studies, Courbet composed the picture on canvas. He described the work to his friends the Weys in a letter of 12 December (Riat, p.76). The whole of the painting was done in an attic of the house in the place des Iles Basses which Courbet had inherited from his maternal grandfather; he was very short of space and wrote to Champfleury: 'I am working blindly, I've got no room to stand back [from the canvas].'

Riat has identified some of the characters in the painting. On the extreme left is Courbet's grandfather Jean-Antoine Oudot, a man of republican sentiments and Voltairean convictions who had died in the previous year. Next come the four pall-bearers, wearing the broad-brimmed felt hats that Alphonse Cuenot used to hire out for funerals. The one nearest to us is Alphonse Promayet, the violinist of *After dinner at Ornans* (134), and the other three are Crevot, Etienne Nodier and Alphonse Bon. In profile behind the last-named is Max Buchon from Salins, the writer who was Courbet's cousin and childhood friend. Father Bonnet, the parish priest of Ornans, is seen in a black cope and surrounded by other clergy and church functionaries: Colard carrying the cross, and behind him Cauchi the sacristan. Some present-day natives of Ornans can still remember the choir-boys, one of whom was Francis

(known as Fifi) Panier. The vergers, according to Franche-Comté custom, wear scarlet robes edged with black velvet, and caps of flared shape; they are Jean-Baptiste Muselier the vine-grower and Pierre Clément the shoemaker. Between Clément and the *curé* we can just see Promayet the organist, Alphonse's father, in a white surplice. Cassard, the gravedigger, kneels on one knee in the foreground.

The men in the central group are not clearly identified by Riat. The Ornans Museum possesses an annotated photograph of the picture, but we have some doubts as to the information it provides. It is hard to see the painter's father, Régis Courbet, in the prominent figure wearing a top hat and with a goatee beard: he is much too young, and Courbet's father was clean-shaven at the time. We think it more likely that Régis Courbet is the man facing the spectator, to the left of the one holding a handkerchief to his face. In that case the order of figures to the right of the vergers is as follows: a man named Sage(?) wearing a hat, then Régis Courbet, then the weeping man (Bertin?); in the row behind, Urbain Cuenot, bare-headed, and one of the two Marlet sons in a top hat; then, as the chief mourner, Claude Melchior Proudhon, deputy justice of the peace and cousin of the famous sociologist and, immediately next to him, the corpulent mayor of Ornans, Prosper Teste de Sagey. The circle of male figures is completed by two 'diehard republicans', *pères* Secrétan and Cardet. The one nearer to us has done honour to the occasion by putting on old-fashioned attire: a tail coat, breeches and a cocked hat.

According to the catholic custom, the men and women are in separate groups. Riat informs us that Courbet's sisters are the three figures in the foreground to the right of the blue-stockinged republican: Juliette is weeping, Zoë's face is buried in her handkerchief, while Zélie looks pensive. History has preserved some names of the peasant and bourgeois women surrounding them. The painter's mother, *née* Sylvie Oudot, is on the extreme right, holding by the hand a small daughter of the Teste family. This is the only portrait of Madame Courbet at present known, although one was exhibited at Besançon in 1860 (no.305) and is mentioned in an undated manuscript inventory in the Cabinet des Estampes at the Bibliothèque Nationale (Box II). We

suggest that the woman at the back on the extreme right of the picture represents the artist's grandmother Thérèse Josèphe Oudot, *née* Saulnier, who died in 1847: she would thus be a 'ghost' forming a pair with her husband at the opposite end of the painting. Her features resemble those of Mme Courbet in front of her; moreover she is bare-headed, which would be unlikely if she were a living person.

A plate affixed to the gate of the cemetery at Ornans states that the first person buried there, on 6 September 1848, was Claude Etienne Teste, a farmer unrelated to his namesake the mayor of Ornans. The old burial ground surrounding the church had become too small, and a new site was chosen half-way up a hill outside the town. This is the scene of Courbet's picture, which shows the landscape as it is actually seen from the cemetery! The town is on lower ground between the spectator and the cliffs seen on the horizon. On the left is the Roche du Château, on which can be seen some houses belonging to the locality called Le Château d'Ornans (cf. 22) the valley of the rivulet of Mambouc separates it from the Roche du Mont on the right.

Father Goguey, the present parish priest of Ornans, has kindly given us some information on funeral customs in the Franche-Comté in Courbet's time. The coffin was supported by palls slung underneath it and hung, as we see, over the bearers' shoulders, a custom still followed by the nuns of the Visitation at Ornans. The tall crucifix of painted wood was used for funerals at the period of the painting, and is still used by the nuns when a sister is buried within the convent precincts. The large pall decorated with crossbones and 'tears' a sign of mourning, was also a customary feature.

Courbet was thus at pains to produce a strictly historical work: the topography is accurate, the individual figures are identifiable and the forms of the ceremony are carefully reproduced. This grandiose work depicts an event of everyday life in which some of the characters are simple village folk: the artist has made an historical event out of an ordinary occurrence, the rustic funeral of a person unknown to us. It has indeed been suggested that the picture represents the funeral of Courbet's own grandfather, whose appearance on the extreme left would thus be in the nature of a ghostly visitation; this may be so, but is by

no means certain. Antoine Oudot died on 14 August 1848; we do not know where he was buried, but presumably not in the new cemetery, since the first funeral there, as we have seen, was that of a different person at a slightly later date. In any case the point is of no importance, since in the whole elaborate scene the only detail that apparently counts for nothing is the identity of the dead person who, by rights, should be the invisible hero of the drama.

Courbet, then, has turned a village incident into an historical event. Beyond the depiction, however detailed, of a mere anecdote we perceive something of universal significance – one of those rare expressions of the feelings and aspirations of a period which make *Burial at Ornans* so impressive as an historical document.

Admirers and hostile critics of Courbet's picture have alike regarded it as an anti-clerical satire; but in our opinion it is full of religious feeling. Despite the profusion of religious sentiment in the nineteenth century, it would be hard to name a work more imbued with piety – not merely superficial devotion, but Christianity as the revolutionaries of 1848 understood it.

Pierre-Joseph Proudhon was not mistaken when he replied to those who denounced the *Burial* as a sacrilegious work: 'Of all the most serious events in life, the one which least lends itself to mockery is death, the last event of all. If anything is sacred both to believers and to unbelievers it must be the close of life – the last will, the solemn farewells, the funeral and the grave ... How can we imagine Courbet taking pleasure in ridiculing such a scene and turning its actors into grotesques?' (Proudhon, p.175).

The best answer to those who believe the picture to be satirical is that Courbet would not have used his family and his fellow-townsmen as characters in an anticlerical work. The Franche-Comté was a deeply religious province. The painter's family was a pious one, even though one of his grandfathers was a free-thinker. His mother was a practising Catholic, and two of his sisters thought of taking the veil. Juliette, a nun in everything except the habit, died as a tertiary of the Franciscan Order. When Gustave died, his father's grief was enhanced by the painter's wish, which he did his best to thwart, that the funeral ceremony should be a civil one only. It was the devout Juliette who in-

sisted on carrying out Gustave's wishes, either out of respect for him or because it gave her pleasure that he, as an unbeliever and a 'limb of Satan', should be buried without religious rites. The father, for his part, refused to attend the ceremony. The reburial of Courbet's remains at Ornans, which took place in 1919, was delayed because the family could not agree to a non-religious interment in his native soil. Such was the atmosphere in which Courbet grew up. The biographers who read so much into young Gustave's refusal to make his first Communion are taken in by the painter's love of braggadocio and his complacency over the fact that the bishop of Besançon was specially summoned to make him see reason, whereas most parents would have settled the matter more expeditiously by a thrashing. Courbet enjoyed telling such stories in later years when he had broken with the church and styled himself 'a man without ideals or religion', but in his youth things were different. When he first arrived in Paris his closest friends were such men as Paul Ansout, who had himself painted with a work by Lamennais at his side (4), or the mystic Marc Trapadoux, who wrote a life of St John of God (1844). Other intimates of his were Baudelaire, Toubin and Champfleury who, in 1848, combined to publish a periodical entitled *Le salut public*: the second of its two numbers was illustrated by a vignette of Courbet's, an imitation of Delacroix's *Liberty on the barricades* to which he added the inscription *Vox Dei, vox populi*. This journal, the mouthpiece of Courbet's friends, was inspired by Lamennais's social and religious ideas, and was composed in the form of versicles, to emphasize the link with *Paroles d'un croyant*; the first number was dedicated to Mgr Affre, the archbishop of Paris murdered on the barricades in June 1848. The second contains the lines, attributed to Baudelaire himself: 'Priests, do not hesitate, throw yourselves boldly into the people's arms ... Christ, who is your master, is ours too. He was with us on the barricades and it is thanks to him alone that we were victorious ... Priests, have the courage to join us; Affre and Lacordaire have shown you the way. We have the same God, why should we have two altars?' (Baudelaire, II, pp.1035, 1557).

The fall of the July Monarchy had inspired French republicans with an upsurge of romantic enthusiasm and a keen

desire for social unity embracing all classes. 'In 1848 Pierre Leroux described Jesus as the greatest of all economists. His kingdom is of this world, wrote Leroux – the gospel proclaimed it in no uncertain terms' (Droz, I, p.402). Or, as Dr Guépin put it: 'The Holy Spirit speaks with different tongues in different times and places. Today, the Spirit is incarnate in socialism' (Droz, *ibid.*).

Flaubert, in *L'éducation sentimentale* (1869), made some caustic allusions to the 1848 revolution, including this description of the work of an *avant-garde* artist: 'It depicted the Republic, or Progress, or Civilization, in the guise of Christ driving a railway engine through virgin forest' (*Œuvres*, Bibliothèque de la Pleiade, II, 330).

True, the urge to combine democracy and religion was of short duration. By 1851 Baudelaire was uttering the Satanic and violent strophes of the *Denial* of *St Peter*, and Courbet himself soon turned against the church. But this should not lead us to forget one of the most striking aspects of the 1848 revolution.

What does the picture represent? Firstly, a cross-section of the whole population of a country town: the nobility, the curé, the mayor, the justice of the peace; the bourgeoisie, landowners, merchants; low-classes, vine-growers, farmers. All these figures are not simply assembled by chance like those in *The painter's studio*, but are united in a ceremony of submission to the cruellest mystery of human existence, that of death. The communion in which they are linked is dominated by the figure of Christ on the cross. Nothing is accidental in Courbet's work, and the choice of a religious symbol is deliberate: had he wished, he could have depicted the theme of popular unity in a non-religious setting. Beside the open grave we see a skull like that which the old painters often represented at Golgotha and which, according to legend, was that of Adam himself. St Matthew tells us that 'Jesus . . . yielded up the ghost . . . and the earth did quake, and the rocks rent; and the graves were opened'; and later Christians piously believed that the skull of the First Man, which had been buried for centuries, thus saw the light of day again (Réau, *Iconographie de l'art chretien*, 1957, II, p.489).

Adam's skull, it should be noted, is not only a Christian but a Masonic symbol;

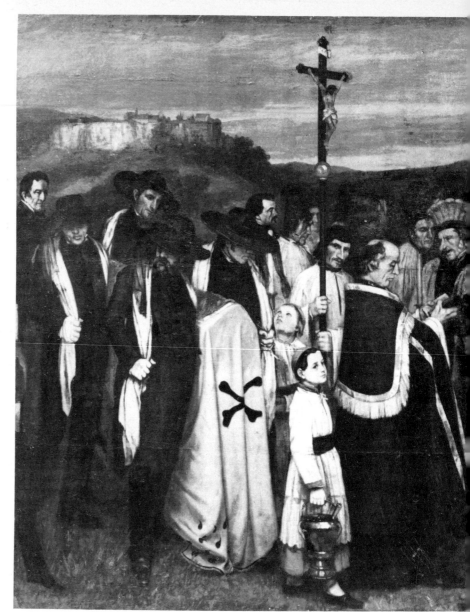
135

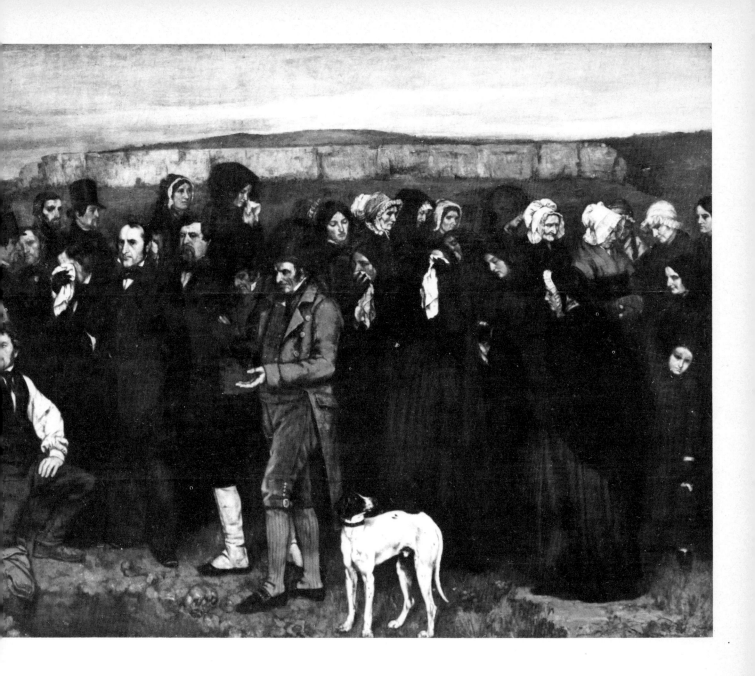

and the theme of deism and universal brotherhood was alive in French Masonry at the time of Courbet's painting. 'Article 3 of the Constitution of the Grand Orient, dated 10 August 1849, calls on French Masons to recognize the existence of God and the immortality of the soul' (Chevallier, II, p.334). 'The Lodges were all but unanimously in favour of religion. The Masonic movement officially turned once more towards God' (ibid., p.335). It is quite possible that Courbet's picture was inspired by this new spirit in French Masonry. We may note that the clergy, standing to the left of the grave, are faced by two men who played a prominent part in the Besançon Lodge, whose motto was 'Sincerity, Perfect Union and Constant Friendship': Prosper Teste, the mayor of Ornans, and Melchior Proudhon, the magistrate, who were initiated respectively in 1831 and 1833. Standing alongside the republicans, they confront the parish priest after the manner of plenipotentiaries about to discuss a treaty. Is it the mayor or the judge who embodies the moral purpose of the work? Bertall's caricature (op. cit.), published at the time of the 1851 Salon, is instructive in this respect: it turns the painting into a Masonic scene of mourning, each figure – save only the vergers and the dog – being represented by a silver 'tear' against a large expanse of black, while the grave in the foreground is of triangular shape. Did the cartoonist correctly discern the meaning of the 'historical' painting executed less than two months after the new, deistic Constitution of the Grand Orient?

In any case, the idea of a reconciliation of all mankind in Christ, which took on political form in the minds of the republicans of 1848, had been in the air for many years; it was inspired by the illuministic theories of Swedenborg, which combined deism with humanitarianism. Courbet's picture was not its first artistic manifestation. At Brussels he must either have seen or heard about a monumental work which created a great stir, namely the *Triumph of Christ* by Antoine Wiertz (1846; Brussels, Musée Wiertz). The *Burial* though in a very different style, is a kind of pendant to that work. 'In his *Triumph of Christ*, Wiertz adopts the pose of a philosopher. His idea of Christ's sacrifice owes as much to Christianity as to the secular, humanitarian, anticlerical theories to which he professed adherence. Some have seen in this work his

rendezvous with death' (Fierens, p.450).

The nineteenth century was one of conscious piety, in opposition to the scepticism of the Enlightenment, and even the most determined freethinkers shared the obsession with philosophy and religion. In 1849 Courbet's friend Paul Chenavard (cf. 109) had been engaged for a year in the colossal task of decorating the walls of the Pantheon with his Universal Palingenesis, the main portion of which is dominated by the figure of Christ. In 1851, when the Pantheon was reconverted into a place of worship, this project was abandoned, and nothing remains of it except the cartoons in the Lyons Museum. Again, in 1865 the same Chenavard painted his *Divine tragedy* (Louvre), with the crucified Christ as its central figure, but with a theme obscure enough to be involved, after the final rift between the church and the Lodges, both by the Catholic Louis Veuillot and by the President of the Grand Orient (cf. Lacambre, 1974, no.47).

The *Burial*, in its sobriety and 'classicism', is clearly a long way removed from the other works in question, with their rhetoric in the style of Raphael or Michelangelo. But it belongs to the same spiritual family, and is all the richer for its 'realism' and its 'popular' treatment of symbolism.

Burial at Ornans is Courbet's supreme manifestation of realism, but also the most romantic of his masterpieces, above all by reason of its subject-matter. From the time of the first beginnings of romanticism among the Neo-classicists we encounter a preoccupation with death, the tomb, cemeteries and funerals. Examples are the Sablet brothers' portraits, in which members of a family are grouped round a tomb (1791, Brest Museum, and others); Girodet's *Atala at the tomb* (1808, Louvre); and Ary Scheffer's intimist painting of *Géricault on his deathbed* (1824, Louvre). In France the theme was commoner in literature than in the plastic arts: thus Madame de Staël wrote in *De la littérature* that 'grief makes us see more of man's character and destiny than any other state of mind'. The Realists continued until late in the century to provide examples of this taste but, unlike Courbet, in the present work, they did so in a purely sentimental vein: one of the last important specimens is Friant's *All Saints' day* (1889, Nancy Museum). The funeral theme was well

represented in popular prints: Meyer Schapiro has pointed out (p.167) that one source of Courbet's picture is to be found in a woodcut of 1830 entitled *Souvenir mortuaire* (*Memory of the dead*). Linda Nochlin has given us a brilliant study of the theme of death as developed by European artists of the mid-nineteenth century (Nochlin, 1971, pp.57–101).

T. J. Clark, following Buchon, suggests an ingenious parallel between the *Burial* and a *Danse macabre* (op. cit.), but we ourselves do not find any moralizing or pamphleteering intent in Courbet's work – only the spirit of peace and human brotherhood.

Courbet wrote to Bruyas (Borel, p.71) that the *Burial* was his 'début' and his 'statement of principles'. Paul Mantz, writing in *L'événement* on 15 February 1851, predicted that it would represent 'the pillars of Hercules of Realism' in the history of modern art. All this is true in one sense and false in another. Certainly Courbet's first monumental canvas bears the strongest imprint of his personality; but what exactly was Realism? This is not the place to analyse finally a mode of expression to which artists of different periods have appealed with greater or less emphasis ever since Caravaggio. Champfleury wrote to Buchon: 'As for Realism, I regard the word as one of the best jokes of our time ... Realism is as old as creation; there have always been realists' (Troubat, p.87). What was the new element that Courbet introduced, with this work in particular? There certainly was one, for those who saw it for the first time were shocked and revolted; Ph. de Chennevières called it an 'impious, ignoble caricature'. What was new was that Courbet painted on a large scale an everyday incident showing human beings as they were – ugly and 'common' in every sense, whereas art was conventionally supposed to ennoble and idealize everything it touched. The smug bourgeois of mid-century France, many of whom had risen rapidly from humble origins, preferred to forget wooden shoes and peasant head-dresses; the family portraits that Courbet offered were too lifelike to be comfortable. Legendary or historical subjects were a different matter. No one was upset by the sufferings of the Russians in Gros's *Eylau* (1808, Louvre), the corpses in Géricault's *Raft of the Medusa* (1819, Louvre) or the expiring mother in Delacroix's *Massacre of Chios*

(1824, Louvre): it was endurable, even laudable for truth to be horrific if the subject was war, oppression or the cruelty of fate. These things were a long way off, and the bourgeois did not feel himself concerned by them; but a slice of daily life should be treated in a gentler, more urbane manner.

The Realists were so often told that they were producing a popular brand of art, seed-bed of the revolution, that they finally believed it. This delusion was characteristic of the demagogic Utopianism of the time. (Why should the masses in fact prefer artists to depict 'popular' subjects? Shop-girls would rather be told about princesses.) Different forms of art are not addressed to particular categories of people but to whoever understands them, irrespective of social background and schools of thought. The genesis of Realism is clear enough: it began at the end of the eighteenth century, when even David saw that neo-classicism and academicism were not all-sufficient. His *Death of Marat* (1793, Brussels, Musées royaux des Beaux-Arts) is among the most powerful of realistic paintings. The new school reached its height in Gros, Géricault and Delacroix; Courbet regarded himself with pride as the heir to these artists, who followed other masters than Raphael and who, with the passion and impetuosity of men born in times of trouble and rapid change, revived the 'plebeian' art – if we may call it so at the risk of misunderstanding – of the great successors of Caravaggio. Courbet painted what he saw and knew: he did not frequent battlefields, and his panorama of history is composed of bourgeois and peasant scenes that were familiar to him from real life.

The first sketch for the *Burial* seems to have been a charcoal drawing (131) which, as we shall see, differs considerably from it. It has long been supposed that Courbet took as his model the large group portraits of seventeenth-century companies of the Civic Guard, which he no doubt saw in Holland in 1846; the principal ones are now in the Rijksmuseum, and the most famous is Rembrandt's so-called *Night watch*. Courbet's picture bears no resemblance to the latter, but seems to be inspired by several other works of this kind. Linda Nochlin (1967, p.211) suggests as an essential source *Captain Bicker's Company* by B. van Der Helst, pointing out that the marksman seated on a barrel corresponds to Courbet's gravedigger kneeling in front

Caricature by Bertall

of the frieze of figures. There may also be a connection between the child in the Dutch picture and Courbet's choir-boy. But van Der Helst's set piece is, except for Rembrandt's, the most lively, colourful and baroque of its kind; while the *Burial* with its stiff, vertical figures, its sombre austerity and atmosphere of silence, is more reminiscent of two other 'civic guard' pieces: *Captain Allaert Cloeck's Company* by Thomas De Keyser and, especially, *The Meagre Company* by Frans Hals. The pallbearers' wide-brimmed hats enhance the resemblance to the large Dutch compositions, but the execution of the *Burial* owes more to Spanish models. When Courbet first arrived in Paris he was a frequent visitor to King Louis Philippe's Spanish Gallery; this collection had been presented to the Louvre, but was returned to Louis Philippe in London after his deposition. There is a strong suggestion of Zurbarán in the deep blacks, the splashes of white, the vivid scarlet robes and the blue of the republican's stockings. There is something Spanish, too, in the characters' crude unsoftened features. Some of their expressions, indeed, are exaggerated to the point of caricature, and this has been ascribed to the influence of popular prints.

There is a further parallel which cannot be accidental, bearing in mind that Ornans is close to Burgundy and that Courbet frequently visited Dijon. The massive figures of the women swathed in cloaks resemble the mourners on Burgundian tombs – those of the Dukes or of Philippe Pot – whose obsequies are thus suggested in Courbet's work.

We do not know much about the studies which preceded the final painting. The Ornans Museum recently acquired the *Portrait of Grandfather Oudot*. Variants of a *Group of choirboys* are to be found in private collections (e.g. the former Cochin collection), as was a *Dog* dated 1856 (possibly a replica?) in the former Marczell de Nemes collection. Some *Portraits* of inhabitants of Ornans, thought to be studies for the painting, are dispersed in various collections.

Courbet first showed the *Burial* to his fellow-townsmen in the spring of 1850, in the chapel of the Ornans Seminary. He then exhibited it at Besançon, having posted advertisements all over the town. It was quite well received there, but an exhibition at Dijon in June was a failure. The town was in the grip of a feud between 'Whites' and 'Reds'; the picture was hung in a tavern belonging to the 'Red' faction, who took little notice of it, while the 'Whites' refused to cross the threshold; so Courbet's expenses were incurred to no purpose.

The picture made its real début in Paris, at the Salon of 1850–1851, where Courbet exhibited nine paintings including

three of the first importance: the *Burial*, the *Peasants of Flagey* (41) and the *Stone-breakers* (Dresden Museum, destroyed in the second world war). These made such a profound impression that Courbet gained the reputation of a painter of peasant subjects ('paysanniste'), although in fact it was a genre that he did not often practise.

The 'Courbet scandal' dates from the same Salon: overnight the artist became famous, lauded to the skies or denounced and ridiculed. There was more condemnation than praise: hands were raised in horror at the 'cult of ugliness, the glorification of vulgarity and odious coarseness'. In the ensuing weeks, few critics failed to utter long diatribes against the painting. Courbet had the satisfaction that his name was on everyone's lips, but the good folk of Ornans resented the Parisian gibes which compared the group portrait to a parade of scarecrows. They conceived a grudge towards Courbet himself, and prepared to give him a rough reception on his return; his sisters calmed people down, but resentment continued to simmer for a long time.

Courbet attempted to exhibit the *Burial* at the World Exhibition of 1855, but of the thirteen pictures he submitted two were rejected, the *Burial* and *The painter's studio*. The rejection of his two chief works prompted him to organize his first 'private' exhibition, in which they took pride of place. The critics were no more friendly than before, but it is worth quoting Delacroix's *Diary* for 3 August 1855: 'This [the *Studio*] shows great progress, yet it has caused me to admire his *Burial*. True, the figures are cramped together and the composition is poor, but there are some superb details – the priests, the choirboys, the holy-water vessel, the disconsolate women and so on.'

When Mary Cassat, at a later date, saw the frieze of weeping women she was reminded of antique sarcophagi and exclaimed 'Why, it's Greek!'

In 1873 Courbet, then in exile, wished to take part in the Vienna Exhibition, but was prevented by the intrigues of Meissonier and Edmond du Sommerard. By way of compensation, the Austrian Art Society offered him the premises of the Artists Club for a private exhibition. They were particularly anxious to have the *Burial*, but in a letter of 31 January Castagnary dissuaded Courbet from agree-ing: '[The *Burial*] was made for a certain setting; it has its own date and its history in France; it ought to remain here.' On 3 February Courbet expressed agreement, adding 'The *Burial* is no good' (Biblio-thèque Nationale, Estampes, Boxes II and VII). We can appreciate today what these phrases meant, and we note that the painter had lost faith in the picture he had once painted with such passion, calling it his 'début' and his 'statement of principles'.

The *Burial* became the property of the Louvre in March 1882. Towards the end of the previous year Juliette Courbet, as her brother's heir, conducted long nego-tiations for the purpose of securing a sub-stantial annuity (8,000 francs per annum) in return for presenting it to the State. Antonin Proust, minister of fine arts, turned a deaf ear to this request, and finally Juliette proposed to make a gift of the work if the State undertook to purchase other items at the sale of Courbet's paintings on 9 December 1881. As administrative delays prevented a firm answer being given by the requisite time, M. Hecht made the gener-ous gesture of undertaking to buy with his own money any pictures chosen by the Museums, the State to reimburse him when it was in a position to do so. This was agreed, and Juliette withdrew the *Burial* from the sale (no.7). Hecht bought four canvases: *Spring rutting*, the *Man with a leather belt* and *The wounded man* (139, 13, 33) and the *Death of the stag in the snow* (sent to the Besançon Museum). Presented with a fait accompli, Juliette wrote a letter ante-dated to 8 December in which she made a gift of the *Burial* to the French Republic (Forges, 1972, p.455).

As an exceptional measure the pic-ture was made over to the Louvre at once, although the legal interval after the painter's death had not yet expired. The other works went to the Musée du Luxem-bourg. The acquisition naturally aroused much controversy, and press campaigns raged over many years. In 1884 Sâr Peladan wrote in *L'Artiste*: 'To allow the *Burial* in the Louvre is to take leave of every aesthetic sense' (p.412). Bitter feel-ings continued to be aroused until the end of the century.

Today we can make a sounder judge-ment. We know that with this work the thirty-year-old Courbet attained the sum-mit of his art. The room in which it hangs in the Louvre is fittingly chosen. Its lower-ing sky matches that of Gros's *Cemetery at Eylau*, while the noble solemnity of the figures, expressing the hopes and aspira-tions of 1848, is a fit counterpart to the sacrifices of 1830 evoked in Delacroix's *Liberty on the barricades*. The work shows, moreover, that the endeavours of Courbet's predecessors had enabled him to present, in a scene of everyday life, one of the finest pages in the history of world painting.

Paris, Musée du Louvre.

136
Departure of the fire-brigade, 1850–1851

Départ des pompiers courant à un incendie 1850–1851 (27)

1850–1851

Canvas: 388 × 580. Not signed.

History: Juliette Courbet coll.; given by Juliette Courbet to the Corps des Sapeurs-Pompiers of the City of Paris, 1882; deposited at the Petit Palais, 1920.

Exhibitions: 1882, Paris, no.147 (supple-ment); 1929, Paris, no.37; 1934, Paris; 1955, Paris, no.21.

Bibliography: Caricature by Bertall in *Le Journal pour rire*, 7 March 1851 (repr. in Léger, 1920, p.16); F. Mercey, *Les arts depuis le dernier Salon* in *La Revue des Deux Mondes*, 1 January 1852, p.140; Champfleury, *Champfleury pages inédites*, *Courbet inconnu* in *Le Figaro*, 9 January 1892; repr. in Lacambre, 1973, pp.168–169.

This painting, Courbet's second large-scale work after the *Burial* is un-finished but is nevertheless one of his greatest achievements. Before studying its pictorial qualities we may review some historical facts concerning it.

On 7 March 1851 the *Journal pour rire* published two pages of cartoons by Bertall making fun of works in the Salon of 1850–1851, including Courbet's *Burial at Ornans* (135) and *Peasants returning from the fair* (41); another work caricatured, although not in the Salon, was referred to as 'an unpublished picture by M. Courbet'. Historians agree in believing that this was the *Fire-brigade*, although the cartoon bears no obvious relation to it and there is no written evidence that might explain the

connection. In general we are not told much about the painting; Riat (p.100) mentions only that Courbet stopped work on it because of the coup d'état of 2 December 1851.

The caption under Bertall's drawing ran as follows: 'Thanks to the wide connections of the *Journal pour rire* we are able to give out subscribers an idea of this magnificent canvas, Courbet's masterpiece. Its happy possessor is M. Masson, France's right arm, who has been parading the work through towns and villages all over the country and apparently has made a handsome profit by so doing. No doubt that is why the picture could not be exhibited at this year's Salon. Note: We understand that the President has commissioned several works from M. Courbet. It is easy to see why – if a man like M. Courbet were to go in for political caricature, he would be dangerous indeed.'

All that emerges clearly from these enigmatic remarks is that the work to which they refer is a political satire of some kind. But who is 'M. Masson, France's right arm'? Perhaps there is a pun on *maçon*, alluding to the fact that Louis Napoleon escaped from the prison of Ham disguised as a builder's mate. According to one story [since denied], the real worker whose cap and overalls the future President borrowed was called Badinguet, thus explaining the fact that Louis Napoleon was afterwards known by this sobriquet.

As for the caricature, it depicts four 'strong men' with moustaches and aquiline noses, one of whom, in the centre, bears on his shoulders a wagon in which are seated three rows of soldiers – infantrymen, helmeted cuirassiers and artillerymen. A second strong man holds a pair of dumb-bells, while a third brandishes a curious lay figure in breeches, with a naïve expression and with locks showing under a three-cornered hat: is this Voltaire's Candide or a satire on the clergy? The fourth strong man holds up three human figures: a bourgeois with an umbrella, an explorer or colonial official in white with a solar topee, and another soldier. Three of the strong men wear tasselled fezzes which give them an Oriental look – another reference to colonialism?

The cartoon bears no iconographic relation to Courbet's *Fire-brigade*, unless it be the resemblance between the cuirassiers' helmets and those of the firemen. But

Caricature by Bertall

the cart, with its iron-shod wheels and benches, is of the type used from 1812 onwards by the *sapeurs-pompiers* whose duty it was to deal with outbreaks of fire in the national palaces.

Was there any anecdotic connection between firemen and the Prince-President? We suggest the following.

In 1844, during his imprisonment at Ham, Louis Napoleon wrote a pamphlet on socialist lines entitled *L'extinction du paupérisme*. It was widely circulated, and appealed so strongly to left-wing thinkers that one of them wrote: 'Louis Napoleon is no longer a mere aspirant in our eyes but a member of our own party, a man serving under our colours.' The pamphlet advocated a plan to relieve poverty by transferring surplus labour to agricultural colonies to be created for the development of the waste lands of France. The workers were to be uniformed, to receive pay and to live in barracks like soldiers since, as the author explained, 'the military type of organization is the only one based on the

well-being of all its members and at the same time on strict economy'. When there was no more waste land in France, they would move on to Algeria and, if necessary, America. Such was the programme which captivated the French socialists. Later, when Louis Napoleon came to power, he seemed to have lost interest in 'extinguishing' poverty, and accordingly his left-wing opponents lost no opportunity of reminding him of the cause he had once espoused. Can there be a connection between this and the caricature with its allusions to firemen, soldiers and the colonial service?

Let us now look at Courbet's picture. The alarm has just sounded and the firemen are setting off. The steam and smoke of the fire-pumps can be seen. A group of firemen with a hand-pump are preparing to follow a woman who has caught up her skirt in her left hand, this being a standard gesture indicative of haste. With a baby in her arms and a child clutching her dress she also symbolizes poverty; she is not, however, down-and-out like the Irishwoman in *The*

painter's studio, but breathes a spirit of pride and rebellion.

The firemen are moving towards her, but their captain points in a different direction: there is a silent opposition between this man with the enigmatic expression and the imperious beggar-woman. Furthermore, who is the man next to the fire chief – the most important in the scene, for all we know – and what does his attitude signify? He has a beaky nose, a moustache and a chin-tuft; he wears a cap and smock that might be those of Badinguet himself, and moves with a curious gait which may be either a run or a limp. What is more, he has two left arms – one raised in a summoning gesture, while the other, in symmetry with his right arm, appears to be drawing something towards himself. Which of these is the original, and which represents the painter's second thought?

Three other figures are of interest. In the foreground a man stumbles across the fireman's path, his cap flying off his head. It is not clear whether they have knocked him over or whether he is trying to stop them. Then, on the extreme right, a bourgeois couple shrink to one side and hasten away from the scene.

What is the significance of this painting, which was already known to the public in March 1851, nine months before the coup d'état? At this distance of time it is often hard to fathom the intentions of satirists: many of Daumier's drawings dating from this period are unintelligible to us. But in any case we can see that *Departure of the fire-brigade*, painted four years before *The studio*, is Courbet's first major politico-social work.

Some accounts say that he began it at the end of 1851 but, as we have already seen it was known about in March. He must have begun work on the picture in 1850. For its power and conviction we may thank the commander of the fire station in the rue Saint-Victor, who arranged for the alarm to be sounded one fine night so that Courbet could see the procedure at first hand.

The model always suggested is Rembrandt's *Night watch* in the Rijksmuseum, Amsterdam. There is undoubtedly a resemblance, both in the general grouping and in specific details. The outstretched hands of the officer and the workman by his side recall the gesture of Captain Banningh Cocq in the Dutch masterpiece, while the man stumbling in

136

216

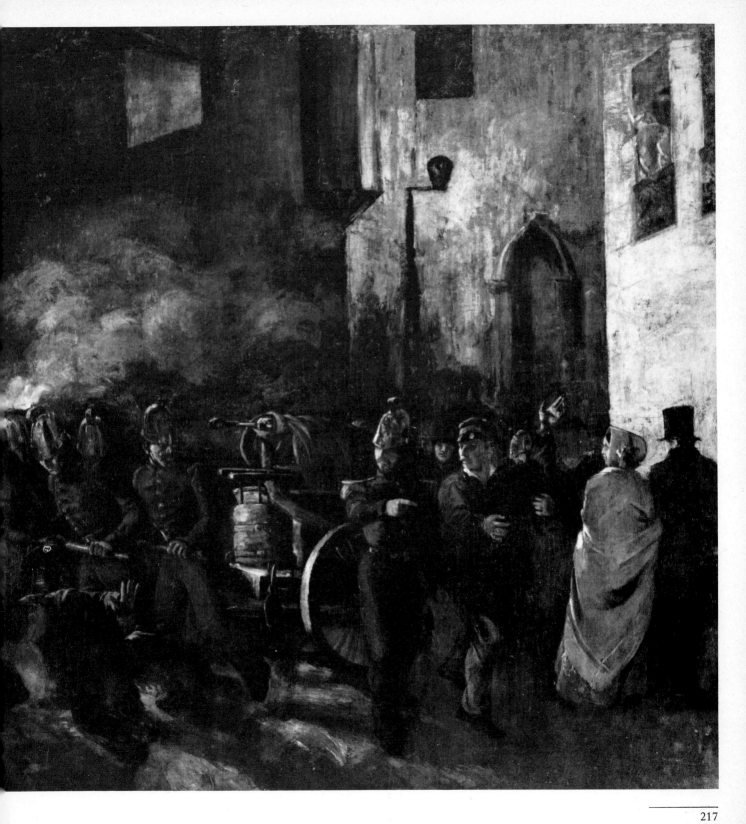

the foreground corresponds to the small boy running in Rembrandt's picture. Courbet's work, however, is classical in composition. In contrast to Rembrandt's baroque arrangement his figures are disposed in a strict and regular frieze, animated only – an ingenious innovation – by the turning movement of the woman advancing on the left and, as a counterpart, the two receding figures on the right.

Linda Nochlin (1967, figs.9, 10) also cites examples of popular prints that may have influenced Courbet.

This work is Courbet's only night-scene, and we must admire his masterly treatment of the light-effects created by the steam of the fire-pumps against the darkness. The chiaroscuro background gives a strange animation to the assemblage of figures, the handling of which shows that Courbet is a great narrative painter.

The fire-brigade is also Courbet's only urban painting, and we may regret that he was not more attracted by street scenes. He may have been influenced by Daumier in this instance, both in his choice of theme and in the use of the female figure representing poverty. Her attitude and her schematized silhouette are unique in Courbet's work but recall many of Daumier's plebeian mothers, notably *In the street* (*c*.1852, Copenhagen, Ordrupgaardsamlingen).

If, however, one had to think of a master who inspired the present work in a pictorial sense, it would be Hals rather than Rembrandt or Daumier. The rapid, spontaneous technique, the direct, slashing and criss-cross strokes are eminently in the style of the Haarlem master.

With all its incompleteness and hesitations, this huge canvas, which may have been left unfinished for fear of prosecution, is one of Courbet's most powerful works and a masterpiece of nineteenth-century painting.

We do not know how many of Courbet's contemporaries were aware of the painting, but it was praised in the *Revue des deux mondes* of January 1852 by F. Mercey, who wrote: 'When the painter, one day, saw a team of firemen pass by with their fire-engine . . . he knew he had found his subject. Making use of facilities afforded by the Ministry of War, he set vigorously to work. We shall soon see the result. To put obstacles in his path, as people are said to have tried to do, is neither right nor

possible. Non-interference should be one of the fundamental axioms of art. The good taste and good sense of the public are sufficient to punish errors and follies.'

An unpublished letter by Courbet throws light on his reason for leaving the picture unfinished. It was not on account of the theme or because of any act committed by Courbet himself, but because the officer in charge of the fire station where he had received permission from higher authority to paint his picture had got into political trouble.

Courbet, writing to his parents from Paris, mentions that he has just heard that his friend Cuenot was being harried on political grounds, and that he considers himself lucky to have left Ornans when he did. 'A fortnight later I would have been in his [Cuenot's] position; a fortnight sooner, in Paris, I would have been in the soup for associating with that idiot Front(?), the fire brigade officer, who has been packed off to [illegible, no doubt Belle-Isle] for staging a revolt of the men under his com-

mand. The same thing might very likely have happened to me, since I put him into my picture. I have been forbidden to go on with it till further notice, and people think me lucky to have fared no worse' (private archives, Paris).

Paris, Musée du Petit Palais.

137
The painter's studio

A real allegory summing up seven years of my artistic life.
1855
Painting, exhibited in the Musée du Louvre, the subject of a 'dossier' found at the end of this catalogue. Cf. p.257.

138

138
Bunch of flowers

Bouquet de fleurs (47)

1855

Canvas: 84 × 109. Signed, dated lower left: *. .55 G. Courbet.*

History: Billeu coll., Paris; given by Verein von Kunstfreuden, 1909.

Exhibitions: 1929, Paris, no.91; 1951, Paris, no.14.

Courbet was fond of introducing flowers into his portraits, but he painted few flower-pieces before his stay at Saintes in 1862, when he painted several with enthusiasm and in a style peculiar to himself (cf. 62). The present attractive picture is one of the exceptions.

A similar painting, acquired by the Metropolitan Museum, New York, in 1929, has been regarded since 1953 as the work of a copyist or forger (Sterling-Salinger, p.112).

Hamburg, Kunsthalle.

139

139
Fighting stags; rutting in Spring

Le rut du printemps, combat de cerfs (61)

1861

Canvas: 355 × 507. Signed, dated lower left: *Gustave Courbet 61.*

History: Juliette Courbet coll.; Courbet sale, Paris 1881, no.22; bought for the State by M. Hecht who advanced the necessary funds; entered the Louvre, 31 July 1882.

Exhibitions: 1861, Paris, Salon, no.717; 1861, Anvers; 1862, London, class 38, no.114; 1867, Paris, no.2; 1881, Paris; 1882, Paris, no.2.

Of all Courbet's pictures of forest animals, this is the most impressive by its size and animation. The painter gave a long description of it in a letter to Francis Wey. 'This springtime rutting, or battle of stags, is something I went to Germany to study: I saw the fights in the game-preserves at Homburg and Wiesbaden. I followed the German hunts at Frankfurt for six months, a whole winter, until I killed a stag that I used for this picture as well as those killed by my friends. I am absolutely certain of the action. In these animals no muscle stands out; the fight is cold, the rage deep-seated, the thrusts are terrible though it looks as if they hardly touched each other; you can understand this when you see their formidable armature ... The landscape with the three stags belongs to early spring, when plants close to the ground are already green and the sap is rising into the big trees ... The action in the painting required it to be at that time of year, but, so as not to show the trees as bare as they actually are, I preferred to use our Jura landscape, which is exactly the same with its mixture of black and white wood. I used a forest like that at Reugney, half bare and half evergreen' (19–20 April 1861, repr. in Courthion, II, 89–90, 92).

The picture was begun at Frankfurt in 1859 and finished in France. The stag on the right is the same, reversed, as in *Stag taking to the water* (140).

The work was very successful at the Salon. The publisher Poulet-Malassis urged that it should be bought for the Luxembourg, but Nieuwerkerke, the directeur des Beaux-Arts, was not convinced.

The records of the Salons at The Hague indicate that a picture of *Stags fighting* by Courbet was exhibited there in 1866 and sold for 4,000 guilders. At this price the picture must have been very large; was it the present work, returned to its author or exchanged for some other?

Paris, Musée du Louvre.

140
Stag taking to the water; stag at bay

Le cerf à l'eau, chasse à courre (62)

1861

Canvas: 280 × 275. Signed, dated lower right: *Gustave Courbet . .61.*

History: Acquired from the artist by the City of Marseilles in 1865.

Exhibitions: 1861, Paris, Salon, no.718; 1865, Marseilles; 1929, Paris, no.76; 1949–1950, London, no.208; 1954, Venice, no.18; 1954, Lyon, no.22; 1955, Paris, no.41; 1959–1960, Philadelphia–Boston, no.35; 1961–1962, Tokyo–Kyoto, no.3.

Bibliography: Nochlin, 1967, p.213, figs.16, 17.

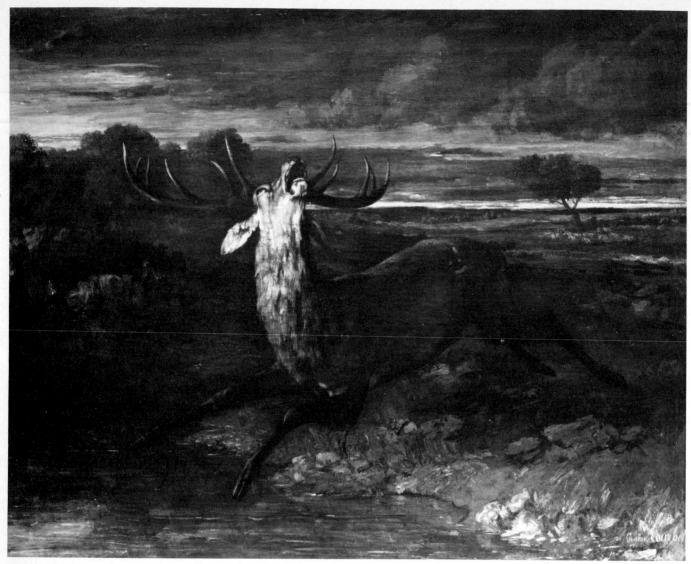

140

Courbet sent this work to the Salon of 1861 together with *Fighting stags* (139); these two are his most important pictures of forest animals.

Courbet's letter to Francis Wey (cf. 139) continues: 'The second picture, *Stag at bay* (*Cerf forcé*), shows a hunted stag taking to the water. I rode with the imperial hunt for five weeks at Rambouillet; on this occasion I was escorting Mme de Violaine, sister of Mme Lafarge . . . As to the landscape of *Stag at bay*, it takes six hours to run down a stag and the scene is therefore in the evening: the sun's last rays are nearly horizontal, and the smallest objects cast very long shadows. The way the light falls on the stag emphasizes the speed with which it is running and makes the picture more impressive. It is entirely in shadow and yet fully modelled, the ray of light is sufficient to indicate its form; it seems to be speeding away like an arrow or a dream. The expression of its head ought to please the English: it recalls the feeling in Landseer's animals' (19–20 April 1861; Courthion, II, 90–2).

Linda Nochlin (*op. cit.*) reproduces an engraving after Landseer, published in the *Magasin pittoresque* in 1851, and argues convincingly for it as the iconographic origin of Courbet's painting; the likelihood of this is confirmed by his reference to Landseer.

Courbet used as a model a stag's head which his German friends presented to him in 1858–1859 and which is seen from different angles in several of his paintings, e.g. *The German huntsman* (57) and *Fighting stags* (139); also a landscape (79). Very possibly this work was begun at Frankfurt at the same time as *Fighting stags*.

Stag at bay combines the representation of a hunting scene with the distress of an animal at the point of death, crying out in anguished protest at the cruelty of fate. In this sense it is one of Courbet's few dramatic works. The hounds are pictured a long way off so that the landscape looks like a deserted plain, emphasizing the solitude of the creature about to die. This is one of the last great manifestoes of romanticism in French painting, imbued with the lyrical and heroic spirit of Alfred de Vigny's poems.

The work was bought by the City of Marseilles, where it had been exhibited. Castagnary may have had some hand in the matter; on 20 January 1865 Courbet wrote

to him: 'I am immensely grateful to you for the Marseilles business. I shall write to my friend Jeanron' (Bibliothèque Nationale, Estampes, Box V). On the day after Courbet's death 'a procession of Marseilles republicans laid a wreath of immortelles, enveloped in crepe, beside the picture in the Museum' (*Le Rappel*, 7 January 1878).

A painting sent by Courbet to the Besançon exhibition in 1860 has been confused with the present one owing to its similar title: no.310, *Stag taking to the water*, 600 fr. It was, however, a smaller work; its present whereabouts are unknown to us.

Marseilles, Musée des Beaux-Arts.

141
Lady in a black hat; portrait of Laure Borreau

La dame au chapeau noir, portrait de Laure Borreau (68)

1863

Canvas: 81 × 59. Signed, dated, lower right: *. .63 Gustave Courbet*.

History: Juliette Courbet coll., Courbet sale, Paris 1881, no.11 (*La dame au chapeau noir, étude d'apres une femme de sang wallon*); acquired by Galerie Durand-Ruel; Reitlinger coll.; Flersheim coll. (1929); Galerie Rosenberg and Co., New York; acquired by Cleveland Museum of Art in 1962.

Exhibitions: 1863, Saintes, no.76 (*La femme aux fleurs*) (?); 1863, Paris, Salon, no.475 (*Portrait de Mme L.*); 1925, Paris, no.21 (*Portrait de femme tenant des fleurs*); 1928, Paris, no.45 (*Portrait de Mme Laurier*); 1929, Paris, no.32 (*La femme au chapeau noir*); 1931, Paris, Rosenberg, no.15; 1935–1936, Zurich, no.71; 1937, Paris, Rosenberg, no.13; 1938, London, no.19; 1938, Amsterdam, no.71; 1941, Cambridge, Fogg Art Museum; 1942, New York, no.2; 1942, Providence, no.20; 1945, San Francisco; 1947, New York, no.2; 1954, New York, no.3; 1956, New York, no.9; 1957, Des Moines; 1959–1960, Philadelphia–Boston, no.40; 1963, Cleveland, no.76.

Bibliography: Gruet, pp.24–5; Caricature by Cham in *Album du Salon*, 1863 (repr. in Léger, 1920 supplement, n.p.); A. T. Lurie in *The Bulletin of the Cleveland Museum of Art*, April 1962, pp.66–71; Bonniot, pp.217–19, 297–9, fig.53.

Courbet must have exhibited this portrait at Saintes, to judge from V. Gruet's remark: 'The *Woman with flowers* is happily treated in parts; her tulle head-dress is a real *trompe-l'œil*' (*op. cit.*). In any case it was shown at the 1863 Salon, with the title *Portrait of Mme L.* (Laure), and

was the subject of a caricature by Cham (*op. cit.*). There is no doubt of the true identification, but the initial L. misled some historians into supposing that the sitter was the wife of Courbet's lawyer friend Laurier (44). Subsequently entitled *Lady with flowers* and *Lady in a black hat*, it was only recognized in 1931 as a portrait of Laure Borreau, who was Courbet's mistress during his stay at Saintes.

Laure is seen here as a still attractive woman nearing forty. She was married to Jules Borreau, a dealer in fancy-goods, whose business life was no more fortunate than his marriage. Courbet, showing his gratitude as a lover, stepped in at one stage to rescue him from bankruptcy. Roger Bonniot gives an amusing description of the the painter's affair with Laure and its sequel (Bonniot, pp.123–6, 209–13, 329–39). Laure's daughter Gabrielle also sat for Courbet (65).

Courbet wrote to Castagnary (Bonniot, p.123) that he was 'in love with a magnificent woman'. He painted two other portraits of her: in one, her dress and pose are similar, but she is bareheaded (private collection). The other, now in the Algiers museum, shows her as elderly and haggard; Bonniot believes it to date from the time of the Borreau family's arrival in Paris, shortly before the war of 1870, when their affairs were in a state of ruin.

The present portrait is certainly the most interesting of the three. The uncompromising black of the hat and dress contrast with the light atmosphere, the yellow gloves, the fresh-coloured flowers and the fluorescent sky. Courbet had a fondness for dressing models in black, such as *Mère Grégoire* (43) or *Mme de Brayer* (53); but these latter are in the sober Dutch or Flemish tradition. The present work too owes something to Rubens, but we feel a new sense of boldness, freedom and modernity, looking towards the *Portrait of the elder M. Nodler* (82). At the Salon of 1863 the portrait of Mme Borreau was displayed not far from Amaury-Duval's *Portrait of Mme de Loynes* (Louvre). Comparing the two *Ladies in black*, it is easy to see that Courbet's picture marks a stage in the art of nineteenth-century portrait-painting.

His new vision shocked the Salon critics, who gave the work a cool reception. Cham's cartoon bore the caption: 'What Courbet can do to a pretty woman! – for

141

we are sure the lady who sat for this portrait is very pretty' (*op. cit.*). In point of fact this Laure is no longer young and cannot be called pretty, but she is highly attractive. She is fond of love; the caricaturist is aware of the fact, and has put his finger on one of Courbet's great merits as a portrait-painter, his ability to express the model's personality. We may quote here a passage from André Fermigier, replying to a somewhat condescending remark of Edmond About's concerning Courbet's realism: 'Courbet was not lacking in subtlety or psychology, he was perfectly capable of identifying with his model; and if "his real medium is iron, stone, bark, hide and hair", it is not because of these that he became the greatest portrait-painter of his time' (Fermigier, p.73).

Cleveland, Museum of Art.

142
The fort de Joux

Le fort de Joux (78)

1864

Canvas: 74 × 61. Signed, dated lower left: *..64 Gustave Courbet.*

History: Sold by the artist to Alfred Bouvet, of Salins, in December 1864; Mme Chantre (1939); Galerie Cassirer, Berlin; private coll., Paris.

Exhibitions: 1929, Paris, no.71; 1935–1936, Zurich, no.73; 1939, Ornans, no.21; 1955, Paris, no.54.

This is the companion to the *Gour de Conches* (74), painted for Alfred Bouvet at Salins. The two works, long separated, are here reunited for the time being.

Formerly a prison for political dissidents (who included Mirabeau and Toussaint Louverture), the fortress no longer housed any captives in 1864. It nevertheless had a symbolic importance for Courbet, who was subjected to close police supervision following the death of his protector, the duc de Morny.

As in the Gour de Conches, Courbet indulged his sense of humour in this work: the rocks in the foreground are shaped like a bust of Janus facing both ways.

Paris, Jacques Guérin collection.

142

143
Sleeping woman

Femme endormie (93)

1865?

Canvas: 56 × 47. Signed, lower left: *G. Courbet.*

History: Hecht coll., Paris(?); Oskar Schmitz coll., Dresden until 1938; Percy Moore Turner Gallery, London; bought by Douglas Cooper in 1943, retained until 1956.

Exhibitions: 1882, Paris, no.27 (*Une dormeuse, tête d'etude*)(?); 1930, Berlin, Galerie Cassirer; 1937, Paris, London, Wildenstein Gallery, *La Collection Schmitz.*

Bibliography: Léger, 1929, repr. p.161.

In coloration and technique this picture seems to us to resemble *The awakening* (144). We suggest a date *c.*1865.

A similar study, belonging to the collector Hecht, was shown at the Courbet exhibition of 1882.

Paris, Jacques Guérin collection.

143

144
The awakening or Venus and Psyche

Le réveil ou Vénus et Psyché (94)

1866

Canvas: 77 × 100. Signed, dated lower left: *..66 G. Courbet.*

History: Sale X (Reitlinger), Paris, 1 June 1908, no.8 (*Les deux amies*); sale x, Paris, 16–17 December 1919, no.232; H. J. Laroche coll.; Galerie Wildenstein; Galerie Paul Rosenberg (1926); W. Raeber coll., Basel; acquired by the Kunsthaus in 1941.

Exhibitions: 1922, Paris, no.31; 1926, Amsterdam, no.27; 1929, Paris, no.42; 1930, Berlin, no.33; 1935–1936, Zurich, no.87; 1949, Copenhagen, no.18; 1950, La Tour de Peilz, no.24; 1955, Paris, no.67; 1962, Berne, no.43; 1959–1960, Philadelphia–Boston, no.61; 1969–1970, Rome–Milan, no.30.

For the Salon of 1864 Courbet submitted a picture painted at Ornans during the previous winter and entitled *Venus jealously pursuing Psyche*. That work was destroyed in Berlin (Gerstenberg collection) during the Second World War. *The awakening*, here exhibited, is a modified repetition of it.

The jury in 1864 rejected the original work on the ground of indecency, despite the mythological title offered as a fig-leaf. The theme of Lesbianism attracted many French writers and artists throughout the nineteenth century, including Balzac, Baudelaire, Gautier and Banville. It has generally been claimed that Courbet's picture was inspired by Baudelaire's *Femmes damnées* or *Delphine et Hippolyte*; but less distinguished authors also took up the theme, and it is quite possible that Courbet's work owed more to the writer and caricaturist Henri Monnier.

Monnier was in the habit of eking out his income with prose sketches of a kind usually found in the 'Erotica' sections of libraries, and in 1863 he entrusted to Courbet's friend Nadar the manuscript of a vulgar parody of Baudelaire to be published in the 'year of joy 1864' by Poulet-Malassis in Brussels. This was entitled: 'Two Lesbians (*gougnottes*), a dialogue embellished with an infamous physiognomy (by Félicien Rops) and a devastating autograph.' The protagonists of the 'dialogue', which was both coarse and stupid, were a blonde, Henriette, and a brunette, Louise (cf. Pichois in Baudelaire, I, 1127). Poulet-Malassis was also Baudelaire's publisher, but it is safe to suppose that he did not boast to him of this prank.

Venus and Psyche was offered by Courbet to the Brussels Exhibition of 1864; it was accepted, but the critics were not slow to express misgivings. A writer in *Sancho* on 25 September exclaimed: 'Is the Exhibition Committee perfectly sure that Courbet's picture "*Deux gougnottes*" – the initiated will understand this term of art, invented in some low dive or other – was meant to be shown in public (*dans une exposition publique*)? In a brothel (*dans une maison publique*) – yes, by all means!' The Belgian journalists were thus in no doubt as to Courbet's source, although Baudelaire himself seems to have been taken in (Baudelaire, II, 885). It was in fact some decades since Courbet had based any work of his on literary allusions; poetry, according to him, was 'aristocrats' talk', and he is likely to have found Monnier's squib more congenial than the elegant strophes of the *Femmes damnées*. He had, moreover, broken with Baudelaire a good while previously, and had even satirized him in another painting submitted to the Salon of 1864, entitled *The fount of Hippocrene*. This work showed a group of poets – Lamartine, Dupont, Mathieu, Monselet, Gautier and Baudelaire – drinking water from a basin into which a woman was spitting; it was never finished, as the canvas was accidentally torn.

At this stage of his career Courbet took a delight in scandalizing the public. Although the supreme painter of his generation, he was tortured by an inferiority complex and a perpetual thirst for praise. From the day when Napoleon III struck his name off the list of those recommended for the Legion of Honour, his desire for publicity became stronger than ever. In 1862 he painted *Return from the conference*, a huge picture of a party of drunken priests staggering along a country road, for the express purpose of 'shocking

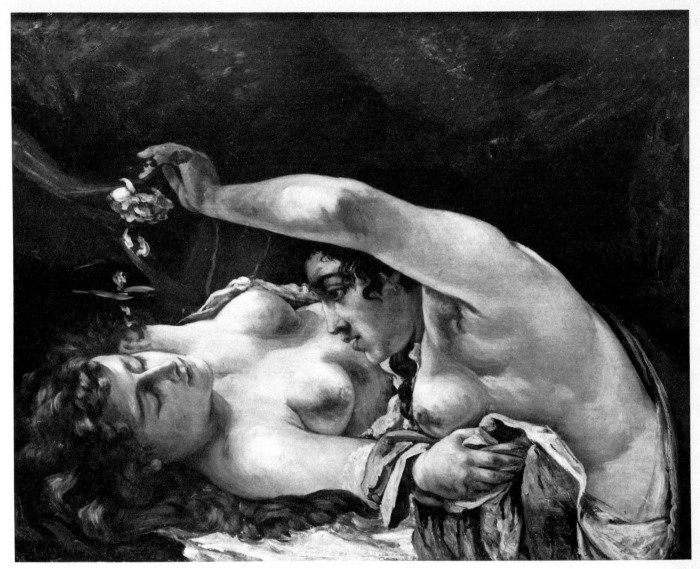

144

the Empress' and the public; this was rejected at the 1863 Salon. As to the rejection of *Venus and Psyche* in 1864, it was not so much provoked by the canvas itself as by Courbet's rodomontade. As he wrote to Fajon, not without reason: 'If that picture is immoral, we ought to shut up all the museums in Italy, France and Spain.'

As Veuillot subsequently wrote, it was Courbet's love of publicity which led him to depict 'first curés half-seas-over, and then courtesans' (*Les odeurs de Paris*, p.222).

Return from the conference (or *Curés in merry mood*) was destroyed in about 1900, in an *auto-da-fé* inspired by religious zeal, while the '*femmes damnées*' were consumed by infernal flames in the bombardment of Berlin. There is no great cause to regret the former work, if we may judge from reproductions and from a canvas at Basle which may be a sketch, replica or copy. *Venus and Psyche*, on the other hand, seems to have been one of Courbet's outstanding works. In a letter to the dealer Luquet he wrote of 'those two life-size naked women, painted in such a way as you've never seen me do before' (Riat, p.216). The new manner is no doubt repeated in the fine *Awakening* – the modified version seen here – in which the women are depicted half-length and in a more unified composition. There is also more vehemence of expression in the second version than in the first: this is due to the nearness of the bodies and the concentrated ardour of Venus, brandishing a rose as though it were imbued with magic power. The women's forms, united in a masterly curve, have an expressive power reminiscent of Michelangelo. Courbet's previous nudes have suggested the influence of Titian, Veronese, Rubens or Correggio; but here comparisons are defied, and he appears as the initiator of a new manner of depicting female flesh.

There are many sketches, variants and repetitions of the figure of Psyche (Winterthur, Oskar Reinhart coll.; The Hague, Mesdag Museum; private coll.). A version of Venus is in the Birmingham Museum.

Berne, Kunstmuseum.

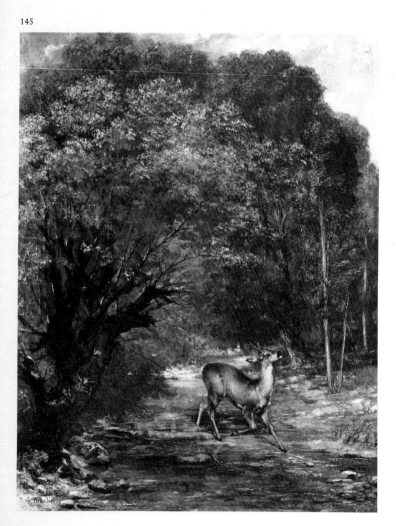

145

145
Hunted roedeer on the alert: Spring

(*104*) *Le chevreuil chassé aux écoutes, printemps*

1867

Canvas: 111 × 85. Signed, dated lower left: *67 G. Courbet.*

History: Sold by the artist to Aristide Boucicaut, founder of the store 'Bon Marché' in May 1868; bequeathed by his widow, Mme Boucicaut to the Louvre in 1889.

Exhibitions: 1868, Paris, Salon, no.609; 1934, San Francisco, no.79; 1934, Los Angeles, no.8; 1949, Copenhagen, no.21; 1956, Moscow–Leningrad, p.100; 1956, Warsaw, no.24; 1958; Agen, no.11; 1962, Mexico, no.31; 1969, Ornans, no.27; 1971, Vannes, no.15; 1976–1977, Tokyo, no.71.

Bibliography: Bruno, 1872, *Le bief de Duranvaux*, p.200.

On 12 May 1868 Courbet wrote to Castagnary: 'I have just sold *Roedeer on the alert* to Boucicaut of the Bon Marché, rue du Bac, for four thousand – just at the right moment!' (Bibliothèque Nationale, Estampes, Box V).

This is a typical specimen of Courbet's woodland scenes with animals, which were in such demand and which he treated with never-failing inspiration and sincerity,

varying them according to the changing seasons.

Critics and cartoonists, generally so harsh towards Courbet, were unanimous in praising this work. Gill published a drawing in the *Salon pour rire* with the caption: 'Amongst the banal and pretentious daubs that clutter up the Salon, the master of Ornans comes charging in (*donne son coup de trique*) and we heave a sigh of relief at two paintings: a delectable *Landscape* (the present work) and a *Beggar at Ornans* who is the last word in enlightenment.' The latter reference is to *The charity of a beggar at Ornans* (108), now in the Glasgow Art Gallery.

Paris, Musée du Louvre.

146
Portrait of Pierre Dupont

Portrait de Pierre Dupont (111)

1868

Canvas: 52×40. Signed, dated lower left: *..68 G. Courbet.*

History: Seized by the authorities from Courbet's studio after he was sentenced; sale of Courbet's confiscated paintings, Paris, 1877, no.7; Sale N, Paris, 1881; Pagenstecher coll., Wiesbaden; entered the Staatliche Kunsthalle in 1927.

Exhibitions: 1935–1936, Zurich, no.98; 1950, Cologne, no.36; 1951, Paris, no.16; 1962, Berne, no.53.

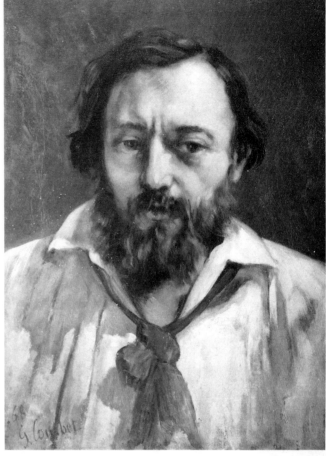

146

Courbet must have met the song-writer Pierre Dupont (1821–1870) soon after his arrival in Paris. It may have been through Dupont that he met Baudelaire, for the two writers were close friends although their work was different in kind. Dupont sang the praises of honest working folk in popular verses, set to music by himself, with a philosophic and socialist tinge and with a strain of real poetry. He soon became successful, and was a celebrity by 1848. In 1851 Baudelaire wrote of him: '. . . some pure, fresh melodies began to be heard in these concerts and in private society. The songs were an appeal to order and an invitation to be natural, and the most corrupt spirits welcomed them as an oasis of refreshment. Some pastoral pieces (*Les paysans*) had just been published, and

were played over and over again, with wild delight, on bourgeois pianos' (Baudelaire, II, 28). Dupont's songs were a counterpart in verse to George Sand's novels on the lives of artisans and on rural themes.

After the Coup d'Etat of December 1851 Dupont was condemned to deportation but received a pardon. Thereafter he lived a somewhat retired life, but he remained famous and his poem *Les boeufs* was still in everyone's memory.

Courbet and Dupont both stayed with Clément Laurier in 1852 (cf. 44), but Courbet did not paint his friend's portrait until much later, in 1868. He included him, on the other hand, in *The fount of Hippocrene* (1864), a satirical painting in which he made fun of various writers, but which was never completed owing to an accident. The

friendship between the two may have had its ups and down, but they were on close terms at the time of the war of 1870. Courbet had a particular fondness for this portrait, which was in his Paris studio at the time of his trial and was confiscated by the state. He tried to buy it anonymously when it was sold by order of the court, but the price rose higher than the maximum he had fixed (Bibliothèque Nationale, Estampes, Box II).

Dupont served as the model for the character of Giraud in Champfleury's *Aventures de Mademoiselle Mariette* (1853). There is a portrait of him by Deroy at the Château de Compiègne.

Karlsruhe, Staatliche Kunsthalle.

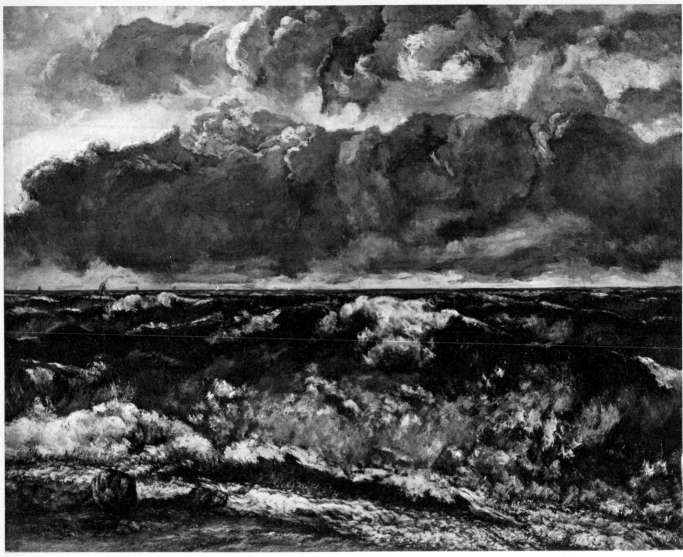

147

147
Stormy sea

La mer orageuse dit la vague (112)

1869

Canvas: 117 × 160. Signed, dated lower left: *. . 70 Gustave Courbet.*

History: Carlin sale, Paris, 1872, no.3; bought by the Galerie Haro; bought from the previous owner by the Musées Nationaux in 1878; exhibited at the Musée Luxembourg; entered the Louvre, 3 December 1889.

Exhibitions: 1870, Paris, Salon, no.671; 1878, Paris, Exposition Universelle, no.214; 1882, Paris, no.106; 1935–1936, Zurich, no.110; 1950, La Tour de Peilz, no.31; 1952, Besançon, no.45; 1954, Lyon, no.44; 1961–1962, Tokyo–Kyoto, no.7; 1965, Lisbon, no.33; 1967, Montreal, no.87.

Bibliography: Caricature by Cham, *Cham au Salon de 1870*; Guy de Maupassant, 'La vie d'un paysagiste' in *Gil Blas*, 28 September 1886; Raymond Lindon, 'Etretat et les peintres', in *Gazette des Beaux-Arts*, 1958, p.356.

In 1869 Courbet stayed at Etratat in Normandy in a house formerly lived in by the landscape painter Le Poittevin, a relative of Guy de Maupassant. The novelist has left a description of a visit to Courbet: 'In a great bare room a fat, dirty, greasy man was spreading patches of white paint on to a big bare canvas with a kitchen-knife. From time to time he went and pressed his face against the window-pane to look at the storm. The sea came up so close that it seemed to beat right against the house, which was smothered in foam and noise. The dirty water rattled like hail

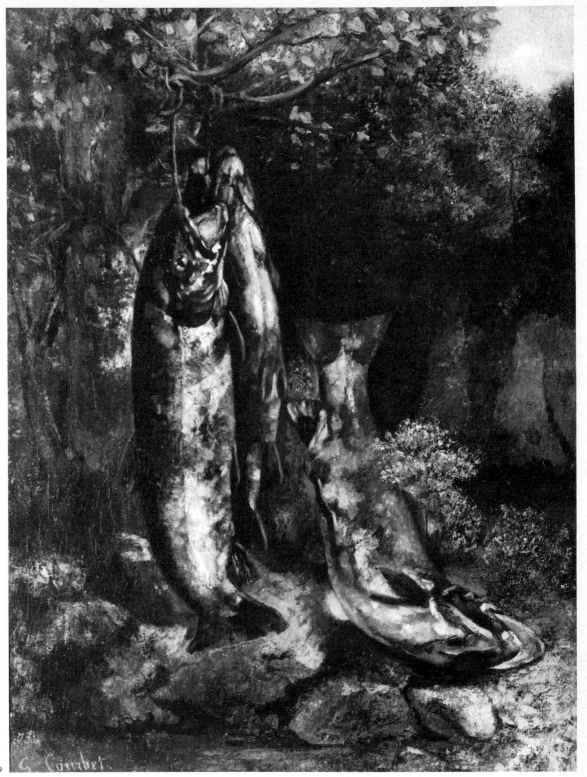

149

against the window and streamed down the walls. On the mantelpiece was a bottle of cider and a half-empty glass. Every now and then Courbet would drink a mouthful and then go back to his painting. It was called *The wave*, and it made a good deal of stir in its time' (*op. cit.*).

This is by far the most important of the many *Waves* painted by Courbet (cf. 112). A copy, signed by Pata, is in the Hazebrouck museum.

Paris, Musée du Louvre.

149
Three trout from the Loue

Les trois truites de la Loue (124)

1872

Canvas: 116×87. Signed, dated lower left: *..73 G. Courbet.*

History: Groesbeck coll., Amsterdam; Mme A. Groesbeck-Assenbroek coll., Amsterdam; Galerie Alfred Daber, Paris; acquired by the Kunsthaus in 1963.

Exhibitions: 1874, Lausanne; 1929, Amsterdam, no.13; 1956, Paris, no.14; 1962, Berne, no.73; 1962, Paris, no.13; 1975, Paris, no.14.

Bibliography: Max Huggler, 'Gustave Courbet, Les trois truites de la Loue' in *Mitteilungen* (Berner Kunstmuseum), March–April 1963, no.61, repr.

At the end of July 1872 Courbet wrote to his sisters from Maisières: 'I have been painting some fish caught by Dr Ordinaire's sons. They were magnificent, weighing 9 pounds' (Léger, 1920, p.123). This is evidently one of the pictures in question, and once again we have to note that Courbet dated his works to suit himself and not at the actual time of execution.

If, as critics agree, this picture was painted at the same time as *The trout* (118), we must admire the versatility of Courbet's genius. The two works are equally finished and powerful, but are completely different in style, conception and technique. In the present version the thick pigment is scumbled, and the dark mass of the fish glistens amid the clarity of a serene landscape.

Berne, Kunsthaus.

150
Grand panorama of the Alps, the Dent du Midi

Grand panorama des Alpes, la Dent du Midi (132)

1877

Canvas: 151×210. Not signed.

History: Juliette Courbet coll., inherited from her by Mmes de Tastes and Lapierre; Courbet sale, Paris, 1919, no.12; coll. Mme Hennet; private coll., Paris, Hirschl and Adler Gallery, New York; acquired by the Museum of Art (John L. Severance Fund).

Bibliography: A. T. Lurie in *The Bulletin of the Cleveland Museum of Art*, March 1966, vol. LIII, pp.74–80.

This picture, the last important one undertaken by Courbet, was interrupted by his death in 1877. He had intended to show it at the Paris Exhibition in 1878, and was full of hope that it would not be rejected out of hand like his offering in 1872. Politics, however, decided otherwise, to Courbet's profound distress. In Castagnary's papers we read: 'He began on a huge canvas for the World Exhibition, entitled *The Swiss mountains* – a view of the magnificent landscape he saw before his eyes every day. The design was completed and the work was forging ahead when, suddenly came the 16th of May' (the political crisis of 1877 in which President MacMahon dismissed the left-wing premier Jules Simon). Another note reads: 'At the news of the 16th of May Courbet stopped painting – he was discouraged, broken' (Bibliothèque Nationale, Estampes, Box IV). Jules Simon's ministry was succeeded by that of Broglie and Fourtou, and to Courbet this meant the extinction of all hope of clemency towards himself.

It is not quite correct to say that this is a view of the Alps from Bon Port: it shows them as they would be seen from the heights on the northern shore of the lake, between Vevey and Montreux. Courbet worked from a large preliminary study (Paris, private coll.) to which he added a foreground with a shepherdess and some goats. This picture is certainly the one referred to by contemporaries who mention a '*Bergère des Alpes*' or a '*Grand paysage aux chèvres*'.

Cleveland Museum of Art.

151
Sketches of Franche-Comté landscape

Paysages comtois, pages de carnet (134)

c.1863?

Album: 14×22. Folio 29 verso, 30 recto. Pencil on white paper. Inscribed lower edge: *Crêt Billard* and *Source du Lison*.

History: Juliette Courbet coll.; inherited by Mmes de Tastes and Lapierre; Tastes coll., bought from the previous owner by the Musée du Louvre in 1939, Inventory No. RF 29234.

Bibliography: Aragon, p.209, pls.49, 50.

This sketchbook includes figures and landscapes, all apparently dating from the artist's first youth. Among the figures we notice two drawings of Paul Ansout with the features seen in the *Portrait* of him of 1842 (4) and a *Man with a pipe, lying down* which Marie-Thérèse de Forges has published as a youthful *Self-portrait* (Forges, 1973, no.9). Among the landscapes are views of a harbour, which Roger Bonniot identifies as Le Havre and not La Rochelle (p.315) and of the Franche-Comté.

We have selected from the album two Franche-Comté landscapes, the *Creux-Billard* and the *Source du Lison*, both beauty-spots near Salins.

Paris, Musée du Louvre.

152
Portrait of Alphonse Promayet

Portrait d'Alphonse Promayet (137)

1847

Charcoal on paper: 32×24. Monogram, dated lower left: *G.C. 1847.*

History: Antonin Proust coll.; Etienne Moreau-Nélaton; given by M. Moreau Nélaton to the Musée du Louvre in 1907.

Exhibitions: 1882, Paris, no.137 (property of Antonin Proust) 1962, Paris, drawings, no.122; 1968–1969, Paris, drawings, no.38.

Alphonse Promayet, son of the organist at Ornans, was a violinist and a childhood friend of Courbet's. His professional life was unhappy and, failing to

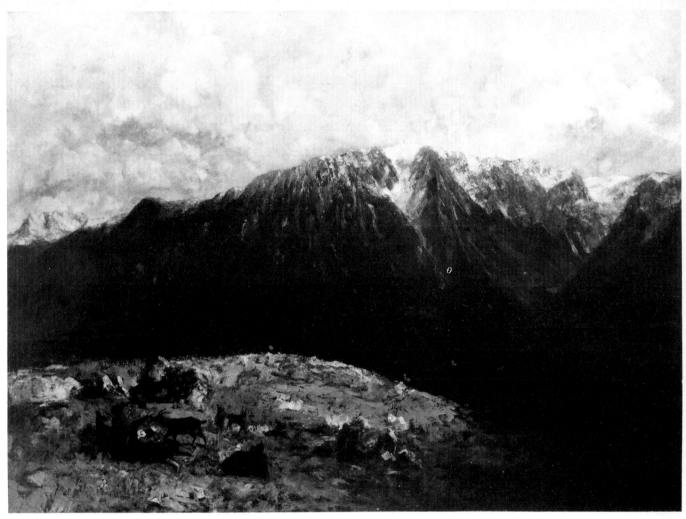

150

succeed in Paris, he took up a post as music teacher to a family of gentlefolk in Russia. He contracted consumption there and died in 1872 at Montpellier, looked after by Bruyas whose home was not far off.

Courbet frequently introduced Promayet into his compositions: he is the violinist in *After dinner at Ornans* (134) and a pall-bearer in the *Burial* (135), and figures in the group of friends in the *Studio* (137). In that painting he is seen holding his violin, as in the fine *Portrait* that Courbet painted of him in about 1850 (New York, Metropolitan Museum).

We have suggested apropos of the *Sculptor* (9) that Promayet is the subject of the companion to that work, the *Guitarrero* (U.S.A., private collection).

Paris, Musée du Louvre.

151

151

153
The stables at Versailles and the 'Fédérés', sheet from a sketchbook

Grandes écuries, Versailles, les Fédérés, page de carnet (142)

1871

Album: 16 × 27. Folio 7. Charcoal on bluish paper. Inscribed lower edge: *Grandes écuries Versailles les fédérés.*

History: Juliette Courbet coll.; inherited by Mmes de Tastes and Lapierre; Tastes coll.; bought from the previous owner by the Musée du Louvre in 1939.

Bibliography: Aragon, p.211, pl.98.

Besides some open-air scenes and landscapes, this sketchbook contains drawings made by Courbet after his arrest on 7 June 1871. On 21 July he was brought to the stables at the palace of Versailles, where Communard prisoners were assembled.

Six drawings represent scenes following the defeat of the Commune: the *Fédérés* (troops of the Commune) encamped under the high vaults of the stables, with mattresses and bundles lying about (fo.4); troops sitting on the ground and eating (fo.5); Courbet in a cell at the Conciergerie in Paris or at Sainte-Pélagie (fo.6);

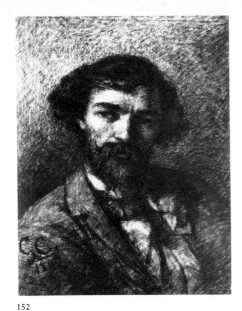

a summary execution, with a woman officer in charge wearing a Phrygian cap (fo.8); a group of civilians being led away by loyalist troops, the latter marching in a long frieze like that in Daumier's relief sculpture of *Emigrants* (Louvre) (fo.11); Courbet standing, half-dressed, in his cell (fo.12).

The sheet exhibited here is fo.7, showing *Fédérés* lying on the ground with a few rays of light striking in through the air-vent.

We do not know whether these sketches were made from life or from memory; the latter is more probable.

Paris, Musée du Louvre.

152

153

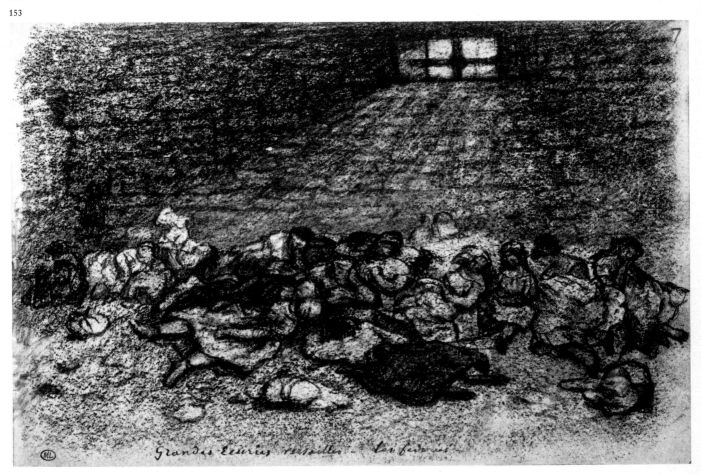

Errata

7
Self portrait entitled
Courbet with a black dog

It is time to correct an error which goes back to Riat (p.34). The landscape in this painting bears no resemblance to the valley of Bonnevaux or the grotto of Plaisir Fontaine, which are in any case two quite different places. The stream known as Plaisir Fontaine gushes out of a cave at the foot of a high rocky wall which shuts in a narrow valley; it thus resembles the Puits Noir (cf. 88). In all probability the present landscape is imaginary, though the spire, sketchily depicted, is suggested by that of the church at Ornans. The outdoor setting is an ancient tradition for informal portraits; it was much used by eighteenth-century British painters, and was introduced into France in neo-classical times. It became extremely popular with Romantic painters all over Europe, and again came into its own with the *plein-airistes* of the second half of the century.

19
Self portrait entitled Man
with the pipe

The *Man with the pipe* was shown at the World Exhibition of 1855 as *Portrait of the artist: Salon of 1850–1*, and again at Courbet's one-man exhibition of 1867 with the title: *Man with a pipe, self-portrait, Paris 1846, rejected at the Salons of 1846 and 1847 by a jury composed of members of the Institute*. Courbet's detailed accounts of his works are quite unreliable, which does not simplify the historian's task. As we see, he makes no mention in 1867 of the Salon of 1850. As for 1846 and 1847, it is quite clear from the receipt book in the Bibliothèque du Louvre that no painting with the dimensions of *Man with the pipe* was submitted in either year. As for the picture having been painted in 1846, this date seems too early.

X-ray examination at the Laboratoire des Musées de France shows that in the original composition the model's hair was not dishevelled as in the present version but was covered by a cap, either a cotton one such as Courbet is wearing in his drawn *Self-portrait* (Salon of 1849; Cambridge, Mass., Fogg Art Museum) or a more elegant one such as artists then wore in their studios. The date of 1846 may apply to the original version; Marie-Thérèse de Forges, however, considers (*op. cit.*) that the supple, mellow treatment points to a date around 1850, when the work was submitted for the Salon.

The theme of a man smoking, and the manner of execution, are reminiscent of seventeenth-century Dutch painting. We may even wonder if Courbet did not see *The smoker* in La Caze's collection (now in the Louvre), a work attributed at that time to Brouwer but now to Craesbeck; if so, the model's shock of hair may have given him the idea of changing his own picture by showing himself bare-headed.

Courbet made a copy of this picture at an unknown date; he mentions it two or three times in letters to M. Legrand, agent of the Galerie Durand-Ruel, who organized his exhibition at the Vienna artists' club in 1873. Thus, on 11 February, 1873: 'If you want the *Portrait with a pipe* and the *Portrait in profile* I will send them to you – these are copies I made for myself, the originals belong to M. Bruyas' (Louvre, Cabinet des dessins). Five days later: 'You do not reply as regards the two self-portraits I have here at Ornans – exact copies, but better done than the originals' (16 February, *ibid.*). Finally on 26 February: 'I shall be sending you the *Self-portrait with a pipe* or *Christ with a pipe* for the Vienna exhibition. I cannot make arrangements at once, I must consult Bruyas who has the originals' (*ibid.*). Perhaps he made other copies as well. 'You cannot imagine,' he wrote to Jules Laurens, 'the total money value of all the requests for *Man with a pipe* that people continue to honour me with ... If I had painted nothing else up to now I could still be rich, but I would be dishonoured and turned into an idiot' (Borel, p.59). Charles Léger (1948, p.31) mentions a repetition in Castagnary's possession dating from 1847.

This self-portrait and the one of the artist at Sainte-Pélagie (123) are the only oil paintings in which Courbet depicts himself with a pipe, though he does so in several drawings and it was his inseparable attribute in real life. Examples are in an early sketchbook in the Louvre (RF 29234, fo.23 recto), a black chalk drawing in the Fogg Art Museum at Cambridge, Mass., and a charcoal drawing, the best of these, in the Wadsworth Atheneum, Hartford, Conn. In 1869 he left at Munich, as a souvenir, a sketch of his pipe with the inscription *Courbet sans idéal et sans religion* (Léger, 1948, p.128).

23
View of Ornans known as
The Bridge of Scey

This landscape is dated 1864 in the catalogue of the Courbet exhibition at Philadelphia and Boston. The date of *c*.1850 in the catalogue of the New York exhibition of 1956 seems more probable; we believe this work to be slightly previous to the sketch of *Young ladies of the village* (27).

Bibliography

Catalogue Note

The volume of literature relating to Courbet is vast, and therefore it was impossible to prepare a complete bibliography for each work catalogued. We have been obliged to severely limit our references and restrict ourselves to citing articles especially devoted to these works when they put forward a new interpretation or present unpublished research. All the monographs on the artist mentioning nearly all the paintings have been studied.

Among exhibition catalogues including essential bibliographies are those of the exhibition *Courbet* shown in Philadelphia and Boston in 1959 and 1960, and the exhibition *Courbet* shown in Rome and Milan in 1969 and 1970.

The books by Georges Riat and Charles Léger remain the basic French works on Courbet. In English one must consult Gerstle Mack and the bibliography in Jack Lindsay's book; in German, the works of Richard Muther and Julius Meier-Graefe. Regarding the Realist movement, one must refer to the works of Leon Rosenthal, *Du romantisme au réalisme*; Emile Bouvier, *La bataille réaliste*; to the essays published under the direction of George Boas in Baltimore; Linda Nochlin, *Realism* and René Huyghe, *La relève d'l'imaginaire, Romantisme, Réalisme*.

The collections of archives which are indispensable to consult are found in the following institutions in Paris: Bibliothèque Nationale (Department des Manuscrits et Cabinet des Estampes); Bibliothèque Doucet (Institut d'Art), Prefecture de la Seine, Ministère de la Defense Nationale, Musée du Louvre (Bibliothèque et Cabinet des Dessins), also the Bibliothèque de Besançon, the Bibliothèque de Montpellier and the Musée Gustave Courbet d'Ornans.

Abbreviations

A.B.
Alan Bowness, author of catalogue entries nos.56, 77, 86a, 86b, 108.

A.G.C.
Les amis de Gustave Courbet, 57 Bulletins published since 1947, Paris–Ornans, under the presidency of Robert Fernier (1895–1977).

(L) Exhibited in London only.

All dimensions in this catalogue are given in centimeters, height preceding width.

In the English edition of this catalogue the titles of exhibits are also given in French, followed by the catalogue number referring to the French edition.

Abbreviations of works cited

Abe
Yoshio Abe, *Un Enterrement à Ornans et l'habit noir baudelairien*. Studies in French language and literature, Tokyo, 1962.

Aragon
Louis Aragon, *L'exemple de Courbet*, Paris, 1952.

Baudelaire
Baudelaire, œuvres complètes, text established presented and annotated by Claude Pichois, Paris, 1976, Bibliothèque de la Pléiade, 2 vols.

Bonniot, 1967
Roger Bonniot, *Interventions en faveur de Courbet en exil* in *Gazette des Beaux-Arts*, October 1967, pp.1–18.

Bonniot, 1972
Roger Bonniot, *Victor Hugo et Gustave Courbet. Un projet de portrait abandonné* in *Gazette des Beaux-Arts*, October 1972, pp.241–248.

Bonniot
Roger Bonniot, *Gustave Courbet en Saintonge*, Paris, 1973.

Borel
Lettres de Gustave Courbet à Alfred Bruyas, published by Pierre Borel, Geneva, 1951.

Bowness, 1971
Alan Bowness, *Art and Society in England and France in the mid-nineteenth century: two paintings before the public*, lecture given in 1971, published by the Royal Historical Society, 5th series, vol.22, 1972.

Bowness, 1972
Alan Bowness, *Courbet's early subject-matter*, lecture given in Manchester, published 1972.

Bruno, 1872
Jean Bruno (alias Jean Vaucheret, alias Dr Blondon), *Les misères des gueux*, Paris, 1872; popular novel illustrated with engravings by Méaulle after the paintings of Courbet. We state precisely the inscription accompanying each vignette for each work concerned.

Bruyas, 1854
Alfred Bruyas, *Explication des ouvrages de peinture du cabinet de M. Alfred Bruyas*, Paris, 1854.

Bruyas, 1876
Alfred Bruyas, *Musée de Montpellier, la Galerie Bruyas*, Paris, 1876.

Chamson
Lucie Chamson-Mazauric, *Comment on perd un tableau* in *La Revue du Louvre*, 1969, no.1, pp.27, 36.

Chevallier
Pierre Chevallier, *Histoire de la Franc-Maçonnerie française*, Paris, 1974.

Clark, 1969
Timothy J. Clark, *A bourgeois Dance of Death. Max Buchon on Courbet* in *The Burlington Magazine*, April 1969, pp.208–212, May 1969, pp.286–290.

Clark
Timothy J. Clark, *Image of the people. Gustave Courbet and the 1848 Revolution*, London, 1973.

Courthion
Courbet raconté par lui-même et par ses amis, texts presented by Pierre Courthion, Geneva, I, 1948; II, 1950.

Crépet
Jacques Crépet, *Baudelaire, Correspondance générale*, Paris, 1948, vol. I.

Davies
Martin Davies, *French School, Early 19th century, Impressionism, Post-Impressionism...*, National Gallery catalogues, London, 1970.

Delbourgo-Faillant
Suzy Delbourgo and Lola Faillant, *I. Courbet du copiste au maître* in *Contribution à l'étude de Gustave Courbet* in collaboration with Madeleine Hours and Marie-Thérèse de Forges in *Laboratoire de recherche des Musées de France, Annales*, 1973.

Delteil
Loys Delteil, *Catalogue raisonné de l'œuvre lithographié d'Honoré Daumier*, 1904.

Droz
Histoire générale du Socialisme under the direction of Jacques Droz, Paris, 1972, 2 vols.

Duret
Théodore Duret, *Courbet*, Paris, 1918.

Estignard
Alexandre Estignard, *G. Courbet, sa vie et ses œuvres*, Besançon, 1897.

Fermigier
André Fermigier, *Courbet*, Geneva, 1971.

Fierens
Paul Fierensk *La peinture en Belgique au XIX^e siècle*, Brussels, 1939.

Forges, 1969
Marie-Thérèse de Forges, exhibition catalogue, *Courbet*, Rome, Villa Médicis, 1969, Milan, Palazzo Reale, 1970, in collaboration with Hélène Toussaint and François Pérot.

Forges, 1972
Marie-Thérèse de Forges, *A propos de l'exposition Autoportraits de Courbet* in *La Revue du Louvre et des Musées de France*, 1972, no.6, pp.451–45.

Forges, 1973
Marie-Thérèse de Forges, exhibition catalogue, *Autoportraits de Courbet*, 'Dossier', exhibition of the Department of Paintings, Musée du Louvre, 1973.

Forges, *Annales*
Marie-Thérèse de Forges, *II. A propos des Autoportraits de Courbet* in *Contribution a l'étude de Gustave Courbet* in collaboration with Madeleine Hours, Suzy Delbourgo and Lola Faillant in *Laboratoire de recherches des Musées de France, Annales*, 1973.

Georgel
Pierre Georgel, *Les transformations de la peinture vers 1848, 1855, 1863* in *Revue de l'art*, 1975, no.27, pp.69–72.

Gruet
V. Gruet, *Coup d'œil sur l'exposition de peinture de Saintes*, Bordeaux, 1863.

Huyghe
Réné Huyghe, *La relève de imaginaire, Romantisme. Réalisme*, Paris, 1976.

Lacambre, 1973
Champfleury, le Réalisme, texts chosen and presented by Geneviève and Jean Lacambre, Paris, 1973.

Lacambre, 1974
Geneviève Lacambre, exhibition catalogue, *Le Musée du Luxembourg en 1874*, Paris, the the Grand Palais, 1974.

Léger, 1920
Charles Léger, *Courbet selon les caricatures et les images*, Paris, 1920.

Léger, 1925
Charles Léger, *Courbet*, Paris, 1925.

Léger, 1929
Charles Léger, *Courbet*, Paris, 1929.

Léger, 1948
Charles Léger, *Courbet et son temps*, Paris, 1948.

MacCarthy
James C. MacCarthy, *Courbet's ideological contradictions and 'The burial at Ornans'*, in *Art Journal*, 1975, vol. XXXV, pp.12–16.

Mack
Gerstle Mack, *Gustave Courbet*, New York, 1951.

Nochlin
Linda Nochlin, *Innovation and tradition in Courbet's 'Burial at Ornans'*, essays in honour of Walter Friedlander, New York, 1965.

Nochlin, 1967
Linda Nochlin, *The invention of the Avant-garde: France, 1830–1880*, in *Arts New Annual*, 1968, vol. XXXIV, pp.11–18.

Nochlin, 1971
Linda Nochlin, *Realism*, Harmondsworth, 1971, reprinted in 1972 and 1973.

Nochlin, 1971, 'Toilette'
Linda Nochlin, *Gustave Courbet's 'Toilette de la mariée'* in *The Art Quarterly*, 1971, vol.34, pp.31–54.

Pérot
François Pérot, exhibition catalogue, *Courbet*, Rome, Villa Médicis, 1969, Milan, Palazzo Reale, 1970, in collaboration with Marie-Thérèse de Forges and Hélène Toussaint.

Proudhon
Pierre-Joseph Proudhon, *Du principe de l'art et de sa destination sociale*, 1865. We refer to the Marcel Rivière edition, Paris, 1939, published with notes and unpublished documents under the direction of C. Bouglé and H. Moisset.

Rewald
John Rewald, *Histoire de l'Impressionnisme*, édition française, Paris, 1955.

Riat
Georges Riat, *Gustave Courbet, peintre*, Paris, 1906.

Robaut
L'œuvre de Corot par Alfred Robaut, catalogue raisonné et illustré, Paris, 1905.

Rostrup
Haavard Rostrup, *Trois tableaux de Courbet*, Copenhagen, 1931.

Schapiro
Meyer Schapiro, *Courbet and popular imagery* in *Journal of the Warburg and Courtauld Institutes*, 1940–1941, pp.164–91.

Scharf
Aaron Scharf, *Art and photography*, Harmondsworth, 1968.

Silvestre
Théophile Silvestre, *Histoire des artistes vivants français et étrangers. Etudes d'après nature*, Paris, 1856.

Sterling-Salinger
Charles Sterling and Margaret Salinger, *French paintings, a catalogue of the collection of the Metropolitan Museum, II. XIX century*, New York, 1966.

Tabarant
Adolphe Tabarant, *La vie artistique au temps de Baudelaire*, Paris, 1963.

Ten Doesschate
Petra Ten Doesschate-Chu, *French Realism and Dutch Masters*, Utrecht, 1974.

Toussaint
Hélène Toussaint, exhibition catalogue, *Courbet*, Rome, Villa Médicis, 1969, Milan, Palazzo Reale, 1970, in collaboration with Marie-Thérèse de Forges and François Pérot.

Troubat
Jules Troubat, *Une amitié à la d'Arthez, Champfleury, Courbet, Max Buchon*, Paris, 1900.

Viatte
Auguste Viatte, *Les sources occultes du Romantisme*, Paris, 1927, new edition, 1969, 2 vols.

Vincent
Madeleine Vincent, *La peinture du XIX; siècle et au XX; siècle au Musée des Beaux-Arts de Lyon*, Lyon, 1956.

Wey
Francis Wey, *Etude sur G. Courbet – Extrait des mémoires inédits de feu Francis Wey*, manuscript and facsimile in the Cabinet des Estampes, Bibliothèque Nationale.

Select bibliography

Astruc Zacharie, *Les quatorze stations du Salon de 1859*, Paris, 1859.

Bazin, Germain et Albini, Adriana, *Courbet à la XXVII Biennale de Venise*, Venice, 1954.

Bénédite, Léonce, *Courbet*, Paris, n.d.

Boas, George, *Courbet and the naturalistic movement*, Baltimore, 1938.

Borel, Pierre, *Le roman de Gustave Courbet, d'après une correspondance originale du grand peintre*, Paris, 1922.

Bouvier, Emile, *La bataille réaliste*, Paris, 1914.

Castagnary, Jules, *Fragments d'un livre sur Courbet* in *Gazette des Beaux-Arts*, January–December 1911, January 1912.

Chamson, André, *Gustave Courbet*, Paris, 1955.

Chirico, Giorgio de, *Gustave Courbet*, Paris, 1925.

Clark, Timothy J., *The absolute bourgeois, artists and politics in France, 1848–1851*, London, 1971; id., *Image of the people, Gustave Courbet and the 1848 Revolution*, London, 1973.

Claudet, Max, *Souvenirs, Gustave Courbet*, Paris, 1878.

Du Camp, Maxime, *Le Salon de 1857*, Paris, 1857; id., *Les convulsions de Paris*, Paris, 1878; id. *Les Beaux-Arts à l'Exposition Universelle et aux Salons*, Paris, 1867.

Durbé, Dario, *Courbet e il Réalismo*, Milan, 1967.

Duret, Théodore, *Les peintres français en 1867*, Paris, 1867.

Fernier, Robert, *Gustave Courbet*, preface by René Huyghe, Paris, 1969.

Fontainas, André, *Courbet*, Paris, 1921.

Fosca, François, *Courbet*, Paris, 1855; id., *L'art moderne*, Paris, 1856.

Gazier, Georges, *Gustave Courbet, l'homme et l'œuvre*, Besançon, 1906.

Grate, Pontus, *Deux critiques d'art à l'époque romantique*, Stockholm, 1959.

Gros-Kost, Emile, *Gustave Courbet, souvenirs intimes*, Paris, 1880.

Guichard, Marie, *Les doctrines de M. Gustave Courbet, Maître peintre*, Paris, 1862.

Hofmann, Werner, *Das Irdische Paradies*, Munich, 1960.

Ideville, Henri d', *Gustave Courbet, notes et documents sur sa vie et son œuvre*, Paris, 1878.

Kaschnitz, Marie-Luis, *Gustave Courbet*, Baden-Baden, 1949.

Lazar, Bela, *Courbet et son influence à l'étranger*, Paris, 1911.

Lemonnier, Camille, *G. Courbet et son œuvre*, Paris, 1878.

Lindsay, Jack, *Gustave Courbet, his life and art*, Somerset, 1973.

Mac Orlan, Pierre, *Courbet*, Paris, 1951.

Malvano, Laura, *Courbet*, Milan, 1966.

Mantz, Paul, *Gustave Courbet* in *Gazette des Beaux-Arts*, June, July, December 1878.

Meier-Graefe, Julius, *Corot und Courbet*, Leipzig, 1905; id., *Courbet*, Munich, 1921.

Muther, Richard, *Courbet*, Munich, 1908.

Naef, Hans, *Courbet*, Berne, 1947.

Nicolson, Benedict, *Courbet, The Studio of the painter*, London, 1973.

Nochlin, Linda, *Gustave Courbet: a study of style and society* (Ph.D. thesis, University of New York, 1963) published 1976.

Rosenthal, Léon, *Du Romantisme au Réalisme*, Paris, 1914.

Thoré-Burger (Théophile Thoré), *Salons de W. Burger, 1861 à 1868*, Paris, 1870.

Venturi, Lionello, *Les peintres modernes*, Paris, 1941.

Zahar, Marcel, *Gustave Courbet*, Paris, 1950.

Zola, Emile, *Mes haines*, Paris, 1866; id., *Salons*, collected, annotated and presented by F. W. J. Hemmings and Robert J. Niess, Paris, 1959.

Abbreviations of exhibitions cited

1846, Amsterdam
Tentoonstelling van levende meesters.

1850, Besançon
Exhibition of one painting by Courbet in the Market Hall, *Un enterrement à Ornans.*

1850, Dijon
Exhibition of one painting by Courbet in a tavern, *Un enterrement à Ornans.*

1851, Brussels
General exhibition of Fine Art.

1852, Besançon
Private exhibition of Courbet, 4 paintings.

1855, Paris
Exhibition et vente de 40 tableaux et 4 dessins de l'œuvre de M. Gustave Courbet, avenue Montaigne, 7, Champs-Elysées.

1857, Brussels
General exhibition of Fine Art.

1858, Besançon
Exhibition of Fine Art.

1858, Dijon
Exhibition of Dijon.

1859, London
Exhibition at the French Gallery, 121 Pall Mall.

1860, Besançon
World Exhibition of Besançon.

1860, General exhibition of Fine Art.

1860, Montpellier
Exhibition of Montpellier.

1860, Paris
Tableaux de l'ecole moderne tirés des collections d'amateurs, 26, boulevard des Italiens.

1861, Metz
Exhibition of Industry.

1861, Nantes
Exhibition, Galerie des Beaux-Arts, under the patronage of S.M. the Empress.

1862, Besançon
2nd exhibition of the 'Société des Beaux-Arts' of Besançon.

1862, Bordeaux
Exhibition of the 'Société des Beaux-Arts'.

1862, London
International Exhibition.

1863, Paris
Courbet, Galerie Cadart et Luquet.

1863, Saintes
Exposition de peinture au profit des pauvres. Hôtel de Ville.

1863, Bordeaux
Exhibition of the 'Societe des Beaux-Arts'.

1865, Bordeaux
Exhibition of the 'Société des Amis de Beaux-Arts'.

1865, Besançon
3rd exhibition of the 'Société des Amis de Beaux-Arts'.

1865, Gand
Salon.

1866, Amsterdam
Arti et Amicitiae.

1866, Boston
Exhibition at the Allston Club.

1866, Brussels
General exhibition of Fine Art.

1866, The Hague
Kunstwerke van levende meesters.

1867, Boston
Exhibition at the Allston Club.

1867, Paris
Exposition des œuvres de M. G. Courbet, Rond-point de l'Alma, Champs-Elysées.

1868, Boston
Annual Exhibition, The Athenaeum.

1868, Gand
Salon.

1869, Boston
Annual Exhibition, The Athenaeum.

1869, Brussels
General exhibition of Fine Art.

1869, Munich
International Kunst Austellung, Glaspalast.

1870, Anvers
Salon.

1870, Boston
Annual Exhibition, The Athenaeum.

1870, Brussels
General exhibition of Fine Art.

1870, Dijon
Exposition au profit des femmes des condamnés du Creusot.

1870, Douai
Exhibition of the 'Amis des Arts'.

1870, Le Havre
Exhibition of the 'Société des Amis des Arts'.

1871, Boston
Annual Exhibition, The Atheneaum.

1871, London
International Exhibition.

1871–1872, Boston
French Exhibition.

1873, Vienna
238th and 239th exhibitions of the Association of Austrian Art.

1874, Lausanne
Exhibition at the Musée Arlaud.

1876, Geneva
Exhibition at Institut National Genevois.

1877, Brussels
Exhibition at the 'Cercle artistique'.

1878, Paris
Exposition rétrospective, tableaux et dessins de Maîtres modernes, Galerie Durand-Ruel.

1881, Paris
Exhibition of pictures by Courbet in the green-room of the Théâtre de la Gaieté.

1882, Paris
Exposition des œuvres de G. Courbet, Ecole des Beaux-Arts.

1883, Paris
Le portrait du siècle, Ecole des Beaux-Arts.

1889, Paris
Exhibition, hundred years of French Art.

1897, Boston
One hundred masterpieces, Copley Hall.

1898, New York
Old masters and modern painting, Union League Club.

1900, Paris
Exhibition, hundred years of French Art.

1903, Boston
Old masters, Copley Hall.

1906, Besançon
Retrospective exhibition of Art in Franche-Comté.

1906, Paris
Rétrospective *Courbet*, at the Salon d'Automne.

1907, Paris
Portraits de femmes, Bagatelle.

1909, London
Exhibition at the New Gallery.

1909, Paris
Exposition de trente-deux tableaux de G. Courbet, Galerie Bernheim.

1910, Paris
Vingt peintres du XIXe siècle, Galerie Georges Petit.

1910, Venice
Courbet, International exhibition of the City of Venice.

1911, St Petersburg
Art français.

1912, Dusseldorf
Sammlung Marczell von Nemes, Städt Kunsthalle.

1912, Paris
La musiuqe et la danse, Bagatelle.

1913, Paris
Exhibition at the Galerie Manzi-Joyant.

1914, Copenhagen
Fransk Malerkunst fra det 19nde Aarhundrede.

1917, Barcelona
Arte francès.

1917, Paris
L'art français, Galerie Paul Rosenberg.

1917, Zurich
Franzosische Kunst des XIX und XX jahrhunderts.

1917–1918, Paris
Courbet, Galerie Bernheim-jeune.

1918, Geneva
Exposition d'art français.

1918, Valenciennes
Geborgene Kunstwerke aus dem besetzten Nordfrankreich.

1919, New York
Works of Gustave Courbet, Metropolitan Museum of Art.

1919, Paris
Courbet, Galerie Bernheim-jeune.

241

1921, Basle
Peinture française, Kunsthalle.
1921, New York
Impressionist and Post-Impressionist paintings, Metropolitan Museum of Art.
1922, London
Pictures, drawings and Sculptures of the French school of the last hundred years, Burlington Fine Arts Club.
1922, Paris
Grands maîtres du XIXᵉ siècle, Galerie Paul Rosenberg.
1923, London
The impressionist school and some great French painters of the 19th century, Lefevre Gallery.
1923, Paris
L'art français au service de la science.
1923, Stockholm
Gustave Courbet, Honoré Daumier, Constantin Guys, Fransk Konstfemte Unställning, Nationalmuseum.
1925, Paris
Cinquante ans de peinture française, Musée des Arts Décoratifs.
1926, Amsterdam
Franske Kunst.
1927, Glasgow
A century of French painting, Lefevre Gallery.
1927, Paris
Exposition à la Galerie Bernheim-jeune.
1928, Besançon
Cinquantième anniversaire de la mort de Courbet, Musée des Beaux-Arts.
1928, Copenhagen
Fransk Malerkunst fra det 19nde Aarhundrede.
1928, Cairo
Exposition d'art français.
1928, Oslo
Fransk Malerkunst fra David til Courbet.
1928, Paris
Portraits et figures de femmes d'Ingres à Picasso, Galerie de la Renaissance.
1928, Pontarlier
Gustave Courbet à Pontarlier, Salon des Annonicades.
1928, Stockholm
Fransk Malerkonst.
1929, Amsterdam
Exposition de peintures françaises, Ecole du XIXᵉ siècle, Galerie van Wisselingh.
1929, Cambridge
French paintings of the XIXth and XXth centuries, Fogg Art Museum.
1929, Paris
Gustave Courbet, Musée du Petit Palais.
1929, Paris, Charpentier
100 ans de vie française, Centenaire de la 'Revue des Deux Mondes', Galerie Charpentier.
1930, Berlin
Gustave Courbet, Galerie Wertheim.
1930, London
19th and 20th century French painting, Independant Gallery.
1930, New York
The H. O. Havemeyer Collection, Metropolitan Museum of Art.
1930, Paris
100 ans de peinture française, Galerie Georges Petit.

1931, Paris
Grands maîtres du XIXᵉ siècle, Galerie Paul Rosenberg.
1932, Buffalo
The nineteenth century, Albright Art Gallery.
1932, London
Exhibition of French art, Royal Academy of Arts.
1932, Manchester
French painting, Manchester City Art Gallery.
1932, Paris
L'Impressionnisme et quelques précurseurs, Galerie Braun.
1933, Chicago
Art Institute of Chicago Century.
1933, London
Ingres to Cézanne, Rosenberg and Helft Gallery.
1933, New York
Courbet and Delacroix, Harriman Gallery.
1933, Paris
Musée du Louvre, nouvelles acquisitions, 1922–1932, Orangerie des Tuileries.
1934, Chicago
Century of progress exhibition, Art Institute.
1934, Los Angeles
Eleven paintings from the Louvre.
1934, New York
Great French masters of the nineteenth century, Durand-Ruel Gallery.
1934, San Francisco
French paintings from the Louvre, California Palace of the Legion of Honor.
1935, London
Nineteenth century masterpieces, Wildenstein Gallery.
1935, Paris
Peintures de Jura et dessins de Courbet, Galerie Attica.
1935, Paris, Galliera
Exhibition of the History Society of Auteuil and Passy, Palais Galliera.
1935, San Francisco
Opening Exhibition.
1935–1936, Zurich
Gustave Courbet, Kunsthaus.
1936, Brussels
Dessins Français.
1936, Cleveland
Great Lake Exhibition.
1936, London
French masters of the 19th century, Anglo-French and Travel Society.
1936, London, Wildenstein
Collection of a collector, from Ingres to Matisse (The private collection of the late Joseph Stransky), Wildenstein Gallery.
1936, Paris
Le Grand Siècle, Galerie Paul Rosenberg.
1936, Pittsburg
Survey of French painting, Carnegie Institute.
1937, Glasgow
French art of the 19th and 20th centuries, Reid and Lefevre Gallery.
1937, Hartford
Forty tree portraits, Wadsworth Atheneum.
1937, Paris
Chefs-d'œuvre de l'art français, Palais National des Arts.

1937, Paris, Rosenberg
Gustave Courbet, Galerie Paul Rosenberg.
1937, Philadelphia
Portrait Exhibition, Pensylvania Museum of Art.
1937–1938, Washington
Portrait Exhibition, Philipps Memorial Gallery.
1938, Amsterdam
Fransche Kunst, Stedelijk Museum.
1938, Baltimore
Paintings by Courbet, Museum of Art.
1938, Bogota
Dibujos francès.
1938, Hartford
Painters of still-lifes, Wadsworth Atheneum.
1938, London
Gustave Courbet, Rosenberg and Helft Gallery.
1938, Lyon
Salon du Sud-Est.
1938, Paris
La peinture française du XIXᵉ siècle en Suisse, Gazette des Beaux-Arts.
1938, Washington
Flowers and fruits exhibition, Museum of Modern Art.
1939, Belgrade
La peinture française du XIXᵉ siècle, Musée du Prince Paul.
1939, Berne
Chefs-d'œuvre du Musée de Montpellier, Kunsthalle.
1939, Buenos Aires
La pintura francesa de David a nuestros dias
1939, Boston
Private collections in New England, Museum of Fine Arts.
1939, Liège
L'eau.
1939, Montevideo
La pintura francesa de David a nuestros dias.
1939, Ornans
Gustave Courbet, Hôtel de Ville.
1939, Paris
Chefs-d'œuvre du Musée de Montpallier, Orangerie des Tuileries.
1939, Pittsburg
French painting, University.
1939, Rosario
La Pintura Francesa.
1939, San Francisco
Masterpieces of five centuries, Golden Gate International Exhibition.
1940, Chicago
Origins of modern Art, The Arts Club.
1940, New York
Masterpieces of art, World's Fair.
1940. New York, Harriman
Courbet, Harriman Gallery.
1940, New York, French Art Gallery
Woman and children in French painting, French Art Gallery.
1940–1941, San Francisco
Painting of France since the French Revolution, De Young Memorial Museum.
1941, Chicago
Masterpieces of French art, Arts Club.
1941, Los Angeles
The painting of France since the French Revolution, County Museum.

1941, San Diego
French painting, Fine Arts Gallery.
1942, Milwaukee
Six Centuries of portrait masterpieces, Art Institute.
1942, New York
Corot to Van Gogh, Rosenberg Gallery.
1942, Providence
French art of the XIXth and XXth centuries, Rhode Island School of Design.
1943, Pontarlier
Courbet en exil, Salon des Annonciades.
1943, Utica
French and American Impressionism, Munson Williams Institute.
1944, Baltimore
19th and 20th centuries paintings, Museum of Art.
1945, Paris
Paysages de France, Galerie Charpentier.
1945, San Francisco
Art of the United Nations, De Young Memorial Museum.
1946, Paris
La vie silencieuse, Galerie Charpentier.
1946, Toledo
The spirits of modern France.
1947, Fleurier
Courbet.
1947, Basle
Kunstschatze aus den Strasburger Museum.
1947, Nantes
Paysans de France, Musée des Beaux-Arts.
1947, New York
Great Masters of the XIXth century, Rosenberg Gallery.
1947, Paris
Berlioz, Bibliothèque Nationale.
1947, Pontarlier
Panorama de l'art comtois, Salon des Annonciades.
1947, Toronto
The spirits of modern France.
1947–1948, Brussels
De David à Cézanne, Palais des Beaux-Arts.
1948, Besançon
Centenaire de la Révolution de 1848, Musée Granvelle.
1948, Boston
The collections of John Spaulding, Museum of Fine Arts.
1948, Decatur
Masterpieces of the old and new world, Art Center.
1948, Paris
La Révolution de 1848, Bibliothèque Nationale.
1948–1949, New York
Courbet, Wildenstein Gallery.
1949, Clamart
Musique française.
1949, Copenhagen
G. Courbet, Statenmuseum for Kunst.
1949, Fort Worth
Centennial Exhibition.
1949, Paris
Courbet, Galerie Alfred Daber.
1949–1950, London
Landscape in French art, Royal Academy of Art.

1950, Belgrade
Izlozba Radova Francuskih Slikara XIX veka.
1950, Cologne
Wilhelm Leibl und Gustave Courbet, Wallraf Richartz.
1950, Detroit
David to Courbet, Institute of Arts.
1950, Gand
Quarante chefs-d'œuvre du Musée de Lille.
1950, La Tour de Peilz
Courbet, Musée Jenisch.
1950, New York
The XIXth century heritage, Rosenberg Gallery.
1950, Paris
Œuvres choisies du XIXᵉ siècle, Galerie Kaganovitch.
1950, Paris, Delacroix
Delacroix et la peinture romantique, Atelier de Delacroix.
1950, Zurich
Europaische Kunst, Kunsthaus.
1951, Amsterdam
Het franse landschape, Rijksmuseum.
1951, Birmingham
Inaugural Exhibition, Museum of Art.
1951, Geneva
De Watteau à Cézanne
1951, London
Recent acquisitions, Tooth & Son Gallery.
1951, London, Tooth
Paris–London, Tooth & Son Gallery.
1951, London, Marlborough
French masters, Marlborough Gallery.
1951, New York
Jubilee loan exhibition, Wildenstein Gallery.
1951, Paris
Impressionnistes et romantiques français dans les Musées allemands, Orangerie des Tuileries.
1951, Pittsburg
French painting, 1100–1900, Carnegie Institute.
1951–1952, Detroit
Travelling exhibition from the Metropolitan Museum of Art, shown also at Toronto, St Louis, Seattle.
1952, Besançon
Courbet, Musée des Beaux-Arts.
1952, London
French drawings from Fouquet to Gauguin, The Arts Council.
1952, New York
Ingres to Lautrec, Rosenberg Gallery.
1952, Paris
La nature morte de l'Antiquité à nos jours, Orangerie des Tuileries.
1952, Paris, Bernheim
Peintres de portraits, Galerie Bernheim-jeune.
1952–1953, Paris
Chefs-d'œuvres des collections parisiennes, Musée Carnavalet.
1952–1953, Rotterdam
Franse Meisters uit het Petit Palais, Boymans.
1953, Brussels
La femme dans l'art français, Palais des Beaux-Arts.

1953, Compiègne
Le temps des crinolines, Musée National du Palais de Compiègne.
1953, London
Gustave Courbet, Marlborough Gallery.
1953, New Orleans
Masterpieces of French paintings through five centuries, Isaac Delgado Museum.
1953, New York
Forty French pictures at Smith College Museum of Art, Knoedler Gallery.
1953, Paris
Célébrités françaises, Galerie Charpentier.
1954, Buffalo
Painter's painters, Albright Art Gallery.
1954, Essen
Franzosisches Malerie und Graphik des 19 jahrhunderts, Museum Kolkwang
1954, Lyon
Courbet, Palais Saint-Pierre.
1954, New York
XIXth Century French painting, Rosenberg Gallery.
1954, New York
Chefs-d'œuvre de la curiosité du monde, Musée des Arts décoratifs.
1954, Rotterdam
Euwen stilleven in Frankrijk.
1954, St Paul
Minnesota State Fair.
1954, Venice
Courbet alla XXVII Biennale di Venezia.
1955, Chicago
Great French painting, Art Institute.
1955, London–Manchester
One picture exhibition, London, Tate Gallery; Manchester, City Art Gallery.
1955, Paris
G. Courbet, Musée du Petit Palais.
1955, Paris, Orangerie
De David à Toulouse-Lautrec, Chef's-d'œuvre des collections américaines, Orangerie des Tuileries.
1955, Rome–Florence
Capolavori dell'Ottocento francese.
1955, Winterthur
Jubilée d'Oskar Reinhart.
1956, Besançon
Natures mortes d'hier et d'aujourd'hui, Musée des Beaux-Arts.
1956, Cleveland
The Venetian tradition, Museum.
1956, Moscow–Leningrad
Peinture du XIXᵉ siècle français, Moscow, Puschkin Museum of Fine Art; Leningrad, Hermitage.
1956, New York
Paintings by Gustave Courbet, Rosenberg Gallery.
1956, Paris
Peinture et Impressionnisme, Galerie Alfred Daber.
1956, Paris, Douai
Chef's-d'œuvre du Musée de Douai, Galerie Heim.
1956, Warsaw
Od Davida do Cezannéa.
1956–1957, Providence
Courbet, Rhode Island School of Design.
1957, Annecy
La neige et les peintres, Palais de l'Isle.

1957, Besançon
Concerts et musiciens, Musée des Beaux-Arts.
1957, Cardiff–Swansea
Daumier, Millet, Courbet.
1957, Montclair
Master painters, The Montclair Art Museum.
1957, New York
Masterpieces recalled, Rosenberg Gallery.
1957, Paris
Chefs-d'œuvre du Musée de Besançon, Musée des Arts Décoratifs.
1957, Paris, Charpentier
Des fruits, des fleurs, des feuilles et des branches, Galerie Charpentier.
1957, Paris, Jacquemart-André
Le Second Empire, Musée Jacquemart-André
1957, Paris, Sainte-Pélagie
Claude Bernard et son temps, Salpétrière.
1958, Agen
Romantiques et réalistes, travelling exhibition, Agen, Grenoble, Nancy.
1958, London
19th and 20th century European masters, Marlborough Gallery.
1958, Munich
Aufbruch zur modernes Kunst, Pinakotek.
1958, Paris
De Delacroix à Maillol, Galerie Alfred Daber.
1958, Santa Barbara
Fruits and flowers in paintings, Museum of Art.
1958, Stockholm
Fem Sekler Fransk Konst, Nationalmuseum.
1958, Stuttgart
Franzoissches Zeichnungen.
1959, Atlanta
Collector's first, Art Association Galleries.
1959, Bordeaux
La découverte de la lumière.
1959, Copenhagen
Grace of Philips Sandbloms Samling, Ny Carlsberg Glyptotek.
1959, Houston
Corot and his contemporaries, Museum of Fine Arts.
1959, London
The Romantic Movement, Tate Gallery.
1959, Paris
De Géricault à Matisse, chefs-d'œuvre français des collections suisses, Musée du Petit Palais.
1959, Paris, Baugin
Des Maîtres des XIXe et XXe siècles, Galerie Baugin.
1959–1960, Philadelphia–Boston
Courbet, Philadelphia, Museum of Art; Boston, Museum of Fine Arts.
1960, Copenhagen
Peinture française de Largillière à Manet, Ny Carlsberg Glyptotek.
1960, Nice
Centenaire de la Réunion de la Savoie à la France.
1960–1961, Travelling Exhibition
Paysage en Orient et en Occident, Rennes, Tours, Besançon, Nancy.
1961, Berlin
Die Nationalgalerie und ihre Stifter, Nationalgalerie.

1961, Gray
Aspects de la peinture française du Courbet à Soutine, Musée du baron Martin.
1961, Paris
Le tabac dans l'art, Musée des Arts Décoratifs.
1961, Vichy
D'Ingres à Renoir, la peinture sous le Second Empire, Palais des Expositions.
1961, Wolfsburg
Franzosische Malerie von Delacroix bis Picasso, Staadthalle.
1961–1962, London
Primitives to Picasso, Royal Academy of Arts.
1961–1962, Tokyo–Kyoto
Art français, 1840–1940.
1962, Berne
Gustave Courbet, Kunstmuseum.
1962, Bucharest.
Francuskie Rysunki i Tkaning.
1962, Mexico
Cien anos de pintura francesa.
1962, Minneapolis
Nabis and their circle.
1962, New York
19th and 20th centuries French painting, Finch College Museum of Art.
1962, Ornans
Gustave Courbet, Hôtel de Ville.
1962, Paris
Peinture 1830–1940, Galerie Alfred Daber.
1962, Paris, Dessins
Ire exposition des plus beaux dessins du Louvre et de quelques pièces célèbres des collections de Paris, Musée du Louvre.
1962, Rome
Il rittrato francese, Palazzo Venezia.
1962, Tourcoing
Paysagiste français du XIXe siècle, Musée Municipal.
1962, Williamstown
Alumni loan exhibition, Williams College Museum of Art.
1962–1963, New York
The Louis E. Stern Collection, Brooklyn Museum of Art.
1963, Cleveland
Style, truth and the portrait, Museum.
1963, New York
Birth of Impressionism, Wildenstein Gallery.
1963, Schaffouse
Die Welt des Impressonismus.
1964, Berlin
Meisterwerke aus dem Museen in Lille.
1964, Dublin
Centenary exhibition of the National Gallery, National Gallery of Ireland.
1964–1965, Munich
Franzosische Malerie des 19 Jahrhunderts.
1965, Berlin
Von Delacroix bis Picasso, Staatliche Museen.
1965, Lisbon
Um século de pintura francesa.
1965, New York
Nineteenth Century Romantic paintings, The Trinity School.
1965, Paris
Trois millénaires d'art et de marine, Musée de la Marine.

1966, Dallas
Landscapes of France in the nineteenth century, Dallas Southern Methodist University.
1966, London
Exhibition at the Marlborough Gallery.
1966, New York
Romantics and Realists, Wildenstein Gallery.
1966, Ornans
Gustave Courbet, ses élèves et ses amis, Hôtel de Ville.
1966, Paris
Courbet dans les collections privées françaises, Galerie Claude Aubry.
1966, Paris, Bibliothèque Nationale
P. J. Hetzel, Bibliothèque Nationale.
1967, Copenhagen
Fransk Kunst, Ny Carlsberg Glyptotek.
1967, Montreal
Terre des hommes, International Exhibition of Fine Art.
1967, Paris
Evocation de l'Académie de France à Rome, Institute of France.
1967–1968, Paris
Vingt ans d'acquisitions, Orangerie des Tuileries
1967–1968, New York, Travelling exhibition
Triumph of Realism, shown at Brooklyn; Virginia Museum of Fine Arts; San Francisco, California Palace of the Legion of Honor.
1968, Atlanta
The taste of Paris, The High Museum of Art.
1968, Paris
La peinture française au Musée Mesdag, Institut Néerlandais.
1968–1969. Moscow–Leningrad
Le Romantisme dans la peinture française, Moscow, Puschkin Museum of Fine Art; Leningrad, Hermitage.
1968–1969, Paris
Baudelaire, Musée du Petit Palais.
1968–1969, Paris, Dessins
Maîtres du blanc et du noir, Musée du Louvre Cabinet des Dessins.
1969, Lisbon
Hector Berlioz, Fondation Gulbenkian.
1969, London–Bristol
Exhibition from the Wildenstein Gallery.
1969, London
French painting from the Mesdag Museum, Wildenstein Gallery.
1969, Minneapolis
French painting, 1800–1900, Institute of Art.
1969, Ornans
Gustave Courbet et la Franche-Comté, Hôtel de Ville.
1969, Paris
Berlioz, Bibliothèque Nationale.
1969–1970, Rome–Milan
Courbet, Rome, Villa Médicis; Milan, Palazzo Reale.
1971, Bucharest
Picturi celebre din muzeele parisului, shown also at Craiova and Jassy.
1971, Budapest
Parizsi Muzeumok remekmuvei.
1971, Gentilly
Hommage à Courbet.
1971, Paris
Centenaire de Paul Valéry, Bibliothèque Nationale.

1971, Vannes
Quelques aspects du paysage français, Musée de peinture.

1972, Darmstadt
Von Ingres bis Renoir, Hessisches Landesmuseum.

1972, Rennes
Maîtres du blanc et noir, dessins du Musée du Louvre, Musée des Beaux-Arts.

1973, Minneapolis
Fakes and forgeries, Institute of Art.

1973, Paris
Autoportrait de Courbet, Sixth Dossier of the Department of Paintings, Musée du Louvre; exhibition also shown at Besançon, Lyon, Nantes.

1973, St Louis
The 19th century – changing styles changing attitudes, Art Museum.

1974, Bordeaux
Naissance de l'impressionnisme

1974, Philadelphia
The beneficent connoisseurs, Pennsylvania Academy of Fine Arts.

1974, Rochechouart
Gustave Courbet, Centre artistique et littéraire.

1974, Zurich
Tierbilder aus unserer Sammlung, Kunsthaus.

1975, Paris
Courbet, Fiftieth anniversary of the Galerie Daber.

1976, Lausanne
Curriculum vitae, Pietro Sarto, Jean Lecoultre, Musée des Arts Décoratifs.

1976–1977, Paris
Centenaire de Louis Gillet, Musée Jacquemart-André.

1976–1977, Tokyo
Millet, Corot, Courbet et l'Ecole de Barbizon, exhibition also shown at Utsunomiya, Kumamoto, Nara, Nagoya.

1976–1977, Vienna
Von Ingres bis Cezanne, Albertina.

1977, Ornans
Hommage à Gustave Courbet, Musée-Maison natale Gustave Courbet.

1977, Paris
Francis Ponge, Centre Georges Pompidou.

Index of lenders

Alphabetical Index

of person's names
of places cited or represented
of titles of works

The dossier on 'The Studio' by Courbet

by Hélène Toussaint

Examination by the Laboratoire de recherche des Musées de France
by Lola Faillant-Dumas

The last page of Courbet's letter quoted on pages 254–255

The painter's studio.
A real allegory summing up seven years of my artistic life

Description

Canvas: 359 × 598.
Dated and signed, below left: *. 55 G. Courbet.*
The date and initials are in brownish-red paint, the remainder in black paint. The signature originally consisted of the initials only, and was completed subsequently. The brownish-red dot after the C is still visible under the O.
Inventory no.RF 2257.

History and provenance

From Courbet's correspondence it appears that he began to paint *The studio* at Ornans in October 1854.[1]

The picture was rejected by the selection committee of the World Exhibition of 1855. Courbet presented it in a private exhibition in a temporary pavilion built for the purpose in the vicinity of the World Exhibition.

Afterwards the picture was kept rolled up, but was exhibited twice by Courbet: in 1865 at the Société des Beaux-Arts de Bordeaux, and in 1873 at the Vienna Artists' Club.

The work was inherited by Juliette Courbet, the painter's youngest sister, who sold it on 9 December 1881 at the Hôtel Drouot (lot 8) to the dealer Haro for 21,000 francs. It was acquired by Victor Desfossés at the Haro sale on 2 April 1897 (lot 108), and was bought back by Mme Desfossés at the posthumous sale of her husband's collection on 26 April 1899 (lot 20). It was used as a backdrop in the amateur theatre at the Desfossés's house, 6 rue Galilée, and in 1919 was disposed of by Mme Desfossés to the dealer Barbazanges. The Louvre negotiated for its purchase, but could not raise the necessary sum (900,000 francs) despite a large contribution by the Amis du Louvre. A public subscription was opened, and the sum was raised in two months. The picture was installed in the Louvre on 13 February 1920.

Exhibitions

1855, Paris, 7 avenue Montaigne, *Exhibition et vente de 40 tableaux et 4 dessins de l'œuvre de M. Gustave Courbet*, no.1; 1865, Bordeaux, Société des Beaux-Arts, no.176; 1873, Vienna, Artists' Club, no.24; 1881, Paris, foyer of the Théâtre de la Gaieté; 1882, Paris, Ecole des Beaux-Arts, *Exposition des œuvres de G. Courbet*, no.3; 1919, Paris, Galerie Barbazanges; 1947, Paris, Orangerie des Tuileries, *Cinquantenaire des Amis du Louvre*, no.57; 1968–1969, Paris, Petit Palais, *Baudelaire*, no.226; 1977, Paris, Galeries nationales du Grand Palais, *Courbet*.

Bibliographical note

The innumerable monographs on Courbet all discuss *The studio*, as do works on Realism. There is no room to cite all these, and we shall confine ourselves to listing a few of the most important studies devoted to the picture.

We wish to pay tribute to these works, which have enriched our knowledge of Courbet by the wide diversity of their judgement. We refer readers to them by way of completing our own analysis and supplementing its brevity from the historical and bibliographical point of view.

René Huyghe, Germain Bazin and Hélène Adhémar, *Courbet, l'atelier du peintre, Allégorie réelle, 1855*, Paris, 1944.

Bert Schug, *Gustave Courbet. Das Atelier*, Stuttgart, 1962.

Werner Hofman in *Das irdische Paradies*, Munich, 1961, republished in 1976; French translation by C. Woerler in *Les Amis de Gustave Courbet*, Bulletin no.33–4, 1965, pp.1–8.

Alan Bowness, *Courbet's Atelier du peintre*, lecture delivered in 1967; published in 1972, University of Newcastle upon Tyne.

Linda Nochlin, 'The invention of the Avant-Garde: France, 1830–80' in *Art News Annual*, vol. XXXIV, 1968, pp.13–16.

Benedict Nicolson, *Courbet: The studio of the painter*, London, 1973.

Max Kozloff, 'Courbet's l'Atelier: an interpretation' in *Art and Literature*, 3, pp.17–34.

Pierre Georgel, 'Les transformations de la peinture vers 1848, 1855, 1863' in *Revue de l'art*, no.27, 1975, pp.69–72.

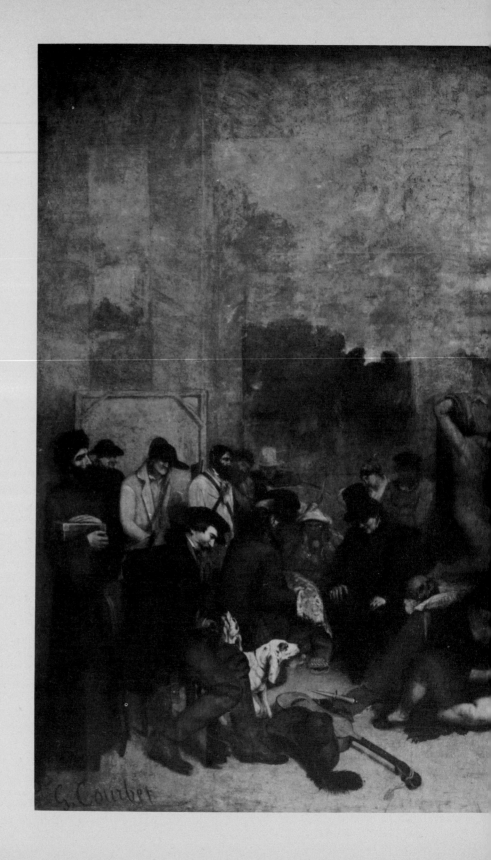

The painter's studio: a problem picture

It is clear at the first glance that Courbet's *Studio* is full of hidden meanings; and this impression is confirmed by the sub-title, 'A real allegory summing up seven years of my artistic and moral life'. Naturally there is a vast amount of literature on the subject. We shall mention the most important studies, but would first offer two general comments. The historical studies, extensive though they are, have ignored, deliberately or otherwise, aspects of the work that are essential to its comprehension. As for the critical studies, some of them reflect a subjective approach and a tendency to over-emphasize Courbet's socialist convictions, with results of greater interest to historians of criticism than to historians of art.

Let us try to look at this huge composition with a fresh eye, as though we were seeing it for the first time, with the aid of the description that Courbet himself provided.

An authoritative explanation

We quote here the text, printed for the first time in its entirety, of Courbet's letter to Champfleury describing his plan for the picture; this letter, it can be shown, was written in autumn 1854.[2]

Dear friend,

In spite of being assailed by hypochondria I have launched into an enormous painting, twenty feet by twelve, perhaps even bigger than the Burial, *which will show that I am still alive, and so is Realism, since we're talking of that (puisque réalisme il y a). It's the moral and physical history of my studio, part 1: all the people who serve my cause, sustain me in my ideal and support my activity; people who live on life, those who live on death; society at its best, its worst and its average – in short, it's my way of seeing society with all its interests and passions; it's the whole world coming to me to be painted. You see, the picture has no title. I will try and give you a clearer idea by a matter-of-fact description. The scene is set in my Paris studio. It is divided into two parts, with myself in the middle, painting a picture. On the right are all the shareholders, that is to say friends, fellow-workers (travailleurs: it is not clear in what sense Courbet meant this) and art lovers. On the left is the other world of commonplace life: the masses, wretchedness, poverty, wealth, the exploited and the exploiters, people who live on death. On the wall at the back are my* Return from the fair *and* Bathers, *and the picture I am working on is one of a donkey-driver meeting a girl and pinching her bottom; there's a landscape with a mill and donkeys laden with sacks. I'll tell you who all the characters are, starting at the extreme left. The first is a Jew whom I saw once in England, making his way through the hurly-burly of a London street; he was holding a casket reverently on his right arm, covering it with his left hand, and seemed to be saying: 'I've got the best of it.' His complexion was like ivory, he had a long beard and was wearing a turban and a long black gown that trailed on the ground. Next to him is a curé with a coarse red face (une trogne rouge) and a triumphant expression. In front of them is a weather-beaten old man, a diehard republican (that Minister of the Interior, for instance, who was in the Assembly when Louis XVI was condemned to death, the one who was still following courses at the Sorbonne last year) – a man 90 years old with a begging-bag in his hand, dressed in old patched white linen and wearing a broad-brimmed hat; he is looking at a heap of romantic paraphernalia at his feet, and the Jew feels sorry for him. Then there's a huntsman (Chasseur), a scytheman, a strong man and a clown, a rag-and-bone merchant, a labourer's wife, a labourer and an undertaker's mute; a skull lying on a newspaper; an Irishwoman suckling a child, and a lay figure. The Irishwoman comes from England too – I saw her in a London street wearing nothing but a black straw hat, a torn green veil and a ragged black shawl, and carrying a naked baby under her arm. The old-clothes man (marchand d'habits-galons) presides over all this, displaying his frippery to all these people, each of whom expresses great interest in his own way. Behind his back, in the foreground, is a guitar and a plumed hat.*

Part 2. Then comes the canvas on my easel, and myself painting in Assyrian profile. Behind my chair is a nude female model, leaning on the chair-back for a moment as she watches me paint. Her clothes are lying on the ground in front of the picture, then there is a white cat beside my chair. Next to the model is Promayet with a violin under his arm, as in the portrait he sent me. Then Bruyas, Cuenot, Buchon and Proudhon (I would very much like to have the philosopher Proudhon, who shares our way of thinking, and I would be very happy if he would pose. If you see him, ask if I may expect his help). Then comes your turn, in the foreground, sitting on a stool with your legs crossed and a hat on your lap. Beside you, still further forward, is a society woman, dressed to the nines, with her husband. Then on the extreme right, perched with one leg on a table, is Baudelaire, reading a great book; beside him, a negress looking coquettishly at her reflection in a mirror. Right at the back, in a window recess, two lovers are whispering to each other; one of them is seated on a hammock. Above the window are voluminous draperies of green serge. Against the wall are also some plasters, a shelf with a bottle (fillette) on it, a lamp, some pots, canvases turned back to front, then a screen, then nothing but a great bare wall.

I have explained all this very badly, the wrong way round – I ought to have begun with Baudelaire, but it would take too long to start again. Make it out as best you can. People will have their work cut out to judge

the picture – they must just do their best. For, of course, there are people who wake up at night shouting and screaming: I want to judge, I must judge! Can you imagine, my dear chap, that when I had already conceived this picture I was suddenly overtaken by a frightful jaundice which lasted more than a month. Knowing how impatient I am once I have made up my mind to paint something, you can imagine what a state I was in – wasting a month, when I couldn't afford to lose a single day! All the same I think I shall manage – I have still got two days for each character, except for the accessories, but somehow or other I must get it done. I shall be sending 14 pictures to the exhibition, practically all new ones except for the Burial, the Stone-breakers and myself with a pipe; Bruyas has just bought this from me for 2,000 francs, and he also bought the Spinner for 2,500. I'm in luck, I'll be able to pay my debts and cope with the exhibition as well. I don't know how I could have done it otherwise – one must never lose heart. I have a country scene of The grain sifters which belongs to the same series as Young ladies of the village, a strange picture too. I feel very depressed – my soul is quite empty, my liver and heart full of gall. At Ornans I drink at a sportsmen's café with 'Gai Savoir' people and go to bed with a servant girl. None of this cheers me up. You know my 'wife' got married. I no longer have her or the child – apparently she was forced to it by poverty. That's how society devours people. We had been together 14 years. I gather Promayet is very unhappy too. Try to help him find something. Pride and probity will be the death of us all. At this moment I can't do a thing, but I absolutely must be ready for the exhibition. Tell Promayet that I haven't received the canvases. I embrace you with all my heart.

Gustave Courbet

Cuenot sends you all sorts of messages, and so do my parents. There is much talk about you on account of your portrait. My best regards to Promayet and the Andlers. Tell Promayet I have written to Bruyas about the Spinner and it will be sent to him without fail. Say that Cuenot will reply to him. That's all for the present – write to me and I'll tell you more. Keep me in touch with things.

As we shall see in due course, this letter was probably 'cooked' for sufficient or even compelling reasons; many of Courbet's terms have a double meaning, but it is nevertheless worth examining the basic significance he ascribes to the picture.

In the first place, the characters are divided into two groups. Like St Michael weighing the souls of the dead, Courbet places on the left those who are cast into outer darkness (by himself or by society – as we shall see, it is sometimes difficult to be sure what Courbet himself condemns); on the right are the enlightened, those who share his views. In between the two groups is the painter absorbed in his art. Courbet does not represent himself as an awakened sleeper reconstructing his dream. He is completely aloof from his surroundings; his back is turned to the elect, while the picture he is working on acts as a screen between him and the reprobate, with the sole exception of the man with the dogs, who is in the foreground and thus within his field of vision.

Let us survey the triptych from left to right in the order of the artist's description. First we come to the Jew, with the suggestion of cupidity and with the claim to 'have the best of it'. Quite possibly there is a touch of anti-Semitism here, of a type which made its appearance in Western Europe shortly before the middle of the nineteenth century: not, as in bygone days, on a more or less genuinely religious basis, but avowedly on social grounds. By the end of the century, when this attitude reached its climax in the Dreyfus case, it was mainly associated with the extreme right; but at the time we are concerned with it originated within the socialist movement. The note was struck in 1845 by a militant Fourierist, Alphonse Toussenel, in a virulent pamphlet entitled Les Juifs rois de l'époque; reprinted in 1847 and several times afterwards, this work describes the Jews as 'hordes of lepers' and 'limbs of Satan'. During the 1848 revolution Jewish families, often of the poorest classes, were savagely persecuted in Alsace and Lorraine.[3] Courbet was a friend of Toussenel's, a fellow-habitué of the Brasserie Laveur. Why, however, should he hold a Jew up to obloquy for his reverence towards money, when his banker friends Bruyas and Mosselman are ranked among the elect on the other side of the picture?

We may note, in any case, that in

1855 Courbet already displayed anti-Semitic sentiments in keeping with his future friendship for Rochefort. The Government, on the other hand, took a different view of the Jewish question. At this very time Robert-Fleury, an opportunist who enjoyed official favour, presented at the World Exhibition an enormous painting of a medieval Venetian mob pillaging a house in the Giudecca: its inmates, an aged man of noble aspect and several distraught young mothers, are confronted by a rabble whose features resemble those of the torturers of Christ in a scene of the Passion. This piously intended work was bought by the state for the Musée du Luxembourg.[4]

Next comes the curé, with 'a coarse red face' and a triumphant expression. We have pointed out, apropos of Burial at Ornans,[5] that in 1849 Courbet, like other socialists, adopted a sympathetic attitude towards religion and the church, while the prestige of the clergy was enhanced by Mgr Affre's tragic death on the barricades.[6] At that time, 'except for some Communists who were also materialists, socialism was largely imbued by a Messianic and Christian spirit'.[7] During the next six or seven years this attitude cooled, but we are still a long way from the scurrilous anti-clericalism of Courbet's Return from the conference (1862)[8] with its procession of drunken priests, or the offensive picture entitled Church expenses or The death of Jeannot,[9] which shows a curé robbing an unfortunate wretch at the point of death. Jules Troubat later described Courbet's evolution in the words: 'Many years later his mysticism gave place to philosophical theories of the most diverse origin; his mind underwent every kind of influence.'[10] In 1855 the curé in The painter's studio is certainly treated with a touch of mockery or hostility, but this is chiefly directed at the higher clergy who supported the Coup d'Etat of 1851; the 'triumph' is that of the Establishment rather than of any individual.

As to the next figure, he is the only one on this side of the picture whose identity Courbet hints at in a few paraphrases. We propose to explain these more fully in the later part of our analysis; for the time being we may be content to see in him a 'diehard republican' full of bitterness and disillusionment, with the dress and accoutrements of a beggar. He looks sadly at the 'romantic paraphernalia', which no

doubt remind him of his vanished hopes. There are two similar characters in *Burial at Ornans*,[5] dressed in an old-fashioned style reminiscent of former glories. This one's garb is of 'old patched white linen', befitting a poor wretch who has been mocked by history.

After the republican, a bare-headed huntsman. Is this because he is one of those who 'live on death'? But Courbet, himself an ardent huntsman, can hardly have blamed him on this account. Next comes a figure who has been described as a farm labourer, but whose cap and beard are not those of the French peasantry. The rest of the 'commonplace' world is represented by a mower, a professional strong man, a clown and some people of the working class.

French rural labourers at this time were in a depressed and discontented state, owing to bad harvests and a social climate which promised little alleviation of their troubles. Courbet, however, does not seem to have had this situation much at heart, and if the 'labourer' in the picture is there as a reproach and a challenge, he is unique in the whole of the artist's work. Courbet's villagers are a happy breed, whether he shows them returning from the fair, sleeping in the fields or dozing beside a spinning wheel. His rural scenes, which are not numerous, generally depict festivity and relaxation. If he does show peasants at work, for example in *The corn sifters*,[11] he paints a fine strapping woman of indomitable energy, to whom labour is child's play – a figure much closer to the novels of George Sand than to the paintings of Millet. This is not to say that the latter was a social propagandist either; but he was undoubtedly concerned to portray human beings bent down by toil or by heavy burdens, their faces sometimes brutalized by the inhumanity of their lot, like the peasants in Balzac's novels. Courbet, on the other hand, was himself a landowner, and it would have been unseemly for him to paint unflattering portraits of those who provided him with an income.

The strong man and the clown seated in front of the old clothes man, seem designed to express the compassion that the nineteenth century felt for circus entertainers – no longer the cheerful mountebanks of former times, but condemned to a life of misery and derision. They are the only figures of their kind in the work of Courbet

who, unlike other painters of his day, was not interested in the theatre. One would not, of course, expect him to be attracted by gaudy operatic scenes of the kind that attracted Delacroix, but neither did he paint cruel, realistic tableaux in the style of Daumier. When, exceptionally, he depicted *Wrestlers* (1853),[12] he handled the subject in a very different manner from Daumier (*c*.1860):[13] Courbet's wrestlers are two men fighting, Daumier's are circus figures seen by a moralist. As we have seen, Courbet did not disdain symbolism, but he was no less chary of illusion than of abstraction.

The rag-and-bone man displays his wares in front of the strong man and the clown. He is not a pedlar as many writers have supposed, but an old-clothes dealer, one of those whose cry could still be heard in Paris streets at the beginning of the present century: his literary prototype is not Lheureux in *Madame Bovary* but Rémonencq in Balzac's *Le Cousin Pons*. He is holding forth an old carpet and some bits of faded finery; a braided hussar's jacket lies beside him. He 'lives on death' in the sense that he sells cheap rags to wretched people. Courbet is not stigmatizing commerce as such, only the shady transactions of the underworld. There is an honest businessman in the right-hand half of the picture: Courbet's friend Cuenot, the rich hatter from Ornans.

Behind this group is a woman of the working class holding a baby, and a worker with arms folded – either unemployed or on strike. Apart from the work of François Bonhommé, this is one of the first representations of the proletariat in French painting; they were to be frequent in the following generation. Courbet, it is true, painted craftsmen such as *The tinker* (*c*.1845)[14] and *The knife-grinders* (1848),[15] but in so doing he and other artists of his time were more concerned with picturesque effects in the spirit of Dutch or Flemish painting than with the condition of the working class. The only labourers in Courbet's work whom we see engaged in toil are the *Stone-breakers* (1849),[16] concerning whom he wrote: 'It is rare to encounter a more perfect expression of wretchedness' (Riat, p.73). Thus Courbet's idea of the acme of destitution is embodied in one who is still half a peasant, who works out of doors unharassed by supervision, and who from this point of view might nowadays be considered to have a reasonably happy lot

(there is in fact a popular rhyme about the 'jolly roadmender'). Ornans, of course, was a long way from the region of factories and spoil heaps; but although Courbet had visited the industrial north of France and the outskirts of the big cities, he never portrayed miners at the coal-face, puddlers working in the glare of blast-furnaces, or the child employees of the Lyons silk looms. He did not care to paint the 'wretched of the earth', and he left it to Daumier, whose style was less assertive but more sincere, to depict the misery of slums and third-class carriages. We may indeed regret that the painter of *Burial at Ornans* or *The fire-brigade*[17] did not apply his skill as a realist to interpreting the industrial epic of his time, with all its tremendous power and all the misery and sacrifice it entailed. But to Courbet the open air meant forests and beaches, not mining villages, and for indoor scenes he preferred boudoirs to factories. Some of his paintings do have a social message, but it is an exaggeration to regard him as politically committed. He liked to consider himself a progressive thinker, but he did not treat his art as a medium of social propaganda. When he wrote to Bruyas in 1868 'I am going to Ornans to paint some socialist pictures',[18] he did so with his tongue in his cheek. What inspired his sensual genius was pleasure, idleness, luxury and the serenity of nature.

In front of the workman is the undertaker's mute – another of those who can say 'Death is my business'. Firmly planted on his chair, he wears a smug expression as though biding his time until his services are needed.

Crouching at the foot of the easel is a ragged woman suckling a baby; Courbet tells us she is Irish, from the London streets. Why did he cross the Channel for an extreme example of down-and-out destitution and social injustice? There is no confirmation that he ever went to London, and critics other than B. Nicolson[19] have disbelieved this. However, it is not far to England from Dieppe, where Courbet used to visit his son, and the trip would not have been so important as necessarily to be recorded. We shall revert to this question apropos of the Jew, whom Courbet also claims to have seen in London. Whether or not he went there, it is not surprising that he chose an Irishwoman as the symbol of abject misery: the potato famine was in

everyone's memory, and in the second half of the century the state of Ireland was a byword for oppression and want. J. Lindsay[20] recalls in this connection Flora Tristan's *Promenades dans Londres* (1840), which contains a description of Irish poverty that might have served as a model for this figure in Courbet's picture.

We may remark that the misery in this case is so overdone as to defeat its purpose: an excess of realism savours of romantic fiction. Later, in *The charity of a beggar at Ornans*, 1868,[21] Courbet depicted a cheerful-looking tramp whose freedom from all social ties excites a feeling of amusement and even envy. In France as in Britain, painters with a social conscience sometimes spoilt the effect of their own work by exaggeration and melodrama. This applies to two large canvases by Jules Breton, destroyed but known from reproductions, entitled *Poverty and despair* (1849) and *Hunger* (1850),[22] in which the victims of injustice are depicted life-size, and to the smaller-scale work of Tassaert. Of the many painters who chose to represent extreme poverty, those who did so with the most poignant restraint and genuine compassion were Belgian artists such as Joseph Stevens, whose *Morning in Brussels* (1847) is a pioneer work of its kind, or Charles De Groux, whose *Banc des pauvres* (The pauper's bench) (1854)[23] is even more impressive.

A lay figure is suspended behind the painting on Courbet's easel. The painter does not explain its purpose, or the meaning of the skull half-wrapped in a copy of the *Journal des Débats*. Following Silvestre, historians have seen here an allusion to Proudhon's gloomy remark that the press was the 'cemetery of ideas'. The lay figure has been interpreted, wrongly in our opinion, as symbolizing Courbet's contempt for academicism.

Before leaving the left-hand side of the picture we should notice the huntsman-like figure in the foreground. Champfleury, in *L'Artiste* of 2 September 1855, refers to him as a *braconnier*: this word normally means a poacher, but formerly also meant a trainer of sporting dogs (*braques*, pointers). Courbet does not mention this character in his letter to Champfleury, and the X ray (cf. pp.283–4 below) confirms that he was added later. Writing to Bruyas in November 1854, Courbet described the picture as containing thirty figures; a few weeks later,

however, he mentions thirty-three,[24] which agrees with the number in the finished work. The two other additional figures are the man in a round cap to the right of the undertaker's mute, and the peasant boy in front of the easel.

In the finished picture, the seated man with the dogs is the key to the formal composition on the left-hand side. The Republican's view of the 'romantic paraphernalia' is not obstructed, as his line of sight travels between the man's shoulder and the back of the old-clothes vendor. The seated man aroused critical attention from the very beginning, and, as we shall see, he figures prominently in the caricature by Quillenbois.

We now come to the central part of the allegory, where Courbet himself is working at a Franche-Comté landscape, having abandoned his earlier idea of a donkey-driver flirting with a village girl: possibly he thought it too explicit and frivolous for a work of this kind. On either side of the painter are a nude model and a small boy, to whom we shall also return.

Continuing with Courbet's friends on the right-hand side, we see first the violinist Alphonse Promayet, son of the organist at Ornans and a childhood friend of the artist, who painted him several times. We believe him to be the model for the *Guitarrero* (1845),[25] hitherto regarded as a self-portrait; he appears in *After dinner at Ornans* (1849)[26] and in the *Funeral* (1849); there is a drawing of him in the Louvre,[27] and a portrait in the Metropolitan Museum New York.

Facing Promayet is Alfred Bruyas, son of a banker at Montpellier and a friend of Courbet's since 1853, when the artist first painted his portrait;[28] he is a principal figure in *The meeting* (1854).[29] A patron of the arts and a shrewd judge of painting, Bruyas amassed one of the most varied collections of his day, which he bequeathed to the Museum of his native town. Courbet, who was given to flattering him effusively, wrote apropos of this picture: 'You have a magnificent position. You are triumphant and *Commandeur*'.[30] (Is it an allusion to Bruyas's Masonic dignity? cf. p.269 below.)

Next, in a compact trio, are three more 'compatriots' of Courbet's: Proudhon, Cuenot and Buchon. Proudhon, the socialist philosopher, lived in Paris from 1847 and remained a fast friend of Courbet's; his

beneficial influence was cut short by his death in 1865. Courbet depicted the philosopher's happy home, life in the well-known posthumous portrait of *Proudhon and his children* (1865).[31]

Urbain Cuenot, another childhood friend, was the son of an Ornans merchant. A well-to-do bachelor, he accompanied Courbet on various travels, hunting trips and escapades and was probably associated with him in politics also, to judge from his letters to Buchon in exile. He is the host in *After dinner at Ornans*,[26] and portraits of him by Courbet are in the Ornans Museum and the Pennsylvania Academy of Fine Arts, Philadelphia.

Max Buchon, an officer's son from Salins-du-Jura, was a distant cousin and an old school friend of the painter's. He had literary interests and played a part of some importance in the Realist movement by collecting and publishing local songs and folk-tales, thus rescuing a peasant tradition that was in danger of dying out. A firm anti-Bonapartist, he went into exile after the Coup d'Etat of 1851. In 1855 he was living at Berne and was the chief figure in a group of opponents of Napoleon III. Courbet visited him there, and they maintained a correspondence which it would be interesting to decipher: a letter in the Metropolitan Museum, New York,[32] which appears to be a catalogue of Courbet's love affairs is in fact probably a political message, encoded to get past the censor. A portrait of Buchon before 1849 is in the Algiers Museum, and he also appears in *Funeral at Ornans*.[5]

Champfleury is seated in a place of honour in the foreground, as befitted Courbet's close friend and ally: the two men co-operated closely for many years, but their friendship went through difficult patches and came to an end in about 1865. They were the joint begetters of the Realist movement. Champfleury wrote ambitious novels on social themes, which do not altogether deserve the oblivion into which they have fallen; in *Les demoiselles Tourangeau* (1864) he depicted Courbet's family as typical(!) of French provincial life. Like his friend Buchon he was one of the first to salvage popular traditions. He deserves to be remembered on this account, and also because he is said to have composed the famous 'Realist manifesto' of 1855: this was prefaced by Courbet to the list of paintings, including *The studio*, presented at a special

pavilion next door to the World Exhibition. Champfleury was not pleased with the portrait of himself in *The studio*, which he said made him look like a general of the Jesuits.[33]

Courbet does not identify the society couple who occupy the chief place on the right-hand side of the picture; we shall discuss them in the second part of our analysis. He makes no mention of the small boy drawing on the floor at their feet, and he does not explain the purpose of the loving couple, with the man seated on a red hammock suspended from the wall at the back. The lovers and the two children bring a note of freshness into the rather stuffy atmosphere of the composition.

Baudelaire sits in a brooding attitude on the extreme right. Courbet and he were friendly for some years, but by 1855 they had drawn apart: the beer-drinker and the 'opium-eater' were not really natural companions. Courbet had painted Baudelaire's portrait in 1847.[34] In the present picture he is shown as a visitor, with his hat on the table beside him. The figure of Jeanne Duval, his mulatto mistress, can be dimly seen where it has been painted over. Baudelaire's lifelong association with the 'black Venus' was a stormy one; he demurred at the exhibition of his private life in Courbet's picture, and at his request Courbet painted the figure out. This must have been one after the picture was first hung, for Edouard Houssaye wrote in *L'Artiste* of 15 April 1855 (with some disregard of ethnography) that 'M. Baudelaire is leaning against a woman of the yellow race'. It is no accident that Baudelaire is placed to one side of the picture: Courbet well knew that the poet was no friend of Realism, which he regarded as the exaltation of ugliness. We possess the draft of an article by Baudelaire, not published in his lifetime, entitled 'Talking of Realism' (*Puisque Réalisme il y a*)[35] and discussing Courbet's exhibition; referring to the suggestion, implicit in the painting, that he should join the movement he says: 'In any case I warn the party that I should be no good to them (*un triste cadeau*). I have not the necessary conviction, docility or stupidity.' Aragon[36] thinks that Courbet and his friends were trying to convert Baudelaire to socialism, but this is a mistake; their approach to him was on the aesthetic level. In any case, Baudelaire's article expresses the annoyance he felt at being portrayed in such compromising company at the moment when his *Fleurs du Mal* were beginning to appear in the *Revue des Deux Mondes*. According to Claude Pichois his appearance in Courbet's picture counted against him in 1857, when he was prosecuted for the immorality of his poems.[37]

Contrary to what Courbet indicated in his letter to Champfleury, *Return from the fair* (1850)[38] and *Bathers* (1853)[39] are not visible in the picture, nor do they appear in Quillenbois's cartoon. Did Courbet change his mind, or delete them before the exhibition? The enormous mural landscape, which is difficult to make out at the present time, was no doubt painted in later, perhaps before the work was sent to Bordeaux in 1865 or to Vienna in 1873. We suggest some hypotheses below in the light of Courbet's afterthoughts as revealed by X rays.

The *étagère* with the bottle, lamp and pots, to which Courbet refers in his letter, have also disappeared, though the lamp can still be seen in the cartoon. All that remains is a plaster medallion of a woman in quarter-profile, whom we shall identify later.

An enlightening caricature

Courbet was a favourite target of cartoonists from the Salon of 1851 onwards. In many cases, such as Daumier, their witticisms were friendly and served to enhance his popularity, but others were more malicious.[40]

We reproduce here a caricature of *The painter's studio* by Quillenbois (pseudonym of the comte de Sarcus), published in *L'Illustration* on 21 July 1855. This provides useful support to the thesis we propose to develop, emphasizing and supplementing certain aspects of Courbet's work.

Caricature of 'The studio' by Quillenbois, L'Illustration, 21 July 1855.

A 'real allegory'

According to Littré the word *allégorie* signifies: 'Saying something other than one appears to say. A kind of continuous metaphor, a species of discourse presenting a literal sense but intended, by way of comparison, to convey another sense which is not expressed.'

We suggested above that Courbet's letter to Champfleury was a protective manoeuvre to conceal the true import of his work, to allay anxiety and forestall dangerous interpretations. The form of the letter is suspect, as it bears neither a date nor a place of origin; and beneath its apparent casualness it shows signs of deep premeditation. It may exist in more than one copy. The one in the Louvre, unquestionably an autograph, is in a perfect state of preservation, although the letter was intended to pass through various hands and no doubt did so. Baudelaire uses a phrase from it (*puisque réalisme il y a*) as the title in his article quoted above, which suggests that it was fairly well known. There would have been no point in Courbet's providing a bogus explanation for the benefit of a friend whom he had no interest in deceiving; the letter must have been intended to reach a wider circle.

'It's the whole world coming to me to be painted'

In the following paragraphs we attempt to unravel the mystery and to identify the characters in Courbet's monumental charade, not merely as types but as individuals symbolizing, under appropriate disguises, the most important political and social phenomena of his time.

The Jew = Achilles Fould (1800–1867)

We suggest that the Jew with his casket represents the financier and statesman Achille Fould. Fould, the son of rich Jewish parents, was a shrewd banker of Saint-Simonian convictions and a member of parliament in 1848. He was a friend of Louis Napoleon (who also leant towards Saint-Simon's ideas), and helped to finance his campaign for election to the Presidency. He was Minister of Finance from 1849 to 1852 and then became a minister without portfolio. A cartoon of him by Daumier (Delteil, no.1873) shows the same aristocratic countenance, with the long nose and broadly-arched eyebrows. True, his beard seems to have been less bushy than in Courbet's picture, but it would have been as well for the resemblance not to be too close. As to the casket and the association with London, it may be recalled that Louis Napoleon was helped financially by his English mistress Miss Howard and, it has been alleged, also by Palmerston, who was foreign secretary from 1847 to 1851 and made no secret of his sympathy for the Prince-President's cause.

Achille Fould in 1849, caricature by Daumier.

The curé = Louis Veuillot (1813–1883)

Veuillot, a Catholic journalist, was the chief spokesman of the Ultramontane party; his virulent attacks on liberal Catholics earned him a censure from the Archbishop of Paris, Mgr Sibour. Courbet, it will be remembered, had illustrated the second and final number of the Christian Socialist publication of 1848, *Le salut public*, edited by Baudelaire, Champfleury and Toubin. Veuillot abominated the attempts of the revolutionaries to come to terms with the Church (a doubtful ally is worse than an enemy), and pursued Courbet with his hostility even when the latter had lost all contact with religion. When Courbet was tried and condemned for his association with the Commune, Veuillot vindictively declared: 'Courbet's canvases stink as much as Carpeaux's marbles.'

At the time we are concerned with, Veuillot's attitude towards the Imperial power was one of submission. Victor Hugo, an exile in Brussels, denounced the enslavement of the French press: 'They write in fetters and chains; independence is gagged, talent is kept under close arrest, honesty is spied on, and Veuillot keeps shouting "I am free!"' (*Napoléon le Petit*, 1852). Similarly Veuillot was the butt of caricaturists like Daumier, Cham and Gill, who depicted him as a priest or a monk, ornamented by a halo or wearing an extinguisher by way of allusion to the conical cap, with a tuft on top, which was then worn by certain of the clergy.

Louis Veuillot in 1865, photograph by Nadar.

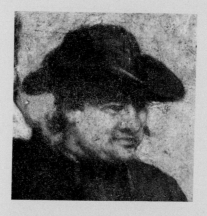

The Republican = Lazare Carnot (1753–1823)

Courbet, in his letter, is fairly explicit about this character. The only member of the Convention who subsequently became a Minister of the Interior was Lazare Carnot, best known as the organizer of the revolutionary armies. Here again, however, Courbet covers his tracks to some extent. Carnot did not live to be ninety, but the painter telescopes his career with that of his son Hippolyte, who was Minister of Education for a brief period in 1848 – hence, presumably, the allusion to the Sorbonne. The Republican in his patched attire is one of the quaintest figures in Courbet's picture, and aptly symbolizes the chequered career of Lazare Carnot. A professional soldier and man of science, he became a revolutionary in 1789 and was Minister of War under the Convention, which voted him the title 'Organizer of Victory'. He was one of those who voted for the death of Louis XVI. He became a member of the Directory in 1795, but was accused by the other Directors of plotting with the Royalists. Arrested by Barras's order in 1797, he escaped to Bavaria, where he used the name Jacquier and was regarded by the émigrés as one of their party.[41] Prior to his arrest he had supported Bonaparte during the Italian campaign, and after the coup d'état of 1799 (the 18th Brumaire) he became Minister of War. He opposed the establishment of the Empire, but supported Napoleon once more during the Hundred Days: it was at this time that he was Minister of the Interior. Condemned as a regicide under the Restoration, he died in exile at Magdeburg. Courbet did not live long enough to witness the last turn of the story: Carnot's remains, buried without honour in Prussia, were repatriated in 1885 and interred in the Panthéon.

As Courbet points out, the Republican in the picture wears a broad-brimmed hat (*chapeau brancard*) of a type common in Germany and sometimes used by the French émigrés. It is a broad-brimmed felt hat with the back turned up, and may thus be regarded as a back-to-front version of the Directory hat – a further hint at the tergiversations of the *Grand Carnot*. As to the reason for his presence, he may be regarded as a reminder of the somewhat variable loyalty that the 'diehard Republicans' had professed towards the Emperor's uncle, Napoleon I.

As the model for Carnot's features Courbet used the posthumous medallion sculpted by his friend David d'Angers.[42]

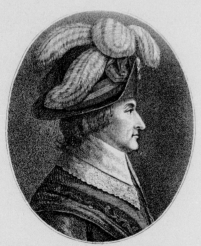

Lazare Carnot in the costume of a member of the 'Directoire Exécutif', 1796.

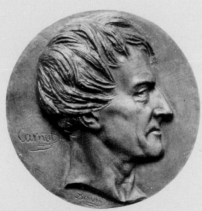

Lazare Carnot, medallion by David d'Angers, Musée du Louvre.

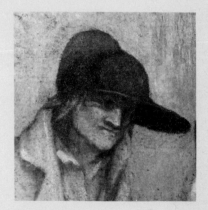

The undertaker's mute = Émile de Girardin (1806–1883)

The pose of this figure is derived from Ingres's *Portrait of M. Bertin*.[43] Bertin, known as 'the elder', was editor of the *Journal des Débats* and one of the outstanding journalists of his time, but had become a symbol of subservience to the régime. Courbet may have seen Ingres's *Portrait* at the Bazar Bonne-Nouvelle in 1846; an engraving of it by Henriquel-Dupont was published in that year, and it was also being shown at the World Exhibition of 1855.

We suggest that the caricature of Bertin is intended to represent another turncoat journalist, Émile de Girardin, who was much in the public eye at this time. Girardin had a pronounced squint, and in the picture his eyes are modestly lowered. He initiated cheap popular journalism in France in the 1830s, and was noted for his opportunism. A republican by conviction,

he nevertheless supported Louis Napoleon for the Presidency in 1848: a famous cartoon by Daumier (Delteil, no.1756) shows him, with the aid of Victor Hugo, hoisting the Prince-President on to a shield. His funeral garb, with the crepe veil, probably does not signify that he is in mourning for his wife Delphine Gay (who died in 1855) but that he 'murdered' the republican Armand Carrel by wounding him mortally in a duel in 1836. We may note that he does not join the group huddled behind the man with the dogs, but keeps his distance. His sly smile intimates that he can be trusted to adapt himself smoothly to any change in the prevailing wind.[44]

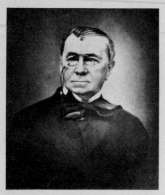

Emile de Girardin, c.1860.

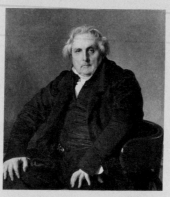

Portrait of M. Bertin by Ingres, 1832.
Musée du Louvre.

The old-clothes man = Persigny (1808–1872)

We believe this figure can be identified with Louis Napoleon's close associate Persigny, who was nicknamed 'the hawker (*commis-voyageur*) of the *Idées napoléoniennes*', a volume published by the Prince in 1839. Victor Fialin, comte and eventually duc de Persigny, began his career as a hussar and, since it was under the Restoration, a royalist. At the outbreak of revolution in 1830 he discovered himself to be a republican, and was discharged from the service by the July Monarchy. When Louis Napoleon's intentions began to take shape he perceived in time where his interests lay. He was one of the chief agents of the Coup d'Etat of 1851, and the grateful Napoleon made him Minister of the Interior.

He is seen here offering his goods; the hussar's jacket, on the ground beside him, recalls his former service. Courbet says of him: 'He presides over all this . . . displaying his frippery to all these people, each of whom expresses great interest in his own way'. We will now try to identify the rag-and-bone man's audience.

Victor Fialin de Persigny, c.1850 (detail).

The strong man = Turkey

We suggest that the strong man with his glittering crescent-shaped ear-rings represents Turkey, an identification helped by the idion *fort comme un Turc*. In 1855 France and Britain were fighting the Crimean War as Turkey's allies against Russia: hence Persigny offering his wares, and the interest the strong man displays in them.

The clown (rouge-queue) = China

In 1849 France acquired a concession at Shanghai, thus increasing her trade outlets in the Far East. Here again Persigny has goods to offer. The clown's get-up includes a long pigtail. This figure should be compared with that of the Asiatic in Pisanello's fresco in Sant'Anastasia at Verona. Courbet may have seen a reproduction of that work, or the preparatory drawing for it, then attributed to Leonardo da Vinci, which the Louvre acquired in 1855 and which was recognized to be an Oriental study.

Pisanello, study for the Asiatic of Santa Anastasia of Verona, detail, Musée du Louvre.

The huntsman (chasseur, cacciatore) = the Italian Risorgimento, represented by Garibaldi (1807–1882)

This armed figure wears the red-striped scarf of Garibaldi's troops, and his rifle-butt is marked with a G. It seems plausible therefore to regard him as symbolizing the fight for Italian unity. France did much to assist the insurgents, and it is natural that he should be paying close attention to Napoleon's influential minister.

The features of this character are those of a previous painting by Courbet known as *Portrait of the huntsman Maréchal at Amancey* (a locality near Ornans).[45] Did Courbet use it because the subject bore a resemblance to Garibaldi? He probably never saw the latter; he may, however, have met Mazzini, the founder of Giovine Italia (Young Italy), who was in Paris in 1848 and often visited Switzerland. But Mazzini's features were more delicate and were not those of a military man.

The *Portrait of the huntsman Maréchal* was shown under that name at Courbet's one-man exhibition in 1967, but was there in fact ever such a person? Conceivably Courbet was punning on Garibaldi's rank 'marshal of *chasseurs*.' In French *Chasseur* means 'Huntsman' but also is a military rank.

Garibaldi in 1849, lithograph by Dantzer

The man in the cap = Kossuth (1802–1894), representing insurgent Hungary

Courbet does not mention this figure in his letter to Champfleury. X-ray examination shows that, to make room for him, the man with the scythe was displaced somewhat to the right. The fur cap he is wearing is not of a Western type but is more reminiscent of Central Europe, and we suggest that the figure is a personification of Hungary. The French revolution of 1848 had a galvanic effect on the national aspirations of the peoples dominated by Austria and Russia, including the Hungarian's who, under Kossuth's leadership, fought desperately for their independence. They were defeated, but in 1852 Kossuth and Mazzini (both in exile in London) concluded a pact with which some Polish patriots were later associated (cf. next paragraph). The solidarity of the national freedom fighters, all of whom placed their hopes in French assistance, is expressed by the compact group of three figures and their attentiveness to Persigny's offerings.

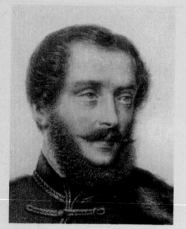
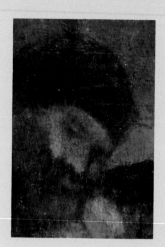

Lajos Kossuth, c.1850 (detail).

The scytheman = Kościuszko (1746–1817), representing insurgent Poland

The term 'scytheman' (*kosynier*) is celebrated in Polish history on account of the peasants mobilized by Kościuszko who, armed only with scythes, defeated a Russian army at Raclawice in 1794. Patriots armed in this way also played a part in the Polish freedom movement in 1848; their heroism impressed the whole of Europe, and the emblem of the scythe would have

Thaddeus Kosciuszko after the portrait by Grassi, c. 1794

Polish patriots enrolled among the Faucheurs.

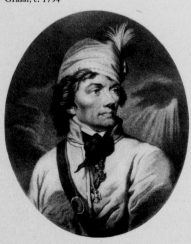

been perfectly well understood in 1855. (Polish commanders and men had also aided the insurgent Hungarians and Italians.)

The features of Courbet's scytheman are those of Kościuszko, who died in 1817 but was still the symbol of Polish patriotism: he may be recognized by his clean-shaven face and pointed nose and the delicate shape of his chin. Here again, no doubt Courbet made use of a sculpture by David d'Angers.[46]

The labourer = Russian socialism, represented by Herzen (1812–1870)

The man with folded arms, turning away from his neighbours, is wearing a surcoat with emerald green braid at the neck and wrists. Neither this garment, appropriate to a colder climate, nor his broad flat cap are typical of a French workman of the period. If, however, we compare the portrait with a photograph of the Russian revolutionary Alexander Herzen we may recognize his deep-set eyes, flattish nose and goatee beard. Courbet was well acquainted with Herzen, who worked with Proudhon in Paris until 1851, when he was exiled from France by order of the Prince-President.

The Russian turns away from the others. For patriotic reasons he cannot sympathize with the other nationalists, though their aspirations are similar to his, and he rejects the blandishments of a country at war with his own. A Russian revolutionary and exile is still a Russian; and Herzen's relations with Proudhon cooled after the Crimean War broke out in 1854.

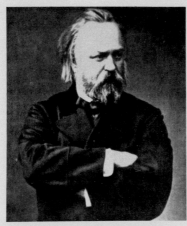 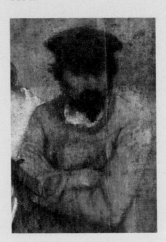

Alexandre Hertzen in 1865, photograph by Levitski.

The 'labourer's wife' is difficult to identify. She appears to be closely associated with the man in the cap (Herzen), yet they are almost back to back. We suggest that she may possibly represent Greece, which tried to ally itself with Russia in 1854 but was prevented by the French occupation of the Piraeus.

As to the wretched woman personifying Ireland, we have nothing to add to Courbet's identification.

One figure that we might have expected to see is Karl Marx or some other incarnation of German socialism. His absence is not really surprising, however, as he was anathema to Proudhon's friends including Courbet: he stigmatized the French sociologist as a 'petit bourgeois', and retorted to his *Philosophy of Poverty* (1847) with a work on *The Poverty of Philosophy*. Mid-century French socialism was opposed to the Marxist cult of violent revolution, atheism and the subordination of the individual to the state.[7]

The man with the dogs = Napoleon III (1808–1873)

We now come to the mysterious figure seated in the left foreground who, it has been thought, was an addition to the original plan. He is not mentioned in Courbet's letter to Champfleury, and the X ray shows that he was painted in over the Republican. He must in that case have been added very soon, however, as Courbet wrote to Bruyas of 'thirty-three characters, all life-size' well before he left Ornans to finish the painting in Paris (Borel, p.61). It is in fact hard to imagine that he was not intended from the beginning: firstly because he is the key to the composition of this part of the picture, and secondly because he is no less important as a figure in the 'allegory'. In Courbet's first letter to Bruyas he mentions thirty figures as opposed to thirty-three, the reason being that there were three whom he only thought of later: these are the man with the round cap (Kossuth in our identification) occupying what was originally the scytheman's place, and the two children – the blond

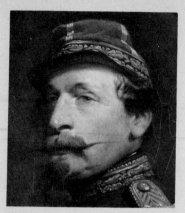

Napoleon III in 1863 by Yvon, Musée
National de Compiègne.

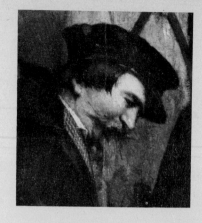

peasant boy and the dark child drawing on the floor. If Courbet refrains from mentioning the man with the dogs it is because he does not know how to refer to him, at all events in writing.

The critics from the outset used the term *braconnier*, and this may have been quietly suggested to them by Courbet. In his time this word had three possible meanings: its original one of a man who trains hunting dogs (cf. p.174 above), the usual meaning 'poacher', and the slang sense of a 'gay dog' or fast liver. All these descriptions were appropriate to Napoleon III, who was well known as a libertine and a dog-lover and who, in Courbet's opinion, had 'bagged' the Republic for his own private ends. The *braconnier's* face may well have been drawn from Napoleon's: we recognize the quizzical and foxy expression, the rounded cheekbones, the twirled moustache and *impériale*, the hair falling over the temple. All this is plain to see, but at the time when the picture was shown nobody could have said so without incurring disagreeable consequences.

It must be remembered that all matters relating to the Emperor or his family were the object of strict police surveillance and a more rigorous censorship than France has known at any other period. Many a journalist found himself in prison for expressions of opinion that smacked of *lèse-majesté*, even though they were not seditious or connected with party politics. Cartoonists who had been free to mock at Louis Napoleon under the Provisional Government or the Presidency were now constrained to silence. True, Daumier's *Ratapoil*, the personification of a Bonapartist agent, developed over the years into a figure uncommonly like the Emperor himself, and there was a clandestine circulation of lampoons, generally printed in Brussels. But cartoonists were forbidden to depict Imperial personages directly, and had to make do with symbols – in the case

of Napoleon himself, the jack-boot. Thus we find booted clowns and Harlequins, asses and foxes and, in the last days of the Empire, he is sometimes represented by a boot and nothing else.[47] Hence, without any doubt, the magnificent pair of thigh-boots worn by the elegant *braconnier*.

We should also take note of the 'romantic paraphernalia' at his feet, consisting of a plumed hat, a mask, a guitar, and a dagger resting on a scrap of red and blue cloth. These objects have been associated with the plays of Victor Hugo or the popular melodramas of the Boulevard du Crime. But the plumed hat is also that of Garibaldi and his legions, while the mask is redolent of secret societies. All in all, the romantic bric-à-brac is well suited to remind the Imperial despot of his youthful association with the Carbonari and the cause of republicanism.

We may notice that the *braconnier* looks directly across to the Irishwoman, the symbol of abject poverty. Is this not a delicate hint to the ex-revolutionary to call to mind the most famous of the works he published during his imprisonment at Ham, *De l'extinction du paupérisme* (1844)? Throughout his years in power, whether as President or as Emperor, democrats never tired of reminding him ironically of this 'socialist' work which had enabled him to secure the votes of many left-wingers.

Quillenbois, in his caricature of Courbet's work, took no chances over too close an identification, but concealed the *braconnier's* features with a thick smudgy beard, he also showed him kicking over a chamber-pot. This may have been a refined allusion to the Coup d'Etat of 1851, bearing witness to this artist's anti-republican or sycophantic views.

The 'art-lovers'

Passing over Courbet's flattering representation of himself, let us take a further look at the other side of the picture. We need not revert to the 'friends' who are so fully identified, but there are still one or two gaps to be filled in.

By a fine euphemism, Courbet describes the pair of 'art-lovers' as 'a

society woman with her husband'. It has been suggested that they are M. and Mme Sabatier, Courbet's hosts at the château de la Tour de Farges near Lunel. Mme Sabatier (1805–1870) was the singer Caroline Ungher; she and her husband were good friends to Courbet, and had the merit in his eyes of being socialists, art lovers and

very well off. However, we cannot accept this identification. The elegant woman in *The studio* bears no resemblance to Ricard's *Portrait of Caroline Ungher-Sabatier*,[48] and what can be seen of the husband does not look like François Sabatier in Courbet's portrait drawing of him.[49] We believe the lady to be another Mme Sabatier, whose

celebrity was of a different kind: she who was known as *la Présidente* and whom Edmond de Goncourt described as 'this fine woman in the antique style, a trifle vulgar; she reminds me of a *vivandière* for wild beasts' (*Journal*, 16 April 1864). It is surprising that this well-known model, who provided inspiration to Théophile Gautier, Flaubert, Meissonier, Clésinger and so many others, should not have been recognized sooner; but there seems to us to be no doubt of her identity, if we compare the portrait here with Ricard's *Lady with a dog*[50] or the bust of her by Clésinger.[51]

Aglaé Joséphine Savatier was born in 1822, the daughter of a sempstress and of the vicomte d'Abancourt. A celebrated beauty, she adopted the more euphonious name of Apollonie Sabatier and, at her salon in the rue Frochot, entertained all the principal Parisian intellectuals and artists. Clésinger immortalized her in his statue of a *Woman bitten by a snake*, exhibited at the 1847 Salon.[51] Her protector was Alfred Mosselman, a rich Belgian aristocrat with a legal wife of his own; his sister, the comtesse Le Hon, was married to the Belgian ambassador but lived in a more or less conjugal state with the comte de Morny. Mosselman's association with Mme Sabatier was equally recognized: Baudelaire, writing to her in 1857, does not forget to send 'kind regards to M. Mosselman'.[52] It is he whom we see in Courbet's picture; the half-hiding of his face would not deceive anybody. There is in the Petit Palais a *Portrait of Alfred Mosselman* by Alfred De Dreux, showing him with his wife and son; the angle of his head, the size of his ears and the cut of his side-whiskers are the same. He was actually fair and not dark, but to avoid embarrassment Courbet was obliged to dissemble to some extent.

The cartoonist Quillenbois knew what he was doing when he put a cigarette between the lips of this 'society woman'. So did the critic Silvestre, who placed after this phrase a large exclamation mark.

By an ironical touch, Baudelaire is seated directly behind the lady whom he admired in secret, and with whom he had a fleeting love affair in 1857. For three years before that he had been sending her anonymous verses; she knew who they were from of course, and used to show them to all and sundry. A poem entitled *À celle qui est trop gaie* contains the lines:

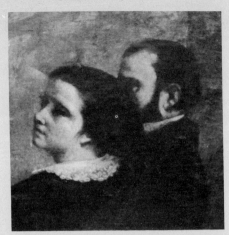

Alfred Mosselman by Dedreux (detail), Musée du Petit Palais

Apollonie Sabatier in 1850 by Ricard, private coll.

Apollonie Sabatier in 1847 by Clésinger, Musée du Louvre.

Les retentissantes couleurs
Dont tu parsèmes tes toilettes
Jettent dans l'âme des poêtes
L'image d'un ballet de fleurs.

The 'dazzling colours' and the 'ballet of flowers' are well illustrated by Mme Sabatier's attire in Courbet's picture.

There is no record of Courbet having been one of those who frequented *la Présidente*, and he is not mentioned in accounts of her life.[53] None of his works appear in the sale catalogues of the Mosselman and Sabatier collections. Why, then, is she given a place of honour in *The studio*? Possibly the painter was angling for an

The sleeping reader, drawing by Courbet, Musée du Louvre.

The child from *The corn sifters*, 1854, Musée de Nantes. Is he perhaps the son of Courbet and Emile-Désiré Binet?

invitation to one of her famous dinners; possibly it was a 'dig' at someone, or, on the contrary, intended as a compliment.

The plaster medallion deserves a moment's attention. It shows the profile of a woman who appears in many of Courbet's paintings and drawings,[54] and whom we believe to be Virginie Binet, his well-loved and fugitive mistress, of whom he speaks in the letter to Champfleury. Thus, by a touching thought, he has followed the fashion of former times, when the departed were included in group portraits as though they were still alive. Virginie's son was born in 1847; his father used to teach him to paint, and in an outburst of paternal pride he once declared: 'There is nothing more I can show him.'[55] We suggest that the son is to be identified with the small boy, not mentioned in the letter, who sprawls on the ground at Mme Sabatier's feet and is drawing the picture of a man. *The studio*, let us not forget, is a résumé of seven years of Courbet's 'artistic and moral life'.

'Devinera qui pourra'

How is it that for the past hundred and twenty years no one has given a true interpretation of *The studio*, and why do Courbet's contemporaries give no clue to its meaning?

The second question is easier to answer than the first. Those who saw the picture undoubtedly talked about it, but words are ephemeral and there were good reasons why they did not put their thoughts into writing.

As we have pointed out, under the Second Empire the press was muzzled. 'If a journalist wants to live in peace, without enemies and without making anyone jealous, he must be careful to say nothing

of the dead and still less of the living; as Figaro would way, he must steer clear of public and private life, palaces and law-courts, the poor and the rich, the stupid and the upstart . . .'[56]

No one would have ventured to suggest in black and white that *The studio* conveyed any special meaning. Another reason for contemporaries' silence is that the picture was not often seen in Courbet's lifetime. He did not re-exhibit it, like the *Burial*, at his private show in 1867. It was seen at Bordeaux in 1865 and at Vienna in 1873, but much time had passed by then and the 'subject' was of less interest.

Castagnary, however, wrote in the

preface to the Courbet sale of 1881: 'The painter's studio contains a whole topical aspect (*tout un côté d'actualité*) which escapes us because almost all those concerned (*les assistants*) have died.' Is not this discreet reference sufficient to put us on the track?

There is, moreover, a still more significant document from Courbet's own pen, which has not been previously related to *The studio*. At the end of 1854 or the beginning of 1855 Courbet wrote to ask his friend Français to persuade the World Exhibition jury to extend the time-limit for the submission of his pictures, on the ground that he had been incapacitated for

two months by jaundice. He added: 'Maybe you'd like to know the subject of my painting – but it would take so long to explain that I'd rather you guess when you see it. It's a history of my studio, everything that goes on there morally and physically. All pretty mysterious – good luck to anyone who can make it out! (*Devinera qui pourra*!).'[57]

There is yet a further possible reason for the conspiracy of silence as to the picture's true meaning, viz. that it had an esoteric connection with Freemasonry. This we shall now examine.

The 'atelier' and the 'loge'

Despite the kind co-operation of the librarians and archivists of the Bibliothèque Nationale, the Grand Lodge of France and the Grand Orient, we have not been able to establish that Courbet was in fact a Freemason. No date or place of initiation have been discovered. On the other hand many of his attitudes, writings and paintings suggest that he was a Mason, and there is oral evidence from the grandson of a close friend of the painter's. This informant tells us that his family always believed that Courbet was a Mason; his grandfather was not one, however, and consequently no formal proof can be adduced.

Roger Bonniot[58] cites an obscure poem by Courbet, *Ode à la lune*, which he believes can only be interpreted as a piece of Masonic symbolism, the moon being 'Queen of the Night'. In the self-portrait of 1845 entitled *The sculptor*[59] Courbet is seen holding the mallet and chisel of an apprentice Mason, but we do not regard this as conclusive. The choice of tools may be fortuitous, or the painter may have drawn inspiration from a Masonic engraving without understanding it, or he may have deliberately used Masonic imagery. As we know, the Romantic generation was much attracted, in literature at all events, by all forms of occultism,[60] and secret societies may well have exerted a similar influence on the plastic arts.

However, *The studio* poses the question in a more specific form, since, as we shall see, it embodies an elaborate symbolism which could only be fully understood by an adept of Freemasonry. It is impossible to imagine that a Mason would have imparted this amount of secret knowledge to Courbet for the purpose of an autobiographical work, and we are therefore forced to conclude that Courbet was himself initiated.

There is a parallel in the case of Balzac: no written evidence of his initiation is known to exist, yet there is a portrait of him in the appropriate garb, and his tale *Séraphita* could only have been written by one thoroughly acquainted with Masonic lore.

A full account of the Masonic significance of *The studio* is being published by Roger Cotte.[61] We shall confine ourselves here to indicating some of the main items of symbolism ,which show that the picture was not merely a satire on current events but contained a moral and intellectual message of some importance.

The first point to note is that in the vocabulary of French Freemasonry *atelier* (studio) is used as a synonym of *loge* (lodge). The studio in Courbet's picture does not agree with the descriptions of his actual studio that we possess, but it may be understood as representing a lodge by virtue of its tripartite composition. Thus the wall facing the spectator would be the eastern wall (denoted by a lamp which Courbet afterwards painted out); on the right we have the southern wall, with a window admitting light, and on the left the northern wall, which is generally in darkness in a lodge and which corresponds to the darker section of Courbet's allegory.

Part of the essential furnishing of a lodge consists of the two Pillars of the Temple, known as Jachin (J) and Boaz (B) (cf. II Chronicles 3:17), which are symbolically regarded as male and female respectively. The former is represented here by the lay figure, whose ruddy hue stands for the Sun, virility and resurrection. The skull at his feet signifies putting off the 'old man' and renouncing worldly things. The second column is personified by the nude model, who as a female represents the Moon shining with reflected light. The child standing between the two is the alchemic offspring of the King (J) and the Queen (B); he symbolizes in the first instance the Freemason, the 'Widow's son' (cf. I Kings, 7:14), but also no doubt conveys deeper meanings which are imperfectly understood at the present day. Mozart and his librettists seem to regard him as an androgynous symbol. Boucher depicted children in the engraving which the Ateliers de la Grande Loge de France use to this day for their diploma.

The supple, lascivious cat at the painter's feet is an essential complement to the allegorical group of the Sun, Moon and Child, over which a lamp was originally depicted. The 'beast', as an ancient symbol of carnal appetite, is traditionally opposed to the lamp, which signifies transcendance. Roger Cotte has drawn our attention to a striking example of this symbolism in Jan van Eyck's *Arnolfini and his wife* (London, National Gallery). The dog in the foreground contrasts with the chandelier overhead: man, neither angel nor beast, stands between the two opposites.

We may notice that in *The studio* Courbet once more indulges his sense of fun: as in other paintings, he gives a human or animal shape to rock formations, so in this work he has given a curious shape to the model's clothes heaped on the floor; they can be seen as a crouching animal of some odd species, with its head between its paws, teasing the cat and thus focusing attention on it.

In the original state of the picture there were two counterpoints to the male and female columns. The first of these consisted of the lamp and medallion on the rear wall, the latter with its circular form and woman's profile symbolizing the moon. This effect disappeared with the deletion of the lamp, but there remains the symbolism

of the lovers in the window-embrasure. Here the woman is fully illuminated, while the man is only a dark mass. The significance may be understood in the light of the following quotations. 'Love, the force which brings hearts together, is the firm foundation of the Masonic edifice, the materials of which are living beings joined in profound affection, that is, of course, in brotherly love' (*Dictionnaire de la Maçonnerie*). 'Brotherly love is the vital principle of Masonry, generating order, harmony and stability' (Oswald Wirth). The couple in Courbet's picture seem to be united by profound tenderness rather than passion; the man, dimly seen, is not individualized, but the woman is a portrait – of whom but Courbet's sister Juliette? We can recognize her angular features and pointed chin, and her coiffure is the same as in the *Portrait* painted by her brother twenty years later at La Tour de Peilz:[62] the hair parted in the middle and combed back smoothly into a small chignon with a few stray locks escaping. Courbet has poetically placed the couple symbolizing brotherly love in front of the main source of light, so that the whole studio is, so to speak, illuminated through them.

Courbet described his picture as summing up a period of seven years. This may signify 1847–1854, as he began to paint it in the latter year; but it seems more likely that the period runs from the revolutionary year 1848 to the Exhibition of 1855, at which Courbet intended the work to be shown. In any case, the number 7 is regarded as lucky in Freemasonry (which is one reason why a seven-year term was adopted for the French Presidency in 1875); so we have here, perhaps, a further instance of Masonic symbolism.

Writing to Bruyas in November 1854 about *The studio*, Courbet used the phrase 'I shall call it the "First Series".'[63] This mysterious expression may refer to the *Loges de première série* or *Loges bleues* which embody the initial series of the three symbolic degrees of Apprentices, Fellows of Craft (*Compagnons*) and Masters. In the letter to Champfleury the word 'series' is replaced by 'part' – either inadvertently or because the Masonic term would have meant nothing to someone who was not initiated.

While, as we have argued, the picture presents the appearance of a lodge, it does not depict a formal meeting (*Tenue*). Most of the characters on the left-hand side, as we have identified them, were convinced Masons, but this does not hold good for those on the right, at the time of the picture anyway. An exception is Proudhon, who was initiated at Besançon in 1847 and made the occasion memorable by raising many profound issues. Bruyas is represented, as in *The meeting*,[29] with a pair of white gloves in his hand; these are part of the formal garb at Masonic meetings. When Courbet calls him *commandeur* (cf. p.14 above)[64] this probably alludes to a high Masonic dignity. As to Champfleury, he was initiated only in 1865.

Another noteworthy point concerns the composition of the picture. In accordance with Courbet's classical training, almost all his compositions are based on two overlapping squares; but *The studio* divides naturally into ten equilateral triangles. The triangle, as is well known, is considered a perfect figure by Freemasons, and we believe that this too is part of Courbet's design.

When and why did he paint out the lamp, originally affixed to the rear wall, which is mentioned in the letter to Champfleury and also appears in Quillenbois's cartoon? Was the change meant to signify that his 'light' was extinguished? Courbet's life was a long series of rifts and quarrels due to his clumsy and erratic behaviour. Conceivably he was expelled from the Craft at some stage, for instance after his conviction in 1874, and thought it proper to erase the symbol of his past association. Although the Masonic authorities after-

Juliette Courbet in 1874, painted by her brother (detail), Sao Paulo Museum.

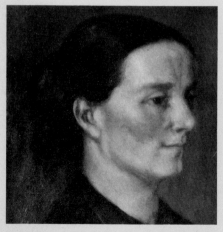

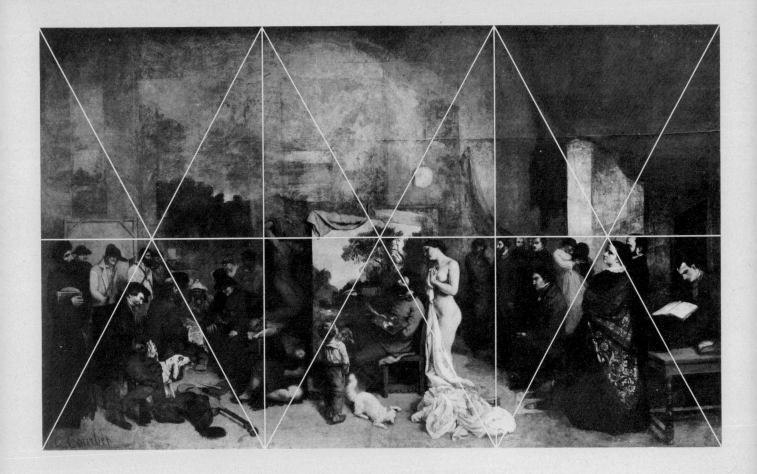

wards relented, they initially took a severe view of any involvement with the Commune: a circular dated 1 August 1871, issued by the Grand Master Babaud-Laribière, contained the words: 'There is no possible solidarity between its doctrines [those of Freemasonry] and those of the Commune; and if some men, unworthy of the name of Masons, have tried to transform our peaceful banner into a standard of civil war, the Grand Orient disowns them as unfaithful to their most sacred duties.'[65]

We may see from this account of the picture's Masonic symbolism that Courbet, whom many have regarded as an insensitive and unspiritual being, was more open to intellectual and moral promptings than is usually thought, and that his aspirations far transcended prosaic reality.

The meaning and source of Courbet's allegory

Was Courbet being pessimistic or cynical when he assembled the 'betrayers of the Republic' on the left-hand side of his picture, as if to show that the best way of achieving dictatorial power is to use democracy as a stalking-horse? Is his work a testament of hope or disillusionment, an Inferno or a Paradiso, a farce or a tragedy? Is its message one of total forgiveness or total scepticism? As Courbet wrote to Champfleury: 'People will have their work cut out to judge the picture . . . For, of course, there are people who wake up at night shouting and screaming: I want to judge, I must judge!'

Another question is who inspired the work, if it was not Courbet's own idea. The *tableau vivant* was a favourite society pastime of the age, and several possibilities come to mind. If we accept the general view of Courbet as a man devoid of culture or intellectual curiosity, it is unlikely that he knew enough about history or politics to produce an elaborate scheme of this kind.

Champfleury may be thought of, but if he were the real author he would probably not have written his rather fulsome critique of *The studio*, ending with the remark that it 'will no doubt gain by being viewed more calmly at a later date'.[66] This suggests that he intended to say more in due course, but he did not. When he next spoke of the work, in 1881, he merely said that Courbet had 'embarked on the treacherous slope (*pente fâcheuse*) of symbolization'.[67] It seems clear that after 1871 those who had been closely associated with the painter and still had kind words for him in his political misfortune were chary of reviving memories which might appear ludicrous or discreditable.

Another possibility is Proudhon, who is thought to have inspired Courbet's first political satire on a large scale, the *Departure of the fire-brigade*.[17] His writings, however, do not suggest that he had much sense of humour. Bruyas is ruled out by the tone of the painter's letters to him. Perhaps it was Courbet's friends at Ornans who brightened up their provincial evenings by inventing a picture which would also be a page of history.

The studio and the censor

Beyond the fact that Courbet's picture was not accepted for the World Exhibition, we know nothing of the official attitude towards it. There is also a dearth of comment on its real significance: critics, as we have seen, were afraid of opening their mouths imprudently, and they may also have suspected Courbet as being an *agent provocateur*. Here was a man who spoke and acted as he thought fit, who criticized the régime at every turn, and who nevertheless received permission to build a special pavilion in which his rejected work was exhibited. Clearly he was either a man of strong character or enjoyed powerful protection, or both.

Courbet had in fact an influential patron at this time in the shape of Morny, who wrote on his police file: 'Noisy but not dangerous'. The Emperor himself seems to have regarded him with good-humoured amusement. There was indeed no reason why he should be offended by the portrayal of himself in *The studio*: it showed him as the master of Europe and the champion of nationalities, a role on which he prided himself with good reason. Besides, a modicum of opposition is the spice of power, and Napoleon III had more sense of humour than many other French monarchs. One of his own jokes went as follows: 'After all, how many Bonapartists are there at Court? My wife is a legitimist, my brother an Orleanist, and I'm a socialist. Oh, yes, there is one, but he's an idiot!'

Doubtless the Emperor was less shocked by the picture than those about him, such as Nieuwerkerke for example. Apropos of the latter, we should recall an incident which may be connected with the origin of *The studio* and which is described in a well-known letter from Courbet to Bruyas.[68] (The letter was believed to date from 1854 until Georges Grimmer gave good reasons for placing it in 1853.)[69] The painters Chenavard and Français arranged a lunch at which they and Courbet met Nieuwerkerke. The latter urged Courbet to stop 'being difficult' (*faire sa mauvaise tête*) – perhaps he had *The fire-brigade*[17] in mind and to submit a sketch for a big picture which would be the chief attraction at the forthcoming World Exhibition; the Government would be duly grateful. Courbet's reaction was what one might expect. It is not impossible that Nieuwerkerke's offer provoked him into painting *The studio*, and this might be a further reason for the Emperor's indulgence: Napoleon III was often irritated by his Superintendent of Fine Arts, who incidentally enjoyed the favours of his cousin, Princess Mathilde Bonaparte.

A well-chosen title

Courbet writes: 'The scene is set in my Paris studio.' From 1849 onwards this was in the rue Hautefeuille, where the printer and bookseller Panckoucke had converted a Premonstratensian college into studios. Courbet's, on the first floor, was alongside the chapel which had been turned into a café (the Rotonde). This was to be his last studio in Paris. It was here that, when he was prosecuted after the Commune, his pictures and other property were placed under seal and then confiscated, to be sold at auction by the Administration of Public Property. This part of the rue Hautefeuille disappeared when the boulevard Saint-Germain was constructed.

Schanne, in his memoirs,[70] describes the layout of the studio and its sketchy furniture, but none of the items can be identified in Courbet's picture except the hammock. Courbet, in fact, gives an abstract representation of the scene: he was not concerned, as so many artists have been over the centuries, to provide an exact record of his place and manner of work. In the same way, his picture of himself is distinctly artificial. He is not busily at work, but seems to be adding a casual touch to a finished canvas. He is quite elegantly dressed, whereas in real life all his visitors noted the sloppiness of his attire. Among his many self-portraits, the only other one that shows him at work is a drawing of 1848, *The artist at his easel*, in which he is wearing slovenly indoor clothes.[71]

Jeannine Baticle has made a study of the many variations on the theme of 'The painter's studio',[72] from which we may see that Courbet's version has no real historical precedent. Its symbolism and references to a non-artistic world place it in a different class from the customary depiction of the artist at work with the instruments of his craft around him; on the other hand, its sincerity and topicality remove it from the realm of pure fiction. J. Lindsay[73] suggests a reminiscence of Ingres's *Apotheosis of Homer*,[74] and maintains that Courbet is out to 'smash the concept of an artificial de-odorized structure of culture' and to 'substitute the real world and the artist in his living connection with that world'. Certainly there is no atmosphere of 'deification', no self-conscious estrangement of the artist from lesser mortals. The spectator is invited to take part in the waking dream: he might, one feels, quite easily step into the picture and take up a position among the life-size figures by whom it is peopled.

Not only was Courbet's picture *sui generis* in its time, but it was not at once followed by any works of a similar character. Fantin-Latour painted *Homage to Delacroix* (1864),[75] in which Baudelaire and Champfleury are seen sitting side by side, and *The Batignolles studio* (1870),[75] which shows Manet at work with his friends looking on. But the atmosphere of these works is quite different, as all the figures in them are united by a common way of thinking and a common aesthetic doctrine. Those in Courbet's *Studio*, on the other hand, are united by no visible bond – in rank, fortune, destiny and mental climate, they are all as isolated as they can possibly be.

There is, however, a work dating from some years earlier which reflects a similar intention, viz. Couture's *Decadence of the Romans*, exhibited at the Salon of 1847. In this huge painting the artist, who depicts himself on the extreme left of the canvas, uses the pretext of an historical work to denounce contemporary society. The motto is taken from Juvenal (VI, 292–3): 'Lust, more deadly than any foe, has laid her hand upon us, and avenges a conquered world.' Couture insisted that his work had no political intent,[76] but contemporary critics were not deceived; they also noted that the artist, in the true spirit of Realism, was concerned to bring down to earth the cold abstractions of neo-Classicism. As Claude Vignon observed with approval, these were not conventional Romans but represented 'living Antiquity'.[77] Eugène Loudon confirmed this in another way by exclaiming that Couture 'shared the inmost feelings of the revolutionary mob', and by stigmatizing as 'socialists' the two philosophers on the right-hand side of the picture, who hold themselves apart and condemn the orgiastic scene.[78]

The *Studio* marks a turning-point: Courbet, for his part, scorns concealment, at any rate in so far as he overtly depicts people of his own time. Whether he intended to be censorious is another matter. If he is satirical, it is without bitterness; he appears rather to be recording a state of fact than taking up a position. He leaves the spectator to form his own opinion, and seems comfortably aloof from polemics, as though he were saying: 'Such is the way of the world.'

We can see in this work how far Courbet had come since *Funeral at Ornans*, in which he expressed the aspirations of the 'men of 1848' by depicting a whole village under the leadership of its mayor and parish priest, in an '*union sacrée*' of social classes and religious and political beliefs. Time has passed, and the painter has matured. The work is transposed on to a wider stage: the mayor has become a sovereign, the village now comprises a whole society. With cheerful mockery Courbet indicates that he has outgrown his illusions, that the scales have fallen from his eyes and that he has learnt the lesson of history.

The description 'real allegory' is indeed subtly chosen and, in its ambiguity, looks forward to expressions of present-day art that Courbet cannot have intended to anticipate. In the study, already referred to,[72] of modern works of the *Studio* type, Pierre Georgel has drawn attention to the mingling of abstraction and *trompe-l'œil* and to the 'debunking' approach of artists whose design is to create a kind of 'sarcastic anti-epic'. This, as we have seen, was not Courbet's object, but there is nevertheless a clear affinity of style between his work and theirs.

Iconographic sources

To what category of painting, then, does *The studio* belong? Its title declares it to be an 'allegory', and it is also clearly a work of the 'homage' type – but a homage to the painter's self, which is unusual.

Many seventeenth-century prints depict a monarch or a great lord, a scholar or an artist, as the central figure of a composition including groups of figures, historical or otherwise, representing his court, his clients and admirers, his emblems and attributes. To illustrate the analogy between Courbet's work and these, we reproduce Lepautre's *Hommage à Louis XIV*. Despite many points of resemblance we do not suggest for a moment that it is a unique prototype: dozens of others might be cited, and doubtless none of them would correspond exactly to Courbet's work. For the most part these allegories were designed as frontispieces to books or dissertations.

Courbet may also have been inspired by an engraving which appeared in the *Magasin pittoresque* in November 1849 and which, with allegorical intent, depicted the studios of Clésinger and Roqueplan. Madame Sabatier, 'la Présidente', is there seen standing behind the painter in the same attitude as the model in Courbet's picture.

We mentioned earlier two figures – the Chinaman and the journalist – who derive respectively from Pisanello and Ingres. These, however, are mere formal borrowings intended to provide an association of ideas. The lay figure seems to be a combination of two works by Ribera: a *Descent from the Cross*,[79] which Courbet may have seen at the Aguado sale in 1843, and an engraved *Martyrdom of St. Bartholomew*. Linda Nochlin[80] compares the Irishwoman with two similar figures in English works, George Watts's *Irish famine* (1849–1850)[81] and Walter Deverell's *Irish beggars* (1850).[82] It is unlikely that Courbet knew these pictures, but the images of destitution derive from the same source as his, namely the traditional *Paupertas* depicted by painters and sculptors since the Middle Ages: a woman in rags, slumped on the ground and suckling a baby.

Most of Courbet's portraits in *The studio* are based on previous ones of his own. He himself is depicted by a replica of the *Portrait of the artist in a striped collar*,[83] painted for Bruyas in 1854. In the book describing his own collection Bruyas quotes Silvestre on the subject of this painting: 'How exactly like Courbet it is! . . . Too noisy and laughing too much, laughing his head off, laughing at everything and nothing – great peals of laughter, even at religious processions.'[84] Perhaps these lines, recalling a joviality which the picture itself does not exhibit, came to be written because it reminded Silvestre of one of the painter's jokes.

Most of the likenesses on the right-hand side of Courbet's picture are taken straight from previous portraits: this is the case with Promayet,[85] Cuenot,[86] Buchon,[87] Champfleury[88] and Baudelaire.[89] For Bruyas he combined two portraits, that in *The meeting*[29] and a profile done at Montpellier in 1854.[90] Proudhon, who refused to pose, is copied from the lithograph by Charles Bazin.

The model standing behind the painter is based on a photograph. In a letter to Bruyas[91] Courbet asked for the return of a 'photograph of a nude woman' which he needed for his work. This is surmised to be a photograph by Vallou de Villeneuve,[92] although the figure in *The studio* differs considerably from it. Courbet also wrote that he would be painting the nudes (the woman and the lay figure) in Paris, where models were no doubt easier to come by than at Ornans.

Courbet told Bruyas[93] that he had made a preliminary sketch for the painting. According to Léger[94] this sketch was still at Ornans in 1870; we do not know what has since become of it. Estignard's book[95] contains a drawing, reproduced as an engraving without indication of origin, showing *The studio* in a partly completed state. Whether this was a preparatory study or a subsequent reminiscence, we have no means of telling.

'My master sees all', homage to Louis XIV, engraved by Lepautre.

Allegory on the studios of Clésinger and Roqueplan, published in Magasin Pittoresque, November 1849.

Images of poverty, The Irish Woman in The Studio; Pity by Danloux, 1800, Musée du Louvre; Hunger, folly, crime by Weitz, 1853, Musée Weitz. Brussels.

Engraving after the Martyrdom of
St Bartholomew by Ribera.

Descent from the cross by Ribera (detail),
Aguado sale, Paris 1843.

Self-portrait of Courbet 'in a striped
collar', 1854, Musée Fabre, Montpellier.

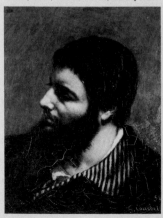

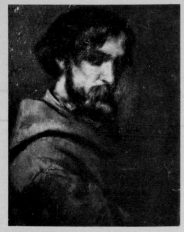

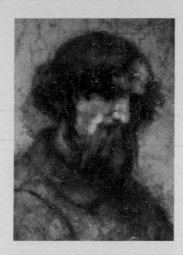

Alphonse Promayet in 1847(?) by Courbet,
Metropolitan Museum, New York.

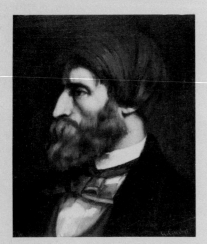

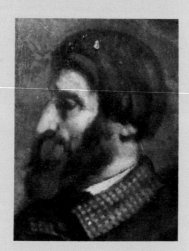

Alfred Bruyas in 1854 by Courbet,
Musée Fabre, Montpellier.

Photo by Vallou de Villeneuve,
acquired by the B.N. in 1853.

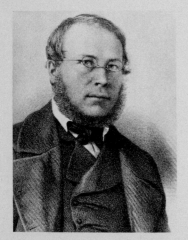

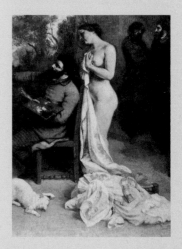

Proudhon, c.1848, lithograph by Ch. Bazin.

Urbain Cuenot by Courbet (detail),
Pennsylvania Academy of Fine Arts.

Max Buchon, *c*.1850 by Courbet (detail),
Algiers Museum.

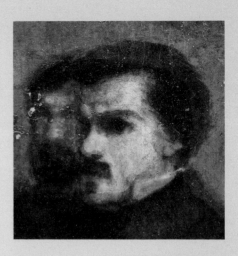

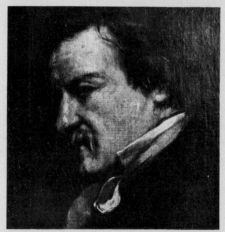

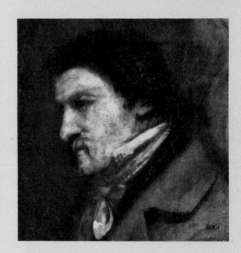

Champfleury in 1854 by Courbet (detail),
Musée du Louvre.

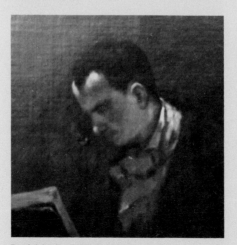

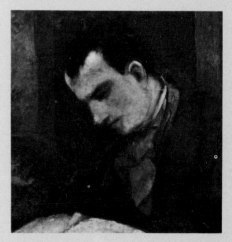

Baudelaire in 1847(?) by Courbet (detail),
Musée Fabre, Montpellier.

The place of 'The Studio' in Courbet's work

The studio was Courbet's third large-scale composition, after *Burial at Ornans*[5] and *Departure of the fire-brigade*.[27] His only two subsequent ones of this size were *Fighting stags*[96] and *The kill*.[97] *The studio* is the last of his major works that could be called 'a picture with a purpose'.

Coming in the middle of the painter's career, this picture has been described as a 'turning-point'. This, however, gives a wrong idea of the way Courbet's art developed: he had many different 'manners', and never finally discarded any of them. He would also produce simultaneously works of a different aesthetic character: *Young ladies of the village*[98] and *The fire-brigade*[27] both date from 1851, and *The comte de Choiseul's greyhounds*[99] and *Plaisir-Fontaine*[100] both from 1866. There are no phases in his art, no steady evolutionary curve, but a circling motion of renewal which is the secret of his eternal youthfulness. *The studio* is an exhibition of disconnected tendencies. When Delacroix objected that the landscape on the easel produced a contradictory impression, that it 'looked like a real sky in the middle of the painting',[101] he put his finger on a basic truth and laid bare the artist's intention. The landscape is not integrated into the composition, and neither is the nude model.

Similarly there is no moral link between the individuals in the painting, who vary in their attitudes and dress and seem to belong to different worlds. We are not thinking here of the charade on the left-hand side, but of the real individuals on the right. Promayet, in a dressing-gown, rubs shoulders with Bruyas, who is attired as though for a country walk. Each separate element of the work, in fact, is treated in its own style. The painter's achievement is to have conferred a unity on this heterogeneous world by the strict use of line and by skilful light-effects.

The magic of Courbet's pictures is indeed largely due to his use of light. In *The studio* the source of light is not explicit; there are areas of diffused clarity and others artificially dark. This is one of Courbet's 'un-realistic' devices: as in *The corn sifters*,[11] the broad patches of 'shadow' on the rear wall are in defiance of nature, lighter than the shadows cast by particular objects. If this does not appear strange, it is because *The studio* is a dream-world, the quintessence of all such worlds in Courbet's work. Its poetry, moreover, is static and not dynamic: what we see in dreams is not analogous to a film but to a series of photographs. Courbet, the mightiest painter of his generation, who boasts of being the heir

to Gros and Géricault, seems in one respect to mark a reversion to the past. Although he came to the fore at a moment when the dynamism re-created by his great forerunners was coming more and more into its own, his pictures give the impression that time and action are suspended. It is clear what a wide gulf separates him, in this respect, from Daumier or even Millet.

It is this timeless effect that gives Courbet's work its serenely peaceful character. This noisy, blustering painter is the prophet of silence. In contrast to Delacroix's trumpet-calls he offers a sense of beneficent languor and stability; the brightness and occasional discordance of his colours are outmatched by his perfect simplicity of compositional structure. Courbet never forgot the training he received, as a youth at Besançon, from Flajoulot, a follower (though not an eminent one) of David. However 'Realistic' his paintings may be, they are always sustained by the long, severe lines of neo-Classicism. This is most of all the case in *The studio*, that majestic work of self-advertisement which sums up Courbet's lyrical fervour and aspirations in 'the most amazing picture that could be imagined'.[102]

Reviews and criticisms

Hélène Adhémar[103] gives a very full account of journalistic criticism of *The studio* from the time it was first exhibited. All the recognized authorities were unfavourable, more on account of Courbet's 'Realism' than of his subject, although A. J. du Pays (in *L'Illustration*, 28 July 1855) accused him of 'metaphysics' and 'logomachy'. Critics complained of the 'leprous' vulgarity and hideous ignobility of his characters; they were like 'monsters escaped from the *Cour des Miracles*' (a

medieval haunt of beggars and vagabonds) and resembled nothing more than a heap of junk from an old-clothes barrow. How – du Pays exclaimed – could Courbet have brought himself to parade all these ragamuffins alongside himself and a friend of his(?) in huntsman's costume?

Others, however, recognized the qualities of the painting. Charles Perrier (in *L'Artiste*, 14 October) declared that in 'this last broadside of M. Courbet's' there were some bits of 'rich, solid painting', while

Paul Mantz was enthusiastic about the coloration: 'There is not a single painter in the Academy who could produce such a variety of tones' (*Revue française*, 1855, II, p.365).

Of all the laudatory comments, however, the most impressive were those of Delacroix; they were sincere, moreover, as he confided them to his *Journal*. 'August 3 . . . I went on to Courbet's exhibition, reduced to 50 centimes. I stayed there alone for nearly an hour, and found his rejected

picture to be a masterpiece; I could not tear myself away from it. It shows tremendous progress, yet it also helped me to admire his *Burial at Ornans* . . . The planes are well organized, there is a feeling of air, and some parts are extremely well painted: the model's hips, thighs and bust, and the woman in front in a shawl. The only trouble is that the picture on the easel gives a misleading effect (*fait amphibologie*): it looks like a real sky in the middle of the painting. They have rejected one of the most singular works of our time; but Courbet is not a fellow to be put off so easily.'

Later Nadar, in a jocular tone, complimented Courbet on having written a page of social history: 'Some twentieth-century Amand-Alexis Monteil will come to you for help in compiling a new "History of all sorts and conditions of Frenchmen"' (*Journal amusant*, 11 December 1858). Monteil (1789–1850), today a forgotten writer, was much in vogue at the time; his History had just been republished with a preface by Jules Janin.

It may seem surprising that Courbet's nineteenth-century biographers – Francis Wey,[104] Gros-Kost,[105] Jules Troubat[10] – say nothing whatever about *The studio*, though they expatiate on less important works. Proudhon[106], who as a rule was never backward in explaining Courbet's hidden intentions, even when little explanation was necessary, merely says that 'in his *Real allegory* he produced a personal picture of no higher value than his *Daughters of Lot*'.[107] It is a pity that for once the philosopher preferred not to enlarge on a theme that would have been of much interest.

Conditions for the preservation of the picture were unfortunate from the beginning. It remained rolled up from 1855 to 1881, except for brief periods when it was sent to distant exhibitions and underwent the hazards of transport. The haste with which it was painted was also prejudicial to its physical state. Courbet wrote to Bruyas: 'I have got exactly two days to paint each character.'[108] At present there are traces of accidents and unavoidable restoration, and the shaded parts of the picture have darkened.

Nevertheless it remains one of Courbet's masterpieces – a testament of supreme authority in which he shows his merit as a painter of portraits, landscapes, animals and still lives, and a master of organization. All the critics who discuss it are reminded of Courbet's acknowledged teachers – Rembrandt, Hals, Velázquez, Giorgione, Gros – yet there is no suggestion in it of pastiche. One cannot discern in any part of it the influence of one Old Master or another: the whole work is an original creation.

In due course *The studio* was placed in the Louvre alongside Gros's *Plague hospital at Jaffa* (1804) and *Eylau* (1808), Géricault's *Raft of the Medusa* (1819), and Delacroix's *Massacre of Chios* (1824), *Sardanapalus* (1827) and *The crusaders at Constantinople* (1840). A fitting companion to these works in its realism and romanticism, it showed that in 1855 Courbet's skill as an historical painter was no less brilliant than that of his predecessors.

Notes

1. Letters to Bruyas, preserved at the Bibliothèque Doucet, Institut d'art, Paris; published by Pierre Borel, Geneva, 1951.
2. L.a., belonging to the Musée du Louvre; given by M. and Mme Decloux, grandchildren of Victor Defossés in 1974; inventory no.89083.
3. *Histoire des juifs en France*, edited by Bernhard Blumenkranz, Toulouse, 1972, p.312.
4. Deposited at the Musée des Augustins de Toulouse, 1891.
5. Musée du Louvre – Exhibition *Courbet*, 1977, no.21.
6. Pierre Chevallier, *Histoire de la Franc-Maçonnerie française*, Paris, 1974, 2 vol.; II, p.334.
7. *Histoire générale du Socialisme*, under the direction of Jacques Droz, Paris, 1972, 2 vol.; I, p.401.
8. The painting was destroyed about 1900 out of respect for religion.
9. Private collection; picture painted in 1868, exhibited at the Salon de Gand the same year.
10. Jules Troubat, *Une amitié à la Arthez. Champfleury, Courbet, Max Buchon*, Paris, 1900; p.117.
11. Musée des Beaux-Arts de Nantes – Exhibition, *Courbet*, 1977, no.43; London, *Courbet*, 1978, no.42.
12. Budapest Museum.
13. Copenhagen, Ordrupgaardsamlingen.
14. Italy, private collection.
15. U.S.A., The Columbus Gallery of Fine Arts.
16. Previously at Dresden Gallery, destroyed during the Second World War.
17. Paris, Musée du Petit Palais – Exhibition, *Courbet*, 1977, no.27; London, *Courbet*, 1978, no.136.
18. *Lettres de Gustave Courbet à Alfred Bruyas*, published by Pierre Borel, Geneva, 1951, p.130.
19. Benedict Nicolson, *Courbet. The Studio of the painter*, London, 1973, p.31.
20. Jack Lindsay, *Gustave Courbet, his life and art*, 1973, p.129.
21. Glasgow, Burrell Collection (cf. cat. no.108).
22. Previously at the Musée des Beaux-Arts, Arras, destroyed.
23. Musées Royaux des Beaux-Arts, Brussels.
24. Borel (*op. cit.*), pp.51, 61.
25. U.S.A., private collection.
26. Musée de Lille – Exhibition, *Courbet*, 1977, no.18; London, *Courbet*, 1978, no.138.
27. Exhibition, *Courbet*, 1977, no.137; London, *Courbet*, 1978, no.152.
28. Montpellier, Musée Fabre, Exhibition, *Courbet*, 1977, no.33; London, *Courbet*, 1978, no.31.
29. Montpellier, Musée Fabre, Exhibition, *Courbet*, 1977, no.36; London, *Courbet*, 1978, no.34.
30. Borel (*op. cit.*), p.61.
31. Paris, Musée du Petit Palais, Exhibition, *Courbet*, 1977, no.83; London, *Courbet*, 1978, no.80.
32. 'Lettres inédites de Courbet' in *A.G.C.*, Bulletin no.4, 1948, p.22.
33. Jules Troubat (*op. cit.*), p.107.
34. Montpellier, Musée Fabre – Exhibition, *Courbet*, 1977, no.15; London, *Courbet*, 1978, no.15.
35. Baudelaire, *œuvres complètes*. Text established, presented and annotated by Claude Pichois, Paris, 1976, 2 vol.; II, pp.57–9.
36. Louis Aragan, *L'exemple de Courbet*, Paris, 1952, p.24.
37. *Album Baudelaire*, by Claude Pichois, Paris, 1974, p.135.

38. Besançon, Musée des Beaux-Arts – Exhibition, *Courbet*, 1977, no.42; London, *Courbet*, 1978, no.41.
39. Montpellier, Musée Fabre – Exhibition, *Courbet*, 1977, no.32; London, *Courbet*, 1978, no.30.
40. Charles Léger, *Courbet salon les caricatures et les images*, Paris, 1920.
41. *Mémoires sur Carnot par son fils*, Paris, 1863, II, pp.186–9.
42. Musée du Louvre, before 1838.
43. Musée du Louvre, 1832.
44. Roger Bellet, *Presse et journalisme sous le Second Empire*, Paris, 1967, p.132.
45. Private collection.
46. Statuette, location unknown, a version is preserved at the Bibliothèque Polonaise, Paris.
47. Caricature by Gill in *L'Eclipse*, 26 December 1869.
48. Montpellier, Musée Fabre.
49. Montpellier, Musée Fabre – Exhibition, *Courbet*, 1977, no.140; London, *Courbet*, 1978, no.132.
50. *Album Baudelaire* (*op. cit.*), fig.136.
51. Musée du Louvre.
52. *Album Baudelaire* (*op. cit.*), fig.216.
53. André Billy, *La Présidente et ses amis*, Paris, 1945.
54. *Les amants dans la campagne* (1845, Musée de Lyon and the Petit Palais – Exhibition, *Courbet*, 1977, nos.11, 12; London, *Courbet*, 1977, nos.11, 12); *Femme endormie près d'un ruisseau* (1845, Winterthur, Oskar Reinhart collection and Detroit Institute of Art); *La blonde endormie* (1849, private collection – Exhibition, *Courbet*, 1977, no.20; London, *Courbet*, 1977, no.20); *La liseuse endormie* (drawing, Louvre – 1849 – Exhibition, *Courbet*, 1977, no.138; London, *Courbet*, 1978, no.130).
55. Robert Fernier, 'Courbet avait un fils', in *A.G.C.*, Bulletin no.10, 1951, pp.1–7.
56. *Le Carillon Stéphanois*, 21 October 1856; cf. Roger Bellet (*op. cit.*), p.9.
57. Published in *L'Art*, July 1883, p.44.
58. Roger Bonniot, *Gustave Courbet en Saintonge*, Paris 1973, p.71.
59. U.S.A., private collection – Exhibition, *Courbet*, 1977, no.9; London, *Courbet*, 1978, no.9.
60. Auguste Viatte, *Les sources occultes du Romantisme*, Paris, 1927, reprinted in 1969, 2 vol.
61. To appear in *La Revue du Louvre et des Musées de France*.
62. Sao Paulo Museum.
63. Borel (*op. cit.*), p.51.
64. Borel (*op. cit.*), p.61.
65. Chevalier (*op. cit.*), II, pp.524–5.
66. 'Du Réalisme, Lettre à Mme Sand' in *L'Artiste*, 2 September 1855; repr. in *Champfleury, Le Réalisme*, texts chosen and presented by Geneviève and Jean Lacombre, Paris 1973, p.177.
67. *Les chefs-d'œuvre du Luxembourg*, Paris, 1881, p.116.
68. Borel (*op. cit.*), pp.63–76.
69. 'Courbet et Chenavard', in *A.G.C.*, Bulletin no.9, 1951, pp.4–6.
70. *Les souvenirs de Schaunard*, Paris, 1886, pp.292–3.
71. Cambridge, U.S.A., Fogg Art Museum, Harvard University; cf. Marie-Thérèse de Forges, 'Autoportraits de Courbet' in *La Revue du Louvre et des Musées de France*, 1972, no.6, p.456; id. Autoportraits de Courbet,

6th Dossier of the Department of Paintings, Musée du Louvre, 1973, pp.35–6.
72. Jeannine Baticle and Pierre Georgel, *Les techniques de la peinture*, *L'atelier*, 12th Dossier of the Department of Paintings, Musée du Louvre, 1976.
73. Lindsay (*op. cit.*), pp.130–1.
74. Musée du Louvre, 1827.
75. Musée du Louvre, Galerie du Jeu de Paume.
76. L.a. of June 1847; sale of autographs from the Benjamin Fillon collection, 15 July 1879.
77. *Exposition Universelle de 1855*, p.209.
78. *Le Salon de 1855*, pp.15–16.
79. Madrid, *Ribera* by Elizabeth Du Gué Trapier, New York, 1952, fig.27.
80. *Realism*, Harmondsworth, 1971, p.122, fig.66, p.259.
81. Watts Gallery.
82. Johannesburg, Art Gallery.
83. Montpellier, Musée Fabre – Exhibition, *Courbet*, 1977, no.37; London, *Courbet*, 1978, no.35.
84. Alfred Bruyas, *La galerie Bruyas*, Paris, 1876, p.182.
85. New York, Metropolitan Museum; drawing in the Louvre – Exhibition, *Courbet*, 1977, no.137; London, *Courbet*, 1978, no 152.
86. Philadelphia, the Pennsylvania Academy of Fine Arts; and Ornans, Musée Gustave Courbet.
87. Algiers, Musée des Beaux-Arts. We have denied that the painting belonging to the Musée Jenish at Vevey, known as the *Portrait of Buchon* is his. Cf. Exhibition, *Courbet*, Rome–Milan, 1969–1970, no.29.
88. Musée du Louvre – Exhibition, *Courbet*, 1977, no.34; London, *Courbet*, 1978, no.32.
89. Montpellier, Musée Fabre, Exhibition, *Courbet*, 1977, no.15; London, *Courbet*, 1978, no.15.
90. Montpellier, Musée Fabre.
91. Borel (*op. cit.*), p.52.
92. Bibliothèque Nationale, Cabinet des Estampes, date of legal deposit, 1853.
93. Borel (*op. cit.*), p.50.
94. Charles Léger, *Courbet*, Paris, 1929, p.172.
95. Alexandre Estignard, *G. Courbet, sa vie et ses œuvres*, Besançon, 1895, p.100.
96. Musée du Louvre – Exhibition, *Courbet*, 1977, no.61; London, *Courbet*, 1978, no.139.
97. Besançon, Musée des Beaux-Arts.
98. New York, Metropolitan Museum.
99. St. Louis, U.S.A. Art Museum – Exhibition, *Courbet*, no.98.
100. Musée du Louvre – Exhibition, *Courbet*, 1977, no.97; London, *Courbet*, 1978, no.92.
101. *Journal*, 3 August 1855.
102. Borel (*op. cit.*), p.50.
103. *Courbet, l'Atelier du peintre, Allegorie réelle, 1855* by René Huyghe, Germain Bazin, Hélène Jean Achérmat, Paris 1944.
104. *Mémoirs inédits de Francis Wey*, Bibliothèque Nationale, Cabinet des Estampes; Manuscript and facsimile.
105. *Courbet, Souvenirs intimes*, Paris, 1880.
106. *Du principe de l'art et de sa destination sociale*, post-humous work appeared in 1865; we refer to the Marcel Rivière édition, Paris, 1939, p.223.
107. Painting of Courbet's youth, Japan, private collection.
108. Borel (*op. cit.*), p.51.

Examination by the Laboratoire de Recherche des Musées de France

by Lola Faillant-Dumas

On the occasion of the *Exposition-Dossier* of Courbet's self-portraits, organized in 1973 by the Department des Peintures of the Musée du Louvre,[1] the Laboratoire de Recherches des Musées de France carried out an X-ray and micro-chemical study of some of the paintings concerned. This threw considerably light on the artist's careful and thorough methods of working, his hesitations and alterations and the process of trial and error involved in the working out of his pictures.

Since then other portraits and compositions of Courbet's have been studied in the Laboratory, and in each case have provided instructive lessons. Some of these have proved to be copies or reworked sketches, or themes rejected by the artist; others are of importance as revealing the development of Courbet's craftsmanship and the ever-increasing vigour and assurance of his technique. In this way scientific analysis has provided fresh documentation of the purpose which he himself defined in the words: 'To record the manners, ideas and aspect of the age as I myself saw them – to be a man as well as a painter, in short to create living art.'

When Courbet painted *The studio* he intended to create a stir. The words 'new' and 'revolutionary' recur time and again in contemporary criticism, whether favourable or hostile. The work indeed reflects to the full Courbet's abundant physical energy and vitality; and we can imagine him smiling, not without gratification, if he were able to see the X-ray photographs of his masterpiece, made a hundred years after his death in order to retrace every stage and uncover every secret of its execution. To examine the whole canvas, 165 X-ray films were necessary.[2] In this catalogue we present the central and lower portion, comprising the 'frieze' of characters, in a form which no doubt answers fairly closely to that conceived by Courbet in the poky and improvised studio in his father's barn at Ornans where, as he records, he had no room to stand back from the canvas.

The X-ray study

The monumental array of figures is even more impressive in black and white than in colour. The X-ray gives a picture of the work 'in depth' by re-creating on a single plane the different stages of its creation, in terms of the greater or lesser density of the oil colours used. Thus figures painted with white lead appear light in the X-ray on account of the high atomic mass of that element, while those painted with earth colours appear dark because of their lack of density.

Courbet alternated light and shade in *The studio* by means of supple dark touches with a broad brush and large white flat patches applied with a palette knife. He thus created a chiaroscuro effect at either side of the picture, converging towards the painter and his model in the centre, who form the densest part of the composition.

In numerous letters to his friends between May 1854 and April 1855, Courbet described at length the conception of the painting and his ideas for its composition and execution. We know that he changed his mind on some points as the work proceeded. Some alterations are visible to the naked eye, as the original layers were not thickly enough covered and tend to show through: e.g. the profile of Jeanne Duval, the hands of the undertaker's mute and the model's drapery. Apart from this, a difference in the appearance of the pigment as between the left-hand side and the rest of the composition has led some historians[3] to surmise that, in the course of execution, Courbet made a change of plan involving an enlargement of the canvas and adding a different ground. It was the object of micro-chemical analysis to answer questions as regards the ground used by Courbet in different parts of the picture, and of the X-ray to throw light on transformations of the support, the density of materials and the method of using them.

To begin with, the X-ray supplied interesting information concerning the support. The picture was relined shortly after its acquisition by the Louvre in 1920. The original canvas, preserved in its entirety, answers to the dimensions indicated by Courbet to Champfleury. It comprises five strips sewn together vertically, plus a horizontal strip on top to give additional height, plus a seventh strip on the left running from top to bottom. The canvas is of linen, somewhat coarse and of close but irregular weave, with an average of 11 warp and 8 woof threads per square centimetre. Each strip, except of course the horizontal one, is sewn on to the next in the same direction as the thread. From a preliminary examination it does not appear that the seventh strip was added subsequently to the others: the seam is similar and there are no nail-marks or signs of the canvas having been turned over, as would be the case if the support had been less wide at the outset.

The composite X-ray of the whole upper part of the picture, not reproduced here, is difficult to decipher, as the support was primed, painted, scraped and repainted. Courbet apparently changed his mind as regards the inclusion of some objects mentioned in his letter of January 1855 to Champfleury. We cannot tell from the X-ray whether he ever actually painted them; if so, he covered them subsequently with patches of ground which, under the X-ray, appear simply as large light areas of high density, with no trace of preparatory drawings, applied rapidly and sweepingly with a broad brush or sometimes a knife.

The X-ray also provides insight into the picture's state of preservation. The paint film is slightly worn in some places and cracked in others. Some dark areas in the lower part and dark shadows at the edges indicate that the paint surface has flaked, but on the whole the picture is in a good state of preservation considering its various adventures: it was rolled up when not yet dry and transported to Paris, remounted on a stretcher, rolled up again, transported and sold several times, and even used as a stage backdrop.

An examination of the assembled X-rays from left to right, and of the figures represented in the picture, throws important light on its history. An obscure area at the top, corresponding to the seventh strip of canvas, presents an opaque area with vague contours on a dense background. The support, though thinly covered, seems to have been primed, cleaned and reprimed; we cannot tell from the X-ray whether the painter used litharge as M. Germain Bazin suggests,[3] but he does seem to have had some difficulty in composing this group. Close study reveals that he first painted the Republican (*veteran de 93*) in a standing position, leaning both hands on a staff or cane, but then erased this version and substituted the seated figure of the *braconnier*. Only the latter's profile and one leg appear clearly, as they were painted with white lead; the rest is a dark mass with vague outlines, owing to the different underlying layers of low-density paint. The addition of this figure led to a change in the composition of the 'romantic paraphernalia' (*défroques romantiques*) in the foreground. A piece of drapery or a dog(?) between the *braconnier*'s feet was painted out; the position of the hat was altered and the guitar added; a change was also made in the dog facing sideways, whose legs seem to have been painted twice over. On the extreme left, the Jew's headgear and the direction of his glance were changed.

The dense, lumpy, appearance of the paint surface in this area of the picture is partly due to reworking which is shown up by X-ray. The succession of layers, causing an alteration in the paint surface, which is also revealed by microchemical analysis.

Continuing the examination of the figures, we find that the scytheman was shifted to the right to make room for a second huntsman who was not part of Courbet's plan as shown in a preliminary sketch. He also changed the position of the hands of the undertaker's mute; the original state has a tendency to reappear.

The lay figure and the Irishwoman suckling her child present no problems. However, the X-ray throws light on Courbet's treatment of this figure: the white patches of her breast, the child's cap and her leg present a contrast with the dark mass of the remainder, recalling X-rays of compositions by Rembrandt.

The central area was the object of much thought and reworking. Courbet is seen retouching a landscape on the easel; his palette, rectangular in the final picture, was originally round. He was accustomed to painting his own features, and executed the present version rapidly, spontaneously and without re-working. In the X-ray the nude model is seen from behind, her buttocks and both legs being shown, whereas in the finished work she is in profile. This has involved a change in the left arm and in the drapery she is holding. The figure as a whole is broadly treated with high-density whites applied with rapid, sweeping brush-strokes.

After painting the cat at his feet Courbet added the charming figure of the small boy, painted with extraordinary lightness and verve. The X-ray shows that the picture on the easel was completely finished when he decided to paint in the child; he did so with rapid strokes with a small hard brush, and the outline of the easel and the picture can be seen showing through.

The addition of the small boy involved moving the cat to the right, thus balancing the central area which constitutes a finished composition in its own right. The paint, which shows up thickly in the X-ray, is applied with the brush or knife and is fluid or clayey by turns, depending on the painter's use of earth colours of low atomic mass or light colours of high density.

Next come the artist's friends – a shadowy area painted with earth colours, with only the faces, of higher density, contrasting as light patches. The small boy drawing on the floor, no doubt the most damaged feature of the whole work, was sketched before the couple in the foreground were painted in, as the outline of his body can be seen beneath the voluminous dress of the lady visitor. Her head and that of her companion have been slightly displaced, and the X-ray shows the lithe silhouette of Jeanne Duval with her face turned towards Baudelaire; the latter is absorbed in a book, as in Courbet's portrait of him in the Montpellier Museum. The X-ray shows for the first time that the table he is seated on originally had legs of Louis XV style.

In the background, the X-ray shows the hammock hung at a lower level than in the final version, with a man standing behind it. His companion's ample dress now conceals the lower part of the hammock and the position he previously occupied.

The right-hand part of *The studio* is the area which has suffered most damage, as witness the flaking of paint especially near the bottom, due perhaps to the canvas being rolled up so many times. It proves to have been one of the groups most freely executed by Courbet: dense work in which we recognize the soft expressive handling of the artist with the alternation of thick touches and glazes. Thus ends our examination of Courbet's *Studio* through the prying but instructive screen of X-ray photography.

Investigation of pictorial material[4]

The examination of minute samples of paint has thrown light on some aspects of Courbet's technique and on the picture's state of preservation.

The overall tonality, which has both dark and warm tints, is accounted for by a fairly thin layer of paint over a ground which varies from a tawny colour to reddish-brown. It consists chiefly of ferruginous earths, brown, red or yellow in colour (ochre, umber), very finely ground with oil. The ground is especially matt in appearance owing to the small amount of binding material, considering the high absorptive capacity of the pigments used. The pigments are sometimes found in clusters of grains of a single colour. The incomplete blending shows that the ground was painted rapidly and somewhat carelessly, perhaps on account of the size of the area to be painted.

The paint layer contains oil in which are mixed some resins: these come, at least in part from the surface varnish which has been absorbed by the paint, having been applied to an insufficiently dry and ill-conserved paint surface.

The left-hand side of the picture has suffered a good deal of change. Apart from the X-ray evidence, the analysis of samples shows that the ground is thinner in places. Moreover, the layer of paint, which is also thin, is less well preserved here than in the rest of the picture.

A white adhesive, which analysis shows to have consisted of wax, glue and white lead, was applied to the back of the original canvas during relining, and has penetrated through this canvas to the painting. The thin paint and probably worn surface offers little resistance to mechanical pressure and the adhesive has at several points seeped through the pigment as far as the varnish, thus producing tiny granulations (the size of a pin's head) which can be seen all over the picture and especially in the strip of canvas on the extreme left. Several authors[3] have suggested that these surface granulations may be due to a ground containing lead pigments, different from that used for the rest of the picture. The examinations, however, have shown that the ground was composed of the same pigments throughout.

Thus laboratory examination of *The studio* has made it possible to retrace the stages of this gigantic composition, the painter's mental processes and the means he adopted to record this 'phase of his artistic life'. The X-ray reconstructs the long evolution of his thought, the changing poses of the figures, and the simplification of the osjects and things so as to concentrate on a single dominant aim. It also illustrates the impetuosity with which Courbet went to work, using a technique found in other pictures of this period such as *The corn sifters*: the powerful rendering of essential elements with thick application of paint, often worked with a knife, and the contrasting use of glazes with a broad, flexible brush for the darker, softer passages wanted by the artist.

The X-ray also shows that the continuity of the pictural material right across the canvas, without any change from one strip of canvas to another. Microchemical analysis, on the other hand, explains the different appearance of the left-hand portion and the work as a whole, the former having suffered more in the relining process on account of previous wear and tear due to the painter's reworkings.

We thus know more than our predecessors did about the picture's internl structure. But if there is still some mystery about Courbet's representation of his symbolic theme, and if it does not correspond precisely to his description of it, should we not respect his right to eliminate one feature or another?

1. Self portrait by Courbet. The *Dossiers* of the Department of Paintings, no.6, Paris 1973 and *Annales* of the Laboratoire de Recherche des Musées de France, 1973.

2. The X-rays have been taken in the following conditions: 50 kV–3 mA–pose: 30 in. distance: 120 m Baltographe camera–100–5. This enterprise was generously carried out by the photographic service of the Laboratoire under the direction of MM. Tournois and Solier.

3. Courbet, monographs of the paintings of the Musée du Louvre, III by MM. René Huyghe, Germain Bazin, Mme Hélène J. Adhémar.

4. Analytical examination carried out by J. P. Rioux.

Designer
Bruno Pfäffli

Photos
Anders, Berlin
Bibliothèque Nationale
Bignon, Dôle
Borel, Marseille
Bulloz
Caisse nationale des monuments historiques
Clements, New York
David
Dingjan, The Hague
Fleming, London
Galerie Daber, Paris
Gérondal
Guignard, Vevey
Held, Ecublens (Suisse)
Mangin, Ornans
Mensy, Besançon
Mills, Liverpool
Newbery
O'Sughrue, Montpellier
Poplin, Villemomble
Réunion des musées nationaux
Rosshandler
Schweiz, Institut fọr Kunstwissenschaft,
Zurich
Stearn & Sons, Cambridge
Studio-Service, Bonn
Roger Viollet
Lending museums

Origination
Colour: Photogravure SOP, France
Monochrome: Haudressy, France